Neo-Avant-Gardes

Neo-Avant-Gardes

Post-War Literary Experiments Across Borders

Edited by Bart Vervaeck

EDINBURGH
University Press

Edinburgh University Press is one of the leading university presses in the UK. We publish academic books and journals in our selected subject areas across the humanities and social sciences, combining cutting-edge scholarship with high editorial and production values to produce academic works of lasting importance. For more information visit our website: edinburghuniversitypress.com

Edinburgh University Press Ltd, The Tun – Holyrood Road, 12(2f) Jackson's Entry, Edinburgh EH8 8PJ

First published in hardback by Edinburgh University Press 2021

Typeset in 10.5/13 Bembo by
IDSUK (DataConnection) Ltd, and
printed and bound by CPI Group (UK) Ltd, Croydon, CR0 4YY

A CIP record for this book is available from the British Library

ISBN 978 1 4744 8609 5 (hardback)
ISBN 978 1 4744 8610 1 (paperback)
ISBN 978 1 4744 8611 8 (webready PDF)
ISBN 978 1 4744 8612 5 (epub)

Contents

Part II: Movements and Authors

Illustrations

Acknowledgements

The present volume resulted from research conducted by ENAG, an international research network sponsored by the Research Foundation – Flanders (FWO). We are very grateful to the Foundation for their support of the network. Many thanks to Thomas Chadwick, who went through all the contributions and improved them considerably. Special thanks to all the people at Edinburgh University Press, most specifically Jackie Jones, Ersev Ersoy, Caitlin Murphy, Fiona Conn, Amanda Speake and Eliza Wright. The Josef Albers manuscripts and poems quoted in Chapter 2 are courtesy of the Josef and Anni Albers foundation.

Notes on Contributors

Inge Arteel is Associate Professor of German Literature at the Free University of Brussels (VUB). Her research focuses on post-1945 and contemporary literature and drama in German, on text and theatricality, the radio play, and gender studies. She is the author of two monographs on Friederike Mayröcker (Wehrhahn, 2012; Aisthesis, 2007). Recent contributions and co-edited volumes address the lyrical in Mayröcker's poetry (Metzler, 2020, with Eleonore De Felip), literary neo-avant-gardes in Dutch and German (Legenda, 2020, with Lars Bernaerts and Olivier Couder), and radio plays by George Tabori (*Germanistische Mitteilungen*, 45 (1–2), 2019) and Gerhard Rühm (*CounterText*, 5 (3), 2019).

Jan Baetens teaches in the MA programme in cultural studies at the University of Leuven. He regularly publishes on word and image questions in popular genres such as comics, photonovels, or novelisations. Some recent books are: *The Cambridge History of the Graphic Novel* (Cambridge University Press, 2018, co-edited with Hugo Frey), *The Film Photonovel: A Cultural History of Forgotten Adaptations* (Texas University Press, 2019) and *Rebuilding Storyworlds* (Rutgers University Press, 2020).

Jeff Barda is a lecturer in French cultural studies at the University of Manchester. He is the author of *Experimentation and the Lyric in Contemporary French Poetry* (Palgrave, 2019) and the co-editor with Daniel Finch-Race of *Textures: Processus et événements dans la création poétique moderne et contemporaine* (Peter Lang, 2015). His solo publications include several articles that bring French poetic practice into contact with sound, performance, digital practice and law. He is currently co-editing with Philippe Charron a special volume on Pierre Alferi (forthcoming with Presses du Réel in 2021) and working on his second monograph.

Lars Bernaerts teaches Dutch literature at Ghent University. His research and publications focus on narrative theory, experimental fiction, contemporary Dutch literature, and the literary radio play. Recent publications include *Luister-rijk der letteren. Hoorspel en literatuur in Nederland en Vlaanderen* (2020, co-edited with Siebe Bluijs) and *Confrontational Readings: Literary Neo-Avant-Gardes in Dutch and German* (2020, co-edited with Inge Arteel and Olivier Couder). Together with the partners of ENAG, he edits the *Online Encyclopedia of Literary Neo-Avant-Gardes* (www.oeln.net).

Vincent Broqua is Professor of North American literature and arts at the university of Paris 8 Vincennes Saint-Denis. His work explores experimental artistic practices from Gertrude Stein to the contemporary period, notably US poetry. His research also focuses on translation studies and research creation. His books include *À partir de rien: esthétique, poétique et politique de l'infime* (2013) and *Malgré la ligne droite: l'écriture américaine de Josef Albers* (2021). In 2019, he co-edited with Dirk Weissmann the first edited trilingual volume on homophonic translation: *Sound/Writing: traduire-écrire entre le son et le sens. Homophonic translation – traducson – Oberflächenübersetzung* (open access: https://www.archivescontemporaines.com/books/9782813002686).

Benoît Crucifix is a researcher in literary history and visual culture, specialised in comics studies. As an FNRS fellow, he completed a PhD thesis at the University of Liège and UCLouvain about comics memory in the contemporary North American graphic novel. His postdoctoral research project, as part of the ERC-funded programme 'COMICS' at Ghent University, focuses on children's drawing and creative tactics of child readers in European French-language comics. He has co-edited with Maaheen Ahmed the essay collection *Comics Memory: Archives and Styles* (Palgrave, 2018) and with ACME the two-volume *Abstraction and Comics | Bande dessinée et Abstraction* (PULg | 5c, 2019).

Dirk De Geest is Professor of Modern Dutch Literature and Literary Theory at the University of Leuven. He has published widely on Dutch literature, literary theory, especially genre theory and systems theory. His recent publications include a monograph on the Flemish Days of Poetry (2017) and articles on neo-avant-garde poetry. He is currently writing a history of post-war poetry in the Low Countries, focusing amongst other things on the role of neo-avant-garde practices.

Michel Delville teaches English and American literatures, as well as comparative literature, at the University of Liège, where he directs the Interdisciplinary

Center for Applied Poetics. He is the author or co-author of around twenty books including *The American Prose Poem: Poetic Form and the Boundaries of Genre*; *J.G. Ballard*; *Frank Zappa, Captain Beefheart, and the Secret History of Maximalism* (with Andrew Norris); *Food, Poetry, and the Aesthetics of Consumption: Eating the Avant-Garde*; *Crossroads Poetics: Text, Image, Music Film & Beyond*; *The Political Aesthetics of Hunger and Disgust* (with Andrew Norris); and *Undoing Art* (with Mary Ann Caws).

Lieselot De Taeye is an FWO postdoctoral fellow at Ghent University. She completed her PhD in Dutch Literature in 2018. Her doctoral dissertation *Tegen het verzinnen* [Against Fiction] examined the literary experiments with non-fiction emerging in the 1960s counterculture in Flanders and the Netherlands. From September 2018 till February 2020 she was a visiting scholar at UC Berkeley. Her current research project investigates the roles of religion and Middle African cosmologies in narratives on Congo published between 1945 and 1975.

Thomas Eder is a lecturer at the University of Vienna (Department for German Studies). He focuses on literary theory and avant-garde studies and has authored several articles on the topic as well edited books on the post-war avant-garde (Vienna Group, Oswald Wiener, Elfriede Jelinek, Heimrad Bäcker, Konrad Bayer, Reinhard Priessnitz, Franz Josef Czernin). Currently he is working on his habilitation thesis, 'Cognitive Poetics. A Critical Re-evaluation', in which he critically examines theoretical issues and applies these theories mainly to works of the avant-gardes.

Roland Innerhofer is Professor of Modern German Literature at Vienna University. His main research areas are literature of the nineteenth and twentieth centuries; fantastic literature, utopias, SF; (neo-)avant-garde literature; and interrelationships between literature, technology, architecture and film. Some recent publications are: *Architektur aus Sprache. Korrespondenzen zwischen Literatur und Baukunst* (Erich Schmidt, 2019); 'Euthanasie und individueller Tod in Franz Werfels Stern der Ungeborenen' (in *Tiefe. Kulturgeschichte ihrer Konzepte, Figuren und Praktiken*, de Gruyter, 2020); and 'Wohnformen des Jungen Wien' (in *Das Junge Wien – Orte und Spielräume der Wiener Moderne*, de Gruyter, 2020).

Nele Janssens is a doctoral researcher affiliated to the Dutch Literary Department of Ghent University. She studies Flemish and Dutch lyrical prose that was published between 1960 and 1975. Her research resulted in a dissertation entitled *Schreeuwend, zwijgend, zingend, tastend. Lyricisering van*

Nederlandstalig proza in de lange jaren zestig (1960–1975), which she defended in January 2021. Janssens is a member of ENAG and of the Study Centre for Experimental Literature (SEL), a research group that focuses on Dutch experimental literature.

Ilse Logie is professor of Spanish in the Department of Literary Studies at Ghent University. Her main research areas are contemporary Latin American narrative (with a special focus on the representation of violence in the Southern Cone) and literary translation. She is the author of *La omnipresencia de la mímesis en la obra de Manuel Puig* (Rodopi, 2001) and the (co-)editor of *Imaginarios apocalípticos en la literatura hispanoamericana contemporánea* (2010), *Juan José Saer. La construcción de una obra* (2013) and *El canon en la narrativa contemporánea del Caribe y del Cono Sur* (2014). Her work has also appeared in *Revista Iberoamericana*, *Acta literaria* and *Iberoamericana*.

Sabine Müller is a scholar of literary and cultural studies at the Department of German Studies at the University of Vienna. Currently she is working on her habilitation thesis in literary studies. She is funded by a habilitation grant by the Austrian Science Fund FWF, which was preceded by a FWF-Postdoc-Grant (2013–17). Between 2006 and 2012 she was researcher at the Institute of Culture Studies and Theatre History at the Austrian Academy of Sciences in Vienna. Currently she is director of the third-party-funded projects 'Atlas of the Viennese Avant-Garde' and 'Understanding democracy. Voicing collectivity in the long 19th century'. Her main areas of research are Austrian avant-gardes, German and Austrian literary and cultural history of the twentieth century, and literary and cultural theory.

Christine Pagnoulle is a practising translator and a retired lecturer at the University of Liège (English literatures and translation). Her fields of research include translation studies and postcolonial literatures. Next to articles and collections of essays (on translation studies) she has published translations of poems in magazines and anthologies as well as in book form, among which Kamau Brathwaite's *DreamHaiti/RêvHaïti* (Mémoire d'encrier, 2013), David Jones's Great War epic *In Parenthesis/Entre parenthèses* (EPURe, 2019) and Lawrence Scott's novel *Witchbroom/Balai de sorcière* (Mémoire d'encrier, 2020). Her translations of other collections by Brathwaite are in search of publishers.

Jean-François Puff is Professor of French literature of the twentieth and twenty-first century at CYU Paris Cergy Université, specialised in French poetry and poetics. He writes poetry and he is an editor, at his recently created

Éditions L'Usage. He has published works on modern poetry (from Mallarmé to Surrealism) and contemporary poetry (mainly on the works of Jacques Roubaud and Emmanuel Hocquard). He has focused his interest on poetic forms and on creative processes, as well as on the theory of the subject in poetry. This topic is developed in his most recent book, *Le Gouvernement des poètes. La poésie dans la conduite de la vie* (Hermann, 2020), which presents a conception of poetic practice as a practical relationship to oneself, in a Wittgensteinian perspective. He presently works on the question of oralisation of poetry and on the use of audio archives.

Antonia Rigaud is associate professor in American Studies at Sorbonne Nouvelle University in Paris and a CNRS visiting fellow at Larca, Université de Paris (2020–21). Her research focuses on American art, literature and performance in the twentieth century. She is the author of *John Cage. Théoricien de l'utopie* (Harmattan, 2006) and has published articles on American art, literature and performance. Her current research looks at the intersections between radical art and politics in the United States from the early twentieth century to today.

Laura Tezarek is a research assistant and PhD student at the Department of German Studies at the University of Vienna. She studied at the University of Vienna and the École normale supérieure in Paris. Her main research interests include twentieth-century Austrian literature, especially neo-avant-garde literature and digital humanities, with her current research focusing on Andreas Okopenko and the early Austrian neo-avant-garde network.

Gaëlle Théval studied at the ENS-Lyon and teaches at Rouen University. She is a member of the MARGE laboratory (University of Lyon 3). Her research focuses on experimental poetry since the 1960s (visual poetry, soundpoetry, videopoetry, performance art), as well as on contemporary poetry. Her main publications include *Poésie & ready-made* (L'Harmattan, 2015); *Livre/poésie: une histoire en pratique(s)* (co-edited with S. Lesiewicz and H. Campaignolle, Editions des Cendres, 2016) and *Poésie & performance* (co-edited with O. Penot-Lacassagne, Editions Nouvelles Cécile Defaut, 2018).

Hans Vandevoorde teaches Dutch literature at the Free University of Brussels (VUB). He is one of the coordinators of the Centre for the Study of Experimental Literature (CEL/SEL) and a member of the Steering Committee of ENAG (the international research community on European Neo-Avant-Garde). During the past decades, he has published several volumes and articles

on nineteenth-century, fin de siècle and interbellum literature and culture, and on post-war poetry. Recent publications are on 'Fictional Autobiography' (in *Handbook of Autobiography/Autofiction*, 2019) and on 'Wartime Diary Writing' (*BTFG*, 2020, together with Arvi Sepp).

Hannah Van Hove is a postdoctoral fellow of the Research Foundation – Flanders (FWO) at the Free University of Brussels (VUB) where she is working on a research project focusing on British post-war experimental women writers. She completed her PhD on the neglected fiction of Anna Kavan, Alexander Trocchi and Ann Quin at the University of Glasgow in March 2017. She has published reviews and articles on mid-twentieth-century avant-garde fiction and has translated some of Flemish modernist Paul van Ostaijen's poetry. She is Chair of the Anna Kavan Society and sits on the editorial board of the *Journal for Literary and Intermedial Crossings*.

Bart Vervaeck is Professor of Dutch Literature and Narrative Theory at the University of Leuven. His research focuses on the post-war novel and on narratology. He is the author of monographs on postmodern fiction and on literary descents into hell. With Luc Herman he has published in journals such as *Narrative*, *Style* and *Poetics Today*. Together they also wrote *Handbook of Narrative Analysis* (2nd edn, University of Nebraska Press, 2019).

Christian Zolles is a Postdoctoral Research Assistant at the Department of German Studies at the University of Vienna and a reader in Modern German Literature. He obtained his PhD in German Studies and History in Vienna, with fellowships at the University of Glasgow and the Center for Literary and Cultural Research in Berlin (ZfL). In his research, he is working at the intersection of literary studies, cultural theory and digital humanities. He is author and co-editor of several publications on the *Cultural History of Apocalyptic Thought* (De Gruyter series), on Austrian literary history, and on digital humanities in the field of German Studies.

Introduction: Neo–Avant–Garde, Why Bother?

ENAG – European Neo-Avant-Garde Collective[1]

During the long sixties – the period stretching roughly from 1955 to 1975 (Strain 2017; McHale 2016) – profound social, political and cultural changes were the order of the day. In art, pioneering trends such as Zero, Fluxus, *arte povera*, minimal art, new surrealism, pop art and *nouveau réalisme*, new Dadaism, conceptual art, performance art, happenings and body art were at one time or another linked to the historical movement of the avant-garde, which remained dominant during the inter-war period. They were considered a new incarnation of the historical avant-garde, whose views, techniques and postures were confronted with and transformed by the social, technological and aesthetic upheavals of the 1960s.

Some art historians study the historical avant-garde in relation to modernism and the neo-avant-garde in relation to postmodernism. Isabel Nogueira (2013) even proposed an integrated art history of the twentieth century on the basis of these four frames: modernism, historical avant-garde, neo-avant-garde and postmodernism. Intricate similarities and oppositions hold these movements together, and more than one of these four dimensions may be at work in a specific period, artistic group or individual work. Still, Nogueira presents a nuanced and interesting perspective on twentieth century art by discussing the first half in terms of modernism and the historical avant-garde, and the second half in terms of the neo-avant-garde and postmodernism. In a similar vein, Mark Crinson and Claire Zimmerman (2010) study post-war architectural innovations in terms of the neo-avant-garde (fifties and sixties) and postmodernism (from the seventies onward). Aleš Erjavec (2003) proposes to study the innovations in Yugoslavian art between 1920 and 1990 in terms of 'three avant-gardes', namely the 'early' form (the historical avant-garde), the 'neo' and the 'postmodern'.

This short list of studies in art history which use the term 'neo-avant-garde' to get to grips with post-war developments and renewals could be endlessly expanded upon. Though the term 'neo-avant-garde' and its concomitant reference to the historical avant-garde have become ubiquitous in art history, neither the label nor the historical linkage have yet made it into the canon of literary historiography. Moreover, the term is sometimes used without any precise definition;[2] hence the need for a theoretically and historically informed study of the history of the term and its creative instantiations over the last few decades. Among recent valuable contributions to the field we would mention Jonas Ingvarsson and Jesper Olsson's enlightening interdisciplinary collection of essays on the artistic media transformation from 'the postwar period of the twentieth century, and more specifically, the Cold War epoch' (2012: 8), which uses the term 'neo-avant-garde' to bring together such diverse phenomena as Fluxus and concrete poetry. Likewise, David Hopkins's *Neo-Avant-Garde* gathers specialists in art and literature who are 'committed to employing the neo-avant-garde as a workable concept, at least for the purposes of trying to pinpoint the defining features of the cultural production of the 1950s, 60s and 70s' (2006: 8). As Hopkins states at the outset, his volume sheds new light on the neo-avant-garde insofar as it uses the term to tackle not just 'fine art', but also other genres such as poetry, performance and drama (2006: 1).

The conspicuous reluctance to use the term 'neo-avant-garde' in literary studies may have to do with the fact that the label was hardly ever used during the 1960s by literary writers, critics or theoreticians themselves. Perhaps this is partly due to the strong identity claims on more specific, culturally and/or geographically determined currents and groups, such as the Vijftigers/Fifties (Low Countries), Gruppe 47 (Germany), the Wiener Gruppe/Vienna Group (Austria) or the *nouveau roman* (France). In 1978, the Dutch author and critic Sybren Polet published a collection of experimental narrative texts and called it *Ander Proza* ('Other prose'). The collection opened with texts from the historical avant-garde, most famously Theo van Doesburg's Dada fiction. Still, the term 'neo-avant-garde' does not occur in the book nor in other discussions of innovative prose from the long sixties. Instead, critics and writers used the label 'experimental fiction'. It is only in hindsight that one might re-label 'other prose' as 'neo-avant-garde' (Vervaeck 2013: 79–85). Similarly, artists in post-war Austria that strove for radical aesthetic innovation rejected the label 'neo-avant-garde'. The prefix 'neo' had for them the *haut goût* of reanimation, of something stale and obsolete. Correspondingly, in Austrian post-war literature traditionalist writers and critics used the prefix, for instance in 'Neo-Dada', as a derogatory term (Innerhofer 1985: 28).

The critical reluctance towards the term 'neo-avant-garde' may also have to do with a broader critical weariness when it comes to the prefixal categories and

obsessions of literary history, at a time when 'neo', 'post' and 'avant' have been affixed – often in conflicting and contradictory ways – to almost every concept, trend, genre or theoretical framework regarding the goals and methods of post-war art and literature. In this respect, the term 'experimental' seems more open-ended as it bypasses the conundrums of fixed temporal periods. Yet the strength of its all-encompassing nature might also be its specific flaw. Based on the recognition that the term 'neo-avant-garde' helps to define specific national and transnational literary trends, this book purports to explore the relevance of the concept of a neo-avant-garde for the study of literary innovations in the long sixties and beyond. As will become clear, we use a transnational perspective that eschews hierarchical ideas of the centre (the source of influence) and the periphery (the almost passive recipient) and that studies international contact as forms of discussions and networks of bidirectional exchanges. Thus, the analyses of Josef Albers and concrete poetry, of Mario Bellatin, and of the Black Arts Movement proposed in this book, reappraise ideas of central and marginal cultures and areas.

This Introduction first looks at some influential recent studies concerning the neo-avant-garde. It then presents our own understanding of the term and draws attention to the pros and cons of its usage. Finally, the Introduction will look at the relevance of the neo-avant-garde frame for the study of the various literary traditions that are discussed in this book, especially based on – but not restricted to – Dutch, French, Austrian, German, British, Caribbean and American examples. This will include an exploration of the possible relevance of neo-avant-garde productions for contemporary writers.

Our attempt to reorient the study of 'experimental' literature by means of a reconceptualisation of the artistic neo-avant-garde is necessarily selective and in that respect incomplete and patchy. As a consequence, the book is not to be read as a representative, let alone an exhaustive, form of historiography, but rather as an intervention, aimed at prompting a new paradigm in literary historiography. In geographical terms, too, the scope has its limits. We do pay attention to North and South America, to the Caribbean tradition and we are mindful of the dangers of Eurocentrism, which are discussed, for instance, by Christine Pagnoulle and Ilse Logie in their studies of Kamau Brathwaite and Mario Bellatin respectively. Still, the corpus of texts we analyse has a strong European focus, which adds coherence to the project but which, once more, shows that our volume presents a selection rather than an exhaustive overview.

NEW BUT BAD AVANT-GARDE

The most radically innovative art of the 1950s and 1960s was regularly labelled as a new form of the avant-garde. As Hal Foster remarks at the outset of his

hallmark study *The Return of the Real*: 'Postwar culture in North America and Western Europe is swamped by *neos* and *posts*' (1996: 1). As for the term 'neo-Dada', it was used by Robert Rosenblum with regard to the visual art of Robert Rauschenberg and Jasper Johns (Dezeuze 2006) but was also applied to the quite different art of Andy Warhol (Donald Judd in Buchloh 2000: 523–4). In literature too, 'neo' was a label with which artists could identify and which proved useful to critics. Even though the term 'neo-avant-garde' was not used in the 1960s and 1970s, the 'Digital Archive of Belgian Neo-Avant-Garde Periodicals'[3] shows that neo-terms (such as neo-surrealism, neo-constructivism and neo-expressionism) were quite popular in texts about experimental literature and art. In international theory it seems to have become widespread only after the initial dismissal of the phenomenon by Peter Bürger (cf. Hopkins 2006: 2).

As is well known, Bürger's *Theory of the Avant-Garde* (1984, originally published in German in 1974) offered a largely utopian view of the avant-garde and a rather dystopian picture of the neo- or post-avant-garde. Bürger's historical avant-garde reacted against the modernist reification and autonomisation of art; it attacked the institution of art (not via a nihilistic destruction but via a Hegelian *Aufhebung* or sublation) and it tried to reconnect art with life. Sadly enough, this attempt failed – according to Bürger because 'the social institution that is art proved resistant to the avant-gardiste attack' ([1974] 1984: 57); according to Dietrich Scheunemann (2005: 35–6) because of the political crises of the thirties; and to which we would add the broader social and economic crises. Whatever the reason, the avant-gardist utopia failed to materialise. After the Second World War, neo-artists used the historical avant-garde and its techniques to legitimise their art, banking on and enhancing the fashionable and institutionalised status of the avant-garde. The original revolutionary ethos, with its refusal of autonomous and institutionalised art, is defeated by what Bürger perceives as the necessary 'institutionaliz[ation of] the *avant-garde as art*': because the social effects of art are irremediably determined by its status as a product, not by 'the consciousness artists have of their activity'; 'the happenings, for example, which could be called neo-avant-gardiste, can no longer attain the protest value of Dadaist manifestations, even though they may be prepared and executed more perfectly than the former' (Bürger [1974] 1984: 57).

While the neo-avant-garde may thus seem to be a perfectly tuned re-enactment, it is in fact essentially an empty rehearsal: 'Neo-avant-garde, which stages for a second time the avant-gardiste break with tradition, becomes a manifestation that is void of sense and that permits the positing of any meaning whatever' (Bürger [1974] 1984: 61). Avant-garde techniques and contents that used to be shocking are turned into easily assimilated gimmicks, empty procedures that can be reproduced and grasped by all.

Benjamin Buchloh (1984), Hal Foster (1996) and Dietrich Scheunemann (2005) have separately criticised Bürger both for his overly positive ideas about the avant-garde and for his bleakly pessimistic conceptualisation of the neo-avant-garde. In general one might say that Bürger's claims were deemed too theoretical (i.e. not really backed up by a lot of concrete examples), too homogeneous (discarding the extreme differences between the many forms of the avant-garde), too teleological (as if history were a living organism with an intention of its own), and too general, especially with regard to concepts such as 'institution' and 'life'. Quoting Anne Friedberg and Germaine Dulac, Scheunemann, for instance, demonstrates that avant-garde cinema wanted very much to be institutionalised and recognised as autonomous art, as it aspired 'to have the cinematic medium taken seriously as an art form' (Friedberg in Scheunemann 2005: 19). The same could be argued about cubism, expressionism, constructivism and, to a lesser extent, futurism, which, far from striving for a reintegration of art and life, embodied in different but related ways the modernist ideals of subjectivism and aesthetic autonomy.

More generally, these 'isms' rejected mimetic, retinal and photographic models, turning away from (or emphatically revealing) conventions of realistic, linear representation in both painting and literature. Buchloh expresses his reservations about Bürger's model as follows and calls for a more historicised and discriminating approach to the complexities and contradictions of critical narratives of the avant-garde:

> Does Bürger seriously believe that it was John Heartfield's primary concern in 1939 to 'destroy art as an institution set off from the praxis of life'? Or, to take the opposite case, would Dalí and Picabia—Surrealists who flirted with fascism at the same time—have cared about this proposal? If theorization of this entire period is at all possible—and Bürger himself voices doubts near the end of his essay when he quotes Adorno's statement that the degree of irrationality in late capitalist society no longer allows for theorization—it would require a much closer and more thorough reading of art history and its constructs and texts. (Buchloh 1984: 19)

Before we present some alternative standpoints on the neo-avant-garde, attention must be paid to Bürger's reaction to the criticisms levelled against him. In 2010 he published a long essay on 'Avant-Garde and Neo-Avant-Garde', which directly addressed (and attacked) some of his critics. On the whole, Bürger recognises the shortcomings in his conceptualisation of the neo-avant-garde, but he sticks to the central claims of his slant on the historical avant-garde. Responding to the critique that his presentation of the avant-garde was

too theoretical and too homogeneous, he reaffirmed his earlier standpoint, saying that his book was titled a 'Theory' and not a 'Historiography':

> There are, of course, differences between futurism, Dada, surrealism and constructivism, for example in their orientation toward technology. A history of the avant-garde movements would have to represent these differences, which can be demonstrated by tracing the intellectual altercations between the various groupings. Theory pursues other goals; thus *Theory of the Avant-Garde* tries to make visible the historical epoch in which the development of art in bourgeois society can be recognized. To this end, it needs to undertake generalizations that are set at a much higher level of abstraction than the generalizations of historians. (Bürger 2010: 703)

Bürger agrees that different avant-garde movements have different aims, and he admits, for instance, that surrealism was not really against institutionalisation or even against tradition (2010: 704). However, in his view these instances of concrete, historical data do not invalidate the general theory.

The failure of the avant-garde project, proclaimed many times in the *Theory of the Avant-Garde*, is integral to Bürger's negative view of the neo-avant-garde. Yet whereas he seems to recognise that his take on the neo-avant-garde may be in need of some adjustment, he sticks to his idea of failure. He starts by redefining it. He says that it consists of three aspects:

> (1) The failure of the desired reintroduction of art into the praxis of life. This aspect was intuited by the avant-gardists themselves and Dadaists and surrealists even made it into a component of their project. (2) The recognition of their manifestations by the art institution, that is, their canonization as milestones in the development of art in modernity. (3) The false actualization of their utopian project in the aestheticization of everyday life. (Bürger 2010: 704–5)

The avant-garde did not realise its ambitious aims, but it did have some lasting effects. It offered techniques that became part of the everyday artistic toolbox, and it destroyed once and for all the idea of one superior or universal art form: 'The historical avant-garde movements were unable to destroy art as an institution; but they did destroy the possibility that a given school can present itself with the claim to universal validity' (Bürger [1974] 1984: 87). Moreover, their utopian ideas are a necessary corrective to the lack of ideals in bourgeois society. As Bürger states in his 2010 essay:

> It is precisely in its extravagance that the project of the avant-garde serves as an indispensible [sic] corrective to a society foundering in its pursuit of

egoistical goals. This project was by no means conceptualized as purely aesthetic but also, at least for the surrealists, as moral. (Bürger 2010: 700)

Just as Bürger sticks to his conceptualisation of the historical avant-garde and its failure to prevent the canonisation and commodification of its post-war legacy, it should not come as a surprise that the change in his assessment of the neo-avant-garde is similarly slight. At first, Bürger partly agrees with his critics, for instance with Buchloh: 'There is, however, one point in Buchloh's critique where he does locate a real shortcoming in *Theory of the Avant-Garde*. It concerns the characterization of the post-avant-garde situation of art' (2010: 703). After a short discussion of the positions taken by defenders of the neo-avant-garde, such as Buchloh and Foster, he proposes an interesting distinction between three forms of historical relations of similarity. The neo-avant-garde is similar to the historical avant-garde, but how can we conceptualise this relation of analogy? A first possibility is the 'conscious resumption within a different context' (2010: 710). That is the view defended by Bürger in 2010. He contrasts it with a second, psychoanalytic and trauma-inspired view that looks upon the reappearance as an 'unconscious, compulsive repetition' (2010: 711). For Bürger, however, a psychoanalytic concept which depends on the unconscious cannot simply be applied to 'historical processes undertaken by conscious, active individuals' (2010: 710).

Here Bürger explicitly turns against Hal Foster, who, as we shall see, tries to study the neo-forms of the avant-garde in terms of the Freudian concept of 'deferred action'. Foster's theory of the neo-avant-garde frames a number of fundamental issues relating to causality, temporality and narrativity of the 'neo' and the 'avant'. For instance: 'Are the postwar moments passive repetitions of the prewar moments, or does the neo-avant-garde act on the historical avant-garde in ways that we can only now appreciate?' (Foster 1996: 4). Criticising Bürger's projections of 'the historical avant-garde as an *absolute origin* whose aesthetic transformations are fully significant and historically effective', Foster asks: 'Did Duchamp *appear* as "Duchamp"? Of course not, yet he is often presented as born full-blown from his own forehead. Did *Les Demoiselles d'Avignon* of Picasso *emerge* as the crux of modernist painting that it is now taken to be?' (1996: 8).

What these examples suggest is that 'deferred action' is more than just repetition, as it implies that the reprise makes the original understandable. Apart from conscious resumption and unconscious repetition, there is a third type of historical similarity, namely the 'return': 'A later event illuminates a previous one, without there being a demonstrable continuity between them. Here we are dealing with what Benjamin called a *constellation* [. . .]. May 1968 made surrealism legible in a manner that it had not been legible previously.' As Bürger concludes: 'This constellation underlies *Theory of the Avant-Garde*' (2010: 711).

To refine the neo-avant-garde resumption, Bürger offers two characteristics that distinguish the historical-avant-garde from its post-war reincarnation: the intention and the context. The neo-avant-garde gave up the intention of the historical avant-garde, namely 'the utopian project of sublating the institution of art' (2010: 712). In addition, 'the historical avant-gardes could rightly consider the social context of their actions to be one of crisis, if not revolution' (2010: 712), whereas this transgressive context no longer holds for the neo-avant-garde. Bürger seems to imply that the context of the 1960s is not to be grasped in terms of crisis and revolution. This last claim is particularly dubious since, even though the historical contexts of the avant-garde and the neo-avant-garde differ substantially, the prototypical presentation of that period tends to highlight these two traits.

We now turn to some of Bürger's critics with a view to describing some alternative takes on the neo-avant-garde while flagging a number of major pitfalls of avant-garde theory. What interests us most particularly is (a) the way they conceptualise the relation between the historical and the neo-avant-garde, and (b) the way they interpret the relation between the neo-avant-garde and the contemporary political, social and cultural context. The first aspect consists of a theoretical side (what kind of frame and concept does the theorist use in linking the pre- and post-war avant-gardes?), and a practical, historiographic side (in which sequence of phases are historical and neo-avant-gardes placed?). As to the second aspect, it will become clear that Bürger's critics share the same basic social and ideological view on art: it only deserves to be called art if it is critical of the context in which it flourishes. In that sense, all of the theorists we discuss, regardless of their respective camps, tend to be evaluative, and this approach underpins any critical process geared towards any structural or theoretical understanding of post-war art theory and criticism.

NEW AND NICE AVANT-GARDE

Hal Foster, undeniably one of the most influential theorists of the neo-avant-garde, conceptualises the relation between the new and the old avant-garde in psychoanalytical terms. The central term is 'deferred action' ('Nachträglichkeit' following Freud, although one can also find the terms 'après-coup' and 'afterwardsness' alongside this canonical translation); the two subsidiary terms are 'anticipation' and 'reconstruction'. As Foster says in the introduction to *The Return of the Real*:

> In Freud an event is registered as traumatic only through a later event that recodes it retroactively, in deferred action. Here I propose that the significance of avant-garde events is produced in an analogous way, through a complex relay of anticipation and reconstruction. (Foster 1996: xii)

The shock tactics of the historical avant-garde are thus likened to a trauma, and one could wonder with Bürger (2010: 711) to whom the avant-garde could have been traumatic and what is so traumatic about it. The idea of trauma implies an event which cannot be fully grasped or recognised at the time it is experienced. Only later, after many refractions of the initial shock have occurred, can it be comprehended and reconstructed. In between the two moments, intimations and anticipations of the enlightening go hand in hand with reconstructions of the trauma. Not that the moment of 'coming to terms' is in any way final. History is an endless process of rewriting, that is, of anticipation, reconstruction and deferred action. In that sense, there is a kind of simultaneity in history as the anticipated and the reconstructed are interdependent. Foster posits 'a temporal exchange between historical and neo avant-gardes, a complex relation of anticipation and reconstruction' (1996: 13). The psychoanalytic trauma theory of 'Freud, especially as read through Lacan' (1996: 29) is used to describe cultural processes:

> historical and neo-avant-gardes are constituted in a similar way, as a continual process of protension and retension, a complex relay of anticipated futures and reconstructed pasts – in short, in a deferred action that throws over any simple scheme of before and after, cause and effect, origin and repetition. (Foster 1996: 29)

Along the same lines, postmodernism is 'in a *nachträglich* relation' to modernism (1996: 32).

As we mentioned earlier, Foster claims that Bürger has a 'blind spot [. . .] concerning the deferred temporality of artistic signification' (1996: 8). Bürger talks of the avant-garde as if it suddenly appeared and was immediately grasped as avant-garde. In reality, Duchamp only became the revolutionary avant-gardist through a gradual process of anticipation and reconstruction, which deferred the recognition. According to Foster, Bürger has a simplified perspective on history, as he starts from a drastic and unique beginning (the avant-garde shock) which can never be repeated or reconstructed. In Marx's terms, the initial tragedy can only return as a farce (Marx 1960: 115). This, Foster claims, does no justice to the simultaneity and the paradoxical combination of historically different phases.

That of course does not mean that Foster does away with periodisation. He distinguishes between two steps in the neo-avant-garde's deferred action. The late 1950s with the return of 'the readymades of Duchampian dada' and the early 1960s with the return of 'the contingent structures of Russian constructivism' (1996: 4) together make up the first phase (which Foster confusingly designates as 'two returns'). The second phase is situated in the early 1960s, with artists such

as Carl Andre and Dan Flavin, and then in the late 1960s, with artists such as Marcel Broodthaers and Daniel Buren. The first phase is more of a 'repetition' (1996: 21) than the second, which is more critical (1996: 24) because it works through the contradictions of the historical avant-garde. The first phase represses (in the Freudian sense) those contradictions by placing the historical avant-garde in an institutionalised context. The second phase involves 'a critique of this process of acculturation and/or accommodation. [...] More generally, this becoming-institutional prompts in the second neo-avant-garde a creative analysis of the limitations of both historical and first neo-avant-gardes' (1996: 24).

Foster is careful not to 'render the second neo-avant-garde heroic' (1996: 25), and in all his analyses he draws attention to the often contradictory workings of the neo-avant-garde, simultaneously attacking and confirming late capitalist logic, for instance in minimalism and pop (1996: 66) or in the works of Jasper Johns and Jeff Koons (1996: 109). In the eighties, this sometimes led to 'satiric literalizations' and 'strategic inversions', which Foster conceptualises in terms of Peter Sloterdijk's 'cynical reason', that is, 'enlightened false consciousness' (1996: 118). Notwithstanding all those nuances, the net effect of Foster's deferred action is that it implies a positive revaluation of the neo-avant-garde, which is no longer discarded as a destruction of the historical avant-garde, a form of emptying and banalising avant-garde poetics, techniques and contents. On the contrary, it becomes a first revelation of its actual meaning, function and importance: 'rather than cancel the project of the historical avant-garde, might the neo-avant-garde comprehend it for the first time?' (1996: 15). Foster enumerates three ways in which the neo-avant-garde 'comprehends' its historical predecessor:

> (1) the institution of art is grasped as such not with the historical avant-garde but with the neo-avant-garde; (2) the neo-avant-garde at its best addresses this institution with a creative analysis at once specific and deconstructive (not a nihilistic attack at once abstract and anarchistic, as often with the historical avant-garde); and (3) rather than cancel the historical avant-garde, the neo-avant-garde enacts its project for the first time – a first time that, again, is theoretically endless. (Foster 1996: 20)

By trying to convince his readers of the critical value of the neo-avant-garde, Foster ironically embraces the same normative frame as Bürger: art is only valuable if it is critical. Contrary to Bürger, he locates this critical power in the aesthetic (form) itself, rather than in artistic intentions. He insists 'that critical theory is immanent to innovative art, and that the relative autonomy of the aesthetic can be a critical resource' (1996: xvi). This is a bit of a circular enterprise, as Foster deliberately excludes non-critical artistic innovations from

the outset: 'I will focus on returns that aspire to a critical consciousness of both artistic conventions and historical conditions' (1996: 1).

The critical and institutional aspects are important not only in Foster's take on the neo-avant-garde, but also in Mark Silverberg's study of *The New York School Poets* (2010). Silverberg starts from the idea that those poets (including John Ashbery, Frank O'Hara and Barbara Guest) are not really revolutionary in political or institutional terms. At first sight, these neo-avant-garde poets are guilty of the neutralisation that Bürger claimed as being typical of all neo-avant-gardists: 'In revising the once radical gestures of the avant-garde, in other words, the neo-avant-garde reverses their revolutionary power: what was once confrontational and critical now becomes merely institutional, an affirmation of the art market's willingness to accept the "unacceptable".' But then Silverberg continues: 'Because Bürger's analysis stops at the level of institutional critique, he is unable to see neo-avant-garde art as anything more than repetition in bad faith' (2010: 23). Following Richard Murphy's *Theorizing the Avant-Garde* (1999: 5–12), Silverberg claims that the neo-avant-garde's 'challenge goes beyond the level of institutional critique to the more general level of ideology critique' (2010: 23). Only by shifting one's attention from the institutional to the ideological can one acknowledge the critical function of the neo-avant-garde:

If we understand the avant-garde's goal as this broader deconstructing and rewriting of the discursive world, then it is much easier to see how the neo-avant-garde can continue to contribute authentically to this counter-discursive project by presenting new departures from and interventions into the dominant social discourses of its own day. (Silverberg 2010: 24)

In fact, the critical function on the level of ideology and discourse may go hand in hand with an accommodation on the level of the institutions. It is not as if the neo-avant-garde can only exist in terms of institutionalised oppositions. Like the New York School, Silverberg's neo-avant-garde does not require manifestos, precepts and groupings. Nor does it need to subscribe to the four main features of the avant-garde as described by Renato Poggioli, namely:

antagonism (the need to 'agitate *against* something or someone,' especially 'that collective individual called the public' [. . .]), *activism* ('action for the mere sake of doing something' [. . .]), *nihilism* ('destructive labor . . . attaining nonaction by acting' [. . .]), and *agonism* (which posits 'the artist as victim-hero . . . a paradoxical and positive form of spiritual defeatism' [. . .]). (Silverberg 2010: 19, quoting Poggioli)

Silverberg's antidote to such aggressive posturing and self-destructive heroism lies precisely in the adoption of a more 'neutral and ironic, less transgressive and more deconstructive' stance (2010: 19).

The recognition of this critical dimension as a prerequisite of valuable art is also to be found in Buchloh's voluminous study *Neo-Avantgarde and Culture Industry* (2000). With its reference to Max Horkheimer and Adorno ([1947] 2002), the title already suggests that art should distinguish itself from the culture industry by being critical in its aesthetics. In the introduction, Buchloh states this in general terms:

> Rather than settling for the comfort that the left has traditionally taken in declaring these spaces and practices of neo-avantgarde production to be foreclosed or corrupted, commercial or contaminated, recuperative or complicit, the title of this collection of essays would signal to the reader that its author continues to see a dialectic in which the mutually exclusive forces of artistic production and of the culture industry as its utmost opposite can still be traced in their perpetual interactions. These range from mimetic affirmation (e.g., Andy Warhol) to an ostentatious asceticism (e.g., Michael Asher) that—in its condemnation to a radical purity of means—more often than not in the last decade had to risk losing the very ground of the real upon which critical opposition could have been inscribed. (Buchloh 2000: xxxiii)

This comes close to Foster's paradoxical combinations of opposed aesthetics. The similarity is not just a matter of general outlook; it also crops up in concrete case studies. One example that reminds us of Foster's: 'the work of Broodthaers and Buren critically transcends the limitations of Duchamp's concept of the readymade, which had kept almost all object-oriented art in its spell' (Buchloh 2000: 20). Significantly, Joseph Beuys's rejection of the critical contributions by Freud, Saussure and Duchamp is labelled as 'infantile behavior' by Buchloh, who resents the artist's transcendental poetics on the grounds that it ignores what he regards as the foundational epistemological shifts of the post-war era (2000: 51).

Scheunemann too takes care to highlight the critical aesthetics of the neo-avant-garde. As opposed to 'Enzensberger and Paz, Bürger and Habermas', who all 'dismiss the neo-avant-garde' as an empty repetition of the avant-garde, Scheunemann asserts that 'the re-appropriation of artistic strategies and techniques of the historical avant-garde in several neo-avant-gardist movements of the post-war period turns into a highly important historical operation' (2005: 36). He conceptualises this reappropriation in terms of Walter Benjamin's 'constellation',[4] suggesting that the return is neither a

repetition of the original, nor a falsification in terms of the present day, but a double articulation of the past in and through the present. Benjamin talks about 'the constellation which his own era has formed with a definite earlier one' (quoted in Scheunemann 2005: 37). The neo-avant-garde grasps itself and the historical avant-garde in one and the same moment. As a result, it is impossible to distinguish between the (positive and pure) original and the (negative and impure) reappropriation. They are interdependent.

Again, this does not mean that there are no historical periods. Scheunemann regards the neo-avant-garde as a third step in the avant-garde. The first, 'formative phase of the avant-garde was dominated by attempts to develop counterstrategies to the advance of photographic reproduction, entailing a radical questioning of the mimetic function of all arts and a wide-ranging exploration of the properties of artistic materials', the second phase saw 'the advent of dadaism and surrealism [which] brought about a fundamental change in the direction of avant-garde experiments' (2005: 28). The first step was opposed to new technology (especially photography), the second one embraced and imported new technologies such as photography and film. The neo-avant-garde is a third step, which updates the old battle between refusal and acceptance of technology, for instance in Warhol's 'photographic silk-screening process' (2005: 39), which paradoxically combines photography and painting, reproduction and uniqueness.

In his conclusion, Scheunemann aligns this threefold model with Hegelian dialectics, replacing both Bürger's resumption and Foster's deferred action. In this view, the neo-avant-garde becomes a sort of synthesis after the thesis of refusal (of technology) and the anti-thesis of acceptance. In sum, Bürger conceptualises the return of the avant-garde in Marxist terms, as farce, while Foster deploys a Freudian logic and sees the neo as a traumatic repetition. Scheunemann suggests a Hegelian view of history in which the phases of the avant-garde (including the neo-avant-garde) develop from thesis to anti-thesis and synthesis. For him, the guiding principle is the avant-garde's response to the way technological develop-ments impact the mimetic function of the arts. Scheunemann's view emphasises (and arguably over-emphasises) this material and technological dimension. It also has an evaluative and normative undercurrent:

> In its best moments the neo-avant-garde re-appropriated a lost practice and advanced it to a new level where ready-made images and forms of hand painting, the technology of photography and mechanical printing proce-dures easily communicate with each other in the production of images. For the future of the avant-garde and its status as an 'ongoing', if discontinuous, project such communication augurs well. The semblance of the autonomy of the artwork, however, has vanished forever. (Scheunemann 2005: 44)

The relation between originality and repetition is also at stake in Rosalind Krauss's influential work on 'The Originality of the Avant-Garde' (1986). Although not directly addressing the issue of the neo-avant-garde, she conceives of these two terms as important for the historical avant-garde. In a typical deconstructivist move she looks at them in the following way:

> Now, if the very notion of the avant-garde can be seen as a function of the discourse of originality, the actual practice of vanguard art tends to reveal that 'originality' is a working assumption that itself emerges from a ground of repetition and recurrence. One figure, drawn from avant-garde practice in the visual arts, provides an example. This figure is the grid. (Krauss 1986: 53–4)

Krauss's grid is emblematic of modern art's turn towards anti-mimetic models, proclaiming its own radical autonomy from the outside world, landing in a place representing a kind of frozen present, and manifesting 'its hostility to literature, [and] to narrative, to discourse' (1986: 9–10). She distinguishes two types of uses of the grid: the first is centrifugal and 'extends, in all directions to infinity' (1986: 18); the second is centripetal and is characterised by a 'within-the-frame attitude' (1986: 21) which lays more emphasis on the materiality of the artwork. If we consider modern art's (and especially the neo-avant-garde's) gradual move away from representation to presentation and to the foregrounding of the physicality of the art object, it is difficult not to agree with Krauss's definition of the grid as the symptom of an artistic movement which is increasingly turned in upon itself, 'follow[ing] the canvas surface, doubl[ing] it' so that it becomes 'a representation of the surface, mapped [. . .] onto the same surface' (1986: 161) in a rather Borgesian fashion. Krauss's general claims about the grid's 'imperviousness to language' (1986: 158), however, are more difficult to apply to the whole history of collage aesthetics and become requalified in her own reading of Picasso's synthetic cubism. Picasso's collages, she writes, create 'a system of signifiers' (1986: 37) which, far from manifesting its hostility to the printed word, incorporates the world of signs in a way that questions modernism's search for 'unimpeachable self-presence' (1986: 38). Instead, it achieves a 'metalanguage of the visual', which engages in 'a systematic exploration of the conditions of representability entailed by the sign' (1986: 39).

Be that as it may, the grid cannot be invented, no one can claim this patent, it can only be repeated. Krauss does not accuse vanguard artists of pretending to be original and of being stuck in repetition or in the throes of meta-representational aporias. On the contrary, her primary goal is to deconstruct the dichotomy between originality and repetition:

[I]n saying that the grid condemns these artists not to originality but to repetition, I am not suggesting a negative description of their work. I am trying instead to focus on a pair of terms – originality and repetition – and to look at their coupling unprejudicially; for within the instance we are examining, these two terms seem bound together in a kind of aesthetic economy, interdependent and mutually sustaining, although the one – originality – is the valorized term and the other – repetition or copy or reduplication – is discredited. (Krauss 1986: 56)

Fully in the train of a deconstructivist twist, the discredited half of the doublet *originality/repetition* is shown to be the real condition from which modernist aesthetic practice derives (and not from the valorised one). We do not want to simply transfer Krauss's pairing of originality/repetition to the relation between the avant-garde and the neo-avant-garde. Nevertheless, Krauss's influential theory will be discussed in some of the case studies in this volume, for instance in the contribution by Lars Bernaerts and by Benoît Crucifix, sometimes at the risk of exposing the historical presuppositions of her views.

The complex relations between originality and repetition are also at the heart of Tyrus Miller's *Singular Examples* (2009). The title of the study encapsulates two basic dimensions of the relation between the historical and the neo-avant-garde. First, art works of the neo-avant-garde are not exemplary in the traditional sense, that is, they are not examples of a tradition. Rather, they offer

an experimental presentation of examples that *anticipate* the context or conventions that would clarify what they intend to persuade us to do or be. Such examples no longer simply refer to an existing repertoire of cultural meanings. Rather, they propose alternative framings and functions of that repertoire and offer novel supplements to it. (Miller 2009: 8)

In that sense, the neo-avant-garde has a proleptic and even utopian side – far removed from Bürger's dystopian outlook. Second, the neo-avant-garde works are 'singular', because they do not want to be the first in a series of reproductions and they do not want to be translated into a political or institutional party line. Instead they want to remain tentative, singular.

Miller studies both the singular and the tentative aspect of the neo-avant-garde on the formal level. He sides with Adorno, who locates the critical and irreducible functions of art in its formal characteristics. In the words of Adorno: 'Form is the artifacts' coherence, however self-antagonistic and refracted, through which each and every successful work separates itself from the merely existing' ([1970] 2002: 142). According to Miller, this 'antagonistic' form is in itself unstable, conflicting,

and therefore ideally suited to express the paradox of 'singular examples'. Contrary to what Bürger seemed to think, the avant-garde form is irreducible to the artist's intentions or to any clear goal; it is characterised by 'ideological indirection' (Miller 2009: 11). It is not surprising that Miller devotes the first half of his study to artists using all kinds of aleatory and chance-based techniques.

Our approach to the neo-avant-garde differs from those which have been developed by Bürger and his critics in three fundamental ways. Firstly, on the theoretical level, we do not want to start from a preconceived idea about the relation between the historical and post-war avant-gardes, be that positive or negative, institutional or psychoanalytical. We would rather consider each individual case prior to deciding what kind of relationship might be involved between periods or theoretical models. Secondly, our main interest is in the *literary* neo-avant-garde. By giving literature its due in the discussion, we are able to question and correct extant views of the neo-avant-garde. Since the theories invoked here are strongly oriented towards the visual arts, and although neo-avant-garde writers may refer to neo-avant-garde arts, we need to be careful in simply adopting them in our approach to literature. These theories cannot merely be transferred, even though the avant-garde tends to blur the boundaries between the arts: poetry can become visual art, and painting can integrate text. In this respect too, we will put the theory to the test by way of close readings of individual works, rather than simply assuming that the theories of Bürger and his critics work for literature in the same way as they seem to do for the arts.

Thirdly, we do not start from an overarching historical sequence of phases. Again, we prefer to look at the neo-avant-garde in and across different traditions and languages in order to see what these case studies can tell us. Obviously, this does not mean we have no conceptualisation of the neo-avant-garde whatsoever – as evidenced in the corpus of cases we have selected – but, rather, that one of our priorities is to bear in mind that literary temporalities are necessarily different from one cultural field to the other. It is now time to look at the minimal requirements we use to decide what can be considered as neo-avant-garde.

COMPILING A CORPUS: SELECTING THE LITERARY NEO-AVANT-GARDE

We believe that four parameters are relevant for any literary work to be considered as neo-avant-garde. Firstly, special attention will be given to texts in which artists deal with their own poetics and aesthetics vis-à-vis the historical avant-garde as a source of either inspiration or frustration. Indeed, in the wake

of the avant-garde, the neo-avant-garde often attacks the dominant aesthetics that celebrates uniqueness and creativity, and pursues mimetic representation. A certain degree of radicalism is thus involved in the claims of the neo-avant-garde, but we can hypothesise that it includes radical forms (e.g. abstract expressionism, neo-Dadaism) as well as less radical forms (e.g. lyrical abstraction) and that these forms are sometimes combined.

Secondly, and more importantly, what is at stake is the formal, material and technical level of the (literary) work of art that is clearly exploited in techniques such as (photo)montage, readymades and collage. Neo-avant-garde works will typically employ so-called experimental techniques, some of which can be connected to the historical avant-garde *stricto sensu*. Experimental procedures include material, stylistic and narrative devices that cannot easily be naturalised or which exceed the boundaries of what is deemed aesthetically, culturally or morally acceptable within a given historical and cultural context. As such, what is experimental is always the result of a negotiation between text, reader and context. One thinks here, for example, of radically unconventional language and style, disintegrated or disjunctive syntax, accumulations of absolute metaphors, enhancing the dissimilarity between the connected semantic fields, and so on. Other technical hallmarks include the frequent use of montage and collage, the incorporation of readymades, the exploitation of aleatoric composition techniques (as in jazz improvisation), algorithmic text production (as in so-called computer poems), and the increased degree of abstraction through musicalisation. Moreover, literary works of the neo-avant-garde often tend to mingle aesthetic with epistemological intentions, thus trying to refine and update a tendency already present in the historical avant-garde, for instance in what Bürger describes as its tendency to strive for 'extra-artistic impact' and its resistance to its conversion into an 'internal', institutionalised aesthetic phenomenon (Bürger 2010: 706).

The formal dimensions cannot be separated from the social and political contexts and conflicts within which they function. This, too, is part of the negotiation – and it is a vital aspect of our usage of the term 'neo-avant-garde'. We do not see it as a neutral idea borrowed from art history, but rather as an Adornoian concept that reconciles the formal with the political. More specifically, we side with Adorno's famous claim that 'art's double character as both autonomous and *fait social* is incessantly reproduced on the level of its autonomy' ([1970] 2002: 5). As a result, the study of literary forms is never merely conceptual or abstract. It is always an investigation into social, cultural and political dimensions, as Pierre Bourdieu convincingly demonstrated in the work of Gustave Flaubert. His work bridges the gap between realism and formalism in what can be labelled as 'formalist realism' or 'realist formalism'

(1995: 107–8). The contributions in this volume will bring to light similar combinations of the literary and the social fields.

A third indication that might prompt one to study a given text from the perspective of the neo-avant-garde is to be found in its paratext, its intertext, its intergenericity and/or its intermediality. Mottos, quotations and pictures embedded in the literary text may point directly or indirectly to the historical avant-garde. Neo-avant-garde artists incorporated or imitated characters, words and (fragments of) texts as had already been done by Kurt Schwitters and others. Books and catalogues may even result from a close collaboration between a writer and an artist or may be the product of a double talent of the author/artist. In visual poetry, the text tends to become a work of art (see the poems of Augusto de Campos). In sound poetry (e.g. Henri Chopin), it becomes sonic art.

One of our main working hypotheses is that the migrations between media (word and image, text and event) are significant recurring tendencies in neo-avant-gardes across Europe. An important example is the catalogue, in which image and word, essay and criticism, prose and poetry come together and even commingle. This book attempts to chart such intermedial and intergeneric experiments, focusing on texts in which the putative borders of essay, poetry and narrative fiction are crossed. Hence, also, the need to acknowledge the constructivist impulse behind the development of the Western avant-garde, whether 'neo' or not, in the context of contemporary art's general shift in emphasis from product to method and process. In order to examine the nature of these interactions we will address the permutations of the historical and the neo-avant-gardes in a way which returns us to Foster's insight that

> the neo-avant-garde is obsessed with the twin problems of temporality and textuality – not only the introduction of time and text into spatial and visual art (the famous debate between the Minimalists and Fried is but one battle in this long war), but also the theoretical elaboration of museological time and cultural intertextuality (announced by artists like Smithson and developed by artists like Lothar Baumgarten in the present). (Foster 1994: 31–2)

In the fourth place, institutional factors may indicate the neo-avant-garde frame and label. Publication in certain journals, performances in particular venues, presentations in experimental circles or in festivals considered experimental – all of these contextual elements may induce one to approach the study of the work at hand from the perspective of the neo-avant-garde. Small wonder, then, that the study of performance regularly appears in some of the contributions. Gaëlle Théval, for example, addresses what Bernard Heidsieck in France called 'Action

Poetry', and Antonia Rigaud covers the 'riotous' performances central to the American Black Arts Movement. This adds to the synthesis of form and politics we advocated earlier in our usage of the term 'neo-avant-garde'.

Obviously, this is not an exhaustive list. Nor should all four conditions be fully met before it makes sense to tackle a (literary) work of art from the perspective of the neo-avant-garde. Our approach is flexible in that it recognises that these characteristics are often a matter of degree, but it is not completely arbitrary in that it does stipulate the necessary prerequisites for an informed and discriminating account of the complexities and contradictions of the recent history of the neo-avant-garde.

Taking these four factors into account, this volume studies the experimental literature of the long sixties (and beyond) from the perspective of the neo-avant-garde, taking major post-war neo-movements (neo-surrealism, neo-expressionism, neo-Dadaism, etc.) across the borders of language and nation into consideration. The relevance and value of that decision can only be judged in and through the case studies. Special attention will be paid to considerations of theory (the conceptualisation of the neo-avant-garde and its relation to the historical avant-garde), historiography (indicating both simultaneity and phasing), and contextualisation (elucidating the link between different avatars of the neo-avant-garde and the contemporary social, political and cultural contexts in which they emerged). By importing the neo-avant-garde frame from art history and adapting it to literary theory and art theory and history, the contributions reconnect the two fields. Though we start with a focus on the long sixties, we will also judge the usefulness and relevance of our conceptual models to more recent, even contemporary developments in art and literature.

THE PROOF OF THE PUDDING: NEO-AVANT-GARDES IN LITERATURE

For clarity's sake we have arranged the twenty-one contributions to this book into two parts. The first ten chapters focus on conceptual issues, matters of genre and technique. The second group of eleven chapters analyse particular authors or movements. The line between the two parts is not strict. For one, the more theoretical issues of the first part inevitably surface from time to time in the case studies within the second and vice versa: reflections on concepts, genres and techniques go hand in hand with analyses of particular writers, texts and movements. Moreover, all contributors follow the perspective outlined in this Introduction: the neo-avant-garde is approached both from a diachronic angle (its ties with the historical avant-garde) and from a synchronic viewpoint (its links to the political, cultural and social context of the time).

In the opening chapter, Thomas Eder examines the relevance of two central theorists of the neo-avant-garde, Theodor W. Adorno with his *Aesthetic Theory* and Peter Bürger with his *Theory of the Neo-Avant-Garde*. He confronts these theoretical approaches with Oswald Wiener's *the improvement of central europe, a novel* (1969) – subsequently *ICE* – a major work of the neo-avant-garde. Eder reads *ICE* as a constitutive work that defines the neo-avant-garde's theoretical and aesthetic presuppositions, outcome and future.

Especially Wiener's critique on semiotics seems related to Adorno's critique on aesthetic forms. The consequences Adorno and Wiener draw from this are, however, quite different. *ICE* and Wiener's following works do away with the importance of signs and forms, and with their relation to the things expressed. Adorno endorses a dialectic relationship between form and content; he conceives of 'forms as a means of aesthetic objectivity [that] distances them from what is to be objectivated' ([1970] 2002: 308). Thus he remains in the nebulous realm of historico-philosophical speculation. By contrast, Wiener aims at a functional description of lively thinking, conceiving of art and literature as only partly interesting fields of inquiry. For him, after *ICE*, what has been labelled neo-avant-garde or experimental art and literature in retrospect is definitely not an insightful means for gaining better understanding of the human mind. Bürger's claim that 'avant-garde could gain a renewed relevance in a future that we cannot imagine' (Bürger 2010: 714) may be re-formulated with regard to Wiener's development, transforming his impetus from art and literature into a psychology of thinking which nevertheless retains its artistic basis: it is only in this sense, that avant-garde may 'participate in enlightenment' (Adorno [1970] 2002: 19).

Vincent Broqua scrutinises the diachronic and synchronic perspective by delving into the relationship between the avant-garde artist and poet Josef Albers (1888–1976) and a generation of neo-avant-garde concrete poets, among whom the Bolivian-Swiss poet Eugen Gomringer (b. 1925). Broqua argues that contrary to what the prefix 'neo' may suggest, a straight line of influence does not account fully for the diverse relations between avant-garde artists and neo-avant-garde creators. Based on close readings and new archival material as well as accounts of their interpersonal relations, the case study of Albers and Gomringer demonstrates how the retroaction of the younger generation on an avant-garde artist is as important as claims by the concrete poets of a debt to the avant-garde. As such, the chapter seeks to theorise temporal relations via a specific case study.

Lieselot De Taeye reflects on one of the techniques typically associated with the (neo-)avant-garde, namely montage. She focuses on how this technique surfaced in Dutch documentary fiction from the long 1960s. She argues that, in

comparison to most of the literary montages written during the historical avant-garde, these montages were often more radical in their movement away from the novel. As the documentary tendency centred around a quest for a more 'direct' relation to reality, and as it cultivated an engaged relationship to society, it provided a welcoming space for experiments with montage technique. The possibility of including heterogeneous pieces of text within the montage was used as a way to democratise literature. The gaps between the different sections in a montage were activated in order to spur critical thinking and provide more structural analyses of society. In reading *Praag schrijven* ('Writing Prague', 1975) by Daniël Robberechts, a book in which the Prague Spring plays a central role, De Taeye shows how montage evokes an ever-changing multidimensional reality, as well as the impossibility of fully grasping it.

Michel Delville investigates the concept of *objet trouvé* and of erasurism in the neo-avant-garde. In an age of uncertainty in which 'suspicious readings' have become the norm, the development of found art has been an important part of experimental literary and artistic experimentation since the 1960s. The history of erasurism, in particular, has been marked by various trajectories and legacies of the first historical avant-gardes while pointing in new, unexpected directions such as Tom Phillips's 'treated novel', *A Humument*, and Jochen Gerner's minimalist erasure of Hergé's classic comic book, *Tintin en Amérique*. As the examples discussed in this chapter demonstrate, erasurism, far from being a purely destructive and nihilistic trend, is as much about adding and creating as it is about subtracting and deconstructing, combining as it does a suspicious attitude to the canon with a willingness to engage in a dialogue with the literary ghosts of the past.

In the fifth contribution, Jan Baetens addresses the notion of 'nomadic poetry', in a theoretical as well as a practical sense. In the first part of his contribution, Baetens discusses certain theoretical presuppositions of nomadism (as practised by Pierre Joris), more specifically its praise of textual hybridity and readerly freedom or, if one wants to put it in a negative manner, its reluctance toward purity and rhetoric. As a point of departure, Baetens takes his own writing, which is both nomadic and non-nomadic. In addition, he investigates examples from modern French literature. In this way, he suggests that all complex forms of nomadism should also take into account their own 'other', namely purity and rhetoric. In the final part of the essay, he discusses some aspects of the genesis and the never-ending transformations of a literary project, 'Ce Monde' ('This world'), which represents Baetens's creative response to Joris's work – a displaced and nomadic one, of course.

Nele Janssens tackles the genre question from the neo-avant-garde perspective. Amid the experimental zeal in Flemish prose in the 1960s, Lucienne

Stassaert published her first short story collection *Verhalen van de jonkvrouw met de spade* ('Stories of the lady with the shovel', 1964). The stories are not conventional prose texts, but feature musical patterns and ungrammatical and metaphorical language. Janssens analyses Stassaert's prose debut as a neo-avant-garde experiment, more specifically as lyrical prose. While critics associate this prose with *Labris*, a Flemish neo-avant-garde periodical that is inspired by French surrealism and the American beat generation, they also present Stassaert as a unique and wayward author. Stassaert cultivates this image herself: in accordance with the *Labris* programme – and using typical *Labris* techniques – she creates autonomous texts, but she also distances herself from this writers' collective. Moreover, her writing has an autobiographical, therapeutic dimension. Janssens studies Stassaert's ambiguous attitude towards *Labris* and the particular intersection of the autonomy of the text and the writer's personal reality.

A similar but different genre matter occupies Gaëlle Théval in her study of sound poetry. She starts from an observation by Bernard Heidsieck: 'Sound poetry', he claimed, 'was derived neither from Futurism, nor from Dada. It did, however, and with delight, rediscover a complicity of thought, research and action there. As a consequence, it [. . .] accepted their avant-gardism' (2001: 188). Indeed as it was invented in the fifties under the impulse of Bernard Heidsieck and Henri Chopin, sound poetry has a close relation to the historical avant-garde. Heidsieck described this relation as a rediscovery. Chopin turned himself into the historian of the various forms this relation took. He was one of the most important actors in the creative return to the historical avant-garde. This historicising effort went hand in hand with a refusal of the group logic typically associated with the historical avant-garde and with an acceptance of its experimental techniques. This makes it possible to study sound poetry as neo-avant-garde. More specifically, Théval's contribution focuses on the manifestos, the historical and theoretical texts, and thus tries to determine the specific neo-avant-garde form of sound poetry.

The next contribution, by Hans Vandevoorde, zooms in on a particular genre (the prose poem) and movement (neo-surrealism), and reflects on a perspective to study this genre and movement through the viewpoint of 'generations'. Vandevoorde argues that the many neo-surrealistic trends in post-war literature should be viewed as legitimate heirs of the avant-garde and should therefore be given the label of neo-avant-garde. Using the prose poem as a case study, he demonstrates firstly how surrealism has been continually reinvented to this day through a series of movements deriving from it. Secondly, he elucidates that the prose poems from those derivative movements are often more disruptive in content and form than the many

restorative literary impulses of their time. To get a literary-historical grasp on the different phases, he relies on the concept of 'generation'. In Dutch literature, it was the experimental generation of the Fiftiers (from the late forties till the early sixties), a Flemish and Dutch 'group' in Karl Mannheim's terms, which bridged the gap with surrealism and Dada. It is no surprise, then, that a great many writers of prose poems emerged at that time. After that, it was not until the nineties that a new wave of prose poems were presented by a second, postmodern, generation of prose poets. That wave led to such a proliferation that the prose poem became mainstream in the next generation, who are still publishing today.

From the perspective of a different genre, namely European French-language comics, Benoît Crucifix considers the asynchronous and uneven development of avant-gardes. The emergence of avant-garde claims in the late twentieth century makes *bande dessinée* an interesting and yet overlooked medium in the context of the neo-avant-gardes. He first looks at the widespread hypothesis of 'belatedness' and situates its implications within the context of neo-avant-garde theories, suggesting the usefulness of thinking about the dynamic interplay between 'rear-guard' and 'avant-garde' in the post-war period. This theoretical gambit is fleshed out through a case study that dramatises this tension: *La Méthode Bernadette*, in which a montage technique is applied to forgotten archives of a catechistic visual culture.

The final contribution of the first part has a similar concern to the first. Indeed, not unlike Thomas Eder, Sabine Müller confronts some concepts prevailing in (neo)-avant-garde theories with the case of the Vienna Group. The essay takes as its departure point the literature and literary studies of the German-speaking world. Their potential to develop a notion of the neo-avant-garde as a bridge between literary studies and art history is probed in three steps. In a theoretical-historical convergence, the specific context in which the concept of the neo-avant-garde emerged is recalled. This context sheds new light on important points in the current discussion of the neo-avant-garde, which reciprocally sheds light on approaches within art theory and literary studies. In a second step, these new dimensions are explored diachronically, with a particular focus on Austrian authors of the Vienna Group and on Ernst Jandl. This provides us with a new look at important conceptual premises, such as trauma, shock, deferred action, culture industry and commodification. In the final step, which argues synchronically, the intergeneric, intermedial and multimodal devices of the literary neo-avant-garde are scrutinised. By means of selected texts from Gerhard Rühm and Eugen Gomringer, Müller shows which premises of neo-avant-garde research in the visual arts ought to be further developed for a genuinely interdisciplinary concept of the neo-avant-garde.

In the second part, movements and authors from various contexts take centre stage. The first three texts broaden the scope by looking beyond the boundaries of Europe. Antonia Rigaud examines the meeting points between political and poetic insurgencies in the works of Amiri Baraka and Gwendolyn Brooks in the 1960s, when they were associated with the Black Arts Movement. Both poets sought to turn against what they conceived to be the institutionalisation of experimental poetry within the framework of Eurocentric cultural references. They prioritised irony in order to find a poetic language that would give recognition to the language of the streets and of the African American experience. Yet in so doing they borrowed many strategies of the first avant-garde, from the shock aesthetic of surrealism and the Dada movement to a modernist-like integration of high and low culture within the poem or through collage techniques. While Brooks and Baraka saw themselves in some respects as the successors of the Harlem Renaissance poets in search of a true African American expression, they were critical of the way poetry was authenticated through its acceptance by white critics. For these two poets, an aesthetic of loudness, taken from popular entertainment and ordinary street life, framed a poetry that was meant to appeal both to politically radical African American activists and to ordinary audiences, while still retaining the poetic complexity of a modernist heritage. This utopian moment, when black poets hoped for a convergence of poetic experimentation and radical political practice, can thus be considered from the perspective of the neo-avant-garde, which selects styles and forms from the first avant-garde while creating a poetry that corresponds to a more assertive moment in the history of black American liberation.

The contribution by Ilse Logie shifts the scene to Latin America. Looking at contemporary novels of Latin American writers from different countries, one soon notices a strong avant-garde undercurrent in the work of dominant figures such as Roberto Bolaño, Mario Bellatin, César Aira and Diamela Eltit. This return to the avant-garde is also a growing topic of interest for scholars, as evidenced in recent studies by Ángeles Donoso Macaya, Reinaldo Laddaga, Julio Premat and Héctor Hoyos. Logie focuses on a representative example: *El Gran Vidrio* ('The large glass') by the Mexican-Peruvian author Mario Bellatin (born 1960), who is currently one of Latin America's leading artists. He became known for his unconventional way of handling key figures from European conceptualism in the visual arts and, in particular, for his references to Marcel Duchamp and Joseph Beuys. In *El Gran Vidrio* he tackles what he calls the 'absurd' project of the autobiography by pushing its boundaries far beyond autofiction. He does so through an unsettling trio of apparently autobiographical stories. Like the Duchamp sculpture from which it takes its name,

Bellatin's text deconstructs the very form of the autobiographical genre. In fact, the reader witnesses several compelling transformations of identity performed by remarkably unreliable narrators. As all of Bellatin's other books, *El Gran Vidrio* can be considered an expression of the author's desire for a post-autonomous form of literature.

In the second part of her text, Logie broadens the field. The resurgence of avant-garde aesthetics is striking not only in Bellatin, but in recent Latin American literature in general. Some critics interpret this as an effort to counter Eurocentrism and dispense with the claim to identity commonly connected with Latin American art. The result of this double positioning – both Latin American and international – is the completely new manner in which Bellatin incorporates well-known themes. Others read Bellatin mainly as an exponent of the *iconic turn*. For them, it is the intermedial dimension of his artistic practice which makes the legacy of the avant-garde relevant again. This leads to the question of whether we should interpret the afterlife of Duchamp in Latin America as an anachronism or as just the opposite, a sign of the contemporary.

Christine Pagnoulle draws our attention to the Caribbean scene through a study of the work of Kamau Brathwaite, who would never have condoned the use of the label neo-avant-garde. He wrote a unique kind of poetry, using what he described as 'Nation language', a way of using words that increasingly became his own, merged with a specific layout which he called his 'Sycorax Video Style'. Yet, aspects of his work clearly relate to neo-avant-garde features, most significantly his blurring of boundaries between literary genres and between art forms. He conjures up different ways of perceiving the world through changes in spelling and plays on sounds; he brings together different traditions; he opens the page to the silence of white space. Pagnoulle explores developments in Brathwaite's work, focusing on *DreamHaiti* and *Barabajan Poems*, a book which started as a speech and turned into a 400-page-long autobiography combined with cultural history and postcolonial criticism, incorporating former poems in new layouts and hijacked scholarly conventions.

In the next contribution, Hannah Van Hove focuses on the ways in which a range of relatively neglected British women writers (including Ann Quin, Anna Kavan, Eva Figes, Christine Brooke-Rose and Brigid Brophy) have been labelled, both during and after the long sixties. By giving an overview of the various categorisations attributed to women's experimental fiction in Britain and the ways in which they have been employed, Van Hove interrogates the reasons for the critical neglect of British experimental women's writing whilst at the same time teasing out to what extent the categorisation of 'neo-avant-garde' might be a useful term in exploring the influences and persisting concerns of this innovative fiction.

Jean-François Puff looks at the Oulipo movement from the perspective of the neo-avant-garde. He does so by concentrating on the question of constraint writing and its situation in the field of the neo-avant-garde. The Oulipo group was created in 1960, and to a certain extent, its activities have to do with experimentation. Nevertheless, the group always presented itself as an anti-avant-garde unit. This poses a specific and arduous problem, which this chapter examines: on the one hand, modern constraint writing has nothing to do with neoclassicism and its concept of rules; on the other hand, it does not completely fit with the concept of neo-avant-garde in the way defined here. Its intention and relation to the social and political context largely differs from the neo-avant-garde, but a large part of its production is linked with it, in a rather loose way, on the stylistic and formal levels. This leads Puff to conclude that most Oulipo productions belong to the tradition of the new.

Another French case study is central to the analysis of Jeff Barda. He examines how, since the 1990s, French poetic practice has maintained an ambivalent, if not conflictual relationship with the avant-gardes. While numerous poets share commonalities with the avant-gardes (critiques of the institutions, techniques of writings, goals and strategies), those practices exhibit different theoretical strands (a different theoretical framework, a rejection of the vanguard posture and of its utopian ethos). Barda's contribution questions the terms and consequences of these engagements, showing how those practices construct a new literary imaginary that invites us to reflect on issues related to temporality, causality, narrativity and creative freedom, poetics and praxis.

Roland Innerhofer analyses Konrad Bayer's novel *the head of vitus bering* (1965). In this work, the combination of several paradigmatic series supplants the evolutionary syntagma that is characteristic for traditional biographies. The literary play with given materials and genres can be seen as postmodern, but *the head of vitus bering* undermines postmodern aesthetic and eclectic pluralism by quoting emotionless descriptions of violence and atrocities. Bayer has thus decisively broken a taboo in post-war Austrian culture that was generally determined to ignore what had happened during the Second World War. In contrast to postmodernism, within Bayer's montage the categories of the new and the original are not dismissed, but rather emerge from the vehemence of negation. His impetus for destruction is not limited to semantics, but extends to the narrative continuum, grammatical structures and individual words. At the same time, the scattered fragments are reassembled in an aesthetic of 'freezing'.

Laura Tezarek and Christian Zolles also focus on post-war Vienna, but draw attention to the development of surrealism. Owing to its fundamental lack of national esteem and slim prospects following both the First World War and the end of the multi-ethnic Habsburg monarchy, there was a tremendous delay

in the historic avant-garde reaching Austria. During the Nazi regime, 'avant-gardist' art and literature was not available in Austria, which also led to a later lack of clarity in regard to what could be considered 'surrealist writing' – the term was often used polemically in order to discredit literary 'enemies'. For a young generation of progressive writers in Vienna at the end of the 1940s and the beginning of the 1950s, who were confronted with the intoxicating and anarchic energies of surrealism for the first time, it became a much-discussed topic: surrealism was perceived as an opportunity to radically break with the predominantly conservative literature of the last decades.

In her contribution on Peter Weiss's *The Shadow of the Body of the Coachman* Inge Arteel looks at the experimental character of this short novel, which was written in the early fifties but not published until 1960. Arteel situates the text in the context of Weiss's aesthetic and political views and analyses its narrative, generic and medial characteristics. Perception of reality and its description, as well as the tension between observation, cognition and knowledge of reality lie at the basis of the experimental techniques Weiss explores. Departing from moments of failure and impediment that the text addresses, Arteel shifts the focus to its generic and medial hybridity and the images this produces. With their formal instability and cognitive irritation these images resist integration in a predictable epistemological grid of reality. Instead, they are presented as real images that confront us with the bits and pieces of modernity. In this way, her contribution sheds light on the links between the neo-avant-garde, experimentation and modernism.

The two final contributions deal with Flemish forms of the neo-avant-garde. Lars Bernaerts presents the towering figure of Flemish neo-avant-garde fiction, Ivo Michiels (1923–2012). In the experimental tradition in Dutch literature, his cycle of novels *The Alpha Cycle* (1963–79) is a main point of reference. The chapter discusses how Michiels associates himself with the artists of the Zero movement and how he integrates the *topoi* of the avant-garde in *Book Alpha* (1963), the first part of *The Alpha Cycle*. The book ties together the main points of Michiels's relation to the neo-avant-garde: the rhetoric of the new and of rupture, radical scepticism toward language, and a tendency towards abstraction. Against the background of theories of the neo-avant-garde, Bernaerts argues that Michiels uses the performative power of language to turn harmful, oppressive speech into a creative and original literary language.

Dirk De Geest and Bart Vervaeck deal with the Belgian neo-avant-garde journal *Labris*, published between 1962 and 1973 as a forum of the so-called sixtiers. The name of the journal refers to the double-bitted axe from Greek mythology, but also – at least in the minds of the editors – to the term

'labyrinth'. The latter association links *Labris* with the hermetic and mannerist tradition; the former one epitomises the journal's ambiguous poetics and its equivocal institutional position vis-à-vis the national and international avant-garde. Indeed, it presented two conflicting poetics, an objective one infused with the international neo-avant-garde of concrete visual poetry and Fluxus, and a subjective one, permeated by jazz and by the American beats. In terms of the historical avant-garde, surrealism and Dadaism were the main points of reference. The chapter discusses authors of the objective and subjective type and concludes with a case study – an experimental novel which presents two strands within a text that hover between experimental word play and a love story, between lyricism and narrativity. As such the novel is read as symbolic of the paradoxical and eclectic position *Labris* held for more than a decade.

NOTES

1. The authors of this text are members of the International Research Community ENAG ('European Neo-Avant-Gardes'), sponsored by the FWO, the Flemish Fund for Scientific Research. They are: Inge Arteel (Free University of Brussels), Lars Bernaerts (Ghent University), Vincent Broqua (University Paris 8), Dirk de Geest (University of Leuven), Michel Delville (Liège University), Thomas Eder (University of Vienna), Brigitte Félix (University Paris 8), Roland Innerhofer (University of Vienna), Ilse Logie (Ghent University), Sabine Müller (University of Vienna), Hans Vandevoorde (Free University Brussels) and Bart Vervaeck (University of Leuven).

2. The term is sometimes found in ill-defined contexts, such as in the recent anthology of French poetry *Poésies en France, 1960–2010. Un passage anthologique*, where Yves di Manno and Isabelle Garon (2017) use the term to define the works of poets of the 1990s such as Pierre Alferi and Olivier Cadiot.

3. See <http://theater.ua.ac.be/dabnap/about.html> (last accessed 24 January 2021).

4. Benjamin introduces the 'constellation' in his introduction to *Origin of the German Trauerspiel* ([1928] 2019: 10–11).

BIBLIOGRAPHY

Adorno, T. W. [1970] (2002), *Aesthetic Theory*, ed. G. Adorno and R. Tiede-mann, newly translated, edited and with a translator's introduction by R. Hullot-Kentor, London/New York: Continuum.

Benjamin, W. [1928] (2019), *Origin of the German Trauerspiel*, trans. H. Eiland, Cambridge, MA: Harvard University Press.

Bourdieu, P. (1995), *The Rules of Art: Genesis and Structure of the Literary Field*, trans. S. Emanuel, Stanford, CA: Stanford University Press.

Buchloh, B. (1984), 'Theorizing the Avant-Garde', *Art in America*, November, pp. 19–21.

Buchloh, B. H. D. (2000), *Neo-Avantgarde and Culture Industry: Essays on European and American Art from 1955 to 1975*, Cambridge, MA: MIT Press.

Bürger, P. [1974] (1984), *Theory of the Avant-Garde*, trans. M. Shaw, Minneapolis, MN: University of Minnesota Press.

Bürger, P. (2010), 'Avant-Garde and Neo-Avant-Garde: An Attempt to Answer Certain Critics of "Theory of the Avant-Garde"', *New Literary History*, 41, pp. 695–715.

Crinson, M. and C. Zimmerman (eds) (2010), *Neo Avant-Garde and Postmodern: Postwar Architecture in Britain and Beyond*, New Haven, CT: Yale University Press.

Dezeuze, A. (2006), '"Neo-Dada", "Junk Aesthetic" and Spectator Participation', in D. Hopkins (ed.), *Neo-Avant-Garde*, Amsterdam: Rodopi, pp. 49–71.

di Manno, Y. and I. Garon (2017), *Poésies en France, 1960–2010. Un passage anthologique*, Paris: Flammarion.

Erjavec, A. (2003), 'The Three Avant-Gardes and Their Context: The Early, the Neo, and the Postmodern', in D. Djurić and M. Šuvaković (eds), *Impossible Histories: Historical Avant-Gardes, Neo-Avant-Gardes, and Post-Avant-Gardes in Yugoslavia, 1918–1991*, Cambridge, MA: MIT Press, pp. 36–62.

Foster, H. (1994), 'What's Neo About the Neo-Avant-Garde?', *October*, 70 (Fall), pp. 5–32.

Foster, H. (1996), *The Return of the Real: The Avant-Garde at the End of the Century*, Cambridge, MA: MIT Press.

Heidsieck, B. (2001), 'Nous étions bien peu en . . .' [1980], in B. Heidsieck, *Notes Convergentes*, Romainville: Al Dante, pp. 177–252.

Hopkins, D. (ed.) (2006), *Neo-Avant-Garde*, Amsterdam: Rodopi.

Horkheimer, M. and T. Adorno [1947] (2002), *Dialectic of Enlightenment: Philosophical Fragments*, ed. G. Schmid Noerr, trans. E. Jephcott, Stanford, CA: Stanford University Press.

Ingvarsson, J. and J. Olsson (eds) (2012), *Media and Materiality in the Neo-Avant-Garde*, Frankfurt am Main: Peter Lang.

Innerhofer, R. (1985), *Die Grazer Autorenversammlung (1973–1983). Zur Organisation einer 'Avantgarde'*, Vienna/Cologne/Graz: Böhlau.

Krauss, R. (1986), *The Originality of the Avant-Garde and Other Modernist Myths*, Cambridge, MA: MIT Press.

McHale, B. (2016), 'The Long Sixties, 1954–1975', in B. McHale and L. Platt (eds), *The Cambridge History of Postmodern Literature*, Cambridge: Cambridge University Press, pp. 67–82.

Marx, K. (1960), 'Der achtzehnte Brumaire des Louis Bonaparte', in K. Marx and F. Engels, *Werke*, vol. 8, Berlin: Dietz, pp. 115–207.

Miller, T. (2009), *Singular Examples: Artistic Politics and the Neo-Avant-Garde*, Evanston, IL: Northwestern University Press.

Murphy, R. (1999), *Theorizing the Avant-Garde: Modernism, Expressionism, and the Problem of Postmodernity*, Cambridge: Cambridge University Press.

Nogueira, I. (2013), *Théorie de l'art au XXe siècle: modernisme, avant-garde, néo-avant-garde, postmodernisme*, Paris: L'Harmattan.

Polet, S. (1978), *Ander proza. Bloemlezing uit het nederlandse experimenterende proza van Theo van Doesburg tot heden (1975)*, Amsterdam: Bezige Bij.

Scheunemann, D. (ed.) (2005), *Avant-Garde/Neo-Avant-Garde*, Amsterdam: Rodopi.

Silverberg, M. (2010), *The New York School Poets and the Neo-Avant-Garde: Between Radical Art and Radical Chic*, Farnham/Burlington: Ashgate.

Strain, C. B. (2017), *The Long Sixties: America, 1955–1973*, Chichester: John Wiley & Sons.

Vervaeck, B. (2013), 'En garde. Poëtica's voor een nieuwe roman', *Tijdschrift voor Nederlandse Taal- en Letterkunde*, 130 (1), pp. 73–95.

PART I

CONCEPTS, GENRES AND TECHNIQUES

Theodor Adorno, Peter Bürger and Oswald Wiener, or How to Apply Neo-Avant-Garde Theory to Neo-Avant-Garde Texts

Thomas Eder

> Today, the only works that count are those that are no longer works.
> – Theodor W. Adorno, *Philosophy of New Music* (2006: 30)

PRELIMINARY REMARKS

Neo-avant-garde theory addresses different fields and topics of art and their relation to socio-political, historical and philosophical issues. As with all theories, their impact and plausibility are strongly dependent on the extent to which they are able to meet the challenges that their objects pose to them. The relation between theories and their objects may best be described with the traditional model following the so-called hermeneutic circle – especially when dealing with soft objects and soft theories which artworks and aesthetic theories represent (as opposed to scientific theories and their objects). From the perspective of a theory of science, this holds of course for each and every theoretical approach, regardless of their objects, albeit to a gradually much lesser degree for natural objects and science as compared with social products and their exploration in the humanities.

In my contribution I will deal with two main representatives of the theory of the neo-avant-garde, Theodor W. Adorno and his *Aesthetic Theory* ([1970] 2002) and Peter Bürger and his *Theory of the Avant-Garde* ([1974] 1984 and his critical review in Bürger 2010). From the outset, it is important to spell out one caveat: Adorno in his *Aesthetic Theory* primarily speaks of modernity and modernism (and not of the [neo-]avant-garde[1]) – nevertheless, I will use some of his theoretical concepts ('the new', the relationship of modern artworks to older ones) to apply them to works – or rather one instance – of German-language neo-avant-garde literature. Adorno's concepts are productive as a

contrasting foil for analysing Oswald Wiener's work, irrespective of whether or not Adorno coined them with regards to the avant-garde or modernism.

I will focus on Oswald Wiener's *the improvement of central europe, a novel* (subsequently *ICE*, Wiener 1969, written between 1962 and 1967, published 1969, before as a series of publications in the journal *manuskripte*). I will present this text as a major instance of an artwork of the neo-avant-garde, or more pointedly: I suggest that we can read *ICE* as a constitutive artwork, defining neo-avant-garde's theoretical and aesthetic presuppositions, outcome and future. In dissecting *ICE*, I will use Adorno's and Bürger's theoretical reflections.

OSWALD WIENER, THE AUTHOR OF *ICE*

Between the years 1955 and 1959 Oswald Wiener (b. 1935) dominated the theoretical orientation of the – subsequently termed – Wiener Gruppe or Vienna Group (Friedrich Achleitner (1930–2019), H. C. Artmann (1921–2000), Konrad Bayer (1932–1964), Gerhard Rühm (b. 1930) and Oswald Wiener), which may be regarded as the most important Austrian contribution to the neo-avant-garde (besides Viennese Actionism).

Wiener produced (see Weibel 1997: 629–57) concrete texts, for example 'beast beast beast' ('tier tier tier'), 'brightbrightbrightbright' ('buntbuntbuntbunt'), and scenic texts, for example 'sorrow' ('die sorge'), 'joy' ('die freude'), 'the red continent' ('der rote erdteil'), 'snot – a viennese play in dialect' ('rotz – eine wiener dialektstück'), 'man – a picturebook' ('der mensch – ein bilderbuch'). Moreover, he wrote so-called constellations ('konstellationen'), montages, for example 'the day – a rigid montage' ('der tag – eine rigide montage'), chansons, experimental prose and the famous (and later lost) 'cool manifesto'. First and foremost, Wiener was interested in theoretical aspects, being one of the first people in Austria outside of academia to take note of Ludwig Wittgenstein's work (first his *Tractatus Logico-Philosophicus*, later his *Philosophical Investigations*). Philosophy of language and linguistic scepticism were Wiener's core fields of interest in the late 1950s, mixing critique of language with political aspects. In this period Wiener essentially relied on his studies of epistemology, solipsism and anarchism (Fritz Mauthner, Max Stirner, M. A. Bakunin).

Wiener brought this theoretical background to the conception and implementation of two literary happenings of the Wiener Gruppe in 1958 and 1959, the so-called literary cabarets (referring to Dada's 'Cabaret Voltaire'). The two cabarets may be seen as happenings, carried out slightly before the endeavours of The Living Theatre or Allan Kaprow's happenings.

Wiener destroyed his (mostly concrete) writings of this phase in 1959 and veered into a bourgeois existence (as head of the Austrian branch of the Italian

office equipment manufacturer Olivetti) from which he was 'cured' by a for-
mer co-member of the Wiener Gruppe, Konrad Bayer. Bayer called Wiener
back to arts and literature around 1962, and Wiener started writing his novel
the improvement of central europe (*die verbesserung von mitteleuropa, roman*) (1969).
Around 1965 Wiener got in contact with the artists of the Viennese Action-
ism, taking part in many of the important happenings: As a consequence of
taking part in the infamous happening 'Art and Revolution' ('Kunst und
Revolution'), 8 June 1968, at the University of Vienna, Wiener and Günter
Brus were prosecuted by the Austrian authorities and had to leave Vienna for
exile in West Berlin (cf. Eder 2000b).

In West Berlin Wiener opened several artists' cafes and restaurants (Matala,
Axwax, Exil) and was one of the leading figures amongst intellectuals and avant-
garde artists. In addition, he studied mathematics at the Technical University
Berlin (from 1980 on; in Vienna in the 1950s he had studied mathematics,
law, music and African languages). In 1986 he left Berlin for Canada, where he
lived, *inter alia*, as a cafe owner in Dawson City, Yukon Territories until 2013.

Living half of the year in Europe he taught as a professor of literary aes-
thetics at the Kunstakademie Düsseldorf (1992–2004). In Canada he addressed
questions of artificial intelligence (Wiener 1990) and turned completely away
from the philosophy of language and from art *in toto*. In his subsequent work
Wiener was basically interested in epistemological questions on the basis of
Alan M. Turing's theory (see Wiener 1996; Wiener et al. 1998). Since 2013 he
has lived in the south-east of Styria, pursuing his scientific work in the field of
automata theory, cognitive studies and psychology of thinking, reintroducing
the hitherto scientifically abandoned method of introspection (Eder and Raab
2015; Eder et al. forthcoming).

THE IMPROVEMENT OF CENTRAL EUROPE – ICE

ICE can be regarded as the definitive *Entwicklungsroman* (coming-of-age novel)
of the second half of the twentieth century in at least two respects. On the one
hand it documents the author's intellectual development and how this led to
profound changes in his thinking: 'so I sit here and write, wondering what
strange changes happened to me in the last few years since the first lines of
which I do not understand a word'[2] (Wiener 1969: CXVII). In this regard, it
marks a turning point. On the other hand, it is a diagnostic and prophetic text
concerning the socio-historical, political and scientific movements and devel-
opments in the Western world since the 1950s.

ICE prefigured Wiener's further development. The aggravation of his cogni-
tive interest may be regarded as a necessary movement of the neo-avant-gardes

as such, tracing their way out of art and into the (natural) sciences, which stands in sharp opposition to Adorno's restoration of the central position of the artwork after the Second World War in his *Aesthetic Theory* (subsequently *AT*).

ICE may be conceived of as the 'suicide of a literary work of art'.[3] This seems in line with Adorno's conception of important artworks as constantly divulging 'new layers; they age, grow cold, and die. It is a tautology to point out that as humanly manufactured artifacts they do not live as do people' ([1970] 2002: 4). Yet, as Adorno continues, the differences to Wiener's conception are evident:

> Artworks are alive in that they speak in a fashion that is denied to natural objects and the subjects who make them. They speak by virtue of the communication of everything particular in them. Thus they come into contrast with the arbitrariness of what simply exists. Yet it is precisely as artifacts, as products of social labor, that they also communicate with the empirical experience that they reject and from which they draw their content [*Inhalt*]. Art negates the categorial determinations stamped on the empirical world and yet harbors what is empirically existing in its own substance. If art opposes the empirical through the element of form—and the mediation of form and content is not to be grasped without their differentiation—the mediation is to be sought in the recognition of aesthetic form as sedimented content. (Adorno [1970] 2002: 5)

Adorno seems to idealise artworks as ontological objects in their own right.[4] Contrary to Adorno's notion of aesthetic form as sedimented content, Wiener develops a more sceptical stance towards the scope of artworks. In *ICE*, the author is aware of what should be rejected and combatted; that is, he identifies clearly which concepts should be classified as failures, he decries them, but without presenting any positive alternatives or aesthetic form as sedimented content – I will return to Wiener's more critical position towards the relation between form and content (*Inhalt*) in the closing parts of my contribution.

ICE consists of several very dissimilar and only loosely connected parts, starting with aphorism-like passages, followed by mock theatre plays ('"allah kherim!" epiphanies are saved. report on the feast of concepts' ('"allah kherim!" die erscheinungen sind gerettet. reportage vom fest der begriffe'), 'PURIM. ein fest' ('PURIM. a feast')), 'two studies on sitting' ('zwei studien über das sitzen'), in which Wiener's epistemological speculations are given literary form. The two closing parts are essays on the so-called bio-adapter (see below). In the first parts of *ICE*, Wiener refers to his past period as an experimental poet, labelling some of its sections as 'core elements regarding

an experimental past' ('kernstücke zu einer experimentellen vergangenheit') (1969: LXXIII) and addressing key questions regarding the relation between language and thought. These parts of *ICE* may be regarded as reminiscences as well as attacks on experimental, neo-avant-gardist movements. They would be – *sensu* Adorno – correctly described as 'self-unconscious historiography of their epoch' (Adorno [1970] 2002: 182) if they appeared without context; as they are contextualised in *ICE*, this differentiates them from Adorno's own notion that 'authentic works are those that surrender themselves to the historical substance of their age without reservation and without the presumption of being superior to it' ([1970] 2002: 182). Wiener's *ICE*, on the contrary, is very conscious of being an instance and a historiography of its epoch; at least its author intends *ICE* to be superior to all historical and other substances. According to this thought, Wiener embeds results from his experimental past into the broader concept of epistemological criticism which unfolds itself in the later parts of *ICE* – in this respect he seems to be in line with a different passage in Adorno's *AT* (if one gratefully neglects Adorno's personalisation of non-living entities): '[A]rt stirs most energetically where it decomposes its subordinating concept. In this decomposition, art is true to itself' ([1970] 2002: 182).

In a different line of reasoning this could imply that *ICE* fulfils all the criteria which have subsequently been established for characterising postmodernist art. Consisting of many, entirely different genres and styles, *ICE* presents itself as a thorough reappropriation of (nearly all, or at least of many) past artistic materials. If one follows Bürger, however, this may also be regarded as a characteristic trait of the avant-gardes (and not only of postmodernism): 'we can say that the avant-gardes brought about, without this being their intention, what would later be characterized as postmodernism: the possibility of a reappropriation of all past artistic materials' (Bürger 2010: 706).

As a kind of absolute rupture[5] within *ICE*, its later sections substantially change in tone and subject: the two parts on the 'bio-adapter' in particular may be characterised as a persistently self-critical essay, which mirrors the development of Western industrial societies as an amalgam of politics, states' affairs and statistics. One possible interpretation of *ICE* is: from the beginning of the twentieth century behaviourism (as dominant scientific model and method) has become the predominant mindset, the entrenched *weltanschauung*, leading to the loss of the remnants of individuality. Behaviourism and cybernetics are the main targets of Wiener's novel, especially of its closing parts (the infamous 'bio-adapter'). The bio-adapter may be described as first drafts of the promises of a virtual reality (*avant la lettre*) in the fusion of man and machine (cyborg). Although constantly undermining

these sketches, they express Wiener's opinion that the bio-adapter offers the 'first discutable sketch of a complete solution to all world problems' (1969: CLXXV). The sections on the bio-adapter are based on the idea of 'functional equivalence'. In psychology, functional equivalence means that, for example, imagined and actually performed actions have the same effects, so that, for example, imagined movements and actually performed movements have similar effects (psychomotorics). Conversely, two stimuli, for example, can have functional equivalence if, although phenomenally different, they provoke the same reactions. Accepting the concept of 'functional equivalence' implies that all transcendental truths evaporate – a view which what has been elaborated on in *ICE* boils down to.

This perspective can be related to Adorno's position stressing the interplay of art and historicity. Artworks

> are the self-unconscious historiography of their epoch; this, not least of all, establishes their relation to knowledge. Precisely this makes them incommensurable with historicism, which, instead of following their own historical content, reduces them to their external history. Artworks may be all the more truly experienced the more their historical substance is that of the one who experiences it. (Adorno [1970] 2002: 182–3)

While Adorno aims at a dialectic explanation of the relation between art and history, Wiener's *ICE* is more straightforward in this respect. Without being inclined to complex dialectic explanations of history, *ICE* may be regarded as a critical analysis of the bold and philosophically rather innocent ideas of scientific progress. It is not the overall relation between artwork and history which is at stake, but rather how the artwork might engender a direct impact on the dominant scientific worldview.

Wiener's development mirrors that of the post-war avant-garde which may itself be regarded as self-unconscious historiography of its epoch. The author himself, however, intends to lay bare the foundations of this historiography and turn it into conscious knowledge. This development addresses the romantic notion that the artist or the writer could oppose science with their work. As such *ICE* can be understood as an argument 'against the scientific worldview, the de facto power of science'. In the course of the twentieth century, the 'effort to oppose to the scientific worldview with an equally consistent "non-mechanistic" artistic method has gotten insurmountably large' (Raab 2008: 46). Wiener's ironic attitude is turned against his own writings, even against the nucleus of romantic art within the avant-gardes. Through this, *ICE* sketches Wiener's development towards becoming a 'renegade scientist' (Raab 2008: 47).

ADORNO

In the remainder of my contribution, I will look to elaborate on whether or not Adorno and Wiener share the tension between autonomous art and art as *fait social* – even if, as I argue, they draw markedly dissimilar conclusions.

In this regard Adorno notes: 'Art's double character as both autonomous and *fait social* is incessantly reproduced on the level of its autonomy' ([1970] 2002: 5). In stating this, Adorno stresses the complicated relation of artworks to empirical experiences, which may not be reduced to aspects of mirroring. Instead he conceives of this relation as a dialectic mediation between form and content. As he continues: 'Artworks participate in enlightenment because they do not lie: They do not feign the literalness of what speaks out of them' ([1970] 2002: 5).

While Adorno seems to reload the autonomy of the artwork with the burden of reproducing art's double character as both autonomous and *fait social*, Wiener seems to aim at overcoming the limitations of art (both autonomous and social). He conceives of artworks as being unable to express and elucidate the (scientific) challenges of the empirical. Artworks can participate in enlightenment only in the following respect: as means to 'explore thought processes or to move the limits of imagination which the writer realizes in the act of his writing' (Wiener 1998b: 10) – this kind of enlightenment is at best equivocally connected to what Adorno calls participation in enlightenment. Adorno and Wiener seem to reside in quite different spheres, Wiener heading towards gaining scientific knowledge, Adorno towards restoring a dialectically informed tension through which artworks allow for the distillation of knowledge from them. Adorno prefers art over the artwork: 'The truth content of many artistic movements does not necessarily culminate in great artworks' ([1970] 2002: 25). Wiener seems, in contrast, to propose a coincidence of art with ways of reasoning and thinking, which he considers the core goals of art in the late twentieth and early twenty-first centuries. This line of reasoning might be realised only retrospectively, which may be regarded as a productive reinterpretation of Hal Foster's notion of deferred action, as understood by Bürger: 'The methodological reflections in *Theory of the Avant-Garde* are also based on a conception of deferred action; namely, that the adequate recognition of an object requires the thorough differentiation of a field of objects as its precondition' (Bürger 2010: 709). Of course, Foster considers deferred action with regard to a different conception (related to trauma and Freud), but as Bürger reads 'deferred action', this conception may be adopted to *ICE*: the differentiation of the scientific field of the second half of the twentieth and the beginning of the twenty-first centuries, sorting out its preconditions and its dead ends concerning cognitive theories of consciousness, could only retrospectively be considered as the main topic in *ICE*.

BÜRGER

It might be worth considering Wiener's movement from an artist to a ren-
egade scientist in light of Bürger's central and even most critical thesis on the
neo-avant-garde. In a 2010 article, Bürger looks back at his seminal book
Theory of the Avant-Garde ([1974] 1984) and summarises its most critical thesis
concerning the 'post-avant-garde':

> On the one hand, the book claims that the 'the social institution that is art
> proved resistant to the avant-gardiste attack', on the other it asserts that
> because of avant-gardist production art 'means are freely available, i.e., no
> longer part of a system of stylistic norms' [. . .]. (Bürger 2010: 704)

Somewhat self-critical, Bürger concedes that the question of how these two
theses relate to the post-avant-garde situation within art remains unanswered
in his 1974 book. One hint in this direction could be – as Bürger comments
on his own book – the chapter which elaborates on the historicity of Adorno's
aesthetic: here he suggests that

> we should seriously consider 'whether the break with tradition that the
> historical avant-garde movements brought about has not made irrelevant all
> talk about the historical level of artistic techniques practiced today' (a refer-
> ence to Adorno's theorem about the continuous development of artistic
> materials). (Bürger 2010: 704)

Later in his 2010 essay, Bürger summarises thus: '[I]n *Theory of the Avant-
Garde*, the situation of the post-avant-garde, after the failure of the avant-garde
project became obvious, was characterized by two theorems: the continued
existence of the autonomous art institution and the free use of artistic material'
(2010: 706–7).

In this respect *ICE* proves to be an artefact (I try to avoid the term 'art-
work' here) that is – paradoxically – a work of art, as its author uses a selection
of different aesthetic material, while at the same time being an – a more or less
intended – attack against the social institution that is art; as it marks a turning
point, the – metaphorically speaking – suicide of an artwork.[6] On the other
hand, Wiener's *ICE* aims at radically changing the attitudes of its recipients,
which brings it closer to Bürger's own reflections on the neo-avant-garde:

> [T]he avant-garde's revival [. . .] of obsolete materials (artistic procedures and
> techniques) succeeded because the avant-gardes did not aim to create works
> of art that would last through time but wanted to use their manifestations to
> change the attitudes of their recipients. (Bürger 2010: 707)

This is at least loosely connected to an earlier stage of Wiener's intellectual and artistic development. His literary and theoretical work during the time in which he was a member of the Wiener Gruppe may be summarised by two different and conflicting intentions. On the one hand, he aimed to augment the aesthetic impact triggered by works of art and, as a consequence, tried to produce more impactful artworks. On the other hand, he attempted to come to a better understanding of the cognitive and emotive processes at play when artworks were perceived.

As Wiener was a poet at this time he tried to come to grips with language and linguistic artworks. Partly on the basis of language criticism he aimed at abolishing conventional language and creating a new, artistic language which might better fit the *Lebensgefühl* (spirit) of the artist. As a consequence, he drafted a statement (later destroyed) entitled 'cool manifesto' (1954), stating that the artist must abandon emotion and empathy as their primary virtue. Wiener describes his 'cool manifesto' retrospectively as follows: 'Everybody was responsible for the quality of his experience himself, the sovereign mind had no need for art at all, as the key is not producing art, but understanding. This was my version of Dada' (2015: 285).

By subsequently exclusively endorsing the artwork-is-knowledge-conception – both in *ICE* and elsewhere – Wiener seems to deliberately step outside the discussion of aesthetic autonomy, which also dominates Bürger's reasoning: 'In retreating to its core domain of aesthetic autonomy, the art institution demonstrates a resistance to the attack of the avant-gardes, yet also adopts avant-garde practices' (Bürger 2010: 707). This, at first glance, paradoxical process shows that 'the failure of the avant-garde's aspirations to alter social reality and its internal aesthetic success (the artistic legitimation of avant-garde practices)' are 'two sides of the same coin' (Bürger 2010: 707). Wiener shows in his *ICE* and implicitly in his own development that the mentioned two-sided coin may be exchanged for a coin representing a very different currency. His *ICE* marks the turning point as it still can be understood as an instance of internal aesthetic success. Today, however, Wiener definitively breaks with art (even avant-garde art), stating that he would prefer somebody to go to the museums with a Kalashnikov and erase all artworks.[7] In this regard Wiener's position is comparable to the radical art-destructive attempts of the historical avant-gardes. It may nevertheless be conceived as a critical amendment to Bürger's theory:

> [T]he neo-avant-gardes adopted the means by which the avant-gardists hoped to bring about the sublation of art. As these means had, in the interim, been accepted by the institution, that is to say, were deployed as internal aesthetic procedures, they could no longer legitimately be linked to a claim to transcend the sphere of art. (Bürger 2010: 707)

Wiener's sublation of art is of course intended in a more straightforward and less dialectically sophisticated sense; it is definitely not 'sicklied o'er with the pale cast of thought'.

READING *THE IMPROVEMENT OF CENTRAL EUROPE* THROUGH THE LENS OF *AESTHETIC THEORY*

In implicit opposition to Adorno's continuity thesis, in the first sections of *ICE* Wiener seems to follow the notion that the works of the Wiener Gruppe are mainly concerned with the impact of language on thought processes as well as on social processes. Wiener's argumentation is critically targeted at all forms of media and communication: 'once again and again and again: it is the language the real, the actual, the only, the tangible, the existing, the benchmark is communication' (Wiener 1969: CLVII–CLVII). Communication is characterised as 'this inextricable tangle of language, state and reality' (Wiener 1969: CXLII).

To some extent, this early glorification as well as condemnation of language resembles Adorno's statements about the problems of form, which are symptoms of suppression by totalitarian societies: 'The unsolved antagonisms of reality return in artworks as immanent problems of form' and 'The more total society becomes, the more completely it contracts to a unanimous system, and all the more do the artworks in which this experience is sedimented become the other of this society' ([1970] 2002: 6, 31).

In a similar way, during his time as a member of the Wiener Gruppe, Wiener was an advocate of the so-called language metaphor (*Sprachmetapher*), that is, the over-estimation of the role of language for thought and mind, for art and for science, which inevitably leads to a behaviourist understanding of human thought: man as being controlled by various external media, and especially by language.

Wiener's *ICE*, first of all the essay on the bio-adapter, may to some degree be compared to Noam Chomsky's (1959) review of B. F. Skinner's influential book *Verbal Behavior* in which Chomsky criticises Skinner's behaviourist conception of language which aims at providing 'a way to predict and control verbal behavior by observing and manipulating the physical environment of the speaker' (Chomsky 1959: 26). According to Chomsky, it is only metaphorically possible to apply Skinner's scientific concepts (e.g. reinforcement learning) to linguistic behaviour – which renders Skinner's endeavour quite unscientific. This is the case as we simply 'cannot predict verbal behavior in terms of the stimuli in the speaker's environment, since we do not know what the current stimuli are until he responds' (Chomsky

1959: 32). Chomsky's review of Skinner's book is commonly regarded as marking the starting point for cognitive science, doing away with behaviourist ideas. In line with Chomsky's arguments, Wiener opens his infamous notes on the concept of the bio-adapter with reflections on linguistics and ontology. Here is a long quote:[8]

> it is not seldom that one comes across statements by the modern linguists to the effect that their science should ideally become part of behaviourist psychology. how close they have come to achieving this aim remains undecided; it is however certain that it has long since conformed, in accordance with the positivist renunciation of the concept of consciousness as a subject of research, to behaviourism's fundamental attitude towards language: behaviouristic psychology and modern linguistics regard the effectiveness of language as limited to a very narrowly defined field, and language itself as one complex of functions among others in society. [. . .] these difficulties certainly arise from a conflict between unrevised principles of sensory-data and a view of language which denies that language has any influence on perception at all and dismisses all reflection on whether a number of investigations in the fields of sensory psychology and the nervous system might not perhaps, in the end, turn out to be simple linguistic forms, of which those that nevertheless seem to live in relationship to the scientific dispute on the other side do not correspond to the verification. [. . .] if language is not a system of representing reality (perhaps it is enough to add the continuation: none except its own), it is nevertheless a self-contained system of natural manifestations, studied without auxiliary sciences, at least without ontology [. . .]. (Wiener 1969: CXXXIV–CXXXV)

At the time writing *ICE*, Wiener conceived of language as a powerful and world-creating medium with its own rules and limitations, hindering the individual from self-determined experiences. Wiener continues with this notion in the 'bio-adapter' as follows – in these paragraphs being in a dialectically motivated stance of indeterminacy regarding the role and power of behaviourist psychology:

> only a linguistics which will have eliminated reality can really enable behaviourist psychology to emerge – not however one which vacillates in this important decision. [. . .] for, paradoxically enough, it is only a language which is not connected to reality which makes objectivity possible; and the realism of the study, which is often driven to extremes, becomes pure solipsism. [. . .] admittedly, this ambivalence of behaviourism already has its

critics; they, however, are looking for points of departure which cannot be mine; I do not wish to declare my solidarity with the philosophers of sense: all too many people feel uncomfortable with the methodology of a philosophy which is solely interested in the behaviour of objects, which goes so far as to theoretically eliminate the observer, or to be more exact, important features of the observer, from the observation process, and vehemently pursues the formal correspondences, limited to a comparatively meagre vocabulary, so that stimulus and reaction are made to serve even the elucidation of teleology. (Wiener 1969: CXXXVI–CXXXVII)

And here is Wiener's alternative criticism of behaviourism in which he departs from the philosophers of sense:

criticism of behaviourism is, however, also important for me – although it has to come from the other side. this whole essay is devoted to this subject. [. . .] a rejection of the whole package (largely tare) always has to begin with a re-examination of language, of language and of the various attitudes towards it. [. . .]. (Wiener 1969: CXXXVII)

And this passage ends with a comparison of cybernetics and Marxism in the Eastern and Western hemispheres (perhaps as a vague reference to the Cold War):

both eastern and western philosophers have made equal contributions to the development of behaviourism, so that in both the east and the west behaviourism is seen as the only possible and only correct sociological and psychological method [. . .] cybernetics is propagated with the same fervour as the fulfilment of behaviourism in both the east and the west (for marxism perhaps, as an unacknowledged way out of the fundamental questions of philosophy), [. . .] that the linguistic theory of behaviourism (because it dogmatically carries out linguistic research as a branch of psychology and not, as would seem to be more logical, psychology as a branch of linguistic research), as also that of marxism (because it dogmatically regards language as a part of reality, for as a reflection it is such, and not reality as an insinuation of language: reality as a 'reflection' of language) produces the most pathetic results [. . .]. (Wiener 1969: CXXXVII–CXXXVIII)

The relation between language and reality is outlined in the following passages in the 'bio-adapter':

trivially enough, language presents itself as a norm, above all in the decisions of society, in sociology and in law (marxism also goes so far as to regard

consciousness as being based on human social lies, and that after all means making language a norm!). the use of language possesses the highly remarkable quality which laing must have had in mind when he wrote that 'our civilisation, suppresses every kind of transcendence: it is a protective wall against the attacks of sensation; language goes right through us, prescribing narrow alleys for the reality of our consciousness, producing identity as name, perhaps hampering possible experience'. (Wiener 1969: CXXXVIII)

In short: language is generally characterised as social consciousness and even as the memory of humanity: 'to take this stale joke literally for once: a revolt against language is a revolt against society' (Wiener 1969: CXLIV).

This was the starting point. Wiener abandoned the study of language in the course of the 'bio-adapter' and of his work after *ICE*. Many of the passages quoted here seem to be reversed in Wiener's later work, for example: 'linguistic research as a branch of psychology and not, as would seem to be more logical, psychology as a branch of linguistic research' (see above) may read as a prominent example of what Wiener later conceived of in the reverse direction, favouring psychology as the foundational 'science'. The proposed decline of the 'linguistic turn', stating that linguistics and philosophy of language are the *via regia* for scientific inquiry, implies further critique towards their towering figure, Ludwig Wittgenstein. Throughout *ICE*, Wittgenstein is being polemically mentioned and addressed and central tenets of his philosophy are quoted at length by Wiener:

someone publishes that definition is the manual for the use of words (wiener? Wittgenstein?)

if somebody says that the meaning of a word is its use in language, this is nice and of course well-intentioned (Wiener 1969: CXXIX)

To use the words. Don't understand a word. 'Using words' sucks. [untranslatable: German saying, grossly obscene, meaning approx.: after dinner you should smoke or copulate – use a female – use a word]: entertainment is essential. have you noticed? (Wiener 1969: CXXIV)

Or:

'That which expresses itself in language, we cannot express by language' [Tractatus 4.121], says the 'dark one' in his post-Socratic fragments – does anything express itself in language? let alone the 'structure of reality'? is anyone familiar with that? (Wiener 1969: XVII)

Examples such as these demonstrate one of the main strategies Wiener uses in *ICE*: concepts which he classifies as failures are refuted without presenting any positive alternatives. In this sense, these passages from *ICE* somewhat paradoxically put forward truths and falsehoods at the same time – it thus 'participate[s] in enlightenment', as Adorno put it, 'because [it does] not lie', which only becomes apparent if the reader considers the perspective from which the author utters such platitudes. The author cracks corny jokes with deprecatory intentions, where he may not offer positive solutions to the deep problems.

AFTER *THE IMPROVEMENT OF CENTRAL EUROPE*

When he wrote *ICE*, Wiener had abandoned the 'language metaphor' (*Sprachmetapher*), critically showing why it is flawed, but lacked any theoretical conception to present alternatives. This seems to be totally in line with the relation between new works and preceding works, between new and traditional works of art, as Adorno conceives of them:

> The traces to be found in the material and the technical procedures, from which every qualitatively new work takes its lead, are scars: They are the loci at which the preceding works misfired. By laboring on them, the new work turns against those that left these traces behind; this, not shifts in subjective feelings for life or in established styles, is the actual object of what historicism treated as the generational problem in art. [. . .] The truth content of artworks is fused with their critical content. That is why works are also critics of one another. This, not the historical continuity of their dependencies, binds artworks to one another; 'each artwork is the mortal enemy of the other'; the unity of the history of art is the dialectical figure of determinate negation. (Adorno [1970] 2002: 35)

Of course, Bürger would criticise Adorno for watering down the category of rupture in his continuity argument. Today, though, the situation has changed dramatically for Wiener himself: he now endorses a very clear-cut version of what he calls *Denkpsychologie* (see below). The turning point is a series of articles Wiener published in the early 1970s, the first of which is entitled 'subject, semantics, mapping relations' ('subjekt, sema[n]tik, abbildungsbeziehungen') (1970).

From that point onwards Wiener increasingly endorses the view that the individual's image of the world is largely independent from its linguistic (or generally: symbolic) representation. Wiener's move away from the idea that

words or sentences may be analysed in order to gain insight into the designated objects or state of affairs has far-reaching consequences. In the period between 1955 and 1959, when he worked with other members of the Wiener Gruppe, Wiener of course did not endorse this view, explicitly marginalising the role of language for the 'understanding of understanding' (Wiener 1970). Retrospectively, Wiener analyses this change as follows: 'understanding of language seemed a royal road to the understanding of all natural phenomena. as far as I am concerned I wanted to become a writer as language seemed to be the hub for all knowledge and handling' (1987: 46). Slightly later, though, Wiener changed his mind and conceived of language as being a 'part of the environment onto which one must project one's own content' (1987: 48).

All this – that the individual's image of the world is largely independent from its linguistic (or generally: symbolic) representation – stands in clear contrast to Adorno's view, as quoted above, namely that aesthetic form is sedimented content. From forms no content may be derived. Moreover, Wiener starts to become critical of 'literary experiments'. The linguistic means used by experimental poets have been reintegrated into traditional ways of expressing contents. He writes: '[i]n the attempts to mobilise a new meaningfulness the old meaning has survived. Exactly the sentences, terms and styles that we used provisionally to describe an awakening now refer to something which we tried to overcome; the tool has failed' (Wiener 1998b: 8). This is why literary experiments after 1945 also failed in their intentions to criticise all 'formal theories of communication with the goal to establish a sound theory for an individualistic point of view (with regard to content)' (1998b: 19). This goes hand in hand with Wiener's new orientation towards science (and his disdain for art and literature) – and this again is clearly opposed to Adorno's 'recognition of aesthetic form as sedimented content'. Moreover, even Adorno recognises the problematic status of the term 'experiment' in conjunction with the 'new':

> The violence of the new, for which the name 'experimental' was adopted, is not to be attributed to subjective convictions or the psychological character of the artist. When impulse can no longer find preestablished security in forms or content, productive artists are objectively compelled to experiment. This concept of experiment has, however, transformed itself in a fashion that is exemplary for the categories of the modern. Originally it meant simply that the will, conscious of itself, tested unknown or unsanctioned technical procedures. Fundamental to this idea of experimentation was the latently traditionalistic belief that it would automatically become clear whether the results were a match for what had already been established

and could thus legitimate themselves. This conception of artistic experimentation became accepted as obvious at the same time that it became problematic in its trust in continuity. The gesture of experimentation, the name for artistic comportments that are obligatorily new, has endured but now, in keeping with the transition of aesthetic interest from the communicating subject to the coherence of the object, it means something qualitatively different: that the artistic subject employs methods whose objective results cannot be foreseen. (Adorno [1970] 2002: 23–4)

Wiener would almost certainly reject these ideas. For him the coherence of the object over the communicating subject is not at the centre of his interests. In fact it is exactly the other way round: the individual may attribute all possible contents to aesthetic forms according to his or her free decisions. This is why after *ICE* experimentation becomes for Wiener always related to the standards of sound knowledge production (albeit not in the sense of current behaviourist science, e.g. in the sense of neuroscientific research).

CYBERNETICS, AUTOMATA THEORY

Around the time Wiener rejected the arts and literature (and also started to consider the philosophy of language and linguistics as fruitless pursuits), he turned to the then relatively new science of cybernetics.[9] Cybernetics was originally designed for the planning of mechanical systems (e.g. in order to steer locks) and was then transferred to the field of information theory (e.g. by Max Bense). Criticising this move and the rise of cybernetics as a science used by governments to increase their power is one of the central aims Wiener pursued in writing *ICE*, and this became even more marked in the work he would subsequently produce. The theory of the Turing machine became Wiener's declared interest from this time on – even when he had to pitifully acknowledge that on the basis of the John von Neumann computer it will never be possible to implement human thinking and behaviour (reading at this time: Iván Flores's *Computer Logic: Functional Design of Digital Computers* (1960) and Boris A. Trachtenbrot's *Why Can Automata Calculate?* (*Wieso können Automaten rechnen?*) (1959)).

His declared ideal became to end *ICE* by a concluding (short) axiom which would describe human thinking and problem-solving. His awareness of the impossibility to do so is the reason why *ICE* often veers into literary elaboration: 'style is excuse'. Questioning how to apply neo-avant-garde theory to neo-avant-garde texts, I would propose: this implies an overlap between Adorno and Wiener: Wiener's attack against style (based on a lack of insights)

is similar to Adorno's complaint about the substitution of means for ends in post-avant-garde art.

In the 'bio-adapter', Wiener expounds the idea that cybernetics supports the power of the state and the government via political organisation, medicine and science. Cybernetics is accused of suppressing and devastating the individual through the use of statistics. As a consequence, in the 'bio-adapter' Wiener brought anarchic ideas to the field of cybernetics (e.g. Max Stirner). Especially the sciences (and their orientation on behaviourism) are to be refuted and combatted, as they become more and more akin to 'theories of pointer-deflections' (Wiener 1969: CXXXVI). As a remedy, Wiener focuses on the irreducible fact of 'consciousness', not as a metaphysical category, but as something which has to be explained by a strong psychological theory and – on that basis – implemented to machines. When writing *ICE* Wiener had no theoretical instruments to cope with the concept of consciousness – that is why many of the pseudo-theoretical parts of *ICE* are polemic, scornful and duplicitous.

While (negatively and sardonically) addressing philosophical questions in *ICE* (ontology: what is real? what does exist?), Wiener turned to functional questions in his work after *ICE*: what does something have to be like so that it equals human phenomenal experiences in the course of its thinking and problem-solving? To what degree is this determined by external factors, by heritage? What is analogy, what is semblance?, etc. In this respect the later parts of *ICE* hark back to opening sections where Wiener tackles language and linguistic theories ('how does language as an external stimulus influence consciousness? Is it comparable to visual stimuli that change the organism's orientation, i.e. its readiness for action?'). In *ICE*, the author tends to over-exaggerate this point and to situate language in the environment. Against this view, as he later realised, it is important to explain how language and thinking (understanding, knowledge, imagination) interact, what aspects in human communication and even individual (silent) problem-solving may count as linguistically bound and which aspects belong to core thinking.

POLITICAL ASPECTS

In *ICE*, Wiener tries to overcome and leave behind art, which may (with Norbert Elias) be called a 'niche for expression' within the 'enclave of the politically defeated people'. By proposing to abandon language and civilization as a whole the individual could return to the natural 'right of the strongest'. Thus, the 'governmental monopoly on the use of force' should be placed back into the hands of the individuals who are suitably talented for forceful acting. (Schuh 1981: 34)

Schuh refers to quotes like the following from *ICE*:

> and how beautiful the world will be if everybody reserves their filthy tongues for spitting; if an enemy is standing in front of me I will not be obliged to describe him or hate him but instead may kill him or otherwise will be killed. And the enemy wants to screw my wife or devour my flesh or simply break my bones and nothing else, especially he does not want to make an impression. [. . .] In such instances we are young and powerful and stab out and kill without being applauded. And your language may not cause me cancer, I will die because I am simply killed without rage because I stand in the way and because I am nourishing. (Wiener 1969: LXII)

These shocks are bound to epistemological issues, in contrast to the shocks elicited by the historical avant-gardes which basically aimed at *épater le bourgeois*.

Wiener does not aim to establish art as 'the conquest of the obscene as a sphere of permitted utterances', but he states that art which 'is directed against any limitation of cognition, is directed against the state' (Wiener 1972: 55). As a consequence, morals will be suspended by 'linguistic nominalism' (Schuh 1981: 41). This is true for *ICE*, but will be relativised in Wiener's later work, as he then denies any type of relation between a string of characters (words and sentences) and any kind of content, unless this relation lies within the individual who connects them in the course of understanding. 'Content' may not be derived from the words used – this is why all forms of 'political correctness' lack their theoretical and empirical basis.[10] The goal is to find the theoretical prerequisites for the fact that character strings may be understood in so many different ways without violating principles of plausibility. Thus, Wiener concludes of the period when he was a member of the Wiener Gruppe that:

> We conceived of language (Whorf) and of the social institutions based on language (as it had to be supposed) as the center for restrictions. the orbit of thought curves back to politics; one has to oppose his own production to the linguistic sovereignty of society, but to avoid getting tricked by it [the production]. This will later be the starting point for progressive conservatives to define 'political correctness'. (Wiener 1998a: 27)

CONCLUSION

In Wiener's view, as it developed after the completion of *ICE*, external character strings do not have any structural relationship to the thoughts they evoke or to the thoughts the author intended to communicate by them. He writes:

The meaning of a sign is a model which has been activated (caused to be willing to run) by this sign. If the sign is external I shall label it the name of the structure being called. As a structure, meaning may only be experienced in the course of processing, i.e. step by step over time; meaning may never be present as a whole. It is thus implicated that a name may render a model 'willing to run' merely in an indirect way, by laying down the tracks for the expansion of specific components of the structure. This expansion is determined by the task or by availability. This process is carried out by the use of 'Weiser' [pointers, but not in the computational sense], for economic reasons and as introspection shows. In a direct way, at best a name may activate a 'Weiser' toward the structure – the name is the name of this 'Weiser' (in a narrow sense), and its meaning is the meaning of this 'Weiser'. (Wiener 2008: 133–4)

This is clearly a refutation of all forms of semiotics. Words, sounds and formal linguistic elements are all mere names for a 'structure' that is called by them. This is also indicated by Wiener's definition of 'structure' which is formulated in the sphere of automata theory in terms of a Turing machine: 'A *structure* of a character string is a Turing machine which accepts or generates this character string' (2015: 100).

This definition, stemming from Wiener's studies on Turing's theory, is the starting point and core foundation of his 'psychology of thinking' (*Denkpsychologie*) (Eder and Raab 2015). Here, Wiener changes from the didactic and epistemological model of the Turing machine to address questions of lively thinking, using the refined method of introspection during problem-solving and during mundane events for his theory. This is the starting point for Wiener's current theory (see Eder and Raab 2015; Eder et al. forthcoming), a realistic description of lively thinking on the basis of introspection aiming at implementation.

In some respect Wiener's critique on semiotics seems related to Adorno's critique on aesthetic forms, even if one keeps in mind the critical difference between signs (character strings) and forms:

What was once objectivated productive force was transformed into aesthetic relations of production and collided with the forces of production. Forms, that by which artworks seek to become artworks, themselves require autonomous production. This at the same time threatens them: The concentration on forms as a means of aesthetic objectivity distances them from what is to be objectivated. It is for this reason that currently models, the ideas of the possibility of artworks, so often overshadow the works themselves. In

the substitution of means for ends it is possible to recognize the expression of a total social movement as well as the crisis of the artwork. Relentless reflection gravitates toward the annihilation of what is reflected. There is complicity between reflection, to the extent that it does not reflect on itself, and the merely posited form that is indifferent to what it forms. On their own, even the most exacting formal principles are worthless if the authentic works, for the sake of which the principles were sought, fail to material-ize; aesthetic nominalism has today culminated in this simple antinomy. (Adorno [1970] 2002: 308)[11]

The consequences Adorno and Wiener draw from this are, however, quite different. This may count as the *succus* of my contribution: both *ICE* and Wiener's subsequent works are a way of doing away with the importance of signs and forms, and with their relation to the things expressed. Adorno endorses a dialectic relationship between form and content, he conceives of 'forms as a means of aesthetic objectivity [that] distances them from what is to be objectivated' ([1970] 2002: 308). Thus he remains in the nebulous realm of historico-philosophical speculation. By contrast, Wiener aims at a functional description of lively thinking, conceiving of art and literature as only partly interesting fields for inquiry. For him, after *ICE*, what has been labelled as neo-avant-garde or experimental art and literature is, in retrospect, definitely not an insightful means for gaining better understanding of the human mind. Bürger's claim that 'avant-garde could gain a renewed relevance in a future that we cannot imagine' (2010: 714) may exactly be reformulated with regard to Wiener's development, transforming his impetus from art and literature into a psychology of thinking which nevertheless retains its artistic basis: it is only in this sense that the avant-garde may 'participate in enlightenment' (Adorno [1970] 2002: 19).

NOTES

1. I do not want to tap into this trap of conflation – as Anne Friedberg puts her concern regarding the 'profound and lasting conflation of what is con-sidered modernism and what is considered avant-garde' (1994: 163).
2. All translations from *ICE* etc. are my own. Wiener's consistent use of lower case letters will be preserved.
3. Wiener, personal communication.
4. See also Peter Bürger's retrospective notes of his 1974 book, with regard to Adorno's restoration of the work of art. 'The significance of the con-cept of the avant-garde developed in *Theory of the Avant-Garde* still seems

to me today to lie in the fact that it [. . .] develops a concept whose indi-
vidual elements are integrally related. At the center of this constellation is
an interpenetration of two principles: the attack on the institution of art
and the revolutionizing of life as a whole. [. . .] In this conception of the
avant-garde, the work of art also loses the central position that it once had
among modern authors and that Adorno, after the Second World War,
would restore once more in his Aesthetic Theory' (Bürger 2010: 696). Of
course, Bürger's notions have been widely criticised for being too selec-
tive. For an overview of Bürger's critics (e.g. Benjamin Buchloh and Hal
Foster), see the article by Dietrich Scheunemann (2005: 20).

5. To some degree this rupture is analogous to the rupture stated by Peter
 Bürger (see below).
6. This is similar to Miklós Szabolcsi's definition of general features of the
 avant-garde: '*dissolution of the relationship between the writer or artist and
 the public*' (1971: 54). This is why 'literature and art cannot fulfill their
 traditional function, the existence of artist and art becomes precarious,
 its justification challenged in the rapidly changing, more and more com-
 plicated and incomprehensible world' (1971: 54). Of course, this has
 far-reaching consequences: '[T]he writer, can no longer see the func-
 tion, aim, meaning and place of his work; consequently, he has to find
 new ways and means; he wants to bring about a radical reform in art or,
 if necessary, in society itself' (1971: 55).
7. Wiener, personal communication.
8. I will quote at length from Wiener's 'bio-adapter' in the following. Lim-
 ited single quotes would render a distorted image of the thoughts behind
 the words in *ICE*. This is due to the fact that *ICE*'s line of reasoning
 is complicated, sometimes ambivalent and apparently self-contradictory.
 Maybe this is part of Wiener's dialogical conception of literature and its
 self-critical potential. I draw on Weibel (1997) for the translations of the
 long quotations from the 'bio-adapter'.
9. The role of cybernetics within the neo-avant-garde is also recognised by
 Szabolcsi: '[T]he technological revolution and its immediate effect upon
 everyday life, and the great experience of cybernetics which offers glimpses
 of hitherto unexplorable territories, greatly contributed to the rise of the
 neo-avant-garde waves' (1971: 64–5).
10. In this respect Wiener's work is very different from contemporary neo-
 avant-garde-positions; see, for example, Szabolcsi: '"the prerequisite of rev-
 olution is a revolution of the language." The claim is formulated in several
 versions: to make revolutionary activity possible, the prevailing ideology,
 i.e. conventional "discours", has to be abolished. The more profound, the

more resolute, the more radical the innovations that a writer introduces into his language and design, the greater the service he does to the revolutionary cause [. . .]' (1971: 69). If any causal relation between form and content is rejected, the manipulation of signs and language loses its revolutionary force. This is definitely the case for Wiener's later work.

11. Cf.: 'If art opposes the empirical through the element of form – and the mediation of form and content is not to be grasped without their differentiation – the mediation is to be sought in the recognition of aesthetic form as sedimented content' (Adorno [1970] 2002: 5). This seems to be at the heart of Adorno's *AT*: aiming at dialectical relation between form and content.

BIBLIOGRAPHY

Adorno, T. W. [1970] (2002), *Aesthetic Theory*, ed. G. Adorno and R. Tiedemann, newly translated, edited and with a translator's introduction by Robert Hullot-Kentor, London/New York: Continuum.

Adorno, T. W. (2006), *Philosophy of New Music*, translated, edited and with an introduction by R. Hullot-Kentor, Minneapolis, MN/London: University of Minnesota Press.

Buchloh, B. (1984), 'Theorizing the Avant-Garde', *Art in America*, November, pp. 19–21.

Bürger, P. [1974] (1984), *Theory of the Avant-Garde*, trans. M. Shaw, Minneapolis, MN: University of Minnesota Press.

Bürger, P. (2010), 'Avant-Garde and Neo-Avant-Garde: An Attempt to Answer Certain Critics of "Theory of the Avant-Garde"', *New Literary History*, 41, pp. 695–715.

Chomsky, N. (1959), 'Verbal behavior. By B. F. Skinner (Review)', *Language*, 31 (1), pp. 26–58.

Eder, T. (2000a), 'Erkenntnis!. Der Weg Oswald Wieners aus der Literatur und Kunst', *manuskripte*, 40 (147), pp. 125–9.

Eder, T. (2000b), 'Kunst – Revolution – Erkenntnis. Oswald Wiener und ZOCK', in T. Eder and K. Kastberger (eds), *Schluß mit dem Abendland! Der lange Atem der österreichischen Avantgarde*, Vienna: Zsolnay, pp. 60–80.

Eder, T. and T. Raab (eds) (2015), *Selbstbeobachtung. Oswald Wieners Denkpsychologie*, Berlin: Suhrkamp.

Eder, T., T. Raab and M. Schwarz (eds) (forthcoming), *Oswald Wiener's Theory of Thought: Talks on Poetics, Formalisms, and Introspection*, Berlin: De Gruyter.

Flores, I. (1960), *Computer Logic: Functional Design of Digital Computers*, Englewood Cliffs, NJ: Prentice Hall.

Foster, H. (1996), 'Who's Afraid of the Neo-Avant-Garde?', in H. Foster, *The Return of the Real: The Avant-Garde at the End of the Century*, Cambridge, MA: MIT Press, pp. 1–34.

Friedberg, A. (1994), *Window Shopping: Cinema and the Postmodern*, Berkeley, CA: University of California Press.

Raab, T. (2008), *Avantgarde-Routine*, Berlin: Parodos.

Scheunemann, D. (2005), 'From Collage to the Multiple: On the Genealogy of Avant-Garde and Neo-Avant-Garde', in D. Scheunemann (ed.), *Avant-Garde/Neo-Avant-Garde*, Amsterdam: Rodopi, pp. 15–48.

Schuh, F. (1981), 'Protest ohne Protestieren. Zur Widersetzlichkeit von Konrad Bayers Literatur', *protokolle*, 4, pp. 31–43.

Szabolcsi, M. (1971), 'Avant-Garde, Neo-Avant-Garde, Modernism: Questions and Suggestions', *New Literary History*, 3, pp. 49–70.

Trachtenbrot, B. A. (1959), *Wieso können Automaten rechnen?*, trans. K.-H. Rupp, Cologne: H. J. Hoffmann.

Weibel, P. (ed.) (1997), *die wiener gruppe – the vienna group: a moment of modernity 1954–1960/the visual works and the actions*, Vienna/New York: Springer.

Wiener, O. (1969), *die verbesserung von mitteleuropa, roman*, Reinbek: Rowohlt.

Wiener, O. (1970), 'subjekt, sema[n]tik, abbildungsbeziehungen. ein pro-memoria', *manuskripte*, 10 (29–30), pp. 45–59.

Wiener, O. (1972), 'ein merkwürdiges urteil. auseinandergesetzt und kommentiert von oswald wiener', *Neues Forum*, 19 (220), pp. 52–7.

Wiener, O. (1987), 'Wittgensteins Einfluß auf die Wiener Gruppe', in Walter-Buchebner-Gesellschaft (ed.), *die wiener gruppe*, Vienna/Cologne: Böhlau, pp. 46–59.

Wiener, O. (1990), *Probleme der Künstlichen Intelligenz*, Berlin: Merve.

Wiener, O. (1996), *Schriften zur Erkenntnistheorie*, Vienna/New York: Springer.

Wiener, O. (1998a), 'Bemerkungen zu einigen Tendenzen der Wiener Gruppe', in Kunsthalle Wien, W. Fetz and G. Matt (eds), *Die Wiener Gruppe*, Vienna: Kunsthalle, pp. 20–8.

Wiener, O. (1998b), 'Einiges über Konrad Bayer', in O. Wiener, *Literarische Aufsätze*, Vienna: Löcker, pp. 7–20.

Wiener, O. (2008), 'Über das "Sehen" im Traum, Dritter Teil', *manuskripte*, 48 (181), pp. 132–41.

Wiener, O. (2015), 'Glossar: *figurativ*', in T. Eder and T. Raab (eds), *Selbstbeobachtung. Oswald Wieners Denkpsychologie*, Berlin: Suhrkamp, pp. 99–141.

Wiener, O., M. Bonik and R. Hödicke (1998), *Eine elementare Einführung in die Theorie der Turing-Maschine*, Vienna/New York: Springer.

Despite Straight Lines: Josef Albers, Concrete Poetry and Temporal Relations

Vincent Broqua

> *No time is — never*
> [. . .]
> *no time is always*
>
> — Josef Albers (1958: n.p.)

The prefix of the term 'neo-avant-garde' in many ways suggests a linear con-
ception of time and temporality. This is largely a misconception of time,
which entails that the movements and practices defined by the term 'neo-
avant-garde' come *after* the avant-gardes and therefore are mere replications
of the gestures and ideas of the avant-garde. Such is one argument in Bürger's
Theory of the Avant-Garde: 'Neo-avant-garde, which stages for a second time
the avant-gardist break with tradition, becomes a manifestation that is void of
sense and that permits the positing of any meaning whatever' ([1974] 1984:
61). It seems common sense to posit that neo-avant-garde artists come *after*
avant-garde artists, and art historians, such as Hal Foster, even suggest that
there are first- and second-generation neo-avant-gardes. The term 'genera-
tion' implies that speaking of neo-avant-gardes is predicated upon a genealogy
in a straight line. What if this was not the case? What if the straight line was
bent or crooked? What if temporal relations between avant-gardes and neo-
avant-gardes functioned *despite straight lines*?

If the notion of neo-avant-garde is to be of value, it is also necessary to
recognise that temporal relations in literature and the arts are more complex
than the straight line, that there are movements of actions and retroactions,
or, as Deleuze notes: 'there are no straight lines, neither in things nor in
language' (1997: 227). This is of course also Hal Foster's argument. Far from
having a simplistic notion of temporality and genealogy, and far from just
breaking linear historical time into a series of origins and generations, Foster

argues – see the Introduction to this book – that temporal relations may imply counter-genealogies:

> historical and neo-avant-gardes are constituted [. . .] as a continual process of protension and retension, a complex relay of anticipated futures and reconstructed pasts – in short, in a deferred action that throws over any simple scheme of before and after, cause and effect, origin and repetition. (Foster 1996: 29)

In recent years, art historians as well as literary scholars have published important studies confronting normative linear conceptions of artistic time, and proposing to value anachronism, reciprocity and retroaction from Warburgian-inspired thinking to post-Oulipian notions of plagiarism by anticipation.[1] In this essay I want to examine how the relations between the painter and writer Josef Albers (1888–1976) and concrete poetry disturb straight categorisations of time, how they work according to a scheme of action and retroaction, and how looking at a particular case study of their relationship may help us rethink temporal relations in the study of literature as well as art. My case study of the relations between the German artist Josef Albers and concrete poetry – I will focus on Eugen Gomringer – aims at exploring what Hal Foster calls 'temporal exchange[s]' between avant-garde and neo-avant-garde artists. I will first analyse Josef Albers's development as a poet, typographer and artist as a necessary step to establish the links between Josef Albers and the concrete poets (action), then show the dialogue that went on between concrete poetry and Josef Albers, which helped him reshape his writing (retroaction).

ALBERS'S EVOLUTION AS A POET

In order to fully understand the relationship between Albers and concrete poetry, it is important to present and analyse Albers's development as a poet. Josef Albers is mostly known for the production of visual artworks such as his *Homages to the Square* and his *Structural Constellations*, produced in the United States of America. Yet writing remains understudied. Indeed, although he did not publish much when he lived in Germany and worked at the Bauhaus as a pedagogue and an artist, his exile to the US in 1933 following the closure of the Bauhaus saw the growing publication of his poetry in German and in English. Anni and Josef Albers were able to flee Germany because they were hired by the newly founded Black Mountain College. Josef Albers did not speak any English, and yet, in this environment, he was able to do what he had never been capable of in Germany: write and publish his poetry. In my book *Malgré la ligne droite: l'écriture américaine de Josef Albers* (2021), I

demonstrate that his new situation in the US as an exile, prominent teacher and experimenter, as well as his, at first limited, knowledge of English, led him to push his writing forward. At the beginning, not only was his English not perfect, but it was so limited that he carefully built a precise and terse idiom. As Albers himself put it: 'I had to be careful not to learn English too well because it would have interfered with my communication' (quoted in Nordland 1965: 4).

Since he was forty-five years old when he arrived in the US, Albers's interest in and his conception of the word as a material thing predate his time in America. In Germany, he had designed modernist fonts in line with the new principles outlined in Tschichold's *New Typography*, used by many modernists: simple, efficient, clear and devoid of ornamentation. Kurt Schwitters, whom Albers much admired, had a similar interest in typography, art and writing. Albers and Schwitters shared a sense that 'abstract poetry' was important: 'Abstract poetry released words from their associations, which is a great achievement, and evaluated word against word' (Schwitters 2020: 193). Indeed, with this conception of 'abstract poetry', words were no longer used so much for their referential value as for the dialogue between referentiality and non-referentiality, or, as Joanna Drucker shows, 'the effect of the material properties of the signifier in its relation to the signified' (1994: 61). In poems such as Schwitters's sneeze poem 'TESCH / TSCHIA / HAICH [. . .]' (Watts 1974: 15) and Albers's nonsensical 'OPSTE / NOCHSOH / SCHTOLL-SPISST'[2] in a letter to his wife, the same notion that nonsense is indeed of value seems to predominate. Abstract poetry, though, did not just signify nonsense. In fact, it was part of modernism's larger project of the 'Revolution of the Word'[3] – to redefine art and writing in opposition to representation and imitation. In line with these avant-gardist concerns, Albers strived for a redefinition of art as *active* and *experiential*. In 'ABSTRACT ———— PRESENTATIONAL' [sic], a crucial text published in 1946 as part of a catalogue of the American Abstract Artists association and featuring some of the most important artists and thinkers of the day, including Mondrian, Moholy-Nagy, Fernand Léger and himself, Albers considers abstraction in those terms:

> Already early in the development of this art the term CONCRETE has been promoted to replace **abstract**. **Concrete** emphasizes a concern with or an aiming at reality. Its disadvantage is its association with **things**, that is, with the external world. [. . .] The term non-representational appears at first quite embracing, but it is complicated and impractical, too long a word. [. . .] Thus we can conclude: What **non-representational** says indirectly PRESENTATIONAL expresses positively. Also the noun **presentation** in its varying connotations – from **an act of presenting** or **producing** or

displaying to **introduction** and **performance** – justifies the neglect of the double prefix non – re. Even the definition of **presentationalism** or **presentationism** [. . .] is in accord with this new term for abstract art. (Albers 1946: n.p., original emphasis)

The non-representational, or rather 'presentational' or even 'presentative conception' of the *action* of literature and art was in line with 'the effective *presence* of material form' proposed by many avant-garde writers, typographers and artists (Drucker 1994: 62). The active and effective work of the material aspects of language on the page was explicitly at the forefront of Tschichold's typographical experiments. For instance, he referred to the physiological effects of colour and type:

the physiological effect peculiar to each color is used to increase or decrease the importance of a block of type, a photograph, or whatever. White, for example has the effect of reflecting light: it shines. Red comes forward, it seems closer to the reader than any other color, including white. Black on the other hand is the densest color and seems to retire the furthest. (Tschichold 1995: 72–3)

Much of the work that Albers did in the US indicates that he shared these beliefs. This is particularly noticeable in the interaction between his writing and his graphic work, where words were not supposed to just describe his graphic work, but to provide *ostranenie*, the foreignisation[4] that Viktor Shklovsky had theorised in his 1917 essay 'Art as Technique' (Shklovsky 2004).

Two things of interest for this chapter are particularly striking in the development of Albers's poetry: (1) how Albers published his poems alongside his drawings, and (2) how Albers reshaped his poems. In 1958, he published a collection of his poems titled *Poems and Drawings*. The collection is not well known, but in it, he prints his poems alongside his *Structural Constellations*. For example, the poem 'No time is — never' (see epigraph of this chapter) appears before and after two *Structural Constellations*. Some of the poems, such as this one, activate language so that it does something like the *Structural Constellations*. In his *Structural Constellations*, he wanted to explore an illogical logic through which drawing 'defeat[s] logic and remain[s] logic[al]'.[5]

These drawings are made of straight lines that create visual paradoxes: what seems groundless seems to have ground; what seems in the foreground suddenly moves to the background; what seems to lie beneath is suddenly above, and so on. In other words, although the drawings are made with straight lines only, the lines seem to bend, and in the reading of the picture, temporal relations of before and after are muddled. Jeannette Redensek's comments on an earlier

Albers series, *Transformation of a Scheme*, is equally true of the graphic works within *Structural Constellations*:

> Albers was aiming for impossible geometries, emergent geometries, forms that cannot be resolved by the generally relied on rules of Euclidean space. Cast in an illusory space of shallow relief, the *Transformations* never stop moving. They cannot be fixed. The eye struggles: you cannot stop looking. (Redensek 2018: 180)

This is exactly what 'No time is — never' and 'Plus = Minus' do. The first poem has a pyramidal structure. Its four lines explore temporal paradoxes by using the same words and reversing their order and meaning, playing on negation and assertion, such as in the first and second lines ('No time is — never / never also everywhere') or the first and last lines ('No time is — never / [. . .] No time is always'). The material display on the page creates a visual prosody that perfectly translates the conundrum of temporal figuration. The paradox according to which 'No time is' yet 'no time is never', is shown in the pyramidal shape of the poem that *activates* a movement of the eye whereby, at the end of the poem, the eye must go back to the beginning of the poem. The huge blank between 'no time' and 'is always' in the last line of the poem confuses the eye, leaving it not sure what it should read first. Moreover, it perfectly illustrates the fact that time in the space of the poem takes a shape that is at the same time always and never, as the poem suggests: 'No time is — never' yet 'No time is always'. It is perfectly logical, and yet the logic seems to be totally illogical as well because two antonyms become synonymous. Moreover, to construct his visual prosody, whereby the rhythm of the poem is realised both by its beats and its shape, Albers constantly uses dashes. Dashes suspend and link, and they also seem to allude to the graphic dimension of the *Structural Constellations*. Such is the effect of the dash in 'Plus = Minus', also published in *Poems and Drawings*. This poem is yet another example of illogical logic, where two antonyms are made synonymous. In fact, just like 'No time is — never', it is a paradoxical syllogism. Its first stanza:

> *The more*
> *the sun shines*
> *the more*
> *water evaporates*
> *clouds appear*
> *and the sun*
> *—shines less*
> (Albers 1958: n.p.)

The second stanza, meanwhile, is the exact opposite: more and less have changed places. The dash operates a suspense between subject and verb, to reveal the hinges of syntax and show that the construction of language is never transparent: language is a material. This is often the case in his poems: conjunctions, adverbs and prepositions are often highlighted by being placed at the end of a line or even sometimes alone on a line. But the dash here also points to the *Structural Constellation* printed on the other side of the page, which one can see beneath the poem because the page is slightly transparent.[6]

Throughout Albers's career in the US, he not only published his poems, but he republished them, recycling them in catalogues, in journals and reviews, and in lectures. As they were recycled, the poems changed shape and layout. 'No time is — never', for instance, was frequently republished. In Gomringer's 1968 Josef Albers catalogue, it is published in a sans serif font and is no longer in italics. Of course, one could argue that the layout was not necessarily within Albers's control, and that all the poems in *Poems and Drawings* were printed in italics with a serif font and that in the Gomringer monograph, the whole text used a sans serif font. That said, Albers was certainly involved in the decisions concerning the design of his books, and, as his archive shows, he paid acute attention to the layout of his books as well as to that of the books that others wrote about him. As we saw with the title of '**ABSTRACT ———— PRESENTATIONAL**', he often relied on typography to activate language.[7] In some cases, the visual shape of his poems changed dramatically. For instance, here is the first stanza of two versions of 'One is walking'.

In *Poems and Drawings* (Albers 1958: n.p.) In Gomringer's 1968 monograph (1968: 172)

One is walking	**One** **is walking**
one is standing	**one** **is standing**

There is not space to comment on the whole poem, but the transformation is rather dramatic. The poem's syntactic quality is highlighted in the second version, as well as its suspension in time. The rhythm is stretched by the isolation of some of the words alone on a line and its poeticity is thus dramatised: rhymes, stanzas and line breaks appear more clearly. Perhaps the new layout gets closer to the meditative mood of the Taoist maxim that this poem draws upon. The change in the last word of the poem (in the first version the last word is 'road', in the second version it becomes 'path') seems to point in that

direction, for although 'road', like 'path', is an accepted translation for the Tao, which the German version makes clear with 'weg', 'path' stresses the meditative and the metaphorical even more. In any case, the poem is not just transformed by the font change, it is also changed so that its visual aspect, what I term its visual prosody, appears more dramatic.

Another poem, 'More or less', went through a similar dramatic change. Albers used it countless times, including at the end of *Search Vs Re-Search*, the written form of a series of lectures. Here are the first two stanzas of this three-stanza poem.

In *Poems and Drawings* (Albers 1958: n.p.)	In *Search Vs Re-Search* (Albers 1969: 40)	
More or less	More	or less
Easy – to know	Easy	to know
that diamonds – are precious	that diamonds	are precious
	and good	to learn
good – to learn	that rubies	are deeper
that rubies – have depth		

How did such a dramatic change happen? My contention is that Albers's involvement with concrete poets played a role in this reshaping of his texts.

ALBERS AND CONCRETE POETRY: ACTION

Now that I have outlined Albers's poetic work and the principles that underpin it, it is necessary to examine his relation with concrete poets specifically. Concrete poetry can be defined as a neo-avant-garde international movement, in that it claims and furthers in writing some of the gestures of the avant-garde. The very name 'concrete poetry' is redolent of avant-gardist debates. Theo van Doesburg's manifesto introduced the term 'concrete' in 1930. Hans Arp, Le Corbusier, Max Bill and others used the term. As we saw, Albers's prose contribution 'ABSTRACT ———— PRESENTATIONAL' is both a manifesto–like proposition to rename abstraction and an activation of the resources of language to make the text *present*. The text shows that one of the terms chosen to replace abstract art is 'concrete art'. Mondrian's contribution to the same publication also claims that 'it is comprehensible that some abstract artists have objected to the name Abstract Art. Abstract Art is concrete and, by its determined means of expression, even more concrete than naturalistic art' (1946: n.p.).

Via their association with the concrete painter and sculptor Max Bill, once a student of Josef Albers's at the Bauhaus, the concrete poets chose the term with these avant-garde debates in mind. Yes, it is true that in his 'Manifesto for Concrete Poetry', Öyvind Fahlström claimed he did not choose the term thinking of concrete art:

> I have related the word concrete more to concrete music than to concrete art in its narrow meaning. In addition, the working concrete poet is, of course, related to form-language-kneaders of all times, the Greeks, Rabelais, Gertrude Stein, Schwitters, Artaud, and many others. (Fahlström in Cobbing and Mayer 1978: 12)

Yet in 1917, avant-garde poet Hugo Ball stated that 'the word and the image are one. Painter and poet belong together' (in Cobbing and Mayer 1978: 16) likewise, Max Bill made the following statement in 1934:

> The term 'concrete art', refers to those works that have developed through their own innate means and laws – in other words, works that bear no relation to external phenomena and are not the result of any kind of 'abstraction' [and where] the individualistic element is pushed aside for the benefit of the individual. (Bill in Cobbing and Mayer 1978: 11)

These two declarations resonate strongly with concrete poetry's own post-World War II agenda. Moreover, in their foreword to their book on concrete poetry, Bob Cobbing and Peter Mayer state:

> we have shown that the term concrete poetry dates back to the first decade of this century, if not before; that concrete visual and sound poetry have developed together and in step with the evolution of the visual arts and of music; and that the study of concrete poetry cannot be separated from the study of poetry as a whole. (Cobbing and Mayer 1978: 5)

Finally, poets and artists Marcel Wyss, Eugen Gomringer and Dieter Roth explicitly emphasise the relation between the new and the older generation. In 1955, at the back of the fifth issue of their journal *Spirale*, they state: 'our aim continues to be the publication of avant-gard [sic] works of young artists side by side eith [sic] those of artists already well known' (Gomringer et al. 1955: n.p.), which shows that they see a continuity between the first avant-garde and their own endeavours.

In light of these definitions, it is both striking yet perfectly in order that Josef Albers should have been associated with the concrete poets. Although Albers never endorsed the artistic neo-avant-gardes that claimed to be his heirs, he did not seem to mind his interaction with the international neo-avant-garde movement. The association is inscribed in diverse ways, first, through the concrete poets' own texts. In 1958, the Brazilian Noigrandes group published their manifesto-like 'Pilot plan for concrete poetry', in which they specifically mention Albers as one of their forefathers: 'in visual arts – spatial by definition – time intervenes (mondrian and his "boogie-woogie" series; max bill; albers and perceptive ambivalence; concrete art in general) [sic]' (in Cobbing and Mayer 1978: 19). Albers is thus referenced directly for his artwork and his conception of illogical logics. Beyond this reference to an avant-garde artist in order to further a neo-avant-garde movement, a kinship appears, as I suggested earlier, between concrete poets and Albers, in that in both his writing and his graphic works, Albers wanted to activate the line and the word so that they enabled an experience for the viewer and reader. Such is also one of the aims of concrete poetry as Emmett Williams sees it in his introduction to his anthology of concrete poetry: 'It was a poetry far beyond paraphrase, a poetry that often asked to be completed or activated by the reader, a poetry of direct presentation' ([1967] 2013: vi).

Though he did not own a lot of contemporary poetry in his library, Albers's archive contains a good number of books and journals of concrete poetry. Via his association with Gomringer, he received his journal *konkrete poesie*, in which some of his graphic works were printed; he also owned copies of Max Bense's journal *Augenblick*, the journal *Material* and the journal *Spirale*. Some of the books received by Albers were inscribed. For instance, in 1959, Carlos Fernando Fortes de Almeida sent his *Poemas* inscribed to Albers 'with sympathy', and Mike Weaver sent him his *Lugano Review* contribution on concrete poetry, published in 1966.

Two people were of prominent importance in Albers's dialogue with concrete poetry. One was his former student, Max Bill, who was in touch with the Noigrandes as well as with the European world of concrete poetry, and the other was Max Bill's secretary, Eugen Gomringer. In 1954, Gomringer sent Albers his own *Constellations*, published in 1953. While I am not suggesting that Gomringer was influenced by Albers in choosing his title – Gomringer linked his title to Mallarmé's 'rien n'aura lieu/excepté/peut-être/une constellation'[8] – one cannot help notice that the title was similar to Albers's then budding body of graphic work called *Structural Constellations*. In Gomringer's book, poems relative to colour seem to connect with Albers's own preoccupations with the interaction of colours. Moreover, in a letter that, though undated, can be traced to 1954, Gomringer tells Albers that

[his] conception of 'poetry' is close to [Albers's] visual art, and that it was even probably influenced by it, because [Max] Bill has known [Albers's] work for a long time [. . .]. [he] thinks that [Albers's] 'images' are one of the rare possible solutions for the modern era.[9]

Josef Albers is thus clearly identified both as belonging to a network of practices and as an influence. One senses that this connection to a founding generation of Bauhaus artists meant a lot to Gomringer. Moreover, in terms of neo-avant mechanisms, the position of Max Bill is extremely interesting, as he seems to be a middleman, almost literally. Younger than Albers but older than Gomringer, Bill was old enough to have participated in the great push of the second wave of modernism before the war, and yet he was also to be discussed in the specific context of concrete poetry. In his article, Mike Weaver notes how 'Max Bill is recognized as the most important single figure in the concrete movement' (1966: 100). Weaver then traces a network hinting that Bill was present when the concrete poets were creating their movement, be it in Brazil or in Switzerland with Gomringer: 'Gomringer staying with Bill until 1958; his first manifesto on concrete poetry had appeared in 1954' (1966: 100). Bill's case shows clearly how avant-garde artists *acted* consciously or not on the emergence of the concrete movement, and how, in turn, the concrete poets may be clearly defined as neo-avant-garde. Albers readily accepted Gomringer's allegiance, and he remained involved with him for many years. Just like Max Bill, Gomringer even wrote a poem in German for Josef Albers, in 1961, just like Albers had written a poem for Cézanne.

 Gomringer's sense of awe is not confined to letters; it was not just a polite deference to a much older Albers – he was sixty-five by the time they corresponded and met. Gomringer acted on his reverence. Indeed, very early on Gomringer associated Albers's work with his own and with the wider nexus of concrete poets, showing Albers as one of the legitimising figures for his work. Gomringer published Albers's visual work in his journals throughout this period. For instance, there is a reproduction of an Albers work in the third issue of *Spirale*. In 1955, the fifth issue of this journal begins with poems and visual works by Albers, and the biography of Albers included in the publication makes no doubt about his status, describing him as 'widely exhibited and published in europe and the americas. represented in leading museums' [sic] (Gomringer et al. 1955: n.p.). Albers is given pride of place in the journal and yet it is one of the first major publications of Albers's written work. Yet the reason that Albers's work can be seen as action, in temporal terms, is that concrete poems by Bellotti and Gomringer were printed after Albers's work. Moreover, Gomringer's four-page manifesto on his own constellations are clearly an echo of two of Albers's own *Structural Constellations* published

in the journal's opening pages. A poem by Gomringer further emphasises this echo. Not only is Albers the first contributor, but one of the last contributions is a prose text by Mondrian – thus the work of concrete poets is framed by two heroes of modernist painting and art. The legitimation is complete and Gomringer would go on to pursue this further by publishing a contribution on Albers in the 1958 issue of *Augenblick*, as well as a whole monograph devoted to him, in which his poems were published.[10]

DESPITE STRAIGHT LINES: GOMRINGER–ALBERS, RETROACTION

Thus far in this chapter I have addressed the conception of temporal relations as a straight line by outlining the chronological development of Albers's poetry, and using the term 'action' for Albers's own influence – as well as that of other avant-gardists – on the development of concrete poetry. I am not saying that linear temporal relationships do not exist; in fact, the exposition of these straight temporal lines was crucial methodologically in order to understand better why one also needs to move beyond them or at least take into account other models of temporal relation. In fact, just as in an Albers *Structural Constellation*, you first see the straight lines and then they suddenly seem bent and not so straight. What he says about his *Structural Constellations* also applies to the temporal relations we are exploring: 'They defeat logic and remain logic[al]'.[11]

Temporal relations work despite straight lines. Although concrete poets definitely associated themselves with Albers's work in order to legitimise the movement in its relation to what they perceived as the heroic avant-garde that had created a revolution in abstraction as well as in typography, things are not just one-sided. The association between Gomringer and Albers is a rare case of mutual interaction, blurring cause and effect. Yes, Albers was an acknowledged influence on the concrete poets, but Albers also benefited directly from this same association with younger poets. As I have shown, Gomringer did a lot to disseminate Albers's work, sometimes even handling his work for him in Switzerland. The interaction between their works outlined in this chapter sheds new light on my previous examination of Albers's publications in the US. Here, I have shown that some of Albers's poems did change over time, emphasising how dramatic the change was for a reading of these poems themselves.

There was a clear shift in the page design and therefore in the poesis: how can we account for such a difference? This is where the narrative of straight-line influence from avant-garde to neo-avant-garde takes a different road.

Although it could rightly be argued that Gomringer's usage of lower-case characters and sans serif fonts is clearly indebted to modernist typography, as he seems to suggest in his letter to Albers, in the second version of the poem 'Seeing Art' (see below), it is as if modernist typography were confronted with itself. It should be emphasised that the German as well as the English versions of the 1968 Gomringer monograph on Albers are set in the non-decorative Akzidenz-Grotesk (i.e. sans serif), which Albers never used in his text prior to this publication, although *Spirale* had used a sans serif font and the American Abstract Artist catalogue was also set in a sans serif font. While Albers did create a modernist font at the Bauhaus, he also indicated that he did not think that sans serif fonts were appropriate for large blocks of text intended to be read:

> The concept that 'the simpler the form of a letter the simpler its reading' was an obsession of beginning constructivism. It became something like a dogma, and is still followed by 'modernistic' typographers. [. . .] When comparing serif letters with sans-serif, the latter provide an uneasy reading. The fashionable preference for sans-serif in text shows neither historical nor practical competence. (Albers 1963: 4)

To some extent, he paralleled some of the lines of the polemics that rattled the typographic milieux after the war with the controversy between Max Bill and Jan Tschichold. While Bill was still advocating a modernist stance and furthering the values of clarity, efficacy and the unadorned page, Tschichold, one of the theoreticians of modernist typography, had reverted to an older form of typography, namely ornamental and serif fonts, as is described in Hans Rudolf Bosshard's *Typografiestreit in der Moderne. Max Bill kontra Jan Tschichold* (2012). Perhaps Albers was confronted with the same problem in a more subtle and unconscious way when he conceived of the page for some of his poems. In the 1950s and 1960s, his publications constantly drift between the sans serif and the serif fonts. His 1946 American Abstract Artists essay and his two poems are printed in a sans serif font that fully participates in his essay's argument about 'presentative' forms. Yet, as I have shown, the page design for his poems in his 1958 collection *Poems and Drawings* is not modernist. Although not all of his poems after 1955 are set in sans serif fonts, my hypothesis is that that his involvement with the concrete poets after 1953 certainly pushed him to a gradual change in the display of his poems.

Both in the fifth issue of *Spirale* (1955) and in the 1968 Gomringer monograph on Albers, via Gomringer and the new interest in concrete poetry, Albers's poems gained a sense of the sharpness and necessity for a page design

that sought to maintain some of the features of the modernist typography that the concrete poets were reactivating. Without Gomringer and the concrete poets, Albers's poetry would have remained set the way it was in *Poems and Drawings*, or in earlier printings of the poems, such as those in the 'Art feature' of the *Mexico Quarterly* (1943).

Further supporting this hypothesis is the fact that when he was invited to the Hochschule für Gestaltung in 1954 and 1955, Albers was constantly working on his *Structural Constellations*, which Gomringer underlines in his monography, thus underscoring the relations between Gomringer's own poetic constellations and those of Albers. For Albers, this was an immensely creative time because he was with a crowd that abided by the same principles as he did and who were interested in what he was doing but who were above all interested in the aesthetic principle of activating the page. The neo-avant-garde poets allowed the avant-garde artist to see his work in a new light. Can we see 'One is walking' as the same poem before and after the Gomringer monograph? And is it not definitely more like a concrete poem?

To demonstrate this, let us examine 'Seeing Art'. The first version that Josef Albers sent to Anni Albers on a postcard in 1956 is a manuscript poem. It does not have a title and is set on the page like this:

> Art is not to be looked at
> art is looking at us
>
> what is art to me
> is not necessarily art to others[1]

Below is the beginning of the version printed in the Gomringer book in 1968:

	Seeing	Art
Art is not	to be looked at	
art is looking	at us	
What is art	to others	
is not necessarily art	to me	

(Gomringer 1968: 175)

The difference is just as dramatic as with 'One is walking' or 'More or less', analysed above. Semantically, the two versions of the poem are largely identical but, in line with the previous analysis of 'One is walking' and 'More or less',

the second version in the Gomringer book is much more interesting, not just because it is more visual or theatrical, but also because it clearly is much more dynamic – dare I say 'concrete'? – showing and highlighting all the syntactical articulations of the poem, reinforcing the poesis of illogical logic through the design of the visual prosody. 'Despite straight lines' could be a description of some of the 'concrete' versions of Albers's poems: the lines are straighter, more symmetrical, more definite and almost more rational; they seem to be clear, as straight lines, and yet those lines are reversed, bent; or it could be said that they just verse into one another by the sheer display of the poem into two columns – potentially creating two line breaks for each line and creating more movement, distorting the straight line into an infinite combination of slanting lines – indeed, to paraphrase Emily Dickinson, there is a certain slant of line, one could say, just like one could say there is a certain slant of light (Dickinson this time) in Albers's *Structural Constellations*.

One question remains: did Gomringer impose a new shape and a new typography? This was certainly done in dialogue with Albers. There are copious letters, and all the correspondence between the two men shows a spirit of camaraderie. While it is impossible that such a radical change in Albers's poems happened without Gomringer in the background, it is also impossible that Albers simply allowed these poems to be published as Gomringer wished. In other words, it is during Albers's association with concrete poets and while the movement was emerging that the dramatic changes happened. One could object that *Poems and Drawings* was published in 1958, and that in 1976 some of Albers's poems were published in serif fonts in his *Gray Instrumentation* portfolio. Yet, as I have tried to express, there might have been two paradigms at work in Albers's view, given that he did publish 'More or less' in the more 'concrete' version in *Search Vs Re-Search* and other publications. Albers was never systematic; he never wanted to be associated with one movement in particular; he called that 'not jumping on the bandwagon'. What this chapter shows, though, is that while concrete poets claimed him as one of their influences, and while he did not relinquish this interaction with concrete poets, he also benefited from them in terms of the conception of his writing. This case study shows that temporal relations among neo–avant-gardes are not different from those in other literary and artistic movements, in that they also function as action/reaction/retroaction. This helps reframe slightly what the term 'neo' seems to suggest too strongly, and while it cannot be denied that Gomringer was born after Albers, it is also striking that someone like Max Bill should have played a role within concrete poetry. The picture is complete when one considers that *Spirale* published a book of drawings by Albers in 1956. At the end of this catalogue, Max Bill wrote a poem for Albers set like a concrete poem.

NOTES

1. Drawing on Aby Warburg's art history, among others, Georges Didi-Huberman (2000) has explored the fruitful notion of anachronism. For other valuable approaches, see Nagel and Wood (2010) and Bayard (2009); for reciprocity, read Marc Midan's PhD dissertation 'Milton and Melville: le démon de l'allusion'; other books tend to broaden our conception of temporal relations, such as Neefs (2001).

2. Josef Albers, letter to Anni Albers, 1952 [ms]. Nonsense poetry invites interpretation. Here, this might be phonetically close to a German dialect version of: 'ob du noch so stolz bist' ('if you are still that proud'). What is more, the reference to pissing in 'pisst' disrupts the resolution in 'bist' ('you are'). Albers wrote other such poems that clearly referenced Schwitters, such as one in which he used the word 'dadá', that is, Schwitters's spelling for what he called 'progressive dada'. See Josef Albers, letter to Anni Albers, 7 June 1955.

3. 'The Revolution of the word' was the title of a manifesto published in issues 16 and 17 of the avant-garde literary magazine *transition* (June 1929). The manifesto has twelve points, the last two of which say: '11. L'écrivain exprime, il ne communique pas' ('The writer expresses, he doesn't communicate') and '12. Maudit soit le lecteur simple' ('Damned be the simple reader'). Albers had issues of *transition* in his library, and Schwitters, Arp and such fellow artists were published in the magazine.

4. Although the received English translation of *ostranenie* is 'defamiliarisation', I choose to use its more literal translation 'foreignisation' to make sure that one reads the foreign into it. It is crucial to the argument that Shklovsky makes.

5. 'About my structural constellations', typescript, The Josef Albers Papers, box 81–11(1).

6. As the proofs for the book cannot be retrieved, one cannot say whether this was a choice of the editor or of Albers. But given Albers's attention to the conception of his other books, one can surmise that he approved.

7. In the Abstract American Artists catalogue in which this text was published, Albers's work is the only contribution that uses a range of typographical solutions to activate the page and 'foreignise' prose. All the other texts are set as conventional prose.

8. This is a montage of a passage from Mallarmé's *Un coup de dés jamais n'abolira le hasard*, quoted in French by Gomringer as an epigraph to his German essay 'vom vers zur konstellation', about his *Constellations*, which appeared for the first time in *Neue Zürcher Zeitung* on 1 August 1954 and was reprinted in the fifth issue of *Spirale* that also featured Josef Albers's texts (Gomringer et al. 1955: n.p.).

9. Undated letter from Gomringer to Albers, JAP 35b (2), box 71.

10. Gomringer also published the first article on Albers's poetry, to this day one of the very few articles on his poetry.
11. 'About my structural constellations', typescript, The Josef Albers Papers, box 81–11(1).
12. First lines of Josef Albers, 'Seeing Art', Josef Albers's postcard sent to Anni Albers, 2 May 1956, The Josef Albers Papers, box 79.13.

BIBLIOGRAPHY

Albers, J. (1946), 'ABSTRACT ———— PRESENTATIONAL', in *American Abstract Artists*, New York: The Ram Press, n.p.

Albers, J. (1958), *Poems and Drawings*, New Haven, CT: Ready-Made Press, n.p.

Albers, J. (1969), *Search Vs Re-Search*, Hartford, CT: Trinity College Press.

Albers, J. [1963] (2003), *Interaction of Color*, New Haven, CT: Yale University Press.

Bayard, P. (2009), *Le Plagiat par anticipation*, Paris: Minuit.

Bosshard, H. R. (2012), *Typografiestreit in der Moderne. Max Bill kontra Jan Tschichold*, Teufen: Niggli.

Broqua, V. (2021), *Malgré la ligne droite: l'écriture américaine de Josef Albers*, Dijon: Presses du réel.

Bürger, P. [1974] (1984), *Theory of the Avant-Garde*, trans. M. Shaw, Minneapolis, MN: University of Minnesota Press.

Cobbing, B. and P. Mayer (1978), *Concerning Concrete Poetry*, London: Writers Forum.

Deleuze, G. (1993), *Critique et clinique*, Paris: Minuit.

Deleuze, G. (1997), 'Literature and Life', trans. D. W. Smith and M. A. Greco, *Critical Inquiry*, 23 (2), pp. 225–30.

Didi-Huberman, G. (2000), *Devant le temps. Histoire de l'art et anachronisme des images*, Paris: Minuit.

Drucker, J. (1994), *The Visible Word: Experimental Typography and Modern Art, 1909–1923*, Chicago: University of Chicago Press.

Foster, H. (1996), *The Return of the Real: The Avant-Garde at the End of the Century*, Cambridge, MA: MIT Press.

Gomringer, E. (1953), *Konstellationen*, Bern: Spirale Press.

Gomringer, E. (1968), *Josef Albers: His Work as a Contribution to Visual Articulation in the Twentieth Century*, New York: Wittenborn.

Gomringer, E., M. Wyss and D. Roth (eds) (1955), *Spirale*, 5, Bern: Spirale Press, n.p.

Midan, M. (2014), *Milton and Melville: le démon de l'allusion*, PhD dissertation, Université de Paris 7 Paris Diderot, <http://www.theses.fr/2014PA070086> (last accessed 31 January 2021).

Mondrian, P. (1946), 'A New Realism', in *American Abstract Artists*, New York: The Ram Press, n.p.

Nagel, A. and C. S. Wood (2010), *Anachronic Renaissance*, New York: Zone Books.

Neefs, J. (ed.) (2001), *Le Temps des œuvres. Mémoire et préfiguration*, Saint-Denis: Presses Universitaires de Vincennes.

Nordland, G. (1965), 'Josef Albers', in *Josef Albers: The American Years*, ed. G. Nordland, Washington DC: The Washington Gallery of Modern Art, pp. 4–42.

Redensek, J. (2018), 'Farbenfabeln: On the Origins and Developments of the Homage to the Square', in *Josef Albers: Interaction*, New Haven, CT/London: Yale University Press, pp. 172–91.

Schwitters, K. (1981), 'Konsequente Dichtung' [1924], in Kurt Schwitters, *Das literarische Werk*, vol. 5, ed. F. Lach, Cologne: DuMont Buchverlag, pp. 190–1.

Schwitters, K. (2020), *Myself and My Aims: Writings on Art and Criticism*, ed. M.n R. Luke, trans. T. Grundy, Chicago : University of Chicago Press.

Shklovsky, V. (2004), 'Art as Technique' [1917], in J. Rivkin and M. Ryan (eds), *Literary Theory: An Anthology*, 2nd edn, Malden, MA: Blackwell, pp. 15–21.

Tschichold, J. (1995), *The New Typography*, trans. R. McLean, Berkeley, CA: University of California Press.

Watts, H. (ed.) (1974), *Three Painter-Poets: Arp, Schwitters, Klee*, London: Penguin Books.

Weaver, M. (1966), 'Concrete Poetry', *The Lugano Review*, 1–5/6, pp. 100–25.

Williams, E. (ed.) [1967] (2013), *An Anthology of Concrete Poetry*, New York: Primary Information.

Multi-faceted Images of Reality: Montage in Documentary Literature from the Long 1960s

Lieselot De Taeye

'Montage, Kathleen, recomposition, that is the password' (Gysen 1966: 30).[1] The narrator in the Flemish experimental novel *Grillige Kathleen* ('Capricious Kathleen') (1966) utters these words to the main character, Kathleen. The fragmentary nature of the book she finds herself in, as he explains, is a reflection of his profound experience of reality: we persistently try to construct an image of it, but that image is necessarily incomplete and tangled up in fallacies and mistakes. An all-encompassing, trustworthy narrative can never be written, but in a montage some fragmented visions of reality can still come together.

Similar preoccupations concerning the relationship between writer, text and reality appear in many Dutch and Flemish literary works of that time. During the 1960s, an important share of Dutch-speaking authors sought to establish a more 'direct' link to reality than they believed the traditional novel was capable of. In most cases, this desire was coupled with an explicit interest in the socio-political changes of the time: protest movements were undermining the authority of the pre-war generations, with many violent incidents exposing deeper social problems (Buelens 2018). The hunger for literary reality also tied in with the more general epistemological doubts that had arisen after 1945. The post-war feeling of absurdity and a growing distrust in human observations had eroded any faith in more traditional ways of knowing and writing (Wispelaere 1967: 113; Brems 2006: 186).

This trend, which spanned the years between 1965 and 1975, could be termed a documentary tendency. It flourished within the neo-avant-gardist surge of the same time, but also branched out into more mainstream literature. Both a bestselling novelist like Harry Mulisch and a marginal experimental writer such as Enno Develing decided to resort to only publishing non-fictional texts on societal issues in the 1960s. In the work of numerous

others (Hugo Raes, Sybren Polet, Lidy van Marissing), non-fictional fragments on environmental problems, colonial abuses and poverty appeared alongside more traditional fictional prose (De Taeye 2018: 13–40). A similar trend arose in German literature, where the so-called *Dokumentarliteratur* came to the fore (Festjens and Martens 2013; Miller 1982). Scandinavia, meanwhile, saw a wave of *dokumentarism* in literature (Houe and Rossel 1997). The documentary tendency, furthermore, bears some resemblance to the American New Journalism (Hartsock 2000; Hollowell 1977) and Australian journalistic writing of the time (Harbers et al. 2016).

The tendency has often been noted in general overviews of Dutch literature (Bousset 1973: 188; Van Aken 1979: 216; Brems 2006: 292–307) and more detailed studies (Beekman 1984). However, not much attention has been devoted to the literary strategies that were developed within this framework. In this chapter I focus on how the montage technique surfaced within the Dutch-speaking documentary tendency of the 1960s. I will argue that, in comparison to most of the literary montages written during the historical avant-garde, these montages were often more radical in their departure from the tradition of the novel. The documentary tendency and its prevailing values and questions provided a welcoming space for experimentation. After a short discussion of the terminological intricacies surrounding the concept of montage, I will take stock of the literary historical position and the meaning avant-garde scholars have attributed to the formal principle. From there, I will outline the specific ways in which the principle has figured in the Dutch-speaking documentary tendency. In my reading of *Praag schrijven* ('Writing Prague') (1975) by Daniël Robberechts, a book in which the Prague Spring plays a central role, I will show how montage evokes an ever-changing multidimensional reality, as well as the impossibility of fully grasping it.

TERMINOLOGY

In Dutch-speaking literary research, preference is given to the term 'montage' (Vitse 2008, 2009), as I will also do in this chapter. It is, however, important to point out that 'montage' is often associated or contrasted with terms such as 'collage', 'assemblage' and 'cut-ups'. Making a clear distinction between these concepts is tricky. 'Montage', 'collage' and 'assemblage' all refer to techniques that were originally developed in artistic domains outside of literature, mostly during the historical avant-garde (Perloff 1986: 72). Marjorie Perloff specifies that the term 'collage' is mainly used to describe static works of art that are organised according to spatial principles, while 'montage' is given more currency in relation to art forms that develop over time (1986: 246). Both terms

take on a metaphorical meaning when applied to literary text, which explains why they were mostly used interchangeably during the 1960s, in reflections about documentary literature in Dutch (De Taeye 2018: 300). For heuristic reasons, it does make sense to trace them back to their origins.

Montage first appeared in the filmmaking world. The Russian cinematographer Sergei Eisenstein was one of the first to experiment with the sequencing of different shots. He used this editing technique to evoke not only causal relationships, but also rhythms and metaphors. The well-known stairway scene from *Battleship Potemkin* (1925), for instance, crosscuts between a baby carriage rolling down the steps and civilians fleeing the military, thus creating a suspenseful portrait of the uprising in Odessa. Similarly famous is the series of juxtaposed photographs published by the montage theorist Lev Kuleshov. By putting the same frontal picture of a man next to three different images (of food, a woman, a young girl in a casket), he demonstrated how meaning can arise, not from the mere images, but from juxtaposition itself (Bordwell 1972: 9).

Collage, assemblage, and later the cut-up, also emerged in the visual arts. Around 1912, Georges Braque and Pablo Picasso distanced themselves from traditional 'realistic' representations by gluing shreds of newspaper and pieces of rope onto their canvases – *coller* in French (Banash 2004). Around the same time, Picasso also started bringing together, or 'assembling', heterogeneous elements in his sculptures.

Soon, texts, theatre and musical compositions were labelled with the terms 'assemblage' and 'collage' as well. André Breton, for instance, published collage poems made entirely out of snippets taken from newspapers and magazines. The same happened for 'montage'. Two novels from the 1920s, *Berlin Alexanderplatz* (1929) by Alfred Döblin and *Manhattan Transfer* (1925) by John Dos Passos, are often mentioned as examples of 'montage novels', as the narratives in these books contain fragments taken from publicity ads and news reports (Gfrereis 1999: 130).

The heterogeneous quality of the snippets in a visual collage and the sequencing of different fragments in a film montage emerge as two sides of the same coin when we talk about literary prose. The various texts that have been called montages, assemblages or collages in literary criticism combine both characteristics: they consist of distinct parts that are still recognisable as such, but which are presented in sequence. David Bordwell recognised this as an abstract feature shared by collages and montages across a range of media. He described the 'assemblage of heterogeneous parts, juxtaposition of fragments' (Bordwell 1972: 10) as a kind of fundamental principle that can be applied across different arts. Perloff, too, preferred to conceptualise collage as a more general artistic strategy than a medium-specific one (1986: 47).

Specifically for literary prose, it is worth mentioning that montage struc-
tures often do not support the construction of narrative. In opposition to
film, the technique instead disturbs the linearity or flow of a story (Valcke
2005: 299; Vitse 2009: 443). Of course, some sort of coherence can still exist
between the different blocks. David Antin, who preferred the term 'collage',
stated that first and foremost, the principle ensures 'weaker' logical connec-
tions between its different parts:

> [C]ollage involves suppression of the ordering signs that would specify
> the 'stronger logical relations' among the presented elements. By 'stronger
> logical relations' I mean relations of implication, entailment, negation,
> subordination and so on. Among logical relations that may still be pres-
> ent are relations of similarity, equivalence, identity, their negative forms,
> dissimilarity, nonequivalence, nonidentity, and some kind of image of
> concatenation, grouping or association. (Antin 1974: 21)

Because of the abstract nature of these logical relationships, a wide variety of
montages can also be found within literature. In order to have a good under-
standing of how this principle functions within a certain period and context, it
is important to pay attention to the gaps in the montage, and how they shape
the meaning of the text.

MONTAGE AS AN AVANT-GARDE TECHNIQUE

Because of its origin, montage has mainly been researched by art theorists and
experts of the historical avant-garde. The technique has even been called 'the
fundamental principle of avant-gardiste art' (Bürger [1974] 1984: 72) and 'the
epitome of avant-garde art' (Valcke 2005: 299). The possibility of constructing
a new work of art by putting together existing, fragmentary material has long
been associated with the expansive projects and ambitions of the avant-garde.
Montages were hailed as a means to disrupt the autonomous, organic work of
art and breach the illusionary wholeness it projected. Peter Bürger emphasised
the insertion of 'reality fragments', because he believed they brought about 'the
destruction of the unity of the painting as a whole' ([1974] 1984: 77). According
to Theodor Adorno, the chaos of true life in the montage did away with the
illusory sense the traditional work of art could still display: 'The artwork wants to
make the facts eloquent by letting them speak for themselves. Art thereby begins
the process of destroying the artwork as a nexus of meaning' ([1970] 1997: 203).
By equating readymades with 'reality', Bürger and Adorno also hinted at the
much-desired unification of art and life in the historical avant-garde.[2]

The technique was also interpreted as a contribution to a new realism, one that was adapted to modernity. Jennifer Valcke describes how the montage presented 'an image or set of re-assembled images that reflect a fast-paced, multi-faceted reality' (2005: 300). Valcke specifies how this matched the context within which the avant-gardes developed: 'Montage thus serves as a sign of an old world shattered and a new world in construction, of the fragmentation of the once-reigning unities of life and an everyday reality that has suddenly burst the frame of experience' (2005: 300).

The elliptical quality of montage was associated with the notion of emancipation. As the members of the audience had to fill in multiple blanks by themselves, it was understood that they necessarily became more critical and engaged. According to Walter Benjamin, Bertolt Brecht's epic theatre brought about a subversive effect due to its montage form:

> [H]ere the interruption does not have the character of fear and pity, but has an organizing function. In the midst of the action, it brings it to a stop, and thus obliges the spectator to take a position toward the action, obliges the actor to adopt an attitude toward his role. (Benjamin 1970: 94)

For this reason, Benjamin considered montage to be the artistic form of the future.

In the literary canon of the inter-war period, however, montage prose did not occupy a prominent position. Perloff has found that literary montages were usually received with disapproval between the wars (1986: 72–4). Critics had problems with the loss of coherence and unity, and with the external origin of the parts of the montage. Both specificities were perceived as eroding the literary 'aura'. At the beginning of the twentieth century, dominant aesthetic norms still defined literary works as original creations with a coherent design (Perloff 1986: 72). According to literary scholar Marianne Ping Huang, highly valued novelistic experiments rather focused on a 'self-reflective and meta-reflective search of epistemological or ontological patterns for the telling or non-telling of individual life stories' (2004: 251). She concludes that modernist solicitudes mostly dominated the renewal of the novel and that the influence of avant-garde remained rather limited. In the exceptional canonised examples of Dos Passos and Döblin, for example, the montage principle is not implemented in a very radical way: the quotations do not make up the entire work and the fragmentary element of the montage does not thoroughly disturb the establishment of a linear story.

Ping Huang generalises her observations for the entire twentieth century. According to her, montage literature never really got a foothold (2004: 251).

When we focus on the experimental tradition in literature, this image should be adjusted. Writers who were active in neo-avant-garde circles during the second half of the twentieth century published a good number of prose montages. The structural principle of montage can be found in the work of Richard Burroughs (who used the term 'cut-up', as coined by his friend, the painter Brion Gysin). German experimental writers such as Alexander Kluge and Helmut Heißen-büttel, and Austrian authors such as Oswald Wiener and Konrad Bayer also deployed the principle, as did the Italian Nanni Balestrini, whose *La violenza illustrata* is also constructed as a montage.

MONTAGE IN DOCUMENTARY LITERATURE FROM THE 1960S

Specifically within the Dutch-speaking documentary tendency, montage became one of the most tried and tested innovations of the 1960s. Nearly all documentary works from that period are structured according to the montage principle – including even the most traditional non-fictional texts. For instance, in *De Parijse beroerte* ('The Parisian stroke') (1968), a reportage about the May '68 events in Paris, Cees Nooteboom included two large sections consisting solely of found citations; aside from pamphlets and historical analyses of the Commune in Paris, he also quoted the street graffiti in Paris. Citations from existing documents also regularly appear in novels published during this period. For example, Wim Hazeu's *De helm van aarde* ('The helmet made of earth') (1970), in which a fictional reporter goes on a trip to future Prague, contains fragments from the 'Manifest of 2000 words' by writer Ludvík Vaculík, which played an important role during the Prague Spring.

I will focus more extensively on more radical examples of documentary montages, in which the structural principle displaces the linear coherence of traditional narratives to a greater extent. Those montages did not merely renew the novel or the reportage, they presented an outright alternative. Since few examples of these more radical montages were published during the inter-war period in prose (examples in Dutch include the work of Kurt Köhler and M. Revis), these radical documentary montages represent one of the more novel aspects of the neo-avant-garde.

The montages of the second half of the 1960s and the early 1970s mostly seek to expose undemocratic tendencies and social issues on the basis of con-catenated pieces of text (both self-written and taken from elsewhere). Wim Hazeu's *Vrolijk klimaat* ('Cheerful environment') (Hazeu et al. 1968), for example, contains multiple kinds of printed texts which show how the Dutch intelligentsia during the inter-war period sympathised with anti-Semitic and

anti-democratic ideas. The year before, Hazeu had documented a large number of censorship incidents in short, stuck-together pieces in a special edition of the literary magazine *Kentering*.[3] In *Leopold II van Saksen Coburgs allergrootste zaak* ('Leopold II of Saxe-Coburg's largest undertaking') (1971), Julien Weverbergh focused on the colonial history of Belgium. Using archival documents, old newspaper articles and cartoons, the work shows how Leopold II enriched himself by exploiting the Congolese people. The documents form the biggest part of the book; Weverbergh added only a preface, some titles and a small number of comments.[4] Earlier, in 1968, Weverbergh had already supplemented *Een dag als een ander* ('Another day'), a novel which he had published in 1965, with documents highlighting abusive practices in Flemish high schools. This collection of texts received a new title: *Het dossier Jan* ('The Jan files').[5]

In the aforementioned montages, the creative contribution of the author is almost reduced to merely selecting and combining various pieces of text. This interpretation of authorship contrasts strongly with the focus on creative language and design in more classical perspectives of literature. Weverbergh, however, believed that the topicality of the 1960s forced the writers to distance themselves from that: 'I believe that in this gladiator era, writers can only express themselves [. . .] through the direct word, in other words, the polemic, the demonstration of the lie through a coolly reasoned argument, the publication of documents and facts with comments' (in Auwera 1969: 186).

In the mid-1970s, a few montages were published which no longer focused on one single social or political problem, such as the colonialism of Leopold II; they were rather about structural issues, such as inequality and discrimination. In Sybren Polet's *De geboorte van een geest. Een kadercollage* ('The birth of a ghost: a frame collage') (1974), for example, a large part of the quotations and narrative sections are about situations of oppression, or the protest against it, in the history of Amsterdam. The writer described the book itself in the attached explanation – with which he incidentally wanted to contribute to the 'demystification of the literary product' – as a 'type of collage or montage within the framework of several clear thematic lines' (Polet 1974: 321). This 'imperfect' form allowed him to use 'varied stylistic devices and literary genres when this better suited [his] goal' (1974: 322). This goal consisted of representing reality in an alternative, critical way. For example, Polet explained that in the structure of his montage book, he had integrated 'parallels or contrasts and dialectical oppositions' because these 'reflected, among other things, the social relations' (1974: 323).

The subject of Lidy van Marissing's debut, *Ontbinding* ('Decomposition') (1972), is also more abstract: it presents the misery that the lower classes have to deal with. In the book, a fictional story about two socially isolated women

– one of whom dies – is alternated with fragments taken from factual genres that evoke poverty and violent situations. The book's back cover reads that the combination of both types of text can provide the reader with insight into the 'objective situation' and 'the social causes of a psychological oppression' (Van Marissing 1972: 154). The montage thus embeds the novelistic situation of the two women in a broader, social context. Nevertheless, the book does not present a well-defined image of 'reality'. In the work of Van Marissing, montage takes on a far-reaching fragmentary form: the texts she includes are often broken off abruptly and do not fit into an unambiguous interpretation: '[t]he text is not a massive frontal object but a remainder' (1972: 141), reads a meta-commentary in the text itself. In the epilogue, the writer argues that she distrusts finished entities, and that she is more concerned with making her readers aware and involving them in the interpretation process: 'In montage, not only the author can share their commentary, the reader is also encouraged to form an opinion through the moment of alienation' (1972: 145).

In the volume *Het mes in het beeld* ('The knife in the image') (1976) – which is a compilation of texts by Robberechts, Van Marissing and experimental author J. F. Vogelaar – montage, first and foremost, brings about a kind of breakdown: existing texts are adapted in all manner of ways, which leads to the emergence of certain contradictions and assumptions. In his contemplative work from that time, Vogelaar indeed emphasised the deconstructive work a montage could do: '[T]he montage technique [is] used critically to break through a make-believe world at the level of the meanings that have actually been used' (1974: 177). A representation of reality was not fully cast aside by Vogelaar in other texts, but like Polet and Van Marissing, he preferred to focus on a deeper, structural level, not on superficial events: 'instead of sticking images together, [montage] should form an understanding' (1974: 26).

In their contemplations, authors such as Van Marissing, Polet and Vogelaar also indicated explicitly that they were inspired by people from the historical avant-garde, especially by politically engaged artists. Van Marissing, for example, referred to Bertolt Brecht in the epilogue of *Ontbinding* to clarify the way in which she employed the montage principle. For example, she quoted, almost verbatim, from the translation Vogelaar made of his work: 'A photographic representation would only show one dimension (the flat front)' (Van Marissing 1972: 145).[6] Robberechts, similarly, fully based his piece 'Kunst / Brecht / kunst' on the writings of Brecht, which he integrated into his own contemplation in the form of quotations. Even the slashes in the title remind the reader of the omnipresent montage principle. In the essay, Robberechts – as expressed by Brecht – argues, among other things, that an 'experience of reality as a totality is no longer possible' (1976: 50).

CONSTRUCTING PRAGUE

Praag schrijven ('Writing Prague') by Robberechts was published around the same time, but contrary to *Ontbinding* and *De geboorte van een geest*, it has a much more specific theme: the book represents the city of Prague in a variety of concatenated pieces of text. In the last part of this chapter, I will analyse this text more extensively, as it foregrounds many of the formal experiments and thematic preoccupations of the Dutch-speaking documentary tendency, especially in the manner in which montage is presented.

The first pages of *Praag schrijven* take the form of a diary. A writer describes how he is getting settled into his home so he can start working on a new project. His plan is to investigate the possibilities of portraying a city in text:

> Let the world outside doze off, now is the time to apply oneself to a deci-
> phering indoors, patiently, with black characters outlined clearly on white
> paper. So Prague? Well – Prague itself is probably not that important, it is
> certainly not as irreplaceable as, for instance, Avignon, or your city of birth.
> The important thing is that an object exists which you can spend your
> words on, a place, which you can make a hertz cable-like invisible con-
> nection with, from this house, besieged by mist and silence. (Robberechts
> 1975: 6–7)

Contrary to Brussels and Avignon, two cities that were important in Robberechts's previous, autobiographical works, Prague is nothing more than a 'pretext, an occasion' (Robberechts 1975: 7) to write. The lack of a personal connection between the writer and the city makes it possible for him to construct something in words, as he explains. He certainly does not want to visit the city, as he is not interested in using lived experience as a starting point. By instead showing the rituals that draw him into his topic, by emphasising the particular pacing and duration of his work, the materiality of the writing process itself is foregrounded, rather than the city's existence as an object (Vitse 2012).

A diary can, tangentially, be considered as a kind of montage, because its different sections are traditionally separated by gaps. While the diary entries themselves evoke something about the process of writing, the blanks between them demarcate jumps in time, in which things other than writing can occur. The balance between life happening and having time to write varies in *Praag schrijven*. Around May 1968, long breaks in time separate the different entries, which remain quite short in and of themselves too. The narrator explains that during those days, he was participating in protests in Brussels (he assisted among others in the occupation of the Palace of Fine Arts there), making it impossible for him to write.

The diary genre sometimes morphs into letters addressed to the inhabit-
ants of Prague in *Praag schrijven*. In the beginning of the book the narrator
announces ominously to them: 'We are, lo and behold, approaching spring.
But I imagine that you are still in the depth of winter?' (Robberechts 1975: 6).
Immediately after these words, a newsreel interrupts the letter. A long series of
reports, all of which are, again, dated, describe the events that would eventu-
ally coalesce into the Prague Spring.

> In January nineteen hundred sixty-seven a non-profitable coal mine and
> two coke ovens are closed. Within the Czechoslovak communist party and
> in the industry, there are differing opinions about the economic reform.
> On June 10 nineteen hundred sixty-seven the diplomatic ties between
> Czechoslovakia and Israel have been cut.
> From June twenty-eighth until June thirtieth, a fourth congress of
> Czechoslovak writers has taken place. The end resolution pleads for more
> plurality, freedom and tolerance. Jiri Hendrych, the ideologist of the
> Czechoslovak communist party, demands a more conformist attitude from
> the writers, and he erases authors who do not comply with the party – a.o.
> Waclav Havel, Ludvik Vaculik and Pavel Kohout – from the list with can-
> didates for the presidency of the writer's union. (Robberechts 1975: 16)

Apart from economic difficulties and dissident writers, the news items also
mention the election of Alexander Dubček, who would later propose a reform
of the strict Soviet governmental model and become a leader of the liberation
movement in the country. The reports seem to point at a rising tension in
Prague but their dry style, and the fragmented way in which they are presented,
leaves a lot open. As the readers of the book, back in 1975 and now, are able to
know, the protests in the city would come to a high around the month of May,
before being violently repressed by Soviet military forces and representatives of
the Warsaw Pact. However, the montage and the day-to-day notation in *Praag
schrijven* evoke the uncertainty that reigned while events were still unfolding.
There are no foreboding hints, and neither the selection of the news items nor
the narrative rhythm or tone reveal any awareness of a certain outcome.

In the following diary entries, the narrator describes his being bewildered
by the changes going on in the city. The mere task of meticulously evoking
Prague in words was already challenging but now the news pushes him to
accept the ever shape-shifting nature of his research object. Nevertheless, he
expresses mostly surprise and gratitude upon this discovery:

> I, the writer, who guilelessly thought that I could reach this unknown,
> uncharted city with my words, I am becoming a chronicler, overwhelmed
> by new events. Your city seems to be moving, maybe I will never track it

down. But how would one not accept, gratefully, this flow of events, as an undeserved sign, an obliging hint. (Robberechts 1975: 27)

Large parts of the book are, accordingly, taken up by more newsreels. Contrary to what often happens in more narrative representations of the Prague Spring, the reports keep appearing even after the uprising has been violently suppressed. Pages and pages of news announcements document the complicated aftermath of the events. Dubček, for example, kept receiving a lot of support from Czechoslovak institutions before he had to step down. The communist party in the country, moreover, started to deal with some existential questions: to what extent could it accept a more democratic approach that was reminiscent of the capitalist West? Was it justifiable to reintroduce censorship, if that could protect the international communist project?

Aside from the newsreels, the Prague Spring is also evoked in other ways. The book includes, for instance, an article in French, written by a Czech activist who goes by the name of Ilia X. The text does not exactly recount the events in Prague but instead analyses the civil unrest of May '68 in Paris against the background of the situation in Czechoslovakia. By citing this text, Robberechts on the one hand highlights the presence of the Czech in Paris, and, thus, emphasises the international dimensions of the protest movements in the 1960s. On the other hand, the dislocated perspective also points at the specificity of diverse geographical contexts and cultural understandings. Ilia X, for instance, blames the so-called failure of the May '68 movement on a lack of societal insight. He contends that the French are sedated by prosperity, while the revolutionary ideas of the people in Czechoslovakia are informed and buttressed by personal experiences of fear, daily suppression and even imprisonment (Robberechts 1975: 86–7).

This perspective throws the representation of the Prague Spring in *Praag schrijven* into relief, as it foregrounds the defining influence of the author's own background, which is closer to the French than to the Czechoslovak situation. Ilia X, additionally, comments on how the French press reports on the events in Prague. Although the situation is portrayed in a complete and uncensored way, according to him, the reports do not provide much analytical understanding. Instead, the sensational, direct and informative forms of address prevail. This criticism also seems applicable to the newsreels that are integrated in *Praag schrijven* itself.

To further complicate the representation, two different translations of Ilia X's essay follow the original text, while the newsreel still continues in the last three lines of each page, drawing the reader's attention to the ongoing changes. The first translation is taken from a literary magazine; the second one is written by Robberechts himself, who was bilingual. The differences between the freer translation from the magazine and Robberechts's more strict translation point

out how a Western European perspective possibly distorts the account of the Czech and how it is rendered.

In various ways, the montage structure brings to the fore the impossibility of representing reality from a single perspective. Robberechts's use of the technique reminds the reader of the multidimensionality of all phenomena, of the constant changes they undergo, and of the mediating role of language and culture. The narrator expresses his becoming aware of these layers and interactions in a meta-reflection:

> And so it happens that we can no longer consider 'history' and 'society' as monotonous lines that are drawn before our eyes, we experience them above us and below us, in the past, now and tomorrow, North, South, East and West as the space in which we live, an enormous molecular construction that becomes transparent under our attention, palpable under our intervention. And we feel small for that space, but by no means powerless: when in one single human life so much more is happening than before, when so much comes to being and so much disappears, then such a life also takes on much more weight than before. (Robberechts 1975: 193)

While the emphasis is very much on agency and action here, the attention in the second part of the book shifts again to more depersonalised views of the city. Gradually, new fragments appear in which the initial project of representing Prague as a far-away object is taken up again, for instance in fragments that meticulously describe the possible materiality of the city. These sections provide, again, a whole different perspective on the city.

In the juxtaposition of all those different kinds of text, multiple tensions come to the fore: between writing and putting one's body in the streets; between the material outline of a city and the changes going on inside it; between the personal issues of a writer and those of the society they are part of; and between the local and the international. The fragmented construction of the text does not resolve these tensions. No single position or perspective dominates, no hierarchy or balance is found. The montage just allows the text to move back and forth between multiple poles and points of view, while integrating them into an ongoing flow.

CONCLUSION

Montage is an important technique within the documentary tendency of the 1960s for several reasons. First, because of its fragmentary nature, the form offered an alternative to the conventional, linear novel. Instead of mirroring what was

going on in society by staging conflicts between a limited number of fictional characters, the structural principle of montage evoked complicated realities and the multiple perspectives on them by combining heterogeneous pieces of text. As this requires an effort on the part of the reader to connect disparate fragments, the form was also attributed a critical potential. Additionally, the montage in the documentary tendency was often associated with a certain democratisation of the text. The formal principle allows, after all, for the integration of texts written by others, formulated in less literary genres, but which resonated well with the political liberation pursued by numerous countercultural movements. Lastly, rather than a straightforward plot or teleology, montages in documentary literature of the 1960s projected uncertainty amidst unfolding events.

The parallels between the traditional interpretations of the avant-garde montage and the objectives of the Dutch and Flemish documentary writers are many. Both in historical avant-garde and in the documentary literature of the 1960s, we find a search for an alternative, more 'direct' representation of reality, paired with the search for a critical approach and a more active role for the spectator or reader. While innovations in the historical avant-garde were mostly implemented in a radical way in the visual arts – for Döblin and Dos Passos, the montage principle remains inferior to the novel – the far-reaching fragmentary and heterogeneous aspect is presented as a full alternative to the traditional novel in the documentary tendency of the 1960s.

The way in which montage appears in the documentary tendency also makes clear how this tendency forms a separate movement within the neo-avant-garde of the 1960s. Contrary to other neo-avant-garde works in other Dutch-speaking literature from the same period, in which self-reflection or abstraction predominated, an image of reality is still established here, albeit in an alternative way.

NOTES

1. Unless otherwise noted, all translations are mine.
2. These interpretations, in which readymades and documents are equated to 'reality', did not simply persist. For example, Hal Foster criticised Bürger's interpretation: 'This dadaist ideology of immediate experience [. . .] prompts [Bürger] to see its primary device, the readymade, as a sheer thing-of-the-world, an account that occludes its use not only as an epistemological provocation in the historical avant-garde but also as an institutional probe in the neo-avant-garde' (1996: 15).
3. For the censorship edition, see *Kentering*, 8 (2) (1967). Hazeu kept supplementing the file, including in *Kentering*, 10 (3/4) (1969), pp. 90–2;

Kentering, 10 (6) (1969), pp. 44–8; *Kentering*, 11 (3) (1970), pp. 42–7. In the book edition, *Wat niet mocht* (1972), Hazeu provided an international overview of censorship incidents.

4. Incidentally, in *Komma*, Weverbergh published a cycle, 'Met de schaar' (with scissors), whose title and heterogeneous typography suggest that the poems are composed of several newspaper fragments; see Weverbergh (1966). On the back cover of that same edition, there is also a collage of newspaper articles on censorship and financial gifts from newspapers to the Pope, 'all cut from the same newspaper'.

5. In addition to their avant-garde tendency, the montages show some affinity to modernist experiments, and, more specifically, to the genre of the multiperspectival novel in which different views of one certain 'reality' are shown (*As I Lay Dying* by William Faulkner is often cited as one of the first multiperspectival novels in Western literary history).

6. A very similar line can be found in Vogelaar's translation of Brecht's *The Three Penny Opera* (1931); see Brecht (1975: 50).

BIBLIOGRAPHY

Adorno, T. W. [1970] (1997), *Aesthetic Theory*, ed. G. Adorno and R. Tiedemann, trans. R. Hullot-Kentor, London: Continuum.

Antin, D. (1974), 'Some Questions About Modernism', *Occident*, 8 (Spring), pp. 6–39.

Auwera, F. (1969), *Schrijven of schieten? Interviews*, Antwerp/Utrecht: Standaard Uitgeverij.

Banash, D. (2004), 'From Advertising to the Avant-Garde: Rethinking the Invention of Collage', *Postmodern Culture*, 14 (2), n.p.

Beekman, K. (1984), *De reportage als literair en avantgardistisch genre. Een kritisch-empirisch onderzoek naar de classificatie van een tekstsoort*, doctoral dissertation, University of Utrecht.

Benjamin, W. (1970), 'The Author as Producer', *The New Left Review*, 62, pp. 83–96.

Bordwell, P. (1972), 'The Idea of Montage in Soviet Art and Film', *Cinema Journal*, 11 (2), pp. 9–17.

Bousset, H. (1973), *Schreien, schrijven, schreeuwen: drie trends in de Nederlandse prozaliteratuur, 1967–1972*, Bruges: Orion.

Brecht, B. (1975), *Driestuiverroman. Een sociologisch eksperiment*, trans. J. F. Vogelaar, Nijmegen: Socialistiese Uitgeverij Nijmegen.

Brems, H. (2006), *Altijd weer vogels die nesten beginnen. Geschiedenis van de Nederlandse literatuur 1945–2005*, Amsterdam: Bert Bakker.

Buelens, G. (2018), *De jaren zestig, Een cultuurgeschiedenis*, Amsterdam: Ambo/ Anthos.

Bürger, P. [1974] (1984), *Theory of the Avant-Garde*, trans M. Shaw, Minneapolis, MN: University of Minnesota Press.

De Taeye, L. (2018), *Tegen het verzinnen. Documentair proza in de Nederlandstalige literatuur van de lange jaren zestig*, doctoral dissertation, Vrije Universiteit Brussel.

Festjens, T. and G. Martens (2013), 'Drie generaties documentaire literatuur. Theorie en voorgeschiedenis van de experimentele documentaire', in A. De Cleene, D. De Geest and A. Masschelein (eds), *Marges van de literatuur*, Gent: Academia Press, pp. 135–53.

Foster, H. (1996), *The Return of the Real: The Avant-Garde at the End of the Century*, Cambridge, MA: MIT Press.

Gfrereis, H. (1999), *Grundbegriffe der Literaturwissenschaft*, Stuttgart: J. B. Metzler.

Gysen, R. (1966) *Grillige Kathleen*, The Hague/Rotterdam: Nijgh & Van Ditmar.

Harbers, F., I. van den Broek and M. Broersma (eds) (2016), *Witnessing the Sixties: A Decade of Change in Journalism and Literature*, Leuven: Peeters.

Hartsock, J. (2000), *A History of American Literary Journalism: The Emergence of a Modern Narrative Form*, Amherst, MA: University of Massachusetts Press.

Hazeu, W. (1970), *De helm van aarde*, Brussels/The Hague: Manteau.

Hazeu, W. (1972), *Wat niet mocht. Een overzicht van censuur, ernstige en minder ernstige gevallen van vrijheidsbeknotting in Nederland (1962–1971) of de stem van de 'zwijgende' meerderheid*, Amsterdam: De Harmonie.

Hazeu, W., J. Meijer and H. Scholten (1968), *Vrolijk klimaat*, The Hague/ Rotterdam: Nijgh & Van Ditmar.

Hollowell, J. (1977), *Fact & Fiction: The New Journalism and the Nonfiction Novel*, Chapel Hill, NC: University of North Carolina Press.

Houe, P. and S. H. Rossel (eds) (1997), *Documentarism in Scandinavian Literature*, Amsterdam/Atlanta, GA: Rodopi.

Miller, N. (1982), *Prolegomena zu einer Poetik der Dokumentarliteratur*, Münchner Germanistische Beiträge 30, Munich: Wilhelm Fink.

Nooteboom, C. (1968), *De Parijse beroerte*, Amsterdam: De Bezige Bij.

Perloff, M. (1986), *The Futurist Moment: Avant-Garde, Avant Guerre, and the Language of Rupture*, Chicago: University of Chicago Press.

Ping Huang, M. (2004), 'Montage and Modern Epic: Transmissions Between the Avant-Garde and the Novel – Alfred Döblin to Günter Grass', in K.-M. Simonsen, M. Ping Huang and M. Rosendahl Thomsen (eds), *Reinventions of the Novel*, Amsterdam/New York: Rodopi, pp. 251–63.

Polet, S. (1974), *De geboorte van een geest. Een kadercollage*, Amsterdam: De Bezige Bij.

Robberechts, D. (1975), *Praag schrijven*, Amsterdam: De Bezige Bij.

Robberechts, D. (1976), 'Kunst / Brecht / kunst', *kreatief*, 10 (4) ('Brecht, naar de letter'), pp. 47–75.

Valcke, J. (2005), 'Montage in the Arts: A Reassessment', in D. Scheunemann (ed.), *Avant-Garde/Neo-Avant-Garde*, New York: Rodopi, pp. 299–309.

Van Aken, P. (1979), *Letterwijs, letterwijzer. Een overzicht van de Nederlandse literatuur*, Brussels/Amsterdam: Manteau.

Van Marissing, L. (1972), *Ontbinding*, Amsterdam: Van Gennep.

Vitse, S. (2008), *Een woestijn die de stad verpulvert. Marxisme, kritiek en representatie in poststructuralisme, Ander Proza en postmodern proza*, doctoral dissertation, Vrije Universiteit Brussel.

Vitse, S. (2009), 'Montage en netwerk: ander proza en de postmoderne roman', *Spiegel der letteren*, 51 (4), pp. 441–70.

Vitse, S. (2012), '"Een door nieuwe gebeurtenissen overweldigde chroniqueur". Over tijdsaanduidingen in het proza van Daniël Robberechts, *Interférences littéraires/Literaire interferenties*, 9 (November), pp. 99–113.

Vogelaar, J. F. (1974), *Konfrontaties. Kritieken en kommentaren*, Nijmegen: Socialistiese Uitgeverij Nijmegen.

Vogelaar, J. F., D. Robberechts, L. van Marissing and H. Verdaasdonk (1976), *Het mes in het beeld en andere verhalen*, Amsterdam: De Bezige Bij.

Weverbergh, J. (1965), *Een dag als een ander*, Bruges: De Galge.

Weverbergh, J. (1966), 'Met de schaar', *Komma*, 2 (1), pp. 6–8.

Weverbergh, J. (1968), *Het dossier Jan*, Amsterdam: De Bezige Bij.

Weverbergh, J. (1971), *Leopold II van Saksen Coburgs allergrootste zaak*, Amsterdam/Brussels: Paris-Manteau.

Wispelaere, P. de (1967), 'Roman van de werkelijkheid en werkelijkheid van de roman', in P. de Wispelaere, *Met kritisch oog*, The Hague/Rotterdam: Nijgh & Van Ditmar, pp. 89–126.

4

Foundists and Erasurists

Michel Delville[1]

If Marcel Duchamp is universally credited as the inventor of found art, a fully-fledged history of modern and contemporary 'foundism' would reveal essential differences between the readymade and the appropriationist strategies developed by artists in the second half of the twentieth century, specifically in the field of neo-avant-garde literature. Among those differences, the most notable are related to a tendency to write through, disfigure and refigure already existing works of art (as opposed to everyday objects or, say, samples of utilitarian prose) with a view to providing an alternative, often critical, reading of familiar texts which are often part of a literary or generic canon. As the examples below will show, what is at stake in appropriation in literature is less a gesture aimed at redefining the institutional parameters of what we call art than a revisitation – in the practical as well as in the hauntological sense made famous by Derrida's *Specters of Marx*[2] – of the source text's original and/or accepted meanings. Such strategies can take the form of pastiche and parody, with various degrees of violence and intensity, or of more respectful intertextual homages and *détournements*.

A survey of found literature could possibly start with Tristan Tzara's famous randomist 'How to Make a Dadaist Poem' (1920), which some champion as a precursor of the cut-up technique.[3] One could also begin with Kurt Schwitters's 1923 'P P P P P P P P P', which the author describes as a 'pornographic poem' originating in an illustrated abecedarium for children (Figure 4.1). The dotted lines indicate where Schwitters cut through the 'harmless' poem, suggesting a rather different story replete with truncated innuendos which, as Craig Dworkin aptly puts it, remind us 'that without censorship there is no pornography' (2003: 149). The meaning of Schwitters's saucy rewriting of the children's primer remains unclear insofar as the poet describes how the

P P P P P P P P P
Pornographisches i - - Gedicht

 Die Zie
Diese Meck ist
Lieb und friedlich
Und sie wird sich
Mit den Hörnern

Der Strich zeigt, wo ich das
harmlose Gedichtchen aus einem
Kinderbilderbuch durchgeschnitten
habe, der Länge nach. Aus der Ziege ist
so die Zie geworden.

Und sie wird sich │ nicht erboßen
Mit den Hörnern │ Euch zu stoßen

Figure 4.1 Kurt Schwitters's 'P P P P P P P P P' (1923).

text came into being without accounting for its ultimate intention. Is it to
undermine classical distinctions between high art and pornography? Is it an
attempt to unveil the possibly repressed psychosexual content of the original
nursery rhyme? And, if so, is the 'pornographic' nature of the poem related
to its overtly salacious content (the abbreviated 'go-at' ('Zie-ge') finds itself
removed from its original, didactic context and evokes a world of satyrs, fauns
and other pansexual creatures)? Or does it refer to the fundamentally *ob-scene*
act which consists in showing what happens behind the scenes of one of the
best-selling avatars of bourgeois pedagogy? Irrespective of the interpretation,
that one of the earliest examples of appropriationist poetry should come from
the inventor of *merzbau* suggests that literary foundism (with a few exceptions
including Charles Coqueley de Chaussepierre's singular and in some ways
unsurpassed 1770 *Le roué vertueux*[4]) is a somewhat belated extension of the
early twentieth-century visual collages of the cubist or Dadaist variety.[5]

 The purpose of this chapter is not to study the collusion between collagist
practices and found art; nor is it to suggest that a clean break exists between
the historical avant-gardes and the neo-avant-gardes in terms of how writers
have domesticated the appropriationist techniques developed by contempo-
rary artists. Whether one looks for continuities or ruptures, the first significant
post-Dada example of textual foundism occurs in the 1950s, at a time when
Brion Gysin and William Burroughs started their experiments with cut-up and
fold-in techniques. For Burroughs, the random juxtapositions generated by
cut-ups, far from espousing the anti-art of the readymade or the shock tactics
of conceptual, proto-uncreative art, are eminently mimetic in their attempts
to capture the jolted cadences of contemporary urban life: 'Cut-ups make

explicit a process that goes on all the time. Every time we walk down the street or look out the window, our stream of consciousness is cut by random factors, random events, random people, random objects. In fact life is a cut-up' (Hawkins and Wermer-Colan 2019: 84). For all its self-proclaimed novelty, the cut-up, which began with Gysin's experiments with sliced newspaper clippings, thus seems firmly rooted in Baudelaire's definition of the prose poem (which also grew out of the poet's experience of the dizzying rhythms of the 'enormous cities' and was strongly linked with the rise of nineteenth-century newspaper culture), on the one hand, and in the uncompromising subjectivism of the modernist stream of consciousness, on the other. (It should come as no surprise that Burroughs acknowledged the influence of John Dos Passos's *USA Trilogy* (1930–6), which constitutes an early, albeit late modernist, synthesis of the cut-up and the interior monologue.)

The second important category in post-war foundist literature is linked with the development of writing-through techniques, of which John Cage's and Jackson Mac Low's respective mesostic rewritings of Ezra Pound's *Cantos* constitute a foundational moment. The method used by both writers consists in producing a radical reduction of the source text (in Cage's case, the final version is only a few pages long) traversed and upheld by a central, capitalised word which can be read vertically. Cage's writing through of James Joyce's *Finnegans Wake* emerges as another salient episode in the genealogy of the neo-avant-garde's engagement with found texts. The 'hidden' words can be likened to the poem's 'spine', which has 'JAMES' and 'JOYCE' down the text's centre. Cage describes his working method as follows:

> Taking the name of the author and/or the title of the book as their subject (the row), write a series of mesostics beginning on the first page and continuing to the last. Mesostics means a row down the middle. In this circumstance a mesostic is written by finding the first word in the book that contains the first letter of the row that is not followed in the same word by the second letter of the row. The second letter belongs on the second line and is to be found in the next word that contains it that is not followed in the same word by the third letter of the row. Etc. If a shorter rather than longer text is desired, keep an index of the syllables used to represent a given letter. Do not permit for a single appearance of a given letter the repetition of a particular syllable. Distinguish between subsequent appearances of the same letter. Other adjacent words from the original text (before and/or after the middle word, the word including a letter of the row) may be used according to taste, limited, say to forty-three characters to the left and forty-three to the right, providing the appearance of the letters, of the row occurs in the way described above. (Cage 1982: 173)

Cage explains the genesis of his work in terms that emphasise the need to break free from the 'rigidity' of Joyce's grammar and approach the 'floating' sparsity of classical Chinese and Japanese poetry:

> Reading *Finnegans Wake* I notice that though Joyce's subjects, verbs, and objects are unconventional, their relationships are the ordinary ones. With the exception of the Ten Thunderclaps and rumblings here and there, *Finnegans Wake* employs syntax. Syntax gives it a rigidity from which classical Chinese and Japanese were free. A poem by Basho, for instance, floats in space. . . . Only the imagination of the reader limits the number of the poem's possible meanings. (Cage, quoted in Perloff 1998: 292)

The reductionist impulse behind Cage's procedural aesthetics is thus geared towards the multiplication of the vectors of meaning generated by the poem, a method which is arguably more 'writerly' in the Barthesian sense than its source text, that is, at least if we assume, like Cage, that the reader will fill in the gaps where the original text's syntactic telos was deleted. An 'ideal' reader of Cage's mesostics would thus experience what Steve McCaffery describes as a kind of 'return of the repressed', 'induc[ing] uncanny configurations around themselves, precipitating extreme cognitive disruptions that decommission conventional methods of reading' (2012: 44). 'Although ordered and restrained by the axial structure', McCaffery adds, the mesostic 'nevertheless resonates as a linear disequilibrium; there is a parsimonious quotient of meaning assembled, as if magnetically, around the theme name and beyond that disperses semantic degradations' (2012: 44).

McCaffery's analysis relates the sense of disorientation and defamiliarisation encountered in Cage's mesostics to Léon Roudiez's Saussurean notion of 'paragrammatics'. For Roudiez, the paragram reading refers to any reading method or strategy which challenges the normative referential structure of a text from within by forming 'networks of signification not accessible through conventional [i.e. linear] reading habits' (McCaffery 2012: 219). Praising the vertiginous 'Saussurean sublime' afforded by paradigmatic composition, McCaffery describes 'the percolation of words through the paragram' as a process which 'contaminates the notion of an ideal, unitary meaning and thereby counters the supposition that words can "fix" or stabilize in closure' (McCaffery 2000: 63), which seems an adequate description of the structural and reception patterns of Cage's mesostics.

Dworkin's own selection of paragrammatic texts in *Reading the Illegible* (2003) comprises examples as various as Guy Debord and Asger Jorn's artist's book *Fin de Copenhague* (1957), Marcel Broodthaers's 1969 'edition' of Mallarmé's *Un coup*

de dés, of which more will be said later, John Cage's *Writing Through Finnegans Wake* (1978) and Susan Howe's palimpsestic experiment, 'Melville's Marginalia' (1993). At the centre of both Dworkin's and McCaffery's work the impact of Gertrude Stein's 'composition as explanation' – in which discursive prose enacts its own critique insofar as interpretation is seen to emerge from the mechanics of writing itself – looms large, as does that of Charles Bernstein's poem-essay 'The Artifice of Absorption', which advocates a poetics of opacity countering the ideals of transparency, sincerity and directness of self-expression promoted by 'official verse culture' (Bernstein 1992: 46). Bernstein's anti-absorptive mode reaches a climax in his own *Veil* (1987), a chapbook containing blocks of prose made of overtyped lines resulting in a typographical cover-up proclaiming its own self-effacing illegibility (Figure 4.2).

Bernstein's anti-absorptive model implicitly addresses the complexities of neo-avant-gardist foundism, which generally partakes of an aesthetics whose obliterative and deletionist tactics encourage heightened attention to the (opaque) materiality of the signifier. Such experiments are perhaps best under-stood in the light of what Marjorie Perloff has described as the paradigmatic shift which takes us from modernist models of unmediated transparency to

Figure 4.2 Excerpt from Charles Bernstein's *Veil* (1987) used by permission of Xexoxial Editions.

a post-war preoccupation with the fabricatedness of the aesthetic moment, one in which 'natural objects' (whether they are concrete or affective) are always already filtered and processed by language and media.[6] (Of course, there are precedents to this kind of writing in the modernist era but these precedents, such as Duchamp's 1920 *French Widow*, or Stein's oeuvre as a whole, emerge mostly as odd fish in modernist waters and precursors of postmodern and deconstructionist things to come.) This emphasis on marked artifice and (inter-)mediation offers foundist artists a crucial ground on which to experiment with Stein's 'composition as explanation' method, revisiting found textual objects in a way which necessarily foregrounds their own material and historical specificities.

EFFACEMENT, DEFACEMENT

The examples examined so far suggest that the influence of found text looms large in post-war neo-avant-gardist poetics. The more specific – and more recent – success story of erasurist poetics also deserves our attention, if only because it has been ignored or relegated to the margins of literary and art history. As we will see, erasurism is rooted as much in contemporary philosophy's deconstructionist turn as in Duchampian found objects and Situationist *détournements*, of which most of the examples examined in this essay constitute both an extension and a critique. Recent and current developments in foundist and erasurist art are closely associated with visual artists and writers (many of them poets) appropriating already existing texts with a view to modulating their meaningfulness and legibility. This says a lot about the relevance of found texts to late twentieth-century and early twenty-first-century culture which, by and large, values concepts over technique, rewriting over originality, self-reflection over aesthetic norms and values. Poised between effacement and defacement, erasure pursues a logic which considers the artwork as an unfinished object that awaits future readings and negotiations to be provisionally refashioned, recycled and reconsumed. As the source text becomes the model for the artists and the victim of their transgressions and violations, the boundaries between creator and creature, process and product, producer and consumer, are dimmed in a haze of colliding gestures and interpretations.

Another notable recent example is David Dodd Lee's *Sky Booths in the Breath Somewhere,: The ASHBERY ERASURE Poems* (2010), a collection of erasures of John Ashbery's poetry which follows a simple rule: the author read through the source poem and selected words or parts of words ('as Ashbery ordered them (consecutively)' in a given collection (Lee 2010: 14)), which he subsequently arranged into new lines, building upon the 'incredible storehouse

of language which is a John Ashbery poem' and 'selecting language with an eye toward absurdity/humor' to create new patterns of suggestion and ambiguity (Lee 2015: n.p.).

Paul Ricoeur memorably identified Marx, Nietzsche and Freud as the founding fathers of a 'school of suspicion' (1970: 32) which steers readers, critics and artists to read between the lines and deconstruct the strategies by which art can conceal its own constructedness and disguise its ideological complicity with dominant structures of power. Should erasure art practised by Lee and countless recent foundist American poets be considered as a casualty of the 'terminal case of irony' in which the humanities find themselves at the present time, driven as they are by an 'uncontrollable urge to put everything in scare quotes' (Felski 2008: 2)? Even though erasurism does not necessarily set out to destroy the art work per se, it is often prompted by a desire to revisit familiar, predominantly canonical texts with a view to foregrounding and/or correcting their limitations and deficiencies.[7]

As suggested above, the 'revisionist' act that underlies erasure poetry can be usefully related to the poetics of found art made famous by Duchamp's readymades. But where Duchamp elevated ordinary objects to the level of art by separating them from their context and use value, erasure artists have pursued rather different goals over the last fifty or so years as their main referent remains the original artwork itself, which is subjected to diverse forms of physical manipulations whose function and significance can only emerge from the tension between the found and the revised, the original and its 'effaced' avatar.

What matters here is that even the most radical form of erasure is essentially a kind of rewriting. As with other more familiar forms of rewriting (Jean Rhys's *Wide Sargasso Sea* and countless other postmodern, perspectival neo-Victorian novels come to mind), the ghost of the foundational text is bound to continue to haunt its 'treated' version. Its obliterated content is always likely to return with a vengeance as its previous vectors of meaning must leak through, in a more or less explicit and visible fashion, irrespective of whether or not readers or viewers are already familiar with the original text. That said, erasure poetics differs from postmodern rewritings – while allying itself to neo-avant-garde aesthetics – insofar as its act of undoing affects not only the content of the text but also (and primarily) textual matter as such. It is this concretist attention to the physical and material properties of language which unites all the diverse forms of deletion, obliteration, covering-up, cancelling, scratching, rubbing out, blotting, and so on, that are grouped here under the umbrella term 'erasure'.

Stéphane Mallarmé appears as the presiding consciousness of a constellation of poets who explore the relationship between absence and presence and for whom the spaces and silences between words matter at least as much as words

themselves or the things they designate. Mallarmé's poetry is geared towards the creation of paradoxical objects which cancel themselves as soon as they are named (one is reminded of his 'absent tomb', his 'flights which have not fled' and the 'abolished bauble of sonorous uselessness' of his aptly de-titled 'Sonnet allégorique de lui-même' (Mallarmé 2009: 68)). Besides unsettling traditional notions of authorial control and controlled authorship in a space effecting the reciprocal annihilation of negativity and positivity ('confronting [the] existence [of chance], negation and affirmation fail', the poet writes in *Igitur* (Mallarmé 1982: 99)), the scattered spatial layout of Mallarmé's textual roll of the dice in his 1897 *Un coup de dés jamais n'abolira le hasard* would seem to afford endless readerly combinations and permutations multiplied by the 'eternal circumstances' of the dice throw ('All Thought emits a Throw of the Dice' (Mallarmé 1976: 429)).

Marcel Broodthaers's 1969 version of *Un coup de dés* resubtitles the Gallimard edition of Mallarmé's poem into an 'IMAGE', obliterating the entire text of Mallarmé's poem and replacing it with black typographical rectangles on the poem's double spreads. In doing so Broodthaers foregrounds the sheer spatial arrangement of the words in the book to the detriment of its referential potentialities.[8] 'IMAGE' parenthesises Mallarmé's prefacing claim that the page should be opened up as a canvas inviting a 'simultaneous vision' and upon which 'the paper intervenes each time an image ceases or withdraws of its own accord' (Mallarmé 1976: 406, 405). It represents a literal extension of the poet's famous pronouncement that 'verse should not consist of words but of intentions, and all words should efface themselves before sensation' (Mallarmé 1959: 137).

Mallarmé's insistence on the (self-)effacement of words and the importance of 'sensation' reflects his more general commitment to 'paint[ing] not the thing itself, but the effect it produces' (Mallarmé 1959: 137). Born out of a recognition that artists can only work 'by elimination . . . all acquired truth being born only from the loss of an impression' (Mallarmé 1959: 245), Mallarmean poetics ultimately suggests that poets themselves are 'merely empty forms of matter' in the face of 'the Void which is the truth' (Mallarmé 1988: 60). The first edition of Broodthaers's 'IMAGE' further emphasises this notion by printing the obliterated text on translucent paper, conveying the depth as well as the two-dimensional plasticity of Mallarmé's verbo-visual experiments. The artistic and philosophical implications of this gesture are perhaps best summarised by Jacques Rancière when he writes that 'IMAGE' 'accomplishe[s] Mallarmé in his refutation', opposing several forms of artistic self-suppression resolved in an 'indifferent spatiality' ruled by 'the power of blankness' (2007: 61). In Broodthaers's 'IMAGE', Mallarmé becomes both the victim and the perpetrator of a radical poetry of (self-)erasure.

The eraser as a concrete and aesthetic object re-emerges in Jérémie Bennequin's ongoing *Ommage*, in which the French artist proceeds to rub out the pages of the Gallimard edition of Marcel Proust's *À la recherche du temps perdu*. The outcome of this process is a series of performances and photographs showing not only the blotted-out pages of the book but also the residues of the performance itself, with worn-out erasers and mounds of blue-grey eraser dust and crumbs being displayed as a miniature *arte povera* installation on the artist's desk. The title's pun on 'gommage' (*gommer* means 'to erase' in French) and 'homage' is symptomatic of the ambivalent status of erasure as a poetic practice capitalising upon the urge to undo and destroy while paying an ambivalent tribute to the object under attack.

Bennequin's erasurist obsession knows no bounds, and one suspects that he will never finish rubbing out Proust, even though he is rumoured to work on a different page of the Gallimard printed text every day for about an hour. By forcing us to look at (rather than read) the fading words, *Ommage* foregrounds their physical vulnerability on the page. As for the creased and wrinkled pages themselves, they bear witness to the fact that any artwork carries the structural and material seeds of its own destruction. Perhaps more importantly, they also breathe a peculiar kind of nostalgia, albeit veiled with irony, which we associate with the dog-eared pages of well-loved books: only a worn-out book can become an object of affection which is the measure of its fading physical integrity.

BLOOM'S CLINAMEN

Erasurism and foundism are about how art can remediate history's fatal flaws by revisiting some of its cardinal sins and canonical objects. Likewise, the canonical status enjoyed by Mallarmé and Proust looms large in Broodthaers's and Bennequin's erasure experiment. Like Broodthaers's 'IMAGE', *Ommage* suggests that such acts of undoing – whether affectionate, ironic or both – often originate in an attempt to deal with the pressure of influence. In *The Anxiety of Influence*, Harold Bloom famously argued that poets since Milton have sought to escape from their predecessors' haunting importance. In view of the examples discussed so far, the erasurist antidote to the danger of being derivative or of producing inferior work would seem to lie in deconstructive attempts to undo the past altogether through the disfiguration or correction of past works and/or the erasure of origin. In many of the works mentioned and analysed above and below, the word 'correction' carries an element of punishment as well as improvement and one is reminded here of Bloom's notion of the 'clinamen' (1997: 19–48), which designates a creative misreading which is likely to remedy the deficiencies and limitations of the source text.

Appropriately enough in the context of Bloom's model, one of the earliest examples of textual erasurism in contemporary poetry is Ronald Johnson's *RADI OS* (1977), a partial obliteration of the first four books of John Milton's arch-canonical *Paradise Lost*, preserving only a few words from each page of the source text. That Johnson reduces Milton's seventeenth-century epic to sparse free verse lyrics whose lexicon generally expresses the presence of natural and elemental forces is significant of how *RADI OS* exposes and unsettles generic hierarchies while undermining the very foundations of the text's logic and episteme (a few years later Johnson published *PALMS*, a similar experiment based on the *Psalms* from which the author claims to have taken out the snake by 'taking out the "S"' (Johnson 2000: n.p.)).

In his introductory note to the book, Johnson claims to have 'composed' the blanks, comparing the crossed-out words to the inaudible notes of Handel's *Concerto Grosso*, 'the inaudible moments leaving holes in Handel's music' (Johnson 2005: n.p.). The word 'RADI OS' (especially to a French or etymologically trained ear) also indirectly evokes medical radiographies: the caesura between RADI and OS in Johnson's title implicitly strips *Paradise Lost* to the bone so as to lay bare its *ossature*.[9]

Jean Clair has claimed that Röntgen's discovery of X-rays in 1895 affected the whole history of art, dividing contemporary painters into two categories according to their ways of representing the body and the skull in particular: the 'traditionals', such as Ensor and Cézanne, who continued to use the calvarium as a symbol of worldly vanities, and the 'moderns', such as Munch or Duchamp, who were interested in exploring the internal mechanics of the body, unencumbered by metaphorical concerns (Clair and Brusatin 1995: xxvii).[10] Marjorie Perloff also evokes radiography in her analysis of the uses of 'arthrography' (an X-ray examination of the structure of a joint) in Johnson's later collection, *ARK*, arguing that Johnson's lettrist manipulation of textual material allows him to examine and diagnose 'what lies beneath the surface' and the plural conditions in which meaning arises from the combination of neighbouring words (Perloff 2004: 197). Johnson's X-rayed version subjects Milton's *Paradise Lost* to a similar treatment, revealing the lyrical backbone of the epic while isolating some of its vital semantic 'organs'.

The poems in *RADI OS* result from the complete deletion of the 'unwanted' words, leaving no trace of the original text except for the layout of the page (the surviving words still appear where they belong in Milton's poem). Other, more recent erasure poets have opted for a format which allows the reader total or partial access to the original work. Jen Bervin's *Nets*, a rewriting of Shakespeare's *Sonnets*, relegates Shakespeare's poems to a faded background text 'upon which' the selected words appear in bold ink. Unlike Johnson's,

Bervin's 'reduction' does not stress the elemental and the natural but, rather, tends to strip the Bard's sonnets to abstract, self-reflexive musings bearing the mark of post-Language writing ('In singleness the parts / Strike / each in each / speechless song, being many, seeming one' (2003: n.p.)), occasionally venturing into Bervin's current historical memory ('I have seen / towers / down-razed / loss / loss' (2003: n.p.)) until the speaker herself paradoxically 'vanishes' into the poem's palimpsestic black ink.

Likewise, the crossed-out parts of Travis Macdonald's *The O Mission Repo*, an erasure of the *9/11 Commission Report*, can still be deciphered by readers interested in exploring the original document and/or in understanding the nature of the erasurist's adjustments and manipulations. Like Bervin, Macdonald allows the reader to return to the full textual source while simultaneously or alternately reading the new text that emerges from the partially obliterated text. In such works, the cancelled words, instead of being deleted or rendered illegible by other means, are placed 'under erasure' (*sous rature*) in a gesture reminiscent of Heidegger's and Derrida's typographical gestures signalling the presence of inadequate yet necessary words. In different but related ways, Heidegger's anti-metaphysical approach to language and Derrida's anti-logocentric *ratures* offer a useful model for an understanding of how erasure art 'works', in theory as well as in practice. What is undone or 'deconstructed' here is less the meaning of words − or, more generally, the relationship between signifier and signified − than the familiar deconstructive aporia that follows from the fact that the question of whether words can actually mean something can only be asked through language itself.

Macdonald's striking through of the *9/11 Commission Report* once again reveals the strong practical and conceptual connections between erasurism, censorship and a certain form of violence perpetrated on the source text which becomes the target of the rewriting. Certain pages of Macdonald's text can be read as a *mise en abyme* of the deconstructive and disfiguring strategies, the object of its 'attack' being itself a response to the 9/11 trauma and an attempt to renegotiate the shifting parameters of counter-terrorism. The sentence (or poem) that appears between the redacted words of Macdonald's text ('All / aboard / the morning / that America's / "Fasten Seatbelt" sign / turned / on' (2008: n.p.)) implicitly compares the United States to a drifting ship and conveys the urgency of action and panic which prompted the redaction of what was nominated as a possible non-fiction National Book Award recipient in 2004. Jenny Holzer's own 'Redaction Paintings', which also proceeds to strike through and cover up declassified US legal documents, evidence a similar impulse, born out of a desire to give voice to the personal tragedies that were 'o-mi[tted]' from the legal documents. The words emerging from Holzer's

erasures debunk the pretence to objectivity of the rhetoric of bureaucracy which characterises 'torture memos' at the same time as they attempt to give voice to those who experienced detainment, confinement and torture.

An exhaustive list of early twenty-first-century erasurist texts would have to also include Stephen Ratcliffe's *[where late the sweet] BIRDS SANG* (another text cut out of Shakespeare's *Sonnets*), Mary Ruefle's correction fluid covered *A Little White Shadow* (based on a late, anonymous, nineteenth-century manual published 'for the Benefit of a Summer Home for Working Girls'), Austin Kleon's self-explanatory *Newspaper Blackout*, Janet Holmes's further reduction of Emily Dickinson's already elliptical verse in *The ms of my kin*, Srikanth Reddy's *Voyager* (an erasure of Kurt Waldheim's memoirs), and Jonathan Safran Foer's artist's book *Tree of Codes* (2010), which die-cuts holes in Bruno Schulz's *The Street of Crocodiles*, revealing 'future' events and allowing the reader to read several pages at once in a way which is reminiscent of B. S. Johnson's 1964 *Albert Angelo*. The lacunary structure of Foer's narrative tragically evokes Schulz's murder by the Gestapo and the loss of many of his unpublished works during World War II.[11]

TOM PHILLIPS'S *A HUMUMENT*

There are two basic ways of practising the art of erasure: the first consists in a partial or total crossing, blanking or rubbing-out of the source text; the second involves covering up the text with extra textual or graphic material which can be credited with an added aesthetic value in and of itself, beyond its capacity to veil or conceal. Among recent literary examples, Crispin Glover's collagist *Rat Catching* (a humorous treatment of Henry C. Barkley's 1896 *Studies in the Art of Rat-Catching* characterised by the use of old prints and other found artwork) clearly falls into the second category, as do Will Ashford's *Recycled Words* (a rather undistinguished rehash of Tom Phillips's *A Humument*) and Matthea Harvey's *Of Lamb*, which was carved out of a biography of Charles Lamb, traversed by the nursery rhyme 'Mary had a little lamb' and subsequently complemented with Amy Jean Porter's illustrations.

Tom Phillips's *A Humument*, begun in the mid-1960s, differs from the radical post-representational thinking that informs, say, Johnson's *RADI OS* as the 'blanks' from which meaning can re-emerge are filled with visual poems and poetic paintings which emerge as so many creative misreadings, extending rather than short-circuiting the process of interpretation. Phillips's cover-up 'ex-humes' W. H. Mallock's 1892 novel, *A Human Document*, each page of the source text being partially painted and pencilled over so as to foreground the remaining textual 'rivulets', which the 'un-author' (as Phillip jokingly refers to himself) isolates as so many 'speech bubbles'. The coherence and consistency

of Phillips's work-in-progress throughout its successive editions is grounded in a number of conceptual continuities. These include the representation of bourgeois interiors (the painted backgrounds of the treated pages often evoke the inside walls, wallpapers, curtains, windows, tapestries and carpets of a room and a sense of domestic intimacy nicely undermined by the humorous content of the 'rivulets'), the appearance of recurrent fictional or 'textual' characters such as Bill Toge (whose last name is a contraction of the words 'together' or 'altogether' as they appear on the pages of Mallock's novel), the emergence of thematic threads related to various aspects of Mallock's Victorianism, and the use of a language- and medium-oriented stance reflecting and exposing the author's goals, methods and aspirations.

A Humument generally posits and foregrounds the materiality of text prior to signification. But its concretist aspects should not obscure the fact that the poetic rivulets that traverse his treated pages are deeply rooted in a close reading of Mallock's novel and its underlying ideologies and representational strategies. As the opening page of the fourth edition of *A Humument* suggests ('The following / sing / I / a / book / a / book of / art / of / mind art / and / that / which / he / hid / reveal / I' (Phillips 2005: 1)), the real purpose of Phillips's obliteration techniques is precisely to hide in order to reveal what the source text was trying to hide.

A full-length reading of Phillips's book would have to stress its attempts to 'doctor' Mallock's novel and purge it of its conservative, anti-Semitic and misogynous tendencies ('we / doctor / books / we / doctor / novels' (Phillips 2005: 23)[12]) while 'unearthing' its repressed latent content. In the light of the sexually charged overtones of Phillips's poetic 'bubbles', it would not be far-fetched to argue that *A Humument* sets out to psychoanalyse its source text, bringing out the symptoms of psycho-sexual frustration that lurk beneath the varnish of Victorian respectability that covers Mallock's fictional world. Phillips has claimed that his innuendo-ridden rewriting is meant to 'tease the odd joke out of a novel which contains almost none' (2012: n.p.). Page 76 of the fourth edition shows a 'shy' incarnation of Bill 'Toge' trying to look up a lady's dress and finding himself 'arrested' by the sight (or the smell) of 'anemones' before considering the woman's inscrutable 'small / well-poised / eagerness' (2005: 76). A confrontation with the source text produces its share of ironies and paradoxes as the original page of Mallock's novel relates the 'mirror story' of Phillips's text to that of the novel's protagonist, Robert Grenville. On that same page in the original text, Grenville retires to his room to meditate on the traditional virtues of simplicity, modesty and 'shyness' which characterise Victorian representations of womanhood while examining 'the photograph of a young girl, with a well-poised head, and eyes that looked with a sort of composed eagerness' (Mallock 1892: 182).[13]

The sixth and last version of Phillips's book was published in 2016, every single page of the first edition having been re-treated at least once, thus bringing the project to its full completion. It is unlikely to be superseded as an example of how erasure can be experienced simultaneously as negation of and as a prelude to the emergence of art. It is also a text which crafts a different, decentred kind of lyricism which surfaces from its saturated novelistic textual matrix ('Join / written / breath / to / written heart / to / the nerves / talking / in a / shirt / to / record / all physical maladies / and yet no / pains of the soul' (Phillips 1998: 246)). The sheer textural richness and depth of *A Humument* is not answerable to the shock tactics of any previous found art tradition. Its complexities and singularities suffice to show that erasure poetics cannot be reduced to a literal version of Eliot's pronouncement that 'immature poets imitate; mature poets steal; bad poets deface what they take, and good poets make it into something better, or at least something different' (2011: 81).

One of the most interesting and innovative successors to Phillips's *A Humument*, Jochen Gerner's oubapian blackout *TNT en amérique* (2002) obliterates the pages of Hergé's 1932 *Tintin en amérique* with black ink, substituting pictograms and isolated one-word balloons for the original panels (Figure 4.3). The selected

Figure 4.3 Excerpt from Jochen Gerner's *TNT en amérique* (2002) reproduced with kind permission of the artist.

details and micro-events of the plot and dialogue become the main focus of attention in the absence of a visible whole by which to contextualise them. Gerner's reduction of 'TINTIN' to 'TNT' evokes the exploded quality of the layout although the words preserved from Hergé's version are reinscribed in their original position on the original page. Gerner's reworking of the plot abstracts key moments and concepts mostly related to the themes of violence and corruption present in the original volume, published a year before Franklin Roosevelt's repeal of the Prohibition Act. In doing so, it translates Hergé's popular story into an abstract, minimalist canvas, a semiotic reduction of the plot to its most basic 'hardware' executed against a dark background, 'black as a reference to censorship, night-time, evil, the mystery of as yet unveiled things'.[14]

The appeal of *TNT en amérique* also lies in its intriguing and wittily crafted 'appendix', which converts Gerner's sixty-two pages into so many short poems, further reshuffling the book's narrative and ideological significance. The opening pieces reproduced here (Figure 4.4) remix words selected from Hergé's bubbles into delightful cubist four-liners worthy of Pierre Reverdy or Max Jacob (Gerner 2002: n.p.).

Figure 4.4 Excerpt from Jochen Gerner's *TNT en amérique* (2002) reproduced with kind permission of the artist.

Gerner's *TNT en Amérique* was published eight years before Martin Arnold's *Shadow Cuts* (2010), which undertakes a similar erasure experiment through the medium of cartoon, taking found film to a different level. Besides their use of different media, one of the main differences between the two lies in the ambivalent nature of the buried narrative 'exhumed' by Arnold's film. *Shadow Cuts* stretches and scratches (in the musical, deejaying sense) the happy ending scene of a Disney short to an intense narrative performed on a black background over several minutes, which constantly threatens to fade it out of existence. The scene, which features Mickey and Pluto laughing out loud in a friendly embrace (Figure 4.5), becomes destabilised through multiple repetitions and rewindings affecting both sound and image. Arnold's ruthlessly analytical eye erases parts of the characters' bodies, forces us to contemplate isolated body parts, gestures, looks and facial expressions severed from their original context (this technique is also deployed in Arnold's equally disturbing Disney-based 'Haunted House' and 'Soft Palate').

Arnold's repetition-with-variation technique spotlights micro-events and visual lapsus which remain unnoticed in the original version and generate a

Figure 4.5 Still from Martin Arnold's *Shadow Cuts* (2010) reproduced with kind permission of the artist.

feeling of unease and discomfort as to what the rewriting actually 'means'. The hysterical jerks and panting cadences generated by Arnold's grimacing turntablism balance Disney's sentimental narrative of friendship against the neurotic, possibly erotically charged content of an endlessly rehearsed (and reversed) flickering choreography which also amounts to a *mise en abyme* of our incapacity to watch a film without interrupting the performance by blinking our eyes.

'Soft Palate' and 'Haunted House' provide an appropriate point on which to conclude this chapter. The haunted Disney shorts return us with a vengeance to the ex-humed linguistic and characterological ghosts haunting Phillips's *A Humument* and, more generally, the aesthetics of spectrality which has characterised the history of neo-avant-gardist foundism. In a digital age where, to quote Kenneth Goldsmith, 'language has become a provisional space, temporary and debased, mere material to be shoveled, reshaped, hoarded and molded into whatever form is convenient, only to be discarded just as quickly' (2011: 218), foundist art can be seen as an alternative to what Mark Fisher diagnosed as the 'pious cult of indeterminacy' (2014: 16) and the 'pathology of scepticism' which, as argued above via Ricoeur, characterised dominant deconstructionist and post-deconstructionist paradigms. Foundism thus conceived of as a hauntological trope and method addresses the psychoanalytical trauma which underlies Hal Foster's perception of the neo-avant-garde as *nachträglich* reprocessing of 'the anarchistic attacks of the historical avant-garde' (Foster 1994: 31). As Jeff Barda argues elsewhere in this volume, such a reprocessing suggests an alternative 'way of thinking and of *being* in time' geared towards an understanding of the complex co-temporalities explored by the recent theories of the likes of Lionel Ruffel, François Hartog and Georges Didi-Huberman 'which all differently advance a regime of historicity no longer based on linear, sequential and historicist times, but on archaeological approach' (p. 310). Found text seems to have given several generations of writers a way to deal with the despondent feeling of emptiness that seizes artists for whom 'stylistic innovation is no longer possible, [where] all that is left is to imitate dead styles, to speak through the masks and with the voices of the styles in the imaginary museum' (Fredric Jameson, quoted in Fisher 2009: 9). In this sense, also, contemporary foundists seem increasingly interested in finding ways of transforming paralysing misology (in the Paulhanesque sense) into more productive revisitations of past texts, not in the spirit of a post-Fordist, Jamesonian culture of constant pastiche and retrospection, but in a critical investigation of an artistic practice that capitalises on the uncanny reciprocity of relationships between the past and the present, the canonical and the new, the historical and the neo-avant-garde.

NOTES

1. Some sections from the second half of this essay were adapted and expanded from my contributions to an exchange with Mary Ann Caws documented in Caws and Delville (2017).

2. The dialectics of presence and absence underlying Derrida's notion of hauntology seem particularly relevant to an investigation of the palimpsestic dynamics of erasurism. Tom Phillips's *A Humument*, arguably the most accomplished erasurist artwork of the last fifty years – and of which more will be said below – echoes Derrida's deconstruction of the metaphysics of presence while bringing into play the question of how (partly) erased textual material can haunt us from beyond the grave, like a ghost which is neither fully visible not invisible or, in Phillips's case, a corpse waiting to be exhumed from its grave.

3. 'Take a newspaper. / Take some scissors. / Choose from this paper an article of the length you want to make your poem. / Cut out the article. / Next carefully cut out each of the words that makes up this article and put them all in a bag. / Shake gently. / Next take out each cutting one after the other. / Copy conscientiously in the order in which they left the bag. / The poem will resemble you. / And there you are—an infinitely original author of charming sensibility, even though unappreciated by the vulgar herd' (Tzara 2013: 39).

4. Available at <https://gallica.bnf.fr/ark:/12148/bpt6k10568643.image> (last accessed 27 January 2021).

5. 'P P P P P P P P P / **p** o r n o g r a p h i c **i**—poem / The go **I** / Its bleating is **I** / Sweet & peaceful **I** / And it will not **I** / With its horns **I** / The line indicates where I cut lengthwise through an innocuous poem from a children's picture book. From the goat came a go. / And it will not **I** become provoked / With its horns **I** to shove & poke' (quoted in Dworkin 2003: 148–9).

6. See, in particular, Perloff (1991: ch. 3).

7. Even though erasurist strategies can conceivably be applied to non-found material, the examples considered here reflect the foundist orientation which characterises the vast majority of contemporary erasurist works, at least in the field of literature.

8. Man Ray's 1924 visually similar 'Lautgedicht' is an important precursor with the essential difference that its main emphasis is on sound rather than space, as evidenced in the silent, residual musicality of its regular metrical patterns.

9. Here, we could go on discussing erasure in contemporary music from Cage to wiping analogue tapes and digital ProTooled remixes.

10. Clair mentions Munch's 1895 *Self-Portrait with Skeleton Arm* and Duchamp's 1959 pun-ridden installation 'With My Tongue in My Cheek' as examples of the latter tendency.

11. One cannot help being reminded of the famous Oulipian precedent set by Georges Perec's lettrist representation of genocide in *La disparition*, where the disappearance of the letter *e* commemorates the erasure of an entire people.

12. As McCaffery suggests, it is possible to read the writing throughs of Pound's *Cantos* performed by Jewish writer Jackson Mac Low as an act of symbolic revolt against his anti-Semitic master (2012: 45).

13. Phillips's *A Humument* and Mallock's original text are available at <http://www.tomphillips.co.uk/humument> (last accessed 27 January 2021).

14. Artist's statement, my translation; see <http://www.galerieannebarrault.com/expositions/gerner.html> (last accessed 27 January 2021).

BIBLIOGRAPHY

Bernstein, C. (1987), *Veil*, Madison, WI: Xexoxial Editions.

Bernstein, C. (1992), *A Poetics*, Cambridge, MA: Harvard University Press.

Bervin, J. (2003), *Nets*, New York: Ugly Duckling Presse.

Bloom, H. (1997), *The Anxiety of Influence: A Theory of Poetry*, 2nd edn, Oxford: Oxford University Press.

Cage, J. (1982), *Roaratorio: An Irish Circus on Finnegans Wake*, ed. Klaus Schoening, Königstein im Taunus: Athenäum.

Cage, J. (1983), *X: Writings '79–'82*, Middletown, CT: Wesleyan University Press.

Clair, J. and M. Brusatin (eds) (1995), *Identity and Alterity: Figures of the Body 1895–1995*, Venice: Marsilio.

Delville, M. and M. A. Caws (2017), *Undoing Art*, Macerata: Quodlibet.

Derrida, J. (1993), *Spectres de Marx*, Paris: Galilée.

Dworkin, C. (2003), *Reading the Illegible*, Evanston, IL: Northwestern University Press.

Eliot, T. S. (2011), *The Sacred Wood: Essays on Poetry and Criticism*, West Valley City, UT: Waking Lion Press.

Felski, R. (2008), *Uses of Literature*, New York: Wiley-Blackwell.

Fisher, M. (2009), *Capitalist Realism: Is There No Alternative?*, Winchester: Zero Books.

Fisher, M. (2014), *Ghosts of My Life: Writings on Depression, Hauntology and Lost Futures*, Winchester: Zero Books.

Foster, H. (1994), 'What's Neo About the Neo-Avant-Garde?', *October*, 70 (Fall), pp. 5–32.

Gerner, J. (2002), *TNT en amérique*, Paris: L'Ampoule.

Goldsmith, K. (2011), *Uncreative Writing: Managing Language in the Digital Age*, New York: Columbia University Press.

Hawkins, J. and A. Wermer-Colan (eds) (2019), *William S. Burroughs Cutting Up the Century*, Bloomington: Indiana University Press.

Johnson, R. (2000), Interview with Peter O'Leary, 19 November 1995, <http://www.trifectapress.com/johnson/interview.html> (last accessed 27 January 2021).

Johnson, R. (2005), *RADI OS*, Chicago: Flood Editions.

Lee, D. D. (2010), *Sky Booths in the Breath Somewhere,: The ASHBERY ERASURE Poems*, Buffalo, NY: BlazeVOX.

Lee, D. D. (2015), Interview with Nick Sturm, *Barn Owl Review*, 8, <http://www.barnowlreview.com/dodd%20lee_interview.html> (last accessed 27 January 2021).

McCaffery, S. (2000), *North of Intention: Critical Writings 1973–1986*, 2nd edn, New York: Roof Books.

McCaffery, S. (2012), *The Darkness of the Present: Poetics, Anachronism, and the Anomaly*, Tuscaloosa, AL: University of Alabama Press.

Macdonald, T. (2008), *The O Mission Repo*, Santa Fe, NM: Fact-Simile Editions.

Mallarmé, S. (1959), *Correspondance Tome 1 (1862–1871)*, Paris: Gallimard.

Mallarmé, S. (1976), *Igitur, Divagations, Un coup de dés*, Paris: Gallimard.

Mallarmé, S. (1982), *Selected Poetry and Prose*, trans. M. A. Caws, New York: New Directions.

Mallarmé, S. (1988), *Selected Letters*, trans. R. Lloyd, Chicago: University of Chicago Press.

Mallarmé, S. (2009), *Collected Poems and Other Verse*, trans. E. H. and A. M. Blackmore, Oxford: Oxford University Press.

Mallock, W. H. (1892), *A Human Document*, Vol. 1, London: Chapman and Hall.

Perloff, M. (1998), *Poetry On & Off the Page: Essays for Emergent Occasions*, Evanston, IL: Northwestern University Press.

Perloff, M. (1991), *Radical Artifice: Writing Poetry in the Age of Media*, Chicago: University of Chicago Press.

Perloff, M. (2004), *Differentials: Poetry, Poetics, Pedagogy*, Tuscaloosa, AL: University of Alabama Press.

Phillips, T. (2005), *A Humument: A Treated Victorian Novel*, 4th edn, London: Thames and Hudson.

Phillips, T. (2012), *A Humument: A Treated Victorian Novel*, 5th edn, London: Thames and Hudson.

Rancière, J. (2007), 'The Space of Words: From Mallarmé to Broodthaers', in J. Game (ed.), *Porous Boundaries: Texts and Images in Twentieth-Century French Culture*, Bern: Peter Lang, pp. 41–61.

Ricoeur, P. (1970), *Freud and Philosophy: An Essay in Interpretation*, trans. D. Savage, New Haven, CT: Yale University Press.

Tzara, T. (2013), *Seven Dada Manifestos and Lampisteries*, trans. B. Wright, New York: Alma Classics.

In Praise of Hybrid Purity: Nomadism and Pierre Joris

Jan Baetens

Although never defined in any 'canonical' way, or perhaps for that very reason, *nomadic* writing – the term 'nomadic' being a nod at Deleuze and Guattari's philosophy of becoming (1987) – is much more than just one more school or movement, even if it has its own manifestoes, its own models and leaders, its own works and anthologies, its own history, and even now its own place in the history of avant-garde writing. Today, the concept of nomadic writing is almost automatically associated with the name and the work of Pierre Joris (b. 1946), the Luxembourg-American poet, translator, teacher, anthologist, essayist, and author of a book of essays called *A Nomad Poetics* (2003) that revised a previous 'Manifesto' (Joris 1994) while being itself permanently reworked, updated and subsequently challenged by the writer himself as well as its readers and critics (Joris 2009, 2017; Cockelbergh 2011). In *A Nomad Poetics*, one reads what remains a very good general presentation of this modernist/postmodernist branch of experimental writing:

> What is needed now is a nomad poetics. Its method will be *rhizomatic*, which is different from collage, i.e., a rhizomatics is not an aesthetics of the fragment, which has dominated poetics since the romantics even as transmogrified by modernism, high & low, & more recently retooled in the neoclassical form of the citation – ironic or decorative – throughout what is called 'postmodernism'. *Strawberry Fields Forever*. A nomadic poetics will cross languages, not just translate, but write in all or any of them. If Pound, HD, Joyce, Stein, Olson, & others have shown the way, it is essential now to push this matter further, not so much as 'collage' (though we will keep those gains) but as a material flux of language matter. To try & think, then this matter as even pre-language, proto-semantic [. . .]. And then to follow this flux of ruptures and articulations, of rhythm, moving in

& out of semantic & non-semantic spaces, moving around & through the features accreting as poem, a lingo-cubism, no, a lingo-barocco that is no longer an 'explosante fixe' (Breton) but an 'explosante mouvante'. (Joris, 2003: 5–6, my italics)

From a historical point of view, nomadic writing as coined by Joris is a good although quite late example of neo-avant-garde writing. Joris's first publications go back to the early seventies and his major theoretical references are clearly those of 'la pensée 68'. His life and work have strong ties with the beat movement (Joris is not only a metaphorically restless but also literally a travelling poet) and share a countercultural interest in non-Western cultures and languages (in his case, yet not exclusively, Arabic and North African). In this sense, his nomadic writing ties in with newer forms of Romanticism and a political concern for the subaltern. Also a great translator, Joris is perhaps best known for the two-volume anthology of twentieth-century avant-garde writings he edited with Jerome Rothenberg: *Poems for the Millennium: The University of California Book of Modern & Postmodern Poetry* (Joris and Rothenberg 1995). Highly representative of the most innovative aspects of the seventies and eighties, Joris's strand of neo-avant-garde writing does not, however, anticipate more recent trends in today's experimentalism, which focuses much more directly on issues of media, intermediality, technology and, to quote Kenneth Goldsmith's (2011) term, 'uncreative writing'.

If one were to pigeonhole a creative practice whose aim is to break free from any fixed form and position, Joris could be called a post-Romantic neo-avant-garde poet – with a strong emphasis on the notion of 'poet'. If one compares, for instance, his take on language nomadism, which combines a lifelong commitment to translation and a frequent use of multilingualism, with Goldsmith's ideas on the same topic, as expressed in *Against Translation* (Goldsmith 2016) – the translation in eight different languages of a manifesto first published in *Rhizome*, 'Displacement is the New Translation' (Goldsmith 2014) – the difference between the first-generation rhizomatics by Joris and the second-generation by Goldsmith are easily identifiable. Here are the opening paragraphs of the latter's manifesto:

Translation is the ultimate humanist gesture. Polite and reasonable, it is an overly cautious bridge builder. Always asking for permission, it begs understanding and friendship. It is optimistic yet provisional, pinning all hopes on a harmonious outcome. In the end, it always fails, for the discourse it sets forth is inevitably off-register; translation is an approximation of discourse – and, in approximating, it produces a new discourse.

Displacement is rude and insistent, an unwashed party crasher – uninvited and poorly behaved – refusing to leave. Displacement revels in disjunction, imposing its meaning, agenda, and mores on whatever situation it encounters. Not wishing to placate, it is uncompromising, knowing full well that through stubborn insistence, it will ultimately prevail. Displacement has all the time in the world. Beyond morals, self-appointed, and taking possession because it must, displacement acts simply – and simply acts. (Goldsmith 2014: n.p.)

The differences between these two forms of nomadic writing are both stylistic (the style of Joris's critical and theoretical writings emulates 'poetry', while Goldsmith's style is argumentative in the traditional sense of the word) and conceptual (the key idea in Joris is movement, the fundamental concern of Goldsmith is rupture).

If poetic nomadism in the sense of Joris continues to be useful in our understanding of what literature – or more precisely poetry – might signify today, it is because it offers a shortcut to what many forms of contemporary poetry are all about. Nomadic writing raises major questions on all basic aspects of the practice and poetry in present and future writing: what is a text? Who is the author of a text? What does it mean to read? What is the medium of a text? What can be the role and place of poetry in culture at large? It also raises questions on the status of theory and critical thinking, in relation not only to poetry but also to society. Finally, it emphasises the necessary link between theory and practice in the reading and writing of poetry today. For all these reasons, the personal reflections that will open and close my own take on nomadism's use value - for this is, after all, the issue literary theory should never forget to tackle: what is it actually good for? - should be taken not only as the symptom of a usually repressed and now happily unleashed narcissism (of course they are as well!), but also, and I hope more importantly, as a way of putting some meat on the nomadic bone while simultaneously demonstrating the remarkable impact of nomadism as a poetic theory on the current development of a practice that was explicitly initiated in a nomadic spirit.

WHY I LIKE NOMADISM, AND WHY IT SHOULDN'T LIKE ME

My own poetic practice and even more some of my own theoretical convictions are close to the basic tenets of nomadism as defined and illustrated by Pierre Joris, although it would be inexact or exaggerated to claim that my works and ideas are as radical and far-reaching as Joris's own. Nevertheless, I feel more than just a family resemblance when reading his creations and criticism. Three aspects

come to the fore: first, my proximity to multilingualism; second, my defence of writing in multiple versions or writing with variation; third, my interest in questions of reading and meaning. However, none of these aspects results in a poetic theory and practice that matches unambiguously the principles of nomadism.

Let me start with the first point, that of multilingualism, which is both central and almost completely absent from my work. As with so many other writers today, I do not write in my mother tongue (or rather mother tongues: my Flemish dialect, spoken at home, and standard Dutch, used in the public domain). Yet while my decision to write in French has certainly something to do with a certain biographical difficulty in striking the right balance between these two mother tongues, I do not consider this existential backdrop particularly important. To a certain extent, the denial of Flemish and Dutch has more to do with political arguments – I do not hide my anti-nationalist sympathies – than with strictly literary arguments – it would be incongruous, I think, to assume or believe that certain languages are more appropriated than other ones, even if one can always feel more empathy towards specific literary traditions. In other words: I am not suffering from any loss, nor am I claiming any new-found ground.

Nevertheless, my permanent, daily travelling between languages has a clear and direct impact on my writing in French, although not the type of impact that one might expect from a nomadic point of view. My writing testifies to a strong sense of linguistic homogeneity. It is plainly French and nothing else, despite my permanent exposure to other languages, other literatures, other cultural patterns and heritages. I do not try to explore the frontier zones or the contaminations between languages. My poetic vocabulary and the syntax that I use are unabashedly French: I borrow few words from other languages and I am very fond of French syntax (I like to buy into the well-known cliché that French vocabulary is poor, at least in comparison with English, but French syntax more challenging to writing). Rather than trying to translate texts or authors that I admire, or to emulate their style in French, I try to rethink their way of writing in French. A good example here may be my attempt to invent a French equivalent of Paul Celan's German idiosyncratic sayings in 'Hôpital' (Baetens and Deprez 2003), a poetic cycle strongly marked by my own reading of Celan that tries to find its own way *against* the canonical and tremendously useful translations by Jean-Pierre Lefebvre (Celan 1998), which I consider much too French (this version 'normalises' the original text by using the traditional mould of French syntax), while avoiding the trap of too strong a literal deconstruction of the French language in order to get closer to the morphologic structures of the German original with its multiple agglutinations, for instance. Here is a short fragment of the last variation of this cycle:

comme
nce
la mort
commence le non-
somme il
est fossoyé

tê
che
bê
te

nettement
nettement va se dé
composant
l'iris la pastille la tache la nuée
de sang
sur le pansement bave vite illi
sible
sable buvant b
avard buvard

dit-on
du temps qu'i
l
sans égard pour person
ne coule la vie humai
ne
joue-moi aux dés
dés-oeuvrement [. . .]
(Baetens and Deprez 2003: 55)

This Frenchness, however, is not self-evident, since there must be, willingly or not, a lot of Belgiumness in the French I write. Is this Belgiumness, then, an example of what Deleuze and Guattari (1986) call a *minor literature*, that is, not a literature based on a small or marginal language but a literature practised by a given minority that challenges the rules as well as the use of a major language from within? I would say definitely so – after all, Belgium has always defined itself as a culture of irregularities (Quaghebeur et al. 1990) – provided one accepts, of course, what the Kafka example of the French critics suggests:

namely, that a minor use of a major literature does not necessarily involve the material destruction of a language's vocabulary and syntax, but a different stance taken towards a given literature. My linguistic and stylistic sense of classic, traditional French has nothing minor in it as such, on the contrary. Yet at the same time my work contains many elements that go radically against the grain of the very core of the major system. I am thinking here of my suspicion towards professionalisation. My defence of Sunday poetry, for instance (Baetens 2009), is a way of deterritorialisation and hence also of politicisation and communitarisation, the two other characteristics of Deleuze and Guattari's minor cultures. But one can read it at the same as an attempt to provoke laughter, not in the now commonly accepted sense of carnival and excess, but in the more old-fashioned sense of irony and self-mockery, as an attempt to reject exaggerated self-reflexivity – together with seriousness, a major feature of French poetry for many decades (Baetens 2014b).

In short, one could say that this tension between a rather classic and very French form and a certain critique of French poetic values does not illustrate in a straightforward way the poetics of nomadism. True, certain influences of multilingualism tend to produce a nomadic drift –and a healthy distance towards canonical forms and usages. On the other hand, however, the continuation of classic forms of writing is no less directly informed by the same multilingualism. Despite the insistent presence of certain nomadic elements, there is no way to classify the final result as typically nomadic.

Similar remarks can be made as far as the second aspect, that of writing in multiple versions, is concerned. Several of my texts are not singular and unique items, but present themselves as variations on a given rule or theme. This compositional technique, not dissimilar to what is often done in music, for instance, might as well appear as typically nomadic. Such an interpretation and such a labelling, however, would ignore other aspects of writing *cum* variation that are definitely not nomadic at all.

The use of variations does not lead imperatively to the abandonment of the idea of unity or cohesion. It suffices, for instance, to maintain a certain form of order or hierarchy, for example by qualifying a given variation as derived from another one, to surreptitiously save the traditional distinction between the original and all its secondary occurrences. Yet even if this is not really the manner in which I am working with variations, there are other, and perhaps even more stringent frames that seriously limit the nomadic dimension of writing in multiple versions or iterative writing. More precisely, these restrictions have to do with the relationship between the after as well as the before of the variations. In absolute nomadic writing, the variations cease to be mastered by either a unique *origin* (the Ur-version old and new philologists

are always dreaming of) or a unique *endpoint* (the definitive version wiping out the previous forms as temporary sketches), and although I do not work with absolute beginnings or final endings, the way in which I manage the first and last step of my writing is decidedly non-nomadic. On the one hand, the variation principle is not an example of what Marjorie Perloff (2008) calls the *differential* text, namely a radically iterative text in which the possibility of distinguishing between the original and the derivative no longer exists: what counts is the multiplicity itself, the process, the infinite possibility of rewriting. Until now, I certainly have not gone this far. Even more significant are the restrictions that burden the starting point, more precisely my strong interest in procedural or constrained writing (Baetens and Poucel 2009, 2010; Baetens 2012). In this kind of literary production, the text appears as the possible exemplification of an underlying rule, which can be hidden or on the contrary (and preferably, as far as I am concerned) be revealed to the reader. As such, the text is indeed never totally unique: by definition, other exemplifications are always possible. But the text itself, in any of its forms whatsoever, remains something that to a certain extent is subordinated to the primary constraint (often compared to a mathematic theorem, of which the text is then a possible demonstration), and although the use of constraints is far from being systematic in my approach towards poetry, the very presence of procedural behaviour in certain texts sheds a kind of non-nomadic shadow on the nomadic play of variations elsewhere.

In a word, the mere technique of iterative writing, which at first sight seems to be a distinctive feature of nomadism, does not prove sufficient to make sure that a text can qualify as nomadic. From the very moment that either the source or the target of the process allows for a kind of hierarchy between the variations of a text, a classic spirit continues to embrace the whole process.

Third, what to think of the concern for the text's interpretation, which is, I think, ubiquitous in my work? The ambivalent status of my writing, torn between nomadic and non-nomadic elements, comes even more to the fore when one takes a closer look at the notion of 'meaning', which for me has not only an internal (linguistic) but also an external (cultural) aspect. Once again, I certainly do not claim that the reader is unable to interpret the text as they want, especially in terms of an aesthetic interpretation (it is preposterous, if not utterly pretentious and therefore finally grotesque to imagine that the reader has to like what the author thinks should be liked!). This fundamental liberty, however, which involves also the liberty to continue writing the text (and like most proceduralists, I am in full support of the idea that textual rules should democratically be shared with the reader so that they can

try to propose other 'demonstrations' of the same 'theorem'), does of course not mean at all that the author should not worry about issues of reading and understanding. Poetry should be on the side of clarity, not on that of vagueness and opacity. Texts will resonate more strongly, that is at least what I assume, if the reader understands them (and what happens after that: well, as Peter Warne/Clark Gable nicely put in *It Happened One Night* (1934): 'then it's every man for himself'). Conversely, the possibility that a text paves the way for free and creative reinterpretations may not be strengthened by the fact that it may mean anything and nothing. This stereotypical view of a multiplicity and multilayeredness does not resist a more in-depth analysis.

It is not enough to understand all the words and all the sentences of a text in order to grasp its meaning. Many other elements play a role, and the treatment of internal and external aspects can prove quite different. In my own case, I give an important role to the referent: the French poetic and literary tradition, the meanings and knowledge that a community may share, and the presence of all kind of *realia*. I consider crucial the readerly perception and understanding of this referent, and this has strong consequences. For this reason, I try to be in this regard as simple and transparent as possible. First of all, I believe that in contemporary societies it is no longer possible to rely upon a poetics of allusion: since there is no longer any shared knowledge, the use of allusions prevents the text from communicating. Second, because my work does not belong to the field of live performance poetry where the contact with the public can be re-established in other ways. From an aesthetic point of view, however, this position is less easy to take than it appears. How to save transparency from didacticism? Which tricks of the trade are efficient? Will it be possible to address various audiences simultaneously? All these questions put a heavy burden on the text itself and all of them seem to push it towards more traditional, anti-nomadic, if not rear-guard stances. However, it is also a wonderful challenge to find solutions that are also aesthetically satisfying: for instance, by using all manner of constraints (and I emphasise that my use of constraints cannot be separated from an ethics of legibility and community: it is only by understanding the constraint that the reader can start writing themselves), or by blurring the boundaries between text and paratext (such as the explanatory footnotes, which I try to elaborate on as carefully as the poems themselves, sometimes to the extent that readers prefer the notes to the texts!), or by opting as radically as possible for stylistic variability (in that case, changes in style point towards changes in meaning, according to most conventional literary handbooks).

In brief, anticipating the reception of the text and taking as a compositional device the concern for possible misunderstandings implements an interaction

with the reader in the very form and style of the work itself, revealing once more the intricate relationships between nomadism and non-nomadism. On the one hand, it is definitely non-nomadic to try to exert too tight a control on the way a text will be read. On the other hand, however, only the initial understanding of the text will allow the reader to continue beyond where the author and the text cease.

LESS IS MORE IN NOMADISM TOO

As the aforementioned examples and commentary suggest, poetic practices and theories may combine both nomadic and non-nomadic elements. Such an observation does not come as a surprise, yet it is possible to take it as a point of departure for a renewed reflection on nomadic writing and nomadic theory in general. The ecumenical mixture of the two dimensions that I have foregrounded until now, can be fruitfully used to rethink the very notion of nomadism. Not in order to draw a sharper line between its already known characteristics and the apparently antagonistic features of non-nomadism, but in order to examine whether one should deconstruct the very difference between both strands and analyse to what extent the inclusion of non-nomadic elements in nomadism – rather than being a form of weakness or betrayal – could provide a better understanding of what nomadism actually is, or, more precisely, how nomadism actually works. I would like to argue indeed that the efficiency of nomadic writing does not depend on the degree to which it manages to oppose non-nomadism, but on the contrary on the degree to which it succeeds in making room for its non-nomadic other.

As theorised by Pierre Joris, nomadic poetics frequently comes across notions such as rhizome, othering, deterritorialisation, anti-essentialism, becoming, and so on. There is, in other words, a strong Deleuzian aspect or dimension in nomadic poetry, which its practitioners, for obvious good reasons, take into account. However, if we follow this thread, two important issues emerge: the tension between hybridity and purity, on the one hand; the tension between making and reading, on the other hand. In both cases, nomadic poetry takes a very clear stance: it does not accept poetic genres as established structures, while it puts a strong emphasis on reading. Either case, however, offers also the opportunity to take a more nuanced position, which I will try to defend in this section.

Nobody will deny that the major example analysed by Deleuze and Guattari, namely the work of Franz Kafka, is a wonderful exemplification of nomadic poetics. In Kafka's writing, however, not everything is nomadic. Some aspects are more nomadic than others. Certain aspects are even, at least at first sight,

not nomadic at all, as for instance the syntax, whose apparent simplicity, if not dryness, borrows from the neutral and sober style of Austro-Hungarian bureaucracy, totally different from the high-literary style of the German classics taught in class and which Kafka's style, minor-culture-wise, opposes in very subtle ways. Even though it may be thinkable (but certainly not easily doable) to propose a nomadic reinterpretation of this syntactic transparency, the clash between what Kafka is saying and the way in which he is saying it is part of his literary approach. This brings me to my first question, that of the supposed antagonism of hybridity (nomadism) and purity (non-nomadism). If it is true that, as I think is the case in Kafka, nomadic writing does also involve non-nomadic elements (in this case: Kafka's apparently hyperconventional use of syntax), how can we make sense of this mix, and which stance should we take towards it?

Roughly speaking, two major answers are possible. One might argue, first, that nomadic writing should try to avoid as much as possible those non-nomadic elements, as remnants of non-hybrid forms of writing that jeopardise any attempt to move into the direction of real nomadism. This dream of what I would call 'pure hybridity', the dream of hybridised writing to downsize or even to exclude non-hybrid, non-nomadic forms of writing, strikes me as naïve, and perhaps even counterproductive. What matters is not that nomadism becomes a 'pure' form (can one only imagine what that would mean? Would that not signify a new form of pure, essential, homogeneous and sanitised writing?), but that nomadism manages to become and eventually to stay the dominant force in the permanent struggle between nomadic and non-nomadic forms.

For that reason, the second possible answer is the one I would like to defend. It consists of trying to cope with the inevitable mix of hybrid and non-hybrid forms, in order to find the most efficient way to use this blend for nomadic purposes. The example of constrained writing, which as I suggested in the first part of this essay nomadic poetics will not spontaneously consider a natural ally, may prove very helpful here. Indeed, constrained writing as well, unless in those cases where it shrinks to a variation on Scrabble and crosswords poetics (as is the case in some of its didactic derivatives), is confronting exactly the same problem. Just as nomadic writing needs to know which elements are nomadic and which are non-nomadic, constrained writing must clearly chart which elements should be ruled by constraints and which should be left outside (and thus abandoned, so to speak, to the more or less free play of improvisation that goes along with any creative process). Only then does it become possible to make the constraints productive. As long as the distinction between constrained and unconstrained elements is not clearly marked, the

intertwining of both types of forms and procedures will prevent the correct appraisal of the work and, much more importantly, its creative continuation by the reader. For only readers who have seen and understood how a work has been composed will prove capable of going beyond its literal decipherment. Only such readers will be able to do more than read and interpret the work, more or less completely, more or less correctly. Only they will dispose of the tools to continue writing in an interesting way - and it would, of course, be an insult to nomadism to suggest that it can be done even irrespective of whether the reader is conscious of it. There are no universal answers here, but there are definitively answers, as demonstrated by the specific solutions given to these questions in specific texts, settings and contexts. In this regard, it would be a mistake to discard a certain need for pedagogy.

Shifting from a synchronic to a diachronic perspective of nomadism, which can be seen as part of the longer story of avant-garde poetry, it may be useful to mention discussions on so-called rear-guard writing (Marx 2008), whose place and status have been redefined quite dramatically in recent years (for an overview, see MDRN 2013). Not only have the boundaries between both extreme positions become blurred, in certain cases the return to more traditional forms is not deprived of innovative and perhaps nomadic undertones. Francis Ponge's tribute to Malherbe, *Pour un Malherbe* (1965), whose role in the strict codification of French prosody is infamously known, is a good example of such a need for superseding the classic distinction between old and new or, if one prefers, between non-nomadic and nomadic. This new approach supposes important theoretical and methodological shifts, as it entails the transition from a formalist to a functionalist approach to literature (in such an approach, the basic question is no longer what a given device or technique or theme may signify, but which role it assumes or is given within a given historical context).

The second major issue I want to raise can in no way be separated from the first one. It has to do with the position of the reader of nomadic poetry – and by reader I mean the reader of nomadic poetry in print, not the real audience participating in a live performance where the process of meaning-making follows different paths. More precisely, what I am naming here the issue of the reader is in fact the issue of misreading, or at least the possibility of it. As we know, misreading is a multifaceted and multilayered phenomenon, which works in various ways. For instance, readers may read non-nomadic texts nomadically – perhaps this is what Francis Ponge is doing with Malherbe, when he highlights the late sixteenth- to early seventeenth-century poet as a model for his own experimentalisms. Or they can proceed the other way round – for example, when readers try to negotiate the strangeness of certain texts by linking them to well-established frames of interpretation. But it would

be an incorrect strategy to neglect misreading as a superficial, epiphenomenal detail. For any poetics whatsoever it is crucial to take a stance towards the possible gap between production and reception as a key problem at all possible levels (as argued above, the idea that the reader can do as they please is not always the best warrant to real creativity and freedom, which must be rooted in knowledge and understanding).

Here as well, two major answers are thinkable. First of all, it is possible to discard the non-nomadic misreading of nomadic writing as the sole symptom of a rear-guard battle. In that case, one should not care, for the misreading in question simply betrays the refusal of traditional readers to cope with the newness or strangeness of nomadic writing. One could even claim that misreading is always a false problem, given the fact that in nomadic poetry the very distinction between reading and writing no longer holds. In that case, raising the very issue of misreading signifies that one simply does not grasp the full meaning of nomadic writing. It is worth noting that similar stances have been defended for quite some time in the field of digital culture, where critical theorists have tried to radically dismantle the distinction between user and producer, but more recent studies have once again become a little more cautious about the idea of 'wreading' as a default option for reading and/as writing in this context. Nomadic poetics should be inspired by this scepticism and thus keep a sharp eye on what actually happens when people read and misread (the various editions of George Landow's *Hypertext*, now already in its 3.0 version (2006), give a good idea of the shifting enthusiasms and scepticisms in this regard).

The second possible answer, however, is namely that misreading is not a synonym of erroneous reading, but a key aspect of any real reading process. In the context of the debate on nomadism, misreading should be taken at face value, not as an example of creative misreading (in that case, there is always the danger of reducing reading to the playful yet impoverishing anarchy of *anything goes*), but as a symptom hinting at the tension between nomadic and non-nomadic elements in the text. If misreading is possible, it is because the reader does not know where nomadism ends and non-nomadism starts, or vice versa. From that point of view, the discussion on misreading can function as a valuable trigger for new interventions in the dialectic relationship between both forces. For this reason, some French translations of Celan, such as the one by Lefebvre which noticeably reduces the nomadic aspects of his poetry, should not be criticised as misreadings or bad translations, but as an alternative used as a springboard towards a better understanding of what is actually nomadic or non-nomadic in Celan's work. In that sense, the supposed formal misreading by Lefebvre becomes a possible guide to new ways of writing.

What are the practical lessons one can draw from this discussion on mis-reading as well as on purity versus hybridity in nomadic writing? Concerning the latter point, it seems clear that nomadic poetics should embrace the importance of non-nomadic elements – and perhaps even anti-nomadic elements, such as clarity and transparency, which have their role to play in the unfolding of the textual dynamic. Such a vision is not a threat to nomadic poetry, but a widening of its perspective. Nomadic poetics is then no longer a matter of crossing the lines between ways of writing and reading, but a way of inscribing poetry within a newly expanded field. Concerning the former point, nomadic poetry should accept to dispose of another of its holy cows, namely the a priori rejection of anything that has to do with rhetoric, often confused with non-nomadic writing in general. If nomadism takes seriously the way in which the reading of a nomadic text is continued as well as transformed by its readers, it will necessarily have to deal with rhetoric in the most traditional sense of the word, referring to the calculation of textual effects on its reader (or listener, spectator . . .). In order to increase the quality of the way in which a nomadic text is appropriated by its reader, it is necessary, I would like to argue, to start the dialogue with the reader as soon as possible. For only readers with a deep understanding of how a text is made will have the necessary competencies to create new texts that are better than the existing ones. Or if one prefers: in nomadic poetics, rhetoric is something that should be actively pursued and systematically put into practice, not in order to manipulate the reader, but in order to create the conditions of a more authentic freedom.

'CE MONDE': AN EXAMPLE OF NOMADIC REWORKING

In 2013 two specialists of contemporary writing with a strong interest in ecocriticism, convener Franca Bellarsi and co-convener Peter Cockelbergh, organised a 'poetry lab' at the Université Libre de Bruxelles (ULB). Entitled 'Moving Back and Forth between Poetry as/and Translation: Nomadic Travels and Travails with Alice Notley and Pierre Joris', this event was a tribute to Joris and Notley as well as a platform for various practice-based theoretical debates on nomadic writing (for the keynote lecture of the lab, see Joris 2017). It did not only give me the opportunity to present and read a work in progress, 'Ce Monde' ('This world'). It also allowed me to reorient it in a way that shows the concrete impact of nomadic writing on my own creative practice. The initial context of 'Ce Monde' did not bear any direct relationship with nomadism, except of course the general but still very vague sympathy I have always felt for this strand of poetic thinking. 'Ce Monde' had originated as a

commission by (SIC), a Brussels avant-garde collective charged by the Minis-
try of Culture to organise a cross-media artist residency at the OFF festival of
the 2013 Venice Biennale. Fifteen artists (musicians, photographers, painters,
filmmakers, soundscape artists, performers, but also three writers) contributed
a site-specific work to a collective volume that also contained anonymous
fragments of the visual diary that all artists had to keep during their residence.
In order to cope with the *in situ* constraint, my own work entailed of course a
poem on Venice, the opening lines of which read as follows:

> *Ce monde en nasse est-il encore le nôtre?*
> *Et cette mer de côte en côte dominée,*
> *Comme un habit jeté sur le vide?*
> *Pour te projeter dans ce monde que d'autres habitent,*
> *Retranche-toi la main,*
> *Que tes doigts ne te mangent plus.*
> *Un monde tient dans une pelure d'orange.*
> *Et toi, où est-ce que tu te caches?*
> *Pourquoi tu te caches?*
> *La ruine manque, et le vide.*
> *Les briques, les pavés, les dalles, les stèles,*
> *Les jeter n'a pas de sens,*
> *La pierre lancée retombe au même endroit*
> *Après chaque nouvel incendie.*
> *Partir en résidence, et au lieu de rentrer ici repartir de là.*
> *La couture déchirée d'un ordre ancien nous appareille.*
> *Oublieras-tu la mer pour l'habiller en monde*
> *Ou seras-tu navire?*
> *On voit passer des souvenirs qui sont vieux déjà de plus d'un demi-siècle,*
> *Durs, intimes, murs*
> *Mitoyens entre nous et ce monde sans nous. [. . .]*
>
> (Baetens 2014a: 17)

It was accompanied by two other creations. On the one hand, a critical reflec-
tion on the very stakes of an artistic residence, which should be more than just
an environment (and a fee!) for the production of a new work but seen as a
springboard to do something else, for and with a given community. On the
other hand, a dialogue with the fourteen other artists, whose personal poetics
I tried to describe through fourteen variations on a classic theme: the impos-
sibility of writing about Venice (each of these texts is dedicated to one of these
artists, so that the reader can start imagining how a paradoxical description of

the city of Venice can also serve as an introduction to the creative practice of someone else).

The preparation of the poetry seminar helped me realise that the central part of my Venice triptych, 'Ce Monde', was in fact already an experiment in nomadic writing, and that the best possible way to highlight that dimension was to adapt and expand it more explicitly in that direction. The text as it stood at the moment of the Brussels poetry lab was a piece of approximately a hundred lines, which started as a commentary on a short fragment by John Ashbery, three lines chosen from his poem 'A Last World':

> *Now all is different without having changed*
> *As though one were to pass through the same street at different times*
> *And nothing that is old can prefer the new.*
>
> (Ashbery [1962] 1997: 56)

They resonated wonderfully with my own experience of Venice and other, similar cities, and it came very naturally to elaborate my own text in the slip-stream of Ashbery's lines. 'Ce Monde', however, is neither a translation nor even a variation on 'A Last World' in the traditional sense of the word. Its ambition is to become a real nomadic double of this text, albeit it a double that does not aim at being completely faithful to the model, which it neither copies nor imitates. 'Ce Monde' does not reproduce the vocabulary or the themes of 'A Last World'. Nor does it keep any of its formal properties: the verse structure (for despite being written in 'free verse', Ashbery's lines do obey strong rhythmic and formal patterns) is quite different and also from a quantitative point of view there is an abyss between the three lines of Ashbery and the more or less hundred lines of 'Ce Monde'. Nevertheless, the dramatic lexical, syntactic, thematic and, I presume, ideological differences between the two texts do not prevent 'Ce Monde' from functioning as a nomadic translation of 'A Last World'. To do justice to a textual relationship that was indeed a translation while at the same time disposing of all traditional features of what a translation, even a very free one, is supposed to be, the concept and practice of nomadism proved not only useful, but were absolutely indispensable to understand what I was doing.

Nomadic writing being a process as much as a product, 'Ce Monde' could of course not end with these hundred lines, which were rapidly transformed into the first movement of a larger whole (at the time of writing, there exist already five of them, each counting more or less the same amount of lines). However, the most dramatic shift undergone by 'Ce Monde' concerned the global perspective and framing of the project. Not only did I realise that the

best way to make the 'translation' truly nomadic was to convert it to a never-ending story, meaning that I had to keep the text as open as possible. Open, first, to a process of infinite corrections, of course in the 'differential' spirit mentioned above: the textual changes would not delete or marginalise the previous, already existing versions of the text, but add up to what was already there, in a resolutely non-hierarchical manner. But open, second, to no less infinite expansions, a feature that is quite familiar to all those working with constraints. The ultimate change, however, came from the nomadic reinterpretation of the notion of authorship.

After having considered an illustrated version of the text, for instance in collaboration with Olivier Deprez, a woodcut artist with whom I have been collaborating for nearly two decades, the theoretical and ideological limitations of such a widening of the project became suddenly very clear to me. Rather than simply adding some visuals to an already existing text, the nomadic spirit I felt now at the very heart of 'Ce Monde' required me to rethink the whole procedure from scratch and, in other words, try to do with 'Ce Monde' what this text had already done with 'A Last World'. From that perspective, it was absolutely necessary to share authorship and to establish a procedure enabling the further development of 'Ce Monde' not just by one single author, but by a community of readers eager to appropriate the 'original' work in their own way. The collaboration with Olivier Deprez, on the one hand, and two sound artists, Vincent Tholomé (a poet and writer himself) and Maja Jantar (a member of the KriKri sound poetry collective), was key to this new direction: all of us agreed on the fact that 'Ce Monde' should not simply be illustrated or performed live, but that the four of us had to consider it one of the building blocks – alongside new visual material and new sound and stage experiences – of something that might take the form of a film, which in its turn could be explored as an echo chamber of what we are all doing individually or in collaboration with others.

Thus are we (and no longer: I) standing now, and the changes that the 'Ce Monde' project is still undergoing demonstrate quite neatly the practical consequences of a theoretical approach inspired by nomadic writing. As such, it exemplifies the fundamental issues – which we consider opportunities – of a type of writing that questions the notion of text as much as it problematises the notion of authorship, medium, reader, communication, work, and so on. Nomadism, however, does not only force us to rethink the basic tools of writing, the basic structures of literary agency, the basic structures of the institutions that mediate between process and product, author and reader, text and aftertext, it also offers concrete models and practices that help shape our current and future ways of reading and writing poetry.

BIBLIOGRAPHY

Ashbery, J. [1962] (1997), *The Tennis Court Oath*, Middletown, CT: Wesleyan University Press.

Baetens, J. (2009), *Pour une poésie du dimanche*, Brussels: Les Impressions Nouvelles.

Baetens, J. (2012), 'OuLiPo and Proceduralism', in J. Bray, A. Gibbons and B. McHale (eds), *The Routledge Companion to Experimental Literature*, New York: Routledge, pp. 115–27.

Baetens, J. (2014a), 'Ce Monde', in E. Sovrani and Y. Van Parys (eds), *La Biennale de Venise 2013*, Brussels/Paris: (SIC)/Les Presses du réel, pp. 20–2.

Baetens, J. (2014b), *Pour en finir avec la poésie dite minimaliste*, Brussels: Les Impressions Nouvelles.

Baetens, J. and O. Deprez (2003), *Construction d'une ligne TGV*, Paris: Maisonneuve & Larose.

Baetens, J. and J.-J. Poucel (eds) (2009), 'Constrained Writing (I)', *Poetics Today*, 30 (4).

Baetens, J. and J.-J. Poucel (eds) (2010), 'Constrained Writing (II)', *Poetics Today*, 31 (1).

Celan, P. (1998), *Choix de poèmes*, trans. J.-P. Lefebvre, Paris: Gallimard.

Cockelbergh, P. (ed.) (2011), *Pierre Joris: Cartographies of the In-Between*, Prague: Litteraria Pragensia Books.

Deleuze, G. and F. Guattari (1986), *Kafka: Toward a Minor Literature*, trans. D. Polan, Minneapolis, MN: University of Minnesota Press.

Deleuze, G. and F. Guattari (1987), *A Thousand Plateaus*, trans. B. Massumi, Minneapolis, MN: University of Minnesota Press.

Goldsmith, K. (2011), *Uncreative Writing*, New York: Columbia University Press.

Goldsmith, K. (2014), 'Displacement is the New Translation', *Rhizome*, 9 June, <https://rhizome.org/editorial/2014/jun/09/displacement-new-translation/> (last accessed 29 January 2021).

Goldsmith, K. (2016), *Against Translation*, Paris: Jean Boîte Éditions.

Joris, P. (1994), 'The Millennium Will Be Nomadic or It Will Not Be: Notes Towards a Nomadic Poetics', <https://pierrejoris.com/nomad.html> (last accessed 29 January 2021).

Joris, P. (2003), *A Nomad Poetics*, Middletown, CT: Wesleyan University Press.

Joris, P. (2009), *Justifying the Margins (Reconstruction),* Cromer: Salt Publishing.

Joris, P. (2017), 'A Nomad Poetics Revisited: Poetry and Translation in a Global Age', *boundary 2*, 11 September, <https://www.boundary2.org/2017/09/pierre-joris-a-nomad-poetics-revisited-poetry-and-translation-in-a-global-age/> (last accessed 29 January 2021).

Joris, P. and J. Rothenberg (eds) (1995), *Poems for the Millennium: The University of California Book of Modern & Postmodern Poetry*, Berkeley, CA: University of California Press.

Landow, G. (2006), *Hypertext 3.0: Critical Theory and New Media in an Era of Globalization*, Baltimore, MD: Johns Hopkins University Press.

Marx, W. (ed.) (2008), *Les Arrière-gardes au XXe siècle: l'autre face de la modernité esthétique*, Paris: Presses universitaires de France.

MDRN (2013), *Modern Times, Literary Change*, Leuven: Peeters.

Perloff, M. (2008), 'Screening the Page/Paging the Screen: Digital Poetics and the Differential Text', in A. Morris and T. Swiss (eds), *New Media Poetics: Contexts, Technotexts, and Theories*, Cambridge, MA: MIT Press, pp. 143–65.

Ponge, F. (1965), *Pour un Malherbe*, Paris: Gallimard.

Quaghebeur, M., J.-P. Verheggen and V. Jago-Antoine (eds) (1990), *Un Pays d'irréguliers*, Brussels: Labor.

Enigmatic and Revealing: Lucienne Stassaert's Neo-Avant-Garde Short Story Collection
Verhalen van de jonkvrouw met de spade (1964)

Nele Janssens

In 1964, Lucienne Stassaert (self-)published her first short story collection *Verhalen van de jonkvrouw met de spade* ('Stories of the lady with the shovel'). The stories in the collection are not conventional narrative prose texts: rather than linear plot development or recognisable characters, they feature rich imagery and a pervasive rhythm. Stassaert is not the only Flemish author who challenged prose conventions in the 1960s. After a period of post-World War II restoration, the authority's teleological discourse was mistrusted and there was widespread suspicion of grand historical narratives (Bernaerts 2013; Brems 2016; Wesselo 1983). Within this context, prose authors began to problematise the core features of literary genres by discussing previously taboo themes and disrupting conventional understanding of continuity, fictionality and narrativity (Bernaerts 2013: 608; Vervaeck 2014: 70).

Amid this experimental fervour, Stassaert sought her 'own voice' (Jespers 1999: 4), which she expressed through what she termed 'poetic prose' (Stassaert 2017: 184). The following excerpt from the title story of her debut collection is a typical example:

> in the yellow cage today I have left the bird with the repetition signs day-day night-night
>> in the hidden after-day after-night I then stepped
>> the distance between others and myself every time swingity swing, a lurid romance with the eventuality that the cords break and the space ulcer cracks my neck (I die an under-lascivious space death being thrown in the soft earth). (Stassaert 1964: 14)[1]

Jan Walravens associates this experimental prose not primarily with the Flemish prose experiment of the sixties, but with the neo-avant-garde periodical *Labris* (1962–73) in which several stories from the collection were originally

published (1965). While he presents Stassaert as one of the most important collaborators of *Labris,* he also emphasises her uniqueness: 'Stassaert's share in the general *Labris* adventure is important because she manages to make use of prose in an entirely unique way. [. . .] [It] seems to us that, as a prose writer, she walks her own course' (1965: n.p.). According to Walravens, Stassaert's prose experiment is both unique and connected to a writers' collective. Many critics who discuss Stassaert's texts arrive at the same conclusion (Bernaerts 2013: 616; Jespers 1999: 9; Roggeman 1975: 280; Van der Straeten and Van Imschoot 2017: 52; Vitse 2013: 634–6) and Stassaert's short story collection should be studied against that background.

In this chapter, I examine Stassaert's *Verhalen van de jonkvrouw met de spade* as neo-avant-garde prose. The neo-avant-garde status of a work of art does not simply depend on technical similarities with a particular avant-garde movement (such as surrealism, cubism or Dadaism), nor does it solely rely on the period in which it was published. In accordance with the definition set out in the Introduction of this book, I define the individual neo-avant-garde work pragmatically, based on five factors. A text or collection of texts is neo-avant-garde if: (1) it uses established avant-garde techniques like collage, montage or denarrativisation (technical factor); (2) it uses a discourse of revolution, originality and play (poetical factor); (3) it refers in the paratext or main text to other arts or avant-garde movements (a factor concerning the author's self-image or 'posture' (Meizoz 2007)); (4) it occupies a marginal position within the literary field (institutional factor); and (5) literary criticism recognises avant-garde techniques, discursive concepts or affiliations in the work (reception factor).

Through these five factors, I examine *Verhalen van de jonkvrouw met de spade* in relation to the international neo-avant-garde and the Flemish experiments in the 1960s. I first discuss several editions of *Verhalen,* which I situate within Stassaert's oeuvre. Next, I focus on Stassaert's prose experiments of the sixties, which I associate with a faction of *Labris* that can be linked to surrealism and the American beat generation. Finally, in order to understand Stassaert's connections to neo-avant-garde groups without losing sight of the particularities of her experiments, I inspect the title story of the collection.

'De jonkvrouw met de spade', which is the second of nine stories in the collection, entails two entitled parts: '1. de putten' ('1. the pits') and '2. monologen tussen de tijd en zij' ('2. monologues between time and them/her'). In the first part, a homodiegetic first-person narrator reflects on her life, which is structured and restricted by social conventions and expectations.[2] She hides in concealed spaces to escape these restraints. 'De putten' ends with 'métamorphose' (11). In 'Monologen', this metamorphosis takes form: the narrator no longer has one recognisable voice but gives the floor to multiple selves who discuss their relation to each other and their surroundings.

EXPECTATION AND DEVIATION: PROSE THAT CHALLENGES NARRATIVITY

The texts in *Verhalen* were originally published at different times and in different locations. Several were first published in the experimental periodicals *Labris* and *Nul* (1961–5). 'De verbindings-fictie' ('The connection fiction'), for instance, was published in *Nul* (1963). *Labris*, meanwhile, published four complete texts from *Verhalen*: 'De ouders' ('The parents') (1963), 'Litanies de la rose' ('Litanies of the rose') (1964), 'De hoer en de tabernakelnikker' ('The whore and the tabernacle negro') (1964) and 'Paarden slapen op hun rechte poten' ('Horses sleep on their straight legs') (1964). The same texts later appeared almost unaltered in the collection.[3]

The first part of 'De jonkvrouw' was published both in *Labris* and in *Nul* (1963a, 1963b). In the periodicals, 'De putten' was presented as a finished story and barely differs from 'De putten' in the collection. One change however, demands our attention: the speaker in *Nul*, unlike in *Labris* and the collection, refers to an audience in the past tense: 'and I dig in the French Moyen-Age / the others *followed* (applauding) usually I fall out of my role and continue to SING' (1963b: 18, my emphasis). In *Labris* and *Verhalen*, this statement is in the present tense, which may indicate greater similarity between the musician and the writer. Indeed, before Stassaert's literary career started, she was a concert pianist and studied at the Royal Flemish Conservatory in Antwerp (Jespers 1999: 2). Only in 1965, after her father's death, did she end her piano career and focus on literature and visual work.[4]

The texts in *Labris* and in the collection allude to the musical aspect of the language. This musical quality relies on the omission of punctuation and figures of speech like repetition, alliteration and assonance (see below). In addition, musical patterns give the impression of spontaneity, which some critics associate with the surrealist *écriture automatique* (Roggeman 1975). In combination with the homodiegetic first person narrator, this spontaneity resembles the stream of consciousness technique most commonly associated with high modernism (Neefs 1965). In these technical aspects we recognise the first factor of a neo-avant-garde work.

Before we discuss this avant-gardist language, we must address a significant visual aspect of the collection: Stassaert's *Verhalen* was printed as a colour stencil in violet ink. In *Souvenirs* (2014, 2017, 2019) a three-part series of notes on her life, work and reading, Stassaert related this visual feature to the musical language in *Verhalen*:

On the typewriter, words appeared as if automatically, as if all the music I knew or had interpreted [. . .] now formed letters under my fingertips,

words that conjured up images, accompanied by their metaphors, in a pro-
gressive pace. New word combinations sprang up from among the more
familiar in a dialogue or monologue. (Stassaert 2019: 99)[5]

Since Stassaert's self-published collection was printed as a colour stencil, it
occupied a marginal position in the literary circuit, which constituted the
fourth, institutional factor of a neo-avant-garde work. The self-published sten-
cil also implies an antagonistic attitude towards mainstream literature, in which
we recognise the third neo-avant-garde factor.

Verhalen was reprinted twice. In 1999, a bibliophile edition was published
by Jef Meert, which included two etchings by Dan van Severen. Twenty
years later the texts were reprinted as the fifth section of *Souvenirs III*: 'V. De
jonkvrouw met de spade' (2019: 141–76). In the reprints, minimal changes
were made to the texts themselves, the most significant of which related to the
presentation of the texts in the peritext. In 1964 and 1999 the title presents
the texts as 'stories'. In the 2019 edition, this presentation changed. Stassaert
no longer presented the texts as collected stories, but rather as a selection of
her early prose included for reasons of clarity as an appendix to autobiographi-
cal notes (2019: 99). The 'stories' specification disappeared from the title of
that section. What is more, the texts were no longer presented as separate
stories. 'V. De jonkvrouw met de spade' now consisted of numbered excerpts;
excerpts that were part of a 'story' in the earlier editions were here presented
as equivalent parts – functioning on the same level. Much less than in 1964 and
1999, this presentation evokes the expectation of completed narratives.

Still, the texts in the first edition of *Verhalen* challenge the narrativity that
its peritext and layout announce. This challenge of narrativity is a fundamental
feature of Flemish neo-avant-garde prose in the 1960s. Amidst a socio–political
climate of progress and contestation, experimental prose authors challenge the
central characteristics of the genre: fictionality, continuity and narrativity. The
fictional aspect of prose was primarily questioned in documentary prose and
so-called collage novels (De Taeye 2018). Narrativity, meanwhile, was chal-
lenged via a number of techniques.

The title story of *Verhalen* challenges narrativity first on a thematic level as
it questions the presentation of life as a teleological process. The two parts in
'De jonkvrouw' follow each other both on the level of the discourse and on
the story level. First, 'De putten' introduces a homodiegetic speaker who tries
to escape the social conventions that structure time. She experiences conven-
tional presentations, like calendar time (presented as a chain of days (9)) and
clock time (compared to the cutting of sunlight (10)), as spurs to fulfil the
'duty. duty. duty.' to move forward (9). This duty implies that she is prevented
from standing still and reflecting: whenever the speaker 'returns from [her]

diving tests' that symbolise introspective episodes, she feels 'guilt. guilt. guilt.' (9). The pressure to progress alienates the speaker from herself: within the rat race of society, she is unable to control the 'swap[ping of] the ten thousand doubles within [her]' (9). Instead she finds refuge in concealed spaces such as an under(water)world (10) or a music box: 'inside the old music box [I will] live encapsulated again playing with bells of woe and catching [. . .] the golden fish I' (10). This game, often considered a waste of time in a progress-obsessed society, is enlightening as the speaker catches a golden version of herself.

At the end of 'De putten', the speaker wants to resist progress entirely and make time stand still. She would then be able to transform: 'will I smash your head, ivory tower of one-way traffic, to pieces against the wall? GONE. Your intellect-springs no longer work. The arm of the clock stands still at six and you speak of "métamorphose"' (11).

The second part of the story describes this metamorphosis. The title 'Monologen tussen de tijd en zij' announces different speakers or narrators. The pronoun 'zij' ('them' or 'her' in Dutch) proves to be the third person plural pronoun.[6] Indeed, several different voices can be distinguished. The homodiegetic first person narrator identifies these other voices as different parts of herself: some are past selves who haunt her (12), others are still active. Some of these selves return as character-narrators and their monologues are preceded by a hard return and a name which identifies the speaker. The identified speakers are Waterputstem ('Draw-Well voice') (13), De jonkvrouw met de spade ('The lady with the spade') (14) and Mummie de wilde kat ('Mummy the wild cat').[7] These collocutors discuss time and experience, but rather than interacting through dialogue, they talk past each other. This results in a succession of monologues without clear narrative progress.

One speaker does reach a form of conclusion at the end: despite metamorphoses and discussions, nothing really changes. The speakers' words either freeze (becoming cold and fixed expressions rather than the authentic representations) or evaporate into thin air:

in bumpy time the space cobblestone rolls over frozen lakes which remained from an expired void that once was now confirmed when I blow in my hands and find my breath
outside of me
in the air
reduced to NOTHING. (18)

The end of the story thus circles back to the beginning, where the metamorphosis starts all over again. This sequence (in which the second part precedes the first part on the story level) is supported by two time indications: at the end

of 'De putten' the clock indicates six o'clock (11), while the first speaker of 'Monologen' states 'it is now ten to five' (12).

The narrativity in 'De jonkvrouw' is also formally questioned as the text reinforces lyricality at the expense of narrativity. Lyricality is a dynamic class of features that can be realised to different degrees in different texts (Wolf 2005). Werner Wolf distinguishes nine tendencies that signal lyricality: language that invites recitation, brevity, deviation from conventional language, musicality, self-referentiality and self-reflexivity, a seemingly unmediated consciousness, a focus on individual (emotional) perception of the agent, a minimum (or lack) of narrative progression and de-referentiality (2005: 38–9). In this description, we recognise Stassaert's ungrammatical constructions and metaphorical language (deviation from conventional language) and her attention to rhythm (musicality). According to Hugo Neefs, 'the stories [in *Verhalen*] are lyrics': every story is 'one internal monologue', they focus on 'the consciousness of the characters' and there is a lack of 'epic powerful impulses' (1965: 76). Here, Neefs indicates another aspect that signals lyricality in Stassaert's stories: the text suggests that we have direct access to the thoughts of a first person narrator, a seemingly unmediated consciousness.[8]

Since the early nineteenth century, narrativity has been codified as the default mode for prose, while poetry is conventionally lyrical (McHale 2009: 14). This does not, though, mean that texts of a certain genre are limited to one mode. Brian McHale shows that texts create meaning through the interaction of different modes: in texts from a certain genre, the dominant mode interacts with additional, secondary modes (2009). In prose texts, the dominant narrative mode is combined with other modes which are realised to a greater or lesser degree. For example, prose texts regularly focus on the individual perception of the speaker, which is considered a lyrical element. The dominance of narrativity is challenged when the lyrical mode is intensified, a process termed lyricisation (Bernaerts 2013). The lyricisation of prose can thus be defined as the intensification of a secondary mode. In order to understand the lyricisation in *Verhalen*, we must examine Stassaert's prose experiment in relation to *Labris*.

LABRIS: ENIGMATIC AND REVEALING

The subtitle of *Labris*, 'Literaris tijdschrift der 60ers' ('Literary periodical of the 60ers'), indicates the editors' progressive and avant-garde attitude (De Geest 2018: 86). It also refers to the periodical's antagonistic attitude towards their experimental predecessors. Still, *Labris* does not distance itself completely from the so-called Vijftigers (Fiftiers) and Vijfenvijftigers (Fifty-Fivers): these

experimental groups all defend the autonomy of art (Buelens 2008: 904). Nevertheless, *Labris* interprets this autonomy in a unique way:

This autonomy is only indirectly concerned with the pursuit of nothingness [. . .] but [it is concerned] with the arbitrary creation 'out of' an emptiness of a language reality that is always cryptic and thus only takes on an individual, separate form for a few. (Neefs 1962: 2)

Labris's autonomy has an esoteric quality. Co-founder and editor Neefs proposes different means to achieve this autonomy: 'multiple rhythm, intersecting associative relationships, typography, encapsulation of a word in etymological ambiguity, abstraction of the image, demonization of classical themes' (1962: 1). We recognise these procedures in Stassaert's prose: ungrammatical constructions, accumulations of metaphors, rhythmic patterns and associative language that suggests an unmediated consciousness. As previously argued, these characteristics signal lyricality.

According to Walravens, these lyrical elements show 'the fantastic course of subconscious thought' in *Verhalen* (1965). He points out the 'versatility suggested in the metaphors' and the 'sentences which deviate from the laws of syntax and which burst open freely according to the demands of her unconscious' (1965: n.p.). Stassaert's experiment is not guided merely by leaps of thought, but also by auditory impulses. In an interview with Willem M. Roggeman, Stassaert compares her writing to composing music:

The texts from *Verhalen* [. . .] are all typed directly and therefore have a lot to do with rhythm. At the time I wrote with my hearing and I believe [. . .] that it was chords, series of word chords that determined the structure and that had their own law. That law was thus based on hearing. (in Roggeman 1975: 285)

This description points to two aspects of *Verhalen*. First, Stassaert draws attention to the musicality of the texts (see above). Second, this description emphasises the calculated aspect of Stassaert's prose experiment. The associations may seem coincidental, but the text is highly structured. After all, the 'hearing' that guides Stassaert's writing is not untrained (see above).

In addition to these 'chords', Neefs (1965) recognises another structuring principle: a predetermined 'mood' or vision. Stassaert would express that mood in 'one inner monologue' that differs from 'the now almost classical one, which was conceived as a stream of consciousness' (Neefs 1965: 76). Neefs refers to high modernism and offers the passage of Molly Bloom from

James Joyce's *Ulysses* (1922) as an example. In contrast to modernist authors, Stassaert does not make associative word links, but expands 'a mood, [. . .] a position that is taken *a priori* by the writer' (Neefs 1965: 76). The associative language in *Verhalen* is therefore not the representation of personal thoughts as they spontaneously occur in the speaker's mind, but the 'poetic' exploration of a vision that the writer has adopted with 'intellectual sharpness' (Neefs 1965: 76). *Verhalen* is, in that regard, at 'the intersection of astute calculation and impulse' (Neefs 1965: 76).

This intersection casts a new light on Stassaert's relation to *Labris*. Stassaert writes: 'the Word prevailed in all its hermetic individuality [in *Labris*], a school that helped me to write poetic prose, [but] this was just the beginning of an adventure I wanted to pursue alone' (2017: 58). As the 1960s progressed, Stassaert increasingly distanced herself from *Labris*, which wanted to purify language at the expense of writers' individual vision. Writers' creative freedom was further restricted by the magazine's strict publishing policy: editors imposed style requirements and even prohibited writers from publishing in other periodicals (Jespers 1999: 4). To Stassaert, this sectarian atmosphere felt like 'yet another prison' (Van der Straeten and Van Imschoot 2017: 52).

We could argue that Stassaert's ambiguous attitude towards *Labris* is essential to her image as a neo-avant-garde author (the third factor). Stassaert cultivated an image as an outsider to emphasise her independence from every social or literary order. This cultivation of originality is a key part of avant-garde discourse. In *The Originality of the Avant-Garde and Other Modernist Myths* (1985), Rosalind E. Krauss discusses the claim of originality. The avant-garde originality is not just an independence from tradition, past or institution, but a 'beginning from ground zero, a birth' (Krauss 1985: 157). This origin is an untouched condition, comparable with childhood before socialisation, often represented by the 'self':

> The self as origin is safe from contamination by tradition because it possesses a kind of originary naiveté [. . .]. The self as origin has the potential for continual acts of regeneration, a perpetuation of self-birth [. . .]. The self as origin is the way an absolute distinction can be made between a present experienced de novo and a tradition-laden past. The claims of the avant-garde are precisely these claims to originality. (Krauss 1985: 157)

The avant-garde origin is not an absolute 'new form', but a domain in which one can constantly start over. Seeing that 'De jonkvrouw' has a circular composition and seeing that the character-narrator ceaselessly transforms through her efforts to find herself (see above), the text can be interpreted as a formal realisation of the avant-garde origin (the second factor).

While Stassaert turned away from *Labris*, the *Labris* programme itself also claimed originality: it prescribed strict rules precisely to free language and start anew. As mentioned before, this purification resulted in autonomous texts. Retrospectively, Neefs recognised two factions in *Labris*, depending on the interpretation of 'the autonomy of art'. The first faction was the objectivity-lyrical ('objectiviteitslyriek') (Neefs 1964: 47–9). Objectivity-lyricists regarded texts as autonomous worlds-in-words, in which words lose their fixed meaning (and social message) and appear as empty forms that are multi-interpretable. The second faction was the subjectivity-lyrical ('subjectiviteitslyriek') (Neefs 1964: 41–3). Subjectivity-lyricists considered texts as autonomous worlds-in-words, but they were not empty forms. In contrast to ordinary language users, subjec-tivity-lyricists did not try to fixate the ('true') meaning of these words. Instead, they followed a-logical impulses (like the subconscious, chance or sound) to explore the wealth of meanings that words can activate. Subjectivity-lyrical texts thus reveal authentic experience. Still, these authentic truths seem foreign as social conventions conceal certain insights that would threaten the existing order. Artists who propagate these truths are not just outsiders, but outcasts. Here, the avant-garde artist resembles the *poète maudit*. Neefs calls them 'inge-nuity artists who give a hallucinatory, outer secret testimony to an anti-poetic, whose sources are: the incredible, the opposite, the ambiguous, the metaphor, the sophism, the allusion' (1962: 4). We must interpret the lyricisation of Stas-saert's prose and her image as a wayward writer against this background.

There are several ingenuity artists who inspire subjectivity-lyricists. The first are surrealists, more specifically 'revolutionary surrealists' such as Benja-min Péret (Bierkens 1972). Surrealism as a revolutionary movement was the result of a conflict between the mind and society: because surrealists felt that their individual creative freedom was threatened by social structures, they created a new world from 'their inner reality' (Decrem 1987: 88). These creations seemed subjective at first, but they expressed universal experiences that were suppressed by a progress-driven society. Paul de Vree emphasised this anarchism. He described *Labris* literature as 'a poetic ritual, characterised by an exploding surrealism and a mental anarchism in the tradition of Antonin Artaud' (De Vree 1976). As a notorious opium user and social outcast, Artaud was the epitome of the *poète maudit*. Like surrealists, Stassaert valued the unex-pected and the subconscious. Accordingly, her associative language demon-strated technical similarities with *écriture automatique* (Jespers 1999; Roggeman 1975). Still, Stassaert claimed that surrealist chance did not structure her texts: 'for me, it was rather an expressionistic feeling that took shape through word combinations and associations' (in Roggeman 1975: 285). As mentioned above, these associations are not arbitrary, but calculated.

The American beat writers are another group of ingenuity artists who influenced subjectivity-lyricists. Jack Kerouac in particular, whose 'drug use [. . .] was not just a gimmick', was revered as a guru (Buelens 2008: 902). Kerouac's associative prose influenced Jef Bierkens alias Max Kazan. He became Kerouac's champion in Flanders (and in Europe) as he published the first ever Kerouac study in a stencilled *Labris* edition (1965). Along with Kazan, Stassaert wrote the experimental epistolary novel *Bongobloesembloed* ('Bongo blossom blood') (1966). These texts both show the ingenuity artists' spontaneity, but critics noticed two important differences between the co-authors. First, Stassaert's spontaneity is calculated, while Kazan's spontaneity resembles jazz improvisations and Kerouac's bebop-like prose (De Geest 2018). Second, her texts have autobiographical details and clearly identifiable themes (Jespers 1999: 21). Here, we recognise the influence of another ingenuity artist, Anaïs Nin. Her relationship with Artaud would become the inspiration for Stassaert's novel *Parfait amour* (1979),[9] but her typical 'self-righteous tone and artificial spontaneity' already left their mark on Stassaert's sixties prose (Stassaert 2014: 44).[10]

In *Souvenirs*, Stassaert describes Nin as 'a mythomaniac for whom building her own myth was the basis of both her stories and diary entries' (2014: 44). This description, in Stassaert's own autobiographical notes, could equally be used to describe Stassaert's own prose. The myths that Stassaert and Nin create are concerned with beauty and the father figure. While Nin is inspired by her father's obsession with her (fading) beauty, Stassaert's writing is driven by an urge to prove her artistic worth to her father who was disappointed when his daughter traded the piano for the typewriter and the canvas. Another similarity between Stassaert and Nin is the erotic theme that predominates their prose. In describing Nin's appreciation of beauty as a means for purification, Stassaert provides an apt description of her own prose:

> That urge to make everything more beautiful and of a flammable purity can be recognized in [Nin's] writing; the erotic theme of her stories is permeated by it. Her diary largely serves as the basis of her texts that [. . .] [move] on that boundary – from reality to a sophisticated dream and from factuality to fantasy. (Stassaert 2019: 46)

Stassaert's *Verhalen* is situated on the same boundary. They are meta-literary reflections on the interaction between the text and reality (Jespers 1999). In *Souvenirs*, Stassaert explains that writing is a 'paradoxical task [. . .] of giving [to] and taking [from reality]' (Stassaert 2017: 184). On the one hand, literature is an escape from reality that it embellishes with sound and image. On the other hand, it is a way to encounter a reality that would be too difficult to confront without literature as an intermediary.

In Stassaert's 'multiple intervention on reality', critics discern 'echoes from a distant, mythical past' which they interpret as 'trans-individual' truths (Jespers 1999: 17). Here, we recognise the ambitions of *Labris*'s ingenuity artist, who wrote esoteric texts in order to reveal universal truths. For Stassaert, these unveiling ambitions were *also* personal: 'poetry [or lyricality] as a smokescreen for an unwanted reality – this is how I would phrase today that very first attempt to come to terms with myself [in *Verhalen*]' (2017: 37). Here, Stassaert ascribes a therapeutic function to her prose experiment. To understand the intersection of the autonomous text, universal truths and the writer's individual reality, I analyse the title story of Stassaert's story collection.

'DE JONKVROUW MET DE SPADE'

In 'De jonkvrouw' metaphors and syntactic figures of speech compare writing to the search for an authentic self. This metaphorical and ungrammatical language can be associated with the lyrical mode that challenges the conventional narrativity of prose (see above). The metaphor of 'digging', which symbolises both writing and reminiscing, is the central metaphor in 'De jonkvrouw' (Jespers 1999: 17). The speaker portrays this digging as a paradoxical process:

> I [. . .] Jonkvrouw met de spade, dig up songs in the clammy cramp soil where I hang nauseous impulses smelling of faith and time reversible phenomenon again [. . .] and is it then that smoke this effaced embalmed life rising like the scent of sick angels? (12)

Digging, or metaphorically capturing memories on paper, cannot entirely preserve the event: even though the event is embalmed, it has also faded. In Dutch, 'effaced embalmed' is a paronomasia: 'uitgewasemd ingebalsemd'. This figure of speech combines words with similar sounds but a different meaning. Here, it simultaneously emphasises the fleetingness and tangibility of memory. What is preserved is no longer viable.

Still, the speaker continues to dig. The impulses in the phrase 'where I hang nauseous impulses smelling of faith' can be interpreted as the urge to write; the faith refers to the belief that memories can be preserved. The smell of faith that those impulses exude, however, is toxic: the speaker wants to believe that time is reversible, but the thought makes her nauseous. Nevertheless, she keeps the faith: as she keeps digging, she hangs up rapidly evaporating memories before she hangs herself.

Why then does she keep digging? It is the only way to confront aspects of the self that haunt her: 'in this standstill life I hear the draw-wells sing I hear the waterputstem I feel everything festering grow-greying all movements like

wounded spiders crawling on becoming after-nights' (13). The standstill life is not a static state, but a space filled with motions. These stirrings come from the speaker's own decomposing body:

> in this standstill life I hear the draw-wells sing I hear the waterputstem I feel everything festering grow-greying all movements [. . .]
> the bears of my skin have been tamed now that the sea is choking on the sand and the centuries yawn in my ash flesh smouldering olympos
> I see the days spin thin feasts hung unbalanced in the drought in the slow seed-summers close autumns ghosts [creeping] I have become a hearing in a well between Genua-yesterday and Mexico-today a second I in a slower time. (13)

The dissolution of the speaker's body comes with the birth of a 'second I'. The speaker appeals to all her senses ('I hear', 'I feel', 'I see') only to sacrifice her body: at the end, she is no longer a receptive body, but (auditory) reception itself. The second self, however, is not automatically amorphous. The phrase 'ash flesh smouldering olympos' links the smouldering flesh with the mythical phoenix and with the eternal flames in the Greek village of Olympus. In that village there is a rock from which flammable gasses escape and catch fire. According to local folktales, those flames come from the Chimera, a mythical creature that has body parts of various animals, (sometimes) including humans. Against this background, the writer, who stands still and sacrifices her body, receives a new, hybrid body.

Here, we recognise the origin of the neo-avant-garde as a space for constant renewal. 'De jonkvrouw' presents two such origins. The first is the 'self' or the decomposing body from which a new ego arises. The speaker purges the body to the extent that it disappears. Purification and destruction go hand in hand. This constant rebirth can only take place in a 'standstill life', or the second origin: the autonomous text as a closed-off space.

In addition to metaphors, musical patterns in 'De jonkvrouw' free words from their everyday meaning. This musicality is part of the lyrical mode, which is reinforced in 'De jonkvrouw' and challenges narrativity (see above). In Stassaert's text, different voices evoke different rhythms. In 'De putten' a lack of capital letters gives the text an easy flow, which is supported by the repetition of words or phrases: 'sand falls back, falls back' (9), 'guilt. guilt. guilt.' (9), 'love love love' (10), 'mono mono monotoon' (11). While there are no capitals at the beginning of sentences, some words are entirely capitalised: 'SNAP' (10), 'TEMPORARY STOP' (10), 'SING' (11). Both the repetitions and the intrusive capitalised words are marked text places. The steady cadence with

salient parts might refer to time as an unyielding process that is both ungrasp-able and undeniable.

When the speaker of 'Monologen' 'leave[s her] wild self / the mummycat', the rhythm changes (12–13). It is frequently interrupted by line breaks. This interruption can refer to the idea that time can be divided into meaningful parts like days or hours (see above). Still, the speaker is aware of the moments in-between: 'I respect the silence between the acts' (13). This awareness is reflected on a formal level: the breaks suggest that meaningful units should be demarcated by silence, but this silence is poignant. Indeed, breaks or white space are characteristic of poetry, but the paratext of 'De jonkvrouw' (one of the stories in a story collection) presents the text as prose. Furthermore, the text exists primarily of prose segments like sections and paragraphs. In prose, line breaks are uncommon and thus attract attention. The white spaces are for-mally deviant and heavy instead of empty. On a semantic level, they are filled with 'dissonance' (13).

Waterputstem also speaks in a jerking rhythm that relies on line breaks. In the demarcated units of her monologue, the repetition of sounds is often accompa-nied by semantic shifts. The polyptoton 'blossoms echo [. . .] the echoes of my hate', for example, evokes both a continuous rhythm (as sounds are repeated) but also a shift in meaning: the first echo is a verb, the second is a noun (14).[11] Here, the rhythm refers to Waterputstem's experience of life at a standstill as a place that is filled with chaotic movements. Here, all units are unstable.

Different voices create different cadences. Seeing that all the voices in 'De jonkvrouw' are (thematically) one speaker, the text is a polyphonic monologue. This richness is associated to the multi-interpretable experiments of *Labris*. It can also be associated with Stassaert's personal struggle to confront different parts of herself. The lyrical quality of Stassaert's text thus reveals an authentic, though inconvenient experience: the self is not a stable subject, but a divided one. Stassaert is able to confront these different selves only through literature.

CONCLUSION

The neo-avant-garde status of Stassaert's *Verhalen van de jonkvrouw met de spade* relies on several factors. With regards to reception, her prose is connected to the neo-avant-garde periodical *Labris*, more specifically to its subjectivity-lyrical faction, and to the prose experiments that took place in Flanders during the 1960s when authors of experimental prose challenged literary conventions. Within that context, Stassaert can be framed as an artist on the margins of the literary field, questioning mainstream literature. Specifically, her work chal-lenges the dominance of narrativity in prose. Stassaert cultivated this anarchist

position by first associating with and then subsequently distancing herself from *Labris*, surrealism and the American beat generation.

While the paratext of *Verhalen* evokes expectations of narrativity, Stassaert's lyrical prose challenges a clear narrative progression. The intensification of the lyrical mode is realised in strong metaphorical language and musical patterns. This lyricisation of prose is a neo-avant-garde technique that – in Stassaert's text – gives the impression of spontaneity. Still, the associative language in *Verhalen* is the calculated and 'poetic' exploration of a vision. In 'De jonkvrouw met de spade', this vision concerns the authentic experience of the self that constantly transforms and contains several voices. 'De jonkvrouw' thus propagates a vision that threatens existing ideas of stability and progress.

On a poetic level, Stassaert's texts revolt against literary and social conventions. The texts in *Verhalen* are autonomous worlds within worlds in which language is freed from conventions. To Stassaert, this purging process has a therapeutic function. Both writing and memory are compared to digging, which both destroys and rejuvenates the subject. The speaker's body and her text are neo-avant-garde origins where destructions and rebirth go hand in hand.

NOTES

1. All translations in this chapter are mine. These translations concern both the primary text (Stassaert 1964) and secondary texts of Dutch criticism (Decrem 1987; Jespers 1999; Neefs 1962, 1964, 1965; Roggeman 1975; Stassaert 2014, 2017, 2019; Van der Straeten and Van Imschoot 2017; Walravens 1965).
2. I refer to the narrator with the pronouns 'she' and 'her', since Stassaert, who identifies with those pronouns, presents the speaker in 'De jonkvrouw' as her alter ego (2014: 15).
3. Changes in the text mainly relate to the lay-out or titles (Janssens 2020).
4. In 1962, Stassaert included several of her own abstract paintings and drawings in the first group exhibition of Onderaards, an avant-garde collective of Serge Largot (Jespers 1999: 76).
5. Like statements in interviews, the poetical reflections in *Souvenirs* are constructions that should not simply be projected onto the text. They do, however, guide interpretation. Moreover, we can consider *Souvenirs* as a retrospective programmatic text. Stassaert presents *Souvenirs* as an 'epilogue to *Verhalen van de jonkvrouw met de spade*, fifty years later' (2017: 95).
6. Time is not a collocutor, but the object of discussion. We could also interpret the title as an indicator of the setting: the monologues take place

in transit spaces: between recognisable segments of time like hours, days, weeks (see below).

7. To stay as close to the text as possible, I use the Dutch names of the character-narrators. While these names are not capitalised in the text, I write them with capital letters to avoid confusion.

8. Consciousness is never truely unmediated, as mediation is inevitable in literary texts. When the boundary between the mediating and the mediated agent blurs or the directness of consciousness-presentation increases, we speak of a *seemingly* unmediated agent (Janssens 2020).

9. American beat writer Henry Miller is another ingenuity artist who was also Nin's lover. Nin captured their relationship in her *Journal of Love* (1931–2).

10. While the published diary covers the life of Nin from 1931 to 1974, her texts remained relatively unknown until the 1940s. Until then, she struggled to find a publisher for her explicit texts and her flamboyant literary style (Stassaert 2017: 46–7). From 1966 onwards, Nin's diaries were published by Harcourt Brace Jovanovich and Swallow Press. It was 'an extraordinary success. She [. . .] is considered the diva of the Women's Movement' (Stassaert 2017: 47).

11. In Dutch, there is no polyptoton, but antanaclasis: 'bloesems galmen [. . .] de galmen van mijn haat' (14).

BIBLIOGRAPHY

Bernaerts, L. (2013), 'De hausse van het experiment. Lyricisering in de jaren zestig', *Belgisch Tijdschrift voor Filologie en Geschiedenis*, 91 (3), pp. 605–27.

Bierkens, J. (1972), 'Benjamin Péret', *Labris*, 9 (3), pp. 17–33.

Brems, H. (2016), *Altijd weer vogels die nesten beginnen. Geschiedenis van de Nederlandse literatuur 1945–2005*, Amsterdam: Bert Bakker.

Buelens, G. (2008), *Van Ostaijen tot heden. Zijn invloed op de Vlaamse poëzie*, Nijmegen: Vantilt.

Decrem, H. (1987), *Het literair tijdschrift 'Labris' 1962–1973: een verkenning van het labrislabyrint. Een onderzoek naar de literatuuropvatting van het tijdschrift*, licentiate dissertation, KU Leuven.

De Geest, D. (2018), 'Labris, sant in buitenland', *Zuurvrij*, 35, pp. 85–95.

De Taeye, L. (2018), *Tegen het verzinnen. Documentair proza in de Nederlandstalige literatuur van de lange jaren zestig*, doctoral dissertation, Vrije Universiteit Brussel.

De Vree, P. (1976), 'Lucienne Stassaert of de weg terug', *De Periscoop*, 26.

Janssens, N. (2020), *Schreeuwend, zwijgend, zingend, tastend. Lyricisering van Nederlandstalig proza in de lange jaren zestig (1960–1975)*, dissertation, Ghent University.

Jespers, H.-F. (1999), 'Lucienne Stassaerts orakeltaal van De Verhalen van de Jonkvrouw met de Spade tot Bongobloesembloed', *Centrum voor Documentatie en Reëvaluatie. Cahier nr. 1*, Antwerp: Jef Meert.

Kazan, M. and L. Stassaert (1966), *Bongobloesembloed*, Bruges: Sonneville.

Krauss, R. E. (1985), *The Originality of the Avant-Garde and Other Modernist Myths*, Cambridge, MA: MIT Press.

McHale, B. (2009), 'Beginning to Think About Narrative in Poetry', *Narrative*, 17 (1), pp. 11–27.

Meizoz, J. (2007), *Posture littéraire. Mises en scène modernes de l'auteur*, Geneva: Slatkine Érudition.

Neefs, H. (1962), 'Akkomodatie als inleiding', *Labris*, 1 (1), pp. 3–4.

Neefs, H. (1964), 'Narcissisme of incest', *Labris*, 3 (1), pp. 39–50.

Neefs, H. (1965), 'Notisie 21: ruimtezweren als dagelijks onweder', *Labris*, 3 (3), pp. 73–6.

Roggeman, W. M. (1975), 'Lucienne Stassaert', in W. M. Roggeman, *Beroepsgeheimen 1. Gesprekken met schrijvers*, The Hague/Rotterdam: Nijgh & Van Ditmar, vol. 1, pp. 277–303.

Stassaert, L. (1963a), 'De putten', *Labris*, 1 (4), pp. 43–5.

Stassaert, L. (1963b), 'De putten', *Nul*, 2 (7), pp. 15–19.

Stassaert, L. (1964), *Verhalen van de jonkvrouw met de spade*, Antwerp: self-published.

Stassaert, L. (2014), *Souvenirs: Aantekeningen in de loop van de tijd*, Leuven: P.

Stassaert, L. (2017), *Souvenirs II*, Leuven: P.

Stassaert, L. (2019), *Souvenirs III*, Leuven: P.

Van der Straeten, B. and T. Van Imschoot (2017), 'Een toerist in het experimentele. Een gesprek met Lucienne Stassaert', in L. Bernaerts, B. Van der Straeten, H. Vandevoorde and T. Van Imschoot (eds), *Legendes van de literatuur. Schrijvers en het artistieke experiment in de jaren zestig*, Ghent: Academia Press, pp. 51–8.

Vervaeck, B. (2014), 'Genre in verandering. Vernieuwingen in de naoorlogse Nederlandstalige roman', *Spiegel der Letteren*, 56 (1), pp. 51–83.

Vitse, S. (2013), '"Klankmuziek – poëzie plus anti-poëzie ineen". Lyricisering in de jaren zeventig', *Belgisch Tijdschrift voor Filologie en Geschiedenis*, 91 (3), pp. 629–53.

Walravens, J. (1965), 'De vrouw met de spade', *Het Laatste Nieuws*, n.p.

Wesselo, J. J. (1983), *Vlaamse wegen. Het vernieuwende proza in Vlaanderen tussen 1960 en 1980*, Antwerp: Manteau.

Wolf, W. (2005), 'The Lyric: Problems of Definition and a Proposal for Reconceptualisation', in E. Müller-Zettelman and M. Rubik (eds), *Theory into Poetry: New Approaches to the Lyric*, Amsterdam: Rodopi, pp. 21–56.

Sound Poetry in France: A Neo-Avant-Garde?

Gaëlle Théval

Sound, phonic, phonetic, action, direct, spatialist, objective, but also *crirythmes*, audiopoems, verbophony, score-poems . . . the multitude of attributive adjectives and names used to describe nascent poetic practices in the decade spanning 1955 to 1965 creates a paradoxical effect: if the recurrence of the same names, mingling within journals and festivals, can give the impression of some form of unity, this diversity contributes to giving the field an image that is heterogeneous, fragmented, and difficult to grasp and identify. In this way, it only seems to be imperfectly compatible with what we usually refer to using the term 'avant-garde', in particular with its inherent group logic: here, it no longer seems to be a question of an 'explicit and collective project, implying both an aesthetic and a comprehensive anthropological project of making art out of life' (Tomiche 2005: n.p.).[1]

Historically, these practices are contemporary with the 'neo–avant-garde' movements that were then nascent in Europe and North America, which Hal Foster broadly defines as 'art since 1960 that refashions avant-garde devices' (1996: 8). In gestation since the mid–1950s, sound poetry seems, in the first place, to have in common with these movements a relation to the historical avant-gardes that outlines their specificity. To what extent can one, in turn, describe these practices as falling into the category of 'neo–avant-garde'? If the historical consciousness of actors as belonging or not belonging to an 'avant-garde' is questioned in the first place, then it is also a question of measuring the analytical pertinence of the term. The very expression 'neo–avant-garde' does not come into being through the writing of involved players. Nevertheless, it is indeed the operation analysed by Foster that many theoretical texts and manifestos seem to be describing and laying claim to, either at the time or retrospectively.

The assessment drawn up by Bernard Heidsieck – one of the first creators of sound poetry along with Henri Chopin – in 1980 for a conference at Cerisy

devoted to avant-gardes is, in this regard, particularly telling and will act as our guiding thread. The inventor of 'score-poems' begins by asking the question of whether sound poetry can be understood as an avant-garde movement, defining several of this latter term's traits: 'its sense of searching and its innovative will', 'the dynamism of an adventurous, provocative, searching mind', 'the spirit of a "group," of a "movement"', but also a historical dynamic making it so that 'only the distance of time can sanction this term' (Heidsieck 2001b: 184). What follows is an examination of the common points, differences and relations of sound poetry to other historical avant-garde genres, particularly to Dada and to lettrism, from which a posture emerges that, as we will consider, may or may not have already been applicable at the time. If an attempt at forming a group did take place under the aegis of Pierre Garnier, then his very failure marks a mutation that also emerges in lessons drawn from historical avant-gardes, which are indeed set up both as counter-models (lettrism, surrealism) and as a recognised legacy (Dada). Nevertheless, far from being a simple formal remake emptied of all political stakes – which Peter Bürger specifically reproaches the neo-avant-gardes for – the way in which sound poetry joins up with historical avant-gardes without replaying them falls within what Foster analyses as an institutional critique, here taking up the characteristics of an approach that will be qualified as mediological.

AN AVANT-GARDE?

Sound poetry, as it is invented in France over the course of the 1950s through the initiative of Henri Chopin, Pierre Garnier and Bernard Heidsieck, has a number of points in common with the historical avant-gardes: the use of experimental techniques, the claim to a dominant aesthetic rupture, internationalism, the abolition of borders between different artistic forms. These go hand in hand with theoretical claims 'that are expressed through a wide variety of media, already used by their predecessors, ranging from the manifesto to periodicals' (James 2012: 198). Two periodicals serve as sites of exchange and experimentation in sound poetry. They are *Cinquième saison*, directed by Chopin, which, starting in 1964, becomes *OU-Cinquième saison* and before long includes a disk (see Théval 2014), along with the journal *Les Lettres*, directed by Garnier, beginning in 1963. Examining their contents allows for a retracing of the make-up and evolution of this neo-avant-garde movement.

The distinctive inter-articity of avant-garde movements is found on several levels in experimental poetry. From the very first issues of *Cinquième saison* that were directed by Chopin, its programme is explicit: the journal 'must be a site for encounters untroubled by race and borders'.[2] Indeed, the journal is

marked by a strong interdisciplinarity that makes artists, painters, poets, and even to a certain extent musicians cross paths within its pages. The journal first welcomes visual artists in 1961 as part of a section entitled 'poetic studies' in which a work – often an abstract one – is placed opposite its poetic commentary. Attempts at 'objective poetry' offered by Chopin put painters, sculptors and poets into contact, the former providing a visual artistic interpretation for the latter's poems. Thereafter, *OU-Cinquième saison*, as it grows in size, hosts original works by artists such as Paul-Armand Gette, Jean Degottex, Jean Dupuy or even Françoise Janicot. Driven by this interdisciplinarity, the journal puts these artistic interventions into dialogue with a poetry that is itself marked by intermediality. Chopin's typewriter poems (*dactylopoèmes*), created using a typewriter, stand alongside Julien Blaine's first 'elementary poetry' compositions (issues 28–29, 1966), Pierre and Ilse Garnier's spatialist poems (issues 26–27), Claude Pélieu's collages, or even Ian Hamilton Finlay and John Furnival's concrete poems (issue 22), Alain Arias-Misson's 'public poems' and Adriano Spatola's visual poems (issues 28–29). Starting in 1964, the journal mainly becomes a means of distributing sound poetry, publishing a 25 cm disk in most of its issues. Henri Chopin reveals this new direction in the journal's last entirely paper issue: 'We have to publish disks in order to illustrate the published works, score poems, phonetic poetry, etc. We must report on the live qualities of these artists' work, and this would be possible if we could publish what took place' (Chopin 1963a: 1).

The key names that made the history of sound poetry are gathered here: Heidsieck and his 'score-poems', François Dufrêne and his *crirythmes*, Mimmo Rotella, Chopin's 'audiopoems', the ultra-lettrist Gil J. Wolman, Paul de Vree's and Arthur Pétronio's manifestos and Michel Seuphor's texts, among others. The reception given to music is otherwise circumspect and is concerned with the polemical mode of a poetry that is looking for its own marks and specificities. The 1967 'Lettre ouverte aux musiciens aphones' ('Open letter to aphonic musicians') is thus an all-out attack on concrete musicians, first and foremost Pierre Henry, who is accused of using the resources of sound poetry without citing his sources. In the letter, Chopin imposes the independence of sound poetry in relation to music: 'To conclude, the publication of my journal confirms it, we do not need musicians, it is often the other way around' (1967–8: 35). Indeed, few musicians appear in the journal's contents. Other poets acknowledge their importance in its genesis. Heidsieck (1998) thus frequently recalled what, for him, was the foundational moment of attending the Domaine Musical near the end of the fifties, where he discovered the then nascent genre of electro-acoustic music. It was in particular his listening to Stockhausen's *Gesang der Junglinge* that led him to discover the electronic

possibilities connected to the spatialisation of sound and of the voice, just at the moment when he was publishing his latest collection of written poetry, *Sitôt dit* (1955): 'poetry, as I conceived of it, as I dreamed of it, suddenly found an expanded operational technique, in this approach was the possibility of acquiring some physical presence that I sought in poetry' (Heidsieck 1998). Visual arts are also determinant in the genesis of Heidsieck's sound poetry. The first manifesto and one of his first sound poems are based on paintings: 'Pour un poème debout . . .' ('For a poem on its feet') originally introduces the poem 'D3Z', dedicated to Jean Degottex's paintings,[3] which he claims to transpose into sound. It is by way of painting that the poet comes back to his own poetic practice, in order to define the directions that it is taking. Accordingly, Heidsieck does not depart from an avant-gardist tradition, and indicates a convergence of tendencies. This intention is made explicit in a letter to the director of the Galerie Kleber where Degottex was exhibited:

> The current 'tendency' demands an identical form of tension, regardless of the chosen form of art or poetry. [. . .] Be that as it may, the notion of aggressiveness will be able to be considered as one of the very first possible common denominators. (Heidsieck 2009: 271–2)

It is this very 'tendency' that Garnier is referring to when he presents his 'mechanical poems', made using a typewriter, as 'action writing' (1968: 100) – related to Jackson Pollock's 'action painting' as well as to the works of kinetic art, which he publishes examples of in *Les Lettres*, while still challenging the idea that visual poetry would be a 'mix' of poetry and painting. Finally, the gesture of cutting out sounds that is performed in many sound poems, according to the 'biopsy' model,[4] calls to mind the reactivation of the readymade by painters within the new realist movement founded by Pierre Restany; and if Heidsieck is not a part of this group, he spends time with some of its actors such as Dufrêne, who is the inventor of *crirythmes*, Raymond Hains, Jacques Villeglé or Niki de Saint Phalle. Moreover, Heidsieck's first disk is published in an issue of the journal *KWY* (1963) devoted to the new realists.

Common tendencies, convergences and collaborations seem to set the tone for the emergence of an avant-garde, and the journals cited here are also the publication site of manifestos whose discursive strategies fall in line with the 'avant-gardist gesture *par excellence*, connected to the founding of a movement, fitting in with a collective' (Margel 2013: 5). Heidsieck's manifesto, 'Pour un poème debout . . .' is released in *Cinquième saison* in 1962. If Chopin does not call his programmatic texts 'manifestos' for reasons that we will come back to, their tonality as well as their claim to rupture can confirm their belonging

to this discursive genre. In this way, in 'Pourquoi la poésie dite "objective"?' ('Why "objective" poetry?') (1962b), the sound poet forecasts the death of 'poetry that we go on naming'. In his response to the 'Pilot Plan presented by Garnier to the presumed authors of the International Committee', published in *Les Lettres*, issue 31 (Garnier 1963c: 1), Chopin highlights the unprecedented nature of the sound experiments that were being led, as they relate to the use of new technologies, making use of a prophetic tone in order to announce a 'new age':

> Dear Pierre Garnier, I thought that your manifesto was incomplete. It comes in the aftermath of the poetic exhaustion of our time. But current art, 20th century art, is not an aftermath. It is the beginning of a new age. We are writing it. (Chopin 1963c: 5)

The shared assertion is that the poetic field is moribund in the 1950s. The last flames of surrealism, 'committed' or 'white' poetry, as well as outdated avant-gardism and the bad faith of lettrism, are dismissed one after another in a feeling of shared weariness: 'We are going nowhere. The mind is going around in circles. Poetry is going nowhere', proclaims Garnier (1963c: 1). The four manifestos published one after the other by Garnier in the journal *Les Lettres* between 1962 and 1964 claim to speak in the name of a movement that they are intending to found, while the evolution of the contents and the editorial line of the journal that Garnier directs starting with its thirty-second issue bear witness to his attempt at establishing one. The 'Manifesto for a New Visual and Phonic Poetry' is published in an issue entirely dedicated to the poet where, through the display of his personal research, he opens up, with the help of the journal, towards building relations with others. In this issue, Garnier sketches comparisons with works carried out by Chopin at that very moment in *Cinquième Saison*, related to 'objective poetry':

> Henri Chopin and the journal *Cinquième Saison*, following extensive research, are bringing phonetic poetry and objective poetry into being. Starting from the same refusal, but following different attempts and different research, I am putting forward visual poetry and phonic poetry. (Garnier 1963a: 1)

At the same time, Chopin publishes a poem by Garnier in issue 11 of *Cinquième Saison*, in 1961, then, in issue 18 in 1963, a 'Brief Manifesto for Visual Poetry', in which one of his notes refers to the 'Manifesto for a Visual and Phonic Poetry'. In the issues that follow, Garnier carries out the task of compiling manifestos

coming from other, more structured movements, especially the German and Brazilian concrete poetry movements, in the interests of internationalism, and also publishes theoretical texts. From issue 30 onward, the journal adopts a sub-title, 'New Poetry', and a 'Note on New Poetry' opens this issue by explaining:

> Practically everywhere in the world, equivalent attempts are made that will be the basis of a renewal of poetry. [. . .] Men are at work everywhere. Almost always alone, they give various names to their endeavors: concrete, phonetic, objective, visual, phonic poetry, etc. They will end up joining together because all of these attempts have only one goal: to release poetry from language and to turn it into an element. (Garnier 1963b: 14)

Once again citing collaborations between painters and musicians in Chopin's attempts at 'objective' poetry, the manifesto provides the movement, which is still being constituted, with a genealogy – 'These attempts have precursors: one can cite Morgenstern, Albert-Birot, Kurt Schwitters, Hugo Ball, Michel Seuphor, some expressionists, some surrealists, some lettrists' (Garnier 1963b: 14) – and offers a bibliography. The 'Second Manifesto for a Visual Poetry' attests once again to the research efforts in progress. This issue hosts a theoretical text by the German concrete poet Franz Mon, 'Articulations', as well as a projective text by Chopin, 'Poetic Mutations': 'In conclusion, objective poetry is the objectification of our languages in the unknown, which we render visual, and visible, phonetic poetry is the song of vision' (Chopin 1963b: 14).

The notion of 'Spatialism' emerges in the following issue. A 'Preliminary Note – Pilot Plan Founding Spatialism' is presented as a project to be amended by its potential signatories, and it announces the creation of an 'International Committee whose duty it will be to publish a liaison report, organize events, exhibitions and conferences'. The text presents itself as a proposal to fuse the varied tendencies that are represented by concrete, phonetic, objective, visual, phonic or cybernetic poetry into a shared movement with however many 'investigations into the meaning of a kind of poetry one might include in the general name Spatial (which includes notions of time, structure, energy)' (Garnier 1963c: 2). In addition each poet will go on to explain what they have in common (objectification of language, destruction of the idea of works in favour of the idea of 'transmitted energy', moving beyond national languages). The pilot plan is published again, along with a few modifications and most importantly co-signed,[5] in issue 32, with the title 'Position I of the Inter-national Movement', bearing an explicitly collective pronouncement, by all appearances enacting the birth of the 'Spatialism' movement. The journal's subtitle changes again, becoming 'New Poetry – Journal of Spatialism', which

points to the publication as the movement's publishing organ. At the same time, the claim to the relevance and vitality of the idea of the avant-garde is put forward in some texts published in *Cinquième saison*; as the Belgian Paul de Vree's remarks (1962) demonstrate, 'the avant-garde is a living concept':

> I name proof of failure to understand (among the traditionalists) and of defeatism (among the modernists), their manner of minimizing the avant-garde or of reducing it to the generation of the futurists and the dadaists' short period of rebellion. [. . .] It is false to purport that the future held all of the promises that they had made, and it is certainly even more false to purport, the results attained notwithstanding, that the avant-garde has nothing left to do other than to deliver itself the hara-kiri. [. . .] Based upon or aided by depth psychology [. . .] the idea of the avant-garde is in the rupture that we can observe concerning the 'repressive' rationalism that is still at work in our era [. . .] (De Vree 1962: 8)

However, this notion is the source of debates that will lead to the movement's failure.

'BEYOND DADAISMS, SURREALISMS, AND ALL OF THE OTHER ISMS' (CHOPIN 1993)

Most often the fruits of a collective utterance, a manifesto aims to 'bring into existence, as an entity, a group brought to life by shared convictions and the desire for action' and has 'as its effect, the structuring and affirming of an identity' (Abastado 1980: 7). Yet the domain of experimental poetry is precisely the scene of divergent strategies. In the same issue of the journal *Les Lettres*, the first instances of friction can be observed: mainly signed by visual and concrete poets, the manifesto is in fact not signed by the person who had nevertheless been presented as its first fellow traveller, Henri Chopin. He decides to offer a response in which he expresses his support for the group, but also his refusal to be affiliated with it, putting forward less a poetic divergence, which is nevertheless real,[6] than a refusal of the model of the 'movement' itself:

> The movement, which we are all 'members' of, does not exist *a priori*. I am not a member of a movement, but I am 'with' the movement. I am the movement. [. . .] what would I have to do with a movement, even if it was international! It is a good thing for a head of state who is speaking about the universal influence of a country . . . It is a good thing for all of the hollow dreamers who popularize a 'judgment' that some poet pronounced on some day. (Chopin 1964: 5–6)

The avant-gardist model is rejected by the poet, who further explains himself in several other published texts whose programmatic character is systematically accompanied by precautions regarding the 'freedom' of the journal's participants: '*Cinquième saison* is a research journal [. . .] our taste is for encountering works, and not a group of artists that might be submitted to any demands' (Chopin 1962a: 46). As Nicholas Zurbrugg (2002) highlights, 'far from attempting to establish a unidimensional "movement," Chopin wanted to promote a wide variety of poets', thus making each tendency in sound poetry heard; he notably defines these tendencies in 'Open letter to aphonic musicians'[7] then develops them in the survey *Poésie sonore internationale* ('International sound poetry') (1979). Avant-gardism, as it appears in the eyes of the actors of sound poetry is, at the time, the avant-gardism that surrealism and lettrism represent, whose polemical nature and hierarchical political organisation are deterring. The manifestos published by Heidsieck do not purport in this way to found a movement, a model that the sound poet rejects in turn. Explaining that he shares in the avant-garde's 'spirit of investigation and its will for innovation', he refuses its group mentality:

> The fact remains that the structure of the Group and its collective conduct, created and lived in an imitation of the disused – and as if it sought after its repetition – fire of surrealism – including its Pope and totalitarianism – abusive, repeated, gratuitous and laughable claims, and a rosary of outrageous insults, were enough to disarm the greatest wills. (Heidsieck 2001b: 191)

Following these reluctances Pierre Garnier has a social obligation to proceed with caution. In the volume *Spatialisme et poésie concrète* ('Spatialism and concrete poetry'), he combines the bio-bibliographic notes of authors 'taking part in research, in experiments, creating new poetry' with a warning: 'These details are fragmentary and are intended as a guide. They do not unite their authors' (Garnier 1968: 190). He recognises this in a later interview:

> It was a proposition to bring a reality together within a movement; I perhaps had a rather false idea of the movement at the time, because Dada had happened, surrealism had happened, expressionism had happened, futurism, and there was no reason that there was not a movement like this in the 60s. But it is possible that the era of movements had already passed and that, on this level, I was late, at least as far as denomination is concerned. (Garnier, in Donguy 1993: 395)

However, group logic is not the only element that distances Chopin from the avant-garde. The debate is indeed focused on a central question: legacy. In a

text entitled 'L'avant-garde?' ('The avant-garde?') published in 1971, Henri Chopin questions this notion, beginning by distancing himself from the very term: 'This term, avant-garde, I have always refused it. It is fine for the military, and it was a strange breed yesterday, definitely not living – I was familiar with it – today it is to be done away with. In short, I am not avant-garde' (1971: 19). In the continuation of his remarks, he maintains that, since Aristophanes can just as well be seated at its table as Charles Cros or Raoul Hausmann, 'the avant-garde does not exist' (1971: 19), and he opposes this notion with one of 'presence': 'one must not confuse presence and avant-garde, the former being self-evident, the latter mere labelling' (1971: 20). He reproaches the founder of lettrism, Isidore Isou, for having denied his legacy, showing himself, in this way, as 'avant-garde' but 'not present': 'If he had been present, he would have never wasted his time remaking what had already been done for 30 years, the vocal lettrism that Albert-Birot, Hausmann, Ball and Schwitters had already produced' (1971: 20). The sound poet thus associates the avant-garde not only with the idea of a group, which he places in opposition to freedom, but also with the 'ideology of progress' and the 'presumption of originality' (Foster 1996: 5), with the ideology of the *tabula rasa* and of leaving behind.

'AS ONE GREETS A VERY DEAR AND ADMIRED FAMILY MEMBER. WHERE ONE RECOGNIZES ONE'S BLOOD, WHERE ONE REDISCOVERS A KINSHIP OF CELLS' (HEIDSIECK 2001B: 187)

Unlike the lettrists who would have denied the debt they owed to Dadaist and futurist research, the sound poets, and in particular Henri Chopin, applied themselves to historicising:

> As for me, I am rather familiar with the precursors of sound poetry. There are plenty of them, and there, without a doubt, one finds Schwitters, Hausmann, and inevitably Pierre Albert-Birot, especially for his 'poems to shout and dance,' and even more so, for his plays 'La Légende' and 'Larountala.' One could also cite Morgenstern, Scheerbart, Anatol Stern, Seuphor, but they are less important than the preceding names.
>
> And furthermore, all of them occupy the place of a great premonition, with the exception of 'La Légende,' published in 1919, which is the height of phonetic poetry that went on to die with lettrism. (Chopin 1971: 25)

Sound poetry, as it is invented over the course of the 1950s, in this way maintains a relation with the historical avant-gardes that is described by Heidsieck

as a reunion: 'Sound poetry was derived neither from Futurism, nor from Dada. It did, however, and with delight, rediscover a complicity of thought, research and action there. As a consequence, it [. . .] accepted their avant-gardism' (2001b: 188). It was not derived from lettrism either, he goes on to say, despite the fact that François Dufrêne and Gil J. Wolman previously belonged to the movement. Indeed, in the middle of the 1950s, the reception of Dada is still relatively restricted. The dominant avant-garde at that time is surrealism, accused of having erased its Dadaist origins, and the first major retrospective of Dada in Paris takes place in 1957. George Hugnet's book *L'Aventure Dada* is published in 1957, Michel Sanouillet's *Dada à Paris* not until 1965. Apart from quarrels linked to lettrism surrounding the phonetic poem – which had already emerged in 1949 upon the publication of *Poésie des mots inconnus* by Iliazd, a book that itself had a very limited distribution[8] – information about the poetic activities of Dada and other historical avant-gardes such as futurism therefore remained initially very partial:

> in the 50s [. . .] all of this was practically inaccessible – we would not have even known about it at the time – and related to myths or strange nebulous premonitions. [. . .] Can we, in fact, pretend, without being ridiculous, that we were the first? [. . .] The beginning of the century was thus, for us, a rediscovery. (Heidsieck 2001b: 188)

This unawareness, if it refutes any possibility of real influence, does not preclude an a posteriori recognition, and the establishment of lines of descent, activating the phenomenon that Hal Foster describes with the help of the figure of the 'parallax' – a distinguishing feature of the neo-avant-garde: 'This figure underscores both that our framings of the past depend on our positions in the present and that these positions are defined through such framings' (1996: xii). Thus, it is through the prism of historical avant-gardes that the art historian perceives sound poetry, at the risk of seeing a regrowth someplace where there is no influence, but it is also through the prism of sound poetry that the latter considers the contribution of historical avant-gardes as 'precursors', passing on their avant-gardism, this time through the phenomenon of 'belatedness' (*Nachträglichkeit*): 'Are the post-war moments passive repetitions of the pre-war moments, or does the neo-avant-garde *act* on the historical avant-garde in ways that we can only now appreciate?' (Foster 1996: 4). Chopin is aware of this phenomenon, in 1961, when he writes in a 'General Note on Poetry Today, and on Verbophony' that one must wait roughly forty years in order for a work to be known by the public, and, projecting himself into the 1980s, includes his own research in a chronological span that erases points of rupture in order to affirm a continuity:

We will therefore know, in 1985, that oral, phonetic, tonal works and tri-als undertaken in the years 1915–1960 by Pierre Albert-Birot, Tzara, Arp, Seuphor, Pétronio, Russolo, F. Tristan, Y. Croutch, Murail, Chopin (even Altagor and the Lettrists too), and we are skipping over some names, not only existed, but also that, technically and through their works, they had found everything. (Chopin 1961: 21)

He goes on:

As for us, and in order to avoid being forgetful of what is active, at the risk of making a mistake, we prefer, in 1961, to assure that all of the previously cited authors have 'pre-established' laws of new composition through the formal (or constant) kinship of their works [. . .] (Chopin 1961: 21)

The pages and creases of *OU-Cinquième saison* are indeed, in large part, devoted to previous research. This translates, first, into the publication of theoretical texts, including 'Naissance de l'art nouveau' ('Birth of new art'), which Cho-pin publishes in two parts in issues 14–15 and 16 (1962) along with summary charts devoted to the period 1930–59, 'the elimination of temporal languages' (1962a: 36) and 'the constructors of spaces' (1962a: 47). Carried out 'with the help of Pierre Albert-Birot, Chopin, Maguy Lovano, Michel Seuphor, and with the details communicated by Altagor, Camille Bryen, Arthur Pétronio and Maurice Lemaître in the volume "Supplemental Note on the Original-ity of Lettrism"' (Chopin 1962a: 36), the poet draws parallels here between poetic, musical, pictorial and sculptural works: therein, art is approached as a system of global creation, and the charts, according to Chopin, 'do nothing but clarify creative constants (that doubtlessly are only now beginning to produce great works)' (1962a: 36).

This historical work will be taken back up and centred on poetry and music in the book *Poésie sonore internationale*, whose first section is devoted to 'trial and error before 1950' and includes chapters on phonetic poetry, lettrism, as well as the figures Pierre Albert Birot, Hugo Ball, Raoul Hausmann, Kurt Schwitters, and so on, up to ultra-lettrism and the first tape recordings by Fran-çois Dufrêne, in which Chopin sees the birth certificate of sound poetry. Ber-nard Heidsieck later on engages in a similar historical work in texts published in journals and assembled in his *Notes convergentes* (2001). Most importantly, Chopin quickly opens up the journal to the publication of major precursors. Starting with the tenth issue of *Cinquième saison* in 1960, Pierre Albert-Birot's 'poster-poems' (*poèmes-pancartes*), graphic poems excerpted from *La Lune ou le livre des poèmes* and from *Grabinoulor* in issue 19 of *OU- Cinquième saison* (1963),

and the 'Poems to shout and dance' are published in issue 33, late 1967–8. The opening text of issue 19 explains:

> For the recent past and the generation of World War I, we situated the work of Seuphor. Today, we are situating Pierre Albert-Birot. The names that might remain are Hugo Ball, Raoul Hausmann, Kurt Schwitters, Arthur Pétronio, etc. The fact remains that we would hope for our publication to no longer have any deficiencies, especially in France, and for it to take the reins. (Chopin 1963a: 1)

The work of redemption is focused in particular on the case of Raoul Hausmann – with whom Chopin maintains a correspondence beginning in 1963 – the Berliner Dadaist living at the time in Limousin, relatively forgotten by his contemporaries, in a battle with the lettrists to gain recognition for his optophonetic poems as a precursor. These poems find their place in the deliveries of issue 22–23–24 (1965), with a poster 'Panorama by Raoul Hausmann', presenting poems from 1919 and the more recent 'ergo sum Dada', collages and photomontages, as well an homage text 'Indisputable Evidence' by Chopin. Issue 26–27 (1966) contains a 17 cm disk on which the recordings of phonetic poems '1918 to 1964 said by him' are featured, and issue 38–39 from 1971 reproduces an unpublished document from Zurich Dada. Chopin accounts for the publication of recordings of phonetic poems spoken by Hausman in 1966 by appealing to the fact that 'the Lettrists, who didn't come around until 1945, treated him as a thief' (2002: 6). This work is pursued through the collection 'OU' in which, in 1970, he publishes *Sensorialité excentrique*.[9] If the connection to Hausmann is looser for Pierre Garnier – who is put into contact with him by Chopin – the Dadasopher also publishes in *Les Lettres* two long texts of historical clarification about the phonetic poem, 'The mutations of languages and the origins of automatic writing and of the phonetic poem' and 'Introduction to a history of the phonetic poem (1910–1939)', in 1963 and 1965 respectively; the latter is followed by an excerpt from 'Consequential Poetry' by Kurt Schwitters. Finally, in 1972, the sound and visual poet Jean-François Bory publishes a first monograph devoted to Raoul Hausmann, highlighting, in turn, the importance of phonetic poems invented in 1918, and the direct influence of sound poetry upon them:

> Raoul Hausmann, Hugo Ball, Tzara and Schwitters's phonetic poems, which make up an essential introduction to irrationalism in literature, must have led to the emergence of an extremely active school of poetry in 1953, directed by Henri Chopin and including poets such as François Dufrêne, Jean-Louis Brau, Gill Wollman [sic], Bernard Heidsieck, etc. (Bory 1972: n.p.)

It is not, however, Chopin's position, far from it even, nor that of any of the poets cited. The responses to the questionnaire 'Anatomy of the Importance and Influence of Raoul Hausmann', published in the 1971 issue of the journal *F* in tribute to the Dadasopher, are instructive in this regard. If the sound poets[10] recognise the importance of his work, none admits to having drawn any influence from them. Younger poets like Julien Blaine and Jean-François Bory think that Hausmann did, however, influence their immediate predecessors, while denying any influence upon themselves, and Chopin writes:

> no influence for me, nor for any of the sound poets that I publish on disk. Neither Brion Gysin, nor Heidsieck, nor Paul de Vree, nor the younger poets that I publish were influenced by Hausmann. The same goes for François Dufrêne and Wolman. (Chopin, quoted in Lepage 1974: 28)

The sound poets thus seem to be located on the fringes of a quarrel setting the historical Dadaists against the neo-Dadaists, insofar as they do claim to be adherents of Dada, but work for the recognition and the proper placement of the historical avant-gardes in the history of poetry. Also, Hausmann himself sharply attacks the new realists as well as Fluxus and those who claim to adhere to neo-Dada; as he writes to Chopin in a letter from 16 June 1963: 'I am necessarily opposed to neo-dadaism because it does nothing but copy what the dadaists already found. I could put neither you nor Pierre Garnier into neo-dadaism because your poems and his do not seem at all neo-dadaist to me' (Jaunasse 2002: 135).

In this way, Chopin intends to restore a legacy without actually taking credit for it, considering his research to be in rupture with the research of the Dadaists: for him, the precursors are 'great seers' while the sound poets are 'actualizers' (Jaunasse 2002: 135). The 'neo' – understood in the pejorative sense that Peter Bürger ascribes to the term as pointing to the sterile repetition of methods that have already been tested by the historical avant-gardes – would not, then, apply to the sound poets, but it would apply to the lettrists. In this way, for Heidsieck, Isou was 'enclosed in a strictly neo-dadaist practice' (2001b: 190).

'IN A COMPLETELY DIFFERENT SPIRIT AND WITH QUITE DIFFERENT OBJECTIVES' (HEIDSIECK 2001B: 188)

Nevertheless, the neo-avant-gardist dynamic as described by Hal Foster is located much firmly in sound poetry, not because it will repeat techniques or aesthetics, but because it calls on them to impart with an entirely different

scope and stakes, a gesture lived as the completion of what the historical avant-gardes did not know how to – or could not – really accomplish. Heidsieck thus accuses Isou of neo-Dadaism insofar as 'the logic of such a rediscovery should have immediately led him to drag the poem outside of the book instead of sinking deeper into it, by inventing new unreadable letters and new signs' (2001b: 190). This is precisely what sound poetry seems to have done, not to confuse it, as a consequence, with phonetic poetry. For Chopin, it is defined above all in mediological terms, by its use of recording technologies, allowing for a retrieval of orality that went unnoticed up until that point:

> Sound poetry has been a reality for twelve years, with the exception of the simple dictions of the phonetic poem [. . .] It is made from the sound of the voice, retrieves orality, which, through the tape recorder, is completely different from what we could have imagined through speech [. . .] (Chopin 1967–8: 25)

'Sound or electronic poetry' reads the title of the second section of *Poésie sonore internationale*. Several branches are then detectable, as described by Chopin; among them poems of letters and phonetic poems, or his own poetics, founded on breath and the abolition of language, just as, at the other end of the spectrum, Bernard Heidsieck's branch, in which semanticism endures, is not being counted among the historical avant-garde's poems on this point. Indeed, one rediscovers in the work of the latter, elements like the juxtaposition of multiple texts in the same work which 'corresponds essentially to the Cabaret Voltaire's practice of simultaneous reading' (Heidsieck 2001b: 188); or else the montage of already made components – so many common characteristics that, moreover, do not seem to have been the object of debate at the time, centred on the question of the phonetic poem. For Heidsieck, if 'formal comparisons' can be drawn, the aim and the critical stakes are completely different:

> it is not about declaring that everything is worth something, or worth nothing, or that they cancel each other out, to deride the rational or logical mind, but it is through the will to more closely delineate, even more closely, our mental mechanisms and our everyday environment. (Heidsieck 2001b: 188)

The follow-up to the avant-gardist project and its much sought-after realisation, is located on another plane, one that is neither the destruction of language, nor the aestheticisation of the readymade as a new means of expression or sociological claim, but rather getting out of the book, the new juncture of poetry and

society by means of technology and its pretence to action. It is in this light that Chopin, in his critique of book-based media and printing, measures the contribution of the avant-gardes:

This half century of drawing into question: Futurists (1909) to ultra-lettrism (1958) created healthy reactions; we knew that written language was complicit in what I recently called The Paper Civilization, whose effects bureaucracies, ideologies, codes . . . never fail to make us go on suffering. (Chopin 1979: 90)

This critique of language, pushed to the extreme in its dismemberment by the phonetic poem, may have resulted, this time according to a historical lecture offered by Heidsieck, in Artaud's 'scream', a point of culmination for the centripetal development of poetry since Baudelaire, folding the poem onto itself, up until its abstraction and then its explosion: 'asphyxiated display of the end of a cycle, this scream made the book explode, tore up the air, in way that inflationist speech no longer could, having reached this ultimate, final stage, this precise era, words were eaten away and rotten, burned' (Heidsieck 2001a: 102–3). For Chopin, the 'audio-poem' will then be a means of liberating the poem, not only from the page and from print, but also from articulated language, letting the breath and the resources of the body come into being by means of direct recording and the montage that the tape recorder offers. In this way, the critique of language is inseparable from a critique of the medium, which Chopin highlights before he even adopts the tape recorder, connecting the 'prosodic profession' with the 'typographic profession': 'the poetry of the book and of the printing press, these temptations to say a lot, was killed by chattering and because the voice and the gaze were no longer anything' (Chopin: 1962b: 4). Sound poetry, for its part, gets back in touch with an orality 'that we had neither "seen" nor "heard" since the sixteenth century. It is the orality of "physical" speech (and its mimes, and its play and its theaters, and its marches . . .) and of song, and of the single word' (Chopin: 1962b: 5). The rejection of the book as the site where the poem folds back onto itself is at the centre of several of Heidsieck's manifestos.

The text of 'Pour un poème debout . . .' is directed against a self-important, self-centred poetry that confronts book-based media to the point of risking its demise. A poetry that is capable of giving its reader, 'at the end of its cycle and its trajectory, nothing but the white reflection in a mirror without silvering or the black hole of a dead-end poetry' (Heidsieck 2001c: 165). We again find a dynamic described by Foster, of the return towards

avant-gardes against a kind of modernism, here represented by a critique of the 'centripetal movement' of poetry folding in on itself in a consecrated medium, the book, and the negation of the autonomy of art in order to restore 'art in relation not only to mundane space-time but to social practice' (Foster 1996: 5). Getting out of the book and making use of recording technologies gives the poem a means for real action upon society by putting it into circulation. The poem

> once again becomes oral, audible and visible, active for saying anything, and for this, now uses the appropriate technique that the radically other era into which we are entering demands, founded [. . .] on modes of visual and oral transmission that are consequently direct, fast, physical and instant. (Heidsieck 2001a: 103)

In the next part of Heidsieck's text, his remarks linger on the claim to a societal mutation that is allowing a new order to emerge, with the poem, then, opening up towards these 'noises': 'The poem is making a 180° turn and opening itself up to the world' (Heidsieck 2001a: 104). One finds, in this manifesto, domestic metaphors, no longer pointing to the poem as an object or a knickknack, but as a means of prosaic action: 'For a sponge-poem . . . for a dishcloth-poem' (Heidsieck 2001a: 124). Returned to the floor, the poem finds itself stripped of its aesthetic vocation so as to be invested in a practical aim. In this sense, the project is eminently political: this is the other meaning of the term 'action poetry', which Heidsieck will soon prefer to the term 'sound poetry', and which is positioned in the heart of society. The manifesto defines and presents modes of action:

> The state, public power, its apparatus and its ceremonies, [. . .] set global targets, think, legislate and regulate in great masses and act on this human capital [. . .]. The poem, by insinuating itself, by placing itself at the cusp of these contradictory forces, at the precise point of their convergence, [. . .] also by potentially cut[ting] into this flesh of signs, of codes, of taboos, of imperatives and signals. All of this in the heart of the same fortress, by acting from 'the inside,' rather than tirelessly screaming, whining, moaning and crying at its door, eyes aimed at a bygone era. (Heidsieck 2001a: 124)

Located in the heart of the noise, the poem can claim to be acting there, joining the avant-gardist variety of project, not as negation of 'an earlier form of art (a style) but art as an institution that is unassociated with life praxis of men' (Bürger [1974] 1984: 49). The critique of the book as an asphyxiating medium

thus falls within an institutional critique: 'if the historical avant-garde focuses on the conventional, the neo-avant-garde concentrates on the institutional' (Foster 1996: 17).

Pierre Garnier's spatialism must also, in the intentions that it displays, lead poetry towards regaining everyday space, but according to a logic with less immediate political aims. For Garnier, man is, today, 'no longer determined by his milieu, by his people, by his class, but by the images that he receives, by the objects that surround him, by the universe' (1964a: 1). Consequently, in order to act, poetry must get out of the book in order to 'enter into cities and homes', basing itself on household objects: 'the poster, ceramic visual poems, calendars made from visual poems, [. . .] neon mobile visual poems, visual poems on post cards, tins inside which a few words will be closed, tapestries—last, and perhaps most importantly, cinema' (Garnier 1963b: 18). From the outset the page is no longer necessarily the privileged material for the spatial poem and the poem is made inseparable from its medium: 'Yet the technical means employed create poetry just as much as the poet does. The tape recorder, the disk, the television must create their own form of poetry' (Garnier 1963a: 7). Rather than pretending to deliver 'feelings or awareness', the poet will ensure that poetry 'keeps us company' (Garnier 1963b: 18).

CONCLUSION

The birth of sound poetry in France allows itself to be analysed through the prism of the neo-avant-garde in several ways. Its inter-artistic nature, its intermediality, its international scope, and the circulation of manifestos sketch the contours of a movement that has numerous results and ramifications, but which nevertheless remains coherently structured. The divergence of the main actors' postures allows one to perceive a constrained relationship with the historical avant-gardes, considered to be both counter-models in their recent demonstrations, or vain repetitions of 'neo-Dadaism' – which in their eyes is made up from lettrism – and as a rediscovered ancestor (Hausmann), whose legacy is accepted. It is exactly this critical relation to the avant-gardist legacy that makes it a 'neo-avant-garde' as Foster defines the term, one which seeks less to overtake than to displace, drawing attention to an institutional and mediatic critique, connected with the societal and technological evolution of the 1960s. In this way, 'beyond dadaisms, surrealisms and all of the other isms', as Chopin's expression states, links are created and networks are woven that persist as the shared logic of a network rather than the restricted logic of the group,[11] and whose influences still apply in the field of contemporary poetry.

NOTES

1. Unless otherwise noted, all translations are mine.
2. This slogan is published in issue 10, in 1960.
3. Jean Degottex was a French painter close to the movement of abstract expressionism
4. Heidsieck uses the image of the biopsy to designate a sampling operation on the 'social body', comparable to a biological sample.
5. The co-signatories are: Mario Chamie, Carlfriedrich Claus, Ian Hamilton Finlay, Fujitomi Yasuo, John Furnival, Ilse Garnier, Pierre Garnier, Eugen Gomringer, Bohumila Grögerova, Josef Hirsal, Anselm Hollo, Sylveste Houédard, Ernst Jandl, Kitasono Katue, Frans van der Linde, E. M de Melo e Castro, Franz Mon, Edwin Morgan, Ladislav Novak, Herbert Read, Toshihik Schimizu, L. C. Vinholes, Paul de Vree, Emmett Williams and Jonathan Williams.
6. For a detailed analysis of these differences, see Royère (2018).
7. In *OU-Cinquième saison*, issue 33 (1967–8). Chopin differentiates three groups: the first one acts 'beyond all literacy', and is composed of the ultra-lettrists Dufrêne, Wolman and Jean-Louis Brau, using the tape recorder as a means of directly recording the 'projected' voice. The second, in which are found Bernard Heidsieck, Brion Gysin and Paul de Vree, conserves semanticism but uses the tape recorder as a means of writing, making use of permutations and superpositions. Finally, the third, in which he includes himself, uses the resources of the microphone and makes the 'particles of the voice' heard, including breath and other sounds coming from the body's machinery.
8. The quarrel between Isou and Iliazd was widely transmitted by the literary press, but the book, a bibliophile's edition, had a print run of only 158 copies with Éditions du Degré 41.
9. Or else when he authors the foreword to Pierre Albert-Birot's late work, *Aux trente-deux vents*, published by the editor and bibliophile Jean Petithory in 1970, in which he recalls his role as a precursor.
10. Among the responses, one notably finds names including Albrecht, Arlette Albert-Birot for Pierre, Ben, Blaine, Bory, Chopin, Cobbing, Dufrêne, Garnier, Gysin, Iliazd, Lemaître, Pétronio, Rousselot, Schwarz, Sidaner, Soupault, De Vree . . .
11. Among the major figures of sound/action poetry, Julien Blaine, already active in the 1960s, created the journal *DOC(K)S* in 1979, whose functioning through the 'mail art' network would also be entirely in contradiction to a group logic. The same goes for the Polyphonix festival, founded in 1979 by Jean-Jacques Lebel, with a rotating director and an international nomadism.

BIBLIOGRAPHY

Abastado, C. (1980), 'Introduction à l'analyse des manifestes', *Littérature*, 39 (3), pp. 3–11.

Bory, J.-F.(1972), *Raoul Hausmann*, Paris: L'Herne, n.p.

Bürger, P. [1974] (1984), *Theory of the Avant-Garde*, trans. M. Shaw, Minneapolis, MN: University of Minnesota Press.

Chopin, H. (1961), 'Note générale sur la poésie aujourd'hui, et la verbophonie', *Cinquième saison*, 13, pp. 20–1.

Chopin, H. (1962a), 'Naissance de l'art nouveau (suite)', *Cinquième saison*, 16, pp. 36–47.

Chopin, H. (1962b), 'Pourquoi la poésie dite "objective"?', *Cinquième saison*, Supplement, 20 January.

Chopin, H. (1963a), *Cinquième saison*, 19.

Chopin, H. (1963b), 'Les mutations poétiques', *Les Lettres*, 30 (2nd quarter), pp. 11–14.

Chopin, H. (1963c), 'Réponse d'Henri Chopin au Plan pilote présenté par Pierre Garnier aux auteurs pressentis du Comité International', *Les Lettres*, 31 (1st quarter), pp. 4–5.

Chopin, H. (1964), 'Réponse d'Henri Chopin à Position 1 du Mouvement international', *Les Lettres*, 32 (2nd quarter), pp. 5–6.

Chopin, H. (1967–8), 'Lettre ouverte aux musiciens aphones', *OU-Cinquième saison*, 33, pp. 24–36.

Chopin, H. (1971), 'L'avant-garde?', *F*, 2–3, pp. 19–27.

Chopin, H. (1979), *Poésie sonore internationale*, Paris: Jean-Michel Place.

Chopin, H. (1993), 'Au-delà des dadaïsmes, surréalismes et tous autres isthmes par des forces d'amour' [1966], in *Poésure et peintire, d'un art l'autre*, Marseille/Paris: Musées de Marseille/Réunion des Musées nationaux, p. 548.

Chopin, H. (2002), 'À propos de *OU-Cinquième saison* – 1958–1974, un quart de siècle d'avant-garde' [1974], in *OU-Cinquième saison: Complete Recordings*, Henri Chopin – Alga Marghen.

De Vree, P. (1962), 'L'avant-garde. Poésie-peinture', trans. from Dutch, *Cinquième saison*, 17, pp. 8–15.

Donguy, J. (1993), 'Entretien avec Pierre Garnier', in *Poésure et peintrie, d'un art l'autre*, Marseille/Paris: Musées de Marseille/Réunion des Musées nationaux, pp. 390–7.

Foster, H. (1996), *The Return of the Real: The Avant-Garde at the End of the Century*, Cambridge, MA: MIT Press.

Garnier, P. (1963a), 'Manifeste pour une poésie nouvelle, visuelle et phonique', *Les Lettres*, 29 (1st quarter), pp. 1–8.

Garnier, P. (1963b), 'Deuxième manifeste pour une poésie visuelle', *Les Lettres*, 30 (2nd quarter), pp. 14–23.

Garnier, P. (1963c), 'Note liminaire – Plan pilote fondant le Spatialisme', *Les Lettres*, 31 (4th quarter), pp. 1–5.

Garnier, P. (1964a), 'Position 1 du Mouvement international', *Les Lettres*, 32 (2nd quarter), pp. 1–5.

Garnier, P. (1964b), 'Position 2 du Spatialisme', *Les Lettres*, 33 (4th quarter), pp. 1–2.

Garnier, P. (1968), *Spatialisme et poésie concrète*, Paris: Gallimard.

Hausmann, R. (1963), 'Les mutations des langues et les origines de l'écriture automatique et du poème phonétique', *Les Lettres*, 31 (4th quarter), pp. 6–11.

Hausmann, R. (1965), 'Introduction à une histoire du poème phonétique (1910–1939)', *Les Lettres*, 33 (4th quarter), pp. 1–4.

Heidsieck, B. (1998), Interview, *DOC(K)S* 'Son', 3 (17/18/19/20), p. 23.

Heidsieck, B. (2001a), 'Notes convergentes. Poésie sonore et magnéto-phone' [1968], in B. Heidsieck, *Notes Convergentes*, Romainville: Al Dante, pp. 51–132.

Heidsieck, B. (2001b), 'Nous étions bien peu en . . .' [1980], in B. Heidsieck, *Notes Convergentes*, Romainville: Al Dante, pp. 177–252.

Heidsieck, B. (2001c), 'Poésie sonore et musique' [1980], in B. Heidsieck, *Notes Convergentes*, Romainville: Al Dante, pp. 163–76.

Heidsieck, B. (2001d), 'Pour un poème donc . . .' [1962], in B. Heidsieck, *Notes Convergentes*, Romainville: Al Dante, pp. 7–10.

Heidsieck, B. (2009), 'Lettre à Jean Fournier d'octobre 1958, directeur de la galerie Kléber, Paris, où exposait à cette date Jean Degottex', in B. Heidsieck, *Poèmes-partitions (1955–1965) précédé de Sitôt dit (1955)*, Romainville: Al Dante, pp. 271–2.

James, P. (2012), *Bohumil Hrabal: 'composer un monde blessant à coups de ciseaux et de gommes arabique'*, Paris: Classiques Garnier.

Jaunasse, D. (2002), *Raoul Hausmann, l'isolement d'un dadaïste en Limousin*, Limoges: Presses Universitaires de Limoges.

Lepage, J. (1974), 'Anatomie de l'importance et de l'influence de Raoul Hausman', *F*, 4, pp. 25–34.

Margel, S. (2013), 'Le temps du manifeste', *Lignes*, 40, pp. 5–7.

Royère, A.-C. (2018), 'Trois poètes dans le laboratoire des poésies nouvelles: Ilse Garnier, Pierre Garnier et Henri Chopin', in C. Dupouy (ed.), *Pierre et Ilse Garnier, deux poètes face au monde*, Tours: Presses universitaires François-Rabelais, pp. 73–104.

Théval, G. (2014), 'Une revue pour sortir du livre: *OU-Cinquième saison*', *La Revue des revues*, 52 (2), pp. 12–23.

Tomiche, A. (2005), '"Manifestes" et "avant-gardes" au XXème siècle', *Manières de critiquer: colloque sur les avant-gardes à l'Université d'Artois*, <https://halshs.archives-ouvertes.fr/halshs-00112236> (last accessed 29 January 2021).

Zurbrugg, N. (2002), 'Vivre avec le vingtième siècle', *OU-Cinquième saison: Complete Recordings*, Henri Chopin – Alga Marghen, p. 4.

Surrealism Old and New in Three Generations of Prose Poets: The Case of the Low Countries

Hans Vandevoorde

Historically, the term 'neo-avant-garde' has predominantly been applied to the visual arts of the sixties and seventies rather than to the years immediately following the Second World War. A similar tendency within literary criticism has limited the concept to a certain form of neo–Dada literature typical of the sixties. It is worth considering, however, a more liberal application of the term. Why should 'neo-avant-garde' not be used for any movement upholding the tradition of the historical avant-garde? Stated more directly: is there any reason not to view the many neo-surrealistic trends in post-war literature[1] as the legitimate heirs of the avant-garde and thus apply to them the label of neo-avant-garde? After all, each new generation of surrealists has attempted to rediscover itself and had to position itself against older generations, or, more specifically, the seminal generation comprised of André Breton and his fellows.

The relationship between post-war generations and that first generation of surrealists does not fundamentally differ from that between the neo-avant-garde movements of the sixties and seventies and the historical avant-garde. Just as those movements often adopted a new banner to identify their new direction (De Nieuwe Stijl, Fluxus, etc.), some members of the new generations of surrealists chose to pursue their activities under a new name. A case in point is the CoBrA movement co-founded by Christian Dotremont, who, as a newcomer, had no problem professing himself a surrealist before the movement's establishment in 1948. He deployed a myriad of strategies normally used by surrealists to secure a position for himself: poem dedications (to Paul Éluard), relocating to Paris, joining a new Parisian group (La Main à la Plume), tracts denouncing other new groups or journals, readings, manifestoes, taking part in exhibitions and so forth (Godet 2019).

At the same time, a neophyte must distinguish himself in order to get noticed. One way to accomplish that is by putting a new twist on the prevailing genres of the movement to which he belongs. Dotremont did exactly this with the prose

poem – which one might call the *generation genre* (Vandevoorde 2018: 239) of the surrealists because of its proliferation. In 'Oleossoonne ou le moment spéculatif' ('Oleossoonne, or the speculative moment') (1941), Dotremont evokes a kind of birth on the morning after an immaculate conception. The poem serves as both a love poem to R. (Régine Raufast) – to whom it is dedicated and who appears in other poems of that time – and a manifesto. The text is also, notably, dedicated to a certain 'E.', Éluard, who was a mentor to Dotremont during the latter's early years in Paris. According to the compiler of *Oeuvres poétiques complètes* ('Complete poems'), the poem was produced through automatic writing (Dotremont 1998: 105). Alain Mascarou uses a more precise term for this textual practice, calling it 'automatico-rousselienne' ('Rousselian automatism'),[2] because of the propulsion of the sentences through forms of word play such as paronomasia (2004: 194). Marscarou also senses some derision of *poésie pure* in the title, because it references a figure from an Abbé Bremond poem ('Oloossone'), and considers the entire poem to be a simulation of a psychotic breakdown and thus 'plagiat transgressif' ('transgressive plagiarism') of *L'Immaculée Conception* by Breton and Éluard (2004: 197–8). Yet, this prose poem would also appear to be too self-reflexive – for instance, through the mention of 'images surréalistes' (Dotremont 1998: 108) – to be categorised as a product of pure automatism according to Breton's formula (1924).[3] Moreover, it takes on greater significance through the material form in which it was published: a poster. It was thus less autonomous than the prose poems of the previous surrealist generation. In the interpretation of Marie Godet (2019: 31), this alludes to the posters the Germans were hanging everywhere at that time. There are also a few allusions to the war (including a phrase from a song banned by the Germans and the abbreviation 'D.T.C.A.', for the Défense Territoriale Contre Avions). This historical anchoring occurred at a time when a new generation of surrealists was emerging – Mascarou (2004: 188) even calls them the 'génération de 1941'. In Belgium, they were promoted both by older poets such as Achille Chavée and by artists such as René Magritte. Dotremont caught the attention of both newcomers and old-timers with this form of poems, but escalating problems with Magritte and his growing distance from automatism prompted him to set out on his own and forge new alliances, such as with the Danish artist Asger Jorn.

Although CoBrA is not immediately recognised as part of the neo-avant-garde by the neo-avant-garde's foremost theoreticians,[4] it is increasingly considered as such in artistic circles (Wetzler 2015). This supports my assertion at the start of this chapter that the post-war generations of surrealists could also be brought under the neo-avant-garde umbrella. Using the Dutch prose poem as a case study, I intend to show firstly how surrealism has been continually reinvented through a series of movements that have derived from it. Secondly, I will show how the prose poems from those derivative movements are often more disruptive

in content and form than the many restorative literary impulses of their time. In other words, the historical avant-garde persistently reappears like a ball dangled in front of the nose of subsequent movements, who must continually swat at it like playful kittens. It is equally important to examine how the prose poem form has managed to constantly cover new ground in its use by various individual writers, with, for example, a focus on instinctive perceptual processes in one instance and cognitive ones in another. Finally, it is also important to demonstrate how one of the primary creative principles of surrealism – psychic automatism through the technique of automatic writing, for which the prose poem would seem supremely suited as a mould into which the writing can flow – was questioned by subsequent neo-movements and even abandoned.

To get a literary-historical grasp on these different phases, I will be relying on the concept of generation. While on the one hand, this concept is still used at every opportunity, on the other, it is rarely taken seriously, except in sociological and historical disciplines (Vandevoorde 2011). In my discussion here, I follow the thinking of Karl Mannheim and the Dutch sociologist H. A. Becker. According to Becker, decisive experiences (Mannheim), of which a war would certainly qualify, have an impact on a category of contemporaries from the ages of ten to twenty-five during their 'formative period' (1997: 17). The effect of what Becker calls 'discontinuous changes' should be noticeable, according to him, for at least ten years. By adding to Mannheim's concept of the generation a new term, that of the 'family' (Vandevoorde 2018), I hope to avert the traditional objection against the generation concept as being too homogenising and thus incapable of accommodating the differences between individual artists or writers.

THE EXAMPLE OF SURREALISM

The prose poem would seem a genre more suited to modernism than to the avant-garde, more about pushing content boundaries than formal experimentation. It is already a hybrid of prose and poetry as a form, which would appear to leave little room for typographic extravagance. Ever since the days of Charles Baudelaire, or in fact since those of the patriarch of the prose poem, Aloysius Bertrand, it has been a genre that lends itself to a different narrative form, especially an associative one, rather than one based on sequential logic. Its compact form promotes a sort of brevity (Bernard 1959: 439; Caws 1983: viii), which could be considered the most defining characteristic for distinguishing prose poems from lyrical prose.

In the twenties, the prose poem was the chosen genre of the French surrealists and the 'cubist' forerunners Pierre Reverdy and Max Jacob, who, although

scarcely delineating it theoretically from their 'normal' poems in verse, unquestionably used it for other sorts of more urgent expression.[5] With the surrealists, then, we see that the form of the prose poem not only accommodates content normally found in verse poems (dreams and the subconscious), but is also directly related to the creative principle of automatism: only prose, Bernard (1959) notes, is capable of capturing the flow created in automatic writing; only the prose poem can decisively rupture the narrative convention of prose by which one action issues from another. Each sentence generates another and another – not in accordance with the logic of the story but based on associations in sound and meaning. This makes it seem as if a new world is created sentence by sentence, as if each individual sentence exists in an 'absolute' state against all the others. As a result, a variety of spaces, times and visions come together in the poem. Moreover, the use of image further reinforces this strangeness because it not only challenges the logic within each sentence, through the limited motivation for the two poles of the metaphor (also referred to as arbitrariness), but also metastasises from sentence to sentence, a device Michel Riffaterre (1969) refers to as the 'métaphore filée' ('extended metaphor', with either the 'tenor' or the 'vehicle' wholly or partially repeated in variation).

In Dutch literature (i.e. literature of the Low Countries), it was the experimental generation of the Vijftigers (Fiftiers, from the late forties through the early sixties), a Flemish and Dutch 'group' in Mannheim's terms,[6] that bridged the gap with surrealism and Dada. It is no surprise, then, that a great many writers of prose poems emerged at that time. After that, it is not until the nineties that we encounter a new wave of prose poems by a second, postmodern, generation of prose poets.[7] That wave led to such a proliferation that the prose poem became mainstream in the next generation, who are still publishing today. Be that as it may, some among this latest generation are definitely writing more audacious prose poems in the wake of their great predecessors.

THE PROSE POEM OF THE FIRST GENERATION

Histories of literature tend to designate a new generation every five to ten years. This does not generally take into consideration, however, whether the respective authors have been subject to some common socialisation that deviates from that of previous cohorts and, thus, whether they actually constitute a separate generation. The poets in Flanders, for example, are commonly divided between the Vijftigers affiliated with the journal *Tijd en Mens* (1949–55) and the Vijfenvijftigers (Fifty-Fivers) affiliated with the journal *Gard Sivik* (1955–64). Curiously, the most famous of these *Tijd en Mens* poets, Hugo Claus, would actually correspond more with that second generation according to when he was born (1929) and not with

the other poets associated with *Tijd en Mens*, who were mostly born in 1920 or 1921. Claus is, of course, an exceptional case, but there are other obvious reasons for seeing the Vijftigers and Vijfenvijftigers as a single generation – in fact, for considering them more as 'families' within a larger generation than as distinct 'groups'. Their formative period was marked by the war, to the extent that members from both North and South avowed that they had been formed more by their experiences during the war than by education.

Today, of course, we know that for a number of these poets, the impact of the war was in part a product of their politics during it. The Dutch poets Hans Andreus and Lucebert, the Dutch-speaking Belgian poet Claus and the French-speaking Belgian poet Dotremont all wrote letters or poems testifying to their rightist bent. While that youthful susceptibility to right-wing ideology should not lead us to read their later work solely as a repudiation of their misguided fledgling years, it *is* true that they were quick as emerging poets to radically distance themselves from established forms and content, perhaps as a result of their youthful lapses. Dotremont, who modelled himself after Arthur Rimbaud in his younger years and emerged as a poet almost as precociously, wrote a number of prose poems during the war.

As this also makes plain, the generation concept transcends languages and national borders, allowing for a more comprehensive examination of the prose poem as genre. When we combine the generation genre and its development with the movements of classical literary history, we can rewrite that history by reclassifying what have previously been held as different experimental generations in Flanders into a single generation with different families, emphasising the overall continuity without homogenising them completely. All these families were highly influenced by surrealism and Dadaism: while the first experimentalists admired the main French surrealists, the family of the Vijfenvijftigers had a predilection for the more marginal Belgian surrealist poets, and the Flemish experimentalists of the sixties admired the Dadaists.

Interest in surrealism grew sharply in the Netherlands just after the war,[8] but it was not until about 1950 that this revolutionary thinking truly broke through, thanks to the work of young poets. The lack of a strong surrealist predecessor explains the shock wave the Vijftiger poets sent through the literary world. Among the older poets of surrealism they turned to Éluard or to poets who had once belonged to the movement, such as Antonin Artaud. Cees Buddingh' professed that 'Dutch poetry only truly came into its own on a European level with this recent connection to surrealism' (1954: 230). The *generation style* that all the neo-surrealists of that time shared was a return to the spontaneous, the irrational; this was both a protest against the 'classical' structure of restoration literature and an embrace of what Lucebert called 'old surrealism' (2011: 24).

The pre-eminent critic of the movement, Paul Rodenko (1991: 193), commented on 'the renaissance of the prose poem brought about by the avant-garde' in 1954 at the end of the introduction to his influential anthology *Nieuwe griffels, schone leien*:[9]

One can hear the echoes of Max Jacob and Henri Michaux, the two primary renewers of the prose poem in France, in Gerard Bruning and in Corneille's 'Tademait', respectively; the genre is also being used, though, by Achilles Mussche, Nes Tergast, Leo Vroman [. . .], Hans van Straten and Erik van Ruysbeek, among others. (Rodenko 1991: 193)

It is worth noting here that he primarily cites the older forerunners of the Vijftigers (not counting Bruning, who died in 1926) and that the painter Corneille was the only member of the CoBrA generation named by Rodenko. Generations often have 'great uncles', as we might call them; in the Netherlands, with regard to the prose poem this was someone such as Tergast (*Werelden*, 1953), and in Flanders, Pol Le Roy (*Lava*, 1956). At the time Rodenko wrote this, in 1954, the greatest poets of the movement had yet to publish their prose poems. Claus was, in fact, holding back an early collection of highly associative prose poems (*Herbarium*, published in 2001) and did not publish his first prose poems until 1955, in *Oostakkerse gedichten* ('Poems from Oostakker'). That same year, Andreus released a complete collection of prose poems titled *Empedocles*. Lucebert, on the other hand, was only sporadically including prose poems in his work (for example, in *Amulet*, 1957).

What were the Vijftigers' prose poems like? Dutch literature had a habit of following artistic developments in the larger European languages closely. It is therefore interesting that in this case, it lacked any surrealism to speak of prior to the Second World War. At the same time, it was open to influences from the visual arts and French literature. Prose poems were already being written in Dutch literature during the *fin de siècle*, under the influence of French (as well as British and German) examples. The Baudelairean model of narrative or descriptive poems remained dominant in the Netherlands for a long time. The more absolute, or – to use M. H. Abrams's term – autonomous, model of Rimbaud's, meanwhile, had few followers until the twenties (De Strycker and Vandevoorde 2014). Given that this lyrical model is predominant in the surrealism of Breton and his followers, my hypothesis is that it only gains a foothold among the Dutch in the fifties when surrealism starts to find a following.

The prose poems by Andreus from *Empedocles* (1955) still belong to the narrative tradition, with the figure of the philosopher appearing as a 'symbol of death, rebirth and resurrection' (Andreus 1955: 9) – an Orphic poeticism, thus. Unlike Andreus, the much overlooked older poet Tergast followed in the

footsteps of a lyricist such as René Char. Claus is an interesting case in that his work embodies both types of prose poem. On the one hand, we are introduced to the French–Belgian poet Michaux in the periphery of his collection of short stories *Natuurgetrouw* (1954), namely in *Zo gebeurde de ontdubbeling van mijn wezen* ('So happened the deduplication of my being'), which remained unpublished for decades (Claus 1999). Across the Belgian border, we see similar narrative poems in which irony and imagination are combined. There is a certain affinity, for instance, between the playfully critical prose poems of the Dutch poet Jan Elburg and the much more word-play-oriented, tortuous stories of the Flemish author Marcel Wauters. Both were fans of Michaux's work. On the other hand, we have the four prose poems from *Oostakkerse gedichten* that were followed by numerous 'post-experimentalists' who would set the literary tone in Flanders, especially in the sixties.[10] Bobb Bern, Paul Snoek and Freddy de Vree gave their quest for cohesion structure by using a symbology of alchemy and other esoteric imagery. One of the formal peculiarities of the experimental generation is the renouncement of punctuation and capitals, as evident, for example, in Ben Klein's 'birds' in his collection *dalai lama* (1958) or in Jef Bierkens's jazz poems in *Navelverbonden* (1961). The latter mutilates the syntax so completely in a poem like 'miles davis'' that all that remains are words (many of them neologisms) and series of words to be associatively strung together: 'tears trot through the room house winter solace wounded in turmoil violable axe-bell shrill existence of ferns flames prison [etc.]' (Bierkens 1961: n.p.).

The diversity of content and the difference between the narrative and non-narrative form, characteristics of the prose poem, have not precluded the underlying poetical views from making the movement more homogenous. As mentioned, the renewal of the Vijftigers was primarily about catching up to surrealism, yet with a slight correction. The Dutch poets abjured automatic writing, as had the Belgian surrealists of the 1941 generation.[11] The critic Jan Walravens, chief editor of *Tijd en Mens*, expressed reservations – fully in keeping with his great predecessor Paul van Ostaijen[12] – about automatism and even called such expressions 'aberrations';[13] Paul de Vree, chief editor of another experimental journal, *De Tafelronde* (1953–73), was of the opinion that the 'oneiric technique' needed to be viewed with a critical eye;[14] and a bit later still, the minor poet Klein condemned all the blind followers of automatic writing.[15] Even when the poetry is chasing jazz, thought intervenes to guide the improvisation in the right direction.

Both forms of prose poem – narrative and non-narrative – have one thing in common: they jump from one world to the next, from one mental domain to another, through association. This is what they inherited from psychic automatism.

A SECOND POST-WAR GENERATION OF, MOSTLY POSTMODERN, PROSE POETS

With a few exceptions, such as the remarkable Francis Ponge disciple Gerrit Bakker and K. Schippers, who was at one time one of the trendsetters of the neo-Dada journal *Barbarber* (Vervaeck and De Geest 2019), it was not until the early nineties that prose poems became popular again. In the middle of that decade, the first postmodern poets started making a name for themselves in Flanders (Erik Spinoy, Dirk van Bastelaere, Jan H. Mysjkin and Stefan Hertmans), soon to be followed by the initial crop of Dutch postmoderns (Tonnus Oosterhoff, Astrid Lampe, K. Michel, Marc Kregting and others). Even the poets closely allied with the late-modernist journal *Raster* (J. Bernlef, H. H. ter Balkt, Huub Beurskens, etc.) now enthusiastically embraced the style. The Flemish postmoderns expressly styled themselves after their predecessors from the historical avant-garde (van Ostaijen) or the experimenters of the Vijftigers/Vijfenvijftigers (e.g. Claus, H. C. Pernath). The most significant poet of this group – whose birth year, 1960, makes him a Baby Boomer on the cusp of Generation X, in terms of his demographic cohort – was undoubtedly Dirk van Bastelaere. He closely followed American poetry and so, in one of his first collections, he reintroduced the narrative poem in Dutch literature, following in the footsteps of John Ashbery and other American poets (McHale 2004), ushering in a boom in long narrative poems. Van Bastelaere in fact wrote his poetry collection *Diep in Amerika* (1994), which includes five prose poems, during a stay in the United States.

An English translation of one of these was included in the anthology *When the Time Comes: A Selection of Contemporary Belgian Prose Poetry* (Lombardo 2001). The title of the book refers to a volume by Maurice Blanchot (*Au moment voulu*, translated as *When the Time Comes*), someone who in turn is also one of Van Bastelaere's major references, in whom he rediscovered his opposition to coherence (Van Bastelaere 2001: 73).

> From its immense yellowness the sunflower looks down upon your soft passing by. The thing that imagined itself happening alongside what was already going in, now, for no apparent reason, manifests itself. Humming you think: *it is something that adds itself on, but was already there.* For Vera, who violently shakes her red hair before her covered face and it flows and flows over her black suit, this is the moment. Also for someone standing in the middle of the garden swinging a zinc bucket in a circle and the water stays inside.

> Those are moments of lynx-time. His appearing is unanticipated, lynx, [be it][16] not capricious. His wondrous, flickering ears focus our attention

wholly into the moment of time before we breathe again. First known is
the unknown when it as unknown becomes known.

At least, this is what it says to us about the ordering of words, something like
the little cloud of thought that deserts us at it speaks in us. (Van Bastelaere
2002[17])

The above poem, 'Lynx-Time', translated by Nicholas Altenbernd, describes
the moment at which something 'that imagined itself happening' does indeed
suddenly happen, and it is called that because the lynx, too, makes an unex-
pected, unannounced appearance. The Dutch version of the final sentence
('Althans, zo praat het ons aan de orde der woorden . . .') is more ambiguous
than the English in that the syntax could also mean the inverse, that it is 'the
ordering of words' saying this to us (what is said about the unknown). All this
happens at the moment between two breaths, when a 'thought cloud' escapes.

We are no longer dealing here with an unconscious epiphany about some-
thing or someone (Baudelaire's unknown passer-by), but confronted with the
sudden emergence of something that 'was already there'. The moment of reali-
sation is part of other, similar 'moments', as the plural indicates. What is critical
here is that this is not about the subconscious surfacing and certainly not about
something divine descending; instead, what has been manifested is something
that exists 'alongside what was already going on'. The same thing is happen-
ing at the level of the poem itself. The fact that the sunflower 'looks' and
the 'unknown' speaks creates a surrealism that engenders a sense of strangeness
in the readers. They become transported by the three-step form of the prose
poem, which, as it were, zooms out in perspective: in the first stanza, which
begins with the lovely image of the sunflower, concrete, recognisable things
happen (the red hair that falls over a black suit; the swinging of a bucket); in the
second stanza, we have the analogy with an animal (the lynx), and the reflective
mood already present in the first stanza is amplified by the epigram at the end;
and in the third stanza, abstraction, depersonalisation and immateriality take
over and the poem becomes self-reflexive in referring to language itself: 'At
least, this is what it says to us about the ordering of words, something like the
little cloud of thought that deserts us at it speaks in us.'

This transition from one possible world to another is familiar to us from
surrealism, but the form, too, of a prose poem and its capacity for elucidating
a process are also reminiscent of that same movement. Within the collection,
'Lynx-Time' follows a poem in verse with the same title, without being a
translation of the previous work in another form. This alternation between
prose poem and verse poem is also familiar from surrealism, as is the mixed

form of poem and prose poem that occurs once in *Diep in Amerika*. It is quite possible that Van Bastelaere's experimentation is rooted in the poets of the Language movement, such as Ron Silliman, who himself displayed an affinity with the anti-generic, anti-prescriptive French tradition of Max Jacob in 'New Prose, New Prose Poem': 'the model of the sentence, for the first time, is derived from the prose, and not the verse' (1986: 160–1).

THE THIRD GENERATION

Van Bastelaere's example was followed by the Flemish writer Peter Verhelst and others, while in the Netherlands, Oosterhoff, Michel and Kregting wrote prose poems in a postmodern vein: they assume an unknowability of the world and avoid any claims to totality. This became the impetus for the gradual rise of the prose poem amongst contemporary poets (Maud Vanhauwaert and many others) who are children of the digital revolution. These days it appears as if the prose poem has become a generally accepted form and that poets can easily switch between verse and prose poem or even mix the two. In this way, the Millennial generation is burying the generation style because it is no longer a distinctive characteristic. It is nonetheless worth examining whether there are any poets continuing in the tradition of the previous generations. To do that, we must return to a group of 'post-postmoderns' who debuted in the nineties, following in the footsteps of the postmoderns from the eighties, while still differentiating themselves with a more direct level of engagement and terse tone.[18] Younger poets such as the Dutch Frank Keizer and the Fleming Arno Van Vlierberghe can be considered as a 'family' within this third generation.

Post-postmodern prose poets of this generation include Arnoud van Adrichem and Samuel Vriezen, promoters of the Language poets in the Netherlands, and the Flemish writer Jan Lauwereyns, who wrote an essay called 'Splash', whose title seems to refer to an eponymous poem by Van Bastelaere from *Diep in Amerika* but may just as well refer to one of Lauwereyns's own poems from the collection *Nagelaten sonnetten* (1999). Blanchot is also an anchor of Lauwereyns's poetic theory; this posits that poetry satisfies our longing for the unattainable (Blanchot) with a greater pleasure that originates from the objectification of desire through writing (Lauwereyns 2005: 84). Lauwereyns is thus interested in 'new mental leaps' and new 'connections and associations'. What he cares about is the movement and not the result, the moment of transition, the 'splash', that 'moment when a high diver breaks the surface of the water' (2005: 88). Such a concept recalls the significance of the 'experience' for the Vijftigers, for whom the experiment emphasised the experimental process (De Geest 1996: 187).

The observations in the poem 'In de strandstoel zat ik, en bleef zitten' ('I was sitting in the deckchair and remained there') (Lauwereyns 2012: 121) appear to be being made from a deckchair on the balcony of a sixth-floor flat at the sea. The realistic description of a late summer day that turns into an autumn day as the rain comes in is intermixed with thought, as in the poem by Van Bastelaere; here it is the sea that breathes 'in and out to the rhythm of my thoughts'; and a 'random memory' from an old drama surfaces: the body of an office woman washes ashore. This intrusion also upends the logic of the story and we are met with an abrupt: 'Mother was dead.' The next sentence is a quote that appears as if it may be from that mother – perhaps she is addressing her daughter here – and the last sentence taciturnly throws everything off: 'Mother and daughter slept on.'

Poems like these seem to lack a centre, or better yet, they destabilise the centre that the lyrical I seems to be. The poem is one long sentence, reminiscent of a glob of automatic writing, in which four semicolons indicate the shifts in perspective from outside to inside and back outside, from high to low and back to high, from distant to close up, then back up high, from the present to the past and back to the present. The poem is a confluence of multiple discourses. We see another such extreme manifestation of this in *N30* (2011) by Jeroen Mettes, who stretched the prose poem to astonishing lengths and, like Lauwereyns, owes a debt to the American Language poets. In that posthumously published work, the reader slides from one new possible world into another, from one sentence to another, something we have seen as a distinguishing feature of the surrealist prose poem, but that was also at the core of Silliman's 'New Sentence' (1987).

CONCLUSION

Perhaps destabilisation can be considered the true legacy of surrealism. Well into the twenty-first century, one might think we were far removed from surrealism and automatic writing, but we are still skipping mentally from world to world, albeit not necessarily in our subconscious or dreams, but also through thoughts, memories, observations and quotes. The prose poem offers the advantage of allowing the imagination free rein in leading the way and enabling an associative process for depicting a decentralised world.

From a literary-historical perspective, the prose poem has been a constant force since the time of Baudelaire, not only in France but elsewhere, as well as an integral part of every avant-garde trend of the day. Despite going through periods of lesser prominence, it still proves to have been a form throughout the Dutch and Flemish literature of the twentieth and twenty-first centuries

capable of expressing a certain problematisation, especially regarding identity, in a narrative or non-narrative form. The genre first gained a wider application among the poets of the Dutch and Flemish neo-surrealism of the Vijftigers, which we identify as a first neo-avant-garde generation with different 'families' (influenced by surrealism or influenced by Dada, more influenced by French surrealism or more influenced by Belgian surrealism), before being deployed in their wake for deconstructive purposes by the postmodern generation. The fact that it is accepted today as an almost natural form of poetry is not the least achievement of subsequent surrealist movements. This does not mean that the revolutionary potential of surrealism is spent: amidst a profusion of hybrid, intermedial art forms, the prose poem remains suitable for creating a sense of strangeness and adopting new experimental forms. When we talk about the neo-avant-garde in contemporary practice, and consequently use the term to designate an open-ended category of writers and movements upholding the legacy of the historical avant-garde, we can certainly include the experiences of the prose poem writers discussed above.

NOTES

1. For an overview, see Penot-Lacassagne and Rubio (2008).
2. Unless otherwise noted, all translations are mine.
3. 'Pure psychic automatism, by which one proposes to express, either verbally, in writing or by any other manner, real functioning of thought. Dictation of thought in the absence of all control exercised by reason, outside of all aesthetic and moral preoccupation' (Breton 1988: 328).
4. See the Introduction to this book.
5. On this matter, see Bernard (1959), still the standard work, and Hubert (1968).
6. For Mannheim (1964: 547), a 'concrete group' is a social constellation, not a biological one. As a demographic cohort, most of the experimentalists were born between 1920 and 1940.
7. As a demographic cohort, these postmoderns were born between 1960 and 1980. Older postmoderns, such as Stefan Hertmans, Huub Beurskens and Anneke Brassinga, started as late modernists.
8. That interest had started as far back as late 1939 (L. Th. Lehmann), continued during the war (Buddingh') and manifested itself shortly after the war in journals such as *Het Woord* (Renders 1989).
9. In a lecture from 1959 about 'Contemporary avant-garde poetry', Paul de Vree observed something similar in retrospect: 'The prose poem was subject to a special fondness' (1960: 158).

10. 'Prose poems are all the rage among the young writers of the journals Baal, Stuip and Nul', Paul de Vree wrote, in response to Bern's *jaden boek jaspis* (1963: 49).

11. See Christian Dotremont (Godet 2019: 54) and Jan Walravens (Depreter 2018).

12. 'Apart from pointing out their "faults" (overly rigid automatic writing, flirtations with communism that led Aragon, among others, to become mixed up with socialist realism), [Van Ostaijen] adopted their advancements as his own: a renunciation of traditional logic, plumbing the subconscious, the mystical impulse' (Hellemans 1991: 382).

13. 'Poetry of and by the word is one of those modern aberrations in technique such as we have encountered before with the technique of automatic writing and the system used by the Lettrists' (Walravens, quoted in Depreter 2018: 73).

14. 'This also demonstrates that the experimental movement has not mindlessly assumed the mantle of surrealism. While surrealism remains the pivot, a critical view has been taken of the subconscious flow, the oneiric technique. [The movement] is more interested in the sound autonomy of dada or in Lettrism and has a particularly strong sense of physiological perspectivism (the physical poem, the body as interface between interiority and exteriority). It is less concerned with poetry's place as pure culture than the organic expressionist, literary cubist or surrealist, nor is it a stranger to a certain constructivism à la Max Jacob (prose poem)' (De Vree 1956: 136).

15. For more on Ben Klein, see Depreter (2018: 81).

16. My addition.

17. Reproduced by kind permission of Gian Lombardo.

18. The Fall of the Berlin Wall was a definitive part of their formative period.

BIBLIOGRAPHY

Andreus, H. (1955), *Empedocles. De ander*, The Hague: Stols.

Becker, H. A. (1997), *De toekomst van de Verloren Generatie*, Amsterdam: Meulenhoff.

Bernaerts, L., H. Vandevoorde and B. Vervaeck (2013), 'Inleiding. Generaties en lyricisering van het experimentele proza', in L. Bernaerts, H. Vandevoorde and B. Vervaeck (eds), *'Een eeuw lyrisch proza'*, *Belgisch Tijdschrift voor Filologie en Geschiedenis/Revue Belge de Philologie et d'Histoire*, 91 (3), pp. 531–60.

Bernard, S. (1959), *Le Poème en prose de Baudelaire jusqu'à nos jours*, Paris: Nizet.

Bierkens, J. (1961), 'miles davis'', in *Navelverbonden*, Sint-Niklaas: Paradox, n.p.

poignant remark in 1981 that contemporary research was already in the process of drying out the anarchical and 'tyrannical radicality' of the Vienna Group through its subjection to a 'conceptual climate' (Schuh 1981: 36) of philosophically bolstered language scepticism – a danger that must still be countered.[2]

At precisely this point, the final section of the present chapter turns to a synchronic approach. It confronts selected, multimodal and intermedial devices of the literary avant-garde, which cross the borders of arts disciplines with the aforementioned problem of inadequate premises. For this purpose, an exemplary, comparative close reading of two texts by Gerhard Rühm and Eugen Gomringer will be undertaken. Both texts approach the theoretically pertinent *topos* of silence – the impotence of a subject caught in primordial speechlessness – with experimental strategies that vary significantly. Decisive here is that the writers both draw attention to the tensions between image and writing, seeing and hearing as well as literature, visual art and performing art in very different ways. These differences make it possible to show which (post-structuralist) terms and concepts must be rethought in order to be able to make the most of potentials opened up by the convergence of disciplines (art history, literary history). With regard to this challenge, the following pages formulate a proposition, which can be understood as a contribution to a new research paradigm for the neo-avant-garde, conceived in an interdisciplinary way.

LOST ORIGINS: RECONTEXTUALISING PETER BÜRGER'S CRITIQUE OF THE NEO-AVANT-GARDE

If one opens a book on the theory or history of the neo-avant-garde, one reference is rarely missing: Peter Bürger's *Theory of the Avant-Garde* ([1974] 1984). Bürger's study is not only cited regularly within neo-avant-garde research but is also just as often criticised and used as a departure point for the presentation of an author's own methodological approach to neo-avant-garde practices, actors or movements, defined via their deviation from Bürger's thought. Bürger's emergence as a negative reference point for the international neo-avant-garde discussion is surely so well established due to the easily quoted brevity and conciseness of Bürger's judgement, which consists of no more than a few, scattered sentences. What contributed to this dubious prominence was the fact that the German literary theorist, hitherto hardly known among international art critics, was invoked in key works of contemporary research on the visual arts. With her famous essay, 'The Originality of the Avant-Garde: A Postmodernist Repetition' (1981), Rosalind Krauss laid the theoretical groundwork for the common criticism of Bürger's thesis, that the historical avant-garde's attack on the bourgeois art system could not be repeated after 1945. By bringing into

focus the repetitive structures of the historical avant-garde with her deconstruction of the dichotomy of the original and the reproduction, Krauss takes away the basis of Bürger's argument, namely that the avant-garde after 1945 could be nothing more than an empty, elitist and self-indulgent gesture of protest, which repressed the failure of the historical avant-garde. In comparison with Krauss, Benjamin Buchloh formulated his doubts more explicitly. His criticism also begins with Bürger's historiographical premises. In doing so, however, it presents the argument that Bürger, with his conception of the relations of art production, culture industry and technology, reduces the complexity of the dialectic between these forces (see Buchloh 2000).

One of the most prominent re-readings of the history of the neo-avant-gardes, Hal Foster's *The Return of the Real* (1996), likewise – following Rosalind Krauss – begins with Bürger's juxtaposition of original and repetition. Foster's central point of contention, though, is with the premise of a linear temporality, bound up with this binary figure. His history of the visual arts in the twentieth century assigns a key historical, socio-political position to the neo-avant-gardes between modernism and postmodernism and between totalitarianism, Critical Theory and poststructuralism. As such, it rests on a model of deferred action informed by Lacan's reading of Freud, and on the temporal logic of *Nachträglichkeit*. Foster's central argument in this regard is that it was only the neo-avant-garde's repetition of the historical avant-garde that brought forth the latter to enact them as originals in their 'totality' and political force.

Across this discourse-shaping import of individual arguments from Bürger's study some aspects were overlooked, which must be fully attended to in putting forward an interdisciplinary concept of the neo-avant-garde. First of all, it should be noted that Bürger understood his *Theory of the Avant-Garde* as an explicitly *literary* study, despite the inclusion of other art disciplines, and as such, it was strongly influenced by this disciplinary context in many ways. This can be seen first of all in Bürger's primary methodological concern. His critique is not, as so many reviews suggest, directed at the neo-avant-gardes, but rather at a particular institutional model of literary historiography that dominated at that time. This kind of historiography not only split form and content, text and context: it also regarded politics and aesthetics as autonomous fields, separate from one another, and – in opposition to the *linguistic turn* that was gaining influence – adhered to a concept of the autonomous artist and artwork. It was precisely against these premises that Bürger's literary, sociological intervention turned, which he understood as *functional history*, distinguishable today for its stark commonalities with Pierre Bourdieu's ([1992] 1995) reflections on the charged history of the literary field's autonomisation.

As an analogy to Bourdieu's model of an always only 'relative autonomy' ([1992] 1995: 248) that is never entirely redeemable, Bürger's interpretation of the historical avant-garde is based on the premise that there is nothing beyond the political – neither in art nor in academia. This can, of course, also be formulated the other way round: for Bürger, the *Theory of the Avant-Garde* was a gesture of taking political responsibility within literary studies. With this, he belongs to an intellectual scene that was linked to the student movement of the 1960s, and was shaped by the establishment of Critical Theory through the Frankfurt School and the new interpretations of dialectical materialism by Theodor W. Adorno, Max Horkheimer and Herbert Marcuse. What brought them all together was the effort to develop and establish new forms of critical thinking and action, which would no longer repress the fact that 'Auschwitz' had been able to happen, but rather took it seriously as a historical challenge.

This intellectual process of coming to terms with National Socialism and the Holocaust took extremely varied trajectories. In his *Theory of the Avant-Garde*, Bürger referred back to Walter Benjamin as a thinker who had already foregrounded his cultural theory in the concepts of shock, trauma, fragmentation, irretrievable origins and originals as well as the interwovenness of an anticipated future with a constructed past as the political catastrophes of the twentieth century were approaching. The way in which Bürger refers to Benjamin's concepts of allegory and history is thereby strongly influenced by theories of fascism, even if Benjamin's well-known thesis of the 'aestheticisation of the political' is not explicitly named (see Benjamin 1969b: 250). Benjamin's analysis of a specifically *fascistic* mass culture forms the implicit theoretical basis of Bürger's interpretation of the history of art's autonomy. He begins this account – historically precise from a German studies perspective – with Friedrich Schiller's influential text, *On the Aesthetic Education of Man* ([1795] 2016). What is decisive about Bürger's recourse to Schiller's theory of a certain freedom in the aesthetic is the great importance assigned to bodily experience. Schiller sees human sensuality and corporeality in an interplay with the force of reason, which becomes the scene of aesthetic freedom precisely in the experience of fluctuation, an 'aesthetic state' ([1795] 2016: 89) that oscillates between proximity and distance, passivity and activity, being touched and touching.

This model of oscillation underlies Bürger's thesis on the dual character of art's autonomy and its fatal (if also necessary) development throughout the nineteenth century. Conceived as a flexible interplay to be realised by the individual in a third space between pure politics (e.g. the French Revolution) and pure, that is, uncoupled and inconsequential aesthetics (e.g. entertainment), the idea of aesthetic autonomy is transformed incrementally alongside the establishment of autonomous cultural institutions (national theatres, museums, etc.). According to

Bürger, the oscillation between freedom and determination originally inscribed in aesthetic autonomy, as framed by Schiller, finally came to a halt around 1900 with (literary) aestheticism. Art becomes autonomous, in the most possible extreme, as it now only refers to itself, even if it critically interrogates its own means in doing so. Hence, art indeed becomes self-reflexive; but in doing so, it squanders its potential for both experiencing heteronomy and confronting it. This phantasma of a paradoxical, terminal stage of art's autonomy which abolishes any scope for freedom in the aesthetic is precisely that which – according to Bürger – the historical avant-garde breaks through and makes visible in its negation of the 'institution of art' – a self-critique of art in bourgeois society that cannot be repeated in this form.

One final point should be considered in this return to Bürger. In comparative contrast to the sharp criticism that it provoked in art historical research on the neo-avant-garde, the *Theory of the Avant-Garde* – even though it triggered a long discussion (see Lüdke 1976) – was by and large received positively within German-language literary studies. This can certainly be attributed to the shared historical and intellectual context, through which Bürger's provocative interpretation of the history of the avant-gardes could be recognised as a political intervention in the methods of literary historiography. There is in this, however, another factor to bear in mind that perhaps contributed to the fact that Bürger's critique of the neo-avant-garde met with comparatively little criticism in contemporary literary studies. At this time, the avant-garde's practices and works from the 'long sixties' between 1954 and 1975 (see McHale 2016) were already being discussed under a different name – and not only in the German-speaking world either. No longer did one speak of the avant-garde but rather experimental art, experimental music and experimental theatre – this was also the case for aesthetic practices that systemically drew from the traditions of the historical avant-garde. This renaming was carried out in a broad, unspoken consensus, in a silent agreement between artists, the public, critics and academia. That said, it did not go entirely unnoticed or uncontested.

Here it is first of all significant that the relabelling of the avant-garde as experimental arts was also criticised by some of its own representatives. Thus, Helmut Heißenbüttel, one of the leading representatives of the Stuttgart Group of concrete poetry, with Max Bense, Reinhard Döhl, Franz Mon and Ludwig Harig, formulated a sincere suspicion with regards to this 'jargon fashion' (Heißenbüttel 1972: 126). In his view, the new 'speech regulation' (1972: 133) brought about a dubious detachment of the practices it referred to from their historical and political contexts. The term 'experiment' serves as a 'neutralising alias' (1972: 132) with a double aim. Insofar

as it denies a relationship between the historical and the 'new' avant-garde, it aims at dehistoricising the perception of contemporary arts. At the same time, the renaming of the avant-garde as experimental art fulfils a programmatic depoliticisation of aesthetic practices, directed at producers of art as well as its recipients. It drives a process of forgetting, an active repression of what is probably the most important hallmark of the historical avant-garde: their belief in the possibility of changing society.

In critiquing the dehistoricising and depoliticising effect of the new, aesthetic collective term 'experimental' art, Heißenbüttel seized upon an argument that had been brought into play three years prior by the German writer and cultural critic Hans Magnus Enzensberger in his essay, 'Die Aporien der Avant-garde' ('The aporia of the avant-garde') (1962). Enzensberger's central thesis was that the new 'incantatory formula' (1984: 73) of the aesthetic experiment served the sole purpose of escaping the processes of working through and out the aporia of the historical avant-garde. The latter would have become entangled in the dialectic of the Enlightenment through insufficient reflection on the dangerously ambiguous, dialectic figure of reason and irrationality. Precisely this problematic foundation was to be taken over by the new avant-gardes, who would nonetheless conceal their very continuity by using the 'invisibility cloak' (Enzensberger 1984: 75) of the term 'experiment'.

The 'nonsensical', 'unusable' and 'unenlightened' (Enzensberger 1984: 73) term 'experiment' would not only fulfil the function of suggesting a break with the social and cultural traditions that had made National Socialism and the Holocaust possible, but, through its coquetry with the aura of natural sciences, it also serves to declare art as an end in itself once again. This borrowed 'lab coat' (Enzensberger 1984: 72), the naturalisation of artistic practices, relieves so-called experimental art of social responsibility and withdraws from its criticism any form of legitimation in advance:

A biologist who conducts an experiment with a guinea pig cannot be responsible for its behaviour. He can only be held responsible for ensuring that the conditions of the experiment are properly maintained. [. . .] It is precisely this moral immunity that the [experimental avant-garde] enjoys. [. . .] What they borrow from science serves only as an excuse. With the word 'experiment', the results can be excused, 'actions' taken, as it were, back, and every responsibility placed accordingly on the recipient. Every audacity is justified, as long as nothing is to go wrong. [. . .] Every sentimental *Heimatfilm*[3] deserves more mercy than an avant-garde, who arrogantly blindsides critical judgment and anxiously seeks to be rid of the responsibility of their own work. (Enzensberger 1984: 72–6)

Enzensberger's 1962 essay is – in spite of its polemic – not solely interesting because it can be related directly to Peter Bürger's thesis from 1974 on the historically regressive character of the neo-avant-gardes. Considering the concerns of the present anthology of essays – the analysis of experimental literature from the perspective of the neo-avant-garde – it is also a text whose *argumentation* is worth keeping in mind. At first, it seems that Enzensberger is aiming to confront the entire spectrum of artistic neo-avant-gardes (Informel, Tachism, monochromatic painting, concrete poetry, beat poetry, serial music, etc.) with the accusation of historical blindness. Looking more closely, however, it becomes evident that he is not criticising forms of artistic *practice*; rather, he is intervening in the *thinking* of this practice, which from his perspective implicitly includes social and art theory, as well as their concepts and premises. Enzensberger thus takes up a detailed, *ex negativo* position on precisely those tasks that the present book is working towards. As he criticises the implications of the renaming of avant-garde as experimental art, Enzensberger *first* demands that this renaming be reversed. His *second* claim is for the correction of the academic distortion that entailed the removal of experimental art of the long sixties from social and cultural history in the twentieth century.

THE VIENNA GROUP: A CHALLENGING CASE

Taking into account the aforementioned contexts and pretexts for the emergence of Bürger's *Theory of the Avant-Garde* (Schiller, Enzensberger), his critique of the neo-avant-garde can be seen in a new light. It can be read as an intended historiographical construction directed against progress-orientated thinking, the latter being programmatically flouted by proponents of Critical Theory. The accusation of regression (Enzensberger 1984; Bürger [1974] 1984) that is made against the neo-avant-gardes is thereby accounted for by the historical fact that a regression, a 'reversion of enlightened civilization into barbarism' (Horkheimer and Adorno [1947] 2002: xix), had already *de facto* taken place in Germany and Austria. The actual target of this criticism, which indeed only stands in as a representative, is the fact that this reversion had not up until this point been worked through or absorbed into the intellectual self-perception of the *Kulturnationen* Germany and Austria. It is to advance this discussion on the roles of art *and* science in the history of National Socialism that Bürger undertakes a re-reading of the repressed, historical avant-garde. The fact that, in his opinion, an unreflected repetition of past practices is out of the question, is based on the conviction that *all* inherited cultural practices, in light of German history (National Socialism, the Holocaust), must be placed under close scrutiny. Faced with this realisation, Bürger concentrates

on the correction of *theoretical* discourses, which are interwoven with the literary historiography that he is criticising. He selects the historical avant-gardes as his object, because they allow for an exemplary reconstruction of the conceptual failure of aesthetic autonomy in Europe between 1800 and 1930. This special focus does not mean, however, that Bürger denies the neo-avant-garde the possibility of a reflected response to the aporias of the historical avant-garde after 1945.

Against this background, numerous points on the discursive front mentioned at the start of this chapter are brought into perspective, between Bürger on the one hand and known positions in current neo-avant-garde research on the other. The *Theory of the Avant-Garde* does not put forward an account of progress but is rather based on a question of the opposition between original and repetition, which can be compared to Rosalind Krauss's rehabilitation of repetitive processes (cf. Krauss 1986). From a historiographical perspective, Bürger works with premises that expose the past as a construct and undermine historical conceptions of a linear temporality. In doing so, he orientates himself – although not explicitly – towards Walter Benjamin's allegorical 'angel of history', who is involuntarily driven forward by progress but whose gaze is, however, directed at the fragments of the past, which are to be reassembled for the sake of the future (Benjamin 1969a: 257). Thus, Bürger's theory and history of the *historical* avant-garde acknowledges the very same concept of paradoxical temporality that Hal Foster (1996) takes as the basis of his theory and history of the *neo-avant-gardes*.

In current art-theorical discourses influenced by poststructuralism, this premise of a temporality of deferred action is closely interwoven with the epistemological figures of trauma, shock and Derridean *écriture*. Conveyed through the work of Walter Benjamin, these are concepts that also underpin Bürger's *Theory of the Avant-Garde*. These correspondences suggest that Foster's history of the *neo*-avant-gardes can be understood as a continuation of Bürger's history of the *historical* avant-gardes. Yet this also raises the question of the extent to which Foster's approach, analyses and concepts (e.g. traumatic realism versus traumatic illusionism) can be used for literary historiography.

It is initially striking that Bürger, the literary historian, and Foster, the art historian, both make a contradictory figure of autonomy the pivotal element of their arguments. At the same time, they both, however, investigate its dynamics with regard to different historical phenomena and contexts. In this instance, Foster places at the centre the history of modernism, whose repression of realistic positions represents, in his view, the decisive, inherited burden of the neo-avant-gardes. According to Foster, the latter faced the difficult task of working through the aporias of modernism: the illusion of a simultaneously

autonomous and (self-)critical art that with its political flipside – the model of fascistic subjectification – stood in unreflected complicity (see Foster 1996: 222). Conversely, Bürger's deconstruction of the misguided ideals of autonomy begins with the history of the differentiation of aesthetic subsystems in the course of the long nineteenth century and suggests also thinking through a parallel differentiation of political subsystems. This systematic differentiation triggered compensatory movements of de-differentiation, a fatal amalgamation of politics and aesthetics, the relevance of which is agreed upon in the research. While in this context Peter Bürger has the totalitarian regime of the 1940s and 1930s in mind, Buchloh and Foster focus on the 1960s – the simulacral omnipotence of commodification in the aestheticised life world of advanced capitalism.

This shows that there is an area of implicit premises that differ significantly in the historiography of the literary and artistic avant-gardes. This problem concerns firstly diachronic questions (historical context, periodisation). It also has consequences, though, for synchronic analyses, which – with a view to a transdisciplinary neo-avant-garde history – inquire into the function of avantgardist practices in and between different arts disciplines.

For both challenges, the history of the Vienna Group (Friedrich Achleitner, H. C. Artmann, Konrad Bayer, Gerhard Rühm, Oswald Wiener) can be understood as an exemplary case with special potential. The authors, who primarily worked closely together between 1954 and 1960, formed the *first* literary avant-garde in Austria, and thus acted on the one hand as a belated historical avant-garde, and on the other as a premature neo-avant-garde (see Rühm 1985a; Weibel 1997; Fetz and Matt 1998). Furthermore, their work was also influenced by the fact that the tradition of aesthetic modernism was not represented in the cultural public and – due to a lack of books, relevant institutions, etc. – was hardly accessible. In their efforts to make up for lost time, the provocations of the Vienna Group were by no means perceived as irrelevant, art-related anachronisms by the culturally conservative, authoritarian-influenced post-war public. Rather, they were attacked as dangers to the state and morals, and their critics did not shy away from the Nazi label of 'degenerate art' (see Eder and Kastberger 2000).

In cultural terms, the starting point of the Vienna Group deviated significantly from that of the neo-avant-gardes as analysed by Foster. Yet in political and social terms also their situation differed greatly from that of their international colleagues. Hence, concepts of trauma and shock had a different meaning in the local context of a bombed-out city shaped by war, hunger and fear, which was divided into four zones of Allied occupation until 1955, compared with those of American consumer culture of the 1950s. What had a traumatising

effect in Vienna was the experience of lived and/or exercised violence, the everyday sight of dismembered bodies and the normality of powerlessness, mortal danger and death. Certainly, the political strategy of presenting Austria as the victim of Hitler's Germany to the Allied powers (USA, France, Great Britain, USSR) also had traumatising potential. As such, the individual need for the *repression* of shared responsibility for National Socialism, the Second World War and the Holocaust became a collective call for the *denial* of the events between 1938 and 1945.

This particular starting point raises the question of whether the works of the Vienna Group can be seamlessly integrated into Hal Foster's re-reading of the relationship between avant-garde, modernism, neo-avant-garde and post-modernism, or whether this re-reading has to be advanced. Against the background of Foster's thesis of a dual origin of the neo-avant-garde, I approach this question with reference to two literary examples. The first text has the title *die gute suppe* ('the good soup') and was written by Friedrich Achleitner in 1958. It is a montage, which takes its material from a 'german language text-book for americans' (Achleitner 1970b: blurb) and it recounts in ten steps the meticulously timed preparation of an evening meal – a 'good soup'. In formal terms, taking up the processes of the historical avant-garde, the text gives rise to a binary world of black and white, good and bad, man and woman, nature and culture, and so on. Subsequently, the initial harmony of the orderly idyll goes visibly wild through a semantically rampant, falsely understood verb. This dynamic of unleashed signs is brought under control by a tautological return to the original harmony – 'the good soup is good' (Achleitner 1970a: 204). With the regular disciplining of this disturbance by an affirmative repetition ('good', 'good') the narrative indeed also comes to an end.

Achleitner's recourse to the material of a German language textbook sug-gests that the text should be read from the perspective of the programme proclaimed by the Vienna Group itself: as a demonstration of the violent determination of the subject through a pregiven language, as critique of soci-ety with the means of language critique (see Aspetsberger 1973). Observing Achleitner's montage from the perspective of Foster's distinction between a first, anti-illusionistic line of the neo-avant-garde and a second, subsequent line that starts with Andy Warhol's traumatic realism, another picture appears. Foster's concept of an anti-illusionistic neo-avant-garde focuses on works that place the 'body' of language (the curtain in front of the Lacanian Real) and predetermined perception at the centre of their critique. Nevertheless, he points out that the ambivalent legacy of modernism – the imaginary structure of an only allegedly autonomous (self-)critique – persists, still unprocessed, in this first phase and line of neo-avant-gardes.

Taking this consideration into account, new facets of Achleitner's text can be drawn out. The primordial muteness of the subject, which produced the hopelessly *subjected* subject, is not an abstract, supra-historical lack or rupture; for it is the German-learning *US-Americans*, whose coaching into a binary reality drives the montage forward.[4] This makes visible the thematisation of very different and very concrete dimensions of violence, shock, rupture and trauma. Until 1955 the Americans were an occupying power that worked systematically on an Americanisation of power, culture and economy within the controlled zones. As central geopolitical opponents of the Soviet Union in the Cold War, they also continued in their efforts after 1955.

What Achleitner's *die gute suppe* demonstrates is therefore not the universal trauma of the entry into the symbolic order of language. It is rather the concrete, historical trauma of a post-fascist society with regards to a dominant nation, which appropriates the German language with the aim of spreading American values. With its dramatisation of repetition and the demonstrated violence of normalisation, the montage allows the pressure of conforming to American ideals around consumption and the nuclear family to shine through. The advertisement for kitchen appliances and a paradisiac variety of goods, which the 'german language textbook for americans' reproduced, is not in this instance – as in the examples analysed by Foster – used for an exposition of the trauma of the commodified subject. What the text repeats and thereby makes accessible is something else: it is the trauma of the fact that the American world of images, signs and commodities puts the historical trauma *under* seal – the traumatisation through National Socialism and Holocaust, through war, hunger, violence and the denial of guilt.

If one compares this mode of literary criticism with Foster's reading of minimalism as the first phase and line of neo-avant-gardist visual art, there appear to be both correspondences as well as deviations. Thus, Achleitner's *die gute suppe* is without doubt in the anti-illusionistic tradition of modernism, which, according to Foster, also influences minimalism. The self-reflection of repetitive structures that Foster observes in minimalism is, however, set out quite differently in Achleitner's montage, as the trauma of the fully unfolded capitalist consumer society is superimposed onto a previous, historical traumatisation. The text directs its critique towards aspects of reproduced reality; primarily, though, it demonstrates how *trauma* reproduces itself, as it becomes overwritten with another trauma. Achleitner's montage is thus based on an aesthetic strategy that is situated between the two genealogies of the avant-garde that Foster has analysed. It lies between the *anti-illusionism* of minimalism and the *traumatic realism* that Foster illustrates with Andy Warhol. Achleitner's text *die gute suppe* thereby demonstrates that the political and cultural specificities of the

post-war years in Austria bring forth a neo-avant-garde tradition of *traumatic anti-illusionism.*

H. C. Artmann is the member of the Vienna Group who worked most starkly with quotations from popular and mass culture, from comics, films and zines. At the same time, he identified himself only to a limited extent with the programme of radical language sceptics that refused referentiality: a position that linked him to Ernst Jandl, among others. These points both make Artmann's works an especially suitable starting point for a comparison between Austrian literary history and Foster's concept of traumatic realism as a second line of the neo-avant-garde, represented by Warhol's Pop Art. The text selected here – *other statistix. eine amerikanische montage* ('other statistix. an american montage') (1957) – is characterised by the fact that it begins with very similar points to Achleitner's *die gute suppe* (1958), although it treads a significantly different path. It is a 'montage' consisting of five parts, which illuminate the facets of the precarious interplay of statistics, biopolitics, commodification and colonialisation from different angles. The five parts work with various multilingual processes of concrete and visual poetry and are each placed on a separate page. They address different forms of visual sense and interlace them – through different, contrasted demands upon understanding – with the haptic, with the turning of the pages.

The first page is designed as a concrete poem, in which the German-language material – instructions to a woman to fetch beer – is shortened line by line. This chain of demands, which is linked to the association of an evening of television, ends with the three letters 'usw' (a common abbreviation for 'und so weiter', i.e. 'and so on') (Artmann 1985: 103). This can be read as flowing into an endless loop of instructions, or – in another possible reception – as the woman increasingly ignoring what is being said.

The second partial poem is also designed as a column of text. It consists of words, which list the ideal body measurements of a woman, including the corresponding numbers and clothing sizes, in English. Perceived as an image, this account gives an idea of a woman's contours, with the imaginary ground on which she is standing being her body weight. The latter is rendered in a jargon that is used (usually by men) to describe animals that are bought or shot on a hunt. The female ideal is thereby threatened as, with the visual emergence of the 'good figure', letters and numbers on the page collide, slip, become illegible and push one another aside.

The third partial poem is a brief, fragmentary, German-language quotation of a cosmetics advertisement, while the next page presents an exuberant montage. This montage places English, Spanish and Latin quotations and speech elements together in such a way – in striking opposition to the previous

page – that can hardly be decoded. Insofar as California is addressed in Spanish, the scene outlined here only shows that the theme of the Americanisation of Europe is interwoven with Latin American immigration to the USA and the discovery of the Americas by the Europeans. This global historical digression is followed on the next page by the summation of the aforementioned female ideal measurements, which concludes with the German words 'schwarz auf weiß', that is, 'black on white' (Artmann 1985: 107).

Like Achleitner with his montage *die gute suppe* (1958), with *other statistix* (1957) Artmann also casts a critical glance at the relationship between language and violence on the one hand, and at the social transformations in 1950s Austria on the other. In terms of both form and content, Artmann treads a fundamentally different path. This is first evident in the theme of statistics, which – as a method of quantification and economisation of the social – fundamentally restructured post-war society. Statistics was the basis of new social technologies – such as political opinions research, market research and scientifically based methods of advertising – that were already in use in the USA. With the new orientation towards the model of American Fordism, they were adopted in Germany and Austria too.

What Artmann aims at with his text, however, is not – as in the tradition of literary anti-illusionism – the *determination* of individuals and society through a new language of numbers and images. Rather, with *other statistix* he touches upon the decisive point of the new, biopolitical logic of power. This is based on the *active* participation of the subject in the new, ubiquitous act of measurement. For it is subjects themselves who regard and evaluate their bodies in terms of this new logic of numbers. They measure themselves and hence they enter into a loop of self-observation, self-discipline and self-optimisation, which becomes a perpetual state – the endless feedback loop of control society (see Deleuze 1992).

While Achleitner refers to the problem of verbal impotence with his critique of the violence of normalisation, Artmann consequently directs his attention to the condition in which individuals themselves actively proceed towards normalisation. Seen from this perspective, power does not have a centre and therefore requires subjects who, with their bodies, produce power as a social system, as a relational, spatial order. The way in which *other statistix* showcases the fashion, advertising and beauty industries draws precisely on this fatal cycle. Artmann takes up methods of Dadaist number poetry; although he does not aim to show the arbitrary, manipulative, dissimulating character of these signs. Instead, he combines numbers and letters in a way that leaves traces, enabling a bodily experience of how subjects produce their own pressure to conform, and thus make themselves into commodities.

That Artmann makes these mechanisms tangible means that the text grants the reader no position from which to observe this shock of being implicated from afar without being affected. The body of the reader also becomes a scene where desires meet fears, and perpetrators and victims can no longer be distinguished. This is already clear in the first section of the poem: it can either be read as a silencing of the woman by the man, or the other way around, as the (quietly ridiculing) silencing of the man by the woman. Part two of the poem is destabilising, as the man's gaze on the woman and the woman's gaze on herself cannot be differentiated. Both melt into an imaginary mirror constellation (the image of the woman), in which the Lacanian big Other, the Real of the numbers-machinery of late capitalist control society breaks in and subverts the Symbolic (see Lacan 1978; Foster 1996: 136). Furthermore, in the three additional partial poems, the recipient is exposed to the same experience of shocked subjectivity as the figures on the fictional level of the text. The interpellations of the subject are countless, they contradict one another, they are carried out in incomprehensible languages and media and originate from innumerable spaces, epochs and geopolitical power relations of (post)colonial global history. This polyphony makes the *lingua franca* of the number (together with the image) appear as a way out, which only further reduces the space for negotiation that the Symbolic opens up.

This is precisely the point at which the relation of Artmann's text to the tradition of (traumatic) anti-illusionism – and with it, its proximity to Warhol's traumatic realism (see Foster 1996: 127–44) – becomes markedly visible. Artmann describes *other statistix* as a 'montage' in the title. However, he executes a transformation of this technique, which works through the modernist burden of the anti-illusionistic model of montage. He does this by expanding the binary structure of the critique of determination through language into a triadic model. This places the focus on the body of the subject in socio-political space and works with bodily experiences that oscillate between activity and passivity, touching and being touched. Artmann's *other statistix* performs a genuinely literary, neo-avant-gardist process, which succeeds in negotiating with the Real through its play with the multilingual and multimodal.

DIFFERENTIATING THE RETURN TO THE REAL: A SUGGESTION

The previous analyses show that, against the background of Hal Foster's (1996) thesis, two strands can be determined in the history of the Austrian neo-avant-gardes, even when they emerge simultaneously in a particular kind of deferred

action. Moreover, the specific local contexts within which the Austrian neo-avant-garde emerged demand that the concepts of shock, trauma and the culture industry are understood differently than in Foster's examination of the history of visual arts as viewed from the United States. Although the USA's political role appears in another light from the perspective of German and Austrian history of the 1950s and 1960s, this does not diminish the potential for a history of the neo-avant-gardes that is orientated towards Foster's model. The necessity of incorporating real, historical contexts in the analysis of modern and avant-gardist artworks can instead be understood as one of the main concerns in Foster's plea for a new, paradoxical 'realism'. The juxtaposition of two different ways of confronting the challenges of the Real not only provides Foster with a foundational model for his *history* of the visual arts of the twentieth century; indeed, the carving out of these two lines also shapes his *theoretical* argumentation. As his analysis of Warhol's traumatic realism demonstrates, Foster advocates for a 'working through' of very particular premises of poststructuralist thought. At the centre of his critique are approaches that let the corporeality of social power structures disappear from view through their one-sided concentration on the 'body' of language – onto the curtain before the Lacanian Real.

With this plea for a new, constructive concept of reality in the research on the avant-garde, Foster builds upon Lacan's concept of the 'gaze' (see Foster 1996: 138–42) and from this basis he formulates the notion that studies of visual culture that limit themselves to critiques of imaginary relations remain trapped in the logical of the Imaginary – the mirror stage. Foster contrasts this limited mode of cultural critique with a model that takes the physical-sensual dimension of politics and history into account in a novel way. As such, art and power, subject and society are thought of within the framework of a triadic constellation, which follows Lacan's concepts of the Imaginary, the Symbolic and the Real.

That said, Foster adds a highly political, 'realistic' component to these psychoanalytic concepts, which has incisive, methodological consequences. From this perspective, the subject and the actual social power structures (as traumatising gaze) exist in a relation of mutual, performative generation. Societal power courses through the body of the subject, who produces the self with regards to the big Other's instructions (see Foster 1996: 216). These socio-political interpellations of the subjects, however – like the subject in its performative corporeality based on self-difference – possess no localisable origin. Both are rather merely scenes of incarnate relations. They are part of a topology, which is experienced both actively and passively, and in which the task falls to art to protect the subject from being 'blinded by the gaze' (Foster 1996: 140). According to Foster, works of visual art ensure this protection, by the taming

of the gaze 'in an image' (1996: 140), through a process of negotiating with the Real – the trauma.

The concept of the 'taming of the gaze' is interesting in the present context because it shows that Foster's approach to the history of the visual arts is based on an *analogy* to Lacan's concept of the Symbolic. However, it should be considered here that Lacan defines the Symbolic as a *linguistic* order that he placed in contrast to the pictorial Imaginary and the mute Real. That Foster's analogy between the historical-political functioning of lexical and visual signs is workable for art history is proven by the analyses in *The Return of the Real* (Foster 1996). The fact that his historiographical thesis of a dual origin of the neo-avant-garde proves effective for literary history can be seen in the previous examples of Achleitner's and Artmann's texts. If one looks closely at Artmann's 'american montage' *other statistix*, however, certain facets come to the fore that cannot be contained in Foster's concept. Admittedly, the multilingual dimension of the text can be explained by the figure of the interpellation. What cannot be described and analysed with this methodological approach, though, is the fact that Artmann places numerical, linguistic and visual signs in *shifting* relation to one another. While word, image and number compete, replace and push each other out in one moment, in the next instance they may be neutral towards one another or even mutually supportive. Precisely this flexible, multimodal game of the senses connecting different types of representation (linguistic, pictorial, etc.) and different arts disciplines can indeed count as one of the central characteristics of the literary neo-avant-garde and thus makes theoretical as well as historiographical demands for consideration.

The point at which this task could be solved is shown through a comparison of two texts from the 1950s that follow different formal trajectories, even if they are similar in terms of content. Eugen Gomringer's 1954 visual constellation *schweigen* (Gomringer 1995), translated in 1960 as *silence* (Gomringer 1968), is among the most renowned texts of concrete poetry in the German-speaking world. It uses only a single word as its raw material: 'silence'. This is arranged into a rectangle as it is repeated fourteen times, leaving a blank space exactly in the middle. This void can be read as a reference to the primordial muteness of the subject, the muteness of the Real, or to the logic of Derridean *écriture*, which connects presence to absence. In whatever way the central blank space is interpreted, it always makes silence *visible*. As such, Gomringer enacts a transfer of lexical signs into visuality, which permits a seamless, distanced and shock-free reception of the poem is its 'entirety'.

Written four years later, Gerhard Rühm's 1958 text *lachen* ('laughter') (Rühm 1985c) can be understood as a response to Gomringer's *silence*. Rühm not only expanded the vocabulary by placing laughter alongside silence as the alternative,

audible stuttering of the Symbolic. He further develops Gomringer's *silence* into a linguistic entity that plays the various aesthetic disciplines, genres and 'sensual regimes' off against one another. Rühm's *lachen* can be read partly as visual constellation, partly as drama, even though it also refers to elements of sound poetry and the visual arts. Thus, the recipient is forced to actively try out different possibilities of reception and to switch between various learned models of sensual perception. Up to the end, the text oscillates between competing techniques to position subjects sensually. This is an aesthetic strategy that defines numerous texts by Rühm, and that was taken up and developed further by Ernst Jandl and Friederike Mayröcker (e.g. Jandl and Mayröcker 1971).

In the present context, *one* aspect of Rühm's literary response to Gomringer's *silence* merits particular attention. While Gomringer prioritises the opposition of text and image with his visual constellation, Rühm further differentiates this relation and distinguishes between spoken and written language. Hence, one can only perceive how *lachen* undermines the genre conventions of drama, of visual and sound poetry when it is received as 'mute speech' (Rancière [1998] 2011) and – with the help of various forms of visual sense – read silently.

At precisely this point, it becomes visible how literary studies can contribute with its specific expertise to an interdisciplinary theory and history of the neo-avant-gardes. As Rühm's *lachen* makes so tangible, literature, drama and the visual arts position subjects in vastly different ways in the socio-political space of a connecting *and* dividing sensuality (seeing/being seen, hearing/being heard, touching/being touched, etc.). The text thereby simultaneously calls for the competition as well as the intertwining of different models of the 'distribution of the sensible' (Rancière [2000] 2004) to be considered as the *common* foundation of the history of literary and visual arts.

If the history of mute, solitary reading is incorporated into a corresponding, interdisciplinary history of the neo-avant-gardes, this will in turn affect the genealogy of (post)modernity put forward by Hal Foster. Viewed from this angle, the realism of the nineteenth century must be ascribed not only to the increasing prevalence of the visual sense, but equally – as a second origin – to literature's falling silent. In this case, the current return of the Real that Foster has criticised would not be the sole responsibility of theorists, practitioners and historiographers of the *visual arts* after all.

NOTES

1. The work on the present essay has been supported by the Department for Cultural Affairs and Science of the City Government of Vienna, in the framework of the project *The Multilingualism of the Vienna Avant-Gardes. A Lesson in Transnational Cultural Research.*

2. All translations are mine.
3. The 'Heimatfilm' ('homeland' or 'sentimental' film) is set in an idealised regional setting, and is a very important genre during the post-war decades in Germany and Austria.
4. For information on the way in which the textbook *German Through Pictures* (Richards et al. [1953] 1956) works systematically with images, see Eder (2010).

BIBLIOGRAPHY

Achleitner, F. (1970a), 'die gute suppe' [1958], in F. Achleitner, *prosa, konstellationen, montagen, dialektgedichte, studien*, Reinbek b. Hamburg: Rowohlt, pp. 196–204.

Achleitner, F. (1970b), *prosa, konstellationen, montagen, dialektgedichte, studien*, Reinbek b. Hamburg: Rowohlt.

Artmann, H. C. (1985), 'other statistix. eine amerikanische montage' [1957], in G. Rühm (ed.), *Die Wiener Gruppe: Texte, Gemeinschaftsarbeiten, Aktionen*, new, enlarged edn, Reinbek b. Hamburg: Rowohlt, pp. 103–7.

Aspetsberger, F. (1973), 'Sprachkritik als Gesellschaftskritik: Von der Wiener Gruppe zu Oswald Wieners "die verbesserung von mitteleuropa. Roman"', in Institut für Österreichkunde (ed.), *Zeit- und Gesellschaftskritik in der österreichischen Literatur des 19. und 20. Jahrhunderts*, Vienna: Hirt, pp. 145–70.

Benjamin, W. (1969a), 'Theses on the Philosophy of History' [1940], in W. Benjamin, *Illuminations: Essays and Reflections*, ed. H. Arendt, trans. H. Zohn, New York: Schocken, pp. 253–73.

Benjamin, W. (1969b), 'The Work of Art in the Age of Mechanical Reproduction' [1936], in W. Benjamin, *Illuminations: Essays and Reflections*, ed. H. Arendt, trans. Harry Zohn, New York: Schocken, pp. 217–52.

Bourdieu, P. [1992] (1995), *The Rules of Art: Genesis and Structure of the Literary Field*, trans. S. Emanuel, Stanford, CA: Stanford University Press.

Buchloh, B. (2000), *Neo-Avantgarde and Culture Industry: Essays on European and American Art from 1955 to 1975*, Cambridge, MA: MIT Press.

Bürger, P. [1974] (1984), *Theory of the Avant-Garde*, trans. M. Shaw, Minneapolis, MN: University of Minnesota Press.

Deleuze, G. (1992), 'Postscript on the Societies of Control', *October*, 59 (Winter), pp. 3–7.

Eder, T. (2010), 'Friedrich Achleitners "gute suppe"', in *Hintergrund*, special issue *Friedrich Achleitner*, 80 (46/47), pp. 45–52.

Eder, T. and K. Kastberger (2000), 'Wien 50/60: Eine Art einzige österreichische Avantgarde', in T. Eder and K. Kastberger (eds), *Schluß mit dem Abendland! Der lange Atem der österreichischen Avantgarde*, Vienna: Zsolnay, pp. 5–26.

Enzensberger, H. M. (1984), 'Die Aporien der Avantgarde' [1962], in H. M. Enzensberger, *Einzelheiten II. Poesie und Politik*, Frankfurt am Main: Suhrkamp, pp. 50–80.

Fetz, W. and G. Matt (eds) (1998), *Die Wiener Gruppe*, exhibition catalogue, Vienna: Kunsthalle Wien.

Fischer, E. and G. Jäger (1989), 'Von der Wiener Gruppe zum Wiener Aktionismus: Problemfelder zur Erforschung der Wiener Avantgarde zwischen 1950 und 1970', in H. Zeman (ed.), *Die österreichische Literatur: Ihr Profil von der Jahrhundertwende bis zur Gegenwart (1880–1980)*, vol. 1, Graz: Akad. Druck- und Verlagsanstalt, pp. 617–83.

Foster, H. (1996), *The Return of the Real: The Avant-Garde at the End of the Century*, Cambridge, MA: MIT Press.

Gomringer, E. (1995), 'schweigen' [1954], in E. Gomringer, *vom rand nach innen: die konstellationen 1951–1995*, collected works, vol. 1, Vienna: Splitter, p. 19.

Gomringer, E. (1968), 'silence' [1960], in E. Gomringer, *The Book of Hours and Constellations*, trans. J. Rothenberg, New York: Something Else Press, n.p.

Heißenbüttel, H. (1972), 'Keine Experimente? Anmerkungen zu einem Schlagwort' [1965], in H. Heißenbüttel, *Zur Tradition der Moderne: Aufsätze und Anmerkungen 1964–1971*, Neuwied/Berlin: Luchterhand, pp. 126–35.

Horkheimer, M. and T. W. Adorno [1947] (2002), *Dialectic of Enlightenment: Philosophical Fragments*, ed. G. Schmid Noerr, trans. E. Jephcott, Stanford, CA: Stanford University Press.

Jandl, E. and F. Mayröcker (1971), 'Fünf Mann Menschen' [1967], in E. Jandl and F. Mayröcker, *Fünf Mann Menschen: Hörspiele*. Neuwied/Berlin: Luchterhand, pp. 23–40.

Krauss, R. (1981), 'The Originality of the Avant-Garde: A Postmodernist Repetition', *October* (Autumn), pp. 47–66.

Krauss, R. (1986), *The Originality of the Avant-Garde and Other Modernist Myths*, Cambridge, MA: MIT Press.

Lacan, J. (1978), 'The Unconscious and Repetition' [1964], in J. Lacan, *The Four Fundamental Concepts of Psychoanalysis*, New York: W. W. Norton, pp. 17–64.

Lüdke, M. W. (ed.) (1976), *'Theorie der Avantgarde' – Antworten auf Peter Bürger*, Frankfurt am Main: Suhrkamp.

McHale, B. (2016), 'The Long Sixties, 1954–1975', in B. McHale and L. Platt (eds), *The Cambridge History of Postmodern Literature*, Cambridge: Cambridge University Press, pp. 67–82.

Rancière, J. [1998] (2011), *Mute Speech: Literature, Critical Theory, and Politics*, trans. J. Swenson, London: Continuum.

Rancière, J. [2000] (2004), *The Politics of Aesthetics: The Distribution of the Sensible*, trans. G. Rockhill, New York: Columbia University Press.

Richards, I. A., I. Schmidt-Mackey, W. F. Mackey and C. Gibson [1953] (1956), *German Through Pictures*, New York: Pocket Books.

Rühm, G. (ed.), (1985a), *Die Wiener Gruppe: Texte, Gemeinschaftsarbeiten, Aktionen*, new, enlarged edn, Reinbek b. Hamburg: Rowohlt.

Rühm, G. (1985b), 'Vorwort' [1967], in G. Rühm (ed.), *Die Wiener Gruppe: Texte, Gemeinschaftsarbeiten, Aktionen*, new, enlarged edn, Reinbek b. Hamburg: Rowohlt, pp. 5–36.

Rühm, G. (1985c), 'lachen' [1958], in G. Rühm (ed.), *Die Wiener Gruppe: Texte, Gemeinschaftsarbeiten, Aktionen*, new, enlarged edn, Reinbek b. Hamburg: Rowohlt, pp. 152–4.

Schiller, F. [1795] (2016), *On the Aesthetic Education of Man*, trans. K. Tribe, London: Penguin.

Schuh, F. (1981), 'Protest ohne Protestieren: Zur Widersetzlichkeit von Konrad Bayers Literatur', *protokolle*, 4, pp. 31–43.

Weibel, P. (ed.) (1997), *die wiener gruppe – the vienna group: a moment of modernity 1954–1960/the visual works and the actions*, Vienna/New York: Springer.

PART II

MOVEMENTS AND AUTHORS

'A riot is the language of the unheard': Neo-Avant-Garde Poetic Uprisings in the Era of the Black Arts Movement

Antonia Rigaud

POETRY AS A 'RIVAL GOVERNMENT'

The intersection between poetry and politics in the United States was perhaps never as strongly debated as it was during the Civil Rights era, when poetry came as a response, continuation and accompaniment to the political struggles of African Americans. Art, and particularly poetry, became the locus of what William Carlos Williams called, in the era of the first avant-garde, 'a rival government' (quoted in Nielsen 2000: 214). Poets intervened in many of the struggles of the New Left, from anti-Vietnam War activism to the emergence of the counter-culture, giving poetry a public presence rarely seen in American culture. But the formative struggle of the time was the Civil Rights movement, and it was here that poetry most profoundly questioned the white norms at the base of the American social order. When, in August 1969, *Ebony*, a mass audience magazine for African Americans, consecrated an entire issue to *The Black Revolution*, a long article by poet Larry Neal was devoted to the Black Arts Movement, and another article to Amiri Baraka, aggressively thrusting the Black Arts Movement into American popular culture.

Conceived as an artistic continuation of the political struggle of Black Power, the Black Arts Movement offered a political as well as an aesthetic platform to allow new voices, or new poetic intonations, to be heard. Conceptualised through many manifestos and written declarations as well as a prolific and varied literary production, the movement mirrored the first avant-garde, adopting gestures from the poets of the Harlem Renaissance and white modernist poetry as well as from surrealism and the Dada movement, in search of new beginnings and poetic liberation. If all these first avant-garde movements shared an oppositional stance, it is the Harlem Renaissance which constitutes the closest connection with the Black Arts Movement's central conception

that 'it is radically opposed to any concept of the artist that alienates him from his community' (Neal 1968: 29). It sought to explore the notion of the *tabula rasa*: 'the Black Arts Movement proposes a radical reordering of the Western cultural aesthetic. It proposes a separate symbolism, mythology, critique and iconology' (Neal 1968: 29). The movement followed Ezra Pound's 'make it new' precept, but shifted its conception of the new as a prominently political concept, endowing it with strong urgency. For Joyce, like Eliot, Pound, and other high modernists, artistic renewal was to be performed in an exemplary exile from the homeland, but the Black Arts Movement sought to reverse this movement, to establish itself at the heart of the communities it catered to. Looking back at the first avant-garde, as a constellation of oppositional gestures[1] in order to find strategies to renew poetry and give it political momentum, the Black Arts poets seem to have been trying to create a synthesis between refusal and acceptance that is evocative of the manner in which Scheunemann defines the neo-avant-garde.[2] This synthesis is also one which conceived of the first avant-garde as bearing what Fred Moten calls 'a geographical-racial or racist unconscious' (2003: 31).

The de-monumentalising gesture of the first avant-garde has led to its own monumentalising, a fate that the Black Arts Movement did not share. At the same time, the first avant-garde sought the autonomy of the artwork, creating standards outside of the social context in which it was produced – a different perspective from that advocated by the Black Arts Movement, which saw in the ideology of the autonomy of the artwork a mask for the installation of Eurocentric standards or the erasure of the ironic force of 'signifying' in black culture and which saw itself as proposing a new melding of poetry and politics.

Two seminal neo-avant-garde poetic voices from the era, Gwendolyn Brooks and Amiri Baraka, exemplify the impact of contemporary politics and social conditions on a self-identified black poetic practice.

Amiri Baraka, while still known as LeRoi Jones, called for a poetics that would organise the convergence of the revolutionary and art and which is probably best illustrated by his 1964 collection *The Dead Lecturer* (Jones 1964) – a charge against White America as well as the established order of poetry. One of his most famous poems, 'Black Dada Nihilismus' (1963), was published in the collection and testified to his ambition to combine poetic and political shock. In 1950 Gwendolyn Brooks became the first African American to win a Pulitzer prize for what the jury called a 'poetry of her own race, of her own experiences, subjective and objective, and with no grievance or racial criticism as the purpose of her poetry' (Canby 1950: n.p.). In stark contrast to the manner in which the Pulitzer jury presented her poetry, she wrote her three-part poem *Riot* in 1969, as a response to actual upheavals as well as a call to a poetry

from the street. The two poets came from two distinct lines of avant-garde poetics – Brooks being in the Harlem Renaissance and Langston Hughes line of what Steven S. Lee (2015) has called the 'ethnic avant-garde' and a focus on the everyday experience of African American life; Baraka coming from the mostly white surrealist and beat-oriented New York City avant-garde of the early 1960s.[3] In 1967, when Brooks met Baraka at the second Fisk University conference on Black Arts, it must have seemed possible that Brooks would go on to reprise the universalist approach taken by Robert Hayden at the 1966 conference, when, famously, he provoked black separatists by proclaiming that he 'happened to be a Negro', but that he had a perfect right to enjoy and use, for instance, the Irish poetic tradition.[4] Yet Brooks did not end up defending a universalist position. She was impressed by Baraka's plea for a black poetic practice aimed at a black audience and proceeded to orientate her own poetry in that direction.

The assertion of a black poetics in the 1960s, one specifically relevant to a black audience, inevitably dealt with violence. The riots of the era, and the turn to a more militant Civil Rights movement which led to the emergence of the Black Panthers, was reflected in the poems of both Brooks and Baraka, whose poetic voices call on their readers to think of this violence dialectically as coming from the established order of mainstream America as well as the uprisings of the time. Their poetry practises a literal avant-garde march against the violence of the era, calling for a reassessment of the notions of poetic and political violence as well as of linguistic violence.

The title of Brooks's collection, *Riot*, pays heed to the vocabulary and reality of insurrection in the United States in a decade marked by social unrest and upheavals. If Martin Luther King's legacy is that of a nonviolent leader, it is important to remember that he reflected on the realities of uprisings a few weeks before his death, making it the theme of his 'The Other America' speech delivered in a climate of great tension on 14 March 1968 at Grosse Pointe High School, located in a predominantly white, upper-class city. In this speech, King conceptualises the notion of a riot as 'the language of the unheard', a phrase borrowed by Gwendolyn Brooks for the epigraph of her collection. King's words still resonate today with great force, presenting riots as a reaction to the violence imposed by society on its minorities, a taking of action in the hope of seeing one's own conditions acknowledged and heard:

But it is not enough for me to stand before you tonight and condemn riots. It would be morally irresponsible for me to do that without, at the same time, condemning the contingent, intolerable conditions that exist in our society. These conditions are the things that cause individuals to feel that

they have no other alternative than to engage in violent rebellions to get attention. And I must say tonight that a riot is the language of the unheard. And what is it America has failed to hear? [. . .] It has failed to hear that large segments of white society are more concerned about tranquillity and the status quo than about justice and humanity. (King 2016: 2)

Beyond the socio-political dimension of these lines, it is striking how King speaks like a poet, calling on the appropriation of a language forceful enough to be heard despite 'America' refusing to hear it. The definition of 'riots' given in this speech is about defining uprisings as a poetic strategy, to demand one's rights in a language that would finally be heard, listened to and that would ultimately be effective in its political demands. The transition, in King's lines, from politics to what one could call poetry, or the power of language, is evocative of the strong connection between politics and poetry that was current at the time. King does not condemn riots in these lines but envisions them in the broader picture of America's moral failing. The emphasis laid on the 'concern with tranquillity' of white America suggests a turning around: the term 'riot', often employed in the mainstream news to underline the unheeded violence of lawless mobs, is here reversed and laid at the door of a 'tranquil' white populace who have created and abetted the problem of black poverty and powerlessness. King is here calling for a redefinition of terms, a reappraisal of the word 'riot' not as equalling destruction and lawlessness but rather as a response to a country deaf to the plight of its people. King suggests that the terminology of uprisings is inseparably part of the political struggle: the everyday function of language is understood as political. He both demystifies the vocabulary of the white media and puts expression and hearing, call and response, at the heart of his political message.

Adopting King's quotation and the word 'riot' as her title allowed Brooks to create a kinship between her poetry and his political fight, thus situating the fight, also, within the realm of poetry, making poetry the locus of a reflection on political conditions while opening it to political activism. The collection plays on the word 'riot', relying on signifying – the 'double-voiced black tradition' defined by Henry Louis Gates as one of 'double-voiced texts that talk to other texts' (1988: xxv)[5] – in order to reconsider our conceptions of what a riot actually involves, politically and linguistically.

This chapter seeks to consider the signifying of violence in the Black Arts Movement era through the prism of Baraka's 'Black Dada Nihilismus', published in *The Dead Lecturer*, and Brooks's *Riot*. Looking at the poetic personas created by Baraka and Brooks as tricksters in the tradition of signifying allows us to see that the neo-avant-garde of the Black Arts Movement entered into dialogue with the

first avant-garde, presenting a renewed and perhaps more concretely politicised vision of their forebears' poetic experimentations. These two contrasting figures, one a flamboyant black nationalist, the other a surprising convert to black radicalism, responded to political unrest by transforming the way they wrote poetry, 'trying to take the language someplace else, just as King and Malcolm were trying to take the whole society someplace else' (Baraka 1989: xi).

'IT'S NATION TIME': POETIC AND POLITICAL TURNING POINTS

Baraka's call to poetic and political insurgency in the 1972 poem 'It's Nation Time' illustrates how the two poets' trajectories are marked by moments of crises, leading to the renunciation of their earlier careers, readers and institutions in favour of poetic explorations of their own communities. Both followed different prophetic figures – Malcolm X for Baraka and Martin Luther King for Brooks – whose assassinations prompted a radical re-evaluation of their poetic practice. The assassination of Malcolm X on 21 February 1965 prompted LeRoi Jones to create the Black Arts Repertory Theater and School as well as to change his name, thus pursuing the movement away from his previous life which started with his trip to Cuba in 1960. He documented his trip in the essay 'Cuba Libre', which marked the beginning of his disassociation from the New York beat scene; he explained in his *Autobiography*: 'having outintegrated the most integrated, [he] now plunges headlong back into what he perceives as blackest, native-est' (Baraka 1984b: 202). *The Dead Lecturer* was published under the name LeRoi Jones in 1964 and presents a shift away from the beat poets and the practice of a new, much more political and fiercer voice, one that becomes more communal than in his earlier poetry, welcoming, in particular, the art of avant-garde jazz as not only an accompaniment, but as a semantically equal partner.

Brooks, who was fifteen years older than Baraka, followed his lead in the search for a more authentic poetic and political experience. Her reaction to King's assassination on 4 April 1968 was to write *Riot* for which she terminated her association with Harper and Row in favour of poet Dudley Randall's small Detroit Broadside Press. The symbolic gesture, for a Pulitzer Prize poet and poet laureate of Illinois to leave her mainstream white publisher in favour of a small press which specialised in affordable publications of contemporary African American poets, was a strong expression of solidarity with the avant-garde political culture of black America.

While *Black Fire*, the 1968 anthology of the Black Arts Movement edited by Baraka and Larry Neal, was published by a mainstream publishing house and

sought to present the new aesthetic to a white and black mainstream reader-
ship, Baraka and Brooks mostly tried to situate their new poetics within new,
community-connected institutions. To do this entailed physical displacement
(in Baraka's case, from Greenwich Village to Harlem, and ultimately to
Newark) and new platforms. Both immersed themselves in African American
communities and attuned themselves to the lively black popular culture of the
time: from the Motown lyrics that seeped into Brooks's poems to the jazz and
blues with which Baraka associated and sometimes recorded. *Riot* sets its scene
in the aural landscape of the Chicago radio 'Voice of the Negro', bringing to
the fore the names of 'James Brown / and Mingus, Young-Hold, Coleman,
John, on V.O.N.' (Brooks 1969: 14), thus alluding to the important role the
medium played in creating a deep sense of community within the Chicago
African American population. The community is defined earlier in opposition
to mainstream America: 'They will not steal Bing Cosby but will steal / Melvin
Van Peebles who made Lillie / a thing of Zampoughi a thing of red wiggles and
trebles' (Brooks 1969: 13). In a similar movement, Baraka chants his 'Black Dada
Nihilismus' as a jazz anthem,[6] through repetitions and variations while celebrat-
ing the full landscape of African American popular culture: 'For Jack Johnson,
asbestos, tonto, buckwheat, billie holiday' (Baraka 1993: 73). Here aspects rang-
ing from boxing with Jack Johnson, to the music of Billie Holiday – along with
the stereotypical characters of Asbestos, Tonto or Billie 'Buckwheat' Thomas –
are extracted from the white gaze and returned in a classic signifying gesture.
The two poems are deeply rooted in African American popular culture which
they celebrate and use to signal the poems' intended audience.

Moving to the margins of the mainstream proved at once a liberating ges-
ture from the institutions' expectations and one that had its limits in the shorter
reach of the distribution system of the presses. The intention was to reach a
new audience that was familiar with the complexities of popular song and the
blues, but that felt alienated from poetry. In the process, radical thought would
be matched to literary experimentation. As Brooks wrote:

> My aim, in the next future, is to write poems that will somehow success-
> fully 'call' (see Imamu Baraka's 'SOS') all black people [. . .]. I wish to
> reach black people in pulpits, black people in mines, on farms, on thrones;
> not always to 'teach' – I shall wish often to entertain, to illumine. (Brooks,
> quoted in Kent 1990: 211)

This quotation reads as a response of sorts to Baraka's 'dead lecturer' whose
texts also seek not to 'teach' or lecture but rather to 'illumine' and 'entertain'.
Both conceived of their poetry as a 'call', whose form would have to espouse

the dissonant ethos of the time, as Brooks explained in a 1973 interview: 'This does not seem to be a sonnet time. It seems to be a free verse time, because this is a raw, ragged, uneven time . . . I want to reach all manner of black people. That's my urgent compulsion' (Gales 2003: 68). Baraka's poetry bears the same sense of urgency and conditions form to the expression of energy.

Baraka's 1960 poem 'Betancourt' reflects on literary influences and illustrates the neo-avant-garde gestures of both Baraka and Brooks at the time their poetry took a turn towards a more radical politics and poetics. Opening with the question 'What are influences?', the poem concludes that poetry is about refusal: 'I think I know what a poem is: a turning away / a madness' (Baraka 1995: 37, 41), a turning away which both he and Brooks practised in their lives as well as in their writing at the time of the Black Arts Movement. They both 'turned away' from their previous poetry in order to try to get closer to their community, to imprint their poems with a much deeper notion of the collective. Their art brings together poetry and politics, in a continuation of the first avant-garde of the Harlem Renaissance, but at a time when the emergence of the Civil Rights movement represented an opportunity to deepen the links with African American readers through politics.

'POEMS THAT KILL': THE AESTHETICS OF LOUDNESS

Baraka's 1965 'Black Art' called for 'poems that kill', a call to insurrection which is shared with Brooks's *Riot*, despite the latter's reputation as a much more conservative poet. Both 'Black Dada Nihilismus' and *Riot* explore death and violence as poetic tropes, allowing the poets to mark their new radical political perspective and to install their art as a poetry of loudness, a thunderous call against the established mores of poetry and politics, as well as a response to the stereotype of blackness as associated with loudness.

'Black Dada Nihilismus', a poem chanted by Baraka, expresses the rage of the 'Black scream / and chant, scream, / and dull, un / earthly / hollering' (Baraka 1993: 72). The poetic voice moves between moments of silence and loud utterances, using notably lists as a way of gathering momentum towards the release of the violent tension that is the foundation of the poem. The scream of rage reads like a Dada poem, often challenging the reader's understanding, yet the word 'nihilismus' illustrates that it is a historical assessment of the plight of African Americans as well as all victims of Western colonialism and slavery: 'a moral code, so cruel / it destroyed Byzantium, Technochtitlan, Commanch' (Baraka 1993: 73). The poem is a collage of different poetic forms, exploring metric and rhythmic distortion, involving the reader/listener in its rush of rage.

Riot functions around a similar movement between tension and release: it is composed of three parts which follow the disordered event of the Chicago riots, focusing first on an imaginary white character, John Cabot who meets his death in the middle of the riot, then on vignettes showing the death of a mother ('A woman is dead. / Motherwoman.', Brooks 1969: 16), and the movements of the crowds, allowing us to hear a multitude of voices ('the Black Philosopher', 'the White Philosopher', unnamed individuals in the crowds, gang members, and newspaper snippets), while the poem's last section is a return to love and quiet ('We go / in different directions / down the imperturbable street', Brooks 1969: 22). Its narrative arc is thus fairly straightforward but the reader's sense of the narrative is overcome by the many different vignettes that decompose the riot into small units which tend to blur the general meaning. The reader is made to experience the chaos and violence of the riot while also getting inside the rioters' minds, in a similar way as 'Black Dada Nihilismus' seeks to create a sensory experience of rage.

Both poems experiment with extreme violence and stage disturbing deaths. Baraka wrote that 'The Black Artist must teach the White Eyes their deaths' (1993: 170), a line which calls to mind Gwendolyn Brooks's killing of the white character John Cabot in the first part of *Riot* as well as the disturbing lines in 'Black Dada Nihilismus' which have made the poem be remembered as the one where Baraka calls for the 'rape and death of the white man and his daughters'. The presence of death, at the heart of these politically conscious poetic experiments, is informed by the context of violent killings at the time: Brooks had written about the killings of African Americans, such as the murders of Emmett Till or Medgar Evers. There is a sense of deep violence that aligns these poems, and others in this period, with André Breton's definition of the quintessential surrealist act: 'the simplest Surrealist act consists of dashing down into the street, pistol in hand, and firing blindly as fast as you can pull the trigger, into the crowd' (1969: 125).

'Black Dada Nihilismus' is indeed typical of Baraka's violent poetics: his poems are calls to arms for an African American audience but also practise violence against their (white) audience, saturating the poem with brutality in order to hurt the reader. The death of the white man imagined by Brooks or Baraka's call to murder and rape creates a barrier between the poems and their readers and critics. The poems' shock value is part of an avant-garde strategy on the poet's part, to refuse access to the text. The texts' physical violence is to be understood as hyperbolic calls to the readers' attention: in both cases, killing functions as a distancing tool, an irony, that separates the poet from the audience.

The violence of the poems creates a loudness, an avant-garde distemper, which introduces sound waves into the politics of race in America, calling for a

reappraisal of who gets to speak and be heard. The poets paved the way for the popular slogan of the period sung by James Brown in 1968, 'Say it loud, I'm black and I'm proud', politicising loudness as a sonic weapon in the struggle. Loudness here belongs to a form of signifying, taking a term which belongs to white stereotypes about African Americans and turning it around so it becomes a weapon.

One of the striking common points between Brooks and Baraka is to be found in the way both question the traditional connection between poetry and beauty. Brooks opens *Riot* on a vignette introducing the reader to the racist mind of this first part's central character John Cabot, looking at the rioting crowd. The narrative voice takes over the racist white man's mind, which has 'almost forgot' the luxuries that have endowed him with privilege. The poetic voice takes over and gives an account of the crowd that seems to be a translation of John Cabot's racist and terrified perception:

> Because the Poor were sweaty and unpretty
> (not like Two Dainty Negroes in Winnetka)
> And they were coming toward him in rough ranks.
> In seas. In windsweep. They were black and loud.
> And not detainable. And not discreet.

> (Brooks 1969: 9)

The crowd is 'loud'. The stanza's negative forms are both a presentation of John Cabot's prejudice and a poetic attempt at bringing forward the necessary 'unpretty' dimension of political action. In its polyphony, the poem lets us hear John Cabot's ironic sacrificial ending or the imagined reaction of (white) onlookers – 'But WHY do These People offend *themselves*?' – as well as the voice of gang members, quoting Richard 'Peanut' Washington, 'a Ranger and a gentleman' (Brooks 1969: 19, 18). Brooks's parody of white speech and the reversal of expectations, calling the gang member a gentleman, participates in the rhetoric of signifying which she uses throughout the poem, throwing words at the reader to destabilise expectations and prejudice, engineering with these words a sonic landscape that is parallel to the visual riot. The poet inverts the mainstream narrative on gang members as thugs, suggesting that Washington 'will not let his men explode' (Brooks 1969: 18). As she had done in her poems on the Blackstone Rangers in *In the Mecca*, Brooks humanises the gangs who are seen as a potentially positive protest force, in the same way as King had imagined when he went to Chicago in 1966 to try to organise the gangs. The poem also responds to the way the newspapers covered the riots, such as the *Chicago Tribune*, which metaphorised the upheavals as 'the crucifixion of a

city' (Risen 2009: 195). The poem throws back at the newspaper its own more toned-down prosody – subtly underlining a white loudness that was allowed according to the codes of segregation in America.

'Black Dada Nihilismus' allows us to hear a voice that is much less narrative than the one in *Riot* yet the poem's incantatory tone allows room for the poet's voice to address its readers directly: 'Why you stay, where they can / reach?' (Baraka 1993: 72). David Grundy has interpreted the poem's great complexity as both 'an impersonation of an impersonation, a minstrel stereotype turned back on its creators' (2019: 79) and as a response to the lack of political involvement of the poet's circle (2019: 79–82); a reading which shows the poem's self-consciousness and allows the poem to underline its violence as a strategy against the art establishment of the time.

The two poets rely on a sonic weapon, where the loudness of the images combines with the sensationalised images of the press, inviting their African American audiences to listen to loudness as a form of social dissonance, a loud call to action, and their white audiences to realise that they need to recognise the loud aesthetic rather than dismissing it as pure discordance.

Baraka and Brooks seem to be responding not only to the storm of events in the Civil Rights era, but also to the first avant-garde. Baraka's tools are on the side of the beat poets and surrealism or the Dada movement; the increasingly discordant and disjunctive jazz of the sixties was also an important model, to Baraka, of what could be done with language. Brooks was closer to Langston Hughes, but also Carl Sandburg or T. S. Eliot: *Riot* is an ode to Chicago which seems to echo *The Wasteland* with its collage structure, the intervention of the Tiresias-like voices of the 'philosophers' and its second section's title, 'The Third Sermon on the Warpland'. Baraka and Brooks enter in dialogue with Eurocentric art forms,[7] which are used as weapons for a political struggle deeply grounded in the historical reality of the time. The proponents of the Black Arts Movement, 'the idol smashers of America' (Gayle 1971: 105), sought to destroy what Amiri Baraka called the 'Anglo-Eliotic domination of the academies' in the 1963 introduction to his anthology, *The Moderns* (1963: 96). Both Baraka and Brooks use avant-garde strategies but seek to strip them of the academic and institutional aura they had acquired in order to produce a poetry of raw loudness.

In his heated debates with Henry Louis Gates Jr. in the *New York Times* at the time of the publication of *The Autobiography of LeRoi Jones*, Baraka explained his poetic project as a linguistic endeavour: 'I did not want to be an imitator of neo-English but an originator of original African-American' (Baraka 1984a). The emphasis on origin returns him to the intentions of the first avant-garde and its quest for a *tabula rasa* and for originality, something which Brooks also sought to do through polyphony. Both sought to evict old

forms – poems made either of dialect or of a 'genteel' language – and to replace them with the rhythms of the streets, with a renewed attention to language and to the American idiom.

'DISCREPANT ENGAGEMENTS': EXPERIMENTATION AND ACCESSIBILITY

Baraka and Brooks put their work at the service of a community seeking to articulate its feeling of rage and dispossession. Having trained themselves in the techniques of modernism – collage, intertextuality, irony, the use of hyperbole and caricature – they publicly turned away from the apparatus of the mainstream white American cultural industry to explore the 'language of the unheard'. The way they signified that term called for different tools that operated all the tonal resources they had at their disposal. If an act of violence against a regime of violence could be seen as a language that evolves from a breakdown in language – from speakers who went from being unheard to 'too loud' by the measure of the largely white institutions – then the poet who is part of the unheard – a black poet – is performing a political act by working on the boundaries of the heard and the unheard. In particular, the shock tactics of an avant-garde that persistently segregated black artists while appropriating black culture (slang, the rhythms of jazz and blues, radio sounds, etc.) could be appropriated to create a 'listening', even if the charge of listening shifted to an urban black audience, to workers, housing project residents, gang leaders, and the like. The poem could become a crossroads for linguistic and political insurrection.

Although, rhetorically, both poets resign from the avant-garde culture that nourished a media-centred, abstracted sense of art, in reality the high modernist tradition and Baraka's 'populist modernism' (Nielsen 2000: 322) still communicated with each other. This is a poetry that makes it hard for the reader to capture, since it seems to rush at us, annulling the distance we expect in poetry. Here the language is always a surprise, following Baraka's wish to make 'words surprise themselves' (Mackey 1993: 275). Avant-garde practices and politics run the danger of being too intelligible and of losing linguistic surprise or unintelligibility and therefore failing to convey meaning. The body of work of Amiri Baraka and Gwendolyn Brooks, in the Black Arts period, is an attempt to forge a language that negotiates between accessible meaning and references and a difficult form which would keep mainstream appropriations at bay. They both seek full engagement with their audience and provocation, creating a poetic experience that corresponds to the way Mackey defines the concept of 'discrepant engagement': a form which 'accents fissure, fracture, incongruity, the rickety, the imperfect fit between word and world' (1993: 19). That vibrational sense

of being is subsumed in the aesthetic of 'loud'. It is not enough to be 'heard' – inasmuch as the controllers of hearing are still firmly in their places. What 'loud' does is undermine the control of hearing, of who gets heard.

Baraka and Brooks bring violence, killings and linguistic violence to the heart of the poem so as to allow for true protest literature. They were in dialogue with what Baldwin criticised about protest literature: 'The avowed aim of the American protest novel is to bring greater freedom to the oppressed. They are forgiven on the strength of these good intentions, whatever violence they do to language' (1994: 13). Baldwin was indicting flat language, clichéd appeals to an unquestioned moral code. Instilling violence at the heart of the poem is part of righting wrongs made to literature and to language by a too literal tradition of protest. Nathaniel Mackey explains the importance of refusing simple writing: 'My view is that there has been far too much emphasis on accessibility when it comes to writers from socially marginalized groups [. . .]. It has yet to be shown that such simplifications have had any positive political effect' (1993: 17–18). Both poets are close to Mackey's position, which calls for a reappraisal of all avant-gardes (black and white) to be considered together as well as for a poetry of counter-accessibility where the poet seeks to be rejected by the white mainstream and accepted by a black audience, remaining 'discrepant' while at the same time being able to gather around them a community of engaged individuals. 'Black Dada Nihilismus' and *Riot* seem to manage to hold this difficult position, resting on the crest of accessibility and inaccessibility.

What Baraka and Brooks sought to do during the era of the Black Arts Movement was to liberate political poetry from the prescriptions of literal meaning, understatement, a certain plain speech, and simplicity, which did not correspond to the music, the street language, or the political movement of Black America in the late 1960s. Baraka's hyperboles, Brooks's caricatures and collages were meant to liberate poetry from the heritage of the first avant-garde by a renewed focus on the intentions of the avant-garde and experimentation outside of the smothering shelter of the institutions (museums, small journals, academia) in which the American avant-garde had taken refuge. Looking towards less structured, less regulated venues – for instance, in encountering the Blackstone Rangers, a street gang, or creating popular theatre in Harlem and Newark – Brooks and Baraka were shifting the audience, the listeners, that would process what they had to say.

'THE CHANGING SAME': THE BLACK ARTS MOVEMENT AS NEO-AVANT-GARDE

In the radical politics of the 1960s, these two poets achieved a synthesis of intention: an attempt to get a 'listening' from a popular black audience. In the end,

both poets moved on, artistically – while never denying the overall purpose that had sustained their change of aesthetic position. They both articulated a similar desire to destabilise the canon and the poetic establishment. In turning their backs on the mainstream and creating a poetry of killings, shock and loudness, they sought to riot, poetically, against the constraints of the institutions that sustained poetry in America. This gesture, in part, seems to re-enact the overthrow of the poetic establishment by the first avant-garde, yet it becomes much more urgently connected to the political realities of the time than was possible in the early twentieth century through its relation to the Civil Rights movement.

The aesthetic of loudness might seem to fetishise raising the tone, but in fact, the scream is, among other things, a strategy. By screaming one can divert white attention, the attention, at least, of those who are the most authorised listeners, allowing for the passage of other meanings, and to make readers hear 'the language of the unheard' through poetic riot. From the blasts of the First World War to those of the 1960s riots, from the first avant-garde to the neo-avant-garde of the Black Arts Movement, Baraka and Brooks belong to a tradition of loudness and dissonance, tropes they appropriate and return to the white poetry establishment in order to create a new avant-garde that would give the truest possible expression to the African American experience.

Baraka and Brooks both practise an insurrectional form of poetry which seeks to infuse new energy into experimental and avant-garde poetic practices. Their neo-avant-garde poetry echoes many of the facets of the first avant-garde: a community of poets seeking to destabilise the status quo, believing in the power of art to transform art and society. In her early twenty-first-century reflections on the 1960s and on her friend Baraka, Adrienne Rich explains: 'There is no progress – political or otherwise – in poetry, only riffs, echoes of many poems and poets speaking into the future and back towards the past' (2010: 122). The Black Arts Movement, as represented in 'Black Dada Nihilismus' and *Riot*, practises a continued riff on earlier poetic activity, yet introduces a louder frequency which sought to give new energy to avant-garde practices and their intersections with politics.

NOTES

1. See the Introduction to this volume, p. 11.
2. See the Introduction to this volume, p. 13.
3. Looking back on his New York years, Baraka emphasised the mainstream and white nature of his milieu, but it should be noted that this assessment leaves out his deep involvement with the Umbra poets.
4. James C. Hall gives a detailed account of the controversies of the Fisk conferences in *Mercy, Mercy Me* (2001).

5. Gates presents signifyin(g) 'as the rubric of various sorts of playful language games, some aimed at reconstituting the subject while others are aimed at demystifying a subject' (Gates 1988: 60).
6. A sung version of the poem by Baraka with the New York Quartet is available at <https://www.youtube.com/watch?v=98oK6zZXmQw> (last accessed 1 February 2021).

 David Grundy also notes that Baraka made a performance of the poem as part of a set with Gwendolyn Brooks at the Asilomar Negro Writers Conference in 1964 (2019: 70).
7. Those forms, whitened as they were, contain within them borrowings and dialogue with non-European forms, from Picasso's use of African sculpture to Artaud's use of Balinese Shadow theatre.

BIBLIOGRAPHY

Baldwin, J. (1994), *Notes of a Native Son*, New York: Bantam.

Baraka, A. (1963), *The Moderns: An Anthology of New Writing in America*, New York: Corinth Books.

Baraka, A. (1984a), 'Answer to Henry Louis Gates', *New York Times*, 8 April, p. 102.

Baraka, A. (1984b), *The Autobiography of LeRoi Jones/Amiri Baraka*, New York: Freundlich Books.

Baraka, A. (1989), 'Foreword', in L. Neal (ed.), *Visions of a Liberated Future*, New York: Michael Schwartz, pp. ix–xix.

Baraka, A. (1993), *LeRoi Jones/Amiri Baraka Reader*, New York: Basic Books.

Baraka, A. (1995), *Transbluesency: The Selected Poems of Amiri Baraka/LeRoi Jones (1961–1995)*, ed. P. Vangelisti, New York: Marsilio Publishers.

Breton, A. (1969), 'Second Manifesto of Surrealism', in A. Breton, *Manifestoes of Surrealism*, Ann Arbor, MI: University of Michigan Press, pp. 117–87.

Brooks, G. (1969), *Riot*, Chicago: Broadside Press.

Canby, H. S. (1950) 'Letter to Dean Carl W. Ackerman', <https://www.pulitzer.org/article/frost-williams-no-gwendolyn-brooks> (last accessed 30 August 2020).

Gales, G. J. W. (2003), *Conversations with Gwendolyn Brooks*, Jackson, MS: University Press of Mississippi.

Gates, H. L. (1984), 'Review of *The Autobiography of LeRoi Jones/Amiri Baraka*', *New York Times*, 11 March, Section 7, p. 11.

Gates, H. L. (1988), *The Signifying Monkey: A Theory of African-American Literary Criticism*, Oxford: Oxford University Press.

Gayle, A. (1971), 'Cultural Strangulation: Black Literature and the White Æsthetic', in A. Gayle, *The Addison Gayle Jr. Reader*, ed. N. Norment Jr., Champaign, IL: University of Illinois Press, pp. 101–6.

Grundy, D. (2019), *A Black Arts Poetry Machine: Baraka and the Umbra Poets*, London/New York: Bloomsbury.

Hall, J. C. (2001), *Mercy, Mercy Me*, Oxford: Oxford University Press.

Jones, L. [A. Baraka] (1964), *The Dead Lecturer*, New York: Grove Press.

Kent, G. E. (1990), *A Life of Gwendolyn Brooks*, Lexington, KY: University Press of Kentucky.

King, M. L. (2016), *On 'The Other America' and Black Power*, Boston, MA: Beacon Press.

Lee, S. (2015), *The Ethnic Avant-Garde: Minority Cultures and World Revolution*, New York: Columbia University Press.

Mackey, N. (1993), Discrepant Engagements: Dissonance, Cross-Culturality and Experimental Writing, Cambridge: Cambridge University Press.

Moten, F. (2003), *In the Break*, Minneapolis, MN: University of Minnesota Press.

Neal, L. (1968), 'The Black Arts Movement', *The Drama Review: TDR*, 12 (4), pp. 29–39.

Neal, L. (1969), 'Black Art and Black Liberation', *Ebony: The Black Revolution*, August, pp. 54–6.

Nielsen, A. (2000), *Reading Race in American Poetry: An Area of Act*, Athens, GA: University of Georgia Press.

Rich, A. (2010), *A Human Eye: Essays on Art in Society, 1997–2009*, New York: W. W. Norton.

Risen, C. (2009), *A Nation on Fire: America in the Wake of the King Assassination*, Hoboken, NY: John Wiley & Sons.

12

The Neo-Avant-Garde in Latin America:
The Case of Mario Bellatin

Ilse Logie

THE AVANT-GARDE AND NEO-AVANT-GARDE IN LATIN AMERICA

So-called historical avant-garde movements, especially surrealism and Dadaism, have played a crucial role in Latin American art, and thus also in Latin American literature. Although the result of genuine transatlantic encounters, they have been largely ignored in international discourse because of the persistence of traditional disciplinary boundaries in academia. Representative yet diverse examples can be found in the Creacionist poetics founded by the Chilean Vicente Huidobro in the early 1910s, the Ultraist Argentine magazine *Martín Fierro* to which Jorge Luis Borges was closely linked in the 1920s, the Brazilian Anthropophagic Movement with its creative use of the cannibalistic metaphor coined by Oswald de Andrade (1928), and the work of César Vallejo, Peru's most prominent vanguard poet.

An important body of secondary literature has been published on the multifaceted cultural activity of these movements and key figures. Recent research, however, approaches the Latin American avant-garde from a substantially different perspective to the key interpretations from the second half of the twentieth century. In his well-known treatise *Los hijos del limo* (1974) (translated into English as *Children of the Mire: Modern Poetry from Romanticism to the Avant Garde*, 1991), Octavio Paz analysed the avant-garde as 'the tradition of the break'.[1] In line with Peter Bürger's theory of the avant-garde's gradual appropriation within a capitalist framework, Paz claimed that his generation was witnessing the end of that tradition and, by implication, the end of the whole concept of modernity as it has been understood since Romanticism. Despite recognising their specificity, Paz essentially links Latin American manifestations of avant-garde poetry to developments in Europe, internalising a metanarrative of modern art as universal.

The aforementioned critical shift was already visible in Ángel Rama's seminal work, first in his article 'Las dos vanguardias latinoamericanas', originally published in 1973, and later in his study *Transculturación narrativa en América Latina* (1982) (translated into English as *Writing Across Cultures: Narrative Transculturation in Latin America*, 2012). Rama highlights the existence of avant-garde writers who worked along a different axis. Unlike Huidobro and Borges, whose projects simultaneously rejected global Western hegemony but adapted the European cultural values and worldviews to their local context, the projects of writers such as César Vallejo and Roberto Arlt emerged from the continent's own historical circumstances. In doing so, they laid the foundation for the artistic practice Rama calls 'transculturation', that is, the combination of experimental techniques with intrinsic Latin American hybridity or *mestizaje*. This transculturation evolved on its own terms and reached its full potential in the work of such modern classic writers as Juan Rulfo, José María Arguedas and Nicolás Guillén.

From the 1990s onwards, several scholars have criticised still more fiercely this opposition between Eurocentric universalism and Latin American otherness. In doing so they look to transcend both the dominant evolutionary or genealogical model of the historical avant-garde's development – according to which Latin America is considered merely as a recipient of these tendencies – and opposing interpretations which read the Latin American avant-garde in autochthonous terms.[2] Art historian Andrea Giunta is one such critic. In her recent essays on contemporary art (for instance, Giunta 2007), she advocates a complete rethinking of the very subject addressed by this book: the neo-avant-gardes of the 1960s through the 1980s, as well as their subsequent contemporary forms. Giunta wants to dismiss once and for all the persistence of the neo-colonial model of the centre and the periphery, which reads Latin American neo-avant-gardes as an echo of an echo, a belated gesture. Her primary concern is that reinterpretations of the historical avant-garde enacted by neo-avant-gardes in Europe and the US, although often seen as would-be advanced avant-gardes that have lost their authentic aesthetic and political possibilities, are to some degree considered original contributions, whereas those produced outside these centres are evaluated as anachronistic derivatives. Contrary to what has been stated by Paz, for instance, Giunta does not believe the neo-avant-garde operating in Latin America is a failed project or a story of decline. In her view, Latin American art 'is not the illegitimate child of modernity but rather the locus of its subversion by simultaneous avant-gardes, which contribute to a reconfiguration of the very concept', as she puts it in an article co-authored with George Flaherty (Giunta and Flaherty 2017: 125). Taking the Arte Destructivo ('Destructive art') exhibition at the Galería Lirolay in Buenos Aires in November 1961 as a case in point, Giunta argues that this event can be more accurately understood

if it is associated with similar exhibitions that were held simultaneously in mainstream artistic centres such as New York and London. In doing so she favours a comparative approach to the neo-avant-gardes in order to enhance the visibility of artistic practices which often remain hidden in conventional narratives of modern or contemporary art. According to Giunta and Flaherty, this is why we should rethink the neo-avant-garde in terms of synchronicity and transnational connectedness, as a counterpart to the teleological structures which still prevail in the history of a predominantly anglophone and Eurocentric modern art. Such a comparative approach is also why we should draw attention to exchanges that move from the south to the north as well as horizontal exchanges (south–south) that move between Latin American 'hubs', and which are characterised by their own temporality. An episode like the Cuban Revolution (1953–9) was, for instance, more significant for Latin American art than the Second World War because it renewed the concept of utopia but also redefined notions of international culture in the sixties (Giunta and Flaherty 2017: 129).

Giunta explicitly connects her views on the neo-avant-garde with Hal Foster's 'return' thought, understood as a revision of Bürger's idea of a 'closing off': the neo-avant-gardists of the 1960s to the 1980s did not renounce the critical potential nor the potential for renewal within the historical avant-gardes, but rather returned to it as shared material, which she calls 'an archive'. Following a non-linear conception of the avant-garde, these repeated returns to the historical avant-gardes instigated by neo-avant-garde movements are not a sign of exhaustion but of productive continuity. In other words, past avant-garde practices have been and are still being redeployed, critically reinvigorated and reactivated from Latin America; in each instance, they display their own temporality.

To Giunta, the highly politicised art scenes that emerged in the 1960s, 1970s and 1980s were not a matter of dependency but of agency: they aimed to act as agents of social transformation. They were also highly connected movements with a radical character that developed in New York and Paris as well as in Bogotá and Mexico City, each time responding in their own particular way to a specific context. These were projects of historical re-evaluation, revision, experimentalism and anti-institutionalism, a situation not immune to the revolutionary climate of the period. Many initiatives used the critique of cultural, political and economic institutions as a device to fuse art with alternative societal projects, or to penetrate and subvert the repressive machinery of the state during periods of military rule. That way, critical structures (in the form of underground movements) could continue to exist and resist, in spite of the political situation. The Colectivo Acciones de Arte (CADA, Collective of Art Actions), also called Escena Avanzada, which

fought the Chilean Pinochet regime through performances and happenings, serves as a good example. Founded in Santiago in 1979, its members (Diamela Eltit, Raúl Zurita and Lotty Rosenfeld, among others) used interventions in everyday life to question the institutional frameworks in which conventional art was validated.

Contrary to the visual arts where the term is commonplace, the term 'neo-avant-garde' is not used as a systematic category in Latin American literary discourse. It is rather a floating signifier, which refers to heterogeneous, primarily poetry movements from the 1960s through to today. It refers as much to the *infrarrealistas*, for example – a Mexican neo-Dadaist poetry group co-founded in the 1970s by Roberto Bolaño, and which was immortalised in his novel *Los detectives salvajes* (*The Savage Detectives*) – as to the *neobarroso* project to which the Brazilian-based Argentine Néstor Perlongher ascribed, *neobarrosa* being a neologism untranslatable into English which associates the glimmering of the baroque with *barro*, the mud of the Río de La Plata. 'Neo-avant-garde', however, can just as well be used to describe Julio Cortázar's iconic novel *Rayuela* (1963), inspired by French surrealism as the CADA group mentioned earlier, and critically evoked by the same Roberto Bolaño in *Estrella distante* (*Distant Star*).

Avant-garde features remained prominent within certain forms of prose common around the turn of the millennium and are still very much alive in the twenty-first century, as evidenced by the fact that two of the most influential contemporary Latin American prose writers constantly return to them. Their work meets all four of the parameters that, according to the Introduction to this volume, are required for a project to be considered 'neo-avant-gardist': these are texts which (1) see artists as adopting their own aesthetics vis-à-vis the historical avant-garde as a source of inspiration or frustration; (2) use experimental techniques and narrative devices such as (photo)montage, readymades and collage; (3) offer indications of a certain radicality in their paratext or intertext, or exploit intergenericity and/or intermediality; and (4) frame themselves institutionally by means of, for instance, a publication strategy which problematises the uncritical consumption of cultural goods and the streamlined literary system.

One of these two authors is César Aira (b. 1949), the most canonised Argentine writer of the moment, who has published over eighty brief but extravagant books at a rate of four per year, all produced according to the same method. His frenetic speed of writing and publication is related to the constraints in which he works. Rather than editing what he has written, Aira engages in what he calls a constant 'escape forward', a more structured version of the surrealists' notion of free associative writing. He never revises or otherwise revisits work he has completed. He also seeks what he calls 'the continuum', a way of

improvising to keep his texts light and under construction. As a result, his fictions jump radically from one hilarious episode to another and from one genre to another, and they deploy narrative strategies from popular culture and sub-literary genres such as pulp science fiction and soap operas, while at the same time reintroducing some of the tropes of high avant-garde culture. His most famous novel is *Cómo me hice monja* (*How I Became a Nun*) (1993), a parody on the *Bildungsroman*, narrated by a six-year-old boy who thinks that he is a girl. In his novella *Duchamp in Mexico*, published in 1997, Aira shows his obsession with procedure and process. According to Aira, as Graciela Montaldo puts it, 'the literature of the future is a private affair. Anyone can make novels, simply by buying a procedure for doing so' (Montaldo 2016: 262). For Aira, it is enough to invent: 'A diagram of a novel to fill in, like a coloring book' (Aira, *Duchamp en México*, p. 48, quoted in Montaldo 2016: 262).

THE CASE OF MARIO BELLATIN

The second author, on whom I wish to focus in more detail, is Mario Bellatin (b. 1960). Born and raised in Peru where he studied theology, Bellatin subsequently moved to Cuba to study screenplay writing and now works in Mexico City. The author of more than forty books, he is currently considered one of Latin America's leading writers. Bellatin's literary work, which is paradigmatic of new artistic and social forms because of the critical way in which it approaches notions of authorship and community, can, like Aira's, be understood as turning with renewed energy to the experiments of the avant-garde. Bellatin became known for his treatment of key figures from European conceptualism in the visual arts, and in particular for his references to Marcel Duchamp (in, for instance, *El Gran Vidrio* (2007), the text discussed below) and Joseph Beuys. In *Lecciones para una liebre muerta* ('Lessons to a dead hare') (2005), a clear allusion to Beuys's 1965 performance *How to Explain Pictures to a Dead Hare* (1965), he rewrites Beuys's provocative piece into a collection of 243 aphoristic entries. But beyond these explicit links, his whole approach to literature is radically unconventional.

Bellatin's work is much darker in tone than Aira's, with violence and deprivation being his main themes. The artist was born with much of his right arm missing, and the fixation with deformity which pervades his stories may well be rooted in this. At the same time, he has elevated the prosthesis he wears to an aspect of his public performances. Bellatin defies what literature can be by constantly reinventing his own writing methods. Instead of using a typewriter or a computer, he now prefers his iPhone as another supplement of his body which he can carry with him everywhere and which allows him a more intimate contact with language.

More generally, Bellatin's view on literary production, like Aira's, can be described as 'procedural'; essentially, they consider the creative process itself the most important artistic product, while engaging in the design of practices that challenge the limits between distinct realms and disciplines.[3] Both authors write stories that dispense with the mimetic representation of reality and overtly subvert psychological realism. This was already the case in Bellatin's best-known novella, the relatively straightforward yet disturbing *Salón de belleza* (*Beauty Salon*) (1994). *Salón de belleza* tells the sad story of a cross-dressing hairstylist who has turned his beauty salon into a mortuary, a place where young men suffering from an unnamed chronic disease come together to die.

When Bellatin was thirty, he joined the Sufi order to free himself from the literary tradition. Many critics see his Sufism primarily as part of his image building (or 'posture') and at most as a way of deliberately placing his authorship outside the Latin American context. Bellatin himself, however, claims that joining the Sufi community has had a real impact on his authorship. Sufis, he declares, have a system of living that he sees as comparable to art and literature's purpose: 'to be able to create a universe parallel to the everyday, with rules that are sufficiently coherent to make that world plausible' (Bellatin 2016: n.p.). In a stimulating article, Tijl Nuyts (2019) relates Bellatin's conversion to Sufism to a paradoxical quest for unity, for a transcendent but unattainable Great Work, a 'mystique of writing' as it were.

In general, all Bellatin's books resist interpretation and are characterised by an elliptical, unsettling style. Although they do not respect the typical realistic conventions of narrative, they are closely interwoven by a restricted number of obsessive, reiterative elements, such as dogs, illness, failed families, the golem, closed spaces or ritualised religion, and correspond to an interior logic which can be called rhizomatic, in reference to the concept proposed by Deleuze and Guattari.

To Bellatin, artistic activity is all-encompassing and something that determines the course of one's existence. Therefore, there is no clear dividing line between his literary universe and his daily life. Moreover, his work shows a refusal to be contained by the printed page. To him, making art transcends the literary field; rather, it is a powerful dynamic, an ambitious project in which texts, visual material (as shown by the inclusion of images in his writings) and public interventions come together into one great, constantly evolving network. He also has a pedagogical calling, albeit a rebellious one. In 2000, he founded the Dynamic Writers School of Mexico City, which he ran until it closed in 2010. His disgust with the productive immediacy expected from writing programmes became obvious in the guidelines he gave to his students: they were not allowed to write but had to restrict themselves to careful observation.

In the last couple of years, Bellatin's work has become part of the transnational canon, anchored in a position that is both local and global. On the one hand, Latin America is without doubt his base and locus of enunciation. On the other hand, as we will see, he constantly borrows from World Literature, and a growing number of his works, including *Salón de Belleza* and *El Gran Vidrio*, have already been translated into English by independent publishers.

THE LARGE GLASS

The novel in which Bellatin deconstructs the very form of autobiography is entitled *El Gran Vidrio* (2007) and was translated from the Spanish by David Shook as *The Large Glass* (2015a). A few years earlier, Bellatin had already tackled the genre of the biography by constructing a false account of a fictional Japanese artist, *Shiki Nagaoka*. According to Bellatin, (auto)biography is an absurd and megalomaniac project because a life cannot be expressed in a truthful narration nor can it be confined to a single genre, which, in fact, always obeys a predetermined form of storytelling. Bellatin himself blurs the boundaries between his texts and his own life. His reader can never be certain as to whether events are real or imagined and in refusing to distinguish between the two, the author forces us to reimagine the opposing poles of fiction and non-fiction.

Let us first examine the paratextual features of the original. Its title echoes Duchamp's unfinished work *Le grand verre* (elaborated between 1915 and 1923), initially called *La mariée mise à nu par ses célibataires, même*,[4] and triggers immediate associations with one of the icons of conceptual art. *Le grand verre* was conceived more or less simultaneously with Duchamp's rejection of a conventional artistic career and embodies this rejection as much as his readymades. The glass construction has been described by art historians as 'a humorous allegory of sexual quest cast in scientific/technological language' (Dalrymple Henderson 1999: 113). It depicts abstract forces rather than worldly objects and portrays a sequence of interactions that can be understood as the impossible erotic encounter between the 'Bride' in the upper panel, and her nine 'Bachelors' gathered in the lower panel. Yet this project is not a discrete whole and suffered further fragmentation when it was broken during transportation and subsequently reassembled by Duchamp in the Philadelphia Museum of Art, where it is still housed. Bellatin's text does not mention the Duchamp sculpture in a referential way but is rather related by the manner in which *El Gran Vidrio* is a reflexive literary work that analyses itself as a medium. Thus, it is the novel's conceptual weight that has the strongest impact. Moreover, the relation between title and text in Bellatin is similar to the one Duchamp

established between installation (*Le grand verre*) and text (*La boîte verte* or *Green Box*, the hundreds of preparatory notes Duchamp published years later, but considered to be as important as the object of art itself). The apparent sense-lessness readers have experienced when reading Bellatin's ungraspable text is comparable to observations about Duchamp's sculpture by Jean-François Lyotard: '*The Large Glass* is made precisely in order not to have a true effect nor even several true effects – according to a mono- or polyvalent logic, but to have uncontrolled effects' (1990: 64).

The subtitle *Three Autobiographies* is similarly paradoxical as the autobiograph-ical pact is evoked but immediately put in perspective: these are autobiographies in the plural which 'deconstruct the very form they embrace' (Bellatin 2015a: cover text). Many readers expect a uniformity of experience or authenticity when they pick up an 'autobiography', but for Bellatin these expectations serve as a decoy through which the author reveals the artifice at the heart of the genre. The cover of the original version, for instance, shows the ruins of destroyed buildings in Mexico City after an earthquake and in the original Spanish cover text, the promise of clarity itself is contradicted. *The Large Glass* is said to be the name of a party that takes place annually within the ruins where hundreds of families live in Mexico City. There is, however, no mention of this tradition in any of the three stories nor are any of the stories situated in Mexico. While the entire paratext creates an illusion of clarity and legibility, what follows under-mines this illusion completely. The voice we hear in the paratext is shown to be unreliable. As we will see, this whole staging is contrived to critique the very genre of autobiography.

The Large Glass brings together three different takes on autobiographical writing: 'My Skin, Luminous', 'The Sheika's True Illness' and 'A Character in Modern Appearance', each of which explores vastly different stylistic and thematic grounds. Each tale in *The Large Glass* also has a totally different form. There is little narrative continuity and no linear progression through time and space.

In the first story, 'My Skin, Luminous', a nameless child narrator describes how his mother takes him to the public baths of a nameless sacred town every day where she displays his huge testicles and his luminous skin to the other women in return for gifts. He is an unwilling prostitute. The mother forbids anyone from touching her son's luminous skin; his body is her property, another object in her collection, on which she can perform experiments. The boy must leave his mother to discover his own identity. The confessions document grim moments of abuse – emotional, physical and sexual. We also catch glimpses of a greater context: the fascist grandfather, the absent father, the complicit headmaster, a traumatic eviction, all related to ominous hints of mental illness and suffering.

This first section is narrated in 363 brief, numbered fragments or as a 363-item list which takes the form of a series of pithy yet startling statements surrounded by a lot of white space, a strategy of genre transformation and typographic play. Over time, the nameless young character is slowly transformed into a type of spectacle, a piece of curiously constructed art meant to be looked at but never touched. The first lines go as follows:

> . . . *on the outskirts of the tomb of Sufi Saint Nizamudin.*
>
> 1 – During the time that I lived with my mother it never occurred to me that adjusting my genitals in her presence could have any serious repercussions.
>
> 2 – I was wrong.
>
> 3 – Later I learned that she even asked other women for objects of value so that they could see them fully.
>
> 4 – Adjusted, choked, to the point of bursting.
>
> 5 – My mother taking advantage of my pain.
>
> 6 – Collecting objects without rest. (Bellatin 2015a: 1–2)

The voyeuristic effect which is evoked in this first autobiography of childhood is reminiscent of Duchamp's last major artwork: *Étant donnés 1° la chute d'eau / 2° le gaz d'éclairage* (*Given: 1. The Waterfall, 2. The Illuminating Gas*). *Étant donnés* is a tableau, visible only through a pair of peep holes (one for each eye) in a wooden door, of a nude woman lying on her back with her face hidden and legs spread holding a gas lamp in the air in one hand against a landscape backdrop.

The second story/section, 'The Sheika's True Illness', presents itself as a rumination on faith and belief, written as a series of long paragraphs. The Sufi narrator, a transposition of the author, recounts the treatment of an illness suffered by his spiritual leader ('sheika'). From the first pages onwards, we are confronted with a metalepsis produced by a writer who is at odds with his own character and deploys a high degree of self-reflectivity.

The narrator explains that what we are reading is an adaptation of a story he has written for *Playboy*. The opposite of what we saw in the first story is happening here: instead of sacralising the profane, we see a profanation of the sacred, in the shape of a mystical dream being sold to *Playboy*. This narrative is intercut with memories of when he was first diagnosed with the illness, and the tale of a friend killed in a road accident. Everything can be understood perfectly, but no clear narrative meaning is constructed. The reader never knows at what level of reality he is; truth and dream are constantly blurred. There is no causal correlation, no clear time lapse: everything is being recounted at the same level.

The collection's third and last autobiography, 'A Character in Modern Appearance', begins with the declaration that the narrator, along with his German girlfriend, is searching for a car. Any suggestion of straightforward autobiography disappears, however, with the discovery on the second page that the narrator is female and that it is impossible that he could have a German girlfriend: he happens to have been converted into a forty-six-year-old woman who lives at home with her parents, grandparents and siblings in a home which has been demolished by a north–south highway. This vivid but absurd story Bellatin has constructed also contains a childhood eviction, and it echoes 'My Skin, Luminous' in the father's exhibition of the narrator when he dresses her as a doll and forces her to dance. The text spins in circles, like the whirling dervishes from Sufism which are frequently evoked.

Bellatin suggests that this constantly shifting narrator is unstable and admits to being a liar: 'One of the main characteristics of my personality is lying all the time' (2015a: 128). Despite the fact that the narrator of the third story struggles with language and communication, she is also a writer herself:

> So far, as I said, I have not fully mastered Castilian. But worst of all is that before this awkward learning there was no mother tongue for me. I am unable to communicate, just like that. [. . .] Nonetheless, since I turned forty years old I have written books. (Bellatin 2015a: 135)

At the end of this third story, we are confronted with a meta-textual display which once again casts doubt on all the assumptions about autobiographies and posits a radical openness of the self. What is more, the so-called real life is of no interest whatsoever to the narrator:

> What is there of truth and what is there of lie in each of the three representations, in each of the three autobiographical moments – *My Skin, Luminous*; *The Sheika's True Illness*; and *A Character in Modern Appearance* – that I have presented here? Knowing is entirely irrelevant. (Bellatin 2015a: 142)

In the last pages of the book, Bellatin explains that his perpetual reinvention is 'not to create new institutions to ascribe myself to. Simply to allow the text to manifest itself in all its possibilities' (2015a: 142–3). He admits that these autobiographies are, in fact, primarily about literature when he writes, 'This journey seems only to have served to some years later convert me simply into a contemporary writer, who almost without noticing offered up his life' and whose 'true desire wound up being the word' (2015a: 143–4).

Here again, a clear link can be established with Duchamp's work, more specifically with *Autour d'une table* (1917), a multiple self-portrait which represents

five images of the artist depicting himself simultaneously from five different vantage points. *The Five-Way Portrait of Marcel Duchamp* suggests the artist's early recognition of the complex nature of personal identity, something he would continue to explore throughout his career. Fascinated by the way portraits shape identity, Duchamp exploited the genre of the self-portrait, often turning traditional codes for portrayal on their head.

THE TEXT'S AFTERLIFE

Bellatin had told the story of 'My Skin, Luminous' much more densely earlier on, using a different title 'Uñas y testículos ajustados' in *La escuela del dolor humano de Sechuán* ('The Szechuan school of human pain') (2001), a collection of short texts. The story of 'My Skin, Luminous' is one of three that also appeared in Bellatin's first book in English, *Chinese Checkers*, in a translation by Cooper Renner (Ravenna Press, 2006). This recycling and rewriting of sequences, so characteristic of Bellatin's poetics, show his interest in how literature is assembled and by what artifices it works. Translations only take these mechanisms one step further given the fact that, for Bellatin, there is no fundamental difference between translations and originals: he considers translation a basic practice inherent in every form of text production. The English translation *The Large Glass* (Phoneme Media, 2015) also differs slightly from the original: it is an expanded text (363 numbered sentences instead of 360), which incorporates two pictures of grilled guinea pigs, an allusion to the narrator's grandfather's pig oven. The cover by the Hungarian artist Zsu Szkurka displays stylised drawings of scenes from the three autobiographies and has nothing to do with the Mexican ruins evoked in the original. In his brief afterword, translator David Shook draws a parallel between the author's reflection on Sufism in 'The Sheika's True Illness' and the translation process. In his view, the 'mystic embracing' of the forgotten ideal world in Sufism resembles the ideal, original text whose essence the translator must recreate through an act of 'divination' (Shook, in Bellatin 2015a: 150).

In 2012, Bellatin was appointed guest curator of the dOCUMENTA (13) art festival in Kassel. While there, he became editor in a project which enabled him to protect his work against market mechanisms, allowing him to sell his books on his own, without going through bookstores. Claiming to be writing so that he could be surrounded by his books at all times, he devised *The Hundred Thousand Books of Bellatin*. The idea was to publish one thousand numbered copies of each of his titles, up to one hundred in total, all using exactly the same small layout. *The Hundred Thousand Books of Bellatin* again contains 'My Skin, Luminous', now entitled, after Duchamp, *La novia desnudada por sus solteros . . .*

así (Goldchluk 2014: 174) with a number of visual variations. Bellatin designed a chest for his project, enabling him to take the books with him wherever he went. The idea behind this is strongly reminiscent of Duchamp's portable *boîte-en-valise* (*Box in a Suitcase*) (1935–41), his ironic alternative to the artist retrospective, in accordance with his lemma '[e]verything important that I have done can be put into a little suitcase'. In 2015, Bellatin launched – and won – a campaign on Facebook against Grupo Planeta, the largest publishing company in the Spanish-speaking world, forcing his editor to withdraw a re-edition of *Beauty Salon* that had been published without his permission. The afterlife of *The Large Glass* also saw a sequel in the pseudo-documentary *Trafficking Author-ship, Bartering Biography* (Bellatin 2015b) made by Phoneme Media to promote the book, which further parodies the autobiographical genre.

BELLATIN'S USE OF THE AVANT-GARDE

Critics have interpreted Bellatin's return to the avant-garde in various ways. However, they all see the 'neo-avant-garde' as embodied by the Mexican-Peruvian author not just as a chronological marker but as a specific form of taking up the legacy of Dadaism. In chapter five of *Beyond Bolaño* (2015) – a critical interrogation of the field of World Literature from the perspective of Latin American Studies – Héctor Hoyos considers this reanimation of the spirit of the historical avant-garde by authors such as Bellatin and Aira as a way of transforming their presence in the international literary circuit. He posits that, although Bellatin writes first and foremost for a Latin American reader-ship, he presents himself at the same time as an avid cosmopolitan who bor-rows from diverse cultural traditions, such as Sufism, Jewish thought, Japanese literature and the European avant-garde. The result of this double positioning is that he modifies World Literature as a Latin American. But the fact that Bellatin often strips his fictional space of concrete, recognisable, geographical or cultural references is also a strategy of turning away from the identity claim that is so connected with Latin American art, a 'Latin Americanness' that often amounts to a type of exoticisation. Thus, Bellatin's reconceptualisation of Latin American art has a double objective: to 'renegotiate the relationship between Latin American tradition and its metropolitan counterparts' and to 'resignify the history of Latin American literature from this paradigm of cul-tural simultaneity' (Hoyos 2015: 172, 181).

Other critics see Bellatin mainly as an exponent of the 'iconic turn', formu-lated in the 1990s by scholars such as W. J. T. Mitchell or Gottfried Boehm and used in contrast to Richard Rorty's famous notion of the 'linguistic turn'. The insight that images, not words, should serve as a key to the interpretation of

literature triggered a movement away from the autonomy of the literary work of art which has also become a topic of growing interest in contemporary Latin American literature. Bellatin's texts exhibit this exchange between art and literature explicitly by including photographs as well as references to his real-life artistic projects within his texts, dissolving the boundaries between art and life. In his essay *Espectáculos de realidad* ('Spectacles of reality') (2007), Reinaldo Laddaga maintains that in entering Bellatin's universe, we become part of a laboratory and partake in an intense artistic experience in which the boundary between subject and object becomes blurred. In *Estética de la emergencia: la formación de otra cultura de las artes* ('Aesthetic of emergency') (2006), Laddaga even detects a change of aesthetic paradigm of a similar importance to that which laid the foundations of modernity. In what he identifies as a change to a 'practical regime' of the arts, the artist no longer sees himself as a specialist in meaning who dictates the forms, but as a mechanism in the flow of information: he no longer produces closed works, but rather promotes situations, 'cultural ecologies', 'experimental communities' (2006: 9, 15), open and cooperative processes, common ways of life and worlds no longer designed for 'a spectator or reader who is a silent stranger' (Laddaga 2006: 7), but an active collaborator.

Graciela Speranza (2006) and Florencia Garramuño (2015) also read the return of the avant-garde today as a moving beyond traditional narrative structures and resources, introducing new ways of thinking about literature and the identities of those who create and experience it. By their interpretation, literary works increasingly exceed the boundaries of the book, and it is primarily this intermedial fluidity that has made the avant-garde legacy relevant once more. This literature 'outside the book' is what the French literary scholars Olivia Rosenthal and Lionel Ruffel have called 'une littérature exposée' ('an exposed literature'). In a seminal article from 2010, Rosenthal and Ruffel claim that contemporary practices of literature are lured by dematerialisation away from the book into the ephemerality of performance. They maintain that our contemporary society disrupts the traditional mechanisms of literary communication embodied in the book, and particularly the notion of publication, which has again become central in a digital age in search of new forms of 'making public'. In the programmatic text 'Escribir sin escribir' ('Write without writing') (included in *Obra Reunida 2*), Bellatin himself emphasises his desire for a 'post autonomous' (Ludmer 2010) form of literature, a constant search for 'writing without writing' or for writing without using words, but by building narrative structures through other means and media (Bellatin 2014b: 10, 22).

In an insightful article on *The Large Glass*, Julio Premat (2017) goes beyond this perception. Although he agrees that the aforementioned interpretations are based on certain features of the work and on manifestations of the author's public persona, he firmly believes that Bellatin is ultimately not a performer

but a writer whose work stems from his desire to write (Bellatin 2015a: 144).[5] In this sense, his work does not confirm the end of a specific literary discourse but quite the opposite: the potential of the written word, if only freed from narrow conventions. According to Premat (2017), the main issue at stake here lies elsewhere: in how Bellatin's project is situated within contemporary conceptions of time and in how the 'contemporary' ties in with the historical avant-garde movements.

At first sight, *The Large Glass* appears to be 'ultracontemporary' because of its rapid superposition of contradictory stories. In this light, it could pass for an expression of a *presentist* regime of historicity, the latter being French historian François Hartog's term for the organisational structures which Western culture imposes on our experience of time. Presentism defines an understanding of history which has turned immediacy into an absolute value, dissociated from the past and the future. For Premat (2017), however, Bellatin's return to the avant-garde points in the opposite direction: it must be seen as a voluntary, anachronistic gesture to generate alternative forms of temporality and, thus, to break with presentism and unsettle the close of history.

Similar to the aforementioned ideas of art historian Andrea Giunta, such a conceptualisation of neo-avant-gardes in terms of simultaneous layers of temporality permits a problematisation of the evolutionary structure of the history of modern art. The past prevails under the form of an archive that, even if it has lost its rupturist edge because the world has become dominated by market forces, can still be revisited in original ways, as a substrate that is not lost but transformed into a productive reinvention. Writing in this way, Bellatin inserts his texts into a network of mnemonic relationships. In the end, Premat determines that both labels – contemporary and anachronistic – apply to Bellatin and suggests a paradox: his texts look more like 'fans that are being unfolded' than 'paths that have been travelled' (Premat 2017: 161), while retaining an alienating character and therefore going against the spirit of our time – and it is precisely this contentiousness that makes them so particularly contemporary, according to Giorgio Agamben's famous definition of that concept. In this sense, to be contemporary means to return to a present where we have never been, to be, at the same time, fully in line with the era but also non-coincident with it, accessing the contemporary as an untimely outsider.

NOTES

1. Unless otherwise noted, all translations are mine.
2. For a more nuanced view and further reading, see Unruh (1994); Rosenberg (2006).
3. As has been demonstrated by Andrea Cote Botero (2014).

4. English title: *The Bride Stripped Bare by Her Bachelors, Even*.
5. In another essay, 'Underwood portátil: modelo 1915' (included in *Obra reunida*, 2005), considered his *ars poetica*, Bellatin also expresses this desire to write, although he characterises this urge as a sort of obsessive typing in which all that matters is the mechanical act of pressing keys on his writing machine.

BIBLIOGRAPHY

Agamben, G. (2009), 'What Is the Contemporary?', in G. Agamben, *What Is an Apparatus? And Other Essays*, trans. D. Kishik and S. Pedatella, Stanford, CA: Stanford University Press, pp. 39–54.

Aira, C. (1993), *Cómo me hice monja*, Rosario: Beatriz Viterbo Editora.

Andrade, O. de (1928), 'Manifesto Antropófago', *Revista de Antropofagia*, 1 (1), n.p. (translated into English as 'Cannibalist Manifesto', trans. L. Bary, *Latin American Literary Review*, 1991, 19 (83), pp. 38–47).

Bellatin, M. (2000), *Salón de belleza*, Barcelona: Tusquets.

Bellatin, M. (2005), 'Underwood portátil: modelo 1915', in M. Bellatin, *Obra reunida*, Madrid: Alfaguara, pp. 483–506.

Bellatin, M. (2006), *Chinese Checkers: Three Fictions*, trans. C. Renner, Edmonds, WA: Ravenna Press.

Bellatin, M. (2007), *El Gran Vidrio. Tres autobiografías*, Barcelona: Anagrama.

Bellatin, M. (2014a), 'El Gran Vidrio. Tres autobiografías', in M. Bellatin, *Obra reunida 2*, Mexico: Alfaguara, pp. 99–167.

Bellatin, M. (2014b), 'Escribir sin escribir', in M. Bellatin, *Obra reunida 2*, Mexico: Alfaguara, pp. 9–22.

Bellatin, M. (2014c), 'Los cien mil libros de Bellatin', in M. Bellatin, *Obra reunida 2*, Mexico: Alfaguara, pp. 653–64.

Bellatin, M. (2015a), *The Large Glass: Three Autobiographies*, trans. D. Shook, Los Angeles: Phoneme Media.

Bellatin, M. (2015b), *Trafficking Authorship, Bartering Biography. Closing Remarks*, Video ALTA 38, Phoneme Media, <https://www.youtube.com/watch?v=wWcHP6cBx04> (last accessed 31 October 2018).

Bellatin, M. (2016), 'The Writer's Block Transcripts: A Q & A with Mario Bellatin', *Sampsonia Way. An Online Magazine for Literature, Free Speech and Social Justice*, 25 April 2016, <http://www.sampsoniaway.org/interviews/2016/04/25/the-writers-block-transcripts-a-qa-with-mario-bellatin/> (last accessed 31 October 2018).

Bürger, P. [1974] (1984), *Theory of the Avant-Garde*, trans. M. Shaw, Minneapolis, MN: University of Minnesota Press.

Cote Botero, A. (2014), *Mario Bellatin: el giro hacia el procedimiento y la literatura como Proyecto*, dissertation, University of Pennsylvania, <https://repository.upenn.edu/cgi/viewcontent.cgi?article=3056&context=edissertations> (last accessed 31 October 2018).

Dalrymple Henderson, L. (1999), '*The Large Glass* Seen Anew: Reflections of Contemporary Science and Technology in Marcel Duchamp's "Hilarious Picture"', *Leonardo*, 32 (2), pp. 113–26.

Donoso Macaya, Á. (2011), '"Yo soy Mario Bellatin y soy de ficción" o el paradójico borde de lo autobiográfico en *El Gran Vidrio* (2007)', *Chasqui. Revista de literatura latinoamericana*, 40 (1), pp. 96–110, <http://faculty.bmcc.cuny.edu/faculty/upload/Donoso_Chasqui.pdf> (last accessed 31 October 2018).

Foster, H. (1996), *The Return of the Real: The Avant-Garde at the End of the Century*, Cambridge, MA: MIT Press.

Garramuño, F. (2015), *Mundos en común. Ensayos sobre la inespecificidad en el arte*, Buenos Aires: Fondo de Cultura Económica.

Giunta, A. (2007), *Avant-Garde, Internationalism, and Politics: Argentine Art in the Sixties*, trans. P. Kahn, Durham, NC: Duke University Press.

Giunta, A. and G. Flaherty (2017), 'Latin American Art History: An Historiographic Turn', *Art in Translation*, 9, pp. 121–42.

Goldchluk, G. (2014), 'Lecciones de realismo para una liebre muerta (sobre la obra de Mario Bellatin)', in M. Caballero Vázquez, L. Rodríguez Carranza and C. Soto van der Plas (eds), *Imágenes y realismos en América Latina*, Leiden: Almenara, pp. 165–78.

Hoyos, H. (2015), *Beyond Bolaño: The Global Latin American Novel*, New York: Columbia University Press.

Laddaga, R. (2006), *Estética de la emergencia. La formación de otra cultura de las artes*, Buenos Aires: Adriana Hidalgo.

Laddaga, R. (2007), *Espectáculos de realidad. Ensayo sobre la narrativa latinoamericana de las últimas décadas*, Rosario: Beatriz Viterbo Editora.

Logie, I. and J. Premat (eds) (2016), 'Abecedario de *El Gran Vidrio* de Mario Bellatin', in Carlos Walker (ed.), *Mil hojas. Formas contemporáneas de la literatura*, Santiago de Chile: Hueders, pp. 345–424.

Ludmer, J. (2010), *Aquí América Latina. Una especulación*, Buenos Aires: Eterna Cadencia.

Lyotard, J. (1990), *Duchamp's Transformers*, Venice, CA: The Lapis Press.

Montaldo, G. (2016), 'How to Be a Primitive in the Technological Era', in M. Bush and T. Gentic (eds), *Technology, Literature, and Digital Culture in Latin America: Mediatized Sensibilities in a Globalized Era*, New York/London: Routledge, pp. 246–67.

Nuyts, T. (2019), 'La dialéctica entre lo uno y lo múltiple. El sufismo de Ibn 'Arabi en la narrativa de Mario Bellatín', *Confluencia*, 34 (2), pp. 37–51.

Paz, O. (1974), *Los hijos del limo: del romanticismo a la vanguardia*, Barcelona: Seix Barral.

Paz, O. (1991), *Children of the Mire: Modern Poetry from Romanticism to the Avant Garde*, trans. R. Phillips, Cambridge, MA: Harvard University Press.

Premat, J. (2017), 'Los tiempos insólitos de Mario Bellatín: notas sobre *El Gran Vidrio* y las radicalidades actuales', in M. Bush and L. Hernán Castañeda (eds), *Un asombro renovado. Vanguardias contemporáneas en América Latina*, Madrid/Frankfurt: Iberoamericana/Vervuert, pp. 149–71.

Rama, Á. (1982), *Transculturación narrativa en América Latina*, Mexico: Siglo XXI.

Rama, Á. (2012), *Writing Across Cultures: Narrative Transculturation in Latin America*, trans. D. L. Frye, Durham, NC: Duke University Press.

Rosenberg, F. J. (2006), *The Avant-Garde and Geopolitics in Latin America*, Pittsburgh, PA: University of Pittsburgh Press.

Rosenthal, O. and L. Ruffel (2010), 'Introduction: la littérature exposée. Les écritures contemporaines hors du livre', *Littérature*, 4 (160), pp. 3–13, <http://www.cairn.info/revue-litterature-2010-4-page-3.htm> (last accessed 31 October 2018).

Speranza, G. (2006), *Fuera de campo. Literatura y arte argentinos después de Duchamp*, Barcelona: Anagrama.

Unruh, V. (1994), *Latin American Vanguards: The Art of Contentious Encounters*, Los Angeles: University of California Press.

Sycorax' Revenge: Kamau Brathwaite and a Caribbean Version of the Neo-Avant-Garde

Christine Pagnoulle

Kamau Brathwaite (1930–2020) would never have condoned the use of such a barbaric, not to say degenerate label as neo-avant-garde. Avant-garde reeks of Western experimentation, something which the 'neo' prefix makes even worse, especially if seen as a frame through which to organise art and literary history. While he developed deep-seated relations of mutual respect and admiration for other Caribbean poets and played a vital role in fostering a sense of community among Caribbean artists,[1] Brathwaite wrote a unique, African-Caribbean poetry, using what he identified and described as 'Nation language',[2] a voice, a diction, a creolised English invigorated with African words and rhythms, laced with echoes of blues and jazz and gospel,[3] a way of using language that increasingly became his own, and which, from the 1980s onwards, he merged with what he called his 'Sycorax video style', 'a use of computer fontage to visualise [his] sense of dream & morph & riddim drama — videolectic enactment' (quoted in Laughlin 2007). Yet aspects of his work clearly relate to features that define the neo-avant-garde as presented in the Introduction to this volume, not least his blurring of boundaries between genres in the jubilation of dancing sounds and shapes. Whatever the publishing format, and even in interviews, Brathwaite's writing cannot be conveniently divided into verse and prose, poems and essays; it runs as one powerful and tumultuous river, including lyrical and reflexive moments, fluctuating between the halting flow of a breathless prose and the syncopation of verse riddled with voids, often in the form of long spaces around full stops whose function is rhythmical and not in any way syntactical.

Precisely because of his challenging stance towards the Western canon, Brathwaite is one of 'those cosmopolitan writers who sought to carve out enunciative positions for non-Western peoples' and thus 'explicitly confronted

the colonized and racialized history of those originary narratives' (Winkiel 2014: 97). This is another feature that brings him closer to a 'decentred avant-garde'. He never bothered to position his work vis-à-vis former avant-garde artists or writers – although he did explicitly contrast his way of writing with traditional English poetry written in pentameter (*Barabajan Poems* 115; here-after cited as BP), and, far more starkly, with O'Grady/Greedy's 'missile' language, Massa's tongue, the idiom of the coloniser (BP 248). Indeed, from the beginning through to the bitter end his art is used as a weapon of love in an ongoing struggle for cultural sovereignty; a struggle to reclaim repressed historical landmarks and to stand up in the name of ignored or oppressed people. It is thus part and parcel of a life's commitment that is both local and global. If his writings are disconcerting and indeed upsetting in the eyes of some readers, it is not simply because of his experimentation with form. Aware of the power of capitalism (or what he more commonly referred to as the 'plantation economy'[4]) to swallow and digest even the most 'transgressive' forms of expression, he attempted never to compromise his commitment (which may account for Brathwaite's not receiving the Nobel Prize in Literature, even though he received numerous other awards).

The very choice of the name Sycorax for his experiment with fonts and layout is a way of countering the evil magic of Prospero, 'The Man Who / Possesses Us / All' (BP 135). In this respect, Brathwaite's use, from 1984 onwards, of Caliban's absent mother, who is emphatically dismissed as a witch in Shakespeare's play, is in some sense the former colony 'writing back' to a canonical text in English literature. Yet this hypothesis too would have been rejected out of hand by the poet, possibly even more forcefully than the neo-avant-garde label, as he refused to be defined or placed in reference to a tradi-tional Western work (an intriguingly similar position to the paradoxical stance of some early avant-garde artists). This is clear in the way he develops his 'plantation personality types' (BP 316–17), where next to redefining Ariel (the mulatto aerial, oriented towards Europe) and Caliban – whom he associates with various Caribbean rebel figures, from Cudjo to Toussaint Louverture, whom he calls Toussaint Legba – he adds various female types, sisters of Cali-ban, which testifies to his growing admiration for the role played by women.

Brathwaite was born and grew up in Barbados, an island where he also spent the last years of his life. In-between he lived for almost thirty years in Jamaica after a short spell in St Lucia. While his life was thus fully anchored in the Caribbean, his seven years in Ghana provided access to the continent from which his ancestors had been transported. However, in his first trilogy, *The Arrivants*, he suggests that the Middle Passage was a one-way transit and that the future of the descendants of slaves or maroons is in the Americas.[5]

The first names his parents had given him were Edward Lawson, yet in 1971, when invited to Kenya by his friend Ngũgĩ Wa Thiong'o, Brathwaite was given that other name *Kamau* by his friend's mother at a naming ceremony in the novelist's native town Limuru. He describes the process in *Barabajan Poems* (BP 239ff.), insisting that Kamau, a name that is both male and female, is his *nam*: 'if / you move / from name / to nam / you begin / to have yr / own kernel / (not kennel) / yr own / sense and / reality of / incontro- / veritible [sic] self' (BP 242–3). As he moved from Edward (or Eddy) to Kamau, so too his work evolved, becoming denser with reverberations and cross-references, including more of the visual elements integral in his use of the 'Sycorax video style'. As he explains in the poem 'X/Self's X[th] Letter from the Thirteen Provinces',[6] he hijacked computer skills from Prospero/O'Greedy/Western engineers and used them in the service of his own people.[7] From then on, and often in the face of the (rather understandable) reluctance of publishers, he would shape his words (and silences) on the page with a definite concern for the visual effect, including his use of pictograms, but also for the rendering of the spoken/sung words, for the music and rhythm (riddim) that move his words, with echoes to musical styles, from Coltrane to calypsos. His video style (a form of visual poetry) may be experienced as disruptive (see Rohlehr 1994: viii), but it actually transcribes on the page the way we ought to *hear* the poem, like a musical score, and both the shapes and the sounds are caught in yet another artistic dimension, even more difficult to describe in words but cogently present, even in his early collections: movement, the dancing body. Two key words in *Barabajan Poems* are 'kinesthesia' and 'choreography' (BP 171, 180).

DreamHaiti in its Savacou lay-out[8] is possibly the text that involves his most daring formal experiments and best illustrates the dovetailing between form and intention, layout and voice. This fifty-two-page-long poem involves at least three voices and many more fonts and styles: a poet up there on the US Coast Guard Cutter (sometimes called Coast Guard Gutter, which I attempted to translate as 'corvette'/'crevette'; see Brathwaite 2013: 38, 58); a Haitian attempting to escape the starvation and persecution he faces on the island in an overcrowded *canot*, soon doomed to be drowned; and a long-drowned African slave, who seals the Atlantic connection. This involves three boats: the unnamed slave ship of the Middle Passage, the US Cutter named 'Impeccable', that is, a place with no sin attached: as Salvini would say, they do not encourage human trafficking, they watch and keep out; and the precarious, soon capsizing raft or *canot*, that flimsy reed of salvation to which refugees cling in vain and which is ironically named 'Salvages'. 'Impeccable' is written in almost blank big letters as contrasted with the massive black letters of 'Salvages', with jagged edges that suggest extreme danger (Figure

where we was to meet the man w/ the canot

░Salvages░

& i remember coughin & thinkin

SEA COME NO
FATHER

REHTAF
ON EMOC AES

as if i was already turnin the leaves of the waves
for a long long history of time before i cd get back

Figure 13.1 From *DreamHaiti*, New York, Savacou North, 1995, p. 24, with kind permission of Beverley Brathwaite.

13.1). The sea is present almost all through in the sibilance of a slender and waveringly elusive font. On the page on which the name of the *canot* occurs that fluid font is used for the voice of the escaping Haitian, and introduces the tall final letters 'sea come no / father', in thick black blocks (with the play on 'further' and 'father', the sea/water/Yemaanja being usually a motherly entity), twice reversed in its inverted version (the words and letters being printed in inverted order, and the solid black replaced by white emptiness). Hollowed-out letters are also used to indicate the way people look through 'Haitian refugees' 'who come to yr ouse / to beg wrok'[9] (*DreamHaiti* 12, 13; hereafter cited as DH). Sometimes a couple of words written in tall bold faces take up a whole page, like the paling of Titanyin, closing an ominous place of mass burial (DH 38), or words stand out in the middle of the page, like the shattered, menacing outline of a cursing *vèvè* (DH 31). Pictograms make references clear such as in La Crête-à-Pierrot, where an anachronistic but highly suggestive machine gun replaces the 'ê' and conjures up the terrible battles that occurred in that particular fort between the free Haitians and the French imperial army (DH 47) (Figure 13.2). In addition, that same page begins with tall, italicised, trembling letters tracing the name of the famous Haitian

tho of course they say nothin at all but jus
went lobbyin lobbyin by w/their heads
up & down in the corꭉⵈe of water & th-
ey arms still ꭉainly tryinto reaeh Mi-
ami & Judge Clarence Thomas & the US
Supreme Coast & their mouths wise open
wise open & ounsi
drinkin salt & dream &the gold-
en sound of the court like

LA CR✦✦TE-A-
PIERROT

Figure 13.2 From *DreamHaiti*, New York, Savacou North, 1995, p. 47, with kind permission of Beverley Brathwaite.

painter Hector Hyppolite, spelled with two ys (for better support?); between which nine uneven smaller lines presumably express the confused aspirations of those (dying) Haitians, with a permutation of 'court' and 'coast'. This in turn reflects their misplaced hope in one of the most conservative among the Supreme Court judges at the time, with the last words dissolving their expectations: with their mouths 'wise open' they become 'ounsi' ('children of the spirits' in the voodoo hierarchy) and swallow 'salt', which is literal for sea water, but also 'dream' and the sound of shooting transmuted into 'the golden sound of the [coast]'.

The last pages of *DreamHaiti* present three forms of epilogue: the radiant sun in the middle of 'Cité S[o]leil', which is the ironic name of a huge, over-crowded slum in Port-aux-Princes, as both a reminder that there is something inescapable in the lot of an exploited people and a contradictory promise of escape through the very name (DH 48); the poet's[10] detached observation from the deck of the Coast Guard Cutter ('watchin them poem', DH 49); the English translation of the lullaby song which opens the text in its Haitian creole version. This illustrates not only polyphony but also intertextuality and the use of multi-semiotic media – (neo-)avant-garde devices.

In *Barabajan Poems* probably more than in any other collection Brathwaite exhibits this gift for a poly-generic performance. He merges, blends, transforms and transmutes genres in a creative and re-creative dance that pays homage to his home island, its heritage and its culture. He plays with scholarly conventions such as the complete (and highly useful) index or the use of endnotes, which occasionally turn into poems in their own right. An early illustration of the manner in which he plays with expectations can be found on page 12, when the short title 'Content/s' seems to be too long so that the final 's' hangs as a snake (Damballa?) or a hook on which to fasten the seventeen parts of his development. The starting point is a speech (in fact, a real performance) delivered/enacted at the Central Bank of Barbados in December 1987; it includes scholarly explorations into history, sociology and literary criticism, despite being distant from any academic convention in its finished form; autobiographical information developed in chronological order, and yielding – after the Bajan language and culture have been retrieved and vindicated and the presence of Shango duly acknowledged – four chapters celebrating 'Barabajan landscapes', and consisting of one or more poems that he retrieves from former collections (*Mother Poems, Sun Poems, Other Xiles*) and to which he gives a new shape and resonance.

Indeed, one of the arresting aspects of what is now available on paper as an instance of his video-style choreography of shapes and sounds is the way Brathwaite retrieves former poems and shapes them anew. 'Sunsum' is one such instance. It is the first poem in the last Section of *Masks*, the second collection in his New World trilogy (*The Arrivants* 65–7; hereafter cited as A), and it is to be found in the 1994 book, with interjections and comments, a different layout and new fonts (BP 78–82). The title refers to some spiritual essence. Africa's *sunsum* was cracked, broken, plundered, stolen and destroyed. The most obvious sign of dislocation in the form of the poem, even in *The Arrivants*, is the number of words that straddle two lines or even two stanzas, or rather are torn in two: words are as broken as the soul of the speaker. The plunderers are those who came with 'the white gun / of plunder, bright bridge- / head of money, quick bullet's bribe'. But the questions in the middle of the poem seem to suggest that this may have been some retribution. The last lines are a terrible description of a place that has been abandoned for over three hundred years. In the later version the poem is headed with a pictogram of Anansi, all weak punctuation is deleted, and tercets are centred instead of being left-justified as far as the last question: 'too ready / with old ceremonials?' and the end of the poem is right-justified. The version in *Barabajan Poems* has an anguished interpolation before the crucial question (why did our gods not save us?); those paragraphs that insist that an answer has to be found if we

want the slave trade to actually stop are laid out as prose, but their rhythm is possibly even more compelling in its staccato repetitions and alliterations than in the retrieved poem.[11] Another justified paragraph is interpolated before 'the pain/ful words of "answer"' (BP 81), evoking the sound of the sea and his feet on the beach, which take him from the heart of Ghana where it was written to Barbados and Brown's Beach.[12]

Another striking metamorphosis is the one affecting the short poem entitled 'Pebbles' in *The Arrivants* (A 196) and taking up to ten pages in *Barabajan Poems* (BP 99–108).[13] In the earlier collection it follows immediately after the triumphant ending of the poem 'Caliban' (quoted in note 5); its first word is 'But', which is left out of the later version, and it gives a more mental image of a pebble's resistance, resilience and barrenness. In *Barabajan Poems* it is almost as if each letter were a pebble on its own, in its dark rounded shape, particularly the 'w's, which are closed above and recall the sign of infinity; the contrast between egg and pebble is somewhat lost because the whole poem is actually a pebble, and 'X. / udes / a sticky / death' (about the cracked egg) is formally conspicuously similar to 'x. / cludes // death' (though what is meant is diametrically different); the word 'o. // pen' is broken in two, though not suggesting any possible breach. After a reference to David slaying Goliath, the last line stresses its sterility, yet the words that immediately follow contradict that statement with their joyous reference to children playing on the beach.

In *Barabajan Poems* too Brathwaite uses expressive pictograms. Stylised Egyptian eyes stand for Sycorax, spiders or crabs with six or eight legs for Anansi the Trickster, the spiralling convolution that replaces the first letters of Shango is evocative of lightning or a cobra unfolding or possibly even of iron being wrought, but certainly of a swift and fluid movement. Page 187 (Figure 13.3) contains Brathwaite's description of the ritual he witnessed as a boy in his uncle Bob-o Bob the Carpenter's shop and how the loa presided over the communal weaving of ties into a tight and intricate spiky ball, something round and impregnable that O'Grady's/Western man's arrow or straight line cannot destroy. Page 248 (Figure 13.4) offers a short extract from a longer passage, partly reproduced/altered from *Mother Poems*, which brings out the Western opposition to Caribbean/Bajan culture in all its aspects from language to cooking; the reference to the *nam* and its echo of 'the precious deep vibrations of the *mmmmmm*' are close to a mystic experience, which is just as impossible to infringe upon as the spiky ball on page 187. The following pages further develop the contrast/opposition between 'O'Grady' and 'Mandingo', that is, between an imperialist colonial approach that seeks to subjugate, rename, and consume the other on one hand, and the independent voice and

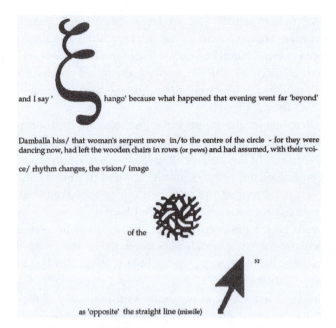

and I say ' ξ hango' because what happened that evening went far 'beyond'

Damballa hiss/ that woman's serpent move in/to the centre of the circle - for they were dancing now, had left the wooden chairs in rows (or pews) and had assumed, with their voi-

ce/ rhythm changes, the vision/ image

of the

as 'opposite' the straight line (missile)

Figure 13.3 From *Barabajan Poems 1492–1992*, Kingston/New York: Savacou North, 1994, p. 187, with kind permission of Beverley Brathwaite.

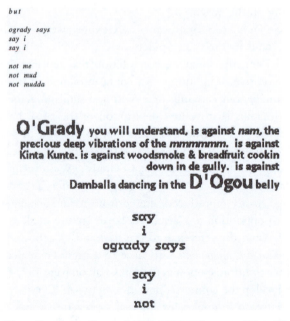

but

ogrady says
say i
say i

not me
not mud
not mudda

O'Grady you will understand, is against *nam,* the precious deep vibrations of the *mmmmmm.* is against Kinta Kunte. is against woodsmoke & breadfruit cookin down in de gully. is against Damballa dancing in the **D'Ogou** belly

say
i
ogrady says

say
i
not

Figure 13.4 From *Barabajan Poems 1492–1992*, Kingston/New York: Savacou North, 1994, p. 248, with kind permission of Beverley Brathwaite.

identity of formerly colonised or transported people who will no longer be silenced on the other hand:

&

so Mandingo, even from his apparently hopeless position,
submerged, it seems, in the mud, & having reached, it wd seem, the
uttar downlimits of downpression, begins to sing, to unsubmerged, to
begin the come
the come
the come back up
assertion/reassertion of the **nam**
(BP 264)

Pages 258–9 of *Barabajan Poems* reproduce the third part of the poem 'Vèvè' (A 265–6) in a very subdued form (small font, no changes in size or style); the one change with the poem as printed in *The Arrivants* is that here it is right-justified. This pagination perfectly fits the vindication of an African tradition finding a new voice in the Caribbean, in spite of, almost through, the planter's violence:

For on this ground
trampled with the bull's swathe of whips
where the slave at the crossroads was a red
anthill: eaten by moonbeams
by the holy ghosts of his wounds

the Word

becomes again a god and walks
among us
(BP 259)

The last section of *Barabajan Poems*, before the forty-four pages of notes, the forty-eight pages of equally fascinating appendices and the twenty-one pages of index, is entitled 'Beginning'. The opening could indeed be the formal beginning of a lecture, but Brathwaite soon refers to the ground covered, both in geographical terms and in terms of thinking and feeling independently, as dancing a Shango dance. This is followed by twelve pages of Bajan proverbs in the local spelling, the final one of which is about the sea not having a back-door. This, Brathwaite immediately counters through his own experience as a boy: 'our house on Brown's Beach was just / that – the sea's / **BACKDOOR**' (BP 283), with the last word almost illegible as it is printed in such a thick bold

face as to look more like some fencing than an actual written word. A door protects and keeps out, but it also opens onto new vistas.

Brathwaite did not stop writing in 1994. In fact, some of his best works came later in collections such as *Born to Slow Horses* (2006) or *Elegguas* (2010). While not relenting in his social and political commitment, he took his mystical exploration of interconnected levels of reality further. In his later work, Brathwaite does not, though, seem to have extended his experiments with form. There are probably two reasons for this: first, his old Mac computer on which he had been able to play around in such creative and stimulating ways gave up the ghost and he did not find the later version as flexible; second, he could no longer maintain Savacou North, which allowed more leeway for visual experiments than more traditional publishing houses, however ready to try and meet his expectations they have proved to be, as was the case with his later publishers, the House of Nehesi and Wesleyan University Press.

As a poet whose voice is often highly disturbing, yet who consistently claimed that he could only write and speak and sing and dance because he was part of a community, because of his utter disregard for boundaries and of his boldly experimenting with innovative forms, Kamau Brathwaite can be perceived as a representative of a postcolonial neo-avant-garde, however misguidedly inadequate each of these words might be.

NOTES

1. Brathwaite was co-founder and secretary of the Caribbean Artist Movement (CAM).
2. '[T]he kind of English spoken by the people who were brought to the Caribbean, not the official English now, but the language of slaves and labourers, the servants who were brought in' (Brathwaite 1984: 6). As Kelly Baker Josephs (2003) notes, in his first collections Brathwaite's use of nation language was at times stuttering and stammering, which may be compared with some of Léon Gontran Damas's poems.
3. His recordings and his live performances testify to the extent that his poetry was also music. Listen, for instance, to show 16, 'Nation Language and Other Revolutions', of Leonard Schwartz's *Cross-Cultural Poetics*, 2 February 2004, available at <http://writing.upenn.edu/pennsound/x/deleted/XCP.html> (last accessed 3 February 2021).
4. Brathwaite shares this lexical preference for the term 'plantation economy', which is also a political statement, with Malcom Ferdinand; the words refer to the ruthless exploitation of both natural and human (labour) resources with little or no regard for their exhaustion.

5. This is beautifully expressed in Caliban's limbo resurrection: 'out of the dark / and the dumb gods are raising me // up / up / up // and the music is saving me // hot / slow / step // on the burning ground' (A 195), or more darkly, in last lines such as 'There is no / turning back' (A 85) or 'we have no name / to call us home no turbulence // to bring us soft-/ ly past these bars to miracle, to god, / to unexpected lover' (A 178).

6. A lot has been written on Brathwaite's use of the letter 'X'. While it can refer to an unknown quantity in algebra or to the cross used instead of a signature by illiterate people, to me it sounds more like a proud assertion of identity within namelessness, as in the case of Malcolm X, and does not necessarily involve the assertion that the 'space – not sound' is central in shaping meaning (see Winkiel 2014: 113); 'X' is a sound, too. The significance of the naming and renaming process is also discussed by Ferdinand (2019: 302).

7. 'what I trying to sen/seh & / she about muse/ // in computer & learnin prospero linguage & // ting // not fe dem/not fe dem / de way caliban / done // but fe we / fe a-we // for not one a we should responsible if prospero get curse / wid im own // curser' (*X/Self* 84–5; *Ancestors* 449).

8. *DreamHaiti* was first published by Longman (1994) in the volume entitled *DreamStories*; yet Brathwaite was dissatisfied with the visual treatment of the piece and he reissued it in his own publishing house, Savacou North. For a comparison of the two layouts, see Pagnoulle (2000).

9. The inversion of letters, here 'wrok' for 'work', or 'flim' for 'film', is a frequent enough occurrence in Caribbean English.

10. To be distinguished from the author, of course, who is anything but a neutral observer.

11. 'more guns, more greed, more coups, more murders & abductions in the night, more starving millions, more pestilence, more & more immoral & immemorial mal- // ice', 'salt fish salt fish salt flesh of maggots – slave trade the new slave trade Passage Mid- // dle Passage the new Middle Passage Passages flowing out across Atlantic now not to factories of cotton sugar flash but to new industries of // faX – computer processes – flowing out from/ flowing in towards . . .' (BP 80).

12. 'As if each bleach each stone I step I step I step on was my heart my hurt my history and at last at last my somehow victory' (BP 81).

13. The plural may have been a reference to the several islands of the archipelago, though Brathwaite was keenly aware of the unique geological nature of Barbados as a coral island as opposed to the volcanic origin of the chain stretching from the Keys to Venezuela.

BIBLIOGRAPHY

Brathwaite, K. (1973), *The Arrivants*, Oxford: Oxford University Press.

Brathwaite, K. (1984), *History of the Voice: The Development of Nation Language in Anglophone Caribbean Poetry*, London: New Beacon Books.

Brathwaite, K. (1987), *X/Self*, Oxford: Oxford University Press.

Brathwaite, K. (1994a), *Barabajan Poems 1492–1992*, Kingston/New York: Savacou North.

Brathwaite, K. (1994b), *DreamStories*, London: Longman.

Brathwaite, K. (1995), *DreamHaiti*, New York: Savacou North.

Brathwaite, K. (2001), *Ancestors*, New York: New Directions.

Brathwaite, K. (2013), *RêvHaïti*, trans. C. Pagnoulle, Montreal: Mémoire d'encrier.

Ferdinand, M. (2019), *Une écologie décoloniale. Penser l'écologie depuis le monde caribéen*, Paris: Seuil.

Josephs, K. B. (2003), 'Versions of X/Self: Kamau Brathwaite's Caribbean Discourse', *Anthurium: A Caribbean Studies Journal*, 1 (1), <http://scholarlyrepository.miami.edu/anthurium/vol1/iss1/4> (last accessed 3 February 2021).

Laughlin, N. (2007), 'Notes on Videolectics', *The Caribbean Review of Books*, May, <http://caribbeanreviewofbooks.com/crb-archive/12-may-2007/notes-on-videolectics/> (last accessed 3 February 2021).

Otto, M. (2009), *A Creole Experiment: Utopian Space in Kamau Brathwaite's 'video-style' Works*, Trenton, NJ: Africa World Press.

Pagnoulle, C. (1990), 'The Labyrinth of Past/Present/Future in Five Recent Poems by Brathwaite', in G. Davis and H. Maes-Jelinek (eds), *Crisis and Creativity in the New Literatures in English*, Amsterdam: Rodopi, pp. 449–66.

Pagnoulle, C. (2000), 'Profil et épaisseur des mots: Kamau Brathwaite, *RêvHaïti*', *Palimpsestes*, 12, pp. 31–7, <https://journals.openedition.org/palimpsestes/1632#text> (last accessed 3 February 2021).

Pagnoulle, C. (2014), 'Brathwaite's DreamHaiti: Translating Ethnicity', *European Journal of English Studies*, 18 (3), pp. 330–8.

Pagnoulle, C. (2016), 'On the Kamau Trail: Tracking Poems from Page to Stage', in G. Collier, G. Davis, M. Delrez and B. Ledent (eds), *The Cross-Cultural Legacy: Critical and Creative Writing in Memory of Hena Maes-Jelinek*, Amsterdam: Brill/Rodopi, pp. 175–85.

Reiss, T. J. (2002), *For the Geography of a Soul: Emerging Perspectives on Kamau Brathwaite*, Trenton, NJ: Africa World Press.

Rohlehr, G. (1994), 'Preface', in K. Brathwaite, *DreamStories*, London: Longman, pp. iii–xvi.

Savory, E. (1994), 'Wordsongs & Wordwounds/Homecoming: Kamau Brath-waite's Barabajan Poems', *World Literature Today*, 68 (4), pp. 750–7.

Savory, E. (1995), 'Returning to Sycorax/Prospero's Response: Kamau Brath-waite's Word Journey', in S. Brown (ed.), *The Art of Kamau Brathwaite*, Bridgend: seren, pp. 208–30.

Winkiel, L. (2014), 'Post-Colonial Avant-Gardes and the World System of Modernity/Coloniality', in P. Bäckström and B. Hjartarson (eds), *Decentring the Avantgarde*, Amsterdam: Rodopi, pp. 96–116.

'Belonging nowhere?': Labelling British Experimental Women's Fiction of the Long Sixties

Hannah Van Hove[1]

INTRODUCTION

During what Arthur Marwick has defined as the 'long sixties', a period stretching from 1958 until 1973–4 (Marwick 1998: 7), a number of women writers – amongst them Anna Kavan, Ann Quin, Brigid Brophy, Christine Brooke-Rose and Eva Figes – were publishing highly innovative experimental novels. Whilst for Kavan, the works she published during the 1960s represented the endpoint of her writing career – she had started publishing what she called '[m]y sort of experimental writing' since 1940 (Kavan 1943) – for the other authors under discussion in this chapter, the long sixties was the era in which they either started writing experimentally or in which their experimentations with form reached a peak. Thus, Kavan's last two novels published before she died in 1968, *Who Are You?* (1963) – a novel divided into two main parts with the latter representing a more concise and subtly different version of events – and *Ice* (1967) – set in a post-apocalyptic landscape in which 'the unreality of the outer world' appears to be, as the narrator puts it, 'an extension of [his] own disturbed state of mind' (Kavan 2006: 60–1) – continue her experiments with narrative structure in their focus on the portrayal of subjective reality.

This is a concern which is equally present in Quin's work. Whilst her first two novels *Berg* (1964) and *Three* (1966), in which she experimented with different modes of writing in representing the interiority of her characters, established her as an exciting new voice within British fiction, *Passages* (1969), a work whose highly innovative form mirrors the schizophrenia of its main characters, and *Tripticks* (1972), a surrealist road novel inspired by the cut-up method, did not fare well in contemporary reviews.

Similar to Quin, Figes started her writing career – which would continue until the publication of her last book in 2008 – in the 1960s with the publication

of *Equinox* (1966), a poetic and fragmented novel which examines the break-up of a marriage and the protagonist's subsequent struggle to rebuild her world. This was followed by *Winter Journey* (1967), *Konek Landing* (1969) and *B* (1972), all works of fiction which explore the inner lives of their characters through innovative means, turning to fragmentation, stream-of-consciousness techniques, lack of punctuation, narrative discontinuities, and so on.

Finally, for both Brooke-Rose and Brophy, the sixties represented a particularly fruitful period for novelistic experimentations. The publication of Brooke-Rose's *Out* in 1964 signalled her turn to a more radically experimental mode of writing and, from this point on, she often worked with some kind of restraint or excision in her fiction, with her 1968 novel *Between*, for example, featuring several languages in order to represent the story of a simultaneous interpreter, entirely written without the verb 'to be'. Brophy had like Brooke-Rose also started writing in the 1950s, but her experimentations with narrative form arguably culminated in her 1969 genre- and genderbending novel *In Transit*; set in a nameless airport lounge, it follows a protagonist who suddenly loses any sense of gender and this confusion is mirrored in the novel's form, which turns to puns, puzzles, columns (which represent the female/male version of events) and various metafictional moments of awareness.

Though the novels of these authors outlined above often enjoyed some attention upon publication, they rapidly fell from view in the latter part of the twentieth century. Writing in the essay 'Illiterations' in 1989, Brooke-Rose stated that '[p]erhaps one of the safest ways of dismissing a woman experimental writer is to stick a label on her, if possible that of a male group that is getting or (better still) used to get all the attention' (1989: 65). Rather than '[f]luttering around a canon', she suggested that '[t]he best way, in my view, for any writer [. . .] is to slip through all the labels, including that of "woman writer"' (1989: 67). She cautioned, however, that the price is 'to belong nowhere', noting that 'this is, on the whole, what happens to experimental writers of all sexes and origins, but more particularly to women experimental writers' (1989: 67). This, then, has been the fate of the five authors listed above, whose works slipped through the labels of conventional literary postwar classifications and largely fell into obscurity in the latter part of the twentieth and early twenty-first centuries.

As Brooke-Rose intimates, early accounts of post-war British literature paid very little attention to experimental fiction, characterising the period after the Second World War as one in which the novel had, in general terms, turned its back on the interiorising impulse of the modernists in favour of a return to a realist style primarily concerned with registering the social scene and the historical event. Within such accounts, British post-war fiction up until the sixties

or seventies was generally considered to be more or less devoid of experimen-
tal writing. Whilst more recent years' studies of the period have contested such
a narrative, Graham Hough's statement that '[t]here is no avant-garde', uttered
in 1960 (quoted in Rabinovitz 1967: 3), continued to dominate overviews
of British post-war fiction up until the late twentieth century. Although this
critical neglect of experimental fiction is now being recognised, studies of
British experimental women writers in the second half of the twentieth cen-
tury remain few and far between.

This chapter therefore aims to focus specifically on the manner in which
a range of relatively neglected British female authors have been categorised,
both during and after the long sixties. Whilst it groups Brophy, Figes, Kavan,
Quin and Brooke-Rose together, these authors did not constitute a group or
school as such (though some of them knew each other and were aware of each
other's writing). Neither does this list of five writers pretend to be exhaus-
tive; there were lots of other women writers writing innovative fiction at the
time (for instance, Doris Lessing, Angela Carter, Penelope Shuttle, Elspeth
Davie, Maggie Ross, Naomi Mitchison, Muriel Spark or Maureen Duffy).
Yet by exploring the reception of experimental writing through a focus on
five particular women who were writing during the long 1960s, this chapter
aims to prepare the ground for a broader overview of women's writing in the
sixties. From Anna Kavan's apocalyptic, feverish and circular 1960s novels,
Figes's fragmented, poetic narratives, Quin's pop- and cut-up-inspired works,
Brooke-Rose's lipogrammatic and typographic innovations to Brophy's rau-
cous metatextual experimentations, the fiction of these women writers – at
the same time as evidencing an interest in older avant-garde practices and a
desire to stretch and strain conventional novelistic form – has been labelled
(or indeed, non-labelled) in a variety of ways. Yet the categorisations used
to refer to this fiction have not been able to guarantee visibility and recogni-
tion of this work. By giving an overview of the various labels attributed to
women's experimental fiction in Britain and the ways in which they have been
employed, this chapter thus interrogates the reasons for the critical neglect of
British experimental women's writing whilst at the same time teasing out the
extent to which the categorisation 'neo-avant-garde' might be a useful term
in exploring the influences and persisting concerns of this innovative fiction.

'EXPERIMENTAL' WRITING IN THE CONTEXT OF
THE 1960S BRITISH LITERARY SCENE

In post-war Britain, the label 'experimental' has always sat uneasily with both
critics and authors alike. Thus, the short-lived popularity of such innovative

authors as Kavan, Quin, Brophy and Figes, who each enjoyed some critical acclaim during their lifetime, reflects the general mistrust which the categorisation 'experimental' seemed to induce amongst the majority of readers and writers of the day. A telling letter from Quin, written in 1966, recounts how she made 'the unfortunate mistake' of showing a draft of what was to become her third novel *Passages* to Don Hutter at Scribners in New York. She reports him commenting disparagingly: 'The whole thing frankly Ann spells Experimental in caps', upon which Quin responded: 'Well if it turns out a ghastly failure it really doesn't matter as it's something I've just got to do' (Quin 1966). Fiction labelled 'experimental' often met with a lot of hostility in both the States and Britain at the time and the term tended to get used by reviewers (and publishers, as evidenced here) in a pejorative manner. B. S. Johnson thus famously stated that '"[e]xperimental" to most reviewers is almost always a synonym for "unsuccessful"', objecting to the label being applied to his own work (1973: 19).

The general distrust of any form of experimentation, propounded loudly in the 1950s by certain representatives of the Angry Young Men movement such as Kingsley Amis and John Wain, continued to dominate the publishing industry throughout the long sixties. In British critical literature of this era, 'experimental' literature was regularly equated with a form of writing which primarily employed 'technical' practices or 'gimmicks'. The implication here is that form stands in opposition to content, with the former being the primary concern of experimental literature whilst content, presumably, is what realist literature was all about. The works of the experimental women authors looked at in this chapter, however, contest this simple binary opposition between 'experimental' and 'realist' literature which has tended to dominate discussions of the British mid-twentieth century novel.

Writing in 1970, in an article entitled 'The Future of the Experimental Novel in English', Robert Nye bemoaned the fact that 'we have not understood the *past* of the experimental novel in English' (1970: 10). Pointing out that William Burroughs's cut-up technique can in fact be traced back to the work of the sixth-century grammarian Vergilius Maro, he suggests contemporary experimental authors 'read better' if they are understood as part of the tradition to which they belong. Reflecting on the term 'experimental novel' and the ways in which it is employed, Nye writes that '[w]e have a *tradition* of "experimental" writing in English but this being commonly referred to as a series of eccentric works the continuity of the thing is lost' (1970: 10). This remark rings true in light of the relative neglect of the authors studied here; by the time Nye was writing, all five authors had arguably enjoyed their heyday and by the eighties most of their names had slipped from view in the British literary establishment.

WOMEN'S EXPERIMENTAL WRITING IN THE CONTEXT OF THE 1960S BRITISH LITERARY SCENE

Whilst the above makes clear that 'experimental' writing of the long sixties generally had a hard time in the face of a British literary climate resistant to experimentation, contemporary reviews of British innovative women's fiction highlight how this writing faced an additional barrier, namely a prejudice (whether this be conscious or unconscious) regarding the ability of women to innovate. They exemplify how this fiction was often considered to be 'infuriating', 'difficult' and 'pretentious',[2] leading critics to thereby dismiss this work. Thus Nye, in his article on the future of the British experimental novel, scathingly pronounced that Quin 'may be committed to silence following the rather academic exercises in her latest novel' (1970: 10). He was referring to *Passages*, whose disorienting form, consisting of layered narratives, present divergent subjectivities as well as different perspectives on the same events. Three years earlier, reviewing Anna Kavan's *Ice* – a novel equally concerned with reflecting the psychic decentredness of the human subject – Nye had deplored the novel's lack of a more 'garrulous feminine sensibility' (1967: 5), evidently wishing that both authors would 'chuck the box of tricks away' (as he advises Quin to do in his review of her last novel *Tripticks*) in order to 'write a whole book in which observation of the heart's affections is permitted to predominate and inform' (1972: 15).

Nye's reviews of both works illustrate the gendered bias in assessing innovative fiction by women that was present in criticism of the period, and serves as a striking example to back up a point made by Brooke-Rose, in an interview with Ellen Friedman and Miriam Fuchs when asked about the difficulties she faced as a female experimental writer:

> the woman experimental writer has more difficulties than the man experimental writer, in the sense that, however much men have accepted women's writing, there is still this basic assumption, which is unconscious, that women cannot create new forms. They can imitate others, they can imitate their little lives, tell their love stories and their difficulties and so on, and they do it extremely well. I'm not downgrading that kind of writing. But if by any chance they dare to experiment, then they are imitating a male movement, and usually one that's already dead. (Brooke-Rose, in Friedman and Fuchs 1989b: 81)

This ingrained prejudice regarding women and experimentation has indeed often led critics to perceive what they conceived of as being a particular derivativeness in the work of experimental women writers. *London Magazine*'s review of *Ice*,

for example, situated the novel within a consideration of so-called 'avant-garde' fiction and its introductory paragraph was representative of a particular post-war critical attitude directed towards innovative fiction in general, but more specifically to women's experimental writing:

> As if Beckett had cut up Henry James, as if Kerouac had written Ulysses, as if Kafka had scripted Marienbad: immersion in the avant-garde stimulates such phrases as a hysterical recoil; and also as a register of the derivativeness, the determined literariness, of the productions, words nurtured on words, silences bred of libraries. (Wilding 1967: 95)

Whilst the label 'avant-garde' has more recently been used to denote formally innovative writing of the long sixties – see, for example, *British Avant-Garde Fiction of the 1960s* (Mitchell and Williams 2019) – experimental writing by women during the long sixties was hardly ever referred to as such. The term itself was aligned with a particular kind of vagueness by critics of the period. Thus, Frank Kermode writes in *The Sense of an Ending* that '[a] great many different kinds of writing are called *avant-garde*', stating that 'we all have a vague notion of what it means in terms of current experiment' (1967: 117–18). Bernard Bergonzi, in the introduction to a collection entitled *Innovations* (1968), posits that

> the 'avant-garde' label has come to seem a little old-fashioned, as it must inevitably do, having been in continuous use for about sixty years, and although a basic avant-garde tenet is the desirability of 'perpetual revolution' this concept is too paradoxical to convey much meaning to a sceptical mind. (Bergonzi 1968: 11)

Even in the editorial of a *Times Literary Supplement* issue dedicated to the avant-garde, the editors concede the cloudiness surrounding the term, which they consider to be 'one of those dynamic but ill-defined concepts which drive men to attitudes if not to action' ('The Changing Guard' 1964: 676). They go on to state that by the Second World War the age of 'truly spectacular avant-garde movements' seemed to be over and 'the great innovators, men born mainly in the 1870s and 1880s, were occupied with exploiting and consolidating their earlier discoveries' (1964: 675). The emphasis on men being the great innovators here illustrates the dominant idea, still very much present in the post-war period, that experimentation and innovation in literature were more or less synonymous with male authorship. Indeed, the *TLS* published two issues devoted to the avant-garde in 1964, but out of the fifty-nine people featured (in its sections 'Special Statements', 'Poems and Other Writings' and

'Signed Articles') only two were women. Just like the label 'experimental', then, that of 'avant-garde' was not particularly helpful in the assessment of women's experimental writing within a 1960s context; as well as being considered a vague and possibly out-of-date term, it was aligned primarily with ideas surrounding male genius.

Contemporary reviewers' conviction that experimental women's writing was fundamentally derivative is often linked to the charge that this fiction, considered to be aiming to imitate so-called 'difficult' (often almost a synonym for 'high modernist') works of fiction, is difficult for difficulty's sake and that it bears little relationship to any form of 'reality'. Figes's *Konek Landing*, for example, is described as 'a dun-coloured, "serious", semi-experimental fiction' which is 'monotonous and often incomprehensive, a novel whose difficult surface seems unjustified by any fundamental complexity of conception' (Raban 1969: 315). Employing quotation marks which question both the so-called 'seriousness' of Figes's endeavour and the extent to which it successfully achieves what it sets out to do, this review evinces a common frustration with experimental fiction's perceived difficulty. Quin's novel *Tripticks* did not fare any better, described as a 'piece of self-gratification' which 'almost deliberately defies analysis or commendation' (Cole 1972: 844). Reviewing Brooke-Rose's first formally innovative novel *Out* in 1964, Francis Hope in the *New Statesman*, declared Brooke-Rose's work tricksy, dull and 'resplendently unreadable' (Hope 1964: 742).

Implicit in these assessments is the idea that these women writers are attempting to show off and/or achieve something which their work does not pull off. This is evident in the reviews Brophy's work often attracted. As Carole Sweeney has pointed out, '[c]ontemporary reviews of her work often insisted on pointing up its "braininess" and its tendency, as they saw it, to highbrow showing off' (2018: 234). Similarly, D. J. Enright notes that 'Brigid Brophy is probably too versatile for her own good, as good goes, and possibly a little too clever, and certainly too much of a writer' (1980: 15–16). Brooke-Rose has been reviewed in comparable terms. Her radically experimental novel *Thru* (1975), for example, was harshly judged for 'cruelly toy[ing]' with the

> cravenly traditional reader, unschooled enough to still crave some story in with the dollops of critical reflection that anti-novels go in for, [. . .] repeatedly tempted to relax with gobbets of what look like mimetic stuff, all on the level; only to tumble through this level onto a metalevel, or to have some metalevel come crunching down on his head. (Cunningham 1975: 119)

Reviews such as these appear to resent the female writer for refusing to simply entertain the reader, backing up Figes's statement regarding the English conservatism and insularity of the 1960s literary scene: 'In England, nobody

really expects a writer to have the intellectual calibre of, say, a philosopher or a mathematician': 'people expect novelists and playwrights to entertain, not to tax their thinking powers overmuch' (1968: 7). Reviews of works by experimental women writers illustrate that this would appear particularly true of female writers. Related to this, Rebecca Pohl has astutely commented on the slippage that occurs with the word 'difficult' in relation to Brooke-Rose's reputation, stating that '[r]egardless of metonymy, where "difficult" grammatically attaches to the "writer" and "author" it is the person who becomes difficult' (2018: 285–6). Brooke-Rose as well as the other women discussed in this chapter who are often considered to be writing 'difficult' works of fiction thus not only become 'difficult writers', but also 'difficult women'; spoilsports who presumably think they are better than their contemporaries and whose imitative writing aims at showing off their intelligence rather than entertaining the reader.

THE (NON-)RECUPERATION OF 1960S INNOVATIVE FICTION BY WOMEN WRITERS

Having discussed the ways in which contemporary reviews of British experimental women's fiction of the long sixties often exemplified an ingrained prejudice regarding women and experimentation – that women cannot create new forms, that they are being derivative rather than innovative in their own right – it is perhaps not so surprising that criticism in the years following this decade generally did not pay much attention to this literature. What *is* striking, however, is the fact that authors like Kavan, Brophy, Brooke-Rose, Figes and Quin have remained largely absent from studies which aimed to recuperate lost women writers of the twentieth century. Even in studies dedicated to experimental literature, these authors are often overlooked; in the *Routledge Companion to Experimental Literature*, for example, only Brooke-Rose gets a brief mention and none of them make an appearance in the only chapter devoted to women's experimental fiction (Friedman 2012).

One factor which presumably has had an influence on this critical neglect is the fact that critics have struggled in the past to situate these writers within a specifically feminist framework or context. Lorraine Morley, writing on Ann Quin, for example, suggests that 'the startling neglect of Quin's work by three generations of feminist literary criticism' (1999: 138–9) is due to the fact that,

from the perspective of a feminist movement struggling for definition and unity, like Woolf before her, who may in fact have provided a critical touchstone, it is the difficulty of pinning Quin's vision down that marks her writing as politically ambiguous, and hence anti- or at least non-feminist. (Morley 1999: 138–9)

Morley's conclusion here is problematic and I would contest the idea that Quin's work is in any way 'non-feminist', but the statement does point to a difficulty in pinning down any form of authorial political intention (whether this means her writing is 'politically ambiguous' is again not a point which necessarily follows). Indeed, the fiction of these writers, whilst addressing some of the most urgent gender issues of their cultural era, also tends to firmly resist glibly gendered terms and readings. This has led to advocates of feminist recovery and reclamation not treating such experimental authors as overtly 'feminist' or 'activist' enough.[3] As a result, their work has often slipped through the label of 'women's writing'.

Another contributing factor in the critical neglect of these authors is the fact that greater attention is regularly paid to their lives than to an engaged study of their fiction. Ellen Friedman has noted that the few studies which have centred on female avant-garde writing 'tended to concentrate on biographical revelation and speculation rather than textual practice' (2012: 154), and this is certainly true of specifically Anna Kavan and Ann Quin, but also Brigid Brophy and Christine Brooke-Rose to a lesser extent. Though it is understandable that references to the authors' lived experiences are made, critics have often tended to focus on autobiographical aspects of their works in favour of a deeper, more sustained form of reading. When critics do consider Kavan's work, for example, they have often focused on Kavan herself as 'a literary curiosity, driven by a raving solipsism' (Garrity 1994: 253), consistently likening the characters of Kavan's novels to the author herself. It is striking that two biographies of Kavan have been undertaken whilst no single-author study of her work has yet been published.[4] Unfortunately, both biographies often conflate fact and fiction, and are guilty of distorting facts and perpetuating the myth of Kavan as mysterious and enigmatic heroin addict, presumably taking the fact that Kavan appears to have destroyed most of her personal papers and diaries as permission to blur the boundaries between real and fictional worlds in a discussion of her life. Similarly, discussions of Quin's work regularly seem to be based on references to 'her own troubled mind' (Stevick 1989: 231), and in Re: Quin (2013) by Robert Buckeye (described in the cover blurb as 'an unabashedly personal and partisan critical biography' though the sparse fifty-two pages would be better described as a personal rumination), quotes which are taken from Quin's novels are also attributed to Quin herself. The focus on the autobiographical in discussions of the work of these experimental women writers has had a largely detrimental effect; conflating life and fiction has meant that their work has often not been studied in much depth.

In more recent years, there has been a renewed focus on experimental writing of the 1960s period. Johnson is generally cited as a key figure within

this context, in large part due to his attempt to locate a community of writers working in opposition to mainstream British literary culture of the 1960s. Thus, his short-story volume *Aren't You Rather Young to Be Writing Your Memoirs?* (1973) is prefaced with a polemical critique on the state of British fiction and lists sixteen contemporary British writers who he thought wrote 'as though it mattered, as though they meant it, as though they meant it to matter' (Johnson 1973: 29). Opening with Samuel Beckett '(of course)', the list included Quin, Figes, Brophy and Brooke-Rose (out of six women mentioned, the others being Angela Carter and Penelope Shuttle). In his introduction, Johnson claimed a certain modernist lineage, emphasising the importance and influence of James Joyce and Samuel Beckett, presenting his work – and that of his selected contemporaries – as furthering the cause of modernist literature, bemoaning the fact that most British authors still seemed to turn to the forms and conventions of nineteenth-century fiction, which he considered 'anachronistic, invalid, irrelevant, and perverse' (1973: 14).

Whilst Johnson certainly was an influential and important figure in British literature of the 1960s, he has nevertheless come to dominate discussions of experimental writing of this period. Thus, when contemporary innovative women writers have been mentioned, they are often cited alongside references to the man Jonathan Coe called Britain's post-war 'one-man literary avant-garde' (2004: 3). Glyn White has, for example, observed that when Brooke-Rose is mentioned, she is usually linked to Johnson and thereby 'lumped in with and somehow spoken for by him' (2005: 121). This exemplifies a particular tendency of presenting women writers in relation to men; as Leigh Wilson, in referring to Kavan, has stated: '[a]s with many innovative women writers, some attempts to assess her critical standing have compared her to male writers – she is "Kafka's sister" in Brian Aldiss's often repeated formulation' (2017: 327). This citational relationship to Johnson has meant that although these writers are often positioned in relation to him, they are never quite granted the same critical attention that he and his works have enjoyed. White has convincingly argued that part of the reason why Johnson has been granted much more attention than Brooke-Rose is that he makes a 'conspicuous' and easier 'target' for 'hostile critics' willing to attack a perceived experimentalist position, stating that 'Brooke-Rose and her novels are much more elusive' (2005: 121).[5] The same might be said of the novels of Kavan, Quin, Figes and Brophy, which either have not been considered 'experimental enough' in surveys that focus exclusively on experimental fiction or have simply been forgotten.

It is only since the early 2000s that there has been a renewed surge of interest in experimental fiction written by women of this period. In this context, such literature has occasionally been referred to as 'neomodernist', reviving the

designation theorised by Frank Kermode in the 1960s to refer to writing that
responds to what he termed 'the modern sense of crisis' (1967: 93) and which is
characterised by 'anti-traditionalism and anti-formalism', features which neo-
modernism shares with 'palaeo-modernism' (the earlier form of modernism of
the late nineteenth and early twentieth centuries whose origins, according to
Kermode, were 'anticipated by Apollinaire' and began with Dada) (1968: 76).
Jennifer Hodgson thus recently suggested that the designation 'neomodern-
ist' might be 'particularly pertinent given the recent re-engagement with the
legacies of modernism', stating that British experimental writers of the 1960s,
'working in the immediate wake of modernism', appear to embody 'the idea
of the continuity of modernisms as a plural persistent within twentieth- and
twenty-first century literary history' (2013: 22). Indeed, the emphasis on the
influence of modernism in the context of 1960s British experimental writing
is useful, but, as Astradur Eysteinsson has remarked, Kermode's approach to
modernism 'is undermined by the narrowness of his focus, which allows him
to make some preposterous generalizations' (1990: 107). Eysteinsson is here
referring specifically to the fact that Kermode restricts himself to the British lit-
erary scene and makes broad generalising claims regarding the politics of both
modernisms; Kermode namely states that '[e]arly modernism tended towards
fascism, later modernism towards anarchism' (Kermode 1968: 88). Eysteins-
son's emphasis on Kermode's focus on a highly selective canon and his exclu-
sively British focus in the development of his theory of neomodernism are
valid and suggest that the category of 'neo-avant-garde' might be more useful.
Equally highlighting continuities between pre-and post-war experimentalism,
the designation 'neo-avant-garde' allows for a broader, more inclusive cat-
egory which looks beyond the confines of the British isles in order to trace
transnational links and concerns.

Having traced the reception of women's experimental writing in Britain,
it has become clear that this literature has consistently fallen foul of post-war
British literary classifications, including that of the categories 'modernist',
'postmodernist', 'experimental', 'avant-garde', 'neomodernist' and 'women's
writing'. The final part of this chapter explores to what extent the 'neo-avant-
garde' designation, in light of the prejudice and neglect this writing has faced,
might allow for the recuperation of this body of work in a meaningful way.

BRITISH EXPERIMENTAL WOMEN'S WRITING
AS 'NEO-AVANT-GARDE'

The works of the experimental women writers this chapter has referred to tick
the four parameters of what constitutes 'neo-avant-garde' fiction as set out in

this collection's Introduction. Thus, Brophy, Kavan, Quin, Brooke-Rose and Figes all expressed concern at moving away from the realist mode of writing which was dominating the British publishing industry during the 1960s, often attacking its aesthetics and proponents. Their work illustrates the influences of the historical avant-garde, in particular modernist literature from the early twentieth century (with the late modernist work of Samuel Beckett proving a critical touchstone for all five authors), but it also borrows from and draws on movements like (post-)impressionism, surrealism, expressionism and Dada. Their fiction, raising fundamental questions about representation and reproduction, explores the formal, material, and technical levels of literature; as Figes herself states, she and the writers she identified with 'were all interested in the book as a physical object, in our attempts to break out of the straitjacket of conventional linear narrative' (1985: 70). In their explorations with form, these authors experimented with paratext and intertext (Quin, Brooke-Rose, Brophy), transgressed the borders of narrative fiction, incorporated poetic language (Figes, Quin), cut-up material (Quin, Brooke-Rose) as well as borrowing from other media such as music (Brophy, Quin), dramatic scripts (Figes, Quin) and film and television (Kavan, Quin) to inform the structure of their works. A lot of this fiction experimented with the graphic depiction of text on the page (Brooke-Rose, Quin, Brophy, Kavan) and with collage (Quin, Brooke-Rose), and/or incorporated images and/or drawings within intermedial experiments (Quin, Brooke-Rose, Brophy). Finally, in terms of institutional factors, whilst (as already mentioned) these authors did not form a neatly defined school or cohesive grouping of writers, they nevertheless published and appeared in places which retrospectively might be identified as neo-avant-garde networks: spaces conducive to and encouraging literary experiment. These places include, for example, magazines such as *Ambit*, *Evergreen Review* and the *London Magazine*; publishing houses like John Calder and Marion Boyars or Peter Owen; bookshops such as Better Books in London or the Paperback Bookshop in Edinburgh; edited collections and anthologies like the Calder and Boyars New Writers series of the long 1960s, *Beyond the Words: Eleven Writers in Search of a New Fiction* (edited by Giles Gordon, 1975) and *The Imagination on Trial: British and American Writers Discuss Their Working Methods* (edited by Alan Burns and Charles Sugnet, 1981).

Fulfilling all four parameters of the neo-avant-garde as theorised in this collection, the fiction of British experimental women writers has thus effectively been labelled. Having categorised it, however, it is worth revisiting the statement that initiated our discussion. As this chapter's opening quote by Brooke-Rose made clear, acts of labelling are often problematic and not only in terms of the implied exclusion they necessarily adhere to. As Brooke-Rose points

out, the labelling of fiction often functions as a dismissive act, stripping the
work of its potential by usurping it into a larger canon, thereby rendering it
harmless and innocuous. According to this reasoning, the work, once accepted
into a canon, often loses its capacity to question or disturb, rendering its 'revo-
lutionary' potential undone. Brooke-Rose's essay, published more than thirty
years ago, raises concerns which continue to be pertinent in the classification
of fiction in the present day. The point that categorising fiction according
to gender distinctions is not particularly helpful resounds today in the often-
debated topic of whether the category of 'women's fiction' is useful or indeed
harmful. Implicit, then, in Brooke-Rose's quote is the idea that works of fic-
tion have political potential and that the act of labelling is a political act in
itself, capable of silencing this potential (whether this be in terms of capitalist,
patriarchal or other advances). Indeed, as this collection's Introduction makes
clear by tracing of the genealogy of the term 'neo-avant-garde', when using
categorisations, it is important to be aware of what is culturally and politically
at stake in the employment of a specific term to designate fiction.

In light of the critical neglect faced by experimental women writers, one
might argue that the resistance of the work of authors like Kavan, Quin, Brooke-
Rose, Figes and Brophy to fit into boxes could be understood as a refusal to par-
ticipate in the status quo, both in literary as well as in political terms. They are
thereby construing themselves as radically other, carving out a space for them-
selves on the fringes. Friedman has pointed out that 'if canonical novels are as
Frank Kermode, Charles Altieri, and others have proposed, "strategic constructs"
to reinforce a society's values', then works which undermine those values might
be thought of as 'anticanonical' (Friedman 1995: 221).[6] This prompts us to ask
the fruitful question, as anti-canonical works of fiction, how does this literature
subvert established ways of looking at the world and at society?

This question suggests that a study of the fiction of British experimental
women's writing which has a recuperative aim must allow for a potentially
political reading of this literature, a reading which has been sorely lacking in
criticism regarding literature of the long 1960s in Britain. Indeed, implied in
the outdated understanding of British post-war literature as falling into one of
two camps (experimental or realist), briefly referred to earlier, is the pernicious
idea that realist novels are political and relate to 'outside reality' whereas exper-
imental novels are 'asocial' or 'apolitical'. As Julia Jordan succinctly puts it:

> any distinction between a realism that has long been assumed to be allied
> with a vague sort of liberal humanism and a reactionary avant-garde is
> imprecise, just as a distinction between the socially-engaged writers of the
> 1950s and the solipsistic experimentalists is unfair as well as inaccurate.
> (Jordan 2015: 155)

Contrary to readings of their works which have either focused too reductively on biography or equated their formal experimentations with a derivative and/or superior solipsism, the works of British experimental women writers can be understood as responding to and critiquing the social, cultural and historical forces at work in post-war Britain. By reading this fiction through the lens of the neo-avant-garde, keeping Friedman's ideas surrounding the political potential of anti-canonical literature in the back of our minds, experimental women's writing of the long sixties can be understood as testing, subverting and disrupting the tenets of British mimetic realism as a literary historical phenomenon through the (re-)employment of avant-garde techniques such as collage, montage, defamiliarisation, splintered portrayals of consciousness and temporality. As such, the neo-avant-garde provides a useful and meaningful framework to understand this hitherto largely neglected fiction as exemplifying avant-garde continuities in post-war Britain whilst allowing us to situate this writing in a continental and transnational (rather than strictly British) context.

NOTES

1. The research for this chapter was financed by the Research Foundation – Flanders (FWO).
2. For example, Julian Symons's assessment of Ann Quin's *Passages* was representative of the reviews it received, describing it as an 'infuriating' and 'difficult' book, written with 'a parade of mystification' (1969: 59). Brooke-Rose has often been referred to as a 'difficult' author (on this, see Pohl 2018) whilst Figes's *Konek Landing* was described as an 'incomprehensible' novel with 'a difficult surface' (Raban 1969: 315). Rebecca West, commenting on Brigid Brophy's *In Transit* (1969), called it 'twaddle' (quoted in Coldstream 2008). Kavan's *Sleep Has His House* (1948) has been referred to as a 'pretentious' novel 'which carefully avoids reality' and her subsequent fiction often attracted similar criticism (Trilling 1978: 218).
3. Notable exceptions to the omission of some of these writers from feminist scholarship are Friedman and Fuchs's collection *Breaking the Sequence: Women's Experimental Fiction* (1989a) and Margaret Crosland's monograph *Beyond the Lighthouse: English Women Novelists in the Twentieth Century* (1981).
4. With the exception of Francis Booth's self-published work *Stranger Still: The Works of Anna Kavan* (2013), though the book presents mostly summaries of Kavan's works rather than in-depth studies of them.
5. Johnson's 'book-in-a-box', *The Unfortunates* (1969), for example, takes the a-chronological order of memory to a literal level by consisting of unbound pages to be read in random succession.

6. Friedman is here writing specifically about the work of Jean Rhys, but her statement applies to all works whose 'posture as quintessential "other" is so stubbornly, unrelentingly, and seemingly unreasonably maintained that it acts as a menace and even a threat to the dominant culture' (Friedman and Martin 1995: 221).

BIBLIOGRAPHY

'The Changing Guard', *Timess Literary Supplement*, 6 August 1964, pp. 675–6.

Bergonzi, B. (1968), 'Introduction', in B. Bergonzi (ed.), *Innovations: Essays on Art and Ideas*, London: Macmillan, pp. 11–22.

Booth, F. (2013), *Stranger Still: The Works of Anna Kavan*, Marston Gate: Francis Booth.

Brooke-Rose, C. (1989), 'Illiterations', in E. G. Friedman and M. Fuchs (eds), *Breaking the Sequence: Women's Experimental Fiction*, Oxford: Princeton University Press, pp. 55–71.

Buckeye, R. (2013), *Re: Quin*, Champaign, IL: Dalkey Archive Press.

Burns, A. and C. Sugnet (eds). (1981), *The Imagination on Trial: British and American Writers Discuss Their Working Methods*, London: Allison and Busby.

Coe, J. (2004), *Like a Fiery Elephant: The Story of B. S. Johnson*, London: Pan Macmillan.

Coldstream, J. (2008), 'The Booker Prize for Friction', *The Telegraph*, 31 August, <http://www.telegraph.co.uk/culture/donotmigrate/3559535/The-Booker-Prize-for-friction.html> (last accessed 4 February 2021).

Cole, B. (1972), 'Burnt Candles', *New Statesman*, 16 June, p. 844.

Crosland, M. (1981), *Beyond the Lighthouse: English Women Novelists in the Twentieth Century*, London: Constable.

Cunningham, V. (1975), 'Text Appeal', *New Statesman*, 25 July, pp. 118–19.

Enright, D. J. (1980), 'A Writer's Fancy', *London Review of Books*, 2 (3), 21 February, pp. 15–16.

Eysteinsson, A. (1990), *The Concept of Modernism*, Ithaca, NY: Cornell University Press.

Figes, E. (1968), 'The Writer's Dilemma', *The Guardian*, 17 June, p. 7.

Figes, E. (1985), 'B. S. Johnson', *The Review of Contemporary Fiction*, 5 (2), pp. 70–1.

Friedman, E. G. (1995), '"Utterly Other Discourse": The Anticanon of Experimental Women Writers from Dorothy Richardson to Christine Brooke-Rose', in E. G. Friedman and R. Martin (eds), *Utterly Other Discourse: The Texts of Christine Brooke-Rose*, Normal, IL: Dalkey Archive Press, pp. 214–30.

Friedman, E. G. (2012), 'Sexing the Text: Women's Avant-Garde Writing in the Twentieth Century', in J. Bray, A. Gibbons and B. McHale (eds), *The Routledge Companion to Experimental Literature*, Abingdon: Routledge, pp. 154–67.

Friedman, E. G. and M. Fuchs (eds) (1989a), *Breaking the Sequence: Women's Experimental Fiction*, Oxford: Princeton University Press.

Friedman, E. G. and M. Fuchs (1989b), 'A Conversation with Christine Brooke-Rose', *The Review of Contemporary Fiction*, 9 (3), pp. 81–90.

Friedman, E. G. and R. Martin (eds) (1995), *Utterly Other Discourse: The Texts of Christine Brooke-Rose*, Normal, IL: Dalkey Archive Press.

Garrity, J. (1994), 'Nocturnal Transgressions in *The House of Sleep*: Anna Kavan's Maternal Registers', *Modern Fiction Studies*, 40 (2), pp. 253–77.

Gordon, G. (ed.) (1975), *Beyond the Words: Eleven Writers in Search of a New Fiction*, London: Hutchinson.

Hodgson, J. (2013), '"Such a thing as avant-garde has ceased to exist": The Hidden Legacies of the British Experimental Novel', in S. Adiseshiah and R. Hildyard (eds), *Twenty-First Century Fiction: What Happens Now*, Basingstoke: Palgrave Macmillan, pp. 15–33.

Hope, F. (1964), 'I, Julian', *New Statesman*, 13 November, pp. 741–2.

Johnson, B. S. (1973), *Aren't You Rather Young to Be Writing Your Memoirs?*, London: Hutchinson.

Johnson, B. S. (1969), *The Unfortunates*, London: Panther Books.

Jordan, J. (2015), 'Late Modernism and the Avant-Garde Renaissance', in D. James (ed.), *The Cambridge Companion to British Fiction Since 1945*, Cambridge: Cambridge University Press, pp. 145–59.

Kavan, A. (1943), Letter to Ian Hamilton, Ian Hamilton Papers, Alexander Turnbull Library, National Library of New Zealand, Wellington, 3 February.

Kavan, A. (2006), *Ice*, London: Peter Owen.

Kermode, F. (1967), *The Sense of an Ending*, Oxford: Oxford University Press.

Kermode, F. (1968), 'Modernisms', in F. Kermode, *Continuities*, ed. B. Bergonzi, New York: Random House, pp. 10–26.

Marwick, A. (1998), *The Sixties: Cultural Revolution in Britain, France, Italy and the United States, c. 1958 – c.1975*, Oxford: Oxford University Press.

Mitchell, K. and N. Williams (eds) (2019), *British Avant-Garde Fiction of the 1960s*, Edinburgh: Edinburgh University Press.

Morley, L. (1999), 'The Love Affair(s) of Ann Quin', *Hungarian Journal of English and American Studies (HJEAS)*, 5 (2), pp. 127–41.

Nye, R. (1967), 'Finding the New', *The Guardian*, 1 September, p. 5.

Nye, R. (1970), 'The Future of the Experimental Novel in English', *The Guardian*, 10 September, p. 10.

Nye, R. (1972), 'Against the Barbarians: New Fiction', *The Guardian*, 27 April, p. 15.

Pohl, R. (2018), 'Selling Difficulty: The Case of Christine Brooke-Rose', *Textual Practice*, 32 (2), pp. 283–99.

Quin, A. (1966), Letter to R. and D. Sward, 23 November, Robert Sward Papers, Olin Library Collection, St. Louis, Washington University, Series 1.1, Box 8.

Raban, J. (1969), 'New Fiction: Family Scrapbook', *New Statesman*, 5 September, p. 315.

Rabinovitz, R. (1967), *The Reaction Against Experiment in the English Novel, 1950–1960*, New York: Columbia University Press.

Stevick, P. (1989), 'Voices in the Head: Style and Consciousness in the Fiction of Ann Quin', in E. G. Friedman and M. Fuchs (eds), *Breaking the Sequence: Women's Experimental Fiction*, Oxford: Princeton University Press, pp. 231–9.

Sweeney, C. (2018), '"Why this rather than that?": The Delightful Perversity of Brigid Brophy', *Contemporary Women's Writing*, 12 (2), pp. 233–47.

Symons, J. (1969), 'Alien Shores', *The Sunday Times*, 30 March, p. 59.

Trilling, D. (1978), *Reviewing the Forties*, New York: Harcourt Brace Jovanovich.

White, G. (2005), *Reading the Graphic Surface: The Presence of the Book in Prose Fiction*, Manchester: Manchester University Press.

Wilding, M. (1967), 'Selected Books', *London Magazine*, 1 August, pp. 95–7.

Wilson, L. (2017), 'Anna Kavan's *Ice* and Alan Burns' *Europe After the Rain*: Repetition with a Difference', *Women: A Cultural Review*, 28 (4), pp. 327–42.

15

Constraint and Rule: Oulipo and the Neos

Jean-François Puff

Whenever it is a question of situating a contemporary work and evaluating its historical relevance, we most often rely on the categories 'modernism', 'avant-garde', 'neo–avant-garde' and 'postmodernism'. With this in mind, the position of constrained writing as it developed over the course of the twentieth century, even before the creation of Oulipo in 1960, poses a problem: these practices, depending upon the point of view from which one considers them, indeed appear to embody the various determinations of the categories mentioned. Their historical and aesthetic position therefore appears to be marked by a contradiction that is difficult to resolve. This difficulty deepens in the present book, where the concept of the neo–avant-garde is discussed: whatever neo–avant-garde is, it is supposed to have a strong relationship, be that of resumption or return, with the historical avant-garde. On the contrary, the Oulipo group, to a considerable extent, was created *against* the avant-garde, particularly against the surrealist group. Raymond Queneau, one the founders of Oulipo, was a former member of the group and one may suppose that he knew well what he subsequently opposed. Nevertheless, the literary production of the Oulipo group is to a certain extent characterised by experimentation, which justifies its presence in this book. I am proposing here to shed light on the terms of the contradiction I have highlighted, which will lead me to distinguish between the two notions of 'constraint' and 'rule' (in the classical sense of the term).

Having introduced the categories 'modernism', 'postmodernism', 'avant-garde' and 'neo–avant-garde', I must nevertheless, following Jacques Rancière,[1] temporarily distinguish between them within my discussion. They are considered by the philosopher, within the scope of his philosophy of aesthetics, as notions that are not disordered in themselves, but which result in disorder. They appear to lead towards drawing an easy dividing line between the 'representative' and

the 'non-representative' (Rancière 2000: 34)[2] in the arts, a line that muddles the shared regime of the works that it refers to, whether it be to praise them or to vilify them. Rancière calls this shared regime the aesthetic regime of the arts. This aesthetic regime differentiates itself, first conceptually, but also, in part, historically, from another regime of the arts: the poetic or representative regime. Let us simplify this to a degree: the poetic or representative regime integrates an Aristotelian poetics of genre that dominated in the classical period; the aesthetic regime meanwhile integrates a sensible mode specific to art that is most fully exhibited in romanticism. From here, the question is as follows: if works of modernism – or of the various historical avant-gardes – enter into the more general framework of an aesthetic regime of the arts, where do things stand for the specific case of constrained writing? Does it represent a return to a set of determinations specific to the representative regime, and especially to the notion of rule? Such a 'return to' might have, for example, led Marc Lapprand (1998) to conclude his work on the Oulipo group with the notion of 'neo-classicism', a thorny notion that the *doxa* of art history has taught us to consider pejorative, which is symmetrically opposed to the neo-avant-garde. I will examine this question and, in light of the results obtained, ask the question of constrained writing's relationship to the concept of the 'neo-avant-garde' in the terms set out in the Introduction of this book.

REPRESENTATIVE AND AESTHETIC REGIME OF THE ARTS

The poetic or representative regime, according to Rancière, identifies art with a set of 'ways of doing and making' that aim to produce imitations. In this framework, such a regime determines the 'forms of normativity' (Rancière 2000: 28–9) that regulate the modalities of this production, and it is in relation to these forms of normativity that a judgement of conformity can be made regarding a given work of art. The normativity that structures representative space actually defines a series of determinations and equivalences: it brings about the distribution of what can be represented and what cannot; it matches a given subject with a genre that is suited to represent it, and matches a specific register to the genre itself. Thus, the form and the mode of representation proceed from the nature of what is represented; hence the establishment of a hierarchical system of genres based on the value granted to the subject.

This connection of the represented to the representer functions in relation to several principles, two of which we will retain: the principle of verisimilitude and the principle of appropriateness. The rules that are characteristic of classical works have as their sole goal the strict observance of these principles. One must therefore consider the dual, interlaced purpose of these rules: formal

rules aiming to produce verisimilitude, that we more willingly retain, rules of connection aiming to produce appropriateness, that, for Rancière are more significant. The representative regime of the arts would not know how, once again according to Rancière, to free itself from a regime of visibility:

> the representative primacy of action over characters or of narration over description, the hierarchy of genres in accordance with the hierarchy of their subjects, and the matching primacy of the art of speech, of speech in action, enter into analogy with a whole hierarchical vision of community. (Rancière 2000: 31)

The work is addressed, in the first place, to whomever is suited, by virtue of their state, to make a judgement of taste about it. Accordingly, poetry is the productive activity of those who possess a highly assured taste for appropriateness, and it actualises their rules. Such a determination of both subjects suited to representation and of representative modes explains the concept of classical rhetoric as Gérard Genette describes it, of a 'zero degree' of language, 'a sign defined by the absence of a sign' (1966: 208) in which things can be said *as they are* so that the space of the figure that makes poetry can then be introduced. Once the *inventio* (the choice of subject) and the *dispositio* (the organisation of parts) have been laid out, the specific space of the *elocutio* (the figural) is then deployed (Rancière 1998: 19). Figurative language carries out the transposition of simple language into the appropriate register for the genre, from thought to expression: Jean Racine, who composed his tragedies first from an argument in prose, did not do things differently.

This system as a whole is slowly going to move towards the implementation of a new regime of art. This new regime bears the name 'aesthetic regime' in that it brings about 'the distinguishing of a sensible mode of being specific to artistic production' (Rancière 2000: 31). The identification of art is therefore no longer performed in accordance with a system of genres that determine ways of doing and making, but through the definition of the work as a pure 'being of sensation' (Deleuze and Guattari 1991: 155). The system that regulates the connection among the arts and the hierarchy of genres is smashed to pieces in favour of a writing that is pure *elocutio*.

Thus, Genette mentions the possible translation of figurative language into the simple language of unornamented thought. On the contrary, in the aesthetic regime, ideas have become totally homogeneous with the very words of the poem. This is again the meaning of Stéphane Mallarmé's famous expression: 'It is not with ideas that one makes poems, Degas, it is with words.' This language is itself homologous with the language of things, with the truth of

things that, therein, are 'more than things themselves'. Here, the model is produced from a language that is suited to deciphering everything, for seeing everything as language. The determinations of genres and of registers that corresponded with what was considered to be representable thus lose all relevance. As Victor Hugo notes in the 1826 preface to what would become *Odes et ballades*:

> Every day, regarding literary production, we hear talk of the *dignity* of some genre, of the *appropriateness* of some other, of the *limits* of this one, of the *latitude* of that one: *tragedy* forbids what the *novel* allows; the *song* tolerate what the *ode* defends, etc. The author of this book has the misfortune of not understanding any of all this; it seems to him that what is really beautiful and true is beautiful and true everywhere [. . .]. Thought is a virgin and fertile territory, which productions want to freely increase the size of, and, as it were, by chance, without sorting, without lining itself up into flower beds like in one of le Nôtre's classical gardens, or like the flowers of language in a treatise of rhetoric. (Hugo 1964: 279–80)

As Rancière writes:

> The figurative mode of language is the expression of a spontaneous perception of things, which does not yet distinguish between proper and figurative, concept and image, things and feelings. Poetry does not invent, it is not the *techne* of a character, the artist, who constructs a realistic fiction for the pleasure of another character named the spectator, who is just as adept at the art of speaking. It is a language that says things 'as they are' for he who is roused by language and thought, as he sees them and says them, as he cannot not see them and not say them. It is the necessary union of speech and thought, of knowledge and ignorance. (Rancière 2000: 37–8)

In the same movement that leads to the end of a poetics of genre, the conception of a form that exists prior to the work itself is destined to die away. In Deleuze's conception, which looks at the cases of the novel and of music, in an aesthetic regime, the 'plane of composition' does not precede the work: it gets into the work, it takes shape at the same time as the work is made. The work of the artist conceived in this way 'entails a vast plane of composition, not abstractly preconceived, but that is constructed as the work moves forward, opening, circulating, undoing and redoing increasingly unlimited combinations according to the penetration of cosmic forces' (Deleuze and Guattari 1991: 155). Hence the privileged place of the novel in the nineteenth century, the

'genre of that which is without genre' (Rancière 1998: 29), infinitely plastic, suited to grasp everything heterogeneous within itself. Description, which was a figure of classical rhetoric, becomes the very language of things, the enactment of a process of deciphering.

At the same time, another new question arises. There are no longer any 'pragmatic criteria' (Rancière 2000: 33) for identifying and judging artistic products, and the space of a contradiction between art's autonomy and heteronomy is opened up – a question that, from this point on, asks: what is this thing that we now call 'literature'? Subsequently, the status of the author shifts, if the work conceived in this way indicates 'the power of a thought that has itself become foreign to itself' (Rancière 2000: 31), with the poem saying 'what is innermost in everything', to use Hugo's expression (Hugo 1964: 265). Hence the Kantian conception of 'genius' that is called upon to travel through the ages: genius is a form of non-self-belonging of the creative subject. In correlation, the question of the work's reception also shifts: artistic productions are no longer given to 'a hierarchical vision of community' but open themselves, virtually, to everyone.

OULIPO AND THE REPRESENTATIVE REGIME OF THE ARTS

It is in the framework of this aesthetic regime that, it seems to me, one must try to think about constrained writing since its return in the twentieth century – and it is precisely the question of a return, even the accusation of a 'return to', that one must do justice to. With emphasis on the notion of constraint, there are indeed a number of determinations of the aesthetic regime (which includes the categories of modernism, the avant-garde and the neo-avant-garde) that, at first glance, appear to be challenged. First of all, the return of rules would lead back to an abstract predetermination of the work's plane of composition. The notion of constraint, as Oulipo approaches it, does not readily distinguish itself from the notion of the work's 'structure', which necessarily follows if there is a work. Constraint is indeed meant to control all of the parameters of the work's form. Let us take the example of the novel, a form which traditionally eschewed rules. In the framework of Oulipian works, such a form is distinctly found to be repatriated into the space of rule:

Whereas poetry was the hallowed ground of the *rhétoriqueurs* and makers of rules, the novel, for as long as it has existed, has eluded every law. Anyone can push an undetermined number of seemingly real characters before it, like a flock of geese, through a long moor of an undetermined number of pages or chapters. The result, whatever it is, will always be a novel. (Queneau 1965c: 27)

Hence the proposal from Queneau for a 'conscious technique of the novel' (Queneau 1965c: 28), based on numbers, which *Le Chiendent* (*The Bark Tree*) provides the first example of. A claim is made for the influence of representative poetics on the form of the novel:

> Each of *Le Chiendent*'s sections is one, with only two or three exceptions that I will be able to justify. It is one, first and foremost as a tragedy, in that it observes the rule of the three unities. It is one, not only when it comes to time, place and action, but also when it comes to genre. (Queneau 1965c: 30)

In this way, the plane of composition precedes the composition itself, as a form of 'anti-chance'. The work is controlled by modes of fabrication.

Secondly, there are constraints that are rediscovered, reactivated or reinvented by Oulipo. Raymond Queneau, who considers Boileau's *L'Art poétique* to be 'one of the greatest masterpieces of French literature' (Queneau 1965b: 326), offers a means of organisation: it is Oulipo's much talked about table of classification of works, whose project dates back to 1973 (Oulipo 1981: 73–7). It is about restoring distinctive properties and putting them in order, whereas the aesthetic regime tended to make them inessential. With this table, it is perhaps not quite a question of, to use Hugo's words, a 'le Nôtre-style garden', but in any case, it is not at all a 'virgin and fertile territory, which productions want to freely increase the size of, and, as it were, by chance, without sorting'. Moreover, it is significant that this table includes the classical genres comedy and tragedy in the section where 'constraints of the semantic order' are classified.

Thirdly, from reconsideration of the notion of constraint, in which specific 'ways of doing and making' are once again emphasised, there stems a new qualification of the creative subject, who aims to eliminate the notions of 'genius' and 'inspiration' in favour of a voluntary and conscious work of form: 'What is the goal of our work? To offer new "structures" to writers that are of a mathematical nature or even to invent new artificial or mechanical processes that contribute to literary activity' – and he adds, with a touch of irony, that these structures are intended to be '[s]upport for inspiration, so to speak, or even, in a way, an aid for creativity' (Queneau 1965b: 321). With this in mind, the work of writing aligns itself with a form of craftsmanship aiming for equivalency of the structure of the text produced with the constraint that brings it about – a work whose endpoint would be recourse to the machine, a machinic production of the text. There would here be a point of radical opposition with the concern, specific to the aesthetic regime, for a self-dispossession of the creative subject in the act of creation.

Furthermore, Oulipo entirely refutes one of the fundamental identifications of the aesthetic regime, what Jacques Rancière calls 'modernatism' (2000: 39): an identification by which the artist produces an aesthetic anticipation of the future in his works. Here, in my view, one encounters the major trait allowing for the differentiation of the historical avant-gardes from the neo-avant-gardes of the second half of the twentieth century, for whom the political dimension is essentially critical. The politics of poets in 'modernatism' has to do with a 'forward' or *en-avant* position for poetry, which is decided as the anticipation of a collective sensible future mode for a community of free men. This is still the position of the surrealist group to which Oulipo explicitly opposes itself. It is doubtless from this standpoint that one must consider the theme of the end of History, without which one cannot easily understand Queneau's body of work. It is a Hegelian theme that Queneau will deploy starting from his commentary on Alexandre Kojève. From this standpoint, refusal to latch the newness of the work onto a political future would have led to viewing literature as a completed thing. From here, there is nothing left but to comb through past forms, or even to derive new forms from them; but, in spite of what François Le Lionnais writes, in an attempt to classify Oulipo among the Moderns: 'The synthetic LiPo [potential literature] establishes the great mission of OuLiPo: it is a question of opening up the new unknown possibilities of old authors' (quoted in Arnaud 1980: 7), in spite of this, therefore, these forms would not be essentially different from old forms, neither in their nature, nor in their destination. On the contrary, in Noël Arnaud's words, Oulipo is 'entering into the interminable' (1980: 7).

As a function of these various points, constrained writing, as Oulipo conceives of it, would be opposed, *at first glance*, with the dominant poetics of the aesthetic regime. This implies that, in spite of its experimental nature, Oulipo cannot come under the concept of the neo-avant-garde.

OULIPO AND THE AESTHETIC REGIME OF THE ARTS

For those, however, who would like to delve even slightly into the poetics of Oulipo's practice, it will quickly become apparent that this 'return to' of the determinations specific to the representative regime is nothing less than essential. One can consider how everything comes undone in one statement from Queneau that appears in 'Technique du roman' ('Technique of the novel'): 'There are no longer any rules, not since they survived value' (1965c: 33) – a statement that, in itself, is contradictory, and whose meaning must be unpacked: on the one hand rules survived, therefore there are rules, still, at work in the space of

literature; on the other hand, 'there are no longer any rules', a clause that is in contradiction with the previous one. Everything is therefore toying with the notion of 'value'. The statement demonstrates a radical disengagement with the notion of rule from its usage in representative poetics. In the latter case, indeed, the rule was, in a way, consubstantial with value. The edifice of the representative regime – its adaptation of a genre and a register to fit a given subject, the hierarchy of genres that proceeded from it – was based on the primacy of value. Accordingly, rules were entirely subordinated to value, and aimed essentially at determining the ways of doing and making suited for adequately representing what Rancière calls a 'hierarchical vision of community'. Starting from this simple statement, the entire comparison of a 'new rhetoric' of constraint – which does not determine any adaptation of a genre to fit a subject – with a representative poetics based on a system of rules, is undone.

First, let us consider Oulipo's table of classification of works: it is a double-entry table that, on the vertical axis, presents a level of language on which transformations are going to be carried out (letters, syllables, words, sentences, paragraphs, then the specific case of semantic constraints, in which classical genres significantly figure) and, on the horizontal axis, the type of transformation carried out (length, number, order, nature). This table is conceived of according to the scientific model of a classification of elements: hence the name 'Queneïef's Table' that it receives, in allusion to Mendeleev's table of classification for chemical elements (Oulipo 1991: 56). With this in mind, Queneau's classification relies solely on certain distinctive properties and absolutely does not determine any hierarchy of the type thus described. It demonstrates, on the contrary, both the strict equality between the constraints, and the indifference of the eventual subject of the text produced to the form and register of this text. As Noël Arnaud writes, 'there are structures that OuLiPo makes available to writers and that can produce, depending upon the user's disposition, romantic or symbolist or surrealist or tuttiquantist works' (1980: 11). Let us take the example of Perec's *La Disparition* (*A Void*), in which a double reversal is carried out in an exemplary fashion: far from the subject controlling a system of rules and an appropriate register, it is, on the contrary, the constraint of the lipogram in 'e' that both gives the novel its subject, according to Jacques Roubaud's principle ('a text written according to a constraint should speak about this constraint'), and that controls its register, or rather its absence of register insofar as the constraint of the lipogram leads the novels to employ all levels of language alike, from the most elevated to the most trivial.

Second, poetics, which follow the Oulipian practice of constraint, result not in the adaptation of a system of rules to a genre, but, on the contrary, in a radical form of trans-genericity. This is precisely what Queneau indicates

when he draws the novel and the poem together: the strictness of the latter's composition needs to be transposed into the former, especially as far as the number of chapters or the recurrence of characters' appearances is concerned: 'I wrote other novels with this idea of rhythm, this intention of making the novel into a kind of poem. One can make situations or characters rhyme like one makes words rhyme, one can even content oneself with alliterations' (Queneau 1965a: 42). The emblematic example of this trans-genericity of constraints is offered by Roubaud's *Hortense* series, a cycle of novels governed by the emblematic form of the sestina – even if Roubaud never carries out the Quenellian assimilation of the novel to the poem. From then on, one must consider that what is maintained using the term 'genre' has no relationship with the specific determinations of the representative regime. Thus, the notion of constraint itself is, to a considerable extent, a notion that subsumes these modes of expression, and as such distinguishes itself from the notion of the rule in the classical sense of the term.

Regarding the status of the author himself, one would not be able to dwell on considerations relating to modes of fabrication and to the modest form of craftsmanship of an 'art that is simple and all execution' (as Napoleon said about war) without causing great damage. Indeed, Oulipo's works lead to a contradiction between two modes of creation. On the one hand, the main task of the *Ouvroir* or Workshop is to rediscover old constraints or to invent new constraints and then to limit oneself to putting them to the test, in applications that have the straightforward status of an exercise. Yet, on the other hand, a member of Oulipo can become an 'Oulipian author' and realise the pure potentiality of constraint in the creation of works that are set loose from the status of an exercise. This contradiction determines a dual horizon.

In the first case, the creation of potentially constructive constraints aims to shield literature from the fact of chance; in doing so, however, the question of unintentionality shifts, which symptomatically points out Oulipo's problems with Genette. He grouped the application of constraints such as the S+7 with a form of automatism, with a 'game of change' that he compared to surrealist automatism, without taking into account, at that time, the notion – one that is certainly problematic – of automatism 'in the conscious domain', which is the specific territory of Oulipo. Such a comparison, however, does teach us something: Oulipo, from this standpoint, would shift the unintentionality out of which the work proceeds from the creative subject towards creative constraint. Here, the first case splits itself in two: a tension edges in between, on the one hand, considering constraint as pure arbitrariness and, on the other hand, latching the notion of constraint onto a mathematics conceived of as the writing of the world. In this case, the practice of constraint returns to the

specific model of the aesthetic regime of a language expressing 'the intimate games of the relations between things' (Rancière 1998: 43).

The other case, that of the arbitrariness of constraint, through its realisation, results in the deployment of a pure object of language, set loose from all subjectivity and all reference. Yet, the effects of such a conception can, just as much as the previous conception, be thought of in the framework of the aesthetic regime. I offer Michel Foucault as a witness, in his book on one of Oulipo's 'plagiarists by anticipation', Raymond Roussel. The philosopher there considers the revelations of Roussel's *How I Wrote Certain of My Books* to be a secret doubling: once the processes of writing has actually been revealed, the text's first riddle leads us towards a second one, which is precisely the riddle of the process itself. The latter's purpose would have only been to deploy the scintillation of a pure language whose subtraction would not return us to any truth. As Baudelaire wrote, '[t]he curtain had risen and I was still waiting' (1857 n.p.): it is precisely that there is nothing else to see aside from the curtain itself, the surface that the process unfolds. In this way, the practice of constraint that aims to deploy a pure game of language in itself makes itself into the privileged occasion for a poetics of writing whose asserted origin is the thought of Maurice Blanchot. The endpoint of a language that is no longer occupied with anything other than itself, and, in that way, is put to use in order 'to dig a void into which being sinks, in which words race into the pursuit of things and in which language endlessly collapses into this central absence' (Foucault 1992: 175). Accordingly, constrained writing would represent one of the endpoints of this 'absolutization of writing' (Rancière 2007: 17) that is characteristic of the aesthetic regime.

Nevertheless, in the specific case of the Oulipian author, another form of unintentionality is deployed, one that it is in contradiction with the preceding form in that, this time, it no longer plays on the level of constraint, but on the level of the text itself that it brings about. Constrained writing demonstrates the carrying out of a deviation that slips into the open space between the abstractly pre-existing structure and its realisation. This deviation has a name: *clinamen*. This world, taken to Lucretian physics, designs the variation one consciously applies to a constraint. The theoretical recognition of *clinamen* demonstrates Oulipo's assumption of a presence of intuition. One would have to, for example, understand what is contradictory about Queneau's proposition:

> There are forms of the novel that impose all of the virtues of Numbers onto the proposed material and, emerging from expression itself and from various aspects of the narrative, of the same nature as the guiding idea, daughter and mother of all the elements that it polarizes, a structure is developed that transmits the last flashes of Universal Enlightenment and the last echoes of the Harmony of Worlds to the works. (Queneau 1965c: 33)

The structure of the novel, so 'abstractly determined' that it may be like the writing of the world by the virtues of numbers, gives birth to 'expression itself'; in its development it is both 'daughter and mother' of the substance of what is expressed. The definitive plane of composition is given in the very movement of writing the novel. Thus, there might be, at the heart of Oulipo's poetics, the presence of a contradiction between the vow of anti-chance that shifts the unintentionality of the subject towards constraint itself and the specific modalities of the implementation that the return of creative intuition indicates. This *Janus bifrons* of constrained writing – with which we can identify two founding figures of the *Ouvroir*, François Le Lionnais and Raymond Queneau – still sends us back to the same thing, that is, to 'the power of a thought that has itself become foreign to itself', a main point of the aesthetic regime.

As for the reception of the work, it completely sets itself apart from what determined representative poetics, aiming for the production of an appropriate-ness made to agree with the tastes of a defined audience. Constrained writing, more than any other writing, actually demonstrates the split between the pro-cess of the work's production and its reception: the effect of constraint in the text can remain entirely unnoticed, as was the case for *Le Chiendent*. Despite the use of rules 'as strict as those of the sonnet' in the novel, 'none of these critics that wanted to speak about it at the time even noticed' (Queneau 1965a: 42). Is it necessary to recall the borderline case of the reception of *La Disparition* by the Oulipians themselves?[3] Constraint is the 'figure in the carpet'; a poetics of con-straint does not in any way regulate the text's reception, it does not give, in spite of appearances (distinguishing between 'soft constraints' and 'hard constraints'), any 'pragmatic criterion' for judging the work, and does not correspond to any specific regime of visibility either. Nothing more opposed to neo-classicism; but nothing more opposed, also, to the mode of appearance of avant-gardist and neo-avant-gardist productions.

As far as the strictly political dimension of this practice is concerned, one can say that, if it recognises the specifically 'modernatist' position as 'unten-able', and the ambition of this position is to offer a 'teleological model', it does not offer anything less than its own vision of the relationship of the autonomy of art to its heteronomy. As Peter Kuon writes: 'Oulipo owes its particularity to the fact that it refuses the avant-garde pathos in order to strongly and lucidly root itself in the rationalist traditions of Western thought' (1999: 27). This rooting takes the utopian form of 'ou x po', a generalisation of the methodical research of potentialities onto all human activities. The meaning of 'ou x po' would thus be to express a conception of History as a patient work of mastery in a regulated form of constructivism. Accordingly, literary activity, activity whose prime material is language, would

be the ultimate model of all human activities of transformation, which is both a little and a lot:

> An Emperor changed the morals of the Chinese by modifying their language, that is what seems very possible to me. There is a strength of language, but one must know how to apply it, there are different kinds of levers and one does not lift up a block of stone with a nutcracker. (Queneau 1965a: 45)

In all likelihood, such an active form of modesty aims to shield us from nihilism.

CONCLUSION

In this way, this analysis seems to have pointed out several approaches, among others, that are aimed at setting the practice of constrained writing free from the notion of neo-classicism. The actual practice of Oulipian authors, as well as those who worked within this approach without belonging to the *Ouvroir*, make it possible to conclude with this partial and modest result, but at least it is a result: if the application of a rule, in the classical sense of the term, implements a constraint, the application of constraint, by contrast, includes neither the domain nor the mode of application of a rule.

For all that, can we still allow Oulipo into the category of the neo-avant-garde? The response is complicated and, for now, I can only outline it. On the one hand, Oulipo, while rightfully falling in line with an aesthetic regime of the arts, is shaped by negating some of the determinations of historical avant-gardes: the *Ouvroir* is, therefore, not derived from these avant-gardes inasmuch as it does not re-enact them in another era (namely the post-war). Accordingly, the category of postmodernism can be relevantly used in this respect, even if it means that one must take several precautions. Nevertheless, on the other hand, the multiplicity of possible constraints and the potential diversity of their domain of application were able to be combined in the works of other authors coming, instead, from the group's second wave, with the influence of the various neo-avant-gardes: the issue of opposition to surrealism drifted away, along with reverence for established literary genres and for tradition in general. The productions of authors such as Michelle Grangaud, Michèle Métail (who left the group), Ian Monk or Frédéric Forte, if they do not rightfully belong to the neo-avant-gardist field as it is described in the Introduction of this book, situate themselves in the sphere of its influence, in stylistic and formal terms, as well as in their relationship with transmediality. One can say that they fully belong to what Harold Rosenberg (1959) called 'the tradition of the new'.

NOTES

1. In his works *La parole muette* (1998) and the extremely dense synthesis entitled 'Des régimes de l'art et du faible intérêt de la notion de modernité' ('Regimes of art and the feeble interest of the notion of modernity'), which is included in *Le partage du sensible* (Rancière 2000: 26–45).
2. Unless otherwise noted, all translations are mine.
3. On this point, see Roubaud (2002: 214).

BIBLIOGRAPHY

Arnaud, N. (1980), 'Et naquit l'Ouvroir de Littérature Potentielle', preface to J. Bens, *Oulipo 1960–1963*, Paris: Christian Bourgois, pp. 7–14.

Baudelaire, C. (1857), 'Le Rêve d'un curieux', in C. Baudelaire, *Les Fleurs du mal*, n.p.

Bénabou, M., J. Jouet, H. Mathews and J. Roubaud (2001), *Un art simple et tout d'exécution: cinq leçons de l'Oulipo*, Paris: Circé.

Bens, J. (1980), *Oulipo 1960–1963*, Paris: Christian Bourgois.

Deleuze, G. and F. Guattari (1991), *Qu'est-ce que la philosophie?*, Paris: Minuit.

Foucault, M. (1992), *Raymond Roussel*, Paris: Gallimard.

Genette, G. (1966), 'Figures', in G. Genette, *Figures I*, Paris: Seuil, pp. 205–21.

Hugo, V. (1964), *Œuvres poétiques I*, Paris: Gallimard, Bibliothèque de la Pléiade.

Kuon, P. (1999), 'L'Oulipo et les avant-gardes', in P. Kuon (ed.), *Oulipo poétiques*, Tübingen: Gunter Narr, pp. 15–30.

Lapprand, M. (1998), *Poétique de l'Oulipo*, Amsterdam/Atlanta, GA: Rodopi.

Oulipo (1981), *Atlas de littérature potentielle*, Paris: Gallimard.

Queneau, R. (1965a), 'Conversation avec Georges Ribemont-Dessaignes', in R. Queneau, *Bâtons, chiffres et lettres*, Paris: Gallimard, pp. 35–48.

Queneau, R. (1965b), 'Littérature potentielle', in R. Queneau, *Bâtons, chiffres et lettres*, Paris: Gallimard, pp. 317–46.

Queneau, R. (1965c), 'Technique du roman', in R. Queneau, *Bâtons, chiffres et lettres*, Paris: Gallimard, pp. 27–34.

Rancière, J. (1998), *La Parole muette*, Paris: Hachette.

Rancière, J. (2000), *Le Partage du sensible*, Paris: La fabrique éditions.

Rancière, J. (2007), *Politique de la littérature*, Paris: Galilée.

Rosenberg, H. (1959), *The Tradition of the New*, New York: Horizon Press.

Roubaud, J. (2002), *La Bibliothèque de Warburg*, Paris: Seuil.

A Third Term? Avant-Garde on the Fence in France Since the 1990s

Jeff Barda

In memory of Greg Mellers and Aleix Gorchs Rovira

Faced with the plurality of forms and approaches that poetry can take today, one may struggle to say with assurance what is and what is not a work of poetry. Given the successive avant-gardes waves, the theoretical revolutions, as well as the emergence of interdisciplinary projects and collaborative works with visual artists, musicians, choreographers and filmmakers, it was inevitable that poetry engaged in its own process and form, becoming a practice that cuts across all forms of stable identifications. Certainly, the plethora of epithets now associated with that substantive – be that 'sound', 'digital', 'action', 'performed' or 'danced', to cite a few instances – demonstrates its liveliness and inherent plurality. If, then, poetry has now become an art that cannot be reduced to a single mode of discourse, the unlimited extension of the concept seems to suggest that poets have achieved – not without contradictions – the prerogatives of the avant-gardes. Not only do those practices assumed to reintegrate art into life endeavour to challenge traditional literary categories, structures of meanings, reception or expectation, but they are also tied to a democracy of experiences, leading to a poetry that can be grasped and reproduced by all.

If such vitality provides an opportunity to continue poetry by other means, allowing some like Jacques Rancière to observe that today 'all artistic skills tend to leave their particular domain and swap places and powers' (2009: 21), such an apparently 'liberating effect' is not devoid of paradoxes, economical and institutional constraints. In response to the so-called crisis of poetry book sales, many critics and poets, not least Jacques Roubaud, denounced

> the quasi-economical inexistence of poetry, poetry is not sold, so poetry has no relevance [. . .] Of course, this literary genre is not the only one to

lose 'market share' in the current cultural context [. . .] but in the case of poetry, we are dealing with an extreme low visibility.[1] (Roubaud 2010: 29)

For his part, Jean-Marie Gleize nuances, suggesting a difference between 'fiction's "commercial production" [. . .] quantitatively mainstream' and more traditional poetic practices which 'continue to survive more or less artificially' as opposed to contemporary experimental practices 'which situate themselves in a "blind spot"' (Gleize 2010: 121).

To counter that risk and in accordance with the paradigm of 'capital visibility' (Heinich 2012), many experimental poets, since the 1990s, have adopted various strategies of visibility, distinguishing themselves from others on the field by playing with conventions and postures. In fact, the interdisciplinary nature of some poetic works and the structuration of the current poetic field with its unending conflicts and tensions give the impression that poetry is caught up in the same logics and brawls as can be witnessed in contemporary arts today. Poetry (and poets) are increasingly present in festivals such as the yearly 'Marché de la poésie', institutions like 'La maison de la poésie' and more dramatically in cultural centres and museums sponsored by multinational luxury companies such as the Louis Vuitton or the Pernod Ricard Foundations.[2] The lack of distinction between pure and large-scale productions oriented towards the public places some poets in the same logic of commodification (economy of consumption, imperative of presence) as some artists today. As Laurent Cauwet observes:

> For those whose practice demands forms of implementation outside of the book (sound, visual, performative, multimedia poetry) and whose gestures share formal links with music, visual or performative arts. It is their responsibilities to accept or refuse the artification of their practice. For those who decide to go on that route, their new struggle mainly consists in learning to function (or not) within the cultural industry. For the others, they must carry on, *differently and in spite of all*. (Cauwet 2017: 21)

Alluding to 'artification', a concept put forward by Roberta Shapiro and which refers to 'a process which institutionalises the object as oeuvre, the practice as art, the practitioners as artists, the observers as audiences' (Heinich and Shapiro 2012: 21), Cauwet identifies a complex process of transfiguration and shift of hierarchies and legitimacy in the poetic scene today. Some, like Pierre Alferi, have strongly rejected such institutional appropriation. Following the opening of the Louis Vuitton Foundation, Alferi published in 2014 an important text titled 'L'Art n'est-il qu'un produit de luxe?'. Co-signed by a roster of philosophers and academics such as Giorgio Agamben, Jean-Luc

Nancy and Marie-José Mondzain, but also poets and artists including Suzanne Doppelt, Manuel Joseph, Christophe Hanna and Jacques Julien, this text not only mounted an implicit attack on the introduction of the 2008 French law which allows cultural institutions to receive endowment funds by private funding as a godsend rather than through internal national resources, but also condemned the incremental development of capitalism within culture, turning those 'noble sponsors' into sheer 'speculators' (Alferi 2014). Crucially, such commodification is understandably anathema to the historical developments of the pre-war and post-war avant-gardes – the attack on the autonomy of art and subsequently on the museum of art – since it turns avant-garde failures into commercial success and runs the risk of what Jean-Pierre Cometti termed, after Walter Benjamin, 'the return of the aura' (Cometti 2016; see also Cometti and Quintane 2017) – the revival of the aestheticisation, museification and autonomisation of avant-garde practices.

Despite the porosity between poetry and other art forms, it is hard to tell whether contemporary poetry will ever be as pliant as contemporary arts towards economic interests or drawn to the same risks, but what I would like to show in this chapter is that since the 1990s, there has been a wide range of attempts and proposals in French poetics to continue poetry 'differently and in spite of all'. Against the traditional dialectic model of *for* or *against* the institution, the continuation of an inward-looking lyric or the reactivation (often farcical) of past models and postures, many poets, hampered by those approaches, have been looking for 'a third term' (Quintane 2014: 51). Striving to ward off the trap of institutional appropriation[3] and to stave off the historical aura that has accrued around the idea of 'poetry', numerous poets have sought to operate what Gleize (2009) calls 'an internal exit'. As Hanna observes, such ambition suggests that 'its institutional existence is, therefore considered as very secondary, not to say completely insignificant [. . .] the ontological question is cleared, at the same time as its mode of social existence' (2009: 9). Gleize situates his own work in those terms when he asserts that he seeks to 'make of this invisibility and anonymity weapons of combat and resistance' (2010: 121). For Gleize, the time of poetry is gone once and for all. He notes that poetry must continue by other means. As he argues, 'what is pertinent is to know whether one wants to write poetry, to be a poet or to pursue other projects' (2009: 173). These other projects, which earned the name 'postpoésie' (postpoetry), repudiate the traditional characteristics of poetry in favour of contextual displacement, remediation, redeployment of texts and repurposing (see Barda 2019). In postpoetry, the prefix 'post', however, does not necessarily imply a clean break with notions of history, actor, narrative and consciousness. It has a double meaning: on the one hand,

it signifies a desire to go beyond existing poetic forms; on the other, it displays an awareness of them and a need to draw all axiological conclusions from previous formal experiments to problematise them differently in response to new forms of human existence under neoliberal economies.

Many writers, critics and theorists who have analysed this school of thoughts have held contrasting views. In their recent anthology of French poetry *Un nouveau monde: poésies en France, 1960–2010*, Yves Di Manno and Isabelle Garron, for instance, qualified that period of neo-avant-garde because of 'a certain extremism and an avant-garde affirmation' (Manno and Garron 2017: 1089). For Jean-Jacques Thomas, the main characteristic of the avant-garde in the present day is that 'it expresses [. . .] our contemporaneity' and appends 'extreme contemporary writing is to express and present realist view of everyday life' (Thomas n.d.). Dominique Viart, by contrast, seems to follow Peter Bürger's prognostic when he claims that 'we remember Literature, with a nostalgia that henceforth refuses Telquellian and formalist manipulations. But this Literature which comes back is only a repertoire of forms, devoid of all necessity, of all links with Meaning which would be urgent to manifest' (Viart 2001). For their parts, Emma Wagstaff and Stephen Forcer offer the single most convincing assessment when they argue that such practices 'represent neither the straightforward continuation or discontinuation of avant-garde practices, but rather an instructive counterpoint in which avant-garde stylists comingle with contexts and themes that do not match standard cultural memory of avant-garde activity' (Forcer and Wagstaff 2011: 9). I shall examine those questions by analysing the implications and connections between those practices and the history of the avant-gardes, to show how those practices favour a radical transformation of cultural forms and visions of history. In particular, I will show how they construct a new literary imaginary, inviting us to reflect on issues related to temporality, causality, historical consciousness – narrativity – which are crucial aspects to comprehend the relationships of such practices with the historical avant-gardes and the present day.

THE (HEAVY)WEIGHT OF THE AVANT-GARDES

The opposition between lyric and anti-lyric poets is an important landmark and a common formula of the history of the avant-gardes. In the twentieth century, many iconoclastic authors grew suspicious of the idea of sentimentality, personal expression and presence. Georges Bataille famously advocated the 'hatred of poetry' against the idealism of surrealism, while Francis Ponge denounced the 'lyric pomp' of post-war poets engaged in the question of the ineffable. The 1990s saw a resurgence of these literary disputes, dividing (again)

the field in two opposing tendencies 'for' and 'against' the lyric (see Barda 2019; Puff 2015). Adherents of that approach, such as Jean-Pierre Lemaire or Jean-Michel Maulpoix, advocated a return to the traditional enunciative apparatus, themes of poetry, casting aside the historical avant-gardes and the theoretical revolutions of the twentieth century. In very strong terms, female poet Martine Broda posited that poetry 'will survive the formalist somersaults, idiotic waffles, exhausted minimalist whiteness that tries hard to imitate minimalist pictorial abstraction' (quoted in Charnet 1998: 18–19). Opponents of that approach like Gleize, as well as Claude Royet-Journoud and Emmanuel Hocquard among others, strongly condemned this return to a worn-out lyric model, a tradition repressed by the avant-garde model of the 1970s in France, and to this logic of fetishism, claiming instead that 'we could not act as if nothing had happened and as if the questions raised by the avant-gardes were exhausted and sorted' (Gleize 2011: 33). Was the return to the avant-gardes the only tactic to counter the revival of an inward-looking lyric? Did this lack of 'resolution' suggest that the dialectical moment of the pre-war and post-war avant-gardes had not reached its synthesis? Or, was it, instead, an incentive to learn all the lessons from those phases to produce something new and insightful?

Evidently, the successive avant-garde waves had left their imprints. The plethora of journals of the time – *Java* (1989–2006), *La Revue de littérature générale* (1995–6), *Nioques* (1990–) to cite a few – offered a critical reappraisal of the avant-gardes and republished many canonical texts. As Jean-Luc Steinmetz observes about *Java*:

> while the 1980s often tended to consider the legacy of the avant-gardes outmoded, the stake of this journal was on the contrary to take a fresh look at them, to critically reappraise them and to examine some of their work so that it might feed the young generation. (Steinmetz 2001: 378)

Some crucial examples of authors of the historical avant-garde (James Joyce, Gertrude Stein, Antonin Artaud), or the neo-avant-gardes (Philippe Sollers, Maurice Roche, Christian Prigent) were featured. Although the (re)discovery of practices of collage, montage, *détournement* and polyvocalism saw a burst of interest, this fascination was, however, accompanied by a strong resistance and an attack on the theoretical efforts lurking in some of those works. In a short text entitled 'Depuis 1988', Nathalie Quintane expresses the struggle faced by those segueing into writing at that time. As she remembers when she was still a teenager, 'at the end of the 70s, the most extreme poets breathed ether. The ambiance was dated, still full of the consequences of 68' (Quintane 1997: 74). Many affirmed the obsolescence of certain characteristics of that period, especially its utopian ethos, political militancy and conceptual framework.

In the 1990s, the aesthetic superego of experimental writing was reduced to the permanence of what Pierre Alferi and Olivier Cadiot (1996) termed ironically 'Queneau's head on Artaud's body'. On the one hand, this period signalled the permanence of notions of 'suffering', 'lack' and the 'impossible', epitomised by the tutelary figures of the French avant-garde (Bataille, Jacques Lacan, Maurice Blanchot) and finding its illustration in the fiery and provocative works of those linked to *TXT*, a very influential and important forum founded by Prigent in 1969, closely associated with the dialectical materialism and textualism of *Tel Quel*; on the other, the formalism of the Oulipo was not spared from these critiques and poetic models and postures. Many poets felt trapped by history and the commonplaces of modernity to the extent that hopes for a true and innovative poetic project had been crushed. As French poet Emmanuel Hocquard suggests:

> How do notions like 'lack' or 'want' or 'absence' or the 'impossible', once taken literally, get turned into rhetorical clichés? Formal inventions into aesthetic games? How does the unbuttered toast start oozing once more with nostalgia, emotion and suffering [. . .] so how does one get round this? (Hocquard 1994: 28–30)

In the two mammoth volumes of *La Revue de littérature générale*, Alferi and Cadiot elaborated further on that point, levelling an explicit attack at the conceptual framework of this system of thought and at its cultural reappropriation (characterised by linguistic distortions, transgression, carnivalesque cadences, estrangement and *jouissance*):

> The driving force of writing was too often considered in negative terms as a type of vulgate of 'lack', specific to French literature. It has reintroduced transcendence, mystery and piety while diverting the great negative concepts, rigorously elaborated in very specific contexts (the impossible, the limit, the unnameable). Far from what made the strength and the relevance of these concepts, the vulgate of 'lack' has narrowed them down to a single grandiloquent theme to create an illusionary scene of writing [. . .] Yet, it is striking to see, on the contrary, how this diffuse ideology falls back into [. . .] the bourgeois commonplace of inspiration. (Alferi and Cadiot 1996: §49)

Interestingly, Prigent was their first interlocutor and target. On the one hand, Prigent was an ardent advocate of the experimental writing of the nineties that he construed as the portent of a new avant-garde phase in French poetic practice. As he observes, the works of Jérôme Game and Sylvain Courtoux, although different in terms of scope and practice, align 'in a completely

different socio-political context, (transhistorical) components of an artistic practice of language and thoughts that can be found in what we called "the avant-gardes'" (Prigent 2006: 6). In Prigent's terms, avant-garde writing is defined by the search for a particular idiom. Reactivating Rimbaud's axiom of 'finding a language' and Ponge's injunction to 'speak against dominant discourses', Prigent comprehends the avant-garde programme as a space where language is turned inside out, pushing language to its extreme limits to the extent that it opens 'a space of semantic indetermination' (Prigent 1996: 39) that forces us to depart from traditional approaches to reading. Furthermore, Prigent published numerous articles on and praise for the work of Olivier Cadiot, Anne Portugal, Christophe Tarkos and many others, and encouraged an entire generation of younger poets to pursue poetic writing, Charles Pennequin being a case in point. In that sense, Prigent's genuine *defence and illustration* of contemporary poetics can be read as retrospectively instrumental as it both reinforces his role in the heated debate on the future of the lyric, but also emphasises his role as a 'mediator' within the reconfiguration of the poetic landscape of the nineties. On the other hand, however, the idea of reviving what Julia Kristeva termed 'the revolution in poetic language' by advocating the idea of poetic language as intransitive, distinct and separate from the everyday was no longer a viable and desirable option.

In very humorous terms, Cadiot recounts in *Providence* the generational gap and hostility opposing older poets and emerging ones:

> We are to say that in the 1980s everything is reversed. But it does not happen overnight. People are funny. By dint of speaking of decades, we end believing in it. Ignoring that things grow in all directions. Some aged avant-garde artists had already understood that it was time to protect themselves. Blockade the bridges, wrap themselves with fat and felt. To plant 7000 oak trees to hide in the forest. (Cadiot 2014: 82)

While implicitly making reference to Jean-François Lyotard's 1979 concept of 'postmodernism' defined by the so-called 'end of grand narratives' and decline of emancipatory and critical thought and exploration of 'metanarrative', Cadiot remains sceptical regarding the so-called 'clean break' with the aesthetic of modernism, recognising instead, like Fredric Jameson, its inherently problematic and ambiguous nature. What remains clear though, is that the generational gap is not so much based, as it often is, on division between the 'old' and the 'new' but on a temporal difference. Against the hierarchy of chronological succession and ruptures (decades) characterised by the avant-gardes, Cadiot favours a rhizomatic and nomadic conception of time characterised by growth

and propagation: 'things grow in all directions'. Hence, rather than reactivating postures and models of pre-war and post-war avant-gardes that they deemed outdated and whose stylistics were perceived as 'hyper idiolectal stylistic gestic-ulations as a sign of late romanticism, not to say retarded' (Gleize 2010: 129), a wide range of poets drew on a rich and disparate poetic heritage incorporating a self-reflexive awareness of their methods. Likewise for those working beyond the text-bound nature of the book: digital poetry, for instance, gained promi-nence from 1985 onwards through a re-engagement with the historical and neo-avant-gardes (Italian futurism and concrete poetry); sound poetry equally never denied the important contribution of the first avant-garde (Dada, 'Zaum poetry', Antonin Artaud) and subsequent practices (lettrism and ultra-lettrism). All those practices, however, had in common the fact that they overtly advo-cated 'an ironic distance, a lack of seriousness, of all that remained romantic in the avant-gardist posture' (Gleize 2010: 125) and emphasised the need to get rid of 'avant-gardist weights', namely messianism, theoretical terrorism or manifesto, aiming, rather, at 'reframings' (Espitallier 2006: 256).

REFRAMING, CONTINUATIONS AND CHANGES

Techniques of collage and montage are often acknowledged as a central strand of twentieth-century art. Artists and authors associated with the first (often known as 'historical') avant-garde, like Dadaists driven by the idea of uniting art with the praxis of life, took possession of found elements to enhance perception of the familiar. Marcel Duchamp's urinal remains the best example. The use of found objects was quickly taken up by the surrealists too. As Peter Bürger observes, those forms sought to attack the institution of art (autonomy, art for art sake) as developed in bourgeois society. In the post-war period, known as the 'neo-avant-garde', collage, juxtaposition of elements, quotation and mon-tage continued to proliferate. This second phase is analysed by Bürger as a re-enactment of the pre-war avant-gardes in the sense that it still contests the bourgeois principles of autonomous art but reduces art production to a reper-toire of forms and styles (Bürger [1974] 1984). Maurice Roche's 1966 *Compact* clearly revisits Duchamp's readymade and Raymond Roussel's multicoloured score of *Nouvelles Impressions d'Afrique*. Guy Debord's *détournement* can also be read as a reinterpretation of Duchamp's inaugural gesture and as a reappraisal of Pierre Reverdy's concept of the analogical image. Citations and appropria-tion could also be found in the work of neo-Dada poets, sound and visual poets. Although the 1990s has often been characterised by cultural historians (Cusset 2014) as a decade characterised by a decline of emancipation and critical thought, the iconoclastic act of adopting, juxtaposing or grafting existing images

and texts to produce hybrid works was not seen as a symptom of a cultural fatigue, but rather as a way to start anew but differently. The appendix of *Revue de littérature générale* showed clear signs and strategies to revise and reprise the models of the past. Some of those strategies were complex, varied and sometimes paradoxical. Some practices revisited techniques of collage and montage; especially the textual readymade (Jacques Sivan, Cadiot, Anne-James Chaton) (see Théval 2015). Other re-explorations were perhaps more stylistic than thematic, as in the case of stuttering (Jerôme Game, Charles Pennequin, Christophe Tarkos). Some models were transposed into new configurations; some poets worked between media (Pierre Alferi, Suzanne Doppelt). This appropriation of pre-existing materials led to the creation of new hybrid poetic forms. While structuralism sought to identify the founding principle of narrative forms – structures of fairy tales (Vladimir Propp), fantastic stories (Tzvetan Todorov) or *récits* (Roland Barthes, Gerard Genette) – but also to determine criteria of recognition between genres, many poets sought to repudiate those tenets by creating what Cadiot and Alferi termed 'OVNI' (Objets Verbaux Non Identifiés ('Unidentified Literary Objects')) (Alferi and Cadiot 1995). Those amorphous forms blurred the traditional distinction between, say, the referential and the fictional, diction and fiction, monologism and dialogism, mixing genres and registers, to the extent that they could no longer be viewed as polar opposites but as interactive elements. Importantly, they developed a common interest in the mechanisms of language and textual formation, namely in the principles of composition based on the manipulation and grafting of pre-exiting pieces of language (cut-ups, permutation, loops, sampling, techniques of collage, montage, lists, etc.) and the hybridisation of media and forms. As Alferi notes:

> One can make use of styles [. . .] Styles instead of *a* style, this would mean: firstly, to draw attention the artifice, to the shapes as they are, but by mere passage from one to the other without turning into their own ends (a formal touch but without formalism). [. . .] Secondly, to embrace literature in a transversal way, to have a relationship with the tradition that is less tied, neither revolutionary (a *tabula rasa* each time) nor captive [. . .]. Thirdly, to obey stylistic contortion [. . .] but without the old pose, not even that of the Promethean avant-garde. Only the shapes of sentences like forms of life. (Alferi n.d.)

Such engagement effectively enabled some poets to promote a differential lyric. By provocatively entitling the first volume of their influential journal *La Mécanique Lyrique*, Alferi and Cadiot argued that the 'mechanics' (an avant-garde metaphor par excellence) and the 'organics' (analogous to the humanist tradition of the lyric) were not contradictory but complementary. By resorting

to pre-existing materials, they replaced the traditional lyric dialectic (narcissism/emotion) with another form of lyric, based on a constructivist approach (objectivity/construction). Such emphasis on technique draws attention to the way language proceeds and how the manipulation of parts of language allows emotion to unleash and inflect our senses.

Gilles Deleuze and Félix Guattari's philosophical constructivism also became fundamental to the work of the post-nineties generation of poets and artists. Their work provided an alternative to the commonplace presentation of modernity, namely the models of 'the sacred' (Bataille), 'the alterity' (Blanchot) or the 'lack' (Lacan), as mentioned earlier. Concepts of 'minor language', 'rhizome' and 'deterritorialisation', which already resonated with the work of Jean-Jacques Lebel and Edouard Glissant, became part of the common lingo. As Nathalie Wourm recently demonstrated, Deleuze and Guattari's influence circled the work of Emmanuel Hocquard, and many others, including Cadiot who, on numerous occasions, famously confessed that Deleuze 'has been like a coach for me' (in Wourm 2017: 34). The widespread leitmotiv of the 'machine' – clearly reminiscent of the avant-gardes – also provided a useful frame for understanding creative thought. Against Lacan and Freud, Deleuze and Guattari advanced a Spinozist conception of desire (Deleuze and Guattari 1972). The metaphor of the 'machine' led to an understanding of creative practice as a 'machine' (rather than a 'stage') capable of being connected to other machines and flux (see Alferi and Cadiot 1995). Just as with the American Language poets, the work of Ludwig Wittgenstein became a reference point. Wittgenstein's recommendation to '[t]hink of words as instruments characterized by their use, and then think of the use of a hammer, the use of a chisel, the use of a glue pot, and of the glue [. . .] The functions of words are as diverse as the functions of the tools' (1958: 67–8) provided an alternative to the structuralist toolbox to think about how 'ordinary language' could be used, repeated and performed through 'language games'.

Significantly, the combination of hindsight and this new framework led to another reading of the avant-gardes. The effervescent theoretical moment of the 1970s – epitomised by *Tel Quel* and *Change* – both isolated some very vibrant poetic works and reviews such as *Les Lettres* (1963) founded by Pierre Garnier, but also advocated a certain view and reading of radical poetics; Cadiot, for instance, admitted that 'It took a long time before I was able to read Artaud and Bataille, with a fresh look, cleared from all those annoying comments' (2013: 21). In an important interview with Jacques Donguy in 1992, Julien Blaine – who founded the important review *Doc(k)s* in 1976 – violently attacked *Tel Quel*'s 'ethnocentric-terrorism' and blatant lack of interest in the international and marginal currents of the avant-gardes. As he recalls, 'If really, in Paris, it is this kind of poetry and poetry only that dominates, I leave Paris

with you, Paris is yours' (Blaine, in Donguy 1993: 357). Against this Paris-centred model, Blaine and many others advocated cosmopolitism and inter-nationalism, drawing attention rather to peripheral practices and aesthetics. *Doc(k)s* sought to rediscover discrete currents of the avant-gardes (ranging from Italian 'visiva poetry' to Brazilian 'concrete poetry'). In the beginning of the 1980s, a vibrant American counterculture was rediscovered (just like Lebel and Claude Pélieu in the 1970s, Lucien Suel translated the beat poets); the emer-gence of Polyphonix, an international festival founded by Lebel in 1979 also gave rise to new forms of cross-fertilisation and collaboration between French and international artists, leading to the birth of new cross-cultural dialogues. Finally, the (re)discovery of American objectivist poets also paved the way for new forms of practice (Lang 2016). Rejecting division between literature and art as well as the concepts of 'intransitivity' and 'autonomy', these prac-tices, just like the previous avant-gardes, seek to explore areas removed from 'dominant culture'. But, in an age of global movement and hypermediation, we are witnessing new forms of collapse of distinction and the emergence of literary imagery marked by fusion, plurality, horizontality and inclusivity.

RETURN TO PRAXIS, POLITICS AND FURTHER DIRECTIONS

The overwhelming number of words, images, sounds and data that surround our existence in our current hypermediated and globalised world have given rise to new forms of practices and appropriation. In an age of post-truth politics characterised by falsified facts and instant emotion, a wide range of poets emerging in the 2000s – including Hanna, Olivier Quintyn, Franck Leibovici but also Thibaud Baldacci and Manuel Joseph – have responded to our digital environment by repurposing documents found online to produce new representations of the political (see Barda 2021). This new paradigm tilted the balance from a performative phase to an ethical and pragmatic one, leading to an important reconfiguration of poetry's relationship to praxis and politics. Often closely associated with 'informational poetry', these practices drawing on pre-existing materials linked to current affairs or media coverage do not seek to produce new texts but to provide new framings and scales. In so doing, they seek to take up a position in the communication flow that surrounds our attention in order to reveal the way in which individuals are engaged in public issues. Striving for effectiveness and impact, Gleize observes that unlike the neo-avant-gardes of the sixties which upended language con-ventions through an opaque language ('a counter-usage'), these poets rather explore a 'meta-usage' based on 'dominant languages to turn them into a

critical poetic writing which [. . .] will target as scene of intervention and action, the public space – billboards, screens, posters etc.' (2011: 39–40) in order to provide new forms of objectification and representation of the political. Yet, just like Charles Bernstein and Édouard Glissant, Gleize promotes opacity – 'a critical opacity' – characterised by a virtuality which contracts multiple temporalities within the present. As he avers:

> for us, it is not a matter of evoking the past (as does poetry in the mode of elegy) nor celebrating the future [. . .] (as 'committed' poetry still claims), but to elaborate what one could call a memorial 'présent antérieur' which is simultaneously a present yet to come. Something resembling a stratified present, 'in action', with the concern for 'what is to come'. (Gleize 2011: 42)

Such diversity of approach looks more for effect than aesthetic output. Yet, in spite of what these poets claim – the strict rejection of the vanguard, their call for an 'exit' of the institution of art, and repudiation of past models and postures – their practices recast some strategies and tactics inherited from the avant-garde and the neo-avant-gardes.

These poets consider that digital technology has significantly impacted the way one produces, perceives and processes language, and, therefore, 'one should exploit them in extreme ways [. . .] to create works that are as expressive and meaningful as works constructed in more traditional ways' (Goldsmith 2011: 44). To that end, Anne-James Chaton's work, for instance, consists in cutting and pasting artefacts produced by modern societies (receipts, bills, leaflets, loyalty cards, train, bus or metro tickets) in order to critically address the economic traceability under control (see Barda 2015). In a different fashion, and inspired by the work of Japanese composer Otomo Yoshihide, Quintyn created in 1997 a multimedia piece titled *Sampling Virus Project*. Taking stock of the avant-garde motif of the 'virus' – explored by Lautréamont, the beat poets, and amongst others, the neo-Dadaist Joël Hubaut – Quintyn repurposed spam letters, images, GIFs or videos found online that he broadcasted on a big screen whilst reading a list of data related to geopolitical conflicts of the previous decade.

Their positions often provide more ambiguities (which seem to represent 'the return of the repressed') than resolutions. Such practices, in fact, tend to have an ambivalent (if not conflicted) relationship regarding the institution and the history of the avant-gardes. On the one hand, they actively participate in the art market – Jean Boîte éditions, but also to a certain extent Presses du Réel are typical of contemporary art productions, marketing and distribution. On the other hand, they seek to act outside of the structures where poetry is

welcomed today (art centres, museums, etc.); and even when they are imple-
mented within those institutions, they require other types of implementation,
drawing into the process people who are not necessary linked to the world of
art. Leibovici, for instance, has displayed and shown his work in the Delme
Synagogue, but also more recently at the National Archives of Paris for the
twentieth anniversary of the Rome Statute alongside law specialists, research-
ers and the minister of justice. In the context of what Heinich (2014) has
famously described as 'the paradigms of contemporary art', Leibovici, who
describes himself as both a poet and an artist, aims to

> find a third term between the art of the 2000s, cut from worldly con-
> cern, and activist art like in the 1970s. Indeed, institutional critique, which
> opposed the artist with a capital A to the institution with a capital I, no
> longer works today: institution is everywhere and even among ourselves.
> Wishing to return to a pre-institutional state does not seem convincing to
> me. (Leibovici, in Terroni 2016)

Hence between a conception of autotelic art (and poetic language) and blatant
political militancy, Leibovici looks for an exit, a third option. The issue is no
longer to be *for* or *against* the institution, but to challenge the ecosystems associ-
ated with institutions to reflect on the type of knowledge and forms of life that
can come out of them. Reflecting on the type of 'actions' that artists or poets
could investigate today against the 'artification' of poetry and the incremental
jolt of luxury within artistic practices, Hanna suggests the following:

> Until now, I have never seen performance consisting, for instance, of publicly
> ridiculing the manager of La Maison de la Poésie or of the Cartier Foundation,
> of insulting them, of telling them some home truth regarding their attitude, the
> way they were appointed, but I think this will happen someday and that the
> author will probably draw a large symbolic benefit, from the moment that such
> action is *traded* as a poetic act.[4] (Hanna 2014: 30–1)

If such actions would indeed be a fitting response to the current incremental
development of neoliberalism within culture, they clearly outline two typical
gestures of the avant-gardes: the attack on the institution and the tactics put
forward by the lettrists and situationists.

Importantly, many of these artists and poets strive to blur the relationship
between art and aesthetics by challenging the aesthetic codes of art galleries, and
museum practices. When curators want to set up an exhibition on war crime,
they resort to archives that they assemble and organise under the supervision

of historians, following given aesthetic codes and institutionalised modes of display. In *muzungu*, Leibovici challenges these conceptions by offering visitors the option to explore the materials themselves, manipulating documents in order to develop their own understanding of the massacre that happened in 2003 in the Bogoro Village in the Democratic Republic of the Congo by the Nationalist and Integrationist Front and the Front for Patriotic Resistance in Ituri (see Barda 2018). It was following the project of *Bogoro* that this exhibition was curated by Leibovici and Julien Séroussi, an International Criminal Court (ICC) legal expert (who happens to be the son of Nathalie Séroussi, a prominent gallerist and collector of avant-garde and neo-avant-garde art in Paris). This project consisted in hanging all the pieces of evidence from the 2014 ICC trial that took place at The Hague (administrative documents, diagrams, transcripts, drawings) on A4 pieces of paper. Like in the book *bogoro* (Leibovici and Séroussi 2016), Leibovici used colour codes and key words to highlight aspects of the trial that were downplayed during it. Through large panels (handwritten letters, sticky notes, maps) documenting the trial, Leibovici sought to put the viewer in the court like a judge to reflect on the case. Such practices seek not to call into question the issue of accountability or liability, but to invite viewers to assemble and disassemble fragments to observe how gestures and shifts in context can produce new forms of knowledge and lead to interdisciplinary and intercultural dialogue. Through this inquiry, Leibovici also believes that such an approach may lead to the adoption of new practices at the ICC. So far, and in terms of use, those materials have been transferred to a book, exhibitions, conference days, and a pan-African radio broadcast. The situation is effectively more ambiguous and more complex than what it seems, to the extent that artists and poets who seem to distance themselves from the pitfalls of the avant-garde may participate in one way or another in the game of its propagation.

If it is clear that those practices eschew the traditional model of 'committed writing' as they bypass it to offer something radically different (which is still nonetheless the essence of political writing), since 2015 two other models of political action have emerged in French poetics. In the wake of the threat of migration crises, terrorism and inevitable recession, and in response to the rise of neoliberalism and the extension of executive power (repressive measures) and social violence, poetry took on a newly significant politicised cast. Direct participation in 'social movements', which either involved documenting them (fieldwork literature) or 'participant observation' – and yet not in the form of a manifesto or leadership – became particularly visible. In *Un oeil en moins* (2018), Quintane offers, for instance, an investigation of the struggle around 'Nuit debout'. In this book, she documents the quotidian of this unrest without transforming or elevating events. Rather than recounting the protest from

a vantage point, like an omniscient narrator, or analysing it like a sociologist would do, Quintane works in the interstice, at the margin. The overall result is a 'collective' kind of inquiry of the day-to-day unrest that takes shape through the juxtaposition of voices, quotes, notes, memories, things seen or heard, becoming a vehicle of political (oblique) critique and dissent.

In her most recent book, ironically dubbed *Les Enfants vont bien* (2019), Quintane provides a monotonous chant of all that has been said about the 'Calais Jungle'. Without adding a single word, Quintane retranscribes the barbarity of the language of 'state of exception' rooted in automatism and short-cuts (with a special emphasis on nominalisation, euphemism, superlative, desemantisation, semantic subduction, use of general terms that can be found in mass media), functioning therefore as an echo chamber of our hypermediated environment.

Finally, recent years have also seen the rise of 'collaborative forms of writings' – a 'poetry made by all' – which do not necessarily leave editorial traces, and that favour ephemera or forms of samidzat and fanzines; see, for instance, Mauvaise Troupe, a collective dedicated to the writing of political struggles through the juxtaposition of words uttered by their protagonists in situ, or the collective PEROU led by Sébastien Thiéry.[5]

'RESTAURATION, INVENTION, NEGATION'

Questioned in the early 1990s about the various possibilities offered to those venturing into writing at that time, Gleize categorically responded: 'Restauration, Invention, Négation' (1994: 66). Under this formula, which may sound like an umpteenth avant-garde slogan, Gleize referred in fact to three paradigms. 'Restauration' suggests a return to past models that cast aside history and literary consciousness; 'Invention' refers to the tradition of the new of the avant-gardes, poetics of rupture and licence to shock; and finally, 'Negation' offers a way out of this tension, a kind of synthesis in which the differences between the other options are not necessarily resolved but open to new conflicts. Strikingly, although at the time of writing nearly twenty years have elapsed since Gleize's response, this formula remains pertinent in describing the current poetic field. More recently, Gleize elaborated further, suggesting more nuanced delineations (2009: 38). While for Gleize and many authors discussed in this chapter, poetry must be pushed towards postpoetry and resist at all cost the inward-looking lyric of 'lapoésie' ('poetry itself', alluding here to 'Restauration'), others in the debate, still enshrined in experimentalism, seek to invent poetic forms through either the combination of old and new forms (the so-called 'repoésie' epitomised by Roubaud or the Oulipo) or the

exploration of new media (sound, visual, digital poetics) as experienced by those that Gleize associates with 'néopoésie'.

Setting aside the fact that those distinctions are not always clear and tend to overlap, I have shown that French poetics holds conflicting positions regarding the avant-gardes. On the one hand, numerous poets share commonalities with the avant-gardes (critique of the institution, techniques of writings, goals and strategies). On the other hand, those practices exhibit different theoretical stands (a different framework, a rejection of the vanguard posture and of its utopian ethos, the idea of pro-gramme, as in 'written ahead'). Additionally, most reject the term 'avant-garde', associating it with formal associations or the adherence to a manifesto, and would rather prefer to speak in terms of 'affinity' for Alferi, Sivan or Vannina Maestri (Wourm 2017: 134), or of 'network' rather than movement for Gleize (Wourm 2017: 129). Furthermore, the literary imaginary put forward by those practices do not, however, suggest an end to narrative or causality, as in postmodernism. Neither do these practices suggest the authors sidestep historical or political concerns. In their various expressions, those practices seek to move away from the aura accrued around 'poetry' whilst searching for new ways to expand our understanding of poetics and praxis. As Jean-Charles Masséra eloquently suggests in *It's Too Late to Say Littérature*:

> To situate oneself – today – in relationship to historicized problematics – arising in specific times with the stake of their times and context – has absolutely no point. It is not in relation to the axis of history of disconnected literature of its time that one has to situate but in relation to the here and now (or else, acknowledge that literature definitely belongs to the past and that can be practiced like visiting an ecomuseum, a museum of art and intellectual traditions). If the pursuit of the *new* does not make sense anymore, one must tell oneself that those are the questions that are new. (Masséra 2010: 12)

Hence, both for critiques and artists, the point is no longer to reflect on the 'successes' or 'failures' of the avant-gardes, nor to construe the 'novel' as the only viable currency for poetic practice. Although those practices seem to reinstate the avant-garde notion that each new generation is a new 'rupture', the issue is neither to idealise the past (or to regain the prestige) nor to re-enact the postures of the avant-gardes, but to be in the *hic and nunc*. Unlike the previous periods of history such as the 'modern' (teleological and founded on an epochal distinctions) or the 'postmodern' (still very much Euro-American in focus), our current world should be the 'contemporary' (Ruffel 2016), and just like the very first avant-garde, the contemporary remains the time of simultaneity,

dispersion and of lack of hierarchy. But this 'present' is not linear: it is as a space of dissonance, distance and anachronism. Temporality is not that of the present only, but a present that still looks into the past.

As discussed in this chapter, the lack of unified consistency, the ambivalence regarding certain aspects of the avant-gardes as well as their resistance, suggests a certain way of thinking and of *being* in time. This constellation of practices does away with the idea of continuity or linearity, suggesting rather 'co-temporality', echoing Foster's conceit of 'deferred action'. Such reading of the present finds an echo in a body of recent theoretical works – from Lionel Ruffel's idea of 'brouhaha literature' (2016) to François Hartog's conceit of 'presentism' (2003) through Georges Didi-Huberman's 'anachronism' (2000) – which all differently advance a regime of historicity no longer based on linear, sequential and historicist times, but on archaeological approach. This is, perhaps, the reason why the 'bricoleur' (Alferi and Cadiot 1995) who applies tools to residues and whose invention lies in previous invention; the 'archaeologist' (Hocquard 1994: 12) who digs into the past to understand the present; or the 'investigator' (Demanze 2019) who observes traces and remnants, remain a recurrent (conceptual) persona in many poetic works. Of course, the fact of living in a stagnant present and the impossibility of thinking about the future is a threat, but the work of contemporary poets helps us to understand what it means to be caught in 'co-temporalities', inviting us to think about new forms of innovation and creative freedom.

NOTES

1. Roubaud denounced the eclecticism of modern poetics and the overwhelming tendency to substitute for metric, intelligibility or *written forms* of poetry, an array of practices ranging from 'slam' to 'poetic document' or what he calls 'vroum-vroum', that is to say, sound poetry. His analysis of the slump in poetry book sales is perhaps valid but it should be said that there has never been a 'golden age' nor a boom year of poetry. That said, since the 2000s we have seen in France the rise of more and more small publishers and magazines promoting poetic practice. All translations are mine, unless otherwise specified.

2. Since 2018, Jérôme Mauche has curated events at the Pernod Ricard Foundation, promoting contemporary poetic practices. French poet Jérôme Game curated the 'Poésie Now' festival in 2015 and Anne-James Chaton ran the 'Radio' programme in 2016 at the Louis Vuitton Foundation.

3. François Leperlier observes a contradiction in this approach, arguing that these poets 'ensure their Œuvres Complètes, keenly attend poetry institutions and fairs by the book' (2019: 137).

4. A recent project led by Hanna and entitled 'Agence de notation' seems to implement such approaches. See <https://evalge.hypotheses.org/le-projet> (last accessed 4 February 2021).

5. <https://mauvaisetroupe.org>; <https://www.perou-paris.org> (both last accessed 4 February 2021).

BIBLIOGRAPHY

Alferi, P. (n.d.), 'Pierre Alferi/Politique', <http://remue.net/cont/alferi4.html> (last accessed 4 February 2021).

Alferi, P. (2014), 'L'art n'est-il qu'un produit de luxe?', *Mediapart*, 20 October, <https://blogs.mediapart.fr/edition/les-invites-de-mediapart/article/201014/lart-nest-il-quun-produit-de-luxe> (last accessed 4 February 2021).

Alferi, P. and O. Cadiot (1995), *Revue de littérature générale, La Mécanique Lyrique*, 95 (1), Paris: P.O.L.

Alferi, P. and O. Cadiot (1996), *Revue de littérature générale, Digest*, 96 (2), Paris: P.O.L.

Barda, J. (2015), 'Espaces de virtualités et essaim de singularité dans la poésie sonore et graphique d'Anne-James Chaton', in J. Barda and D. Finch-Race (eds), *Textures: Création et processus dans la production poétique moderne et contemporaine*, Berg: Peter Lang, pp. 147–67.

Barda, J. (2018), 'Forensic Poetics: Legal Documents Transformed into Strange Poems', in N. Parish and E. Wagstaff (eds), *Poetry's Form and Transformations*, *L'Esprit Créateur*, 58 (3), pp. 86–102.

Barda, J. (2019), *Experimentation and the Lyric in Contemporary French Poetry*, New York: Palgrave Macmillan.

Barda, J. (2021), '"Prose in Prose" in Contemporary French Poetic Practice: Appropriation, Repurposing and Pornography', in M. A. Caws and M. Delville (eds), *The Edinburgh Companion to the Prose Poem*, Edinburgh: Edinburgh University Press, pp. 310–27.

Bürger, P. [1974] (1984), *Theory of the Avant-Garde*, trans. M. Shawn, Minneapolis, MN: University of Minnesota Press.

Cadiot, O. (2013), 'Réenchanter les formes', interview with M. Gil and P. Maniglier, *Les Temps Modernes*, 676, pp. 6–34.

Cadiot, O. (2014), *Providence*, Paris: P.O.L.

Cauwet, L. (2017), *La Domestication de l'art*, Paris: La Fabrique.

Charnet, Y. (1998), 'Malaise dans la poésie: un état des lieux', *Littérature*, 110, pp. 13–21.

Cometti, J.-P. (2016), *La Nouvelle aura: économie de l'art et de la culture*, Paris: Questions Théoriques.

Cometti, J.-P. and N. Quintane (eds) (2017), *L'Art et l'argent*, Paris: Amsterdam Editions.

Cusset, F. (2014), *Une histoire critique des années 1990*, Paris: La Découverte.

Deleuze, G. and F. Guattari (1972), *L'Anti-Œdipe*, Paris: Minuit.

Demanze, L. (2019), *Un nouvel âge de l'enquête*, Paris: José Corti.

Didi-Huberman, G. (2000), *Devant le temps: histoire de l'art et anachronisme des images*, Paris: Minuit.

Di Manno, Y. and I. Garron (2017), *Un nouveau monde: poésies en France, 1960–2010*, Paris: Flammarion.

Espitallier, J.-M. (2006), *Caisse à outils: un panorama de la poésie française aujourd'hui*, Paris: Pocket.

Donguy, J. (1993) 'Entretien avec Julien Blaine et Jean-François Bory', in *Poésure et peintrie, d'un art l'autre*, Marseille/Paris: Musées de Marseille/Réunion des Musées nationaux, pp. 345–62.

Forcer, S. and E. Wagstaff (2011), 'Introduction', *Nottingham French Studies*, special issue on 'The French Avant-Garde', 50 (3), pp. 1–10.

Foster, H. (1996), 'Who's Afraid of the Neo-Avant-Garde?', in H. Foster, *The Return of the Real: The Avant-Garde at the End of the Century*, Cambridge, MA: MIT Press, pp. 1–34.

Gleize, J.-M. (1994), 'La Forme-poésie va-t-elle, peut-elle, doit-elle disparaître?', *Action Poétique*, 133–4, pp. 65–7.

Gleize, J.-M. (2009), *Sorties*, Paris: Questions Théoriques.

Gleize, J.-M. (2010), 'La Post-poésie: un travail d'investigation-élucidation', *Matraga*, 17 (27), pp. 121–33.

Gleize, J.-M. (2011), ' Opacité critique', in J.-C. Bailly, J.-M. Gleize, C. Hanna, H. Jallon, M. Joseph, J.-H. Michaud, Y. Pagès, V. Pittolo and N. Quintane, *'Toi aussi, tu as des armes': poésie et politique*, Paris: La Fabrique, pp. 27–44.

Goldsmith, K. (2011), *Uncreative Writing*, New York: Columbia University Press.

Hanna, C. (2009), 'Assez vu!', preface, in J.-M. Gleize, *Sorties*, Paris: Questions Théoriques, pp. 7–17.

Hanna, C. (2014), 'Argent', *Nioques*, 13, pp. 30–5.

Hartog, F. (2003), *Régimes d'historicité: présentime et expérience du temps*, Paris: Seuil.

Heinich, N. (2012), *De la visibilité: excellence et singularité en régime médiatique*, Paris: Gallimard.

Heinich, N. (2014), *Les Paradigmes de l'art contemporain: structures d'une révolution artistique*, Paris: Gallimard.

Heinich, N. and R. Shapiro (eds) (2012), *De l'artification: enquête sur le passage à l'art*, Paris: École des Hautes Études en Sciences Sociales.

Hocquard, E. (1994), *The Library of Trieste*, trans. M. Hutchinson, Paris: The Noble Rider.

Hocquard, E. (2011), 'Gazette de la Villa Harris', *Cahier du Refuge*, 203, pp. 11–13.

Lang, A. (2016), 'The Ongoing French Reception of the Objectivists', *Trans-atlantlantica*, 1, <http://journals.openedition.org/transatlantica/8107> (last accessed 4 February 2021).

Leibovici, F. and J. Séroussi (2016), *bogoro*, Paris: Questions Théoriques.

Leperlier, F. (2019), *Destinations de la poésie*, Paris: Lurlure.

Masséra, J.-C. (2010), 'It's Too Late to Say Littérature (Aujourd'hui recherche formes désespérément)', *Revue Ah!*, 10, pp. 1–10.

Prigent, C. (1996), *À quoi bon des poètes?*, Paris: P.O.L.

Prigent, C. (2006), 'L'incontenable Avant-garde', <http://www.pol-editeur.com/ouverturepdf.php?file=006-incontenable.pdf> (last accessed 4 February 2021).

Puff, J.-F. (2015), 'Le Sujet littéral: réflexion sur la querelle lyrisme vs littéralité', in *Une rose est une rose: Michel Parmentier & pratiques contemporaines*, Paris/Clermont-Ferrand: Galerie Jean Fournier/FRAC Auvergne, pp. 141–55.

Quintane, N. (1997), 'Depuis 1988', Java, 16, pp. 74–6.

Quintane, N. (2014), 'Un présent de lecture troublées (plus que de textes illisibles)', in B. Gorillot and A. Lescart (eds), *L'Illisibilité en questions*, Paris: Presse Universitaires du Septentrion, pp. 49–58.

Quintane, N. (2018), *Un oeil en moins*, Paris: P.O.L.

Quintane, N. (2019), *Les Enfants vont bien*, Paris: P.O.L.

Rancière, J. (2009), *The Emancipated Spectator*, trans. G. Elliot, London: Verso.

Roubaud, J. (2010), 'Obstination de la poésie', *Le Monde diplomatique*, 670 (1), pp. 29–30.

Ruffel, L. (2016), *Brouhaha: les mondes du contemporain*, Paris: Verdier.

Steinmetz, J.-L. (2001), 'Java', in M. Jarrety (ed.), *Dictionnaire de poésie de Baudelaire à nos jours*, Paris: Presses universitaires de France, pp. 377–8.

Terroni, C. (2016), 'Sur quoi opère l'art: entretien avec Franck Leibovici', *La vie des idées*, 14 October, <http://www.laviedesidees.fr/Sur-quoi-opere-l-art.html>, (last accessed 4 February 2021).

Théval, G. (2015), *Poésies ready-made XXe–XXIe siècle*, Paris: L'Harmattan.

Thomas, J.-J. (n.d.), 'Avant-Garde', <https://www.academia.edu/39816378/Avant-Garde> (last accessed 4 February 2021), pp. 1–10.

Viart, D. (2001), 'Écrire au présent l'esthétique contemporaine', in F. Dugast-Portes and M. Touret (eds), *Le Temps des lettres: quelles périodisations pour l'histoire de la littérature française au XXe siècle?*, Rennes: Presses universitaires de Rennes, pp. 317–36, <http://books.openedition.org/pur/33321> (last accessed 4 February 2021).

Wittgenstein, L. (1958), 'The Blue Book', in L. Wittgenstein, *The Blue and Brown Books*, New York: Harper and Row.

Wourm, N. (2017), *Poètes français du 21ème siècle: entretiens*, Leiden: Rodopi.

The Austrian Post-War Anomaly: Konrad Bayer's Montage *the head of vitus bering* and the Category of the 'New'

Roland Innerhofer

THE LATENCY OF THE AVANT-GARDE IN POST-WAR AUSTRIA

Konrad Bayer (1932–1964), whose texts were largely written in dialogue with the authors of the Vienna Group – Friedrich Achleitner, H. C. Artmann, Gerhard Rühm and Oswald Wiener – is one of the most important representatives of the Austrian neo-avant-garde. *Der kopf des vitus bering* (*the head of vitus bering*)[1] was first published in 1965 by the renowned Swiss publisher Otto F. Walter, one year after Bayer's untimely death by suicide – he was not yet thirty-two years old. With its roughly fifty pages, *the head of vitus bering* is Bayer's longest completed text. During his lifetime, only one small book, *der stein der weisen* (*the philosopher's stone*) (1963), had been published. With the novel *der sechste sinn* (*the sixth sense*), from which Bayer read out at the meetings of the Group 47 in Saulgau in 1963 and in Sigtuna in 1964 and for the publication of which he was under contract to Rowohlt, a breakthrough in the German literary scene was on the horizon only to be thwarted by Bayer's suicide. The novel fragment *the sixth sense* was first published in 1966. Although Suhrkamp published a second edition of *the head of vitus bering* in 1970, it was only following the growing interest in the works of the Vienna Group in the 1980s that Bayer's texts reached a wider audience. After *the head* was republished in 1985 and 1996 as part of Bayer's *Complete Works* edited by Gerhard Rühm ([1985] 1996a), a new edition was released in 2014. In this chapter, I will explain why this work is not only of paradigmatic significance for understanding the pecularity of the Austrian post-war avant-garde but also marks a challenge to the theory of avant-garde and neo-avant-garde.

According to Peter Bürger's influential theory of the avant-garde, the neo-avant-garde of the 1950s and 1960s can no longer claim transgression, 'given that

avant-garde practices had in the meantime been incorporated by the institution' (2010: 712). This statement misses the singularity of the Austrian neo-avant-garde for two reasons.

Firstly, the situation in Austria after 1945 was different from that in other European countries (such as Germany, France or the United Kingdom) after World War II. In Austria, almost no reception of the historical avant-garde had taken place. Indeed, it is indicative that such an influential author as Karl Kraus disqualified Dada as literature written by boys who have not yet mastered grammar: 'What ostentatious boys are those / who have a "not sufficient" in form?' (1920: 20).[2] The historical avant-garde was merely latent in post-war Austria. For example, publications or translations of the French surrealists were rare and hard to find in antiquarian bookshops (Eder and Kastberger 2015: 308), and the discovery of the historical avant-garde was to an extent a process of inventing a tradition. On the other hand, the historical avant-garde was only one point of reference for the Vienna Group. In his 'patriotic list', Bayer named, along with the Dadaists Raoul Hausmann and Walter Serner, among others Sigmund Freud, G. W. F. Hegel, Franz Kafka, Heinrich von Kleist, Johann Nestroy, Friedrich Nietzsche, Adalbert Stifter and Ludwig Wittgenstein (2000: 20). This list was obviously neither exclusively avant-garde nor particularly patriotic. The post-war Austrian avant-garde was in a certain sense the first Austrian avant-garde, or at least had to reinvent itself as avant-garde. Moreover, this reinvention produced actions and works that were different from those created elsewhere in Europe during the same period. In Germany Jürgen Becker, a German representative of experimental literature, told an anecdote that is emblematic for the isolation of the Viennese neo-avant-garde of that time. In a discussion after his reading from *the sixth sense* at the meeting of the Group 47 in Sigtuna in 1964, Bayer had been vehemently criticised; according to Becker, in the evening Bayer refused to socialise with colleagues and instead retreated into the basement of the event building to play billiards against himself.[3]

Secondly, conservatism dominated Austrian post-war literature, and institutionalised art was still traditional and oriented towards the classical-realistic tradition. In Austria during the 1950s and 1960s, the works of the Vienna Group and associated authors such as Friederike Mayröcker, Ernst Jandl and Andreas Okopenko were largely met with a lack of understanding, with rejection, ridicule and open hostility. Paradoxically, it was precisely this isolation and this opposition against a conservative society and culture that stimulated the Austrian neo-avant-garde. As Oswald Wiener remarked in retrospect: 'the pressure of compact society kept all the divergences of the outsiders together' (1982: 252). The institutionalisation of the avant-garde occurred only in the 1970s, long after Konrad Bayer's death and also after the dissolution of the Vienna Group (Innerhofer 1985: 43).

To explain the Austrian post-war avant-garde, Hal Foster's theory of the neo-avant-garde as a repetition of traumatic shocks is particularly formative. According to Foster, these repetitions are 'a warding away of traumatic significance *and* an opening out to it, a defending against traumatic affect *and* a producing of it' (1996: 132). In particular, Freud's and Lacan's concept of afterwardsness as a return of the suppressed can help to grasp the post-war Austrian avant-garde. Bürger distinguishes unconscious repetition from conscious resumption (2010: 710). Since the Austrian post-war avant-garde had to discover a latent tradition, unconscious repetition could gradually change into conscious resumption. With the Austrian post-war avant-garde, originality and repetition were simultaneous. Bürger's proposition that the neo-avant-garde illuminates the avant-garde (2010: 711) is based on the assumption of a historical sequence that is not inherent to the Austrian avant-garde. Following Foster and with a view to the Austrian neo-avant-garde specifically, Klaus Kastberger diagnoses the collapse of the schema of cause and effect, origin and repetition: 'Avant-garde and neo-avant-garde form a complex circuit of anticipated future and reconstructed past, both are inseparably interwoven' (2000: 25). As a result, the Austrian avant-garde had to play catch-up with a first avant-garde that it had not participated in, it had to reconstruct the past, and, at the same time, try to anticipate the future. It is striking how the early Austrian post-war avant-garde sought to form its own tradition.

In the Austrian post-war situation, Foster's 'return of a traumatic encounter with the real' (1996: 138) obtained an additional and very specific, concrete political meaning. As Johann Sonnleitner (2008: 95–6) and Gisela Steinlechner (2015: 232–3) pointed out, the works of Bayer broke a taboo in post-war Austrian culture. In this period, a general determination to ignore what had happened during World War II was predominant. The traumatic experience of the war and the Shoah, and the dehumanisation of their victims had been suppressed and rendered taboo. Bayer's descriptions and quotes referring to cannibalism and other atrocities are neutral, sober and emotionless. Characters are not involved in what they are doing, and they feel no empathy with those who suffer. They act like machines, they feel no fear, no pain, no dread and no guilt. The artificiality of these characters that are compounded from quotations enables Bayer to break the post-war taboo and to address the suppressed history of the Nazi period. Whereas Bürger points out that we should 'not lose sight of [the avant-garde's] originally intended effect, that is, to draw out the claim of authenticity in the seemingly most unserious products' (2010: 714), *the head of vitus bering* relinquishes authenticity in favour of preformed, second-hand non-literary linguistic materials. With this approach, Bayer does not intend an avant-garde transfer of art into life practice (in the sense of

Bürger), but rather the examination of the suitability of found material for its own artistic purposes. This intention resembles that of Marcel Duchamp as described by Dietrich Scheunemann:

> This was not at all meant as an attack on the institution of art exhibition, nor as an attempt at sublating art into life – rather the opposite: explored in this act are the conditions under which an ordinary article of life transforms into a work of art. What makes an object a work of art, is the provocative question raised. (Scheunemann 2005: 30)

GENERIC IMPURITY AND THE CATEGORY OF THE 'NEW'

Bayer's companion Friedrich Achleitner remembers that in the last years of his life Bayer had doubts about the durability of his artistic experiments and wanted to try to write a new 'rigorous' and 'clear realism' (Eder and Kastberger 2015: 294). Achleitner sees in Bayer's *the head of vitus bering* and *the sixth sense* 'the exiting "parallel track" of exact descriptions and "abstract", incredibly imaginative poetic texts', and he compares these with Aragon's *Le Paysan de Paris*, with a radical political realism of late texts by Breton and Aragon (2015: 270).

As Oswald Wiener states in his essay 'Einiges über Konrad Bayer' ('Something about Konrad Bayer'), 'experimental writing has become research, an attempt to obtain models of human understanding that do without isomorphs of sign systems and content-related coherences [. . .]' (1982: 261). According to Wiener, Bayer's 'writing has not been a means of artistic "representation", but rather an instrument for investigating thought processes and for the writer a natural lever for pushing out the barriers of imagination that become noticeable to him in writing' (1982: 253). Experimental writing is therefore an exploration of the possibilities of communication. According to Wiener, Bayer conceived poetry as 'body movements and showing of objects, of events as unconsumed *codes*' and he played with the idea of 'himself being a machine that builds itself into new dimensions and exploits the *necessities* of a more primitive phase as building blocks of arbitrariness' (1982: 262). *the head of vitus bering* can be understood as an attempt to break up encrusted forms of thought, perception and language and to undermine narrative patterns and genre distinctions. In this sense Bayer called his text 'perhaps a trepanation'.[4] He uses the effects of a seemingly precise descriptions of facts and of an excessive dissemination of materials to stress disruptions, discontinuity and breaks.

This composition of his texts from fragments is essential in order to understand the specific nature and significance of the 'new' in Bayer's work. Whereas

postmodern theorists such as Boris Groys (2014) or Wolfgang Welsch (1987) understand the category of the new in an economic sense and 'leave the decision on the value and quality of art and literature ultimately to the market' (Kastberger 2000: 23), Theodor W. Adorno considers this concept indispensable for modern esthetics. As a result, the category of the new appears essential for the avant-garde. According to Bürger, the new has been exhausted in the first avant-garde since it failed in translating art into life ([1974] 1984: 52–3). For Adorno, however, innovation is the 'hidden telos' (Adorno [1970] 1997: 22) of modern art in general. Although Adorno does not speak of the (neo-)avant-garde, but of modernism, his concept of the 'new' can be profitably applied as a heuristic instrument for the analysis of the Austrian neo-avant-garde – as Thomas Eder's contribution on Oswald Wiener in this volume shows. Adorno emphasises the 'destructive element of the new': 'Through the new, critique – the refusal – becomes an objective element of art itself' ([1970] 1997: 20, 22).

When looking at Bayer's *head of vitus bering*, a nuanced and differentiated approach to the concept of innovation is essential. Adorno offers two aspects that allow us to grasp what kind of innovation a text like *the head of vitus bering* accomplishes. The first is innovation in the area of genres. Adorno remarks: 'so long as genres were givens, the new flourished within them. Increasingly, however, newness has shifted to genres, because they are scarce' ([1970] 1997: 308). The second aspect is the unavoidable impurity of art. In Adorno's view, it is naïve to cling to the idea of pure art: 'It is evident that supreme works are not the most pure, but tend to contain an extra-artistic surplus, especially an untransformed material element that burdens their immanent composition' ([1970] 1997: 181).

In its first edition Bayer's text bore the subtitle 'portrait in prose' (1965). This subtitle is to be attributed to the wish of the publisher. Much more appropriate is the new concept of 'summary biography' ('summarische biographie', Rühm [1985] 1996: 790) coined by Bayer. For *der schwarze prinz* ('the black prince'), the precursor of *the head of vitus bering*, Bayer used the term 'summary story' ('summarische erzählung', Rühm [1985] 1996: 794). Both concepts emphasise the additive, paradigmatic series. However, the 'sum' does not result from a congruent series, but from the incongruent combination of heterogeneous fragments. Bayer himself points this out in his foreword written for a reading of *the head of vitus bering* for the radio station Sender Freies Berlin in 1963: he called Bering 'a fixed point [. . .] from which to establish various connections, just as a fisherman casts a net in the hope of making a catch' (1994: 7). In *the head of vitus bering*, the combination of several paradigmatic series supplants the evolutionary syntagma that is characteristic of traditional biographies. The main text of *the head of vitus bering* is supplemented by an 'index', a scientific apparatus containing a collection of quotations. As is noted in a book review, the index 'doesn't work like an index but like an extension

of the fictional part of the book, supplying additional meanings, sending the reader back to the beginning to reread the whole book [. . .]' (Shigekuni 2010). Both the main text and the index are structured according to the pattern of a catalogue: an incongruent list that juxtaposes scientific explanations and mystical experience reports, travelogues and fragments of mythological tales, finds from medical guides and descriptions of magical rituals.

In *the head of vitus bering*, an alternative model to the chronological sequence of narrative becomes the text's modus operandi. Bayer had a preference for using aleatoric methods and mathematical series for the production of literature. Such playful writing corresponds to the fact that the characters in *the head* are treated as tokens that can be substituted arbitrarily. This becomes apparent in a sentence like 'the king could move forward as well as backward' (Bayer 1994: 13). This sentence refers, on the one hand, to the chess game (Zorach 1986: 622) and, on the other hand, to the character of the king in the text and to the czar Peter the Great who is mentioned in the adjacent sentences. The abeyance in the sign relation leads to a multi-strand reading process along different levels of meaning. These are discontinuous and often collide:

> in tahiti the king's runner was sent to the countryside to assemble the able bodied officers who were harvesting in the fields at the time. vitus bering prepared to leave. the flesh of those killed in combat was spread out on the battlefield and in dried condition prepared for transport. vitus bering took the king. annoyed, louis the fourteenth rose in 1680 and left the hall. (Bayer 1994: 15)

The gap between the semantically incongruent cannot be closed, neither on a syntagmatic nor on a paradigmatic level. This applies as well to the following passage:

> vitus bering was regarded as being reserved and taciturn in temperament. no wonder there were persistent rumours concerning his personality. people were eaten at every occasion: at the construction of a house, at a boat launching, in celebration of a courtier's departure, at festivities marking the coming of age of the king's son, and so forth. (Bayer 1994: 13)

DECONSTRUCTING AND REASSEMBLING POLAR TRAVEL REPORTS

In addition and connected to the biography, the polar travel report is another genre that Bayer has deconstructed and redesigned. *the head of vitus bering* anticipates the boom of polar texts in the 1980s, after the period around 1900

was already characterised by a dense appearance of such texts. Examples of the revival of this genre in German-language literature in the 1980s are Sten Nadolny's *Die Entdeckung der Langsamkeit* (*The Discovery of Slowness*) ([1983] 1987), Christoph Ransmayr's *Die Schrecken des Eises und der Finsternis* (*The Terrors of Ice and Darkness*) ([1984] 1991) and Michael Köhlmeier's *Spielplatz der Helden* ('Playground of the heroes') (1988). In none of these novels, however, is meaning so radically destroyed as in *the head of vitus bering*. The dissolution of the longing for meaning is not experienced here as loss, but as liberation. The polar journey and its locations are no longer 'playgrounds for heroes', but the site of a language game. Thus the motifs of ecstasy associated with the polar journey – as they manifest themselves in epilepsy and madness, intoxication and mystical experience, magic and shamanism – have become materials that are presented as quotations in their linguistic predominance. At the same time, this linguistic material, which comes from the margins of recognised knowledge, refers to the limitations of socially recognised significations and discourses.

Inserted in such expeditions to non-rational areas are scientific descriptions, for example of the freezing of the sea:

first there is the formation of very fine needles which elongate themselves, stick to each other, cross and finally make up a delicate fabric gradually turning into a gritty squash forming flat cakes up to several meters in diameter, in loose connection. if the temperature sinks the gritty squash freezes to solid lumps. (Bayer 1994: 40)

Without losing its concrete meaning, this description of an icing process, through its integration into a heterogeneous network of texts, releases further associations and acquires poetic qualities. Thus, the process described evokes the peculiarity of the text constitution in *the head of vitus bering* and can also be understood as a metapoetic metaphor. The originality of Bayer's montage results from the idiosyncratic compilation of the quotations. As Ena Jung points out: 'Bayer explores the creative potential of language, especially with respect to generating new meanings through surprising contexts' (2009: 101). The repositioning and recombination of preformed language materials unleashes unexpected meanings. As Malcolm Green writes in his afterword to the English edition of *the head of vitus bering*, Bayer

intensifies the black romanticism and surreal invention of his texts by the montage method, now applied to whole text sections, bridging them as it were by the very gaps that separate the often unrelated and non-sequitur building blocks of his text and creating a whole which surpasses either the montage per se or its romantic and surrealist element. (Green 1994: 59)

If a poetics of crystallisation is already mixed in the gesture of scientific objectivity, then syntactic permutations break up the flow of encyclopedic explanation completely: 'the salt changes by degrees of water the freezing point!' (Bayer 1994: 40). Similarly, narrative passages become a quarry for word material, which is then processed, enriched and mixed up:

> while the bow slowly breaks the ice surface, the crack closes again behind the stern. [. . .] while not closes the itself bow the crack ice behind always sur to the face slow lier stern not open breaks closes the crack not bow [. . .] he chop night breaks he shoots he at sicker then then crack the hand the shot face chop. (Bayer 1994: 38, 41)

The words are negated, chopped up, reduced, hardened: 'heck' ('stern') becomes 'hack' ('chop'), 'schliesst' ('closes') is transformed into 'schiesst' ('shoots'). The description of a movement becomes a speech movement in which the disordered simultaneity of things is reflected alongside the confusion of a consciousness in a trance state. More than a travel narrative, it is an inventory of the words and sentences associated with it:

> the keel of the ship is covered with ice.
> the anchors are covered with ice.
> the flag is covered with ice.
> the masts are covered with ice.
> the sails are covered with ice.
> bering's skin is covered with ice. (Bayer 1994: 39)[5]

The text quotes sample sentences from the genre of polar expedition reports and arranges them into a series of examples, as in a language textbook, whose lessons are grouped around a topic and follow the pattern drill method. Bayer shares his preference for lists and tables with the expedition reports, from which he takes quotations. A prominent example is Fridtjof Nansen, who is not only repeatedly quoted in *the head of vitus bering*, but also appears as a character in it; in his very popular expedition report *Farthest North*, Nansen lists over many pages the names and résumés of the ship's seamen, the ship's equipment, as well as the exact incomes and expenditures of the expedition (1897: 54–81).

If the game played in *the head of vitus bering* is a linguistic one then the intellectual adventure is staged in the writing process. Pole and cold are less *Archive des Schweigens* ('Archives of silence') (Roth 1980–91), which would be made to speak by expedition reports and scientific investigations, than places of a 'topology of language' (Bayer [1985] 1996b: 527). The inventory of motifs from the polar journey is presented and its elements are decontextualised, spelled out and combined

with other motif complexes such as shamanism and cannibalism. The aim of these textual strategies is primarily to uncover a structure, not to convey content. In Julia Kristeva's sense, Bayer's text operates on the level of the semiotic, which dissolves the ideology of the monotonous language of representation and, in a process of destructuring and restructuring the language material, crosses the boundaries of body, subject and society (Kristeva 1984). *the head of vitus bering* plays a parodistic game with those polar travel reports that have been staging themselves as guarantors of authenticity since the beginning of the twentieth century in a double sense: because they claim first of all constantly to be based on actual journeys, and secondly they stress that the extreme exertions and terrible yet beautiful experiences of nature bring real, intensive experiences and promise to re-establish the connection to elementary nature lost through technical comfort and media consumption (Haselböck 1996: 71–5). What connects Bayer's text with the tradition of literary polar travel fantasies is the search for a new approach to the world. The emptiness of polar regions becomes a place of mystical self-dissolution, where physical states of emergency and ecstatic experiences coincide. The object of this self-dissolution is not a sovereign subject, but a grammatical function. The literary text lists nothing other than the inventory of the sentences in which Vitus Bering appears. The grammar of Vitus Bering's appearance is part of a set of linguistic rules. Consequently, 'Bering' is a subject that can be replaced by any other name, as the following passage demonstrates:

> vitus bering bent over the railing, reached for the hatch cover and pulled it up. [. . .] james cook pulled the hatch cover from the wooden rail and, while sir martin spread his legs and john davis bent his knees, simon deschneff put it carefully on a plank that ran along the inside of the railing. (Bayer 1994: 41)

As a linguistic construct, the subject is interchangeable. As a result, the boundaries between language, consciousness and body become blurred; language and body are set into one. The affinity of word body and organic body is a characteristic of Bayer's montage technique: 'Especially in the montage texts there are strikingly many words and fields of meaning that dock in some way to the body or its metonymic entourage such as clothing, food, sexuality, sensory perception, speech, pain and death' (Steinlechner 2008: 177).

The index programmatically quotes 'views of life and legends of the Eskimos' testified by polar explorer Knud Rasmussen: 'every person consists of a soul, a body, and a name' (Bayer 1994: 44). In *the head of vitus bering* the identifying function of the names disappears: what remains are individual sentences and

words in disparate contexts, whose use is demonstrated and whose medial materiality is exposed. The words and sentences do not fit into any argumentative or narrative continuum. Rather, their distribution on the text's surface creates a network of dynamic relationships to one another and to the system of language. In order to demonstrate the text-topological field of forces and relations, Wittgenstein's theory of language games calls for an investigation of the 'complicated network of similarities overlapping and criss-crossing' (Wittgenstein 1953: §66). The text does not establish coherence at the level of meanings, but by the rules of language. The word only unfolds its effect when it appears repeatedly. Thus, it proves to be part of a textual strategy that dissolves rigid models into dynamic networks of relationships. For example, certain clusters, accumulations and bundles become visible in *the head of vitus bering* in the occurrence of the word 'blue' (Innerhofer 2015: 55–6). When calling up word fields and creating word lists, associations are serially lined up. Prefabricated language elements are sorted, assembled and permuted. The subjectivity of the selection is combined with the randomness of the found objects.

The text can be seen as a field in which language movements take place. The 'topology of language' is the result of a choreography of writing. For Bayer, topology is not a system of *topoi*, commonplaces and images that lend coherence to the texts through the constitution of meaningful connections, but a force field of changing positions, constellations and variations of sentences and words. When Bayer's text refers to the genre of the expedition report, it does not address a geographical space, but the spatiality of writing: 'sentences are determined [. . .] exclusively by constellation, variation, change of location and sequence, they are not related to expression and are not treated as mediators of messages of a thinking, experiencing and planning interior' (Vogel 2008: 36). The decisive factor is the arrangement of the sentences on the book page: they are removed from the reference texts and reconfigured. The structural specifications of syntax and grammar also function as game material and rules by varying and permutating them.

These language games, however, revolve around a few clearly identifiable themes. Remarkable association clusters are formed around body phenomena, namely psychophysical borderline situations, mutations and transgressions. Pain and violence, illness and death are the intransigent topics. Word body and the organic body are both often erotically charged and violently worked on. Diseases such as epilepsy and scurvy lead to an intermediate area between life and death. Analogous borderline situations are raptus and ecstasy in the area of the psychic, which always overlaps with the physical in Bayer's work.

If the arrangement of the text parts in *the head of vitus bering* appears to be accidental, such contingency is at the same time thematically motivated: it is

not least a question of visualising a 'disturbed consciousness' (Janetzki 1982: 99) and the chaos to which the phenomena in *the head of vitus bering* become confused. The text calls up the scheme of the (adventurous) journey, which traditionally functions as a metaphor and model of the journey through life. At the same time, it revokes this scheme: formally, by progressing in a series of collisions of the incongruent, and contentwise, by thematising ecstasy and the raptus as decisive experiences of life. These themes shape the form and procedure of the text: 'By taking on the form of ecstasy himself, Bayer's text accomplishes what he is talking about' (Grizelj 2009: 101).

MONTAGE: NEGATION AND INNOVATION

Both Adorno and Bürger conceive of the montage as a crucial technique of avant-garde and modern art. For Adorno, the role of montage is to negate sense syntheses by combining disparate parts and so breaking up the unity of artworks:

> Montage is the inner-aesthetic capitulation of art to what stands hetero-geneously opposed to it. The negation of synthesis becomes a principle of form. [. . .] The artwork wants to make the facts eloquent by letting them speak for themselves. Art thereby begins the process of destroying the art-work as a nexus of meaning. (Adorno [1970] 1997: 155)

In contrast, according to Bürger, 'the avant-gardist work does not negate unity as such [. . .] but a specific kind of unity, the relationship between part and whole that characterizes the organic work of art' ([1974] 1984: 56). The unity produced by the montage is a disharmonic one – a contradictory rela-tion between heterogeneous parts. Bürger's approach seems to be confirmed by Bayer's montage technique, especially because his text cites less facts than heterogeneous text types that often address supernatural processes. The mon-tage of quotations in *the head of vitus bering* is not arbitrary but rather follows certain strands of structure and content. In the cited materials, a preference for the excess, for psychic limit states and border crossings can be observed. Topics such as shamanism and cannibalism, pathological states such as epilepsy, and all kinds of intoxicating expansions of consciousness are predominant. Frag-mentation is a process that can be observed in the semantics as well as in the structure of the text.

The montage technique in *the head of vitus bering* links two contradicting principles: on the one hand, montage breaks up organic or linguistic integ-rity, reducing sentence structures to fragments and ellipses; on the other hand, Bayer's text is the result of a process of recomposing the fragmented parts and consolidating them in a congealed form: 'the formal staging of the breakup

through the montage is contrasted with the inverse figure of freezing in the ice' (Steinlechner 2015: 238).

The procedure of montage is adopted on a formal and on a thematic level. In respect of structure, *the head of vitus bering* is a montage of elliptical fragments; the sources of the quotes are multifarious. Concerning genre, *the head of vitus bering* combines traditional genres such as the treatise, the travelogue, the biography, the legend, and the lives of the saints. The result is a text that cannot be attributed to any of these genres; it circumvents generic patterns and subverts the reader's genre expectations. The method of montage is also adopted on the semantic level, with respect to themes and motives. Already the title *the head of vitus bering*, which refers to a body part, prefigures a crucial topic and a basic structural feature of the text: it deals frequently with the dismembering of bodies; shamanism and epilepsy offer examples of self-dismembering and of the fragmentation of the spirit and of thoughts. The severing of the head in particular is a continuous theme; as Günther Eisenhuber has pointed out, the text 'is teeming with severed heads' (2015: 73). A text about shamanism quoted in the index describes the following process: 'the spirits cut off his head, which they set aside (for the candidate must watch his dismemberment with his own eyes), and cut him into small pieces' (Bayer 1994: 54). This passage not only refers to a shamanistic practice, but also to Bayer's poetic approach. War, cannibalism and eating are all connected with the principle of the montage. Just like shamanism, the topic of cannibalism can also be applied to Bayer's approach to materials and quotations. In the film *The Head of Vitus Bering* directed by Ferry Radax, Jürgen Becker comments on Bayer's book: 'statements on the person are directly connected with statements on guzzling persons' (*Der Kopf des Vitus Bering*: 9:20).

'time is only the dissection of the whole and through the senses' (Bayer 1994: 51). This self-quotation from *the sixth sense* can be regarded as programmatic for the intention of Bayer's montage technique – it unites different areas and times, the present and the future. The paradigm of space takes priority over time. A quotation from H. G. Wells's novel *The Time Machine* (1895) serves as evidence for such a relativising integration of time into a spatial paradigm based on simultaneity: '"scientific people", said the time traveller, after the pause required for the proper assimilation of this, "know very well that time is only a kind of space . . ."' (Bayer 1994: 50–1). Thus, the arc spans from the alternative knowledge of shamanism to science in fiction. The outer and inner voyage of Vitus Bering freezes in a state of rigidity within which all the delirious images of murder, sacrifice, torture, cannibalism, decapitation and dismemberment of atrocious religious rituals and mechanical horrors coincide and collapse. Ultimately, not only the figure of Vitus Bering, as Bayer writes in his foreword, but also the reader shall be liberated from logic, from 'opinions and thoughts' (1994: 8) and ready for the passage into another spiritual and physical state. 'his head

was bent backwards, the teeth tightly clenched together. his body was twisted
and arms and legs stretched out. the fingers were placed over the folded thumb.
he didn't breathe and slowly his face turned / *blue*' (Bayer 1994: 41).

In a certain sense, *the head of vitus bering* had already surpassed postmod-
ernism. Modern in this text is the primacy of the constructive over the
genealogical paradigm. The literary play with found materials and genres can
be seen as postmodern, but postmodern aesthetic and eclectic pluralism is
undermined by an obsession with violence and the crossing of borders. The
process of destruction is not limited to semantics, but extends to the narra-
tive continuum, grammatical structures and individual words. In contrast to
postmodernism, the categories of the new and the original are not dismissed,
but emerge from the vehemence of negation.

NOTES

1. In Bayer's manuscript, the title, as well as the entire text, is written in
 lower case letters throughout. Nevertheless, the first edition of the book
 in 1965 used capital letters in the title.
2. Unless otherwise noted, all translations are mine. Ironically, some scholars
 (e.g. Perloff 2019) now consider Kraus an avant-gardist writer.
3. According to Jürgen Becker's oral statement at the conference 'Fluxus
 und/als Literatur. Zum Werk Jürgen Beckers', 13–16 June 2013, at Freie
 Universität Berlin.
4. Bayer writes in a letter to Otto Breicha on 26 August 1964: '(If you ask me
 what [the head of vitus bering] is, it is difficult for me to answer; perhaps
 a trepanation.)' (quoted in Janetzki 1982: 182–3).
5. 'der kiel des schiffes ist mit eis bedeckt. / die anker sind mit eis bedeckt. / die
 flagge ist mit eis bedeckt. / die masten sind mit eis bedeckt. / die segel sind
 mit eis bedeckt. / berings haut bedeckt sich mit eis.' (Bayer [1985] 1996a:
 555). What the translation does not take into account is the fact that in the
 original, the last sentence is syntactically constructed differently from the
 others. It describes a process, not a state: 'bering's skin covers itself with ice.'

BIBLIOGRAPHY

Achleitner, F. (2015), 'Bemerkungen zu Konrad Bayer', in T. Eder and K. Kast-
 berger (eds), *Konrad Bayer: Texte, Bilder, Sounds*, Vienna: Zsolnay, pp. 267–70.
Adorno, T. W. [1970] (1997), *Aesthetic Theory*, ed. G. Adorno and R. Tiedemann,
 newly translated, edited and with a translator's introduction by R. Hullot-Kentor,
 London/New York: Continuum.
Bayer, K. (1963), *der stein der weisen*, Berlin: Fietkau.

Bayer, K. (1965), *Der Kopf des Vitus Bering. Ein Porträt in Prosa*, Olten: Walter.

Bayer, K. (1966), *der sechste sinn*, ed. G. Rühm, Reinbek: Rowohlt.

Bayer, K. (1970), *Der Kopf des Vitus Bering*, epilogue J. Becker, Frankfurt am Main: Suhrkamp.

Bayer, K. (1994), *the head of vitus bering*, trans. W. Billeter, London: Atlas Press.

Bayer, K. [1985] (1996a), 'der kopf des vitus bering', in K. Bayer, *Sämtliche Werke*, ed. G. Rühm, revised new edn, Vienna: ÖBV-Klett-Cotta, pp. 531–72.

Bayer, K. [1985] (1996b), 'der stein der weisen', in K. Bayer, *Sämtliche Werke*, ed. G. Rühm, revised new edn, Vienna: ÖBV-Klett-Cotta, pp. 520–30.

Bayer, K. (2000), 'vaterländische liste', in T. Eder and K. Kastberger (eds), *Schluß mit dem Abendland. Der lange Atem der österreichischen Avantgarde*, Vienna: Zsolnay, p. 20.

Bayer, K. (2014), *der kopf des vitus bering*, ed. and epilogue G. Eisenhuber, Salzburg: Jung und Jung.

Bürger, P. [1974] (1984), *Theory of the Avant-Garde*, trans. M. Shaw, Minneapolis, MN: University of Minnesota Press.

Bürger, P. (2010), 'Avant-Garde and Neo-Avant-Garde: An Attempt to Answer Certain Critics of "Theory of the Avant-Garde"', *New Literary History*, 41, pp. 695–715.

Der Kopf des Vitus Bering, film, directed by F. Radax, based on texts by K. Bayer and J. Becker. Camera: M. Wingens and others. Actor: J. Becker. Black and white, 26 min. Germany: WDR, 1970.

Eder, T. and K. Kastberger (moderators) (2015), '"Er war schon immer so weit weg und wollte weiß Gott was noch erleben". Gesprächsrunde mit Freundinnen und Freunden Konrad Bayers am 21. 9. 2014 im kunsthaus mürz', in T. Eder and K. Kastberger (eds), *Konrad Bayer: Texte, Bilder, Sounds*, Vienna: Zsolnay, pp. 293–312.

Eisenhuber, G. (2015), '"er schmiedete seinen *kopf* und zeigte ihm, wie man die buchstaben darin lesen kann". Die Köpfe in *der kopf des vitus bering*', in T. Eder and K. Kastberger (eds), *Konrad Bayer: Texte, Bilder, Sounds*, Vienna: Zsolnay, pp. 72–83.

Foster, H. (1996), *The Return of the Real: The Avant-Garde at the End of the Century*, Cambridge, MA: MIT Press.

Green, M. (1994), 'Afterword', in K. Bayer, *the head of vitus bering*, trans. W. Billeter, London: Atlas Press, pp. 57–61.

Grizelj, M. (2009), 'Epilepsie und Schamanismus in Konrad Bayers *der kopf des vitus bering*', in B. von Jagow and F. Steger (eds), *Jahrbuch Literatur und Medizin*, vol. 3, Heidelberg: Winter, pp. 89–119.

Groys, B. (2014), *On the New*, trans. G. M. Goshgarian, London: Verso.

Haselböck, K. (1996), 'Zum Motiv der Polarfahrt in der deutschen Literatur von der Aufklärung bis zur Gegenwart', unpublished thesis, Vienna.

Innerhofer, R. (1985), *Die Grazer Autorenversammlung (1973–1983). Zur Organisation einer 'Avantgarde'*, Vienna/Cologne/Graz: Böhlau.

Innerhofer, R. (2015), 'Shades of Blue. Blaupausen im *kopf des vitus bering*', in T. Eder and K. Kastberger (eds), *Konrad Bayer: Texte, Bilder, Sounds*, Vienna: Zsolnay, pp. 55–71.

Janetzki, U. (1982), *Alphabet und Welt. Über Konrad Bayer*, Königstein im Taunus: Hain.

Jung, E. (2009), '. . . ellipses . . . epilepsies', *Modern Austrian Literature*, 42 (1), pp. 85–111.

Kastberger, K. (2000), 'Wien 50/60. Eine Art einzige österreichische Avant-garde', in T. Eder and K. Kastberger (eds), *Schluß mit dem Abendland. Der lange Atem der österreichischen Avantgarde*, Vienna: Zsolnay, pp. 5–26.

Köhlmeier, M. (1988), *Spielplatz der Helden*, Munich/Zurich: Piper.

Kraus, K. (1920), 'Dichterschule', *Die Fackel*, 554, pp. 20–1.

Kristeva, J. (1984), *Revolution in Poetic Language*, trans. M. Waller, New York: Columbia University Press.

Nadolny, S. [1983] (1987), *The Discovery of Slowness*, trans. R. Freedman, New York: Viking Penguin. (Original title: *Die Entdeckung der Langsamkeit*.)

Nansen, F. (1897), Farthest North, *vol. I, London: Harrison and Sons*.

Perloff, M. (2019), 'Avant-Garde in a Different Key: Karl Kraus's The Last Days of Mankind', *Critical Inquiry*, <https://criticalinquiry.uchicago.edu/Avant_Garde_in_a_Different_Key/> (last accessed 5 February 2021).

Ransmayr, C. [1984] (1991), *The Terrors of Ice and Darkness*, trans. John E. Woods, New York: Grove Press. (Original title: *Die Schrecken des Eises und der Finsternis*.)

Roth, G. (1980–91), *Die Archive des Schweigens*, 7 vols, Frankfurt am Main: Fischer.

Rühm, G. [1985] (1996), 'anmerkungen', in K. Bayer, *Sämtliche Werke*, ed. G. Rühm, revised new edn, Vienna: ÖBV–Klett-Cotta, pp. 747–819.

Scheunemann, D. (ed.) (2005), *Avant-Garde/Neo-Avant-Garde*, Amsterdam: Rodopi.

Shigekuni (2010), 'Konrad Bayer: The Head of Vitus Bering', *Shigekuni* [book blog], <https://shigekuni.wordpress.com/2010/03/04/apokoinu-konrad-bayers-the-head-of-vitus-bering/> (last accessed 5 February 2021).

Sonnleitner, J. (2008), 'Die Literatur der Wiener Gruppe und der Zivilisa-tionsbruch', in T. Eder and J. Vogel (eds), *verschiedene sätze treten auf. Die Wiener Gruppe in Aktion*, Vienna: Zsolnay, pp. 87–96.

Steinlechner, G. (2008), 'kämme mich, – etwas behutsam. Aus der Lehrmittel-kammer der Wiener Gruppe', in T. Eder and J. Vogel (eds), *verschiedene sätze treten auf. Die Wiener Gruppe in Aktion*, Vienna: Zsolnay, pp. 174–91.

Steinlechner, G. (2015), 'Ein Findelkind und sechsundzwanzig Namen. Konrad Bayers Auswege aus dem Erzählen', in T. Eder and K. Kastberger (eds), *Konrad Bayer: Texte, Bilder, Sounds*, Vienna: Zsolnay, pp. 229–40.

Vogel, J. (2008), 'Auftritte, Vortritte, Rücktritte – Konrad Bayers theatrale Anthropologie', in T. Eder and J. Vogel (eds), *verschiedene sätze treten auf. Die Wiener Gruppe in Aktion*, Vienna: Zsolnay, pp. 29–38.

Welsch, W. (1987), *Unsere postmoderne Moderne*, Weinheim: VCH, Acta Humaniora.

Wiener, O. (1982), 'Einiges über Konrad Bayer', in V. von der Heyden-Rynsch (ed.), *Riten der Selbstauflösung*, Munich: Matthes und Seitz, pp. 250–63.

Wittgenstein, L. (1953), *Philosophical Investigations*, New York: Macmillian.

Zorach, C. C. (1986), 'Geographical Exploration as Metaphor in Recent German Narrative', *German Quarterly*, 59 (4), pp. 611–27.

Surrealism in Post-War Vienna

Laura Tezarek and Christian Zolles

One can study only what one has first dreamed about. Science is formed rather on a reverie than on an experiment, and it takes a good many experiments to dispel the mists of the dream.

– Gaston Bachelard, *Psychoanalysis of Fire* (1964: 22)

THE (INTER)NATIONAL NETWORKS OF THE (NEO-)AVANT-GARDES

Notwithstanding all reasonable doubts concerning the use of the concept of the '(neo-)avant-garde', this chapter starts with the assumption that it can serve to establish coherence. Indeed, it creates *historical coherence* insofar as experimental artists themselves referred to ancestors and pioneers and continuously revised and archived their own work in order to position themselves within their given time, generation and tradition. Thus, through the protagonists' own initiatives to orientate and legitimise themselves within their 'constellations' (Bürger 2010: 711), the essentially 'reactionary' moves of canonisation, institutionalisation and conservation primarily occur outside absolute social or epistemic structures and make things coherent and memorable. From this point of view, while the *materialistic theoretical* discourse tends to stagnate, the academic debates can contribute to the resumption of these specific *historiographic* and also *archival* efforts (see Bürger 2010: 703).

With an approach like this, the '(neo-)avant-garde' movements stand as testimony to the existence of a network within the twentieth-century arts that was heterogeneous at the synchronous level and mutable at the diachronic level, but which together reveals distinct nodes of contact and exchange (see van den Berg 2009; van den Berg and Fähnders 2009: 9–12). Implying a rhizomatic structure similar to the internet (a development apparently even anticipated by some of

the artists involved, such as the Austrian experimental writer Andreas Okopenko as discussed below), the different movements had great influence on each other and were aesthetically, organisationally and genealogically linked to one another. This definitely included interdisciplinary and inter-medial aspects, but above all the *international* influence and outwards orientation (see Benson 2002). In this respect, the idea of the '(neo-)avant-garde' as a network seems to be ideal for highlighting the interdependencies and conflicts between global and regional factors that have been examined under the heading of *glocalisation*.

By the same measure, Thomas Hunkeler has recently explained the emergence of the historical avant-garde through the lens of the dialectic of internationalism and nationalism (see Hunkeler 2018; see also Hunkeler 2014; Jurt 2019). Since the rise of French symbolism, the artists associated with 'avant-garde' or 'modernism'[1] have tended to be outsiders within the literary field, often multilingual and/or migrants. The avant-garde's reception of foreign artists and the response to their work from like-minded artists abroad led to an international exchange that was also tied in with the major socio-cultural developments around 1900. It was an Italian in Paris, Filippo Tommaso Marinetti, who in 1909 propagandised futurism beyond traditional boundaries, causing an effect far beyond French and even European borders (see Boschetti 2016). It has also often been emphasised that the transgressive pan-European and universalistic approach of all the other 'isms' – cubism, fauvism, expressionism, Dadaism, constructivism, surrealism and so on – led to an overcoming of nationally bound representations and could thus be adopted by the political discourses of the 1920s.

This development, however, illuminates only one side of the coin: Hunkeler also understands the historical avant-garde as a discourse phenomenon within the arts that triggered specific developmental phases of *national* identity. As is aptly demonstrated by Italy – which has previously been perceived as desperately politically backward and regionally divided – the genesis of the historical avant-garde also played an important role in the processes that led to the formation of national unity being accelerated. Thus, it is not only the chauvinist, imperialist and even fascist aspects of futurism that can be better understood but also the counter-reactions to it, which emphasise the national differences and peculiarities in the European art context. In French cubism as well as in German expressionism, a patriotic development can be observed, which inevitably intensified by the outbreak of the First World War, especially since many immigrant artists had to demonstrate their national loyalties all the more. Even the surrealists, leading propagandists of the limitlessness of dreams, were aware that Paris had to remain the *ne plus ultra* with regards to innovative art – a rank that it was to lose to New York decades later at the time of the 'neo-avant-garde'.[2]

All this demonstrates that the '(neo-)avant-garde' concept can elicit not only historical but also *political* coherence – not to be understood as the attribution to political camps, an aspect that would soon become dominant in times of totalitarianism and Cold War, but as a reflection of the national discourses within a fundamentally new geopolitical context. It is precisely this aspect, moreover, that holds the most interest when it comes to investigating the reception of the historical avant-garde and surrealism in *Austria*. Owing to its fundamental lack of national esteem and the future prospects following the First World War and the end of the multi-ethnic Habsburg monarchy, there was a tremendous delay in the historical avant-garde reaching Austria – as well as a lack of clarity in regard to what could be considered 'avant-gardist writing' – both by contemporaries, who often used the term polemically in order to discredit literary 'enemies', and retrospectively by literary scholars. This development was also due to the still dominant heritage of 'Viennese modernism' in the first decades of the twentieth century. It was only after the Second World War that a young generation was confronted with the intoxicating and anarchic energies of surrealism, which, according to Walter Benjamin ([1929] 2005; and Bürger [1974] 1984, despite all criticism), seemed through its projection of visions of a non-ethno- and Eurocentric culture (see Barck 2000) to offer the only artistic weapon and way of life to counter an ill-fated bourgeois capitalistic society and its tendencies towards fascism.

EARLY TRACES OF SURREALISM IN AUSTRIA: OTTO BASIL'S *PLAN*

The enormous creative power of 'fin de siècle' and Viennese Modernism that had seen Austria achieve a unique international standard in the arts and sciences around 1900 (see Puff-Trojan 2009: 311–12) was soon to be overshadowed by severe political shifts. The deep crisis of language representation, described at the time in 'Ein Brief' ('A Letter') (1902) by Hugo von Hofmannsthal, would persist through several different forms of governance: the Monarchy (until 1918), the First Republic (1918–33), the Corporate State (1933–8), the National Socialist dictatorship as part of the Third Reich (1938–45) and the Second Republic under Allied occupation (1945–55). It was only then – in a nation that had been torn apart by strict social and ideological tensions since the end of the multinational Habsburg Empire and had formally ceased to exist within the Greater German Empire – that young writers could start to redefine their status and seek new identities through the reception of new forms of international art that had up until recently been supressed and were still derided as 'dirt and rubbish'.

Accordingly, in the late 1940s and at the beginning of the 1950s, 'modern art' and subsequently 'modern literature' slowly became a subject of debate in Austria's capital, the atmosphere of which was characterised by a US American reporter in the following words: 'A surrealist in Vienna must feel as lonely and misplaced as an Eskimo in Darkest Africa, for in this city, probably more than in any other capital in Europe, art is conventional to a picture postcard degree' (Okopenko 2000a: 26).

In the immediate aftermath of the Second World War, it was only Otto Basil's cultural journal *Plan* – the first issue of which had already been published in 1938, its second issue prohibited by the press police and its third issue confiscated by the Nazis – which published international modern literature. Basil and his editorial team had set it as their goal to become the focal point for all those forces that were promoting the stabilisation of the concept of a democratic republic in the cultural life of Austria and the rebuilding of an intellectual Austrian identity (see Basil 1945a: 1).

Apart from Basil and his editorial team selecting 'activist vanguard' ('aktivistischer Stoß- und Vortrupp') as their self-designation, nothing suggests an avant-gardist stance at this particular time. The third issue, however – confiscated in 1938 – was a special issue dedicated to surrealism (including excerpts of André Breton's *Surrealist Manifestos*). Although Basil introduced writers and artists such as Lautréamont, Arthur Rimbaud, Louis Aragon, Paul Éluard, Salvador Dalí and Hans Arp to his Austrian readers in the issues from 1945 onwards, and even surrealist literature from Czechoslovakia, he no longer published the *Surrealist Manifestos* or other texts of André Breton. Surrealism had become just one of various discourses within the scope of modern art that were frequently mentioned and discussed in *Plan* (see Schlebrügge 1985: 27).

The German painter Edgar Jené – the *Plan*'s picture editor – studied fine arts at the École nationale supérieure des Beaux-Arts in Paris during the inter-war period and is of particular importance for the reception of surrealism in Vienna. His influence extended not only to other painters but also to writers like Paul Celan, who had been part of a surrealist group in Bucharest before coming to Vienna and had written a few surrealist texts in Romanian (even if he later rejected any attribution of his works to surrealism). Jené had also collected surrealist literature during the inter-war period (see Muschik 1967: 47). Together with the painters Arnulf Neuwirth and Rudolf Pointner, Jené organised an exhibition of surrealist art accompanied by a reading of surrealist literature (texts of Celan, Breton, Georges Henein, Benjamin Péret, Werner Riemerschmid and others) at Vienna's Agathon Galerie in March 1948 (see Ivanovic 2001: 63–4).

Being labelled as a 'surrealist' in the press, however, Jené's drawings also encountered ridicule and mockery (see Basil 1945b: 254). In a number of

letters to the editor, concerned readers declared themselves offended by the choice of paintings in *Plan*, which they ascribed to 'surrealism (or cubism? Or neo-cubism? It does not make any difference!)', and the 'excesses of avant-gardist art' (Koselka 1946: 769).[3] It seems clear, then, that the paintings labelled 'surrealist' tended to scandalise to a greater extent than avant-gardist writings in the immediate post-war period. This is probably in part due to the fact that there was still no contemporary surrealist literature being published but also due to the uncertainty about how surrealism actually manifested itself in literature.

In November 1947, the weekly newspaper *Welt am Montag* announced that the 'black-red flag of surrealism' had been unfolded in Vienna on the occasion of Edgar Jené's 'First surrealist lecture evening', in the course of which a picture representing a painted version of 'the most important Surrealist Manifesto' had also been displayed and a public reading of surrealist poetry by Lautréamont, Breton, Éluard and Henein, presented by Werner Riemerschmid, took place (see Neuwirth 1947: 8). Another article, published in the same month by Jené's wife, Erica Lillegg-Jené, explains the dispute between the French surrealists and Jean-Paul Sartre to the Viennese readership and depicts Sartre as someone who 'possesses not enough intuition to recognise the eminent dynamics of surrealism' (Lillegg 1947: 9), thus taking up the cudgels on behalf of surrealism. These two positive reports demonstrate how public opinion was not exclusively against surrealism and that surrealists or people associated with surrealism were given the opportunity to publish favourable articles in newspapers.

Nevertheless, the lack of knowledge of the original French surrealist texts is striking and there is a similar lack of consensus as to a definition of surrealism itself. For issue 4 of *Plan*, the psychoanalyst Theon Spanudis wrote a piece attempting to explain 'Was ist Surrealismus?' ('What is surrealism?') and portrayed the surrealist artist as 'quieter' and 'less militant'; since they worked 'with the abundance of human emotions', one felt 'deeply moved' in the face of their 'sensitive' works (1945: 434–5). Without quoting a single source, Spanudis describes surrealist creations, for example, as 'a child's shenanigans' and as infantile behaviour, 'evoking a feeling of happiness in the artist, but, on the other hand, the incomprehension and rejection of so many people' (1945: 436).

While Spanudis's unusual definition might have fuelled subsequent misunderstandings, a different attempt at explaining surrealism came from the Viennese art critic 'Abu Nif' (Arnulf Neuwirth's pen name; see Ivanovic 2001: 65), according to whom 'surrealism' meant overcoming the limitations of naturalistic painting in two respects: (1) finding a point of view from which contradictions stop being perceived as antithetic (that is, suspending the opposition of dream and reality) and (2) uncovering the irrational (see Nif 1946/7: 968–9).

What both approaches share is that again they refer solely to fine arts and not to literature. The first Austrian attempt at clarifying the concept of surrealism in literature does not appear until Werner Riemerschmid's 'Über surrealistische Lyrik' ('About surrealist poetry'), which appeared in *Plan* in 1947. Riemerschmid joins those who had pronounced surrealism dead in France with Maurice Nadeau's *The History of Surrealism* (1945), but asks the crucial question: 'But what is surrealism, actually?' (Riemerschmid 1947: 256) He goes on to criticise Nadeau's vague definition ('surrealism is a whole, something thoroughly alive'), but still refers to Nadeau's further explanations: the surrealist movement was anti-literary, anti-poetic and anti-artistic – it was against everything; it demanded space for the dream, instead of logical reasoning, and for the unconscious, the *écriture automatique*. Other characteristics, according to Riemerschmid, were:

> hypnosis, hallucination, the 'objective hazard' (André Breton's *Nadja*), the postulate of 'convulsive beauty', black humour, dialectic materialism, 'critical paranoia' (Salvador Dalí), proverbs [. . .], puns [. . .], collages, montages (Max Ernst), poems made out of newspaper phrases, scandalous 'revues'. (Riemerschmid 1947: 257)

After citing André Breton, Paul Éluard, Louis Aragon, Benjamin Péret, Philippe Soupault, Max Jacob, René Crevel, René Char, Aimé Césaire, Jacques Prévert and Henri Michaux as leading figures of literary surrealism in France, Riemerschmid analyses his own German translations of Éluard's 'Passer' and Péret's 'Allô' and quotes from Dalí's *La Conquête de l'irrationnel* and from Breton and Éluard's *Notes sur la poésie*. He thus demonstrated considerable expertise compared with previous essays published on the same topic in Austria.

THE ART-CLUB AND THE NETWORK OF *NEUE WEGE*

As demonstrated above, surrealism was not only a much-discussed topic within fine arts in the late 1940s, but Austrian artists also actually created artworks that can be considered 'surrealist', unlike Austrian writers (save a few exceptions). The painters' more extensive knowledge resulted in part from the foundation of the Austrian branch of the International Art-Club in 1946/7. A node of contact and exchange, the Art-Club would be a starting point – to some extent – for international connections, mainly to Italy (e.g. the Austrian exhibition in June–July 1947 in Rome), France (see Schmeller 1980: 32; Fuchs 1981: 39) and even to the United States (see Art-Club 1951). Albert Paris Gütersloh, president of the Austrian Art-Club, programmatically announced in his opening speech that the Art-Club would approve of heterogeneous schools or tendencies: 'I do

not agree with what you have to say, but I'll defend to the death your right to say it' (1947: 8, quote wrongly attributed to Voltaire); naturalism, impressionism, expressionism, magic realism and surrealism should be equally welcomed, as long as their artworks remained in a state of experimentation. Ernst Fuchs, considered part of the 'surrealist' wing, remembered the Art-Club similarly as a 'stronghold of the absurd and surrealist, of the fantastic, less for abstraction and [. . .] opposed to the decorative' (1981: 39). The members of the Art-Club collectively declared war on nationalism and provincialism, 'not because we do not love our people and our country and want to prevent others from loving their people and their country' (Gütersloh 1948: 9) but to target narrow-mindedness. Gütersloh's counter-argument to the 'death of surrealism' was that 'Viennese surrealism' was called 'surrealism' for want of a different name, but that it barely resembled the one pronounced dead elsewhere. Like others, however, he did not clarify the essence of 'Viennese surrealism' (Gütersloh 1952). Similarly, as Alfred Schmeller stated: '[One part of the Art-Club] was the surrealist group, which one also called surrealists at that time, without knowing exactly what surrealism actually is' (1980: 33). How highly their impact was generally assessed can be exemplified by Friedensreich Hundertwasser's recollection: 'When it comes to the fantasts [. . .], they made Vienna a centre of surrealism at that time, comparable to what came about in Belgium and to the Parisian group around Breton'; as he added: 'Maybe one was a bit behind time in Vienna' (1980: 44).

The so-called surrealist group of the Art-Club – later known as the Vienna School of Fantastic Realism – consisted of Arik Brauer, Ernst Fuchs, Rudolf Hausner, Anton Lehmden, Wolfgang Hutter and others and can be described, from today's perspective, as being influenced by surrealism or close to surrealism rather than the members actually being surrealists themselves; they were not entirely against reason, and the irrational and the absurd was not their main purpose (see Muschik 1976: 56).

In various recollections gathered together in a volume edited by Otto Breicha (1981), the members of the Art-Club and those associated with it stress the spirit of comradeship as much as their diverging interests and emphasise the fact that there was no comparable association in Austria at the time, in which various art forms intermingled to such an extent and inter-medial exchange took place: 'Artists were interested in music, musicians in literature, writers in fine arts' (Kont 1981: 47).

Three years after the enraged letters to the editor were published in *Plan*, the term 'surrealism' was still a powder keg. In January 1950, *Neue Wege* ('New ways') – a journal dedicated to cultural representation and promotion among pupils and providing aspiring young writers with an opportunity to publish – organised a meeting of young writers. The Austrian writer Andreas

Okopenko (1930–2010), best known for his hypertext novel *Lexikon-Roman* ('Dictionary novel') (1970) and who considered himself as an avant-gardist at that time, meticulously documented the developments on the avant-gardist literary scene in his diaries (Okopenko 2019) as well as in retrospective essays.

In 'Die schwierigen Anfänge österreichischer Progressivliteratur nach 1945' ('The difficult beginnings of Austrian Progressive Literature after 1945') (Okopenko 2000a), Okopenko describes three circles of writers in post-war Austria: firstly, a group of writers who started to publish immediately after 1945 in journals such as *Plan* and *Lynkeus*, and who gathered around Hermann Hakel and Hans Weigel; secondly, a cohort associated with the journal *Neue Wege*; and thirdly, a second circle that formed around Hakel after 1951. Okopenko focuses on the second group, which brought together various writers who shared the goal of fighting for an 'active modernism' (2000a: 15). These different groups of writers in post-war Austria resembled the Art-Club's different 'wings' moving closer together for the common goal of modern art (see Mikl 1980: 44) or for the collective sense of departure from traditions (see Hoflehner 1980: 45). According to Okopenko, the young editorial committee of *Neue Wege* represented a first public and militant manifestation of experimental literature in Austria.

He divides this group, once again, into three parts: a 'right wing' – artistically speaking – conscious of traditions and conservative in their writing; a level-headed 'centre', critical towards both other 'wings'; and an anti-bourgeois 'left wing', comprising what could legitimately be called 'surrealists', because of the carefree and alogical elements in their writing (see Okopenko 2000a: 15). Surrealism seemed to be an appropriate aesthetic model for an artistic reorientation after the Second World War, precisely because it had not or barely gained ground in Austria before (see Ivanovic 2001: 62). In this regard, Okopenko's diaries provide evidence that surrealism was perceived (at least among certain writers) as an opportunity to explore traditions different to those of Austrian literature in the inter-war and pre-war period, which they condemned as conservative. These authors could thereby attempt to reposition themselves and legitimise their writings.

However, even among progressive writers, this was a highly controversial matter. These literary movements of the 'historical avant-gardes' had by no means been acknowledged or incorporated by any institution at this point (see Bürger 2010: 712) and Okopenko's notes convey how much disagreement and mockery the topic of surrealism caused at the first writers' meeting in January 1950:

Dr [Franz] Häußler declared the conference open. It was highly inspiring.
[Friedrich] Polakovics banged his fist on the table in a way that made the woodworms hole up and ghosts of the Hofräte [title for high-ranking senior Austrian civil servants] turn pale. [. . .]

[René] Altmann stood up and called for equal status for surrealist art. When Altmann spoke about surrealism as a 'leading trend in art', [Sieglinde] Kaipr and [Hanns] Weißenborn shouted in unison: 'Ho . . . ! Ho . . . !' (Okopenko 2019: 16 February 1950)

From January 1950 onwards, Okopenko started to participate regularly in editorial meetings of *Neue Wege*. Being part of the young editorial commit-tee, he made several acquaintances and friends that are crucial to his subse-quent career as a writer, such as H. C. Artmann (1921–2000), René Altmann (1929–1978), Friedrich Polakovics (1922–2011) and Ernst Kein (1928–1985). Artmann, nine years Okopenko's senior, quickly became his closest friend. Their discussions are, to an extent, documented in Okopenko's diaries and in 1950 revolved mostly around surrealism. In his diary, Okopenko introduces his friend as follows: 'Artmann must be distinguished from Altmann; interest-ingly enough, they are both surrealists' (Okopenko 2019: 16 February 1950).

CATCHING UP WITH SURREALISM

Since Austria was considered to be 'in a remote position' – especially due to the vilification of 'progressive art' as 'degenerate art' by the National Social-ists and subsequent writing bans and book burnings, international avant-garde literature was simply not available – Austrian artists and writers were desper-ately trying to catch up with international developments in art in the post-war period (see Schmied 1981: 36). The same can be said of their knowledge of their own national pioneers: according to the Dadaist Raoul Hausmann, for example, the younger generation had no idea about 'the range of literary experiments I have had published outside Austria' since 1918 (1982: 69; see Kastberger 2009: 43).

As already stated – and supported by the revelations within Okopenko's diaries – one of the sources of modern or contemporary international literature in the early 1950s was literary journals (such as *Plan* and *Neue Wege*) and news-papers. Sometimes translations of non-German poems and prose excerpts were published in the review section of *Neue Wege*, while at other times short essays on international modern writers such as Mayakovsky, Aragon, Gide, Camus and Saint-Exupéry appeared. *Neue Auslese*, published by the Allied Informa-tion Service, was also of importance to Okopenko; it was in this journal that he came across some of T. S. Eliot's poems for the first time. In addition, he also read *Welt am Montag*, a weekly newspaper established by the French occupation forces, in which one could get information about 'the most modern literary life abroad' (Okopenko 2000a: 16), that is, mainly in France. He also discovered a

few issues of *Plan* and would go on to found his own literary journal *publika-tionen einer wiener gruppe junger autoren* ('publications of a viennese group of young authors') to succeed it. Furthermore, Jené and Max Hölzer's journal *Surrealistische Publikationen* ('Surrealist publications') was published in 1950 and devoured by Okopenko and his circle. It contained several translations, mostly from recent and contemporary French literature, such as parts of André Breton's *First Surrealist Manifesto*, Pierre Mabille's 'La Pensée dégagée', several poems from Benjamin Péret's 'Un point c'est tout' and other works – some of them translated by Paul Celan. In the review section of *Neue Wege*, the new journal was welcomed as a very necessary initiative, considering the prevailing confusion regarding defini-tions (see Dietrich 1950: 32).

Okopenko's diaries reveal that international literature was also discussed both at editorial meetings of *Neue Wege* and in conversations with friends. H. C. Artmann, in particular, had a reputation for being able to find rare modern works of world literature, some from fairly remote places, in second-hand bookshops (see Okopenko 2000a: 20):

> At 1 p.m., the same three as yesterday [H. C. Artmann, Ernst Kein and Friedrich Polakovics] dropped by my place again. [. . .] We talked about strange things like the greguerías, with which Artmann made me acquainted, and about Eliot, whom, they say, I'm destined to translate. Artmann is going to lend him to me; he left me Flemish poetry along with the original text here to read. (Okopenko 2019: 23 February 1950)

A year later, in his own literary journal, Okopenko continued in the tradition of *Neue Wege* and *Plan* and published poems from international writers (such as Aloysius Bertrand, Alfred Jarry, Max Jacob, Henri Michaux, Ramón Gómez de la Serna, Odysseus Elytis, Gabriela Mistral, Dylan Thomas, Isidor Ducasse, Guillaume Apollinaire, T. S. Eliot, W. H. Auden and William Gear). This suggests that, rather than provoking a rupture with tradition in general, the object of the journal was to break with certain tendencies in pre- and inter-war Austrian literature and to look for an 'alternative tradition'. The intention was not – at least not at that point – to create a general counter-canon (see Bürger 2010: 704), but rather to find links and points of contact, to share them with others and to gain allies in spirit.

How, then, was Austrian surrealist literature any different from the French tradition? In spring 1950, Okopenko notes in his diary that he was called 'a leading surrealist' by H. C. Artmann, who was – according to Okopenko – 'deeply moved' that someone else was joining 'his fight for the surreal'. Artmann now placed him alongside 'those such as Éluard and Mayröcker' and stated that

one could undeniably see something 'Middle European' in Okopenko's lines, and that this would be of importance if it came to forging an autonomous ('Austrian') surrealism. Artmann did not – at least as far as Okopenko's diaries report – expand on the characteristics of 'Austrian surrealism', however (Okopenko 2019: 18 March 1950).

Shortly after receiving such praise, Okopenko becomes slightly apprehensive. Just a few days later, he writes in his diary: 'I developed qualms about surrealism' (2019: 23 March 1950) and displays an ambivalent attitude in the following period. His stance is characterised by being torn between scepticism and enthusiasm, with his predisposition for the surreal, as he reflects later, being caused by his anti-bourgeois stance, his readiness to overcome prejudices and his interest in depth psychology (*Tiefenpsychologie*), by his wish to expand his terminology and diction (see Okopenko n.d.b).

Nevertheless, he experiments with associative and semi-somnolent writing, encouraged by Artmann's verdict of him being 'the only surrealist whom we have' (Okopenko 2019: 18 April 1950). Together with his friends, he writes so-called 'word-salads' ('Wortsalate'), a term borrowed from psychiatry meaning schizophasia and designating the incoherence of speech with respect to logical concepts; Okopenko defines it as low-level conscious (*minderbewusste*) improvisation steered by ideas over which control is minimal and barely effective (see Okopenko n.d.a). Some of these 'word-salads' (not only by Okopenko but also by H. C. Artmann, René Altmann, Hanns Weißenborn (1932–1999) and others) are preserved in Okopenko's estate, and, what is more, a few notes about the circumstances in which they were created are recorded: 'Hanns Weissenborn Improvised dictation (with eyes closed, rocking on a tubular chair), taken by AOk [Andreas Okopenko] and Janczyk)' (Okopenko n.d.a); and:

> Word-salad Artmann, taken on: 29 8 50 after 4 p.m., thunderstorm, window flowers, [Theodor] Kriesch and Okopenko present. Spoken with eyes closed and in slow dictation. Previously, an experiment of similar type with Kriesch that failed, however, because of Kriesch's lack of seriousness during this – for him – new activity. Starting point: a gregueria that just came to Artmann's mind, 'The window flowers are the tongues of the thunderstorm', written down by AOk [Andreas Okopenko]. (Okopenko n.d.a)

Some of Okopenko's semi-somnolent notes were preserved in his estate, along with a few remarks, such as:

> In addition, the picture of a perforated pig, en face, with a (rather small) top hat on top of his head. The most delightful surrealisms are the spontaneous

ones that were not provoked, for which one merely has to stay in a state of suspension and not make any efforts otherwise. I think this is only possible when half-asleep. (Okopenko n.d.a)

In April 1950, Okopenko wrote the 'Resolution für den Surrealismus' ('Resolution for surrealism'), a manifesto-like open letter, in which equality for 'so-called modern art' is demanded by H. C. Artmann, René Altmann, Gerhard Fritsch (1924–1969), Friedrich Polakovics, Hanns Weißenborn, himself and others. It was an appeal to take modern art seriously and to not regard it as an aberration, and for giving the public not only access to modern art but also appropriate spaces for discussion. The letter was written in the provocative and rebellious tone that also dominated Okopenko's diaries at the time: 'We won't shy away from having the artists' organisations, media and educational establishment [. . .] as our enemies' (Okopenko 1950a).

SURREALISM CONTROVERSY

It is important to note that those within the circle of young progressive writers around the editorial team of *Neue Wege* who were inclined to write surrealist texts were met with criticism from fellow writers, not only from outside their circle but also from within it. During an editorial meeting, the line 'the sun is waltzing with the neighbour's pig' (from the poem 'Frühlingstraum' ('Spring's dream') by Igomar Leitner) – which was labelled as 'surrealist' – reportedly caused a tremendous uproar among the young writers.

In April 1950, Herbert Eisenreich (1925–1986), who was also part of the young editorial committee of *Neue Wege*, published a provocative article entitled 'Surrealismus und so' ('Surrealism and such') in the journal. In 1947, he had already published a sweeping attack on jazz, influences from French modern art – which he termed 'frenchifying daubers, abreacting their perverted daydreams in works of art' – dishonest journalists, politicians and others, in appealing for more responsibility in intellectualism in *Plan* (see Eisenreich 1947). In 'Surrealism and Such', Eisenreich complains about the lack of a definition of surrealism and accuses surrealists of writing in a deliberately incomprehensible way, ignoring punctuation marks, exclusively using lower-case letters, and building sentences that become easily unbalanced; they thought they could ignore logic in general by denying the logic of language (see Eisenreich 1950).

Despite the provocative tone of his article, Eisenreich and the so-called Austrian surrealists, above all Artmann and Okopenko, continued to work together. For the next issue of *Neue Wege*, however, Okopenko wrote a reply entitled 'Apologie ohne Surrealismus' ('Apology without surrealism') (1950b).

In his response, he blamed his opponents for harbouring unrealistic images of surrealism. This was primarily aimed at Eisenreich, who was said to associate Austrian surrealists with dictums of Aragon and Breton such as 'Je ne travaillerai jamais, mes mains sont pures' ('I will never work, my hands are pure') (Aragon), 'Ouvrez les prisons' ('Open the prisons') and 'L'acte surréaliste le plus simple consiste, revolvers aux poings, à descendre dans la rue et à tirer au hasard, tant qu'on peut, dans la foule' ('The simplest surrealist act consists of dashing down the street, pistol in hand, and firing blindly, as fast as you can pull the trigger, into the crowd') (Breton). For Eisenreich as much as for other art critics, 'surrealism' was, according to Okopenko, a general term for literary craziness, a sin, a desperado's heroism. Taking aim at this generalisation, Okopenko concluded his essay thus: 'Today, Schiller would not have written "The Robbers" but, instead, "The Surrealists"' (1950b: 17).

Notwithstanding this response to Eisenreich's critique, Okopenko began to increasingly distance himself from surrealism. He abandoned his 'word-salad' experiments, and started to work on the 'de-surrealisation' of his poems, looking for both new points of contact to the tradition of international avant-garde and connections to his avant-gardist contemporaries.

Despite many efforts to reach agreement, the tension grew within the *Neue Wege* editorial team. The young writers also faced external resistance, and feuds, such as those anticipated in Okopenko's 'Resolution', could not be avoided. In March 1950, the 'Bundesgesetz über die Bekämpfung unzüchtiger Veröffentlichungen und den Schutz der Jugend gegen sittliche Gefährdung' ('law for the prevention of indecent publications and the protection of youth from moral endangerment') became effective in Austria. Although it was mainly aimed at comic books, there was pressure to apply the law to the works of young progressive writers as well, and some even wanted to ban them from publishing their material (see Okopenko 2000a: 25). The adjective 'surrealist' became especially loaded in the context of these discussions (see Okopenko 2019: 22/24 November 1950). Simultaneously, the pressure from the editors of *Neue Wege* to comply with their editorial policy in regard to 'appropriate' content and the 'correct' use of grammar also increased. These restrictions proved incompatible with the wishes of Okopenko and his friends. In November 1951, he and other writers quit the young editorial committee.

At the same time, Okopenko inquired, also on behalf of H. C. Artmann and Ernst Kein, whether the Art-Club was interested in founding a literary section. Since the opening of the club's most famous meeting place – the new Strohkoffer bar – their poems had long been stuck onto the walls for everyone to read. Readings of their works took place there (e.g. on 31 January 1952),

while Werner Riemerschmid was still presenting French surrealist literature (25 January 1952, 1 March 1952) and H. C. Artmann and Hanns Weissenborn read from Federico García Lorca's poems (18 April 1952).

There were, however, drawbacks to the independence they had won by leaving *Neue Wege*. Due to the lack of resistance on the part of the ministry of education – to which *Neue Wege* had been subordinated – the young writers realised that they had rebelled within a very small circle, without any demonstrable impact. Since Okopenko's *publikationen* was read almost exclusively among other writers, they felt isolated and ineffective; or, as the painter Ernst Fuchs put it: 'The public that was there for us at that time was, basically, we ourselves' (1981: 39).

In spring 1952, Okopenko wrote in his diary: 'The silence one meets as a hostile encapsulation within the bourgeois world is unbelievable' (2019: 10 May 1952). He abandoned *publikationen* in 1953. In his diary, he points out: 'Above all: No hope for a breakthrough anymore. Austrianised. The ground on which I'm standing is so small. Next to it, the abyss of modern formalism and traditionalism' (2019: 12 December 1953).

THE RISE OF A NATION

Most of the Austrian literary surrealists' works remained unpublished and never gained a wider audience. It is clear that the complex surrealist programme was only ever partially received in Austria, with the focus mostly on aspects of the irrational, which avoided any political implications (see Ivanovic 2001: 63, 66). The crucial role that surrealism played in literature at the time was not motivated by certain contents, topics or ways of writing to any great extent, instead being more important as a label that provoked discussions about modern art, avant-gardist literature and the freedom of art in general. With regards to the broader public, 'surrealism' served as an umbrella term and an emotive word for every progressive or modernist way of writing (see Blaeulich 1994: 88), mostly in the sense of a cultural position that had to be fought by the public in the service of the 'occident' (see Strigl 2008: 77–8). One should not forget, though, the deeper political stratum of the discourse on surrealism, at least in the way it was linked to the formation of a national discourse.

Retrospectively, Okopenko described the *publikationen* as the 'only or last avant-garde magazine in post-war Austria that nurtured the illusion that it could change the world with a few poems and a handful of employees' (1966: 101). The project was doomed to failure, the more the political landscape turned out to be deadlocked and suddenly 'seemed frozen for millennia' (Okopenko

2000a: 27), as Okopenko would recapitulate in his 'Klage um den Vormai' ('Lament for pre-May'):

> I thrived in the atmosphere of a young state, which I experienced *before* any politics [. . .]. Suddenly, literary recollections of 'Austrian idiosyncrasy', of the splendour of the day before yesterday, began springing up everywhere like mushrooms. [. . .] Nobility became fashionable again, nostalgia would be the headache of the next thirty years, causerie replaced caustic, to each artist his little castle, sounded the unprinted manifesto. In time for its State Treaty, Austria quickly became old. (Okopenko 2000b: 305–8)

According to Okopenko, the first intense phase in the reception of surrealism in post-war Vienna took place in a time *before* any politics, at the political ground zero, when the *possibility* to fundamentally change the world with poetry seemed intact. It was not long before old myths were excavated by the authorities and Austria finally, in time for the State Treaty that ended Allied occupation, became not just an autonomous but also a traditional country again. The conservative manifestos remained unprinted, but were reflected *ex negativo* in the printed manifestos of experimental art. The lateness of this development in Austria was to lead to a specific synchronicity of the 'historical avant-garde' and the 'neo-avant-garde' and may have been responsible for the explosive (up to military) character for which Austrian experimental art – especially by the 'Viennese actionists' – was to become well known (see Kastberger 2009: 44–5).

In the new climate, writers like the members of the Vienna Group continued to search for international contacts: 'For lack of contacts and discussion partners in Austria [. . .], the group turned abroad. [. . . They] intended to get into contact with international authors, architects, musicians, and academics. Yet, nothing seems to have come of this plan' (Kastberger 2009: 41–2). There was also a gradual tendency towards an institutionalisation of the networks of Austria's progressive authors in the 1960s, as 'the Group's internal organization [. . .] – "establishment of a head office", "compilation of an index", "clarification of concepts under avoidance of ideologies" – almost strike us as an ironic anticipation of the institutionalization which would take place ten years after' (Kastberger 2009: 42). For it was then, with the foundation of the Grazer Autorenversammlung in 1973 (see Innerhofer 1985) and the advent of a new cultural policy orientated towards social democracy, that the 'neo-avant-garde' in Austria is generally regarded as having come to an end – after having shaped the unique character of an Austrian counterculture.

Gradually, the initial surrealistic dream seems to have been dispelled by a good many (and many good) 'avant-garde' experiments (Müller and Innerhofer 2012) – with the intention of achieving, more or less seriously, a *Verbesserung*

von Mitteleuropa ('Improvement of Central Europe') (Wiener 1969) during a time of Cold War cybernetics. Nonetheless, the moment *before* the 'moment of modernity 1954–1960' (Weibel 1997) should not be forgotten. For as Andreas Okopenko's *Erinnerung an die Hoffnung* ('Remembrance of hope') (2008) demonstrates, the idea of fundamentally changing politics through poetic energy seemed indeed to be alive for a short moment in Austria's history and should take its rightful place – ideally as an X-ray picture on the *first* page[4] – in books on the historical evolution of Austrian national consciousness.

NOTES

1. Conceptually, 'avant-garde' and 'modernism' are synonymously used in the Anglo-Saxon area, whereas continental European research still differentiates between the two (see Wood 1999: 10; Klinger and Müller-Funk 2004). There is, however, a significant geopolitical divide between 'West' and 'East': while 'modernism tends to occur in the advanced and progressive western countries (such as the US, England and, on the border, France), relatively backward countries (such as Germany, Italy, Russia and other Eastern European nations) form the core countries of the avant-garde' (Klinger and Müller-Funk 2004: 12, our translation). In the Netherlands, the term 'modernisme' has been used for 'avant-garde' since the 1980s. At least in the field of German literary studies, the historical dimensions of these concepts have been excellently explored by, among others, Böhringer (1978); van den Berg and Fähnders (2009); Barck (2010); as well as the contributions in Mauz et al. (2018).

2. Incidentally, the North American identification with the 'neo-avant-garde' can be traced to Clement Greenberg's 1939 essay 'Avant-Garde and Kitsch' (see Barck 2010: 567–70: 'America becomes Avantgarde').

3. All translations are ours unless otherwise noted.

4. See Benjamin ([1929] 2005: 210): 'For art's sake was scarcely ever to be taken literally; it was almost always a flag under which sailed a cargo that could not be declared because it still lacked a name. This is the moment to embark on a work that would illuminate as has no other the crisis of the arts that we are witnessing: a history of esoteric poetry. Nor is it by any means fortuitous that no such work yet exists. For written as it demands to be written – that is, not as a collection to which particular "specialists" all contribute "what is most worth knowing" from their fields, but as the deeply grounded composition of an individual who, from inner compulsion, portrays less a historical evolution than a constantly renewed, primal upsurge of esoteric poetry – written in such a way it would be one of those scholarly confessions that can be counted in every century. The last page would have to show an X-ray picture of Surrealism.'

BIBLIOGRAPHY

Art-Club (1951), 'Ausstellungen', *Mitteilungen des Art Club*, n.p.

Bachelard, G. (1964), *Psychoanalysis of Fire*, London: Routledge & Kegan Paul.

Barck, K. (2000), 'Surrealistische Visionen des Politischen', in W. Asholt and W. Fähnders (eds), *Der Blick vom Wolkenkratzer. Avantgarde – Avantgardekritik – Avantgardeforschung*, Amsterdam/Atlanta, GA: Rodopi, pp. 525–44.

Barck, K. (2010), 'Avantgarde – ein paradoxes Zeitverhältnis', in K. Barck, M. Fontius, D. Schlenstedt, B. Steinwachs and F. Wolfzettel (eds), *Ästhetische Grundbegriffe*, vol. 1, Stuttgart/Weimar: Metzler, pp. 544–77.

Basil, O. (1945a) (with publishing house and editorial team), 'Zum Wiederbeginn', *Plan. Literatur, Kunst, Kultur*, 1, p. 1.

Basil, O. (1945b), 'Was alles auf den Plan tritt', *Plan. Literatur, Kunst, Kultur*, 3, p. 254.

Benjamin, W. [1929] (2005), 'Surrealism: The Last Snapshot of the European Intelligentsia', in W. Benjamin, *Selected Writings*, ed. M. W. Jennings, H. Eiland and G. Smith, Cambridge, MA: Harvard University Press, vol. 2, pt 1, pp. 207–22.

Benson, T. O. (2002), 'Exchange and Transformation: The Internationalization of the Avantgarde(s) in Central Europe', in T. O. Benson and É. Forgacs (eds), *Central-European Avant-Gardes: Exchange and Transformation, 1910–1930*, Cambridge, MA/London: MIT Press, pp. 34–67.

Blaeulich, M. (1994), 'Der Wiener Keller', in H. C. Artmann (ed.), *Der Wiener Keller. Anthologie österreichischer Dichtung. Wien 1950*, Klagenfurt/Salzburg: Wieser, pp. 85–90.

Böhringer, H. (1978), 'Avantgarde – Geschichte einer Metapher', *Archiv für Begriffsgeschichte*, 22, pp. 90–114.

Boschetti, A. (2016), *Ismes: du réalisme au postmodernisme*, Paris: CNRS.

Breicha, O. (ed.) (1981), *Der Art Club in Österreich*, Vienna: Jugend und Volk.

Bürger, P. [1974] (1984), *Theory of the Avant-Garde*, trans. M. Shaw, Minneapolis, MN: University of Minnesota Press.

Bürger, P. (2010), 'Avant-Garde and Neo-Avant-Garde: An Attempt to Answer Certain Critics of "Theory of the Avant-Garde"', *New Literary History*, 41, pp. 695–715.

Dietrich, M. (1950), 'Zur Debatte: Surrealistische Publikationen' [review], *Neue Wege*, 57, pp. 32–3.

Eisenreich, H. (1947), 'Von der Verantwortung im Geistigen', *Plan*, 5, pp. 341–3.

Eisenreich, H. (1950), 'Surrealismus und so', *Neue Wege*, 54, pp. 18–20.

Fuchs, E. (1981), 'Für uns vom surrealistischen Flügel', in O. Breicha (ed.), *Der Art Club in Österreich*, Vienna: Jugend und Volk, pp. 38–9.

Gütersloh, A. P. (1947), 'Was ist nun der Art Club? Rede vom 12.4.1947 zum ersten Hervortreten des Art Clubs mit einer Vorschau auf die für Rom vorbereitete Ausstellung seiner Mitglieder', in O. Breicha (ed.), *Der Art Club in Österreich*, Vienna: Jugend und Volk, pp. 7–8.

Gütersloh, A. P. (1948), 'Was denn, wenn nicht unser Bestes! Aus dem Katalog der 1. Jahresausstellung des Art Clubs in der Wiener Kunsthalle, April 1948', in O. Breicha (ed.), *Der Art Club in Österreich*, Vienna: Jugend und Volk, pp. 8–9.

Gütersloh, A. P. (1952), 'Der unterirdische Art Club', *Weltpresse*, 11 January, n.p.

Hausmann, R. (1982), 'Briefe an Alfred Kolleritsch und Ernst Jandl', *manuskripte*, 78, pp. 65–83.

Hoflehner, R. (1980), 'Es tut mir leid um den Art Club', in O. Breicha (ed.), *Der Art Club in Österreich*, Vienna: Jugend und Volk, pp. 45–6.

Hundertwasser, F. (1980), 'Ich hatte wenig mitzureden', in O. Breicha (ed.), *Der Art Club in Österreich*, Vienna: Jugend und Volk, pp. 41–4.

Hunkeler, T. (ed.) (2014), *Paradoxes de l'avant-garde européenne: la modernité artistique à l'épreuve de sa nationalisation*, Paris: Garnier.

Hunkeler, T. (2018), *Paris et le nationalisme des avant-gardes 1909–1924*, Paris: Hermann.

Innerhofer, R. (1985), *Die Grazer Autorenversammlung (1973–1983). Zur Organisation einer 'Avantgarde'*, Vienna/Cologne/Graz: Böhlau.

Ivanovic, C. (2001), '"des menschlichen farbe ist freiheit". Paul Celans Umweg über den Wiener Surrealismus', in P. Goßens and M. G. Patka (eds), *'Displaced': Paul Celan in Wien 1947–1948*, Frankfurt am Main: Suhrkamp, pp. 62–70.

Jurt, J. (2019), 'Die Dialektik von Internationalismus und Nationalismus der historischen Avantgarde. Zu Thomas Hunkeler, Paris et le nationalisme des avant-gardes 1909–1924', *Romanische Studien*, 10 April, <http://blog.romanischestudien.de/internationalismus-und-nationalismus-der-avantgarde-j-jurt-ueber-th-hunkeler> (last accessed 7 February 2021).

Kastberger, K. (2009), 'Wien 1950/60. Eine österreichische Avantgarde – Vienna 1950/60. An Austrian Avant-Garde', in B. Ecker and W. Hilger (eds), *Die fünfziger Jahre. Kunst und Kunstverständnis in Wien – The 1950s. Art and Art Appreciation in Vienna*, Vienna/New York: Springer, pp. 35–46.

Klinger, C. and W. Müller-Funk (2004), 'Einleitung', in C. Klinger and W. Müller-Funk (eds), *Das Jahrhundert der Avantgarden*, Munich: Fink, pp. 9–23.

Kont, P. (1981), 'Von der Musik her', in O. Breicha (ed.), *Der Art Club in Österreich*, Vienna: Jugend und Volk, pp. 46–7.

Koselka, F. (1946), 'Avantgardekunst – Isolierung oder Verständigung? Zum zweiten Diskussionsabend des *Plan* am 13. August' [letter to the editor], *Plan. Literatur, Kunst, Kultur*, 9, pp. 768–73.

Lillegg, E. (1947), 'Der Kampf Sartre-Breton um den Surrealismus', *Welt am Montag*, 17 November, p. 9.

Mauz, A., U. Weber and M. Wieland (eds) (2018), *Avantgarden und Avantgardismus. Programme und Praktiken emphatischer kultureller Innovation*, Göttingen/Zurich Wallstein/Chronos.

Mikl, Josef (1980), 'Um sich unabhängig zu entwickeln', in O. Breicha (ed.), *Der Art Club in Österreich*, Vienna: Jugend und Volk, pp. 44–5.

Müller, S. and R. Innerhofer (2012), 'Humanversuche. Avantgarde, Experiment und Wissenschaft im Kon/Text der *verbesserung von mitteleuropa*', in E. Großegger and S. Müller (eds), *Teststrecke Kunst. Wiener Avantgarden nach 1945*, Vienna: Sonderzahl, pp. 201–32.

Muschik, J. (1967), 'Porträt eines Anfangs', in O. Breicha and G. Fritsch (eds), *Aufforderung zum Misstrauen. Literatur, Bildende Kunst, Musik in Österreich seit 1945*, Salzburg: Residenz, pp. 42–9.

Muschik, J. (1976), *Die Wiener Schule des Phantastischen Realismus*, 2nd edn, Vienna/Munich: Jugend und Volk.

Neuwirth, A. (1947), 'Dichterlesung vor dem Minotaurus. Schwarz-rote Fahne des Surrealismus in Wien entfaltet', *Welt am Montag*, 10 November, p. 8.

Nif, A. [A. Neuwirth] (1946/7), 'Surrealistische Vorposten in Wien', *Plan. Literatur, Kunst, Kultur*, 12, pp. 968–9.

Okopenko, A. (1950a), 'Resolution', in *Teilvorlass Andreas Okopenko*, 2, ÖLA 269a/05, Literary Archives of the Austrian National Library.

Okopenko, A. (1950b), 'Apologie ohne Surrealismus', *Neue Wege*, 55, p. 17.

Okopenko, A. (1966), 'Der Fall "Neue Wege". Dokumentation gegen und für einen Mythos', *Literatur und Kritik*, 9/10, pp. 89–104.

Okopenko, A. (2000a), 'Die schwierigen Anfänge österreichischer Progressivliteratur nach 1945', in A. Okopenko, *Gesammelte Aufsätze und andere Meinungsausbrüche aus fünf Jahrzehnten*, vol. 1, *In der Szene*, Klagenfurt/Vienna: Ritter, pp. 13–38.

Okopenko, A. (2000b), 'Klage um den Vormai', in A. Okopenko, *Gesammelte Aufsätze und andere Meinungsausbrüche aus fünf Jahrzehnten*, vol. 1, *In der Szene*, Klagenfurt/Vienna: Ritter, pp. 305–9.

Okopenko, A. (2008), *Erinnerung an die Hoffnung – Gesammelte autobiographische Aufsätze*, Vienna: Klever.

Okopenko, A. (2019), *Tagebücher 1949–1954*, ed. R. Innerhofer, B. Fetz, C. Zolles, L. Tezarek, A. Herberth, D. Hebenstreit and H. Englerth, Vienna: University of Vienna and Austrian National Library, vers. 2.0, <https://edition.onb.ac.at/okopenko> (last accessed 7 February 2021).

Okopenko, A. (n.d.a), 'Notizen zur Psychologie des Surrealismus', in *Teilnachlass Andreas Okopenko*, 4, ÖLA 357/09, Literary Archives of the Austrian National Library.

Okopenko, A. (n.d.b), 'Der surreale Bereich', in *Autobiographische Fragmente, Nachlass Andreas Okopenko*, LIT 399/12, Literary Archives of the Austrian National Library.

Puff-Trojan, A. (2009), 'Österreich', in H. van den Berg and W. Fähnders (eds), *Metzler Lexikon Avantgarde*, Stuttgart/Weimar: Metzler, pp. 311–13.

Riemerschmid, W. (1947), 'Über surrealistische Lyrik', *Plan. Literatur, Kunst, Kultur*, 4, pp. 256–62.

Schlebrügge, J. (1985), *Geschichtssprünge. Zur Rezeption des französischen Surrealismus in der österreichischen Literatur, Kunst und Kulturpublizistik nach 1945*, Frankfurt am Main: Peter Lang.

Schmeller, A. (1980), 'Ein Sammelsurium', in O. Breicha (ed.), *Der Art Club in Österreich*, Vienna: Jugend und Volk, pp. 31–4.

Schmied, W. (1981), 'Ein Umschlagplatz für Ideen', in O. Breicha (ed.), *Der Art Club in Österreich*, Vienna: Jugend und Volk, pp. 35–6.

Spanudis, T. (1945), 'Was ist Surrealismus? (Versuch einer Deutung)', *Plan. Literatur, Kunst, Kultur*, 5, pp. 433–6.

Strigl, D. (2008), 'Die Neuen Wege – Zentralorgan der literarischen Avantgarde?', in G. M. Bauer and B. Peter (eds), *'Neue Wege'. 75 Jahre Theater der Jugend in Wien*, Vienna/Berlin: LIT Verlag, pp. 73–86.

van den Berg, H. (2009), 'Gegen die Unterscheidung zwischen "historischer" und "Neoavantgarde". Hinweis auf die Kontinuität der Avantgarden des 20. Jahrhunderts als Netzwerk', in F. Lartillot and A. Gellhaus (eds), *Années vingt – années soixante. Réseau du sens – réseau des sens. Quels paradigmes pour une analyse de l'histoire culturelle dans les pays de langue allemande? Zwanziger Jahre – sechziger Jahre. Netzwerk des Sinns – Netzwerke der Sinne. Welche Paradigmen für eine Analyse der Kulturgeschichte in den deutschsprachigen Ländern?*, Berne/New York: Peter Lang, pp. 173–90.

van den Berg, H. and W. Fähnders (2009), 'Die künstlerische Avantgarde im 20. Jahrhundert – Einleitung', in H. van den Berg and W. Fähnders (eds), *Metzler Lexikon Avantgarde*, Stuttgart/Weimar: Metzler, pp. 1–19.

Weibel, P. (ed.) (1997), *die wiener gruppe – the vienna group: a moment of modernity 1954–1960/the visual works and the actions*, Vienna/New York: Springer.

Wiener, O. (1969), *Die Verbesserung von Mitteleuropa. Roman*, Reinbek bei Hamburg: Rowohlt.

Wood, P. (1999), *The Challenge of the Avant-Garde*, New Haven, CT: Yale University Press.

Images of the Real: Generic and Medial Hybridity in Peter Weiss's *The Shadow of the Body of the Coachman*

Inge Arteel

In 1966 Gruppe 47, a network of authors and critics founded in West Germany in 1947, was invited to Princeton University for its yearly meeting. Through its leader and organiser, Hans Werner Richter, the group had strongly advocated for the revival of a realist poetics, against the continuation of a conservative 'German spirit' (Böttiger 2012)[1] by the pre-war literary generation. By the mid-1960s the group had gained an unprecedented and influential position in the literary field of the then Federal German Republic. Dissenting voices, both internal and external, had become louder too, opposing the group's aesthetic programme and commercial influence but also the self-declared moralising stance of politically active members like Günter Grass and Siegfried Lenz.[2] At the 1966 Princeton meeting two of these oppositional voices, Peter Handke and Peter Weiss, spoke out (Honold 2012: 239).

Literary history particularly remembers the intervention by the young Peter Handke (1942–), who, invited to the meeting for the first time, caused a shock with his attack on both the realist literature of the time as well as its critics. In his view, authors and critics alike impotently clung to the illusion of a natural, transparent link between word and object, or signifier and signified, without reflecting on the use of language as primary material. For a later essay (1967) Handke would self-confidently choose the title 'Ich bin ein Bewohner des Elfenbeinturms' ('I am an inhabitant of the ivory tower'), advocating for the autonomy of literature and claiming abstinence from straightforward societal engagement (Handke 1972).

Peter Weiss (1916–1982), a Germanophone author of Czech-Swiss, Jewish parentage born near Potsdam, had been attending group meetings since 1962 and in Princeton he was considered the second most important participant after Günter Grass (1927–2015). By 1966 Weiss had indeed gained international fame

with his documentary plays, such as the 1964 play *Marat/Sade* on the French revolutionary Jean Paul Marat, which analysed the violent dialectics of revolution and restauration. *The Investigation: Oratorio in 11 Cantos* (1965), based on documentary material from the Frankfurt Auschwitz trials and Weiss's own observations of the hearings, premiered on fifteen stages simultaneously, both in West and East Germany as well as in London.

In Weiss's Princeton speech, tellingly entitled 'I Come Out of My Hiding Place', Weiss voiced a radically different position to Handke's, even though both authors shared a protest against the self-important irony of Grass and his 'hunger for power' (Erich Fried, quoted in Böttiger 2012: n.p.). Weiss not only rejected any insistence on artistic autonomy but also the, in his opinion hypocritical, defence of objectivity and instead passionately pleaded for a radical political engagement of artists on the side of the oppressed: 'my endeavour to express in my work my solidarity with the oppressed and exploited was not enough. I had to speak out for them, had to voice their unarticulated reactions and hopes' (Weiss 1970: 14). His words were symptomatic of the growing internal political disagreement and the shift of several members from the support of socialist party politics to a more radical, often communist conviction, motivated by both the Cold War and the war in Vietnam, worldwide decolonising movements as well as political developments in West Germany itself.[3]

DISPLACEMENT AND BELATEDNESS

In retrospect Weiss's speech does not so much read as a political provocation but rather as an introspective tracing of the shifts in his artistic attitude from what he considered a mere individualistic programme towards active political engagement. Through a harsh self-assessment he reconstructs how in earlier years he had adopted a 'passive' attitude without 'sympathy' ('Anteilnahme', Weiss 1970: 11), concerned only with making life liveable for himself. In the subsequent stage his art was meant to investigate the world, to try to understand why atrocities and catastrophes happened and continued to do so. Yet this too was not enough, Weiss concludes, as it only objectively analysed the lives of the oppressed without engaging with them, thus keeping the world a 'no man's land' (1970: 12) where one contented oneself with artistic freedom. In 1970, however, Weiss states that the question to be asked is that of active engagement: how can my writing contribute to making not only my own life but the environment, the lives of others more liveable?

Scholars have pointed to the pervading sense of displacement underpinning this journey (Honold 2000: 45; Langston 2008), which originated in Weiss's emigration and exile during the Second World War and subsequently developed

through his experience of not belonging to the post-war West German society which he rarely visited from his Stockholm home. In a published letter written to Hans Werner Richter in 1965, Weiss identified the reason for his not settling in Germany as 'this fundamental atmosphere of authoritarianism that is still to be felt everywhere in Germany', 'the whole complex of punishment, breaking will power, obedience, patriarchy' (Weiss 1971a: 12). His 'belated recognition as a German language writer around 1960' – Weiss had contacted a German publisher as early as 1948 – probably only exacerbated his 'sense of separateness from Germany and German culture' (Garloff 2000: 7).

This belated recognition happened overnight with the publication of his short novel *Der Schatten des Körpers des Kutschers* (*The Shadow of the Body of the Coachman*), written in the early 1950s but not published until 1960, by Siegfried Unseld's Suhrkamp. The book was greeted as an example of a new kind of descriptive literature that reflected on, problematised and ultimately destroyed any straightforward link between perception, interpretation and writing. More-over, its combination of text and cut-up images anticipated the experimen-tal programme of collage and fragmentation that Helmut Heißenbüttel would describe a few years later (Bohley 2011: 265). As its author obviously did not belong to any school or group, the publication at the same time boasted an individualistic quality. Indeed, in stressing 1952 as its date of origin and down-playing the revisions that were made for the eventual publication, Weiss was styled – and indeed positioned himself – as a forerunner of experimental prose, writing against the restoration climate pervading German literature in the early 1950s (Bohley 2011: 266–7).

EXPERIMENTAL FILMMAKING

Before turning in more detail to *The Shadow of the Body of the Coachman* and its experimental character, another medium of Weiss's artistic expression merits attention: film. Weiss first started out as a painter and a literary writer in Swed-ish. In 1952, after a long stay in Paris where he visited screenings of pre-war surrealist films, he began to make short experimental films, at the same time as he began to write more exclusively in German. These films can be considered to transmedially reinforce a graphic quality in the filmic medium (Vogt 1993: 60): with the fixed camera position and static framing, and the contrastive, tableau-like arrangement of white bodies and objects against a black back-ground. Often the bodies are presented as being cut up into parts, arranged in a way reminiscent of cubist paintings or collages. The expression of existen-tial and psychological dimensions of alienation and disintegration within these figures has also been noted (Spielmann 2000: 79). Weiss's preoccupation with

the afterlife of the trauma of the Holocaust and his psychoanalytical interest in often violently suppressed drives certainly supports these interpretations.

Weiss's films are intermedial on another level too, a level that counteracts the static quality often attributed to them: in a conspicuous theatrical way the scenes are full of embodied movements. Especially in his most famous film, *Studie II (Hallucinationer)* ('Study II (hallucinations)'), which lasts less than six minutes, references to older corporeal performance genres abound, including ballet, pantomime and shadow play. The scenes try out various interactive constellations with bodies, body parts and small objects. The impression that the bodies lie on or move in front of black curtains enhances the theatrical atmosphere. Strikingly, straightforward signs of violence are absent – no bloody cuts nor expressions of pain – as are stereotypical erotic suggestions. The naked bodies and their parts move slowly and handle each other and the objects in a subdued, often even tender way. A ritual performance seems to take place here, in which each detail is controlled and nothing happens by chance.

This is not to say that alienation and disintegration are not addressed. The human subject is not whole in an idealistic sense but presented as a grotesque assemblage with unclear boundaries – with a proliferation of limbs, a doubling of heads and torsos, and an intricate interrelation of the visual and haptic senses. Rather than pointing directly at traumatic experiences and their causes, the performance seems to expel them in its uncanny ritual and move on to ask what kind of human figure, what kind of human vitality is imaginable after the catastrophe, a vitality that must get its energy from the interaction of body parts rather than whole bodies. That said, while the visuals of the film seem to suggest a relaxed confidence towards that prosthetic energy, the soundtrack of acousmatic, mechanical noises counteracts this outlook with its nightmarish disconcerting sounds (Langston 2008: 93). Richard Langston, in his book-length study subtitled *German Avant-Gardes After Fascism*, convincingly concludes that Weiss's films transpose the pre-war surrealist film aesthetic into a post-fascist condition (2008: 94): rather than evoking a nightmare that disrupts reality, it is living on after the nightmare that is at stake.

Weiss himself has written about the importance of avant-garde film to his work in his book *Avantgardefilm*, first published in Swedish in 1956.[4] He especially admires the films of Luis Buñuel: here, surrealism and psychoanalysis work together to violently draw the spectators out of the comfort zone of civil society. Weiss presents avant-garde filmmakers not only as aesthetic but also as political revolutionaries, indicating the political potential of their anarchic energy. Though he admits their historical failure – 'they have not been able to prevent the political racketeering nor the war' (Weiss 1968: 17) – he stresses

the need to continue their project: 'they have not come to an end, on the contrary, they are a start. They can be developed and continued. [. . .] We are again in need of violent artistic practices – in our condition of saturated and contented sleep!' (1968: 17), a call that will be radicalised in his 1966 appeal for political engagement.

The Shadow of the Body of the Coachman predates both the 1956 book and the 1966 speech by several years but overlaps with the making of *Studie II*. How does its experimental character manifest itself and how radical is it? Does it foreshadow the 1956 plea for a violent artistic energy and is it in any way related to the critical self-analysis that Weiss gave in his 1966 speech? In order to shed some light on these questions, I will look at the experimental as a theme in the story-world and at the medial and generic hybridity at the level of discourse.

THE EXPERIMENTAL SETTING OF THE STORY-WORLD

The story of *The Shadow of the Body of the Coachman* is situated on a secluded farm or boarding house in the countryside, about a day's distance by horse from a city. The farm is presented as a microcosm peopled by an assembly of eleven anonymous 'guests' (Weiss 2006: 26). No background or motivation is given for this group of guests, nor any psychological reflection. Its composition seems both random and unchangeable. Towards the end another guest, the coachman, arrives, as he obviously has done many times before, unloading a huge load of coal. At the end of the story the coachman leaves again, after having had sex – or so it seems – with the housekeeper. The first-person narrator, one of the inhabitants, observes and describes the routine-like everyday life of both himself and the others at the boarding house. This narrator keeps his distance, yet he remains part of the world at the farm. He hardly talks to the others but does help out in a modest way, mainly when another character is helpless. At intervals the narrator, withdrawing to his room, conducts experiments with his eyes in order to stimulate hallucinatory visions that he subsequently describes.

Within the realist narrative of the story-world this microcosm functions as an experimental setting or 'Versuchsanordnung' (Bohley 2011: 269) for the narrator to investigate the relation between the perception of reality and its description, as well as the tension between observation, cognition and knowledge of reality. Perceptions do sometimes directly lead to knowledge, as in a laboratory experiment with a predictable outcome: the narrator, familiar even with the smallest details in the structural composition of his surroundings, can

recognise what he sees and hears because of knowledge gained through previous observations. In such instances, he automatically integrates the references of his perceptions in his existing knowledge, as he does with an acoustic perception while sitting on the toilet in the opening scene of the story:

> The jerky back-and-forth of the saw, now stopping for a moment, now violently starting up again, indicates that it is in the hand of the hired man. Even without this special characteristic, often heard and confirmed and verified, I would not find it hard to guess that the hired man is handling the saw. Aside from him, only I take care of the wood in the shed [. . .] (Weiss 2006: 1)

Knowledge of reality here equals the capacity to harmoniously integrate the references of sensual perceptions into a well-known structural grid, established through previous experiences, observations and conventions. The passage goes on for several more sentences in which the narrator, still sitting on the toilet, extensively describes the hired man handling the saw as a kind of verifiable imagination, deducing his image entirely from previously gained knowledge: 'I see him in front of me [. . .]; I hear him humming [. . .]; I can imagine him straightening his back [. . .]' (2006: 2). Perception, cognitive integration and imaginary ekphrastic description all contribute to and strengthen the predictable order of reality. Such instances of successful integration are written in the present tense, grammatically suggesting the simultaneity of perception and '[w]riting down my observations' (2006: 2).

Several situations, however, present considerable impediments to the narrator's perception. First of all, there are instances of chaotic simultaneity or irregular patterns that are difficult to comprehend. 'The mere irregular distribution of boarders in the room makes right away for a pattern of interconnected movements and sounds that is hard to survey' (2006: 11), the narrator remarks about the after-dinner atmosphere in the hallway, when everyone gets together to have coffee. In his extensive description of that irregular but interconnected 'pattern', the interconnectedness is necessarily modified: the linear description of one component of the pattern after another turns it into a compilation of elements that are first and foremost linked textually, through their consecutive syntactical sequence, not through a perceived simultaneity, let alone deductive predictability. Moreover, considering the admitted difficulty in surveying the situation, the empirical basis of the description becomes questionable. At the same time, because the description is rendered in the present tense, it is suggested that the narrator describes what he sees, stressing that the truthfulness of the textual compilation is guaranteed by the narrator's actual

corporeal presence at the scene. The narrator might not be able to capture the irregular pattern as such. Thus, the cognitive integration in and strengthening of a predictable grid does not take place in this description, but his detailed, cumulative rendering of the elements of that pattern is presented as a textual doubling in its own right; a simultaneous textual supplement of reality.

A second kind of discrepancy between the description and the scene it is meant to describe is visible in the scenes where the narrator witnesses conversations between the other guests where he cannot or can only partially hear what is being said. Here it is the acoustic perception that is thwarted. In a long description of a chaotic conversation between several guests, the narrator again and again stresses his impeded hearing and only mentions isolated words captured from the voices. Sometimes he offers alternatives between brackets, as if to indicate his uncertainty about what he has heard. Consequently, the singular words are written down without any integration in a structured description. Even the linear syntax is elliptically reduced, as is the interpunction. The narrator can only offer a random collection of words as if they are building blocks for a story yet to be written.

As a kind of temporary escape from the real-time observation of reality, the narrator conducts experiments of an altogether different nature, a physiological manipulation of his visual perception in order to 'bring up images': 'For this, I lie stretched out on the bed; within reach, beside me, on the table, there is a plate full of salt from which I occasionally take a few grains to put in my eyes' (2006: 6). This immediately leads to tears and a blurred vision, a physiological haze that covers the clear contours of perceived reality. Out of this blurring of perception, a space of hallucinatory visions opens up: multicoloured three-dimensional geometrical objects in a state of constant movement and figurative metamorphosis. After applying some more salt, these non-human visions abruptly give way to a dreamlike setting with a naked female body, an image that disappears as soon as the narrator makes a move to try and reach the imaginary woman.[5] Strikingly, the physiologically induced images appear clearly in front of the eye of the narrator, as a fully-fledged virtual reality. Furthermore, their textual rendering happens retrospectively – the past tense signals this – which does not seem to pose any problems, as if those images brought about by ocular irritation facilitate retrospective narration.

To sum up, the complex relation between sensory perception, cognitive integration and documentary description is addressed and dealt with in a number of experimental ways by the first-person narrator. A quasi-simultaneous account of his perceptions is complicated by the complexity of his material circumstances and vantage point. Perception is, in itself, limited also, as the perceiving body is confined to a specific time and space and its comprehending

capacity is restricted. Reality itself also transgresses human understanding, and even empirical verification cannot grasp when 'surreal' things happen. A telling scene occurs when the narrator cannot understand how the huge amount of coal could have fitted in the coach that delivered it:

> I lost count. What I didn't understand, considering the large number of sacks and the size of the coal heap, was how all these sacks filled with coal had found room in the coach which hadn't even seemed fully loaded; and after I had gone back and forth several times between the coach and the coal heap in order to compare the spaces, this became even more incomprehensible. (Weiss 2006: 36)

Confronted with this incomprehensible situation and the impossibility of adequately verifying it, the narrator goes on to question the epistemological validity of his written observations, soon considering them to be trivial. As his writing is meant to verbalise his perceptions and give form to his observations in order to gain insight into reality, the confrontation with its failure induces a writer's block and even a feeling of total indifference, in regard not to reality but to the potential of documentary writing itself. As we have seen, however, in several of the scenes in which his capacity is impeded the text tends to loosen itself from the need for a verifiable documentary description of reality. The textual rendering here gains a more autonomous quality, whilst at the same time remaining firmly linked with the corporeal reality of the narrator.

DISCURSIVE DENARRATIVISATION AND LYRICISATION

As a writer, the narrator is time and again confronted with the aporetic nature of his endeavour, with real events defying the integrating order his documentary writing seeks to impose. By stressing this aspect of failure (see Bohley 2011: 274; Honold 2000; Abrantes 2008), one can read this short novel as an allegorical rendering of impossibilities: the impossibility to communicate, to understand, to integrate, to write. If we examine the aforementioned instances of a more autonomous literary style within the novel, however, moving the analysis to the discourse level, we can see that it is aesthetic possibilities that are assembled, not in a way that integrates them into a coherent document but rather in a way that indicates their open and hybrid character. The discourse level thus does not so much ignore impossibilities; it rather starts from them and looks at what is aesthetically possible from there onwards, offering to move on with the bits and pieces that remain when confronted with the incomprehensibility of real events

(see also Pourciau 2007; Klawitter 2008), not unlike what *Studie II* does with the deliberate interaction of incomplete bodies.

Though presented as narrative prose, the text displays a generic hybridity that opens it up for denarrativisation and lyricisation. This hybridity also illustrates the gradual transition between story-world and discourse level. It is precisely in those situations where the narrator indicates that his perception is impeded, and thus where he fails to truthfully describe the reality of his perception, that the denarrativisation or lyricisation of the descriptive prose becomes most evident.

A good example of denarrativisation can be found in a passage towards the end of the book, where the narrator tries to describe a 'hurly-burly of simultaneous movements' (Weiss 2006: 32) following an incident with a locked door. In the scene, the door was broken open with such a force that not only the door but also the people breaking it open fell into the room. The setting at first does seem to meet the basic requirements for narrativity: it is a world where things happen and evolve due to 'deliberate human actions' (see Ryan 2004: 8–9), and where these happenings – here, a chaotic string of events amongst people in a room – can be traced back causally or psychologically to an action – in this case, the forceful opening of the locked door. The retrospective description of the chaotic events, however, negates any causal or psychological interpretation. It accumulates the events in such a way that the relation with the original singular cause becomes irrelevant. Quite literally, in reading the endless list which goes on to cover several pages, we forget about the original context. Moreover, the events themselves can hardly classify as such, as it is singular gestures, tiny movements and actions without any consequence that are minutely registered.

This denarrativisation is not absolute. Two elements bind the description of the chaotic scene together and prevent complete disintegration. Grammatically, the long series of precise observations is presented in a regular way: as a list of asyndetically joined main clauses, connected with commas, and all with the correct syntactical inversion after the opening phrase of the enumeration, '[i]n the hurly-burly of simultaneous movements' (at least in the German original, not in the English translation where the inversion is grammatically not needed). This syntactically signalled dependence on the opening phrase holds the endless enumeration of clauses together *and* it identifies all clauses as being elements of the alleged simultaneity. In the story-world too, narrative coherence is lent to the chaos as it all takes place within one room that opens at the beginning and is closed at the end of the scene – not coincidentally by the narrator. Consider once again the opening phrase, followed by the first elements of the enumeration (as said before: without the typically German

inversion), and then the closing lines (the omitted passage comprises a sentence of nearly three pages in the original):

> In the hurly-burly of simultaneous movements, the hired man bent over the door, and Schnee over the crowbar, the father rubbed his head, the housekeeper and the mother stumbled to the couch [. . .] I went by the tables, the chairs, the back of the couch, the chest of drawers, to the door, the hired man picked the cards up from the floor, I opened the door, the wood of the housekeeper's broom hit the wall and the legs of the plant table, I crossed the threshold and shut the door behind me. (Weiss 2006: 32–3)

Neither the narrative quality nor its denarrativisation are thus absolute categories. In the story-world and on the discourse level, both modes are characterised by effects of disintegration (by, for instance, the impeded perceptions of the narrator of the story, and the endless accumulation in the discourse) and coherence (by, for instance, the clear spatial and corporeal localisation in the story, and the grammatically uniform regularity in the discourse).

A similar hybridity manifests itself with techniques of lyricisation. Consider, for instance, the following passage in which the narrator puts his ear to the mouth of the doctor, in order to understand what he is saying, as he is speaking without voice:

> now I could make out the following words from his breath and his tongue-motions: wounds not heal, whichever way I cut, hollow out deeply, down to the bone, knife on the bone, grates, scrapes, breaks off [. . .], instruments lost, lost, lost, in the dark, swabs dropping, find ether, clamps, needle, thread, wound open, at random [. . .] (Weiss 2006: 22)

This is only a short extract of a scene which stretches over several pages. The doctor probably complains about his wounds that do not heal and continue to fester, driving him to drastically cut out the wounded part until the bones lie bare. Within the story-world, the doctor's impaired speech – that is, his incapacity to use an audible voice – is paralleled with the narrator's impaired hearing. The ineffable experience of pain and violence is here linked with the incomprehensibility of the doctor's voiceless monologue for the narrator. Thus, in the story-world the subjective borders between the characters are not absolute. They share a cognitive impairment and they are even joined corporeally, as the ear of the narrator is nearly touching the mouth of the doctor and later on, when both leave the room, the narrator supports the body of the weakened doctor.

For the reader, the narrative situation enhances the semantic instability already suggested by the vocal and hearing impairments. Indeed, considering his hindered perception, we are not even sure whether the words related by the narrator are a retrospective mimetic rendering of what he could actually deduct from the doctor's mouth or rather his own summation. Focusing on the discourse level, the generic instability is enhanced through the lyricisation of the narrative prose. The 'at random' quality of the doctor's desperate self-treatment finds a parallel in the seemingly at random proliferation of lyrical language. The long list of elliptical clauses, partial phrases and single words matches the materiality of the wounded, cut-up body, but it also transgresses this allegorical similarity, as the language plays with sounds and rhythms, with repetition and variation, and at times seems to improvise in its search for yet another word – a lyric mode that reminds us of experimental poetry of the neo-avant-garde and, when spoken out loud, even the more recent phenomenon of slam poetry. The randomness does not characterise the semantic level, though, as the words function as key words from the semantic fields of corporeal wounds and pain and their – often violent – infliction and surgical treatment. The lyrical characteristics together with the semantic coherence loosen the words from their respective origins in either the doctor's speech or the narrator's hearing and lend the passage an autonomous character, a lyrical autonomy that, just like the narrative hybridity, evokes coherence as well as disintegration: it lends coherence in its foregrounding of the intersubjective dimension of semantics, and it facilitates disintegration in its resistance against integration within a pre-given order.

MEDIAL HYBRIDITY

Next to the hybridity of the narrative mode, the medial hybridity of the short novel, which supplements the text with seven collages of visual art, is probably its most conspicuous intermedial characteristic. Discussion remains as to whether the text started from the collages or whether they were added afterwards, and about how far they were adapted for the eventual publication (Bohley 2011: 266–8). The collages all contain cuttings from pre-found visual materials mainly taken from nineteenth-century scientific publications, such as medical, chemical and botanical manuals (Bohley 2011: 268). An anachronistic interdiscursive field of scientific knowledge is thus juxtaposed to the text, referring to practices that gradually but not yet completely separated empirical knowledge from the realm of mystification and superstition. The collages remain disparate in their pictorial quality, not offering a totalising image of their fields of reference but leaving visible the cuts and borders within and

between the clippings. Nevertheless, they are held together by recurring internal references (for instance, to scopophilia or to prosthetic devices for arms and legs), by a grid-like framing on the page and by their subdued, nearly monochrome colours, thus performing an intricate 'interdependency between part and whole': 'Far from merely repeating surrealism's proto-psychoanalytic exercises, or even reconciling the body in pieces as a normative transhistorical condition', the collages possibly even critically reflect on this 'limited binarism of fragmentation-versus-wholeness' (Langston 2008: 83–4). With the story-world, the collages are related in a mixture of difference and similarity. They double textual motives such as the narrator's focus on the gestures of singular body parts, as well as textual structures such as the enumerative accumulation of observations. They differ from the text, however, in their stronger suggestion of the multiple origins of their material, whereas the single embodied cognition of the textual narrator only at times shifts into intersubjectivity.

Within the text itself, a quite specific intermedial characteristic is Weiss's reference to shadows, especially in the description of the shadow spectacle with which the novel ends. A few nights earlier, the narrator witnessed a sexual encounter in the kitchen between the coachman and the housekeeper, but neither directly in situ nor as a voyeur through a peephole. While 'leaning out of my window inhaling the night air', he could see 'the shadows falling from the kitchen window onto the ground in the yard' (Weiss 2006: 37). The shadows are very distinct, reminding us of the pin-sharp black silhouettes popular in the late eighteenth century (the *Schattenrisse*) and, as they are moving, also of the shadow play that is considered a precursor of cinematography (Langston 2008: 85). The narrator describes their shape and interaction from memory but still in an unerring manner: obviously, he can perfectly identify and name what happened – after the intercourse, he even distinguishes the 'rising and falling in heavy respiration' (Weiss 2006: 38) of the shadows of the two bodies – as if the shadows are part of the well-known grid of his reality or as if he watched filmic images – which he did not – or had seen this spectacle before – which he had not. The precision of the observation is demonstrated in the very syntax of the description: each and every element of the scene is consistently described as 'the shadow of', lending the description a mechanical quality and again, as in the lyrical mode, foregrounding the word material itself. Both as word and as image, the shadow thus takes centre stage. Every material or corporeal phenomenon is doubled in its shadow, making the shadow a kind of living image insolubly linked to and referring back to that material reality, not as a mirror image but as a reality attached to the corporeal one.

In her article 'Infernal Poetics', Sarah Pourciau reads the structural role of the shadow in the novel as a symptom of the 'grammar of hell'. For Pourciau,

Weiss's short novel represents a first step in his lifelong rewriting of Dante's *Divine Comedy*, a project with which he looked for 'a narrative structure' and 'a revolutionary form' (Pourciau 2007: 158) to write his historical critique of modernity, the urgency of which had grown exponentially since the Holocaust. Pourciau situates the importance of the text's intervention 'in the living hell of modernity' (2007: 165) in the narrator's effort to describe reality as a singular 'now', though he lives in the 'over and over of hell' (2007: 163); '[t]o write from the hellish perspective of the damned (un)dead – from the perspective, that is, of the survivor – should be an exercise in futility' (2007: 168).

Shadows are the opposite of suppressed drives and phantasmagoric mirror images. Indeed, lingering between presence and absence, challenging identification and interpretation, they offer a figuration that loosens itself from interiorisation and psychologisation and dichotomic epistemological structures. They do not belong to the economy of cutting up and reassembling; neither do they promise a recovery of the whole, unbroken body. Rather, they infer 'that non-totalizing forms of embodiment can be rectified by smashing the mirror and, with it, the blueprint for an ideal anatomy' (Langston 2008: 85).[6] Linked to the violence of history, relentlessly reminding the spectator of the catastrophes of modernity, they cannot be reduced to a status of victimisation. They act and bring things into being when the bodies they refer to are unable to do so. Thus, they do not offer a way out but instead the next figurative step in dealing with the 'living hell of modernity'.

Following this interpretation, the description of the 'shadow sex' is even more remarkable, as it might be the most radical passage of the novel in dealing with the aforementioned impossibilities and impediments. Paradoxically, perception and description, so often thwarted in the novel, seem to be realised here in the retrospective capturing of this quite grotesque and elusive performance – this play, indeed – of acts of sexual vitality by shadowy bodies. In describing the shadow play, the narrator visualises the presence of absent agents, thus acknowledging the importance of the creative mediation of their presence and finding his own role therein. In this final retrospective description, the act of writing culminates not as a verifiable and predictable integration of perceived reality, but as a supplement to it through the revival of images of the real.

CONCLUSION: THE ENERGY OF IRRITATION

Both in the descriptive and corporeal experiments conducted by the first-person narrator and through the generic and medial hybridity of its discursive form, *The Shadow of the Body of the Coachman* foregrounds an incongruence that

defies any conclusive interpretation. A reading that solely focuses on disintegration (of subjectivity, language, the body) or failure (of gaining knowledge through description, for instance) reduces the complexity of that hybridity. Rather, the interplay of modes and media, while starting from those absolute negatives, brings them a step further and allows for disharmonious but energetic interaction. The 'irritation of perceptive and cognitive unification' (Bauer 2007: 19), as aimed at by the historical avant-garde, is unmistakably part of Weiss's programme in this text, as it is in his experimental films of the time. Out of this irritation, incomplete, uncanny and unheroic images that are in constant movement come to the fore. As such, they cannot be automatically integrated within a grid of knowledge of reality. Rather, their formal instability and cognitive irritation present images of the real that are insolubly joined to the reality that provoked them. Though they might fall short of the mid-sixties claim for direct political activism, advocating artistic intervention for a more liveable world, these images of the real probably could disturb the contented sleep of readers and spectators, as Weiss urged a decade earlier, confronting them with the bits and pieces that they would have to deal with.

NOTES

1. I am quoting from the unpaginated digital edition. Unless otherwise noted, all translations are mine.
2. In the context of the neo-avant-garde it is notable that the experimental author Helmut Heißenbüttel attended the group meetings too. According to literary historian Helmut Böttiger (2012), Heißenbüttel mainly functioned as a poster boy to show off the group's openmindedness, a function Heißenbüttel himself gladly used to his own advantage, considering the near absence of a German platform for experimental literature.
3. This is not to say that the radical left was a homogenous faction in itself. A few months after the Princeton meeting, a dispute would break out between Weiss and Hans Magnus Enzensberger in the latter's journal *Kursbuch*, with Weiss insisting on speaking out and taking a clear political stand, whereas Enzensberger polemically pointed towards the comfortable position of Western authors paying mere lip service to radical movements (see Böttiger 2012; Weiss 1971b). In December 1966, a coalition was built in West Germany between the conservative party CDU and the socialist party SPD, much to the disappointment of leftist Gruppe members. A politician with a past as a member of the NSDAP, Kurt-Georg Kiesinger, was to become prime minister and the ultra-conservative Bavarian Franz

Josef Strauß defence secretary. Willy Brandt, with whom Günter Grass was closely linked, became the SPD secretary of foreign affairs.

4. The full-length German translation entitled *Avantgarde Film* appeared as late as 1995; an abbreviated version had been published in 1963.

5. Richard Langston has pointed out the differences between these experiments and the surrealists' use of hallucinogenic drugs, regarding both the corporeal effects and the character of the images: 'Instead of closing his eyes and activating the realm of the unconscious to disclose a forbidden world of fantastic and random assemblages, he achieves with eyes wide open what he otherwise cannot: capturing the spectacle of a whole body' (2008: 81).

6. See, however, a negative existentialist reading of the shadow motive in Bohley (2011: 279–80). For an in-depth reading of shadows in diverse contemporary art forms, see Breidbach (2017).

BIBLIOGRAPHY

Abrantes, A. M. (2008), 'Gestalt, Perception and Literature', *Journal of Literary Theory*, 2 (2), pp. 181–96.

Bauer, M. (2007), 'Des-Integration und Trans-Figuration: Überlegungen zur intermedialen Poetik von Peter Weiss', in Y. Müllender, J. Schutte and U. Weymann (eds), *Peter Weiss: Grenzgänge zwischen den Künsten*, Frankfurt am Main: Peter Lang, pp. 17–36.

Bohley, J. (2011), '"Es gibt keine Psychologie, nur Physik u Chemie"? Peter Weiss' *Der Schatten des Körpers des Kutchers* im Laboratorium des Nicht-Erzählens', in M. Bies and M. Gamper (eds), *'Es ist ein Laboratorium, ein Laboratorium für Worte': Experiment und Literatur III 1890–2010*, Göttingen: Wallstein, pp. 263–80.

Böttiger, H. (2012), *Die Gruppe 47: Als die deutsche Literatur Geschichte schrieb*, Munich: Deutsche Verlags-Anstalt, n.p.

Breidbach, A. (2017), *Übertragene Körper: Diskurse des Schattens im Werk von Hans-Peter Feldmann, W. G. Sebald und William Kentridge*, Paderborn: Fink.

Garloff, K. (2000), 'Cosmopolitan Leftovers and Experimental Prose: Peter Weiss's *Das Gespräch der drei Gehenden*', in J. Hermand and M. Silberman (eds), *Rethinking Peter Weiss*, New York: Peter Lang, pp. 1–19.

Handke, P. (1972), 'Ich bin ein Bewohner des Elfenbeinturms' [1967], in P. Handke, *Ich bin ein Bewohner des Elfenbeinturms*, Frankfurt am Main: Suhrkamp, pp. 19–28.

Honold, A. (2000), 'Deutschlandflug: Der fremde Blick des Peter Weiss', in J. Hermand and M. Silberman (eds), *Rethinking Peter Weiss*, New York: Peter Lang, pp. 45–73.

Honold, A. (2012), 'Schreibprozesse unter den Bedingungen ihrer Veröffentli-
 chbarkeit: Peter Weiss, Siegfried Unseld und der Literaturbetrieb', in C.
 Morgenroth, M. Stingelin and M. Thiele (eds), *Die Schreibszene als politische
 Szene*, Munich: Fink, pp. 239–60.
Klawitter, A. (2008), 'Fiktionen des Intermediären', *Orbis Litterarum*, 63 (2),
 pp. 89–109.
Langston, R. (2008), *Visions of Violence: German Avant-Gardes After Fascism*,
 Evanston, IL: Northwestern University Press.
Pourciau, S. (2007), 'Infernal Poetics: Peter Weiss and the Problem of Postwar
 Authorship', *The Germanic Review*, 82 (2), pp. 157–78.
Ryan, M.-L. (2004), 'Introduction', in M.-L. Ryan (ed.), *Narrative Across
 Media: The Languages of Storytelling*, Lincoln, NE: University of Nebraska
 Press, pp. 1–40.
Spielmann, Y. (2000), 'Theory and Practice of the Avant-Garde: Weiss's
 Approaches to Film', in J. Hermand and M. Silberman (eds), *Rethinking
 Peter Weiss*, New York: Peter Lang, pp. 75–91.
Vogt, J. (1993), *Peter Weiss: mit Selbstzeugnissen und Bilddokumenten*, Reinbek:
 Rowohlt.
Weiss, P. (1968), 'Avantgarde Film' [1963], in P. Weiss, *Rapporte*, Frankfurt
 am Main: Suhrkamp, pp. 7–35.
Weiss, P. (1970), 'Rede in englischer Sprache gehalten an der Princeton Uni-
 versity USA am 25. April 1966, unter dem Titel: *I Come out of My Hiding
 Place*', in V. Canaris (ed.), *Über Peter Weiss*, Frankfurt am Main: Suhrkamp,
 pp. 9–14.
Weiss, P. (1971a), 'Unter dem Hirseberg' [1965], in P. Weiss, *Rapporte 2*,
 Frankfurt am Main: Suhrkamp, pp. 7–13.
Weiss, P. (1971b), 'Brief an H. M. Enzensberger' [1966], in P. Weiss, *Rapporte
 2*, Frankfurt am Main: Suhrkamp, pp. 35–44.
Weiss, P. (2006), *Marat/Sade – The Investigation – The Shadow of the Body of the
 Coachman*, ed. R. Cohen, New York: Continuum.

From Zero to Neo: Ivo Michiels, *Book Alpha* and the Neo-Avant-Garde

Lars Bernaerts

At the end of the third book of *The Alpha Cycle* by the Dutch-speaking Belgian writer Ivo Michiels (the pseudonym of Henri Ceuppens, 1923–2012) we find a remarkable sign. It is placed roughly in the middle of the cycle and it is at once textual and pictorial. In the middle of a blank page we can see one single letter that can also be read as a number: the 'o' or zero. As the 'o', it is the alpha's omega as it were, while the zero suggests a new start. It is a moment of rupture, shock, radical abstraction, monochromy and novelty which shows the ambition of *The Alpha Cycle* (1963–79) as a whole. By opening up multiple ways of reading, the nearly empty page stands for an excess of meaning linked to avant-gardist thought. In this chapter, I wish to offer a view of Michiels's neo-avant-garde work through a contextualised close reading of *Book Alpha* (1963), the first novel of the cycle, to elucidate the neo-avant-garde poetics of Ivo Michiels. My reading revolves around the paradox of the new, the 'neo', and 'beginning' as it is developed in the theory of the avant-garde and built into *Book Alpha*. *Book Alpha* moulds the new out of the old, I argue, and breaks with tradition by continuing the avant-garde tradition of rupture.

Before zooming out let us dwell a bit more on the 'o' in order to acquire an initial understanding of Michiels's avant-garde. If we want to understand the 'alpha', we need to understand the 'omega'. The 'o' is put at the centre of the penultimate page of *Exit*, the book following *Orchis Militaris* (second book) and *Book Alpha* (first book). *Exit* is followed by *Samuel, o Samuel*, the title of which alludes to Samuel Beckett, and *Dixi(t)*. *Dixi(t)* closes the first cycle of experimental novels and offers a bridge to a following cycle of ten novels published by Michiels between 1983 and 2001. The 'o' in *Exit* is part of a last will and testament in which the speaker – not really a narrator since there is no story in any traditional sense – bequeaths an absurd series of personal belongings, cultural goods and language materials. The testament is basically a list made up of vertical

lists (Neven 2019: 193–225), inconsistently organised around vague categories, but consistently presenting fifteen items: fifteen sounds, colours, smells, games, questions, commands, protests, dates, and so on. The lists are witty and playful but in the context of a testament at the end of a novel in which the speaker is a detainee, they become a catalogue of human existence itself.

One would expect lists to bring order to chaos, but the reverse is true for the testament in *Exit*. In that respect, the testament is a clear-cut continuation of the rest of the book. The book consists of *fifteen* language fields, of which the testament is only one. In each field a particular type of language is imitated, sometimes parodied, sometimes only evoked in rhythmic repetitions or frag- mented sentences. By incorporating and deforming familiar utterances – such as those of card players or a priest in a sermon – *Exit* attacks linguistic and literary conventions, indicating that they can be replaced by a fresh, creative language with a strong liberating potential. At the same time, this requires the old conventions to be destroyed. Read as a zero, the figure on the last but one page represents this reduction to nothing. This is in keeping with the playful destructive imagery elsewhere in the book, for example in a game of battleships:

Water. I 3. Hit?
Water.
I 5. Hit?
Water.
I 6. Hit?

Hit. Submarine has sunk. G 3. Hit?
Hit.
G 2. Hit?
Water.
F 3. Hit? (Michiels 2007: 243)[1]

The final list of the testament is not presented as an enumeration, but it does *imply* a list of the first fifteen letters of the Greek or Roman alphabet. It is introduced as follows: 'I bequeath to myself the fifteenth letter of the alphabet which I take on my final journey, namely:' (Michiels 2007: 265). In the Greek alphabet, the fifteenth letter is the omicron, but since there is so much emphasis on 'ending' in this passage, we may also want to read it as an omega, the final letter of the alphabet. The ambiguity is crucial. On the one hand, the 'o' is placed at the end of the testament, at the end of *Exit*, and it accompanies the speaker on his '*final* journey', that is: death. As an omega, the figure stands for the end of writing which for the speaker is not detached

from the end of life itself. Viewed in the light of the cycle, it marks the end of a certain type of writing that is conventional, narrative, linear, natural. This idea is also conveyed through the visual placement of the letter at the centre of the page: the linearity of the reading process is obstructed and the reader has to foreground a spatial, visual reading. The end of conventional writing coincides with the end of conventional reading.

On the other hand, the 'o' is in the middle of the alphabet and *Exit* is in the middle of the five-part *Alpha Cycle*. It is a point of transition between a destructive tendency – breaking the conventions – and a constructive tendency – establishing a new language (Bousset 1988: 526–30). The 'o' is the little rabbit hole through which one reaches the second part of the cycle (cf. Bousset 1988: 527) and it is a familiar expression of wonder. It should come as no surprise that the playful, seemingly uninhibited speaking persona of *Exit* takes this aesthetic and affective attitude with him to the grave. Also, the 'o' is the point zero that marks the end of a countdown, which in turn implies the launch of a new kind of writing and a new way of reading. In sum, beginnings and endings are intertwined in *The Alpha Cycle*. In my view, they must be central to any understanding of the cycle's avant-gardist claims as well. In the historical as well as the neo-avant-garde, starting anew and breaking with tradition are commonplace (see, for example, Bürger [1974] 1984; Bru 2018; Foster 1996). This is the reason why I will turn to the beginning of the cycle and the idea of novelty in *Book Alpha* in the fourth section of this chapter. In the second section, though, I wish to move from 'zero' to Michiels's own positioning in the neo-avant-garde before making some theoretical reflections in the third section.

FROM ZERO TO NEO

The image of a launch after a count-down, activated by the zero in *Exit*, is also used by the visual artists of Zero (Pörschmann and Schavemaker 2015). Looking through the lens of Michiels's life and works, Zero art is an inevitable intertextual link for the penultimate page of *Exit*. In the 1950s Michiels devoted several pieces to the artists associated with Zero when he was an art and literary critic (1948–57) for the Flemish newspaper *Het Handelsblad*. His articles can be considered as a laboratory for his ideas about the arts, literature, music and cinema. His work as a critic also allowed him to develop a network of friends and contacts in all those fields. Among other projects, this led to the realisation of *Meeuwen sterven in de haven* (*Sea Gulls Die in the Harbour*) (1955), one of the first Flemish movies in a modern style reminiscent of international cinematic innovations. Around the same period, towards the end of the 1950s, Michiels also became close friends with the painter Jef Verheyen, visited Piero Manzoni and Roberto

Crippa in Milan, wrote letters to Lucio Fontana, directed Manzoni's attention to the German Zero group (Heinz Mack, Otto Piene, Günther Uecker), brought art works to Belgium and was involved in legendary exhibitions at the Hessenhuis in Antwerp. In sum, Michiels participated in the transnational collaborative spirit that was so characteristic of the Zero movement (see Caianiello and Visser 2015) and the avant-garde (Poggioli 1968: 4, 17). It marked a new beginning in Michiels's literary career, as he moved away quite emphatically from his own Catholic and conservative background. Immediately after the Second World War, he was still involved in the rightist, anti-modernist, literary magazine *Golfslag*, but a decade later he was active among neo-avant-gardists.

As his fiction and essays show, the affinity with Zero was fundamental for Michiels. Not only did he refer to Zero and its artists, he also subscribed to their main ideas and attempted to develop literary equivalents for their methods of expressive reduction (Bernaerts 2012). Lucio Fontana's perforations (*buchi*) and incisions (*tagli*) in his monochrome paintings turn the canvas into an object in its own right while at the same time opening up a route to another dimension (Hegyi 2003), which the reader or viewer is free to imagine, not unlike the 'o' in *Exit*. Fontana's *Manifiesto Blanco* ([1946] 1970) amounts to a plea for a radically new synthesis of all areas of life, a plea that echoes the historical avant-garde in many ways. Jef Verheyen termed his own project of radical reductionism 'essentialism'; his achromatic paintings were intended to capture a universal space (Pola 2010). A similar taste for the workings of colour, light, vibration and space can be found in the art of Manzoni, Mack, Piene and Uecker.

When Michiels veered towards a radically new style of writing in *Book Alpha*, Zero is certainly one of the points of reference. Yet, Michiels's taste for the neo-avant-garde is not limited to Zero. In retrospect, he reconstructs his experience as follows:

> we did not belong to one avant-garde, we belonged as it were to dozens of avant-gardes. There was that of the Lovers Without Compromise, Manzoni, Fontana, the Zero movement, the tabula-rasa workers of the Big White, the Monochrome Blue, as far as I am concerned the long-term companions that are most dear to me: my own way of writing directly springs from it. But paradoxically we simultaneously felt attracted to the wild poetry of Cobra and in addition to that of the masters who – how was it even possible! – escaped any common label. (Michiels 1995: 293)

Michiels reads a conflict-free openness into the avant-garde, disregarding its typical compartmentalisation and antagonism. He does not adhere to any 'ism'

in particular, but nonetheless expresses an attachment to all avant-gardes. He clearly considers the post-war avant-garde as a multitude. The avant-garde is not one but many. The context of this passage is one of the many occasions when Michiels commented upon the avant-garde: a lecture in 1994 in Amsterdam as part of a series called 'The Heritage of the Avant-Garde'. Integrated in the seventh book of *Journal brut* in 1995, the lecture becomes part of Michiels's second experimental cycle of novels. The cycle strings together heterogeneous text types, such as anecdotes, memoirs, fictional stories, scripts and essays. Metatexts such as 'The Heritage of the Avant-Garde' are integral to the cycle.

In his characterisation of the avant-garde, Michiels adopts the idea of rupture: avant-gardists aim for *tabula rasa* and seek to escape familiar labels. In that respect, he accepts the evolutionary nature that is so characteristic of avant-garde discourse in Peter Bürger's view: art history follows a chronological path that leads from causes to effects. Consequently, the neo-avant-garde art is seen as a belated and watered down version of what preceded it. As Hal Foster remarks, Bürger follows this type of discourse in presenting history as 'punctual and final' (Foster 1996: 10). Even though Michiels constructs an alternative tradition of the experiment throughout his work, he sketches a post-war avant-garde that breaks with tradition, which implies a rupture in history.

As a former art critic, Michiels is very aware of the achievements of the historical avant-garde. Still, Michiels ascribes this claim of revolutionary novelty to the neo-avant-garde as well. Unlike Peter Bürger, Michiels believes in the vitality of an avant-garde that seemingly repeats gestures from the historical avant-garde: the monochromes of Manzoni or Fontana are 'novel' and effective despite earlier works by, for example, Malevich. This view is incommensurate with Bürger's conviction that the neo-avant-garde is somehow violating a central principle of the avant-garde: 'the neo-avant-garde institutionalizes the *avant-garde as art* and thus negates genuinely avant-gardiste intentions' ([1974] 1984: 58). Indeed, Michiels himself furthered the institutionalisation and musealisation of the avant-garde through his activities as a cultural mediator and as a literary author. He consolidates avant-garde movements and techniques in his reviews, essays and his own fiction.

In the quoted passage above, Michiels constructs the 1950s and 1960s as the period of his formation as a true artist, even calling it a point of departure: 'my own way of writing directly emerges from it'. Elsewhere, he explicitly renounces his earlier work, which is more traditional in style and ideology. In other words, the neo-avant-garde has the status of a pure origin in the narrative of his authorship. For the avant-garde and the neo-avant-garde alike, these *topoi* of avant-garde discourse – starting anew, novelty, revolution – are

essential. 'Perhaps the best way to view the European avant-gardes', Sascha Bru writes in his 2018 study on that topic, 'is as an uninterrupted series of new beginnings (never absolute, always in the plural) founded on appropriation' (2018: 187). This idea of beginning and novelty will provide anchor points for my reading of *Book Alpha* as a neo-avant-garde work and they are present throughout *The Alpha Cycle*. In particular, the cycle reflects a search for an alternative to linear, psychological narratives and to a language contaminated by power relations.

PUTTING THE NEO INTO THE NEO-AVANT-GARDE

What exactly can and should be subsumed under 'novelty', 'rupture', 'break with tradition' in the avant-garde? In Theodor Adorno's widely influential and much criticised *Aesthetic Theory* ([1970] 2002), the category of the new is key to an understanding of modern art. His claims about the new are not limited to the avant-garde, but his view of critical modern art applies to the avant-garde in the first place. There is a risk, however, that art reproduces the logic of commodification in yielding to the temptation of newness. Adorno warns us against that risk, explaining that novelty is 'the trademark of consumer goods', which art draws upon to mark itself off from 'the ever-same inventory in obedience to the need for the exploitation of capital' ([1970] 2002: 21). How, then, can art avoid the risk of reproducing the capitalist notion of novelty? In a sense, art must become its own opposite, or rather its antithesis. It needs to become antiart. According to Adorno, art needs antiart in order to survive as art ([1970] 2002: 29). This is the case in any definition of the avant-garde. Antiart subverts tradition (while at the same time, of course, continuing the tradition of subversion) and is a logical link in Adorno's dialectical view of art history, which is part of the larger dialectic of enlightenment. The category of the new, then, is both subversive and conformist. It is normative despite itself: modern art relies on the idea of a break with tradition, and the new – which implies overthrowing traditional norms – installs itself as a norm ([1970] 2002: 23).

As Bürger explains in his *Theory of the Avant-Garde*, the newness of art in modernism and the avant-garde differs from that of other claims of novelty in literary history ([1974] 1984: 59–60). It is not the invention of new themes, the variation within strict literary models or the shock of defamiliarisation. Rather, it is the negation of tradition ([1974] 1984: 60). Bürger criticises Adorno for this concept of the new. He disagrees with Adorno's insistence on the autonomy of art and singles out those avant-gardés that in fact try to reconcile art and life. Whereas Adorno's modernism is a protest against social reality, the avant-garde defined by Bürger integrates art into that reality. In its emphasis

on the autonomy and specific subversive potential of the literary work as well as in its concept of rupture, Michiels's notion of the avant-garde is closer to Adorno's. Michiels cultivates the myth that Rosalind Krauss describes as 'the originality of the avant-garde': 'avant-garde originality is conceived as a literal origin, a beginning from ground zero, a birth' (Krauss 1985: 157). This idea surfaces in the forms, techniques and discourse of the avant-garde. Krauss's prototypical example of the grid, which we discussed in the Introduction to this volume, is not unrelated to Michiels's approach to language and literature, in that it is a figure of strong, palpable repetition that resists narrativisation and purports to be 'original'. We will find such abstract patterning also in the language of Michiels's novel.

In *The European Avant-Gardes, 1905–1935* (2018: 171–3), Bru distinguishes between three ways in which the avant-gardes position themselves as new, underscoring, however, that at the same time they appropriate traditions and history in general (2018: 187). The first typical way of conceiving the 'new' is to refer to the technological, scientific and societal processes that we associate with modernisation. Art incorporates and responds to the new technologies and inventions of its time. Secondly, avant-gardists tend to consider the work of art itself as a new intervention. It does not represent an extant reality and it did not exist before. This second claim can be found in Michiels's *Alpha Cycle*, whereas the first one is much more ambiguous: a reference to Marinetti's futurist manifesto – referring to the technology of war – is incorporated in a very ironic context in *Orchis Militaris*, the second book of the cycle (Michiels 1979). The third and final notion of novelty identified by Bru is the newness emerging from the *procedures* used by the avant-gardes: 'the novelty of their work resided perhaps first and foremost in the procedures they used to process given materials', as for example in readymades, collage, or chance operations (2018: 173). For Michiels, those materials are the familiar literary and daily uses of language, as we will see. His new procedures are (anti)narrative as well as linguistic.

In Dutch literature, Michiels is not the only post-war writer who inscribes himself in this discourse of beginnings and newness. The manifestos of experimental magazines in the period 1955–70 teem with these *topoi* (see Boelaert 1989). In the discourse of the neo-avant-garde in Flanders and the Netherlands, Bart Vervaeck (2014: 79–85) distinguishes a double rhetorical and literary move. On the one hand, writers want to reduce literary tradition to zero, and on the other hand, they aim to create new forms starting from that zero point. These new forms can draw upon other media or other genres. For Bert Schierbeek, the author of the first Dutch post-war experimental novel (*Het boek ik* in 1951), it is the merging of poetry and prose that can innovate literature. Sybren Polet crafts a new kind of literature from extant materials – using collage techniques – but

also from the 'reality' of the human mind (Vervaeck 2014: 83–4). For Michiels, Vervaeck argues, the new is a continuation of an experimental tradition (2014: 81). Whether and how this translates into *Book Alpha* is the question we now need to broach.

STARTING ANEW IN *BOOK ALPHA*

In a letter to his close friend Jef Verheyen, Michiels reveals in 1961 that he is writing an experimental novel that 'will constitute a revolution in literature'. He is prepared to 'sacrifice everything for my work', leaving behind 'the entire petit bourgeois mess around here'.[2] The book announced will be published in 1963 as *Book Alpha*. As the title already intimates, it is a work of literature drenched in an avant-garde spirit of beginning anew. On the one hand, it is a 'book' rather than a 'novel', announcing its rejection of a conventional narrative genre. On the other hand, the 'alpha' denotes the beginning of an alphabet, a new basic repertoire of writing. Needless to say, if zero marks a visual, spatial and mathematical beginning, then alpha stands for a linguistic, textual and writerly beginning. The title ironically alludes to the primers children use to learn the alphabet, as if *Book Alpha* were itself a children's book. In many ways, it is just that: it is a book that portrays childhood and children as important, albeit abstract characters, that evoke original, formative experiences (beginnings), and that involves a process of learning to write and learning to read.

The book's prologue already stages this interconnection between 'novelty' and childhood. In the opening scene, a group of children are stuck in the mud during a familiar local tradition in Belgium: on New Year's Day children walk from door to door and sing a song to wish the town a Happy New Year. I quote a long passage from the beginning of *Book Alpha* to offer a sample of the style of writing, which is central to Michiels's project:

> At the crossroads he had seen the mud coming together, the sodden earth with the puddles, the potholes, the cart ruts from four directions converging, intersecting, squashing each other, continuing, and had wondered whether to turn right or left or carry on straight ahead, and then hesitated for a long time without saying anything, fearing they might have lost their way, had merely looked, at the crossroads and at the ruts in the mud and at the three pairs of muddy feet around his, around his spattered legs which were the oldest and yet not even older than eight. And in his legs the unwillingness to start moving, to take the decision that he finally did take because he was the oldest and had to see them home safely as he had promised that morning, hours, days, weeks ago, with a 'yes' on his lips and a 'yes' in his eyes, and from head to toe a 'yes,' yes and therefore finally began to move, taking a

step, and another, choosing as he went to go straight ahead, without why or wherefore, until suddenly the mud snapped at him and his foot shot out of his shoe, as an omen. (Michiels 1979: 3)

In long-winded, jerking sentences the first paragraph of the novel stages a beginning that is at the same time an *in medias res* (not unlike the middle annex ending that we have seen earlier). The children are in the middle of their circuit; the novel starts in the middle of the events; and the word 'crossroads' – not coincidentally the first noun of the novel – indicates that there is a road behind and a road ahead. But we are at the *start* of a new novel and a new year, in the company of characters who are at the beginning of their lives.

Through the focalised experience of an anonymous main character we recognise a touch of despair because he feels lost, a hesitance as well as a desire – out of responsibility – to move forwards, which results in a resolute 'yes'. The dramatic tone of the scene reflects the naïve perspective of a child faced with a frightening and disorienting situation and at the same time it shows how this 'childish' gaze is not innocent. The scene is full of symbolic imagery that prefigures the entire novel: childhood, mud, the crossroads, feelings of guilt, the determination to move ahead . . . The motif of movement and the inability to move echoes the final words of Beckett's novel *L'Innomable* (*The Unnamable*) (1955): 'you must go on, I can't go on, I'll go on'. The motif recurs in *Book Alpha* as an image of the human subject as both submissive and defiant. In staging an array of situations in which the main character escapes physical and verbal repression through his imagination, the novel promotes a state of passive resistance (Bousset 1988). The central character, from whose memories and desires the successive scenes in the novel seem to spring, is a soldier standing guard in front of a barracks. He is not allowed to leave his post – which would amount to treason – but has a strong desire to do so. He longs to see a girl called An. Time and again, the narrative returns to the dilemma, pivoting around it as it were and consistently jumping from there to scenes in childhood and puberty. The ritualistic, almost archetypal nature of these scenes is tied to the power of language and the attempt to design a new (literary) language, as we will see. The seemingly endless, meandering sentences full of salient repetition already announce this intention from the book's very first page.

Together with the emphatic repetition of 'yes' – reminiscent of the final words of James Joyce's *Ulysses*: 'yes I said yes I will yes' – the end of the prologue prefigures the liberating power of creative language, which can be deployed as an antidote against oppressive language:

Behind him he heard six-years and seven-years also stirring and he paused briefly and when they were beside him he said: 'Sing.' He said it loudly

and without premeditation and tasted the warmth of the word and felt how here and now words were needed only for the warmth they spread and hardly because of what they meant and again he said: 'Sing,' started a song and sang, louder and louder until the others joined in and even five-years detached his hot fist from his fist and sang, so that everything was again just as it had been hours ago when they went from door to door and from yard to yard and from farm to farm, although now there was nowhere a door or a farm to be seen. After a time it dawned on him that they had left the crossroads far behind and he could not even remember whether they had turned right or left or gone straight ahead and so only the awareness remained that they were on the move and singing, singing as they walked through the mud, the rain, the grayness of the new-year's day, their hands clasped on the bags in front of their stomachs. (Michiels 1979: 6–7)

Pursuing their willingness to go on, the children start singing. The song, which goes hand in hand with movement, is a positive answer to a hopeless situation and represents an optimistic belief in the future and in change. In the act of singing and moving regardless of content or direction the children liberate themselves (literally: from the mud). Not only is this scene a comment upon the ideological and ethical impasse after the Second World War (left or right?, how to deal with the 'mud' of collaboration?), it also hints at a literary impasse. While conventional literary novels have a clear content and direction, the 'neo'-literature or antinovel proposes an alternative model. A new literary language, then, prioritises form over content, 'the warmth' of words over the direction of the story. What matters is that 'they were on the move and singing'. The concept of novelty foregrounded here is that of an autonomous literature, which exploits the material and sonic qualities of language and which breaks with tradition, while also continuing one (that of Beckett and Joyce, for example).

The break with tradition is a prevalent idea in the avant-gardes that is often recognisable in motifs of childhood and primitivism. As Bru explains, the primitivism that is omnipresent in the historical avant-gardes indicates 'a desire to go back to an original state, to the beginning of what is' (2018: 145). Similarly, the 'infantilist aesthetic' documented by Sara Pankenier Weld in *Voiceless Vanguard* (2014) is a major force of attraction in the avant-gardes because 'the child' creates the illusion of an 'original state', liberated from all kinds of societal, moral and artistic constraints. The infantilism translates into a variety of forms, which Pankenier Weld investigates in case studies from the Russian avant-garde. Typical strategies including scribbling in visual art, babbling in literature and performance, naïve perspectives, alogical speech and formal simplification. One can also think of Cobra art here, one of Michiels's points of reference.

This naïve, defamiliarising perspective was already evident in the open-
ing of *Book Alpha*, and it becomes even clearer in a passage I will quote from
shortly. Later in the *Alpha Cycle*, Michiels will even go so far as to incorporate
the babble of a baby as one of the language fields in *Exit*. While *Book Alpha*
does not go back to the preverbal state of the infant, it does hone in on child-
hood and first experiences in a way directly connected to Michiels's view of
the avant-garde. The paradigm of childhood is deployed in the novel as an
alternative to a muddy, contaminated tradition. Still, the scenes with children
show how the so-called state of innocence is always already contaminated as
well – and language is the principle site of contamination. Early in the novel,
this becomes apparent in a conversation between two boys. The scene has
a ritualistic nature, in which the older boy confronts the younger one with
the power of violence. The boy says he is planning to hit someone until that
person dies, he starts torturing a chicken and after that he suffocates a cat. The
other boy, who is to be understood as a younger version of the soldier, does
not participate in the violence, but neither is he able to prevent it. The entire
scene has the tone of an initiation ritual for the younger boy, who is being
prepared to dominate others as well.

The first experiences evoked in the novel are sometimes literally rituals of
initiation. When the boy starts working in a factory he is submitted to haz-
ing: his head is plunged into a bucket full of glue. While the scene is violent,
he silently resists the violence by drawing the figure of a cross on the bottom
of the bucket with his nose. Another initiation ritual is the boy's first sexual
encounter. It takes place after the boy is bullied by some other boys, who
leave him naked and rubbed with grease. His body – arms spread wide –
forms a cross on the floor. A girl approaches him and relieves the violence by
lying on top of his body. Throughout the novel, violence and oppression are
transcended in language, imagination and love. One can escape oppression in
creative, new language, 'the first cry, the AAAAA of the first voice' (70).

This subtle play can be found throughout the novel. As already mentioned,
the prologue suggests that an old language brought us to an impasse (the mud)
and that a new language (the singing) is necessary. In several scenes, *Book Alpha*
dramatises both the problem of the old and the solution of a new creative
language. In a complex way these two are intertwined. The following scene,
which can be read as one of the flashbacks by the soldier on guard, makes this
point quite clearly. As a schoolboy he locks himself in a toilet to escape the
chaos of the school and the rest of the world:

> and although he had only let his pants down he felt as if he was completely
> bare, bare under the orders that were coming down upon him, and it was
> as if he had been born into the world only so as to be bare forever, and to

listen forever to commands, and the more tightly he pressed his hands to his ears the faster they multiplied; they came pouring toward him, from the classroom windows, and they boomed from the kitchen and the bedroom and they were in the church as well and in the street and in the playground and there was hardly a minute of the day without orders and it began early in the morning with hop out of bed and hop say your prayers and hop go wee-wee and it went on with hop say grace and hop eat your breakfast and hop say grace and hop kiss your dad who is off to work and hop kiss your mom who is staying at home and hop your satchel and hop your brother and so on with hop prayers and hop silence and hop start playing and hop stop playing and hop to the blackboard and hop your lesson and hop your knuckles and hop put your arms up and hop put your arms down and so on again with hop prayers and hop be quiet and hop start singing and hop stop singing and [. . .] hop to church and hop kneel down and hop bow your head and hop your sins and hop ask forgiveness for all your sins (for the ball you stole or for the ball you didn't steal but which everybody says you stole so that in the end you did steal it and for the dirty things you did when the big boy said that girls do it differently from boys and you answered I want to see and the big boy said come along then, I'll show you something) and hop do as you're told and hop tell a lie just for once and [. . .] hop in the procession and hop kneel in the dust and kneel in the mud and kneel on the cobblestones and hop kneel in the snow and hop be a lamb and hop be an angel and hop be Jesus and hop be holy. (Michiels 1979: 14–15)

In this hammering sentence, which goes on for several pages, it is not the soldier who is commanded and must obey, but a young boy, whose mind is flooded with orders. After the mention of 'orders' and 'commands', the interjection 'hop' is used to indicate this speech act. In the Dutch language, however, the word 'hop' is used for friendly encouragements and kind invitations. Ostensibly, the boy experiences each and every directive speech act, such as requests and invitations, as an order, whereby the will of a speaker is imposed upon him. Even an activity that we would expect to be self-motivated, such as playing, is presented as an order. In other words, all actions and even thoughts are revealed to be extrinsically instead of intrinsically motivated.

The omnipresent order is used in *Book Alpha* to explore the way in which the language of the other generates and constrains the self. By stressing the performative nature of the order we can notice the way *Book Alpha* both criticises and transforms language. The novel shows a distinct fascination for the creative potential of language. The performative speech acts, which it evokes time and again, create the reality they denominate: 'I promise' brings about a promise, 'I order you' realises the order. In *Book Alpha* this potential of language to create

the self and reality is – in a first movement – presented as problematic. The self is repressed by the orders of others. Suggesting that this is an institutional process of discipline, the quoted passage shows a range of oppressive voices: family, education, the school and the church. Elsewhere in the novel it is also the military and the state who control the individual with their institutionalised orders.

What we see in the passage, though, is that the oppressive language of the order gradually morphs into the unfamiliar territory of a repetitive, rhythmic, antinarrative language. *Book Alpha* exploits and recalibrates the language of oppression, turning it into a form of singing as it were, a litany in which the words are 'needed only for the warmth they spread and hardly because of what they meant', to refer to the prologue. It is a language freed from certain conventions of punctuation and syntax. Shifting attention to the material qualities of language – a neo-avant-gardist gesture – the text shows how the language of oppression itself offers means to liberate the self from oppression. In sum, the performativity of language is pushed to its extremes to turn an ethically suspect mechanism into a tool of political emancipation.

This happens time and again in *Book Alpha*. The performative potential of language is wielded as an instrument of both oppression and liberation. Early in the novel, the soldier on guard can hear the obtrusive and escapable rhythm of marching soldiers – 'the air filled with the *left-right left-right left-right* within the walls behind his back' (7) – which connotes violence and war. By the end of the novel, this rhythm of violence is replaced by its antithesis, a rhythm of love that is liberating instead of oppressive – even named after An, the idealised partner of the soldier, whose name starts with the first letter of the alphabet: 'he heard it all, right through the *An-An* of the boots within the walls behind his back, *An-An An-An* like himself' (73). At the end of the novel, the soldier seems to leave his post and is relieved from all the violence in an estranging, repetitive dialogue with An. It is in imagination, dialogue and a new language – key ingredients of literature itself – that the subject can find a way out of the impasse with which the novel started. In that way, the end of the novel represents a new beginning.

CONCLUSION

Extrapolating from the case study, we can now draw some conclusions about Ivo Michiels's interpretation of the neo-avant-garde. After his Catholic phase, Michiels became one of the main Belgian promotors of the post-war avant-garde. In the fifties he was a voracious critic who discussed a great deal of modernist and avant-garde works of literature, visual art, cinema and music in

newspaper articles and critical essays. In particular, he was susceptible to the discourse of Zero and modernism in literature. This resulted in an open, inter-artistic and at the same time autonomous approach to his own creative work. His literary ambitions bridged the gap not just with the contemporary avant-garde in the arts but also with the historical avant-garde. On many points, it was the contemporary avant-garde that was the biggest influence on his work.

Through the discourse of novelty and primacy circulating in and around the novel, *Book Alpha* is a distinct contribution to the neo-avant-garde. It is an antinovel in that it resists familiar modes of narrativity, it avoids explicit psychological motivation of characters, it effaces the boundaries between actions, thoughts, desire and memory. What is highlighted, is the negative, oppressive as well as the positive, creative power of language. Right from the start, it is clear that the new is not new and that first experiences are never innocent: rather, the new is moulded out of the old as an antithesis in Adorno's sense. Indeed, *Book Alpha* appropriates traditions of abstraction and expressive reduction in literature and the arts. In that way, it is one of the typical ways in which the avant-garde turns to an experimental tradition. In *Book Alpha*, beginnings are new appropriations, antimimetic procedures that can transform the old (e.g. the oppressive language of commands) into something new (a more abstract, rhythmic language). The obtrusive rhythmic pattern of the hop passage may even call to mind the image of a grid as it is read by Krauss. For Krauss, the grid is a case which reveals the *repetition* in claims of *originality* in the avant-garde. A similar dialectic can be traced in Michiels's novel. In that respect, it is not hard to see how *Book Alpha* is a site of deferred action in Foster's (1996) terms. Standing at the crossroads after the Second World War, the novel offers an understanding of previous avant-gardes, as if for the first time.

NOTES

1. Unless otherwise noted, all translations are mine.
2. Letter d.d. 31-05-1961 (personal archive of Jef Verheyen).

BIBLIOGRAPHY

Adorno, T. W. [1970] (2002), *Aesthetic Theory*, ed. G. Adorno and R. Tiedemann, newly translated, edited and with a translator's introduction by R. Hullot-Kentor, London/New York: Continuum.

Bernaerts, L. (2012), 'Alfa, Cobra, Zero. Abstractie, abstracte kunst en *De alfacyclus*', in L. Bernaerts, H. Vandevoorde and B. Vervaeck (eds), *Ivo Michiels intermediaal*, Ghent: Academia Press, pp. 45–59.

Boelaert, I. (1989), *Programmaverklaringen in de Vlaamse literaire tijdschriften, 1955–1965*, Kapellen: Houtekiet.

Bousset, H. (1988), *Lezen om te schrijven. Een progressieve en cumulatieve lectuur van Het boek Alfa van Ivo Michiels*, Amsterdam: Bezige Bij.

Bru, S. (2018), *The European Avant-Gardes, 1905–1935: A Portable Guide*, Edinburgh: Edinburgh University Press.

Bürger, P. [1974] (1984), *Theory of the Avant-Garde*, trans. M. Shaw, Minneapolis, MN: University of Minnesota Press.

Caianiello, T. and M. Visser (eds) (2015), *The Artist as Curator: Collaborative Initiatives in the International ZERO Movement 1957–1967*, Ghent: Mer. Paper Kunsthalle.

Fontana, L. et al. [1946] (1970), 'Weißes Manifest', in G. Ballo, *Lucio Fontana*, Cologne: Phaidon, pp. 185–9.

Foster, H. (1996), *The Return of the Real: The Avant-Garde at the End of the Century*, Cambridge, MA: MIT Press.

Hegyi, L. (2003), 'Sensualität – Pathos – Spiritualität. Kampf um Totalität', in W. Renn (ed.), *Der unbekannte Fontana*, Ostfildern–Ruit: Hatje Cantz Verlag, pp. 11–16.

Krauss, R. E. (1985), *The Originality of the Avant-Garde and Other Modernist Myths*, Cambridge, MA: MIT Press.

Michiels, I. (1979), *Book Alpha and Orchis Militaris*, trans. A. Dixon, Boston, MA: Twayne Publishers.

Michiels, I. (1995), *Daar komen scherven van. Journal Brut, Boek Zeven*, Amsterdam: De Bezige Bij.

Michiels, I. (2007), *De alfa-cyclus*, Amsterdam: De Bezige Bij.

Neven, E. (2019), *Lijsten vertellen. Een dynamische studie van de aard en functie van de lijstvorm in de Nederlandse literatuur*, dissertation, KU Leuven.

Pankenier Weld, S. (2014), *Voiceless Vanguard: The Infantilist Aesthetic of the Russian Avant-Garde*, Evanston, IL: Northwestern University Press.

Poggioli, R. (1968), *The Theory of the Avant-Garde*, trans. G. Fitzgerald, Cambridge, MA: Belknap Press.

Pola, F. (2010), 'Bodies of Light and Dialectics of the Immaterial: Spazialismo, Essentialisme, Achrome', in *Jef Verheyen: le peintre flamant*, Brussels: Asa Publishers.

Pörschmann, D. and M. Schavemaker (eds) (2015), *Zero: Let Us Explore the Stars*, Amsterdam: Stedelijk Museum Amsterdam.

Vervaeck, B. (2014), 'En garde. Poëtica's voor een nieuwe roman', *Tijdschrift voor Nederlandse Taal- en Letterkunde*, 130 (1), pp. 73–95.

Flemish Hybridity: The Magazine *Labris* (1962–73) and the Neo-Avant-Garde

Dirk De Geest and Bart Vervaeck

INTRODUCTION: THE AMBIVALENCES OF THE NEO-AVANT-GARDE

During the 1960s, the Belgian neo-avant-garde scene was very active, yet at the same time thoroughly dispersed. As far as the arts were concerned, a number of stunning exhibitions and happenings took place, especially in larger cities such as Brussels and Antwerp. In this respect, the organisation of the World Exhibition in Brussels in 1958 acted as a strong catalyst, providing the most up-to-date artists, both from around the world and within Belgium, with a unique forum to show their work to a broad public. In addition, various formal and informal networks of international contacts came into being. In the field of literature, a similarly productive dynamics can be observed, involving numerous, innovative 'isms' and relying on a fervent interest in the contemporaneous international neo-avant-garde as well (Bern et al. 1988).

Yet, in spite of this progressive profile, there remains a fundamental ambivalence within the Belgian neo-avant-garde of this time, which can also be observed in other European countries. First of all, the Belgian literary neo-avant-garde circles – both in the francophone and the Flemish language area – deliberately opted for a marginal stance, next to or even entirely outside of the so-called established literature.[1] This marginal or ex-centric position is in fact an essential component of the innovative programme, comprising both poetics and institutional aspects. As to poetics, young artists and writers concentrated mainly on a negative, even polemical or antagonistic programme. In their opinion, writers should refuse to participate in the treacherous literary establishment and instead give absolute priority to their own individual and collective creative odyssey, in contrast to the fossilised and outdated formulae of traditional literature, both formally (the prevailing

poetic forms and narrative schemata) and thematically (with dominant literature as the emanation of bourgeois and capitalist society). Instead, neo-avant-gardist writers, such as Bert Schierbeek, Lucebert and Ivo Michiels, concentrated on the individual adventure of creation, which was presented as risky, explicitly corporeal and irrational (or even anti-rational).

As far as institutional aspects are concerned, virtually all relations with the literary establishment were taboo. Instead, small and rather informal publishing channels emerged, or authors resorted to self-publishing in very limited editions; books and magazines were printed manually or distributed cheaply via xerography; fixed literary genres were rejected or transformed into hybrid text types. At the same time, however – and here emerges a crucial paradox – the neo-avant-garde does not merely want to realise a kind of anti-literature or non-literature, which would place it outside the domain of literature. Rather, it has the ambition to present a valuable literary alternative. In that sense, the common mechanisms of literary production, canonisation and literary criticism still continue to play an important role, and the same holds for the printed publications, even in the case of texts intended for happenings or oral manifestations. In addition, it can easily be observed that after some time those revolutionary and utopian ideas become less prominent, and some neo-avant-garde writers are integrated into the loathed establishment, financially as well as symbolically. Their oeuvre is no longer supposed to destroy the established cultural hierarchies, it is actually becoming a genuine part of the cultural system. The observation that their oeuvre constitutes a certain affirmation of traditional expectations is in itself enough for younger and more radical colleagues to contest the merits of their former idols, which once again leads to new, supposedly revolutionary neo-avant-garde practices. Indeed, it seems to be an inherent feature of the literary neo-avant-garde that it has a particularly volatile and temporary character.

A similar ambivalence stands out when we look at the way the literary past is used. On the one hand, there is the myth of revolutionary momentum, which intends to break with the past and culminates in presentism – the idea that the past and the future only exist in the form of the present (see Hartog 2003; Heise 1997) – and in futuristic projections peculiar to the rhetoric of many avant-garde artistic movements. The representatives of the neo-avant-garde not only vehemently oppose their traditional contemporaries, but in fact stress their differences with the historical avant-garde in order to underline their own innovative merits and the permanent actuality of the neo-avant-garde. Yet, at the same time neo-avant-gardist writers continue to cultivate their historical roots, not only because of their legitimising value but also as a source of inspiration and creative energy. In this respect the proclaimed discontinuity is less important than the precarious tension between innovation and (avant-garde) tradition.[2]

A CASE OF THE FLEMISH LITERARY NEO-AVANT-GARDE: THE MAGAZINE *LABRIS*

As mentioned, the neo-avant-garde was particularly productive in Belgium during the turbulent sixties. Marcel Broodthaers was active in Brussels. In Antwerp the restored Hessen-house became a centre for artistic innovation, and in the streets the notorious happenings of artists such as Wout Vercammen and Panamarenko attracted a lot of attention.[3] Many remarkable artists of that time, however, have since fallen into oblivion. This is even more so for the countless writers who at that time claimed to propagate their own indispensable variation of neo-avant-garde practices. These activities involved continuous collaborations and virulent polemics, centred around small magazines that emerged suddenly and yet quickly dispersed into a kaleidoscope of new initiatives and journals, of which in most cases only a few issues were published (Pas 2017).

A peculiar exception to this fleeting dynamism is the Flemish magazine *Labris*, which managed to persist for more than a decade (1962–73) during those turbulent years. The remarkable sustainability of the magazine is related to the editorial programme, which, while consistent, remained relatively open at the same time. Moreover, the fact that *Labris* was not published in the centre of Antwerp, as was typical, but actually created in a smaller nearby town of Lier plays an important institutional role as well. Indeed, most of the magazine's core editors lived in the immediate vicinity of the bustling metropolis, but at the same time they maintained a degree of independence from that intricate tangle of groups, controversies and self-proclaimed niches.

The concrete impulse for the founding of *Labris* lay in the dissatisfaction of some young writers with the magazines in which they published at that time. In their opinion, these journals looked like faceless anthologies, publishing literary texts that were both extremely diverse and of inferior quality; such a pragmatic approach left too little room for a far-reaching avant-garde attitude. As a result, a small but close-knit group emerged and started its own magazine, *Labris*. This title refers to the double-bitted axe from Greek mythology, but also to the (proposed but also criticised) etymological similarity with the term 'labyrinth'. Hence, a web of meanings and backgrounds can be uncovered.

In the first place, the title of the magazine refers to the editors' intention to delve into all kinds of mythological and hermetic backgrounds. Secondly, the reference to the labyrinth is not only a metaphor for the multilayered literary work in which both writers and readers have to find their way, it is also a reference to Gustav René Hocke's cult publications, *Die Welt als Labyrinth* ('The world as labyrinth') (1957) and *Manierismus in der Literatur* ('Mannerism

in literature') (1959). As a matter of fact, this German art historian (who, it should be noted, was originally Belgian) had underlined in a large number of publications the importance of mannerism as a literary style and of the labyrinth as a central cultural symbol, not only historically but also in connection to contemporary art and literature. *Die Welt als Labyrinth* was considered an inspiring book by many authors, also outside the circles of *Labris*. Hocke's views, for example, played an important role in the neo-avant-garde magazine *De Tafelronde* ('The round table), in which Paul de Vree and Henri-Floris Jespers reflected upon developments in visual literature in the 1960s.[4] The interest for Hocke and other art historians and literary critics illustrates how the collaborators of *Labris* intended to upgrade their work, both artistically and philosophically. The complex, erudite and heterogeneous network of references to mythology, mannerism, contemporary art, and philosophy established the magazine as an outsider within the context of Flemish literature, which tended to concentrate on its own local identity.

The main reference in the title of the magazine, however, points to the mythological two-headed axe. That image is in itself programmatic for the direction of the magazine: in spite of its militant character (the military connotation of the axe as a weapon is fairly obvious, and is linked to the military connotations of the term 'avant-garde'), *Labris* refused to limit itself to a uniform programmatic line. From the outset, the editors wanted to highlight two widely diverging, if not diametrically opposed, literary practices. Their ultimate goal was by no means the realisation of some sort of synthesis; on the contrary, they wanted to demonstrate that collision was a productive strategy for neo-avant-garde poetics.

The editors of *Labris* themselves defined these two poles as a 'subjective' and an 'objective' form of literature. The first term can be described as a far-reaching variant of expressive romantic poetics, in which poetry is considered to be a radical expression of the individual author's instantaneous experiences. The second term, on the other hand, aims at a thorough abstraction, schematisation and objectivity; in this sense, it embodies a variant of concrete visual poetry, one of the most important expressions of the neo-avant-garde dynamics during the 1960s, with a worldwide network of practitioners.

It is symptomatic of this versatility that the very first issue of the magazine is not accompanied by a collective manifesto. Instead, one member of the editorial team, Hugo Neefs, gave his personal view both on the magazine and on literature in general. Although Neefs's text has been interpreted as a real manifesto of the magazine, it did not function as such in reality. When scrolling through all the issues from the first year, one notices that each issue is introduced by a similar credo from one of the other editors. Instead of one collective statement, the diversity of individual opinions is thus addressed from the outset.

Not only do the ideas expressed in these introductory texts differ substantially, the style and the genre of these statements are also very diverse, including even a poem and a typographical construction of letters and words. This cult of multiformity in itself illustrates *Labris*'s attempt to function as an anthological and a programmatic journal at the same time. Yet, this rather 'open' and 'smooth' profile does not alter the fact that the magazine can still be termed dogmatic in certain respects. All contributing authors are expected to experiment with literature: with text types, with style and rhetoric, with themes and motifs, with structures and genre labels. In addition, they must adhere to the autonomous literary criteria of the editors, who thoroughly discuss all submissions in extensive team meetings. Finally, the editors agree not to publish their texts elsewhere, or at least to submit their work for publication in *Labris* first.

The consequences of these principles are considerable. First of all, the contributions of the editorial team constitute the majority of what is published in the magazine, although even some of their texts are initially rejected as unsuitable, since the magazine's literary principles are considered of prior importance. From an outside perspective, the magazine may be an attractive publishing forum for experimentalists of all kinds, but in many cases their input remains rather limited. Only a few contributors (such as Mark van den Hoof, Wilfried Wynants, Louis Dieltjens, Marcel Bogaerts and Mon Devoghelaere) managed to participate in the magazine for a sustained period of time and to become involved in the editorial policy and the material production.

For the editors themselves it was not always obvious how to maintain and renew this experimental writing practice in a productive manner. Moreover, the diversity and the varying literary quality of what was being published in some issues is at odds with the collective (self-)standard. Conflicts among the editors regularly manifested themselves as a result of not only literary differences but also interpersonal struggles. In particular, the status of Leon van Essche – who was twenty years older than the other *Labris* members – as the guru and 'spiritual' leader of the group proved to be intimidating for some collaborators, as we shall see in due course. Other discussions are related to differences in poetics. Marcel van Maele – despite being one of the godfathers of the Flemish neo-avant-garde and an initial advocate of *Labris* – left the editorial board after the first year. He wanted to maintain the spontaneous dimension within his writing without being controlled by his colleagues, and he also desired to publish in whichever publications he could, which did not fit in with the strict editorial principles of *Labris*. Leonard Nolens too left the group because he felt inhibited in his creativity by the fierce editorial discussions. These quarrels and divergences led to a serious reduction of the central editorial team; in the end, *Labris* relied on no more than a handful of people.

Nevertheless, *Labris* managed to earn its place in the literary landscape for more than a decade as the most radical inheritor and transformer of historical avant-garde poetics. This seemingly stable continuity – especially in the eyes of the outside world – is related closely to the fact that all members of the small team fully identified with the magazine's principles and were intensively involved in both editorial affairs and the material production of the magazine. The doyen and symbolic leader, Leon van Essche, was mainly concerned with the layout of the issues and the actual printing of the stencils. Van Essche was assisted by the other editors, yet it often proved difficult to find enough people to type texts for days, to stencil for hours, and above all to pick out, sort and collect the piles of printed paper that make up each *Labris* issue. These activities were often performed in the family home of Godelieve Peeters, the daughter of the legendary modernist abstract painter Jozef Peeters. This particular space created an almost mystical continuity with the historical avant-garde, as the entire house (including furniture and wallpaper) was originally designed by the artist.

In the editorial team Ivo Vroom was responsible for delivering the issues all over the world. He was not only the editorial secretary of the magazine, but as an employee of the Belgian postal service, he could provide packaging and shipping facilities and ensure the smooth reception of international shipments. Moreover, he also had a large number of free train tickets enabling him to recruit collaborators for the magazine's international issues in Eastern Europe and Southern Europe. After a few years, his responsibilities were taken over by Mon Devoghelaere, a newspaper journalist with extensive administrative qualities and a considerable network, especially as far as jazz music was concerned.

The contributions were, of course, of the utmost urgency for any literary magazine. At the outset, *Labris*'s intentions were clear and flexible. According to its subtitle, 'Literaris tijdschrift der 60ers' ('Literary magazine of the 60ers'), the magazine endeavoured to become the main forum for an entire generation of upcoming writers during the roaring sixties, young people who were considered social 'outsiders' and had to earn their symbolic independence vis-à-vis their predecessors. The label 'Sixtiers' placed the *Labris* authors in direct opposition to earlier generations of Dutch and Flemish neo-avant-garde writers who were commonly called the 'Fiftiers' and the 'Fifty-Fivers' (Brems 2006: 108–44, 202–37). As we have stated before, however, the stern attitude of the editors soon started to deter newcomers. Although dozens of poets, prose writers and essayists made an appearance in *Labris*, most of the pages were reserved for the editorial group themselves. This sustains the image of a fixed core with changing circles of national and international contributors. At the same time, *Labris* took care to address the

different literary practices it promoted in each volume. A detailed biblio-graphic overview of these contributions exceeds the scope of this chapter; however, in order to show both the diversity and the continuity underlying *Labris*'s neo-avant-garde project, we focus on a few central actors who each represent a specific position within the magazine. Successively we will look at Jef Bierkens as the major representative of the so-called subjective poetics, Ivo Vroom and Leon van Essche as representatives of the objective visual poetics, and finally Hugo Neefs as an intermediate figure who embodies the hermetic and mannerist dimension.

SUBJECTIVE LITERATURE: JEF BIERKENS/ MAX KAZAN

The most prominent representative of so-called subjective literature within *Labris* is definitely Jef (Jozef) Bierkens. From early on, he considered himself an anti-bourgeois, and this nonconformist attitude attracted him to the younger generation of neo-avant-gardists.[5] Yet, Bierkens was acutely aware of his para-doxical situation represented by his own life: after a few years, he started to work in his parents' commercial firm, he got married and became embedded within the quintessential bourgeois routine of a settled, domestic existence. As a result, literature to him became much more than a form of entertainment; it symbolised a fully-fledged 'second life', an identity which Bierkens considered authentic and entirely independent of societal and materialistic constraints. His reading material was mainly international. Dutch literature was dismissed as uninspiring and unfit to cope with the contemporary mentality. Bierkens instead developed a passion for French and American literature, and more specifically for all kinds of underground culture. In French literature, Bierkens delved into the *poètes maudits* and surrealism, from Charles Baudelaire and Lau-tréamont to André Breton and the many post-war surrealist poets: these texts inspire his associative visual language, with metaphoric chains which hardly seem semantically coherent. Only an active and creative reader can make sense of the text as a labyrinth of meanings.

Even more important is Bierkens's interest in contemporary neo-avant-garde literature. In fact, he considered the historical avant-garde to be a com-pleted dynamic; an experimental literature that perfectly fitted the artistic and social constellation of the past but which could not be simply transposed onto the 1960s. Bierkens had an exceptional fascination with what was going on in the new world of the United States. This passion even saw him publish much of his work in *Labris* under the American-sounding pseudonym Max Kazan (maybe inspired by the socially critical film director Elia Kazan). In *Labris*,

Bierkens drew the attention of his readers to all sorts of underground titles and to recently discovered authors, from Henry Miller and Anaïs Nin to Lawrence Ferlinghetti, Charles Bukowski and LeRoi Jones. This list, to which dozens of other lesser-known authors can be added, illustrates Bierkens's broad reading frame, but it also demonstrates his particular fascination with figures on the fringes of established literature and bourgeois society.

As both a reader and a writer, Bierkens was obsessed by the ways in which social structures control the lives of individuals, while recognising at the same time that these mechanisms provided an essential stimulus for the creative energy of the outcast – that is, the angry young man and the beat writer, the underground artist and the African American author. Bierkens found these ideas and ideals embodied in the life and work of Jack Kerouac. His experimental work is analysed in great detail in a number of Bierkens's contributions in *Labris*, and the very first book-length study on Kerouac and his work appears as a stencilled edition of the journal: *Jack Kerouac: goudgeneratief gebopbaar & mistigmistieke madman der droevige verdwazing* ('Jack Kerouac: goldgenerative bebopable & mistymystical madman of sad bewilderment') (1965). The monograph is not only exceptionally comprehensive and detailed, it also has an experimental dialogue form and is partly written in the associative style of Kerouac's most innovative works. To Bierkens, the neo-avant-garde of Kerouac is as important as the two forms of the historical avant-garde most dear to him, namely Dadaism and surrealism: 'Jack Kerouac is the antenna of the Beatniks, the antenna of an important post-war generation which to me is as important as the Dada Movement and the *Mouvement Surréaliste*, THE BEAT GENERATION' (1965: 151).[6]

Bierkens sent a copy to Kerouac himself, who replied that he would contribute to an English translation, but unfortunately this vague plan never materialised. Later, Bierkens continued to publish in *Labris* on his beloved beat author, but he also ensured that work by Bukowski, LeRoi Jones and many others appeared in the magazine in translation.

Bierkens's own poems are influenced by that heterogeneous frame of reference, but his most emphatic source of inspiration is undeniably jazz music. Together with jazz journalist and jazz musician Mon Devoghelaere, Bierkens enthusiastically attended concerts in Belgium and abroad, subsequently reporting them in the magazine. Above all they bought jazz records all over the world. The melodic phrases, the striking rhythms, the singing and crying instruments, the compelling interplay of repetitions and contrasts were elements that they attempt to integrate into their experimental jazz poems. Devoghelaere's poetry tries to remain faithful to the music and the cultural background of jazz. In his 'biopoems' as he calls them, the poet evokes the life and work of famous musicians, in a style that mixes narrative and associative lyrical fragments but which remains largely readable.

Kazan/Bierkens, on the other hand, is much more radical in his pursuit of authentic jazz lyricism. For him, it is not merely about the evocation of jazz music and jazz musicians in thematic phrases, or about the use of musical images and motifs. Rather, the poet has to become his own jazz instrument, with verbal compositions in which sound and rhythm are pushed to their limits and in which spontaneous improvisation dominates. To this end, the common syntax is broken up entirely, confronting the reader with blocks of isolated words that must be forged into (more or less) meaningful connections. Moreover, the poem often consists of opaque compound words and mannerist neologisms intended to increase the possibilities of meanings and connotations. In addition, abundant attention is paid to rhythm and dense sound patterns (involving alliterations, assonances and quasi-anagrams). It is entirely up to the reader to come to terms with these associative eruptions of words and to distil all kinds of (provisional) meanings from these elements.

The result is an intriguing but hermetic mix of elements reminiscent of surrealism, jazz and beat literature. Recurring themes in Bierkens's poetry are the severe criticism of civil society and its cult of capitalism, religion and sexual norms. Through alternative, phantasmatic visions of transgressive sexuality, mysticism, intoxication and ecstasy are also evoked, but there are images of violence and destruction too.

OBJECTIVE LITERATURE: IVO VROOM AND LEON VAN ESSCHE

Diametrically opposed to the subjective linguistic eruptions of poets such as Bierkens/Kazan and Devoghelaere is the objective lyricism of *Labris*. Representatives like Leon van Essche and Ivo Vroom do not opt for the far-reaching exploration of the subjective I nor for a spontaneous style. On the contrary, they take the objective structures of language as a starting point for their poetic experiment. In their search for the 'pure' essence of language as an autonomous, closed system, they drew their inspiration mostly from concrete visual art and literature.

In those years, visual poetry flourished in a broad international network, stretching from Brazil to Japan.[7] In Belgium, these autonomous ideas were defended most fervently by Paul de Vree with his magazine *De Tafelronde*. *Labris*'s collaboration with De Vree was turbulent, since De Vree wanted to be the guide for all neo-avant-garde young writers – a role Van Essche claimed for himself in the *Labris* group – and also because De Vree's ideas about the relationship between visuality and poetry changed quite often. In the 1960s, for example, he abandoned the principles of concrete visual poetry in favour of the political commitment of the Italian *poesia visiva* artists. De Vree's poems

became predominantly visual collages of various elements which, in combination with linguistic elements, were meant to convey political criticism and action. There is little or no explicitly political commitment in the creations of the *Labris* representatives. More important to *Labris* is the experiment with the intricate relationships between word and image and between form and meaning. *Labris* investigates the ways in which visual constellations can be constructed by combining, repeating and varying language blocks (words or morphemes), anagrammatic letter patterns, and so on.

In this respect, Van Essche is definitely the most radical experimental author within the group. His work gradually shifts towards abstraction and reduction, but at the same time becomes more hermetic. He creates a challenging interaction between words on the one hand (in different languages and combined into associative chains instead of grammatical sentences) and visual spatiality on the other. Words are dissected into isolated letters or syllables, and those building blocks are typed in various directions across the page. Yet, the poet is not only concerned with presenting visual images; in his diagrams he discerns self-made languages and mysterious messages in line with tarot and with the hermetic and esoteric traditions he had studied for years, including number symbolism, mannerisms, the Rosicrucian and the Sufi symbolic language.

Ivo Vroom's texts, in contrast, remain more in line with what is commonly called concrete visual poetry. He shifts from language-oriented poems towards poetry in which the typographic and the graphic arrangement prevails. This concentration on the visual dimension can be related to a growing international interest in his work, and Vroom consequently starts to integrate languages other than Dutch (especially English) into his visual poetry.

The international focus was even more important for the representatives of the objective literature in *Labris* than for their subjective colleagues. In fact, Leon van Essche and Ivo Vroom were members of an informal international network of concrete poets and associated neo-avant-garde artists, including artists from Fluxus. They made use of the already existing connections of De Vree and his magazine *De Tafelronde*, but *Labris*'s contacts gradually covered the entire Western world, from the United States to Brazil, from Scotland to Canada, from Russia to Portugal. After a while, *Labris* reserved a lot of space for creative contributions from abroad (original work or copied from other marginal neo-avant-garde magazines), and from the fourth year onwards the magazine really went international.

In the summer of 1966, a bulky double issue of more than 200 pages was published, offering a unique sample of international concrete poetry. In addition to numerous new names and tendencies, all established stars of international concrete and visual poetry were represented, together with new recognised

talents: the French Henri Chopin and Ilse and Pierre Garnier, the Swiss Eugen
Gomringer, Austrians Ernst Jandl and Friederike Mayröcker, Brazilians Augusto
and Haroldo de Campos, the English Michael Horovitz and Brian Patten, the
Scot Ian Hamilton Finlay, and the Americans Charles Bukowski, LeRoi Jones,
Gary Snyder and Mary Ellen Solt. In the years that followed, many of these
artist-writers published regularly in *Labris*. In addition, various visual poets from
(amongst others) Greece, Italy and Czechoslovakia appeared in the interna-
tional issue of the seventh year.

Of course, the completion of such an international anthology took an
impressive amount of time. Letters had to be written in numerous languages
and collecting names and addresses from potential collaborators turned out to
be a real ordeal, not only in the case of Eastern European communist coun-
tries. To solve these problems, the magazine's international network of con-
tacts proved invaluable. One of the German visual poets, for example, knew
the address of Ernst Jandl, and he provided the *Labris* editors with a list of
names and addresses of innovative (often completely unknown) visual poets
in Czechoslovakia and other Eastern European countries. The contacts with
the American poets, on the other hand, were based mostly on already existing
relations with various small presses and underground publishing houses. One
of the early collaborators of *Labris* was the American poet Mary Ellen Solt,
who in 1968 published the 'bible' of concrete poetry: the repeatedly reprinted
anthology *Concrete Poetry: A World View*. In that book, the Belgian represen-
tatives occupied a not insignificant place, with the editors of *Labris* next to
De Vree himself. Through this internationally acclaimed anthology, the work
of Vroom and Van Essche has continued to enjoy international fame to the
present day and the magazine is still mentioned in international overviews
of neo-avant-garde visual poetry, such as the comprehensive collection on
UbuWeb (ubu.com).

HERMETIC LITERATURE: HUGO NEEFS

In 1963 Hugo Neefs – a literary critic in the *Labris* group, but also active as
a poet and a writer of experimental prose texts – published *De kulturellen*, a
short novel, if that genre indication may be used for this experimental form of
poetic prose. The book appeared as the sixth volume of the 'labirintuitgaven'
('labyrinth editions'), a collection of xeroxed books with a limited number of
copies produced by *Labris* itself. There are no page numbers[8] and there is no
blurb to help the reader. The title of the novel is not an existing Dutch word.
At first sight, it seems to be a contamination of 'culture' ('kultuur' in the then
fashionable progressive spelling used by *Labris*) and 'riots' ('rellen' in Dutch).

As such, the reader might expect a book about social upheaval and cultural revolutions, but the social world of the sixties is hardly mentioned.

In fact, 'de kulturellen' refers to a group of people who meet in a club, 'a dirty hole underground' (Neefs 1963: 30), and spend their time talking about art and culture. The term, which we will translate as 'the culturals', is derogatory. Perhaps, the title alludes to the French 'culturals', with its association of snobbishness. The club members think they are better than the rest, but they only recycle clichés: 'their passive bodies long for stable sleep but in between them hovers the threadless drooling cultural dispute bloodless listless' (66). They think they are an elite, but in reality they are 'a mass with the word culture as an excuse for impotence' (80). The culturals consists of vague characters like 'johan', 'jozu', 'papa pepie', the painter 'dias' and 'onan'. They are voices rather than embodied beings, with one exception, 'dandi', who is one of the two main characters of the story.

The culturals feature only in the chapters titled 'recitative'. The term refers to the combination of language and music, but not, as might be expected in the context of *Labris*, to jazz. Typically, the recitative is a part of classical music, more specifically operas, oratorios or cantatas. In contrast to an aria, a recitative stays close to the rhythm and flow of ordinary language and restricts the musical contributions to an accompaniment. Obviously, the combination of word and sound, language and music ties in with the poetics of *Labris*, with its focus on the materiality of language rather than on its semantic and referential aspects.

In *De kulturellen*, the recitatives always introduce the central story of the two main characters, 'de keyser' (henceforward De Keyser) and 'dandi daufin' (henceforward Dandy). This appears to be a logical systematisation and indeed the book as a whole has a clear structure. It consists of five parts plus a prologue with each part having a date as its title: July 13, October 22, December 24, February 20, March 24. This suggests a chronological evolution, involving the four seasons. As we shall see, the book may indeed be read as the seasonal evolution of a romantic relationship. In addition, each part consists of three chapters: first the introductory recitative featuring the culturals, second the story of the two main characters, and lastly the love story between Dandy and 'silvie' (henceforward Sylvie), entitled 'the hanging gardens of Babylon'.

The prologue contains an untranslatable pun highlighting the metafictional scope of the book from the very start. It is called '(pro)LOGOS als (voor)STELLING', which comes close to '(pro)LOGOS as (an initial) THESIS'. This suggests that the word ('logos') is to be taken as a hypothesis and as an attempt at creating a system, similar to mathematics. However, as soon as the reader has digested the first words of the prologue, any form

of systematisation seems a remote possibility. The preface consists of two chapters: 'the biography of de keyser' and 'the biography of dandi de daufin'. Here are the first words of the first biography: 'cerberus resides in the last boat / supreme basalt monk (because he paints sonorous lethal dangers hammering open satanic daughters thrown together around the teeth of keys sulphuric acid poison demolition yard the blackest hands wing rascal asthmatic thundering)' (5).

Both as a biography of the main character and as a thesis supposedly governing the book, this beginning seems to fall short. It does, however, make clear that the world we are about to enter is a world of words combined not because of their semantic ties, but because of their sound, rhythm and imagery. What we get is a form of a descent into hell (hence the Cerberus), the hell of the underground club that is the culturals. The way to reach that underworld is not via a lucid guide like Virgil (in Dante's canonical descent), but via an experimental play with the materiality of language.

Gradually, the experiment does allow for some semantic elucidation in the form of narrative elements such as characters, events and setting. The name of the main character, De Keyser, suggests he is an emperor ('keizer' is 'emperor' in Dutch), but the text clearly states he has lost his fame, money and power. Maybe the character refers to the Dutch experimental poet Lucebert who was generally known as 'the emperor of the Fiftiers', the consecrated experimental poets against whom *Labris* had to position itself. The poets of labrys, the double-headed axe, may also be symbolised by De Keyser, who is described as a dual artist, a writer and a dancer, a 'doubleheaded janus' (8). In general, De Keyser stands for the mannerist, experimental and hermetic tradition; in particular, the character is modelled on Leon van Essche, the guru who introduced Neefs and his friends to the world of experimental art and whom they regarded as the new Lucebert. De Keyser used to be a hypnotist, helping psychiatrists to delve into the subconscious of their patients (88). As such, he may be linked to the surrealist tradition. Now, he lives in an ivory tower reduced to an attic, and he writes about the Minotaur, 'Daludes' (a clear transposition of Daedalus), 'Adriane' and 'Dariane' (both transpositions of Ariadne), and Icarus.

'Dandi de daufin', or Dandy Dauphin, is on the one hand the heir to the emperor. That is symbolised by his family name, dauphin. He is described as 'the only witness and patient listener' (39) left to the isolated De Keyser, and even as his pupil (78) and follower (36). On the other hand, he is a dandy, he will always remain partially uncommitted and free of ties, even within the experimental tradition of De Keyser. His writing is not as experimental as De Keyser's. He has simplified the baroque richness of De Keyser's language and

searches for the self: 'since then the words had become so simple (signs for everyone different) that they had disappeared from his thoughts: this is how the writing of BEING ITSELF had started' (13). As a result, Dandy continually wavers between two traditions: the labyrinthine tradition of De Keyser and the classic tradition of self-expression, of language as a mirror to the self. This is part of the dialogue between the two characters and the two types of literature: 'one day, then we fall to our death in the labyrinth [. . .]. our final straw remains the classic: we mirror ourselves in the classic, perfect shadow' (24).

This classic quest narrative is at the core of 'the hanging gardens of Babylon', the third narrative strand in addition to the recitative and the story of the two protagonists. This is in fact a love story, ecstatic and poetic in nature but also tainted by the unattainability of the loved one and by the dark undertones of love: fear, decay and death. The language here tries hard to capture the sensual and corporeal aspects of love, it wants to dig deeper than 'the words which build de keyser: grey skin' (80). Dandy is trying to develop a language that will get under the skin. Interpreted on a metafictional level, the story tells about the difficulties of reconciling language (Dandy) and body (Sylvie, 'body sliding through the day as the light does', 81). Dandy comes close, but in the process he seems to lose his 'thread' of Ariadne (91) and shrinks in fear in front of the mirror. He smashes the mirror, which looks like a form of self-destruction and defeat. Sylvie, his beloved one, has to comfort him and urges him 'to carry on dandi go on living' (93). This advice fills the final page of the book and appears to echo the thesis of the prologue. Maybe the central thesis of the story is that we have to carry on – carry on the experimental tradition and, in so doing, carry on living.

The three parts of the narrative whole – the recitative, the story of the emperor and the dauphin, the love story of Dandy and Sylvie – are clearly interrelated. On the level of characters, Dandy is present in the three narrative worlds: he visits the club of the culturals, frequents the attic of De Keyser and he is the main character in 'the hanging gardens of Babylon'.[9] On the level of style, the three strands combine prose and poetry, albeit in their own way. The story of De Keyser is the most baroque and hermetic, the love story is the most ecstatic and concise, and Dandy's narrative hovers between the two. On the semantic level, the three planes combine love and death, passion and decay. De Keyser writes mythological stories about the labyrinth and the murders that take place around it. In the end, he disappears, leaving his lover, the concierge, and his friend, Dandy, behind, 'hopelessly alone and already estranged from the world' (90). The painter 'dias', one of the culturals, kills his beloved muse. Only Dandy, who attempts to kill himself by smashing the mirror, is summoned to go on living and loving.

On the whole, *De kulturellen* can be read as a neo-avant-garde experiment typical of *Labris*. That is exactly what happened in the two reviews that were devoted to the book and that appeared in the third issue of the second volume of the journal. The first one, written by Louis Dieltjens, starts with a motto taken from Gustav René Hocke's *Die Welt als Labyrinth*. It states that mannerism tries to find an emblematic and deformed form for the hidden. Dieltjens describes the culturals as the enemies of mannerism and of *Labris* (1964: 82). Then he goes on to describe Dandy's evolution from wavering between the classics (which he aligns with the culturals) and the labyrinthine artists (De Keyser) as a choice for life and love. Dandy is 'a modern Ulysses' and Neefs is one of 'the angry young men' (1964: 83). Dieltjens also compares the author to the two most (in)famous literary neo-avant-gardists, Bert Schierbeek in the Netherlands and Ivo Michiels in Flanders, but he says that Neefs differs from both of them in that he tries to find a psycho-logic behind the mannerist association of sounds and words. Neefs combines the sound associations and metaphoric networks typical of mannerism with a psychological systematisation, which sets him apart from other experimental writers (1964: 84–5).

The second review, written by Max Kazan, stays closer to the text and consists largely of a chapter by chapter paraphrase. Like Dieltjens, Bierkens sees De Keyser as a labyrinthine or *Labris* writer and he interprets the culturals as 'pseudo-high-brows' (Kazan 1964: 89). Again, Joyce is used as a reference: Dandy's love Sylvie is compared to Molly Bloom (1964: 90) and once more, Neefs is preferred over Bert Schierbeek, because he (Neefs) adds substance to the word play so typical of the neo-avant-garde: 'It is not restricted to superficial phrasing – Schierbeek is an example of this – since phrasings are here filled with ESSENCE, lacking in a great number of young poets who dare to call themselves "modern"' (1964: 91). Bierkens links Dandy's shattering of the mirror to the emblematic and deforming role of the mirror in the mannerist tradition (1964: 92). More specifically, he refers to the famous painting by Parmigianino (Francesco Mazzola), *Self-Portrait in a Convex Mirror* (1523).

On the whole, both *De kulturellen* and the reviews of the book bear witness to the balancing act performed by the type of neo-avant-garde exemplified by *Labris*. As to past traditions, they explicitly refer to mannerism and modernism (Joyce). Moreover, *De kulturellen* employs the style and the psychological descent into the subconscious typical of surrealism. As to the present, they are critical of the classical literature symbolised by the culturals, but they are equally critical of the experimental literature of the day, personified by Lucebert, Bert Schierbeek and Ivo Michiels. They are even critical of their own emperor, Leon van Essche. *Labris* is a double-headed axe indeed.

CONCLUSION

This very succinct overview of the magazine *Labris* needs to be comple-
mented by a more detailed discussion of its view on foreign literature and
avant-garde art. Moreover, alongside the main issues of the magazine, a
large number of leaflets were distributed in order to cope with all manner of
urgent messages and new publications. Yet, in spite of these restrictions, this
chapter has demonstrated how *Labris* tries to formulate its own view on the
neo-avant-garde, taking into account the international dynamics as well as
the Dutch–Flemish tradition. This results in what could be called an eclectic
conception of literature, combining elements from the historical avant-garde
(notably surrealism) with various contemporaneous types of innovative lit-
erature and culture (including jazz music, African American literature, beat
literature and concrete visual tendencies). Instead of cultivating a consistent
programme, *Labris* tried to propose opposite literary practices by publishing
subjectivist eruptions of language as well as objectivist, visual constructs and
mannerist experiments. This ambiguous view not only proved stimulating
for the group of collaborators, but it also inspired the numerous writers from
around the world who contributed to the magazine.

NOTES

1. For a general overview of the various instances of neo-avant-gardism in
 the Low Countries, see Brems (2006).
2. A comprehensive discussion of the relation between the Flemish neo-
 avant-garde and the historical avant-garde (notably the works of Paul van
 Ostaijen) is to be found in Buelens (2001).
3. The role of happenings in Brussels and Antwerp is discussed in Wouters
 (2016). For a general overview of the artistic dynamics in Belgium, see
 amongst others Geirlandt (2001); Dewachter and Ceuleers (2012).
4. Pas (2012) deals with De Vree's position in the context of the international
 neo-avant-garde.
5. The information concerning the self-positioning and the poetics of the
 authors we discuss here is based on an in-depth investigation of the *Labris*
 archive deposited in Het Letterenhuis (The House of Literature) in Antwerp.
6. All translations are ours.
7. Ramon (2014) provides a detailed overview of the contribution of the
 Low Countries to the international scene of concrete poetry.
8. We have numbered the pages ourselves. The text starts on page 4 with the
 title of the prologue and ends on page 94.

9. De Keyser's story about the labyrinth deals with Daludes' plan 'to build a garden of delights that would equal the hanging gardens of Babylon' (Neefs 1963: 70). As such, the love story of Dandy and Sylvie may be read as an embedded narrative, a part of the stories told by De Keyser.

BIBLIOGRAPHY

Bern, B. et al. (1988), *Antwerpen de jaren zestig*, Schoten: Hadewijch.

Bierkens, J. G. (1965), *Jack Kerouac: goudgeneratief gebopbaar & mistigmistieke madman der droevige verdwazing*, Antwerp: Labris.

Brems, H. (2006), *Altijd weer vogels die nesten beginnen. Geschiedenis van de Nederlandse literatuur 1945–2005*, Amsterdam: Bert Bakker.

Buelens, G. (2001), *Van Ostaijen tot heden. Zijn invloed op de Vlaamse poëzie*, Nijmegen: Vantilt.

Dewachter, L. and J. Ceuleers (2012), *Nieuwe kunst in Antwerpen 1958–1962*, Antwerp: MHKA.

Dieltjens, L. (1964), 'De kulturellen (h neefs)', *Labris*, 2, (3), pp. 81–5.

Geirlandt, K. J. (2001), *Kunst in België na 1945*, Antwerp: Mercatorfonds.

Hartog, F. (2003), *Régimes d'historicité: présentisme et expériences du temps*, Paris: Seuil.

Heise, U. K. (1997), *Chronoschisms: Time, Narrative, and Postmodernism*, Cambridge: Cambridge University Press.

Hocke, G. R. (1957), *Die Welt als Labyrinth. Manierismus in der europäischen Kunst und Literatur*, Hamburg: Rowolt.

Hocke, G. R. (1959), *Manierismus in der Literatur. Sprach-Alchimie und esoterische Kombinationskunst*, Hamburg: Rowohlt.

Kazan, M. [J. Bierkens] (1964), '"De kulturellen" (h neefs)', *Labris*, 2 (3), pp. 86–92.

Neefs, H. (1963), *De kulturellen*, Antwerp: Labris.

Pas, J. (2012), *Neonlicht. Paul De Vree en de neo-avant-garde*, Brussels: AsaMER.

Pas, J. (2017), *Artists' Publications: The Belgian Contribution: Books, Magazines, Artists, Publishers*, London: Koenig Books.

Ramon, R. (2014), *Vorm & visie. Geschiedenis van de concrete en visuele poëzie in Nederland en Vlaanderen*, Ghent: Poëziecentrum.

Solt, M. E. (1968), *Concrete Poetry: A World View*, Bloomington: Indiana University Press.

Wouters, S. (2016), *Vluchtigheid en verzet. Sporen van het internationaal happeninggebeuren in België*, Brussels: VUBPress.

Index